oᴙ+12

VIRTUE AND VICE

INDEX OF CHRISTIAN ART

RESOURCES I

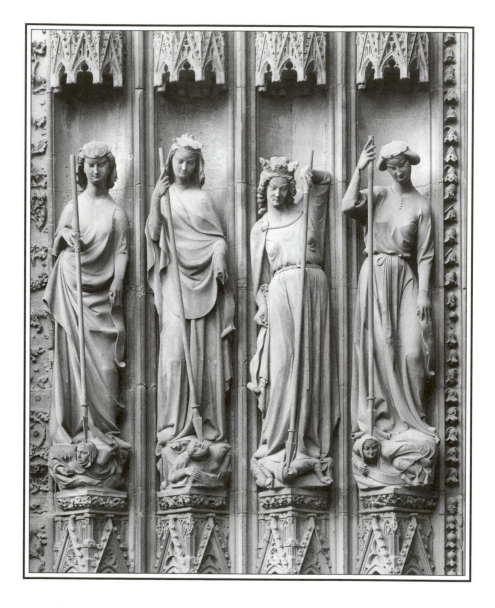

Virtue & Vice

THE PERSONIFICATIONS IN THE INDEX OF CHRISTIAN ART

EDITED BY

COLUM HOURIHANE

INDEX OF CHRISTIAN ART
DEPARTMENT OF ART AND ARCHAEOLOGY
PRINCETON UNIVERSITY
IN ASSOCIATION WITH
PRINCETON UNIVERSITY PRESS

Library of Congress Cataloging-in-Publication Data

Virtue and vice : the personifications in the Index of Christian art /
edited by Colum Hourihane.
p. cm. — (Index of Christian art resources ; 1)
Includes bibliographical references and index.
ISBN 0-691-05036-8 (cloth : alk. paper) —
ISBN 0-691-05037-6 (paper : alk. paper)
1. Virtues in art—Indexes. 2. Vices in art—Indexes.
3. Personification in art—Indexes. 4. Christian art and
symbolism—Medieval, 500–1500—Indexes. I. Hourihane,
Colum, 1955– II. Princeton University. Dept. of Art and
Archaeology. Index of Christian Art. III. Series.
N8012.V57 V57 2000 704.9′482—dc21 99-056975

Books published by the Department of Art and Archaeology,
Princeton University, are printed on acid-free paper and
meet the guidelines for permanence and durability of the
Committee on Production Guidelines for Book Longevity
of the Council on Library Resources.

This book has been composed in Trump Medieval by
Impressions Book and Journal Services, Inc.

Printed in the United States of America by CRW Graphics

Produced and designed by Laury A. Egan

1 3 5 7 9 10 8 6 4 2

Contents

🎔

PART 1: ESSAYS

PART 2: CATALOGUE OF VIRTUES AND VICES IN THE INDEX OF CHRISTIAN ART

Acknowledgments

THE FIRST PUBLICATION by the Index of Christian Art was the volume by Helen Woodruff which detailed the resources and cataloguing guidelines of the archive. It was nearly twenty years later that the Index's second publication appeared: the pioneering study by Isa Ragusa and Rosalie Green of the manuscript of *Meditations on the Life of Christ*.[1] This paved the way for a number of more recent publications which have combined the twin focuses of iconography and methodology for which the Index has always been known.[2] All of these publications have attempted to reflect the range and scope of the archive and to convey its particular strengths. It is hoped that the present publication will fulfill a similar task and do credit to the scholars who have developed the resource over the last eighty years. It would be impossible to name all of the individuals who have laboured over the compilation of the files on the Virtues and Vices and the many other subjects in the Index of Christian Art's archive. The Index has a life of its own which depends on but is greater than the individuals who have given selflessly of their scholarship.

My thanks, however, must go firstly to the contributors who have, at short notice, contributed their fine essays to the first part of this volume. They have all cooperated in meeting stringent deadlines with good humour and charm. Marie Holzmann, in her typical good-humoured and efficient manner, and with the able assistance of a group of students, painstakingly checked the manuscript of the catalogue of Virtues and Vices against the card files and traced that missing entry or that scrambled reference. John Blazejewski, as always, was equally considerate and efficient in meeting the inevitable photographic demands that this publication required. The photographs of the Notre Dame Virtues and Vices which appear in the catalogue were taken by James Austin.

A general note of thanks must also be given to the curators and archivists who generously responded, usually at very short notice, to our queries regarding current inventory numbers and present locations of the objects in their collections. In particular, Carol Togneri of the Provenance Index, Getty Research Institute, Los Angeles, was instrumental in filling some of the gaps in information regarding panel paintings. Alyce Jordan generously reviewed a section of the catalogue with her expert eye, and for that I am grateful.

The current scholars in the Index, Adelaide Bennett Hagens, Lois Drewer, and Achim Timmermann, must be thanked not only for the information they provided for this volume, but also for the heroic work which they have undertaken in developing the files in the archive. They are the named few who, together with all of the past directors and scholars, must be thanked for creating the most important repository of medieval scholarship in existence. I

hope that none of the unnamed will take offense if they are not mentioned individually but will accept this general and sincere expression of thanks.

The publication of this volume was generously supported by the Publications Committee of the Department of Art and Archaeology, Princeton University. My sincere thanks go that committee and to Susan Lehre, manager of the Department of Art and Archaeology, for practical advice and assistance. My greatest vote of thanks must go, once again, to Christopher Moss, editor of publications in the Department of Art and Archaeology, who has enthusiastically supported this project since its inception. He has worked with all of the contributors in a good-natured, efficient, and scholarly manner and has made valuable suggestions at all levels. He also served as managing editor of this volume. One of his most significant contributions to this publication, however, was his research on the catalogue, which improved it greatly, bringing to light, among other things, the current locations, attributions, and dates of a large number of objects.

<div align="right">
COLUM HOURIHANE

Director, Index of Christian Art
</div>

NOTES

1. *Meditations on the Life of Christ: An Illustrated Manuscript of the Fourteenth Century, Paris, Bibliothèque Nationale, Ms. Ital. 115* (Princeton, 1961).

2. *The Ruthwell Cross: Papers from the Colloquium Sponsored by the Index of Christian Art, Princeton University, 8 December 1989*, ed. B. Cassidy (Princeton, 1992); *Iconography at the Crossroads: Papers from the Colloquium Sponsored by the Index of Christian Art, Princeton University, 23–24 March 1990*, ed. B. Cassidy (Princeton, 1993); *Image and Belief: Studies in Celebration of the Eightieth Anniversary of the Index of Christian Art*, ed. C. Hourihane (Princeton, 1999).

Note on the Contributors

RON BAXTER began his career in the field of science before taking his Ph.D in art history from the Courtauld Institute of Art, University of London, in 1990. The subject of his thesis was the Latin bestiary in England, which was subsequently published as *Bestiaries and Their Users in the Middle Ages* (1998). Since 1987 he has been academic slide librarian in the Courtauld Institute, where he is also involved in the teaching of medieval art. He has published extensively on manuscript studies, including works on medical and scientific texts. A fellow of the Society of Antiquaries and the British Archaeological Association, he is also editor of the British Academy's *Corpus of Romanesque Sculpture in the British Isles*.

ANNE-MARIE BOUCHÉ is a graduate of the Department of Art History of Columbia University, where she studied under Jane Rosenthal, Stephen Murray, and Caroline Bynum. She received her Ph.D. from Columbia in 1997, writing a dissertation titled "The Floreffe Bible Frontispiece and Twelfth-Century Contemplative Theory." She has lectured extensively on image and exegesis in medieval art. Prior to joining the Department of Art and Archaeology at Princeton University in 1998, where she is now assistant professor, she worked at the Cloisters Museum and at Long Island University.

JESSE M. GELLRICH is professor of English at Louisiana State University. He has also taught at the University of Michigan, Santa Clara University, and the University of California. He has published extensively on his particular interest, the book in the Middle Ages, including *The Idea of the Book in the Middle Ages: Language, Theory, Mythology, and Fiction* (1985) and *Discourse and Dominion in the Fourteenth Century: Oral Contexts of Writing in Philosophy, Politics, and Poetry* (1995).

COLUM HOURIHANE studied archaeology at University College, Cork, before receiving his Ph.D. at the Courtauld Institute of Art, University of London, where he studied under George Zarnecki. He has published on Early Christian iconography and standards for art-historical classification, and was the editor of *Image and Belief: Studies in Celebration of the Eightieth Anniversary of the Index of Christian Art* (1999). He has been the director of the Index of Christian Art since 1997.

S. GEORGIA NUGENT is associate provost and lecturer in the Department of Classics at Princeton University. She received her Ph.D. from Cornell in 1978 and has served as professor of Classics on the faculties of Swarthmore

College, Cornell University, and Brown University. A recipient of National Endowment for the Humanities, Fulbright, and other research fellowships, she is the author of over three dozen articles, reviews, and papers. Best known for her study *Allegory and Poetics: Structure and Imagery in Prudentius' Psychomachia* (1985), she has just completed work on a monograph titled *The Representation of Women in Roman Epic*, to be published by Oxford University Press.

ACHIM TIMMERMANN received his Ph.D. from the Courtauld Institute of Art, University of London, in 1996, writing a dissertation entitled "Staging the Eucharist: Late Gothic Sacrament Houses in Swabia and the Upper Rhine," which examines late medieval architecture, iconography, and spirituality in southern Germany. His particular interest and the focus of a number of his publications is central European Gothic art. Prior to joining the Index of Christian Art in 1998 as a scholar, he worked at the Courtauld Institute, where he was editor of the CD-ROM publication of Garrison's *Italian Romanesque Painting: An Illustrated Index.*

List of Illustrations

Frontispiece: Strasbourg Cathedral, west porch, Virtues vanquishing Vices (photo: Conway Library, Courtauld Institute of Art, London)

The Art of the Tongue: Illuminating Speech and Writing in Later Medieval Manuscripts
JESSE M. GELLRICH
(pages 93–119)

The Virtuous Pelican in Medieval Irish Art
COLUM HOURIHANE
(pages 120–147)

Catalogue of Virtues and Vices in the Index of Christian Art
(pages 151–442)

Abbreviations

✎

Bartsch	*The Illustrated Bartsch*. Ed. W. L. Strauss. New York, 1978– .
CCCM	Corpus Christianorum, Continuatio Mediaevalis
CCSL	Corpus Christianorum, Series Latina
Col.	Colossians
Cor.	Corinthians
CSEL	Corpus Scriptorum Ecclesiasticorum Latinorum
Dan.	Daniel
Eph.	Ephesians
Ex.	Exodus
Gal.	Galatians
Gen.	Genesis
Is.	Isaiah
Jer.	Jeremiah
LCI	*Lexikon der christlichen Ikonographie*. Ed. E. Kirschbaum et al. Eight vols. Rome, Freiburg, Basel, and Vienna, 1968–76.
Lk.	Luke
Matt.	Matthew
Phil.	Philippians
PG	Patrologia Graeca
PL	Patrologia Latina
Prov.	Proverbs
Ps.	Psalms
Ps. Gall.	Psalms, Gallican version
RDK	*Reallexikon zur deutschen Kunstgeschichte*. Stuttgart, 1937– .
Rom.	Romans
Th.	Thessalonians

VIRTUE AND VICE

Introduction

THROUGHOUT the more than eighty years of its existence the Index of Christian Art has always attempted to externalize its resources beyond its home at Princeton University. This was due in large part to the founder of the Index, Charles Rufus Morey (1877–1955),[1] who was one of those rare turn-of-the-century scholars for whom geographic boundaries did not exist. His aim, consistently reflected in the Index of Christian Art as well as in his own scholarship, was not only to bring together resources from around the world, but also to make them available to as wide an audience as possible. Prior to his death he oversaw the pioneering 1942 publication by the then director of the Index, Helen Woodruff, of the cataloguing standards and guidelines used by the archive.[2] This was the first publication of its type, and indeed nothing comparable has been attempted since. It was also the first attempt to inform the scholarly world of the resources that were available in the Index of Christian Art. Even though no individual works of art were described in that volume, it did let scholars know of the subject terms and the range of material covered by the Index. It also had the desired effect of providing interested institutions with a framework for their own cataloguing procedures.

In keeping with this spirit of sharing the scholarship and standards of the most important archive of medieval art in existence, copies of all of the text and image files were made and dispersed to four various locations in Europe and the United States between 1940 and 1964. Before the age of computerization these provided the best available means of bringing the Index closer to scholars. With the introduction of computers into the archive in 1991, improved access was made possible at the parent site in Princeton, and this was followed in 1997 by Internet access to the database. This new interface allows the electronic text and image files that had previously been available only in Princeton to be used by the scholarly community throughout the world at the press of a button. The ease of access and the speed with which these resources can now be made available to scholars everywhere are developments that we believe would have pleased Charles Rufus Morey.

When the Internet was in its infancy, it was understandably but foolishly believed that the end of traditional paper publications was imminent. The publication of the text files in the present volume makes a statement not only about the wealth of material the Index has gathered, but also about its commitment to making its holdings available in a variety of formats. Electronic publications are a strong focus of the Index, but it is hoped that this volume will make the resources of the archive available to an even wider public. Although the Index's cataloguing guidelines have been published in both elec-

tronic and hardcopy formats, this is the first publication of an extract from its text files.

The task of selecting a body of material for this first publication of the Index's resources proved to be a difficult one. It would have been possible to document, for example, the largest listing of saints in existence, or to select a theme such as the 27,000 Crucifixion scenes classified in the Index's files. The reasons underlying the choice of the Virtues and Vices were manifold. This file, like so many of the other subjects in the archive, is the largest such catalogue available to the medievalist. It is not only the most comprehensive list of known personifications, but also includes many that have never previously been documented. Personifications such as Oblivion, Oath-Keeping, Long-suffering, Love of Neighbor, and Guilelessness accompany the better-known moral values, which range from Ambition to Wrath and from Abstinence to Wisdom. Altogether, this catalogue includes 227 different personifications and documents their appearance in well over a thousand works of art up to the start of the fifteenth century.

The practice of representing moral qualities in human form can be traced back to the classical period, when the human form was frequently used to convey abstract ideas and values.[3] The change from literal to symbolic values has been dealt with in numerous studies.[4] In his pioneering work on this theme, Adolf Katzenellenbogen believed that the earliest depictions of these personifications were not static representations but dynamic images that showed the actual struggle or battle between the opposing moral values.[5] The introduction of this theme has been credited to the fourth- or early fifth-century Spanish author Prudentius in his work the *Psychomachia*,[6] which has survived in sixteen manuscripts dating largely from the ninth century, all of which are included in this extract from the Index's files. Prudentius's work details the battles between a series of opposing values, such as Faith and Idolatry, which ultimately end with the Virtues triumphant. In contrast to this dynamic representation of the concept, which draws extensively from battle scenes such as those on the Late Antique sarcophagi, there is a second and more subtle means of depicting these moral values. This is the static image, in which individual concepts are shown as single entities, often depicted in isolation, but sometimes related to larger groups of similarly static personifications. In such depictions it is possible to see single values of virtue or vice, complex groups of either good or evil, or any possible variation of this theme. Once again, this group dates to the ninth century but continues throughout the entire medieval period. Although Katzenellenbogen[7] was, quite sensibly, unwilling to create a third group, it is also possible to find representations which combine elements from the *Psychomachia* with those in static form.

Even though the works of art catalogued in this publication are presented in a form abbreviated from the more extensive records in the Index, every effort has been made to provide scholarly support for future research on this subject. Objects from twelve of the seventeen different media found in the Index are included, ranging from glass to panel paintings, enamels, and sculpture, with the largest section, not surprisingly, devoted to manuscripts. The subject identifications are drawn from the catalogue of over 26,000 themes developed by the Index over the last eighty-odd years since 1917, when the

archive was founded. As comprehensive as this file is, there are bound to be omissions, but it is hoped that these will be outweighed by the wealth of material which is included. Throughout its existence the Index has been partly built on the material which scholars feed back into the archive, and we hope that this publication will also have that effect.

The choice of this subject matter was also driven by its popular appeal and by the lack of scholarly attention which the subject has received in relation to its importance.[8] This relative neglect may have been due in part to a general lack of information about which personifications had been depicted in the medieval period. One of the first scholars to deal with this subject was Helen Woodruff, director of the Index of Christian Art from 1933 to 1942, an interesting link between the Index and the theme of this publication. With the exception of the medieval manuscripts which attempted to catalogue personifications of virtue and vice, and which are included as primary material in this catalogue, the history of classifying and analysing these moral values begins in earnest in the seventeenth century with the works of Cesare Ripa.[9] The pioneering and most important modern study is the previously mentioned work by Katzenellenbogen. His analysis of the themes and principles underlying the representation of Virtues and Vices in art is unparalleled and will not be emulated in this publication.

Instead, this volume focuses on the approach for which the Index of Christian Art has always been renowned: the presentation of objective iconographical descriptions for scholarly evaluation. What we have done in this catalogue, and indeed in the Index files themselves, is to deconstruct the entire group of personifications and to provide objective analysis of the Virtues and Vices for further research. By separating them and placing individual themes within the broader framework of similar works of art, we have disentangled the associations of many of these personifications. But by preserving the primary heading for every work of art, the overall sense of context and association is retained. This will make it possible to document relationships that have been noted in the compilation of this large corpus of material but which have not been previously explored or evaluated. One example of such a relationship is the frequent association of David with personifications including Envy, Idleness, Idolatory, Ignorance, Lust, Luxury, Pride, and Wrath in a wide range of media, such as the mosaics in the Church of S. Remi in Reims or the enamel plaques in the British Library (Egerton 1139). Similarly, Isaiah is depicted with the personifications Deceit, Despair, Disobedience, Falsehood, Gluttony, Idolatory, Injustice, Luxury, Petulance, Pride, or Sedition, as he is, for example, in the windows in the Church of Dionysius in Esslingen. We hope that the files published here will provide many scholars with the incentive to investigate such works of art further.

The material in this extract has been gathered from a variety of disparate sources and in some instances represents works of art which can no longer be traced or may no longer exist. This is particularly the case with works that are privately owned and which over the eighty years of the Index's cataloging activities will in all probability have changed hands several times. In some cases, for example, the Hyland collection of Greenwich, Connecticut, we in fact know that a collection has been dispersed, but it has not been possible to

locate the current owners of all of the works. Rather than exclude such works of art from this publication, we have included them exactly as they were documented, with the provenance as it is found in the Index files. Other discrepancies in institutional and geographic names may also have been inadvertently included in this extract. For example, in the centralization of museums that has taken place, especially in Europe, it is possible that smaller local collections may no longer exist or that their collections have been subsumed into larger institutions. Significant changes in geographic boundaries have also occurred, especially in eastern Europe, where countries have been divided into smaller independent entities. Borders have changed, and cities, towns, and other sites may no longer exist under their previous names. The updating of this material, which is constantly being carried out, involves considerable research and labour. Although every effort has been taken to ensure that the material in this extract is current, every change that has taken place since the material was catalogued may not be reflected. New material for addition to the Index is gathered from many sources, one of the most fertile being publications on medieval art. Such publications, however, may be selective in their coverage, and even though the Index makes every effort to be as comprehensive as possible, there will be cases where entire works of art are not fully detailed.

It has not been possible to reproduce all of the information recorded in the Index card files, and what is presented here is a greatly abbreviated version restricted to four fields. We have excluded such data as bibliography, previous ownership/provenance/location, and the free-text descriptions of the subject matter for which the Index is renowned. To include all of these elements for all of the works of art in this publication would have required many volumes. The format and structure of what is presented here, however, replicates the Index's standards. An iconographical analysis is created for every work of art using a series of specially devised subject terms. These 26,000 terms give access to a range of topics extending from Alpha and Omega to the signs of the Zodiac. Every work of art has one principal subject which provides the entry point into the complete text record. The main record for the work of art will be found under this principal subject term. Secondary elements within each work are found under their respective subject terms with a cross-reference back to the main subject record. There is no limit to the number of subject terms that can be applied to any work of art, but there is only one main subject term through which the full record for the work can be accessed. The personifications included in this extract may be either the main subject of the work of art or a secondary element in a larger composition. Where the latter occurs, in this extract the primary or main subject of the work is listed as the final field in each entry. This acts as a cross-reference to the main subject of the work. Many of these compositional relationships, such as Discretion and Indiscretion, Generosity and Stinginess, Hate and Friendship, are the traditional balance of opposites. More interesting, however, are personifications such as Poverty, which appears both as a symbol of virtue and of vice, or where such personifications are associated with individual characters or scenes. The personifications in this catalogue have been researched by a number of scholars since 1917, and even though the archive is renowned for its objective

approach to iconographical classification, it is clear that some interpretations may be open to discussion, and that not everyone will agree with those proposed in this publication.

This same variety of scholarship is also evident in the series of essays that accompany this extract. They are all loosely related to the general concept of good or evil and attempt to cover as wide a range of subjects and media as is possible. By an interesting coincidence, a number of the contributors have strong associations with Princeton, and these include the author of the first essay, Georgia Nugent. Her study on Prudentius's *Psychomachia* provides an encyclopedic and invigorating introduction not only to the whole concept of virtue and vice, but also to the series of essays that follows. The actual conflict of the Virtues and Vices, as first documented by Prudentius, details the seven battles between these moral values and is one of the most significant works to bridge the period between pagan beliefs and Christian values. It has long been accepted that such battle scenes were derived from parallels in Roman art, but little attention has been given to the physiology of the principal characters. In this innovative study Nugent evaluates the significance of the sex of the protagonists with interesting results. Based largely on the textual evidence, she has assiduously avoided modern perceptions of feminine physiology and has based her study on what the evidence relates.

It was not only humans that were imbued with symbolic values in the Middle Ages, but also animals and plants, as Ron Baxter's insightful and instructive essay demonstrates. Such a practice can again be traced back to the classical period in the text of the *Physiologus*, but it was not until the twelfth and thirteenth centuries that the formal structure of these manuscripts developed. Although strictly not a text on the virtues or vices, the *Physiologus* has a didactic structure which analyses the moral values of animals. The later bestiaries were as significant as the *Psychomachia* in the role of disseminating beliefs on the virtues and vices as represented by animals and plants. Even though such references have not been included in this extract from the Index files, where bestiary animals, once again, constitute a sizeable file, this essay presents an analysis of the values associated with the principal characters in the text.

In addition to these two overall views and studies of some of the pivotal manuscripts in the history of the Virtues and Vices, this volume includes four other specific case studies. The first of these looks at one of the most intriguing twelfth-century manuscripts in existence, the Floreffe Bible, which was made for the Premonstratensian canons of Floreffe Abbey in present-day Belgium sometime around 1153. This manuscript has been discussed by numerous scholars who focused on the sequence of personified virtues in the frontispiece. In a careful and methodical approach to both text and image, Anne-Marie Bouché convincingly presents a new and holistic interpretation of this important sequence which has eluded so many scholars until now. By abandoning modern perceptions, she shows how the medieval viewer would have understood the sequence in relation to ideas broader than those that are simply shown in the illumination.

The difficulties of looking at iconography not from a modern standpoint but from a medieval perspective is one of the principles underlying Jesse Gell-

rich's study of illuminations of speech and writing from the late medieval period. Beginning with a series of intriguing images, he has attempted to see how the oral and the written were represented against what is known of such practices. His study is framed against the context of such images within manuscripts and how they can inform us about the whole history of the book.

The last two essays look at previously unpublished material from the Gothic period from two widely different areas. The first of these examines the little-known architectural sculpture from German sacramentary houses in relation to the subjects of good and evil. Against a broad-ranging survey which provides rich background material, Achim Timmermann focuses on the unique series of figures on the sacrament house at Ulm. He convincingly analyses these figures in relation to their iconography as marginal types, the structure on which they are represented, and their function. The final essay makes an appeal for greater study of the Gothic period in Ireland by looking at one such subject, that of the pelican, against the material that can be found and which has remained unpublished for a variety of reasons. It shows, like the German material discussed by Timmermann, how the Gothic style became subtly interwoven and fused with local traditions.

Although this is the first extract to be published from the files of the Index of Christian Art, we hope that it will not be the last. Since 1917 the Index has continued to give of its treasures and has similarly received in the true spirit of scholarship. This work could never have been accomplished without the help of all of those who have toiled over the years to make the resource what it is today. This publication is dedicated to them.

<div style="text-align: right">

COLUM HOURIHANE
Index of Christian Art

</div>

NOTES

1. M. Lavin, *The Eye of the Tiger: The Founding and Development of the Department of Art and Archaeology, 1883–1923* (Princeton, 1983); *The Early Years of Art History in the United States*, ed. C. H. Smyth and P. Lukehart (Princeton, 1993).

2. H. Woodruff, *The Index of Christian Art at Princeton University* (Princeton, 1942).

3. On this subject, see the valuable study by H. A. Shapiro, *Personifications in Greek Art: The Representation of Abstract Concepts, 600–400 B.C.* (Zurich, 1993).

4. For example, J. Elsner, *Art and The Roman Viewer: The Transformation of Art from the Pagan World to Christianity* (Cambridge, 1995), 190–246.

5. A. Katzenellenbogen, *Allegories of the Virtues and Vices in Mediaeval Art, from Early Christian Times to the Thirteenth Century* (London, 1939; reprinted Nendeln, Liechtenstein, 1968 and 1977, and Toronto, 1989), 1–13.

6. J. Bergman, *Aurelii Prudentii Clementis Carmina*, CSEL 41 (Vienna and Leipzig, 1926), 165ff.

7. Katzenellenbogen, *Allegories of the Virtues and Vices* (as in note 5), 27.

8. The most comprehensive bibliography on the entire subject, including many original manuscript sources, is to be found in R. Newhauser, *The Treatise on Vices and Virtues in Latin and the Vernacular* (Turnhout, 1993), 18–53. Few monographs have dealt exclusively with the concept of virtues and vices. Among the most important

studies is G. Schmidt, *Ueber dei Sprache und Heimat der Vices and Virtues: Ein Beitrag zur Mittelenglischen Dialektkunde* (Leipzig, 1899). Richard Stettiner documented the surviving manuscripts of the *Psychomachia* in *Die illustrierten Prudentiushandschriften* (Berlin, 1895); this study was extended by Helen Woodruff in "The Illustrated Manuscripts of Prudentius," *Art Studies* (1929), 33ff. This was followed ten years later by the pioneering art-historical study by Katzenellenbogen, *Allegories of the Virtues and Vices* (as in note 5). Other studies include M. Barry, "The Mounted Vices and Virtues in Medieval Literature and the Fine Arts" (M.A. thesis, Columbia University, 1947); *Four Late Gothic Flemish Tapestries of Virtues and Vices from the Collection of William Randolph Hearst, Given by the Hearst Foundation to the Detroit Institute of Arts* (Detroit, 1955); F. Nordström, *Virtues and Vices on the Fourteenth-Century Corbels in the Choir of Uppsala Cathedral* (Stockholm, 1956); M. Schapiro, "Virtues and Vices in Ambrogio Lorenzetti's Franciscan Martyrdom," *Art Bulletin* 46 (1964), 367–72; Z. Swiechowski, "Die Figurierten Säulen von Strzelno," *Zeitschrift für Kunstgeschichte* 30 (1967), 273–308; R. Green, "Virtues and Vices in the Chapter House Vestibule in Salisbury," *Journal of the Warburg and Courtauld Institutes* 31 (1968), 148–58; J. Houlet, *Les Combats des Virtues et des Vices: Les Psychomachies dans l'art* (Paris, 1969); T. Campanella, *Delle Virtu e dei Vizi, in particolare* (Rome, 1976); P. Foot, *Virtues and Vices and Other Essays in Moral Philosophy* (Oxford, 1978); J. Wallace, *Virtues and Vices* (Ithaca, 1978); M. Bloomfield, *Incipits of Latin Works on the Virtues and Vices, 1100–1500, Including a Selection of Incipits of Works of the Pater Noster* (Cambridge, Mass., 1979); K. Haworth, *Deified Virtues, Demonic Vices, and Descriptive Allegory in Prudentius' Psychomachia* (Amsterdam, 1980); R. Markowska, "Ikonografia cnót I Przywar na Kolumnach w Strzelnie," *Studia Zródloznawcze* 26 (1981), 79–111; M. Friedman, "Sünde, Sünder und die Darstellungen des Laster in den Bildern zur Bible moralisée," *Wiener Jahrbuch für Kunstgeschichte* 37 (1984), 157–71; J. S. Norman, *Metamorphoses of an Allegory: The Iconography of the Psychomachia in Medieval Art* (Bern and New York, 1988); J. O'Reilly, *Studies in the Iconography of the Virtues and Vices* (New York, 1988); A. Phillips, *The Virtues and Vices and All the Passions* (Edinburgh, 1991); Z. Swiechowski, "A Jednak Hildegarda," *Rocznik Muzeum Narodowego w Warszawie* 36 (1992), 105–18; J. Tripps, "Giotto an der Mauer des Paradises zu Padua," *Pantheon* 51 (1993), 188–92; R. Newhauser, *A Catalogue of Latin Texts with Material on the Vices and Virtues in Manuscripts in Hungary* (Wiesbaden, 1996); E. Paul, F. Miller, and J. Paul, *Virtues and Vices* (Cambridge, 1998).

A number of other studies have dealt, either exclusively or in passing, with single personifications:

Anger: L. Little, "Anger in Monastic Curses," in *Anger's Past: The Social Use of an Emotion in the Middle Ages* (Ithaca, 1998), 9–35

Anger, Constancy, and Gluttony: H. M. Brown, "Ambivalent Trecento Attitudes towards Music: An Ideological View," in *Music and Context: Essays for John M. Ward*, ed. A. Shapiro (Cambridge, Mass., 1985), 9–107

Avarice: L. Little "Pride Goes Before Avarice: Social Change and the Vices in Latin Christendom," *American Historical Review* 76 (1971), 16–49

Charity: R. Freyhan, "Evolution of the Caritas Figure in the Thirteenth and Fourteenth Centuries," *Journal of the Warburg and Courtauld Institutes* 11 (1948), 68–86; W. R. Levin, "The Iconography of Charity *Redux:* The Origins of Two Little-Known Symbols for *Amor Proximi* in Fifteenth-Century Italian Art," *Fifteenth-Century Studies* 20 (1993), 119–99

Luxury: E. Kosmer, "Noyous Humoure of Lecherie," *Art Bulletin* 57 (1975), 1–8; M. Schapiro, *Romanesque Art* (New York, 1977), 36–38, 69–73, 76–77, 86, 120–21; D. Hammer-Tugendhat, "Venus und Luxuria: Zum Verhältnis von Kunst und Ideologie

im Hochmittelalter," in *Frauen, Bilder, Männer, Mythen: Kunsthistorische Beiträge* (Berlin, 1987), 130–34

Justice: J. Reiss, "Justice and Common Good in Giotto's Arena Chapel Frescoes," *Arte cristiana* 72 (1984), 69–80; E. Frojmović, "Giotto's Allegories of Justice and the Commune in the Palazzo della Ragione in Padua: A Reconstruction," *Journal of the Warburg and Courtauld Institutes* 59 (1996), 24–47

Temperance: L. White, "Iconography of Temperantia," in *Action and Conviction in Early Modern Europe: Essays in Memory of E. H. Harbison* (Princeton, 1969), 197–219

The Seven Deadly Sins have been studied by F. Furnivall, *Early English Poems and Lives of Saints* (Berlin, 1862), 17–20; J. Audelay, "De Septem Peccatis Mortalibus," in *The Poems of John Audelay*, ed. E. K. Whiting (London, 1931), 182; A. Watson, "Saligia," *Journal of the Warburg and Courtauld Institutes* 10 (1947), 148–50; M. Bloomfield, *The Seven Deadly Sins: An Introduction to the History of a Religious Concept* (East Lansing, Michigan, 1952); *A Litil Tretys on the Seven Deadly Sins*, ed. J. P. W. M. van Zutphen (Rome, 1956); R. Tuve, "Notes on the Virtues and Vices," *Journal of the Warburg and Courtauld Institutes* 26 (1963), 264–303, and 27 (1964), 42–72; P. Mijović, "Personification des Sept Péchés Mortels à Sopoćani," in *L'Art byzantine du XII^e siècle* (Belgrade, 1967), 239–48; W. Gibson, "Hieronymous Bosch and the Mirror of Man: The Authorship and Iconography of the Tabletop of the Seven Deadly Sins," *Oude Holland* 87 (1973), 205–26; C. Martin, "On the Seven Deadly Sins, Edinburgh University Library Manuscript 93: An Annotated Edition of Selected Devotional Treatises, with a Survey of Parallel Versions" (thesis, Edinburgh University, 1977), 358–64; W. Voelkle, "Morgan Manuscript M. 1001: The Seven Deadly Sins and the Seven Evil Ones," in *Monsters and Demons: Papers in Honor of Edith Porada*, ed. A. Farkas, P. Harper, and E. Harrison (Mainz am Rhein, 1987), 101–14; H. Harrauer, *Wednesday's Child is Full of Woe, or the Seven Deadly Sins and Some More, Too* (Vienna, 1998).

9. C. Ripa, *Iconologia, overo descrittione di diverse imagini cavate dall'antichità e di propria inventione* (Rome, 1603).

PART 1

ESSAYS

Virtus or Virago?

The Female Personifications of

Prudentius's *Psychomachia*

S. GEORGIA NUGENT

THE *Psychomachia*, written in the late fourth century A.D. by the Christian Latin poet Prudentius, is considered to be the first fully fledged example of personification allegory, the genre which became so popular in the Middle Ages. While instances of personification appear in literature from the time of Homer onward, Prudentius takes the step of deploying such personifications as the sole figures in an extended narrative. The text presents seven battles between personified virtues and vices, concluding after the final successful struggle with the construction of a temple to Sapientia, "Wisdom," to commemorate this victory "in," "of," or "for" the soul—as Prudentius's title, *Psychomachia* or "soul battle," has been variously interpreted.[1] Prudentius's innovation effects a transformation of classical battle epic, with personified abstractions replacing human actors on the epic stage. From the critical perspective of the contemporary world, one of the most extraordinary aspects of this development is that the traditional machinery of classical battle epic has remained in place, but it is now "manned" entirely by female characters. When *vir*-tus, the very essence of manhood, becomes a woman, the world seems to have been turned topsy-turvy. Yet, despite the deployment of women as warriors, the majority of gendered stereotypes remain firmly in place in this new form of epic. A memorable example is the hyper-feminine portrayal of Luxuria, which unquestioningly assumes a stereotypical view of woman as drunken, lascivious, and foolish.

For the most part, the anomalous introduction of women on the field of battle has been explained (or explained away) by linguistic constraint. Since the grammatical gender of abstract nouns in Latin is feminine, the argument goes, their representation as female characters was unavoidable. This provides a comfortably philological rationale for the unprecedented population of the epic battlefield by female warriors, but the fact that the combatants in this battle for the generic—and therefore unmarked, male—soul are female is not a mere grammatical accident.[2] Rather, it can be shown throughout that gender is strongly embedded in the overall conception of the work—and therefore the Christian psychology it presents—as well as in the narrative shaping of the individual battles.[3]

Virgin Birth

The structuring concept of the battle itself is introduced, in lines 11–14 of the preface, in terms of giving birth to a legitimate child:

> nec ante prolem coniugalem gignere
> Deo placentem, matre Virtute editam,
> quam strage multa bellicosus spiritus
> portenta cordis servientis vicerit.
> (*Praefatio* 11–14)

We beget no child of wedlock pleasing to God, with Virtue as mother, before the battling spirit has overcome with great slaughter the monsters in the enslaved heart.

Thus, the entire narrative of battle which comprises the *Psychomachia* serves the purpose of enabling (in an unspecified way) the birth of offspring which will be pleasing to God. A deep ambivalence, however, toward the normal generative process of birth from women surfaces just a few lines later with important allusions to Melchisedech and to Abraham's wife, Sara.[4] Four entire lines are devoted to the mystery of Melchisedech's birth, a genealogy which entails no father and no mother, and is known to God alone.[5]

> origo cuius fonte inenarrabili
> secreta nullum prodit auctorem sui,
> Melchisedech, qua stirpe, quis maioribus
> ignotus, uni cognitus tantum Deo.
> (*Praefatio* 41–44)

whose mysterious birth from a source that cannot be named has no ostensible author—Melchisedech, whose line and forefathers no man knows, for they are known to God alone.

This absence of origins renders Melchisedech particularly fit to serve as origin himself—specifically, as the figural forerunner of the Christian priesthood, which will, of course, through the doctrinal enforcement of celibacy, avoid the entanglement of sexuality.[6]

Directly following this discussion of Melchisedech, Prudentius alludes to the pregnancy of Abraham's wife, Sara. While the story of Sara's conception does not bypass human sexuality altogether, as does Melchisedech's mysterious origin, the birth of Isaac long after Sara had passed the age for fertility introduces an alternative to what may be regarded as "normal" human procreation. A number of feminist biblical scholars have called attention to the frequency of such alternative birth scenarios in the early biblical history of Israel and to the way in which these tales have the effect of shifting the agency for procreation from being a regular function of the human female to representing a special intervention of the supernatural male.[7]

In fact, the entire preface of the *Psychomachia* shows a recurrent concern with the rejection of sexuality, coupled—however irrationally—with the desire to establish a male line of descent. At line 54, it is *foeda libido*, "filthy lust," from which the body must primarily be freed. And we will shortly find

Libido the first threat to be faced in battle, after the rejection of pagan cult practice. With the concluding lines of this prefatory statement, the theme of an unutterable origin (*inenarrabilis*, "not able to be spoken"), originally introduced in the case of Melchisedech, returns once again, this time in the characterization of Christ as the true priest whose paternity is beyond telling:

> Mox ipse Christus, qui sacerdos verus est,
> parente inenarrabili atque uno satus. . . .
> (*Praefatio* 59–60)

Then Christ himself, who is the true priest, born of a Father unutterable and one. . . .

With Christ's entrance into the human heart, however, the way will be prepared for the soul to conceive and give birth. The imagery of childbearing as a way of discussing the spiritual life is both extremely strong and also very clearly focussed on the goal of providing an heir to the male (God-the-father).

> Animam deinde Spiritus conplexibus
> pie maritam, prolis expertem diu,
> faciet perenni fertilem de semine,
> tunc sera dotem possidens puerpera
> herede digno Patris inplebit domum.
> (*Praefatio* 64–68)

And then the Spirit, embracing in holy marriage the soul that has long been childless, will make her fertile by the seed eternal, and the dowered bride will become a mother late in life and give the Father's household a worthy heir.

In this preface, Prudentius's work exhibits a focus on fruition and paternity, while also rejecting or devaluing sexual procreation. Might we not presume, then, that gender will play a significant role in the representation of the females who follow?

In her examination of another Prudentian work, the *Peristephanon*, Martha Malamud has emphasized that "Prudentius was writing at a time when the ancient paradigm of sexuality was being redefined by the ascetic movement," and she has suggested that "the tension between different ideals of sexuality and different notions of the nature of the body is very apparent in his poems."[8] One such sexual issue eliciting substantial controversy in the fourth century is undoubtedly virginity—a state which is emphatically *not* a pre-Christian ideal.[9] In redefining the value of virginity, Christian thought also necessitates the redefinition of familial—and especially feminine—roles and expectations. In the *praefatio* to the *Psychomachia* we see, in particular, a concern with the difficulty of reconciling or integrating virginity and fertility, transposed into a metaphorical, spiritual key: how can the "virgin" soul beget "offspring" for God? The problem is most starkly, physically represented in the body of the Virgin Mary. Yet in the *praefatio* Prudentius's thought seems to turn not so much to the possible virginity of the maternal body as to the possible fecundity of the male body. It is a choice of paradoxes—the mother who has known no male or the mother who *is* male.[10]

"Neither Male nor Female"[11]

It has seldom been remarked that, in the innovative representational strategy of the *Psychomachia*, Prudentius tends toward elaboration of transsexual, rather than asexual figures.[12] The personified abstractions of his allegory are females, yet—as soldiers on the soul's field of battle—they are dressed as and comport themselves as males. In her recent study of the cultural implications of transvestism, Marjorie Garber has emphasized that, confronted with figures who confuse gender categories via transvestism, the almost universal response is to erase the phenomenon by looking "through" it rather than "at" it.[13] That is, we determinedly read the cross-dressed figure as "really" either male or female, refusing to admit the possibility of its doubleness, that it is "both/and" rather than "either/or." The problem of virgin birth presents another similar physical paradox—the body which is both virginal and pregnant or parturient. Orthodox Christian theology entails an even more extraordinary stumbling block to reason, however, in the figure of Jesus, who is *both* god *and* man.

These doctrinal paradoxes present a puzzle to which Prudentius returns many times in both of his theological expositions, the *Apotheosis* and the *Hamartigenia*. In the *Apotheosis* Prudentius emphasizes the virginal aspect of Jesus' birth: *enixa est sub lege uteri, sine lege mariti* (*Apoth.* 98); *hominem de virginitate creavit* (*Apoth.* 437); *iam mater, sed virgo tamen, maris inscia mater* (*Apoth.* 575). Yet he seems even more intrigued by the dual nature of the Christ figure: *est Deus, est et homo; fit mortuus et Deus idem est* (*Apoth.* 230); *Christus forma Patris, nos Christi forma et imago* (*Apoth.* 309). The extraordinary quality of a being both binary and unitary fascinates; he speaks of Christ as literally "putting on" or "wearing" the mother's bodily (i.e., human) form (*Deus et se corpore matris/induit*, *Apoth.* 436–37) and even comes close to the (heretical) assertion that this fusion creates a third term, a *new* substance which is "neither/nor": *nunc nova materies*—yet he retreats hastily to an orthodox assertion: *materies sed nostra tamen, de virgine tracta* (*Apoth.* 167–68).

Even more explicitly in the *Hamartigenia*, Prudentius concerns himself with the logical impossibility and theological necessity of the God-man's essence being one form which is two. The purpose of this poetic treatise is to argue specifically against the doctrine that there are *two* divine forces—one of good and one of evil. Presumably, the nature of the opponent dictates the form of Prudentius's argument, since he chooses to elaborate on the unity of the godhead in terms which repeatedly emphasize *not* trinity, but the transcendence of binary form (*Ham.*, praef. 44–45, 2ff., 17ff.). Emphatically, Prudentius asserts that god is *not* double, but single: *nos plenum sine parte Deum testamur et unum/in quo Christus inest, idem quoque plenus et unus* (*Ham.* 27–28); *genusque/unum, quod Deus est, summam revocatur ad unam* (*Ham.* 54–55). Indeed the poet even suggests that a twofold being could not sustain itself: *quae tandem natura potest consistere duplex* [?] (*Ham.* 17).

In the *Psychomachia*, however, Prudentius notes explicitly that the nature of man is not unitary, but internally divisive: *fremit et discordibus armis/non simplex natura hominis* (*Psych.* 903–904). This doubleness of man's nature in

fact lies at the heart of the problem which Prudentius explores in the *Psychomachia*. While Christ is able to transcend the duality of his nature, man is continually besieged by his own doubleness. For Prudentius, it is non-trivially true to claim that "We have seen the enemy—and he is us." Even more unfathomable, then, is the *simplex* nature of Christ, which is able to transcend both the ontological division between God and man and also man's own inherently divided nature.

In this context, we should be particularly sensitive to the doubleness of Prudentius's representational choice in the *Psychomachia*. The allegorical warriors of this poem are certainly not the traditional male warriors of epic, but neither are they fully female. It would be more accurate to say that they are females who take on not only the clothing but also some of the attributes of males. The paradoxes of such gender-crossing show up quite explicitly in the battles with Superbia and with Luxuria. In the former, the Vice Superbia casts aspersions on the opposing forces for their lack of manly bellicosity (*imbellesque animos . . . gelidum iecur*, *Psych.* 237–38)—but they're *not* men. Again, Superbia expresses shame at even engaging in battle with a female band (*quam pudet . . . /cum virgineis dextram conferre choreis*, *Psych.* 240, 242). But—the careful reader wants to object—Superbia herself *is* female.

It is not surprising that enemies taunt one another with effeminacy (even though they are feminine), given that allies do the same. In the crucial battle with Luxuria, Sobrietas finds it necessary to upbraid her comrades by charging them with effeminacy, taunting them particularly with the charge of cross-dressing (across both gender and cultural lines). So overcome by Luxuria's blandishments are her fellow Virtues that Sobrietas fears they might even stoop to wearing perfume and stepping delicately in flowing silk robes, Eastern-style. Indeed, they might go so far as to confine their manly hair with a golden headband (*ut mitra caesariem cohibens aurata virilem . . .*, *Psych.* 358). Oh horrors! But hold on—this is the "manly hair" of *women*.

The poet, most likely, has in mind the taunts of Eastern effeminacy leveled in Vergil's text against Aeneas and his men by both their African and Italian opponents. In *Aeneid* IV, Iarbas, as he prays to Jupiter Ammon, alludes thus disparagingly to the newly-arrived Aeneas:

> et nunc ille Paris cum semiviro comitatu,
> Maeonia mentum mitra crinemque madentem
> subnexus
>
> (*Aeneid* IV.216–18)

And now this "Paris" with his effeminate entourage, his chin and
dripping hair tied in a Phrygian cap

Later, in Italy, it is just such a taunt from the fatuous Remulus which induces Ascanius to kill his first man:

> vobis picta croco et fulgenti murice vestis,
> desidiae cordi, iuvat indulgere choreis,
> et tunicae manicas et habent redimicula mitrae.
> o vere Phrygiae, neque enim Phryges
>
> (*Aeneid* IX.614–17)

Gleaming purple robes embroidered in saffron
are your delight, and you love to indulge in dances.
You wear tunics with long sleeves and bonnets with ribbons.
Really, you're not even Phrygian men, but Phrygian women

But when Prudentius transfers such anti-effeminate rhetoric to warriors who
are in fact female, the result is complicated. One can understand that the
female warrior *does*—to the extent that she is "male-identified"—eschew the
feminine. And yet, the dire threat of effeminacy hurled against a female—
rather like the French cuff extending too far beyond the jacket sleeve—fits
badly and thereby calls our attention to the cross-dresser. Prudentius's text
both reveals and conceals this figure, choosing to represent it sometimes as
maid and sometimes as man but never fully admitting their coexistence in the
poem's representational strategy.

Yet the figure who disturbs clear-cut divisions between categories by tak-
ing on the clothing and appearance of the other recurs multiple times in Pru-
dentius's text—and is explicitly perceived as threatening and dangerous. We
have seen that Sobrietas fears that her comrades might take on the accou-
trements of the other, but this is expressed only as an unrealized, hypotheti-
cal anxiety. In the subsequent combat, however, this possibility becomes a
reality, with serious results. The Vice Avaritia, in the battle against Virtue,
avails herself of disguise. Assuming the demeanor and clothing of Thrift
(*Frugi*), the text says that she *becomes* (*fit*) this Virtue: *fit Virtus specie vul-
tuque et veste severa/quam memorant Frugi* (*Psych.* 553–54). The effect of
this counterfeit on the army of Virtues is disastrous—severely disoriented and
unable to discern friend from foe, they are rescued just in the nick of time by
Good Works (*Operatio*), who rushes onto the scene and strangles this danger-
ous Virtue-impersonator:

> Attonitis ducibus perturbatisque maniplis
> nutabat Virtutum acies errore biformis
> portenti, ignorans quid amicum credat in illo
> quidue hostile notet
> (*Psych.* 568–71)

> With the leaders stunned and the soldiers thrown into turmoil, the
> army of Virtues faltered before this twofold creature, not knowing
> whether to consider it friend or foe

In fact, with the conquest of this insidious threat, the army of Virtues believe
their troubles are over (*curae emotae, Psych.* 629). The troops remove their
armor (whereupon their robes fall to their feet, indicating that under the
shields and swords they are clothed in the gowns of women, rather than the
short tunic of the male soldier) and prepare to return their victorious stan-
dards to camp (*Psych.* 632–45).

This confidence in victory, however, turns out to be premature, as Virtue
is beset yet again by a cross-dressed Vice. Discordia or Heresy has left behind
her own garb, assumed that of the Virtues, and infiltrated their ranks.

> Nam pulsa culparum acie Discordia nostros
> intraret cuneos sociam mentita figuram.
> Scissa procul palla structum et serpente flagellum
> multiplici media camporum in strage iacebant.
> Ipsa redimitos olea frondente capillos
> ostentans festis respondet laeta choreis.
> <div align="center">(Psych. 683–88)</div>

With the army of the Vices repulsed, Discordia entered into our ranks, disguised as an ally. Her split gown and her whip braided of serpents lay far away in the midst of the slaughter on the field. She herself displays her locks wreathed with an olive branch and responds joyfully to the festive songs.

Thus treacherously "passing" as a Virtue, she is the only Vice who actually succeeds in inflicting a wound. It is striking that at this moment of wavering identity, Prudentius's own text seems to waver over the wounding, wanting to have it both ways, to make two mutually contradictory narrative assertions: both that the insidious treachery of Vice disguised as Virtue really *is* successful and that the Virtue remains invulnerable, immune to such a travesty. Thus, Prudentius strives to refine and revise his narration of the wounding spear and the question of its penetration, stressing first that it was repulsed by Concordia's sturdy armor (despite the fact that the disarming of the army of Virtues has just been described), then reiterating that the spear did not penetrate to the body's interior (*penetrare in viscera*, *Psych.* 677). A dozen lines later, however, reiterating again that the vital parts of the body were not breached (*sed non vitalia rumpere ... /corporis*, *Psych.* 691), the poet also clarifies that the exterior of the body was indeed wounded, the surface of the skin marked by blood (*signavit sanguine*, *Psych.* 693).

This insistence on the disjunction between the mere surface of the body and its interior seems less appropriate to the harmonious nexus that is (or should be) Concordia than to her treacherous foe, Discord. But such a sharp delineation between the corporeal exterior and corporeal interior seems very much in tune with Prudentius's elaboration and deployment of the personifications as figures who are now female, now male, depending upon the aspect under which we consider them. The view that the poem's allegorical figures are female simply as an accident of linguistic history overlooks important aspects of the narrative's development—and I would argue—of its significance. Indeed, the view that the characters *are* female (or male, for that matter) does not fully do justice to the complexities introduced by the text.

At some points, Prudentius draws upon traditional *topoi* which assimilate his allegorical personifications to the masculine warriors of classical epic, for example, in the use of heroic nudity or the presumption that effeminacy is a taint to be avoided. Yet another aspect of Prudentius's allegorical construct seems in fact to exploit the embodiment of the personifications as females, in a way which emphasizes the spiritual threat presented by the feminine body. As with the paradox of the procreative Virgin soul, Prudentius's representational strategy strives to have it both ways.[14]

Going for the Jugular

The first combatant who takes the field, Fides (Faith), is described at once as: *nuda umeros, intonsa comas, exerta lacertos (Psych. 23)*, "with bare shoulders, unkempt hair, and exposed upper arms." Each of these attributes in another context might signal sexual availability or readiness, but Prudentius's text sublimates each of these potentially erotic signs of undress, immediately diverting them to the signification of *heroic* nudity. This in itself introduces a blurring or crossing of gender lines, since the exposed *female* body is here made to signify the heroic *masculine* disposition. Fides, we are to understand, is so confident of her own invincibility that she takes no thought for protective armor. This confidence seems well placed, for the ensuing closure with the enemy is brief and brutal, resulting in instant victory for Fides. That enemy is entitled Cultura of the Old Gods, conflating to some extent the "cult" worship of the pagan deities and that studied "cultivation" which is so evidently lacking in Fides's rough-and-ready approach to the encounter.

"Rough" is certainly an appropriate characterization of Fides's treatment of her foe. This first of the *Psychomachia's* battles introduces an element of brutality and cruelty in combat which marks much of the ensuing work, and which has caused substantial controversy among interpreters. Put most succinctly, the problem is that the Virtues prove truly vicious in the treatment of their adversaries. In the case in point, Fides, having felled her opponent with a single crushing blow to the skull, then proceeds—quite gratuitously, it seems—to crush her eyeballs underfoot and then strangle her, for a horrible, agonizing death.

> Illa hostile caput phalerataque tempora vittis
> altior insurgens labefactat, et ora cruore
> se pecudum satiata solo adplicat, et pede calcat
> elisos in morte oculos; animamque malignam
> fracta intercepti commercia gutturis artant,
> difficilemque obitum suspiria longa fatigant.
> (*Psych.* 30–35)

> But she [Faith], rising higher, struck her enemy's head and the temples wreathed with a priestly fillet; she bore to the ground that mouth sated on the blood of sacrifice and trampled underfoot the eyes dashed out in death. The broken passageway of the slit throat contracts, and slow gasps draw out a difficult death.

The result is an enemy who is *very* dead, a victor who is ecstatic (*exultat victrix, Psych.* 36), and a puzzled and troubled critical readership. The delight in blood and gore is unseemly on the part of virtue.

Controversy on the point has continued, since C. S. Lewis first observed categorically that "fighting is an activity that is not proper to most of the virtues. Courage can fight, and perhaps we can make a shift with Faith. But how is Patience to rage in battle? How is Mercy to strike down her foes, or Humility to triumph over them when fallen? Prudentius is almost everywhere embarrassed by this difficulty"[15] On this view, to the extent that

fighting itself is "embarrassing" for virtue, positively reveling in what one critic has called "bloodbaths," is all the more so. Christian Gnilka, in his study of the *Psychomachia*, returns repeatedly to what he calls the *grausamkeit* of the work.[16]

One plausible answer that has been given to this problem is that such moral squeamishness is entirely misplaced. It stems from taking the Virtues and Vices as *individuals*, rather than as the abstract universals Prudentius has created. While it might give pause—so this argument goes—for a humble *person* to exult over a fallen foe, it is the very nature of *humility itself* to be opposed (diametrically, in some sense violently) to pride itself.[17] This is the level of abstraction at which Prudentius is constructing his fiction, and so it is inappropriate to carry over to this new genre our residual epic-reading habits which concern affect, emotion, and the like on the part of notionally human characters.

Another, less philosophically oriented response would explain (or explain away) the *Psychomachia*'s brutality as a literary-historical phenomenon, citing the notorious Silver Age penchant for blood, gore, and general dismemberment, and placing Prudentius's work at the endpoint of that line of development.[18] I suggest, however, that both the philosophical and the literary-historical "solutions" to the "problem" of excessive violence in the *Psychomachia* overlook the gendered aspects of that perceived problem. In the very viciousness with which the Virtues fight we may recognize the cultural commonplace that women's destructive instincts are ungovernable, that they lack the masculine rule-governed concept of "the fair fight" and would therefore be particularly bloodthirsty in battle.[19] Further, I believe that the particular deaths of the Vices, insofar as the vanquishing of vice is the very *point* of the work,[20] are central to the understanding of Prudentius's allegory, and that we must look more specifically at the *kinds* of violence enacted here.

Of the seven Vices who are defeated in the course of the narrative, six suffer at the hands of the Virtues deaths which are uncannily alike. The seventh, Ira, dies by her own hand, her excess of rage leading her to fall upon one of her own weapons, pierced through the breast.[21] For the rest, a recurrent pattern stresses the need either to compress or to cut the throat, and in several cases images of strangling and severing are commingled. Recurrent as well are rather disgusting images of pollution and the disgorging of blood. Even in instances where some other mode of violence results in another kind of wounding, the coup de grace focuses inexorably on the throat.

Why should that be? After all, the effort to represent abstraction physically, to inscribe moral concepts on the body, would seem to mandate a variety of appropriately *significant* or signifying wounds. And the tradition of Latin epic, particularly as practiced, say, by so-called Silver Age authors like Lucan— whose characters display such multifarious wounds that they verge at times on human pincushions—would yield a multiplicity of models for the truly marvelous variety of ways in which mortality may overtake the epic warrior. Has Prudentius fallen prey to sheer lack of imagination? Or is there a rationale which dictates the sameness of these death throes?

Classicists are likely to think at once of Nicole Loraux's well-known study of the modes of death which the Greek cultural imaginary deemed appropri-

ate to women.[22] Particularly telling for our purposes is the analysis of strangulation as the favored mode of demise which "seals" in death the woman's body, perceived as disturbingly open. Supporting this pattern of thought is the homology of oral with vaginal orifices which conceptually links woman's speaking or ingesting mouth with sexual availability and/or voraciousness. If woman is, by nature, excessively "open," at least she can finally be "shut up" in death. Loraux is concerned with this pattern in the genre of Greek tragedy, but it plays a much broader role in the Western narrative tradition, as has been highlighted by Hélène Cixous and Kaja Silverman, among others.[23]

Recently, E. Jane Burns has shown the prominence in a later medieval genre, the Old French *fabliaux*, of a view which depicts female identity "stereotypically as a single sexual orifice. And that orifice appears more specifically as a vaginal mouth, a mouth without teeth or tongue, a mouth devoid of speech."[24] Such a characterization calls to mind quite specifically the *Psychomachia*'s depiction of the oral mutilation of Luxuria,

> Casus agit saxum, medii spiramen ut oris
> frangeret et recavo misceret labra palato.
> Dentibus introrsum resolutis lingua resectam
> dilaniata gulam frustis cum sanguinis inplet.
> Insolitis dapibus crudescit guttur et ossa
> conliquefacta vorans revomit quas hauserat offas.
>
> (*Psych.* 421–26)

The stone fell in such a way that it shattered the windpipe and pushed the lips back into the hollow palate. The teeth were crushed inward and the lacerated tongue filled the slashed throat with blood. Her gorge rose at this unaccustomed meal, and swallowing liquified bone she vomited up the bits she had drunk in.

as well as the "final solution," which neatly puts an end to Discordia's (or Heresy's) speech by putting a javelin through her tongue:

> Non tulit ulterius capti blasphemia monstri
> Virtutum regina Fides, sed verba loquentis
> inpedit, et vocis claudit spiramina pilo,
> pollutam rigida transfigens cuspide linguam.
>
> (*Psych.* 715–18)

Faith, the queen of the Virtues, could bear no longer the blasphemies of the captive monster. She halted the speaker's words and closed the voice passage with her javelin, transfixing that polluted tongue with its rigid spear-point.

Burns demonstrates that violence practiced upon female orifices reveals both anxiety about feminine sexuality and the desire to control the troubling possibilities of feminine speech. "In female protagonists," she notes, "association with the rational mind is denied as the female mouth is reduced—by association with the eroticized female body—to a wholly sexual orifice."[25]

With these associations in mind, let us return to the specific confrontations of Virtues with Vices. In the immediate and decisive opening victory of Fides

over Cultura, we do indeed find both the constriction and the severing of the throat, as well as a striking image of Cultura's blood-filled mouth, described as sated with the blood of sacrificial animals—a rather hyperbolic representation of the meat-eating which is a concomitant of sacrificial cult.[26] It is somewhat surprising that the allegorical representation of pagan cult practice would come to focus on the throat, yet it is also not immediately evident where, in or on the body, one *would* lodge the allegorical signification of paganism.

Much more surprising, however, is the similar representational strategy in the following confrontation, that with Libido. That this is explicitly sexual desire (and not, say, gluttonous desire) is spelled out quite clearly in the designation of the Vice as *lupa*, "whore" (line 47), and *meretrix*, "prostitute" (line 49), as well as *Sodomita* (line 42). The importance of the sexual body—as well as its rejection, in favor of a miraculously procreative virginity—is also stressed in the episode by the repeated refrain of *post partum virginis* (lines 70, 71), "after a virgin has given birth"[27] as a means of characterizing the new and improved era of the Christian dispensation, as well as by further concentration on the marvel of the virgin birth (lines 71–75).

Why, then, in the defeat of Libido, does the focus of attention once again become the throat, rather than any body part we might associate more directly with sexuality?

> Tunc exarmatae iugulum meretricis adacto
> transfigit gladio; calidos vomit illa vapores
> sanguine concretos caenoso; spiritus inde
> sordidus exhalans vicinas polluit auras.
> (*Psych.* 49–52)

> Then with a sword-thrust she pierces the disarmed harlot's throat, and she spews out hot fumes with clots of foul blood, and the unclean breath defiles the air nearby.

Again, models for a violence more directly focused on the sexual organs are not lacking. One might think, for example, of Tacitus's famous portrayal of Agrippina, who—confronted with assassins sent by her own son, Nero—points to the womb which bore him and exclaims "Strike here!"[28]

Loraux's study of death is extremely helpful here. "There is a conclusion of this analysis," she claims, "that we cannot avoid: death lurks in the throats of women, hidden in their beauty." The "fantasy of the knife on the throat," she continues, "reveals tragedy's conception of feminine seduction, which is especially dangerous for the woman who is its too vulnerable agent."[29] Although Loraux is concerned quite specifically with the genre of Greek tragedy, her recognition of the female throat as an eroticized and dangerous site is more broadly generalizable, as she herself indicates with the brief suggestion that "to cast light on the regularity—one might almost say the monotony—of this pattern [i.e., women's death by the throat] one should look . . . toward the gynecological thinking of the Greeks, where woman is caught between two throats."[30]

The identification or interchangeability of the orifices of the female body and the wide cultural diffusion of this image in both Greek and Latin materi-

als has been well documented by Giulia Sissa.[31] If we recognize the prevalence of a concept of woman as being a creature bounded by two "throats," as well as being excessively "open," the *Psychomachia*'s obsessive concern with the enemy's throat comes into a much clearer focus. Specifically, we can begin to understand why Vices of quite disparate natures may all be appropriately countered by "going for the jugular." But if we are right to understand the emphasis on the throat as a corollary of the problematically sexual body of the female, we must also recognize that this representational preference indicates a reduction of all of the Vices' threats—whether that of Pride, Avarice, or even Heresy—to that of the sexual body.[32]

The hypothesis that the homology between the two "necks" of the female body is indeed at stake in the gory demises of Prudentius's Vices is strengthened by the repeated association of the throat with blood—found in the deaths of Libido, Superbia, Luxuria, and Avaritia.[33] While in some cases blood flows from the neck—as we might expect—as a result of either puncture or slash wounds, in other instances the text insists upon a rather peculiar conflation of bleeding with constriction or suffocation. Of course in the very first combat, suffocation alone—dwelt upon in some detail—provides the paradigm of death.

It is now possible to explore how gender, far from being accidental or irrelevant, is a primary determinant of Prudentius's allegorical construct. Helen King has traced very sensitively the structural relations among bleeding, strangulation, and the cultural construction of women's sexuality in Greece.[34] In particular, she notes the opposition between strangulation equated with "shedding no blood" and the bloodshed—whether of menstruation, defloration, or birth—which punctuates the life of the sexually active woman.[35] Structurally, then, the strangled woman is a polar opposite of the sexual woman. In the course of her analysis, King demonstrates how the eternally virgin goddess, Artemis, negotiates this opposition. She describes a ritual which pits two groups of virgins against each other in combat and then declares that those who died were "pseudo-virgins," on the principle that the *real* virgin does not bleed. King notes that Artemis—just like the "real" virgin victors in the ritual—"does not bleed, but she does shed the blood of others."[36]

In the case of the *Psychomachia*'s combats, distinctions between bleeding and strangling are not so clear in the depiction of the Vices as in the ritual described by King; in fact they seem confusingly commingled. But this is perfectly in keeping with the representational program of the work—as I have tried to show elsewhere[37]—which stresses the very indiscernibility of vice. We may note, on the other hand, that the Virtues correspond quite straightforwardly to King's paradigm of the virgin Artemis: they shed the blood of others but not their own, which may itself serve to certify their virginity. We may recall here Malamud's assertion that Prudentius's work is in fact deeply affected by contemporary controversies over the (newly valued) status of virginity.

Prudentius's bloodthirsty yet invulnerable Virtues, as well as the Vices who—equally predictably—are strangled, asphyxiated, and/or decapitated, provide a way to figure this problem of (the woman's) virginity, a problem which, as Sissa has shown, *already* uses a corporeal sign to represent a spiri-

tual disposition, thus attempting to transform the metaphysical into the physical. It should not escape us that Prudentius, in writing his allegory, is attempting a similar transubstantiation of the physical to the metaphysical by representing Christian psychology in terms of a narrative which recognizably corresponds to classical battle epic.

This attempt to delineate a Christian psychology devolves importantly upon questions of feminine physiology. What is to be made of the fact that this pioneering effort to represent the male psyche actually focuses on the female body?[38] The question is perhaps both complicated and clarified by recognizing that, in the modern era, the most successful and influential attempt to formulate a psychology also has its origins fundamentally in the bodies of women—in this case, the hysterics who first led Freud to posit that the psyche was indeed inscribed in/on the body.

In this light, it is possible to identify yet another resonance of the particular fate which befalls the defeated in Prudentius's contest between female warriors. Since antiquity, hysteria has been identified as a disease of females, although its symptomology as well as its aetiology and treatment have been differently understood in different periods. In ancient discussions of the condition, the primary hysterical symptom is *pnix*,[39] which is to say, strangulation. This is not to claim that Prudentius is explicitly representing hysteria in his Vices. Instead, it is suggested that enduring cultural stereotypes of the female body as constructed with two homologous throats, and as susceptible to congestion with blood and stifling or suffocation, are over-determined, and thus for multiple reasons may play an important role in the way that Prudentius chose to represent the defeat of vice. This reduction of the Vices, in the last instance, to female sexual bodies which must be closed (or decapitated) is itself motivated by the issue with which we began, namely, the work's important—but largely overlooked—concern with the problem of virginity, and especially how to reconcile virginity and Christian procreation.

What Prudentius effects, through his elaboration of the personifications, is a mode in which these female figures do indeed "give birth" to Christian progeny (i.e., the doctrinal lessons embodied in the allegory), while at the same time the bodies of the women are both explicitly sexualized, and that sexuality is—in violent and bloody terms—repudiated. The gender of these allegorical warriors is not a linguistic accident; for the construction of the fruitful Christian soul, it's a logical necessity.

NOTES

1. On the interpretation of the title, see, e.g., C. Gnilka, *Studien zur Psychomachie des Prudentius* (Wiesbaden, 1963), 19–26; M. Smith, *Prudentius' Psychomachia: A Reexamination* (Princeton, 1976), 113–14; and K. Haworth, *Deified Virtues, Demonized Vices, and Descriptive Allegory in Prudentius' Psychomachia* (Amsterdam, 1980), 116–22.

2. "To a great extent, the gender of an abstract noun determines the gender of the personification, but that is not the end of it": J. Ferrante, *Woman as Image in Medieval Literature* (New York, 1975), 5–6. Ferrante emphasizes the way in which "women can be forces for good as well as evil" in this representational scheme (42).

3. Smith, *Prudentius' Psychomachia* (as in note 1), correctly emphasizes, passim, that what Prudentius is presenting, after all, is a theory of Christian psychology.

4. On the interpretation of Melchisedech and Sara, see Smith, *Prudentius' Psychomachia* (as in note 1), 214–20; Ferrante, *Woman as Image* (as in note 2), 43–44.

5. Hebrews 7:3 [Melchisedech] "Without father, without mother, without descent, having neither beginning of days, nor end of life; but made like unto the Son of God; abideth a priest continually." Cf. Gen. 14:18.

6. For a cogent analysis of the logic which asserts that "only a cessation of sexual activity can bring about a life without death"—a construct which has held sway in Western metaphysics since Hesiod's formulation of the Pandora myth—see J. Bugge, *Virginitas: An Essay in the History of a Medieval Ideal*, International Archives of the History of Ideas 17 (The Hague, 1975), 20.

7. See P. Trible, *God and the Rhetoric of Sexuality* (Philadelphia, 1978), 34–38; and M. Bal, *Death and Dissymetry: The Politics of Coherence in the Book of Judges* (Chicago, 1988), 73.

8. M. Malamud, "Making a Virtue of Perversity: The Poetry of Prudentius," in *The Imperial Muse: Ramus Essays on Roman Literature of the Empire*, ed. A. J. Boyle (Victoria, Australia, 1990), 280.

9. See P. Brown, *The Body and Society: Men, Women, and Sexual Renunciation in Early Christianity* (New York, 1988); A. Rouselle, *Porneia: On Desire and the Body in Antiquity*, tr. F. Pheasant (Oxford, 1988), 131–34, 186–93; S. Elm, *Virgins of God: The Making of Asceticism in Late Antiquity* (Oxford, 1994).

10. On later spiritual traditions which elaborate the concept of Jesus as mother, see C. W. Bynum, *Jesus as Mother: Studies in the Spirituality of the High Middle Ages* (Berkeley, 1982), 110–69.

11. Cf. Galatians 3:28: "There is neither Jew nor Greek, there is neither bond nor free, there is neither male nor female: for ye are all one in Christ Jesus."

12. See Jacques Fontaine on Fides: "La Femme dans la poésie de Prudence," in *Etudes sur la poésie latine tardive d'Ausone à Prudence* (Paris, 1980), 415–43.

13. M. Garber, *Vested Interest: Cross-Dressing and Cultural Anxiety* (New York, 1993), 9–10.

14. For two analyses which explore the multiple and even contradictory meanings of female cross-dressing in early Christian texts, see K. J. Torjesen, "Martyrs, Ascetics, and Gnostics: Gender Crossing in Early Christianity," and J. L. Welch, "Cross-dressing and Cross Purposes: Gender Possibilities in the Acts of Thecla," in *Gender Reversals and Gender Cultures*, ed. S. P. Ramet (Routledge, 1996), 66–91.

15. C. S. Lewis, *The Allegory of Love* (Oxford, 1958), 69. Cf. A. D. Nutall, *Two Concepts of Allegory: A Study of Shakespeare's "The Tempest" and the Logic of Allegorical Expression* (London, 1967), who is also concerned with "aesthetic embarrassment" on these grounds in the *Psychomachia*.

16. See Gnilka, *Studien* (as in note 1), 50. Cf. J. P. Hermann, *Allegories of War* (Ann Arbor, 1989), 14: "Hence the problem for the modern reader . . . in trying to think through a violence that, finally, can only be applauded with moral difficulty. . . . The critical problem . . . is how to make sense of spiritualized brutality in an influential Christian text."

17. See E. Hanson-Smith, "Be Fruitful and Multiply: The Medieval Allegory of Nature" (Ph.D. diss., Stanford University, 1972), 116–17; Gnilka, *Studien* (as in note 1), 47–48.

18. On the violence of Silver Age poetry, see G. Most, "*Disiecti Membra Poetae*: The Rhetoric of Dismemberment in Neronian Poetry," in *Innovations of Antiquity*, ed. R. Hexter and D. Selden (London, 1992), 391–419.

19. On women being more vicious than men, cf. L. Helmes, " 'Still Wars and Lechery': Shakespeare and the Last Trojan Woman," in *Arms and the Woman: War, Gender, and Literary Representation*, ed. H. M. Cooper, A. A. Munich, and S. M. Squier (Chapel Hill, 1989), 26. See also J. Stiehm, *Bring Me Men and Women: Mandated Change at the U.S. Air Force Academy* (Berkeley, 1981), 293–94, who cites M. Mead, "National Service as a Solution to National Problems," in *The Draft*, ed. S. Tax (Chicago, 1967), 107–8, and G. Quester, "Women in Combat," *International Security* 4 (Spring, 1977), 91.

20. See Smith, *Prudentius' Psychomachia* (as in note 1), 109, who states unequivocally of "the *Psychomachia*'s representation of a complete, victorious moral struggle": "It can convert others to Christ."

21. It is perhaps noteworthy that Ira is described immediately as foaming at the mouth (*spumanti fervida rictu*, 113), a condition which Nicole Loraux, drawing on the Hippocratic writers, identifies as "the key symptom of asphyxiation": "The Strangled Body," in *The Experiences of Tiresias: The Feminine and the Greek Man*, trans. P. Wissing (Princeton, 1995), 106.

22. N. Loraux, *Tragic Ways of Killing a Woman*, trans. A. Forster (Cambridge, Mass., 1987), 50–55. See also "The Strangled Body" and "Bed and War" in Loraux, *Experiences of Tiresias* (as in note 21).

23. H. Cixous, "Castration and Decapitation," tr. A. Kuhn, *Signs* 7.1 (1981), 41–55; K. Silverman, *The Acoustic Mirror: The Female Voice in Psychoanalysis and Cinema* (Bloomington, Ind., 1988), 67.

24. E. J. Burns, "This Prick Which Is Not One: How Women Talk Back in Old French Fabliaux," in *Feminist Approaches to the Body in Medieval Literature*, ed. L. Lomperis and S. Stanbury (Philadelphia, 1993), 188–212.

25. Burns, "This Prick" (as in note 24), 197.

26. It is difficult to understand the gratuitous crushing of the Vice's eyeballs underfoot. Hermann, *Allegories of War* (as in note 16), 11, assumes that what is at stake is "the *concupiscentia oculorum* (concupiscence of the eyes), equated with the desire for knowledge in exegetical tradition [which] requires violent suppression."

27. *Virginis* here is an "objective," rather than "subjective" genitive.

28. Tacitus, *Annals* XIV.8.

29. Loraux, *Tragic Ways* (as in note 22), 52–53.

30. Loraux, *Tragic Ways* (as in note 22), 61.

31. G. Sissa, *Greek Virginity*, tr. A. Goldhammer (Cambridge, Mass., 1990), 53–70.

32. The death of Pride (Superbia):

> Illa cruentatam correptis crinibus hostem
> protrahit, et faciem laeva revocante supinat;
> Tunc caput orantis flexa cervice resectum
> eripit, ac madido suspendit colla capillo.
> (*Psych.* 280–84)

The death of Avarice (Avaritia):

> Invadit trepidam Virtus fortissima duris
> ulnarum nodis, obliso et gutture frangit
> exsanguem siccamque gulam; compressa ligantur
> vincla lacertorum sub mentum et faucibus artis
> extorquent animam, nullo quae vulnere rapta
> palpitat, atque aditu spiraminis intercepto
> inclusam patitur venarum carcere mortem.
> Illa reluctanti genibusque et calcibus instans
> perfodit et costas atque ilia rumpit anhela.
> (*Psych.* 589–97)

The death of Heresy (Discordia):

> Non tulit ulterius capti blasphemia monstri
> Virtutum regina Fides, sed verba loquentis
> inpedit, et vocis claudit spiramina pilo,
> pollutam rigida transfigens cuspide linguam.
>
> (*Psych.* 715–18)

33. Libido: . . . *ora cruore/de pecudum satiata* (*Psych.* 31–32); Superbia: *Tunc caput orantis flexa cervice resectum/eripit, ac madido suspendit colla capillo* (*Psych.* 282–83); Luxuria: *Dentibus introrsum resolutis, lingua resectam/dilaniata gulam frustis cum sanguinis inplet* (*Psych.* 423–24); Avaritia: . . . *obliso et gutture frangit/exsanguem siccamque gulam* (*Psych.* 590–91).

34. H. King, "Bound to Bleed: Artemis and Greek Women," in *Images of Women in Antiquity*, ed. A. Cameron and A. Kuhrt (Detroit, 1983), 109–27.

35. See also G. Clark, "Bodies and Blood: Late Antique Debate on Martyrdom, Virginity and Resurrection," in *Changing Bodies, Changing Meanings: Studies on the Human Body in Antiquity*, ed. D. Montserrat (London and New York, 1998), 106–8.

36. King, "Bound to Bleed" (as in note 34), 120.

37. S. G. Nugent, *Allegory and Poetics: The Structure and Imagery of Prudentius' Psychomachia* (Frankfurt, 1985), 71–85.

38. I assume throughout that the Christian psyche characterized by Prudentius's narrative is, in linguistic terms, "unmarked"—i.e., male.

39. Helen King has recently offered a revisionist reading of the early history of hysteria, but she does not question the primacy of *pnix* as a symptom: "Once Upon a Text: Hysteria from Hippocrates," in *Hysteria Beyond Freud*, ed. G. S. Rousseau (Berkeley, 1993), 3–90.

Learning from Nature:
Lessons in Virtue and Vice in
the *Physiologus* and Bestiaries

RON BAXTER

THE *Physiologus* was originally composed in Greek, probably in the second century A.D., and translated into Latin sometime before 388.[1] The entire work, in a recension known as the B-text, became the core text of the bestiaries produced all over Europe, but especially in England, between the eleventh and fifteenth century. While surviving bestiaries vary enormously in their length and organisation, with textual material added mainly from the *Etymologiae* of Isidore of Seville and from a wide variety of other writers, including Ambrose, Petrus Londiniensis, and Giraldus Cambrensis, the ghostly presence of the *Physiologus* is always detectable.[2]

The *Physiologus* is not an allegorical treatise on virtue and vice; nowhere do virtues and vices actually appear as personifications either in the text or in the miniatures of any illustrated *Physiologus* or bestiary. Hence it was outside the scope of Adolf Katzenellenbogen's pioneering study on the Virtues and Vices, and indeed that author specifically excluded it from consideration.[3] Instead it is a didactic text made up of thirty-six chapters of varying lengths, each dealing with one or more characteristics (*naturae*) of either a creature or a stone, which the text then interprets as a Christian lesson or moralization. One of the more straightforward chapters illustrates how Christians can learn from nature.

The hoopoe (*upupa*) is a bird which, according to the *Physiologus*, looks after its parents when they grow old, pulling out their old feathers so that they can fly properly and grooming their eyes to improve their failing sight (Fig. 1).[4] In much the same way, children look after their parents in old age to repay their care in raising them from infancy. The *Physiologus* text concludes, "if these irrational birds behave to each other like this, why do men, who are rational, fail to repay their parents for bringing them up?"[5]

This straightforward injunction to follow the Fifth Commandment, which is quoted in the text (Ex. 20:12), provides a simple illustration of the way the *Physiologus* uses examples from the natural world to convey lessons in Christian behaviour. The point, of course, is not that birds, beasts, and stones are more virtuous than humans, but that God has provided them as lessons and as warnings for the attentive Christian to read.

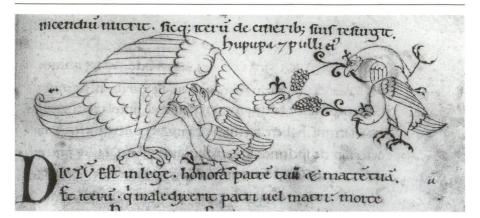

1. Oxford, Bodleian Library, Ms. Laud. misc. 247, f. 145r, *upupa*

To judge from the list of chapter headings, the order of chapters seems to be random, and it is true that no zoological taxonomy is attempted in the *Physiologus* (Table 1), although it is in some classes of bestiary. There is, however, an organisation based on the moralizations, so that the text could function as a series of short sermons which are thematically grouped.

Table 1: Chapter Order of the *Physiologus* B-text

CHAPTER / SUBJECT		CHAPTER / SUBJECT	
1	*Leo* (lion)	19	*Ydrus* (hydrus)
2	*Autolops* (antelope)	20	*Caper* (goat)
3	*Lapides igniferi* (fire-stones)	21	*Onager et simia* (wild ass and ape)
4	*Serra* (serra—sea monster)	22	*Fulica* (coot)
5	*Caladrius* (caladrius—bird)	23	*Pantera* (panther)
6	*Pelicanus* (pelican)	24	*Aspidochelone* (whale)
7	*Nicticorax* (night-raven)	25	*Perdix* (partridge)
8	*Aquila* (eagle)	26	*Mustela et aspis* (weasel and adder)
9	*Fenix* (phoenix)	27	*Assida* (ostrich)
10	*Upupa* (hoopoe)	28	*Turtur* (turtle-dove)
11	*Formica* (ant)	29	*Cervus* (stag)
12	*Syrene et onocentauri* (sirens and centaurs)	30	*Salamandra* (salamander)
13	*Herinacius* (hedgehog)	31	*Columbae* (doves)
14	*Ibis* (ibis)	32	*Peredixion* (peridexion tree)
15	*Vulpis* (fox)	33	*Elephans* (elephant)
16	*Unicornis* (unicorn)	34	*Amos* (Prophet Amos—goats)
17	*Castor* (beaver)	35	*Adamas* (diamond)
18	*Hiena* (hyena)	36	*Mermecolion* (pearl)

Built into the structure of the text are two alternative models of human behaviour, one resulting in salvation, the other in damnation.[6] The man who is damned is a seeker after the pleasures of the world, which are snares laid by the devil to trap him; the saved man follows the lessons taught by Christ, ignoring the world and its delights.[7] Again and again in the text, the two possibilities are repeated, and another example will serve both to demonstrate the strategy and give a flavour of the work.

The ibis is an unclean bird (see Leviticus 11:17) because, according to the *Physiologus*, it eats carrion:[8]

> It walks by day and night along the shores of the water, seeking either dead fish or any other corpse which has been thrown up, putrid and rotten from the water. For it dares not enter the water because it cannot swim. . . . Therefore you, man of Christ, who are now reborn by water and the Holy Spirit, must enter the waters of understanding and spirituality, that is to say, the depths of the teachings of Christ, and there you must eat the spiritual and wholesome meals listed by the apostle, saying, "The fruit of the spirit is charity, joy, peace, patience, long-suffering, generosity, benevolence, gentleness, faith, modesty, self-control, and chastity."[9]

The alternative is to ignore the teachings of Christ, to stay on the shores of the waters of understanding and eat the fetid corpses washed up on the shore, "of which the apostle says: These are the works of the flesh, which are uncleanness, adultery, fornication, immodesty, lechery, idolatry, drunkenness, greed, and ambition."[10]

Each chapter begins with a story describing one or more characteristics of a bird, beast, or stone, and follows it up with a moralization which interprets the story for a Christian audience. Of the thirty-six chapters in the *Physiologus* B-text, most deal, some broadly, some more specifically, with virtue and vice. In order to see the emphasis of the work, and to explore just what was considered to fall into these categories, it is worth examining those chapters where particular virtues or vices are named (Table 2). Where virtues and vices are listed in Latin, they are quoted directly from the text. Entries in English state the virtue or vice considered in the chapter concerned.

Table 2: Virtues and Vices in the *Physiologus*

CHAPTER	VIRTUES	VICES
Autolops		*Adulterium, fornicationem, avaritiam, invidiam, superbiam, homicidium, detractionem, ebrietatem, luxuriam*[1]
Lapides igniferi		Lust
Serra		*Cupiditate, superbia, ebrietate, luxuria*[2]

continued

Table 2: *continued*

Formica	Prudence	
Sirenae et onocentauri		*Deliciis huius saeculi et pompis et theatralibus voluptatibus, tragediis ac diversis musicis melodiis dissoluti*[3]
Ibis	*Caritas, gaudium, pax, patientia, longanimitas, boni-tas, benignitas, mansue-tudo, fides, modestia, continentia, castitas*[4]	*Immunditia, adulteria, fornicatio, impudicitia, luxuria, idolatria, ebrietas, avaritia, cupiditas*[5]
Vulpis		*Adulteria, fornicationes, idolatria, veneficia, homicidia, furta, falsa testimonia*[6]
Castor	*Caritatem, gaudium, pacem, patientiam, bonitatem, fidem, mansuetudinem, continentiam, castitatem*[7]	*Omnia vitia et omnis impudicitiae actus*[8]
Fulica	Prudence	*Saecularibus desideriis ac voluptati-bus delectatur corporalibus*[9]
Aspidochelone		*Voluptatibus et lenociniis*[10]
Turtur	Chastity	

[1] Adultery, fornication, avarice, envy, pride, murder, calumny, drunkenness, luxury

[2] Lust, pride, drunkenness, luxury

[3] The delights and displays of this world, theatrical performances, tragedies, licentious music

[4] Charity, joy, peace, patience, long-suffering, generosity, benevolence, gentleness, faith, modesty, self-control, chastity

[5] Uncleanness, adultery, fornication, immodesty, luxury, idolatry, drunkenness, greed, ambition

[6] Adultery, fornication, idolatry, sorcery, murder, theft, lying

[7] Charity, joy, peace, patience, benevolence, faith, gentleness, continence, chastity

[8] All vices and lewd acts

[9] Worldly desires and voluptuous pleasures of the flesh

[10] Pleasures and pandering

The protagonist of the story can teach the lesson by acting as a model for either good behaviour, like *upupa*, or bad behaviour, like *ibis*. Sometimes the lesson is taught by having the creature rewarded or punished. The antelope (*autolops*) loves playing with its long horns in a certain shrub which grows on the banks of the Euphrates, but it soon becomes entangled and it cries out,

attracting the attention of the hunter, who kills it. Playing in shrubs with one's horns would not seem to merit this kind of drastic punishment, but the point is that the two long horns are reminders of the Old and New Testaments, which the man of God must study in order to live a sober, spiritual, and chaste life, avoiding the impressive list of vices taken from Galatians 5:19 (Table 2).

In the chapter on *vulpis*, the fox lays a trap to catch birds, and it is the birds who are punished for their imprudence and who provide the cautionary example. The fox, we are told, is a cunning and very fraudulent animal. When it is hungry, it finds a place where there is red earth and rolls around in it so that it looks bloodstained; then it lies on the ground, holds its breath, and pretends to be dead. Then birds, seeing the fox apparently dead, fly down and perch on him, and he quickly snatches them and eats them.

The fox is specifically described as a symbol of the devil (*vulpis igitur figuram habet diaboli*). All who live carnally suppose him to be dead, and he swallows them up, while for those who are spiritual and perfect in faith he truly is dead and powerless. The fox is not the only character described in the *Physiologus* as standing for the devil: the same is true of the hedgehog, whale, partridge, dragon (in the chapters on the elephant and the *peredixion* tree), and the hunter (in his appearances in the chapters on the antelope and beaver). In every case, the devil's prey is mankind in the moralization, and in every case too the character who stands for the devil can only succeed if its prey makes a mistake of some kind. Sometimes the devil-character merely takes advantage of the carelessness of its prey, as in the case of the antelope, described above, or *herinacius*, the hedgehog, who steals grapes from the man who does not take proper care of his vines. In other cases, the devil lays a trap for mankind, as does *vulpis*, the fox, in the example above, and *aspidochelone*, the whale who lures little fish into its mouth by producing a sweet odour. These little fish are compared with people of little faith, "by pleasures and panderings, which are like the odours of the devil, they are absorbed by him,"[11] and a biblical quotation is supplied to reinforce the message: "they are delighted by ointments and diverse odours, and thus the soul is brought to ruin" (cf. Proverbs 27:9).

The devil, of course, is not always successful in his quest for souls. *Castor*, the beaver, is hunted for his testicles, which have medicinal uses. Before he is caught, however, he bites his own testicles off and throws them to the hunter to preserve his life (Fig. 2).[12] If he has already used this stratagem in a previous hunt, he displays his rear to show that he is not worth chasing. Testicles provide an appropriate symbol for all vices and lewd acts (*omnia vitia et omnis impudicitiae actus*). These belong to the devil and must be thrown in his face. Likewise, if the devil sees that his prey has nothing of his, i.e., no vices, he will give up the chase.[13]

Turning from the punishment of vice to the reward of virtue, some of the lessons in the *Physiologus* designed to teach Christian morality mirror their cautionary counterparts extremely closely. Thus the panther, who stands for Christ, emits a sweet odour from its mouth when it roars, and this attracts all the other animals to him except, predictably, the dragon. Unlike the whale's sweet odour, which stands for pleasure and panderings, the panther's stands for

2. Formerly Alnwick Castle, Ms. 447, Northumberland Bestiary, f. 11v, *castor*

the words of Christ, and a battery of biblical quotations is used to back up the metaphor, including, from Psalms, "how sweet are your words to my taste, lord, sweeter than honey and the honeycomb to my mouth" (Ps. 118:103).

Just as animals with negative associations, like the antelope, may be punished as a warning to mankind, so positive ones may be rewarded to provide an improving lesson. The ant (*formica*), for example, is rewarded for its prudence with food. When they see an ant walking along with a grain of food in its mouth, the other ants do not ask for food from the ant that has it; instead they follow the trail of the first ant to find the source of the food and take it back to their nest. This story is unusual in that the moralization is itself parabolic. The prudent ants are like the wise virgins in the parable, who conserved their oil, rather than the foolish ones, who used their oil up and asked for oil from those that still had some (Matt. 25:1–13).

If the lists of vices specifically referred to in the *Physiologus* (Table 2) are studied, it is at once apparent that a very high proportion of them are of a sexual nature. Sexually related practices under various names account for no fewer than thirteen of the thirty-two occurrences of vices. The most common proscription otherwise is against drunkenness (*ebrietas*), which occurs three times. In fact, the long lists of sins of the flesh which appear in various chapters of the *Physiologus* have their sources in only two passages from the New Testament. The vices given in *autolops* and *ibis* are apparently taken from Paul's letter to the Galatians (5:16–21), where they form part of an exhortation which begins *Dico autem: Spiritu ambulate, et desideria carnis non perficietis* (This I say then: Walk in the Spirit, and you will not fulfil the lust of the flesh). Despite specifying sins of the flesh, Paul goes on to list a wide variety of vices. The complete list in the Vulgate version (Gal. 5:19–21) is:

fornicatio, immunditia, impudicitia, luxuria, idolorum servitus, venefi-
cia, inimicitiae, contentiones, aemulationes, irae, rixae, dissensiones,
sectae, invidiae, homicidia, ebrietates, comessationes, et his similia
(fornication, uncleanness, lewdness, luxury, idolatry, sorcery, hostility,
contention, jealous rivalry, anger, brawling, dissension, faction, envy,
murder, drunkenness, gluttony, and the like).

It is not to be expected that the *Physiologus* would quote the Vulgate
directly. It is a fourth-century translation from a Greek text, and biblical quo-
tations are normally translations from that text, which predates the compo-
sition of the Vulgate. More significantly, Paul's even-handed condemnation of
all kinds of vice is modified in *autolops* and *ibis*, which concentrate more on
the sexual nature by omitting most of the vices related to anger and strife,
while retaining the sins of the flesh and even adding one in adultery.

The list of vices in *vulpis* is taken from Christ's sermon on defilement in
Matthew 15:19–20. The Vulgate gives *De corde enim exeunt cogitationes*
malae, homicidia, adulteria, fornicationes, furta, falsa testimonia, blas-
phemiae: haec sunt quae coinquinant hominem (For out of the heart proceed
evil thoughts, murders, adultery, fornications, thefts, false witness, blas-
phemies: these are the things which defile a man.)

The difference is not marked here: evil thoughts are omitted from *vulpis*,
and *veneficia* (sorcery) is substituted for *blasphemia*, but this could simply be
a feature of the translation from the Greek source.

It is nonetheless true that the text of *Physiologus* is far more concerned
with lust and its manifestations than with any other vice. Even *castor*, the
beaver, which is ostensibly aimed at all vices, inevitably calls lust to mind by
its metaphoric use of the creature's testicles. Lust is ultimately a snare of the
devil, of course, but we are left in no doubt that its proximate cause, for the
audience of the *Physiologus,* was women. This is most clearly expressed in
the chapter on fire-stones, which opens with what appears to be a picturesque
explanation of the mechanism of a volcano.

> Fire-stones (*lapides igniferi*) are found in a certain mountain in the east.
> Some are male and others female. If male and female stones are kept a
> long way apart, they do not catch fire, but if, for any reason the female
> approaches the male, fire breaks out immediately, so that everything
> around the mountain is burnt.[14]

The *Physiologus* cannot by any stretch of the imagination be described as
a scientific text, and the anecdotal volcanology of the first section is imme-
diately followed by the Christian lesson which transforms it into a miniature
sermon:

> Wherefore you, men of God who live this life, must keep well away from
> women, or a fire will ignite in you which will consume the goodness which
> Christ has placed there. For there are angels of Satan (*angeli satanae*) who
> always attack the just, not only holy men, but chaste women, too. So were
> Samson and Joseph both tempted by women; the one triumphing, the other
> defeated. Eve and Susanna were likewise tempted; the former fell and the
> latter was victorious. Therefore the heart must be guarded, and its divine

principles defended, for the love of women from whom sin began—that is, from Adam until now—rages in disobedient men.[15]

Despite a rather distracting nod towards a possible female audience in the reference to Eve and Susanna, this warning about the dangers of lust is aimed primarily at a community of religious males (men of God who live this life), and this agrees with what is known about the users of *Physiologus* manuscripts and bestiaries. Of the twenty-one surviving English bestiaries which can be localized, no fewer than twenty belonged to male religious houses.[16]

The best-known bestiaries are lavishly illustrated in bright colours, sometimes embellished with gilding. Such twelfth- and thirteenth-century luxury books as the Worksop Bestiary (New York, Pierpont Morgan Library, Ms. M. 81), the St. Petersburg Bestiary (St. Petersburg, Saltykov-Shchedrin Library, Ms. lat. Q.V.v.1), the Ashmole Bestiary (Oxford, Bodleian Library, Ms. Ashmole 1511), and the Monhaut Bestiary (Oxford, Bodleian Library, Ms. Bodley 764) bear comparison in terms of sumptuousness with any manuscript of the period. Nevertheless, many bestiaries and *Physiologus* manuscripts contain no illustrations at all, and some of the most interesting ones are rather sketchily illustrated with line drawings. An example is the eleventh-century Brussels *Physiologus* (Brussels, Bibliothèque Royale, Ms. 10074) produced for Saint-Laurent, Liège,[17] whose fifteen pen-drawn miniatures, illustrating the first twelve chapters of the text, are unusual in illustrating the moralization of the stories as well as the animals or stones which provide their ostensible subject matter.

The illustration to *lapides igniferi* on folio 141v (Fig. 3) is a complex three-part composition on two registers which follows the text it illustrates. The decision to place illustrations before or after the text to which they refer depends on two considerations. One is compositional, relying on the exemplar, and the other functional, depending on the intended use. When a book is copied it is usual to follow the arrangement of the exemplar unless powerful user-constraints demand a change. In this case, the only surviving illustrated *Physiologus* older than the Brussels manuscript, Bern, Burgerbibliothek, Ms. 318, has miniatures preceding the relevant text,[18] but it was certainly not the exemplar for the Brussels *Physiologus*, and since it is a ninth-century book, it can hardly be taken as a guide to normal illustration practice in the eleventh century. For manuscript books in general, Weitzmann gave examples of both systems of illustration placement, but only for ninth-century books.[19] If we turn to books approximately contemporary with the Brussels *Physiologus* and from the same general area, we can easily find examples of both methods.[20] On balance it must be assumed that user-considerations determined the decision to place the miniatures after the relevant text rather than before it, if not in this manuscript, at least in an exemplar.

In deciding to position the miniature after the text, the compiler of the Brussels *Physiologus* has subordinated the image to the text: the reading of the image is conditioned by the text which precedes it. Nevertheless, the *lapides igniferi* miniature contains features which go further than the text in emphasizing the role of women as agents of lust. The upper register shows, on the left, the half-naked male winged figure of the *angelus satanae* gesturing towards a central figure who appears to be female, since her dress lacks the

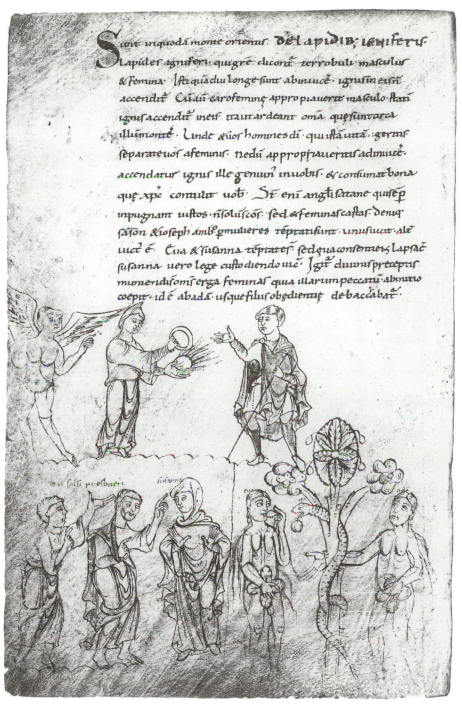

3. Brussels, Bibliothèque Royale, Ms. 10074, f. 141v, *lapides igniferi*

normal male overskirt.[21] She wears a hoodlike cap on her head, and holds the two fire-stones, one in each hand. The artist has used an entirely unambiguous visual code to distinguish between male and female stones. The ring-shaped female stone is unaffected by its proximity to its male counterpart, a spherical object which has burst into flame. The imagery thus differs significantly from the text in showing the female stone inflaming the male while remaining unaffected itself. The woman holds out the two stones towards a young man wearing a short tunic and cloak, and carrying a spear. He responds with an open-handed gesture of acceptance. Again emphasis is being placed on the role of the female in awakening lust: it is the woman who is the agent of lust, bringing the stones together to inflame the male one, while the young man is represented as the recipient of her action.

The lower register illustrates Susanna and Eve. The Susanna scene chosen does not show her bathing. Instead she is shown on the following day when the two elders (rubricated *falsi presbyteri*), tried to save their own reputations at her expense by claiming to have surprised her consorting with a young man. At the left, the elders gesture towards her head, commanding her to uncover her face and reveal her beauty, while a shocked Susanna recoils from their accusations. What is illustrated, therefore, is not specifically the lust of the elders but Susanna's steadfastness in resisting it, and her reliance on God (who duly saves her through the intervention of Daniel). On the right of this register is a scene of the Fall, with the tree placed centrally, Eve on the left, and Adam on the right. The serpent is coiling up the tree with the fruit, which it offers to Eve, impaled on its tongue. Eve is tasting the fruit and Adam holds his hand towards her to take it. Both progenitors wear leaves covering their genitals. Once more, while the text simply referred to Eve's fall from grace, the miniature dwells on her role in Adam's fall.

The details of the textual relationships between the *Physiologus* and the different classes of Latin bestiary will not be dealt with in this study.[22] It is sufficient to make the point that some bestiaries, like Oxford, Bodleian Library, Ms. Laud. misc. 247, are almost indistinguishable from the raw *Physiologus*. Many of the later bestiaries are much longer, more encyclopedic, and differently organized, but even when extra material is added, the *Physiologus* stories and their moralizations tend to remain, and the bestiaries retain their didactic function and their preoccupation with virtue and vice.

That this was how they were viewed by their medieval users is readily demonstrable. It has already been pointed out that the evidence of localised survivals among the English Latin bestiaries points overwhelmingly in the direction of male religious houses as the prime users of these books. Much more information can be gained from a study of the lists of books of various kinds—catalogues, borrowers' lists, gifts, etc.—that have survived. A survey of 83 medieval booklists from 62 houses has isolated 45 mentions of bestiaries in lists from 21 houses.[23] In many cases these amount to no more than a statement that a house possessed a bestiary when the list was made, but when the list is a detailed library catalogue, such as the Dover Priory catalogue of 1389[24] or the post-1493 catalogue of the Leicester Augustinians,[25] two further types of analysis are possible, and both tend to confirm the view that bestiaries were considered primarily to be treatises on virtue and vice.

Where catalogues are arranged by subject, and not by chronological order of accession or by donor, then, according to the broadness of the subject categories employed, the cataloguer has had to take a view of the general type of book a bestiary was. At Dover Priory the only book which contained a bestiary as its main text was shelved in the section devoted to sermons and other theological books. At St. Augustine's, Canterbury, the classification system places bestiaries among works on the monastic life, like Nigellus de Longo Campo's *Speculum stultorum*. Finally, the catalogue of the Augustinian house at Leicester places them immediately after the penitentials and sermons, and alongside works on vice and conscience. In all these cases, then, the librarians who imposed a subject classification on the books in their care treated bestiaries as works of theology and shelved them alongside sermons, penitentials, and works of moral philosophy.

It is also worth looking at the other texts with which bestiaries were bound when mixed volumes were assembled. This is the kind of analysis that must be done statistically, because for individual cases there could well be peculiar constraints which determined combinations of texts. For example, texts could be bound together to suit the needs of a particular monk, or because they were given by the same donor, or simply because they happened to be in quires at the same time. Looking at surviving books is not likely to be helpful either; unless the original bindings remain undisturbed there is no way to know when the texts in a mixed volume were brought together. It is necessary to turn once again to those medieval library catalogues that are sufficiently detailed to list the entire contents of each volume. In this survey of library catalogues, thirty entries were found from fifteen houses where bestiaries were combined with other texts, and the results of this analysis are given below (Table 3).

Table 3. Texts Commonly Combined with Bestiaries

ASSOCIATED TEXT	FREQUENCY	PERCENTAGE
Virtue and vice, penance, heresy	9/30	30%
Sermons	8/30	27%
Saints' lives, exemplary lives	8/30	27%
Miracles, marvels, and visions	4/30	13%
Biblical narratives	3/30	10%
Lapidaries	3/30	10%
Medical texts	3/30	10%

Bestiaries are combined with other types of text, too, but no statistical importance has been attached to types of text which occur fewer than three times. The percentages in the third column do not add up to 100, since bestiaries are often combined with several other texts.

The texts most commonly associated with bestiaries are on virtue and vice, and a few examples will demonstrate the nature of this material. A volume noted in the late fourteenth-century catalogue of the Benedictine abbey of

Peterborough includes, along with a bestiary, Augustine's *De conflictu vitio-rum et virtutum*; the *Formula vitae honestae*, a treatise on the four virtues by Martinus Pannonius; and a *Libellus de quattuor virtutibus cardinalibus*. The same text of Augustine also appears in combination with a bestiary in the circa 1400 catalogue of the Premonstratensian house at Titchfield, while the 1396 catalogue of the Cistercian abbey of Meaux notes a bestiary bound with the *Formula vitae honestae* and *De conflictu vitiorum et virtutum*, attributed to Gregory. Among surviving books it is worth mentioning London, British Library, Ms. Harley 3244, demonstrated by Evans to be a single compilation produced under Dominican patronage ca. 1255, which includes, alongside a bestiary, the *Liber penitentialis* and the *De sex alis cherubim* of Alanus ab Insulis, the *Summa de vitiis* of Peraldus, Grosseteste's *Templum Domini*, and an anonymous treatise on confession.[26]

Apart from the lapidaries and medical texts, all of the other associated texts are either sermons or commonly serve as sermon *exempla*.[27] For the lapidaries and medical texts, it is probable that the items listed as bestiaries were not what is thought of as bestiaries at all, but something similar to the *Liber de virtutibus bestiarum in arte medicina*, ascribed to Sextus Placitus.[29]

In conclusion, the *Physiologus* was a structured set of sermons, primarily concerned with the benefits of virtue and the avoidance of vice, which was modified and supplemented in bestiaries in ways which made it at once more encyclopedic and more of a reference book, like a book of *distinctiones*, to be used in the compilation of sermons. The frequency of bestiary references in surviving sermons, especially those of the Cistercians, who used bestiaries more than any other order, attests to this.[28]

NOTES

1. For the dating of the Greek text, see F. Sbordone, *Ricerche sulle fonti e sulla composizione del Physiologus greco* (Naples, 1936), 154–59. For the date of the translation, see R. Baxter, *Bestiaries and Their Users in the Middle Ages* (Stroud, 1998), 29 n. 1.

2. Baxter, *Bestiaries and Their Users* (as in note 1), passim.

3. A. Katzenellenbogen, *Allegories of the Virtues and Vices in Mediaeval Art* (London, 1939; repr. Toronto, 1989), 60.

4. Quotations from the *Physiologus* in the text are free translations of the edition printed in *Physiologus Latinus: Éditions préliminaires, versio B*, ed. F. J. Carmody (Paris, 1939).

5. *Physiologus Latinus* (as in note 4), 22.

6. Baxter, *Bestiaries and Their Users* (as in note 1), 72–82.

7. The *Physiologus* assumes a male reader throughout.

8. For an examination of early Alexandrian understanding of the Jewish food laws, see M. Douglas, *Purity and Danger: An Analysis of Concepts of Pollution and Taboo*, 2d ed. (London, 1978), 43–47.

9. *Physiologus Latinus* (as in note 4), 27–28. The passage in quotations marks is from Galatians 5:22–23.

10. Ibid., 28 (cf. Gal. 5:19–21).

11. *Physiologus Latinus* (as in note 4), 44.

12. The Northumberland Bestiary, from which this image is taken, was formerly Alnwick Castle, Ms. 447; it was sold in 1990 to an anonymous collector in the United

States. A complete set of photographs of the manuscript has been deposited in the Conway Library, Courtauld Institute. See also E. G. Millar, *A Thirteenth-Century Bestiary in the Library of Alnwick Castle* (Oxford, 1958).

13. *Physiologus Latinus* (as in note 4), 32–33.

14. Ibid., 13.

15. Ibid., 14.

16. Baxter, *Bestiaries and Their Users* (as in note 1), 150–51.

17. See H. Silvestre, "A propos du Bruxellensis 10066-77 et de son noyau primitif," in *Miscellanea Codicologica F. Masai Dicata* (Ghent, 1979), 131–56.

18. *Physiologus Bernensis: Voll-Faksimile-Ausgabe des Codex Bongarsianus 318 der Burgerbibliothek Bern*, ed. C. von Steiger and O. Homburger (Basel, 1964), passim.

19. K. Weitzmann, *Illustrations in Roll and Codex: A Study of the Origin and Method of Text Illustration* (Princeton, 1947), 72–73.

20. Brussels, Bibliothèque Royale, Mss. 9987–91, a Prudentius from Saint-Amand, has miniatures generally preceding the relevant text, while the first illustrated Life of Saint Amand (Valenciennes, Bibliothèque Municipale, Ms. 502), datable between 1066 and 1090, has miniatures following the chapters to which they correspond.

21. I am grateful to Kathryn Morrison for this observation.

22. Baxter, *Bestiaries and Their Users* (as in note 1), 83–143.

23. Ibid., 161–63.

24. M. R. James, *Ancient Libraries of Canterbury and Dover* (Cambridge, 1903), 407–96.

25. M. R. James, "Catalogue of the Library of Leicester Abbey," *Transactions of the Leicestershire Archaeological Society* 19 (1936–37), 118–61; 21 (1939–41), 1–88.

26. M. Evans "Peraldus's *Summa* of Vice," *Journal of the Warburg and Courtauld Institutes* 45 (1982), 14–68.

27. See J.-Th. Welter, *L'Exemplum dans la littérature religieuse et didactique du moyen âge* (Paris, 1927), 9–64; Baxter, *Bestiaries and Their Users* (as in note 1), 192–94.

28. Baxter, *Bestiaries and Their Users* (as in note 1), 191–92.

29. Baxter, *Bestiaries and Their Users* (as in note 1), 179–81; J. Morson, "The English Cistercian and the Bestiary," *Bulletin of the John Rylands Library, Manchester* 39 (1 Sept. 1956), 146–70.

The Spirit in the World: The Virtues of the Floreffe Bible Frontispiece: British Library, Add. Ms. 17738, ff. 3v–4r[1]

ANNE-MARIE BOUCHÉ

EVER SINCE Adolf Katzenellenbogen first accorded it a brief mention in his pioneering study on the Virtues and Vices,[2] the two-page frontispiece that opens the second volume of the Floreffe Bible (Figs. 1, 2), which was made around 1153 for the Premonstratensian canons of Floreffe Abbey,[3] has been recognized as a significant example of the theme of personified virtues in Romanesque art.[4] To a viewer familiar with similar personifications in other Romanesque sources, especially those in medallions used as ancillary figures in the margins of larger compositions, the Floreffe Virtues seem to occupy a surprisingly central place in the general design of the frontispiece. Organized into a wheel-like structure of medallions within medallions and circles within circles, they dominate the left-hand page and draw the eye to the standing figure of Charity, who gazes calmly outward from the center of the wheel, a still center of an otherwise dynamic composition. Whereas the rest of the imagery in the frontispiece is arranged in horizontal registers, the Virtues impose a forceful circular element that seems to emanate outward from the center of its page, echoed by the bowing of the bars separating the horizontal registers. It is clear that the Virtues must play a significant role in whatever meaning can be attributed to the frontispiece as a whole.[5]

The first scholar to attempt an interpretation of the volume two frontispiece was Adolf Katzenellenbogen. He can be credited with having identified most of the elements on the left-hand page, including the central wheel of the Virtues, as a visualization of parts of Gregory the Great's commentary on the Book of Job, the *Moralia in Job*.[6] But while Katzenellenbogen was initially attracted to the Floreffe Bible because of these Virtues, he did not investigate their meaning in any detail, in part because he seems to have had only half of the frontispiece (the left-hand page) at his disposal.[7] With no sense of the scale or meaning of the whole, and a larger agenda to pursue, he did not consider why the designer of the Floreffe frontispiece departed from Gregory's

42

text in choosing particular and rather unusual identities and tituli for his Virtues. More recently, Walter Cahn[8] and Herbert Köllner[9] briefly treated aspects of the frontispiece's meaning; they, too, passed over the specificities of the Virtues without remark.

For Cahn and Katzenellenbogen especially, there was a relatively straight-forward explanation for the left-hand page of the frontispiece: it derived from the *Moralia*. But when the iconography of the frontispiece began to diverge from that written source, with the Works of Mercy in the bottom register of folio 3v and the Last Supper and Transfiguration on 4r, their interpretations foundered. The real interest of the frontispiece is, however, precisely this: that it begins with a well-known textual source, then conspicuously fails to adhere to it, and builds instead an entirely new exegetical structure on that patristic foundation. For the correct interpretation of the entire frontispiece program, the distinctive qualities and texts attributed to these Virtues are of the greatest significance.

While a complete explanation of the frontispiece's imagery cannot be undertaken here, this paper will provide a general sense of the program's meaning, and show how the designer's calculated choices of specific Virtues and their associated inscriptions created a necessary bridge between the derived exegesis of the upper part of folio 3v and the new exegetical material introduced in visual form on the bottom of the page.

The frontispiece designer used Gregory's exegesis of the very beginning of the Book of Job, verses 1–2 and 4–5:

> There was a man in the land of Uz, whose name was Job. . . . And there were born to him seven sons and three daughters. . . . And his sons used to go and hold a feast in the house of each one upon his day; and they would send and invite their three sisters to eat and to drink with them. And it happened, when the days of their feasting were gone about, that Job sent and sanctified them, and rose up early in the morning, and offered burnt-offerings according to the number of them all, for Job said, "It may be that my sons have sinned, and blessed God in their hearts." Thus did Job continually.[10]

In the two scenes located in the upper registers of folio 3v (Fig. 1), Job performs a sacrifice on behalf of his children and, below, the children feast together at a banquet table. The scenes are separated by a horizontal bar in which an inscription is written, explaining the purpose of Job's sacrifice: "Ne peccent nati sunt a patre sanctificati / Dum pro quoque Deo fert data grata pio."[11]

In the *Moralia*, Gregory interpreted these events in three distinct ways, each corresponding to one of the ancient categories of scriptural exegesis: literal, allegorical, and moral. The frontispiece designer drew on both the "allegorical" and the "moral" exegeses provided by Gregory.

In his "allegorical" commentary, Gregory equates the seven sons with the Twelve Apostles, who, filled at Pentecost with the sevenfold grace of the Holy Spirit, go forth to preach.[12] This interpretation is rendered visually in the frontispiece by depicting the apostles in the register below the central roundel at the moment when they are receiving the Spirit at Pentecost. Job's sons take

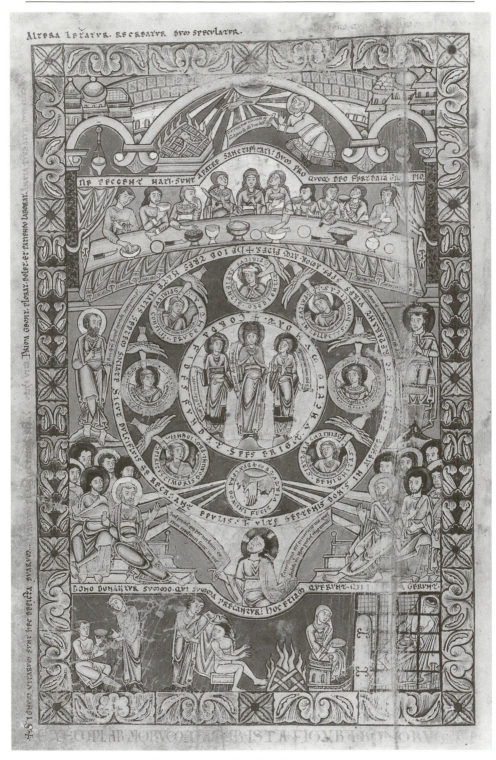

1. London, British Library, Add. Ms. 17738, Floreffe Bible, f. 3v

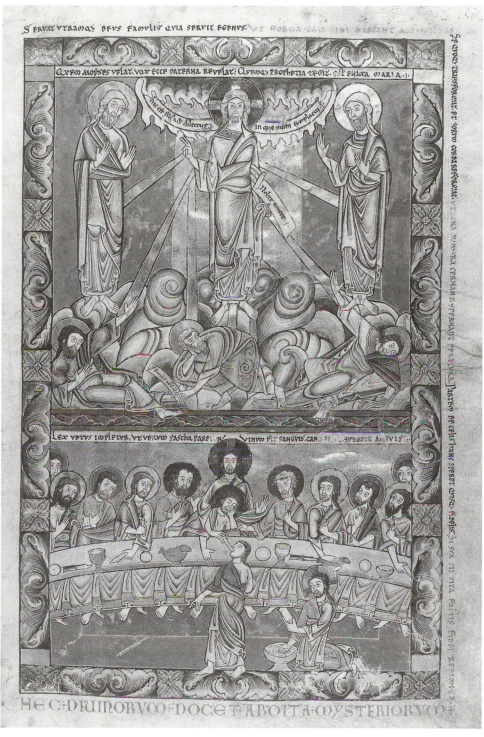

2. London, British Library, Add. Ms. 17738, Floreffe Bible, f. 4r

turns entertaining their three sisters in their various homes, just as the apostles, in diverse regions of the world, distribute the food of virtue to the three divisions of the Christian community, i.e., priests, the celibate, and married people.[13]

Job's sacrifice on behalf of his children also has, according to Gregory, an "apostolic" significance: the episode corresponds to the occasion described in John 17, in which Christ petitioned the Father on behalf of the apostles upon their return from preaching.[14] This incident is represented in the frontispiece (in perhaps its only occurrence in medieval art) in the form of the half-length figure of Christ inserted into the middle of the Pentecost register, holding his petitions inscribed on two banderoles: *Pater serva eos in nomine tuo quos dedisti mihi; Non pro his rogo tantum, sed pro eis qui per verbum eorum credituri sunt in me.*[15] In a narrative context, the appearance of Christ in the middle of the Pentecost scene would be impossibly anachronistic; it only makes sense when we realize that Gregory is indicating a typological relationship between Job and his children, on the one hand, and Christ and the apostles, on the other.[16]

The roundel of personified virtues occupies a privileged position in the center of the page, between the Old Testament types at the top and their New Testament antitypes at the bottom. In the center, three standing, full-length female figures are shown against a gold ground within a framed circular field. These represent the theological virtues faith, hope, and charity. Surrounding this central roundel are eight smaller medallions, seven of which contain female busts, personifications of seven additional virtues. Each of these holds an inscribed banderole and is accompanied by a dove representing a Gift of the Holy Spirit. The names of the Virtues and their associated Gifts are inscribed in their medallion frames. The eighth medallion, at the bottom of the circle, contains a Hand of God surrounded by the inscription *Dextera Domini fecit virtutem.*[17]

This unusual composition corresponds (as Katzenellenbogen realized) to an alternative exegesis of the same short text from Job, drawn this time from Gregory's "moral" interpretation. Here Gregory interprets the seven sons of Job, not as apostles, but as the seven Gifts of the Holy Spirit (Isaiah 11:2), which he associates with seven virtues. Job's three daughters are interpreted as the theological virtues faith, hope, and charity.[18]

Although the association of the Gifts of the Holy Spirit with personifications of virtues is unusual in art, the imagery closely follows the sense of Gregory's exposition: "seven sons are born to us when, through the conception of right thinking, seven virtues are raised up in us by the Holy Spirit." Gregory goes on to say that these seven virtues cannot be effectively exercised in the absence of the three theological virtues, who in the frontispiece composition dominate the surrounding half-length Virtues both by reason of their representation as full-length figures and by their position in the center of the composition. Together, Job's sons and daughters reach the mystical number of perfection, ten; the seven virtues which are the Gifts can only fully operate when joined to the three theological virtues.[19]

In the circular frame surrounding the rosette of the Virtues an inscription enlarges on Gregory's allegory, suggesting a parallel between the refreshment

enjoyed by Job's children at their banquet and the restorative properties of the virtues in the minds of the faithful:

> De Job tres natae natis septem sociatae
> Sicut dulcifluis se recreant epulis
> Fulte septenis donis in mente fidelis
> Sic reparant vires spes, amor, atque fides.[20]

In the center of the rosette, the theological Virtues hold banderoles inscribed with appropriate tituli quoted or paraphrased from Scripture: *Justus ex fide vivit;*[21] *Diligens diligetur;*[22] *Spes non confundit.*[23] An inscription in the surrounding frame confirms these identifications and describes the operations of the theological virtues on human hearts in more detail: "Corda fides fundat. Spes erigit. Unctio mundat."[24] Thus each theological virtue has a carefully distinguished function in preparing the heart for the spiritual experience to come, a function that in each case is derived from a broadly-based and venerable tradition.

The idea that faith functions as a foundation goes back to patristic roots. By means of faith the believer makes a dwelling place, or temple, for Christ in his heart. Thus, the founding of the rebuilt temple of Jerusalem is allegorized by Bede as this internal habitation, created "through faith" in the hearts of the newly converted.[25] Since faith is the essential precursor, it acts as the foundation of the spiritual temple. Faith thus comes to have both a spatial and an architectonic connotation: it is a foundation located in the depths of the heart. Similarly, hope, since it has the property of "lifting" the spirits, is localized spatially in the heights.[26]

If the operations attributed to faith (founding) and hope (raising) in the Floreffe frontispiece thus seem to be common *topoi* in exegetical literature, what of the cleansing function attributed to the third theological virtue, charity? Unlike her two sisters, Charity has undergone a change of name: in the inscription she is referred to, not as Caritas, but as Unctio (Unction). The Bible contains many references to unction and anointing. Old Testament priests were anointed,[27] and both Saul and David received unction as kings. Inanimate objects, too, could be sanctified by unction, as in the case of Jacob making an altar of his stone pillow by pouring oil over it (Gen. 28:18). The oil of unction was also used in ritual cleansing, as after disease or injury.[28]

But the primary idea associated with unction in Christian exegesis and liturgical practice was that of the Holy Spirit. The sacramental anointing of the baptized was held to correspond to the descent of the Holy Spirit on Christ at his own baptism, the event that marks the beginning of his public life of preaching, teaching, and healing. Christ's very name refers to unction: "Christus" means "unctus." Thus, speaking of baptism, both of Christ and of the faithful, Rupert of Deutz writes:

> To be baptized in the Holy Spirit is to receive the grace of the Holy Spirit (Rom. 6) . . . Indeed, the baptism of Christ is a royal and sacerdotal anointing (I Petr. ii), on account of which, having been anointed in the presence of all his followers, he himself is called "anointed" (Ps. xliv), since "Messias" in Hebrew and "Christus" in Greek are translated as

"unctus" in Latin. Thus he alone is fully anointed in such a way that he is able especially to anoint others, and to make adopted sons and "anointed ones" that is, "Christians," so called after himself, which is what is meant by the saying: "It is he who baptizes in the Holy Spirit."[29]

The strong association between unction and the Holy Spirit meant that almost any account of unction could be interpreted as the unction of the Spirit, e.g., Jacob anointing his stone pillow[30] But the unction which most often evokes this exegetical train of thought is that mentioned in the first epistle of John.[31] This text, which refers to unction as the agent that "teaches all things," is related to two other texts in the Gospel of John that identify that which "teaches all things" as the Holy Spirit;[32] thus unction is identified with the Holy Spirit.

But why, then, does the frontispiece give a name (Unction) normally applied to the Holy Spirit to the theological virtue charity? The reason is that these three concepts, in Christian exegesis, are intimately related; "unction," "Holy Spirit," and "charity" (love) are three ways of referring to one reality, God's love. Rupert of Deutz writes:

> The Holy Spirit . . . is the Lord and Arbiter, and, indeed, the efficient cause [*efficiens causa*] of all things which have been done or are to be done concerning our salvation. Why, indeed, did the Father send the Son into this world, or that Son, with his blood, reconcile us to his Father when we were enemies, if not on account of his love? What indeed is the Holy Spirit except the love of Father and Son?[33]

This identification of charity with the Holy Spirit is already linked to unction in Augustine, who quotes St. John:

> I have written these things concerning those who would seduce you, so that you may know that you have been anointed, and that the unction which we accept from him shall remain in us (John 2:26–27). This is the sacrament of unction, its power is invisible; this invisible unction is the Holy Spirit; this invisible unction is that Charity, which will be like a root in whoever has it, so that, however hot the sun might be, he will not be withered.[34]

The same association of unction with the Holy Spirit/*caritas* is also made by Bede: "He awaits gifts from the Lord, the wheat of celestial grace, that is to say, the words of the Lord and the oil of Charity and the unction and illumination of the Holy Spirit."[35]

"Caritas," in this sense, is therefore more than a virtue; it is in fact God's love, which is the Holy Spirit, consubstantial with both Father and Son.[36] But since it is therefore a property belonging to God, how does it come to be distributed to the human race, and be manifested as a virtue? It is found as a virtue in people only because it was poured into the hearts of the apostles through the Spirit which was given to them at Pentecost, and then distributed by them to the rest of the Church.[37]

The Old Testament type for this is the fragrant oil poured over Aaron's beard and running down onto the collar of his vestments, cited in Psalm 132 as a metaphor for the sweetness of brotherhood.[38] Explains Rupert of Deutz:

What is this garment [of Aaron]? It is the holy Catholic Church. For the beard of Aaron, which means "the mount of fortitude," this beard, I say, represents Christ's apostles, and apostolic men, strong and perfect. For the Holy Spirit is a regal and sacerdotal anointing oil, of which the whole quantity is on the head, that is Christ, and from thence descends first into the apostles, as into the beard, then into the whole Church, and unto the extremities of the Church, as into the collar of the garment.[39]

In changing the name of "Caritas" to "Unctio," the frontispiece designer not only stressed the identification of the virtue Charity as the Holy Spirit, but also evokes the *means* by which the Holy Spirit is transmitted, that is, through the apostles. In other words, the frontispiece designer is underscoring one of Gregory's main themes in the *Moralia*, which is the role of the apostles in the process of salvation. And, as we will see later on, the process of salvation—that is, the historical unfolding of God's plan for the world—is the larger theme of the whole frontispiece, in which Gregory's *Moralia* interpretations are just a starting point.

Unction/Charity is not merely the greatest virtue; she is the source of all virtue, the Holy Spirit. The sacramental anointing that follows baptism signifies the transmission of the Spirit; it is the visible sign of the invisible grace passed from God to Christ and thence to the apostles and the whole Church, creating a single organism of many members.[40] Unction brings with it the connotations of cleansing, purification, and healing, all functions of the Holy Spirit; the act of anointing, of pouring out the oil, suggests a metaphor for the way in which these benefits are transferred, through (as it were) the power of gravity, from God to the humblest and most remote members of the Church, by way of Christ, Christ's apostles, and their successors.

Rupert of Deutz called the Holy Spirit the "efficient cause of all things which have been done or are to be done concerning our salvation." Rupert's use of the Aristotelian term "efficient cause" arises from a quite specific and widely accepted theological position that regards the Holy Spirit as the agent that powers the process of salvation, working the will of God in the succession of historical events that comprise the temporal order from Creation to the Last Day.[41]

Within this temporal order, the nature of the relationship between the Holy Spirit and the world was not constant, but changed over the course of history. At Creation, the Spirit was "moving over the face of the waters"; and like the Logos, it was already extant, consubstantial with God. But it was not yet a separate presence in the interactions between God and the world; in the Old Testament, God intervenes in human history directly, as with Moses on Mount Sinai.

But the incarnation and birth of Christ, prefigured in Isaiah's prophesy of the flowering of the stem of Jesse,[42] inaugurated a new stage in the relationship of the Spirit to the world.[43] At the moment of the Annunciation, the Spirit appears for the first time as a separate actor on the stage of history, as the instrument of the Incarnation. On Christ, the flower that bloomed on Jesse's stem, "rested" the sevenfold gifts of the Holy Spirit. And this moment when the Spirit "rested" on Christ is identified with the hovering Spirit in the

form of a dove that appeared above Christ at his baptism. From that moment, which marks the beginning of Christ's public life, God's will is accomplished in a different way, through the physical presence and acts of the second person of the Trinity. Rupert of Deutz writes:

> It is affirmed that this same Lord in the form of a slave [i.e., as a man] received these gifts [of the Holy Spirit]; according to the Prophet who says these things in his person [i.e., as if Christ were speaking], *The spirit of the Lord is upon me, because the Lord has anointed me* (Is. 61:1); *he has sent me to bring good news to the poor* (Lk. 4:18). For in that book of Isaiah the prophet states these things to have been said, concerning this unction of his, that the Holy Spirit was seen upon him, in the form of a dove.[44]

From the Baptism to Pentecost, then, the Spirit works through the person of Christ. But eventually Christ must separate from his followers, and when that happens a final era begins in the relationship of the Spirit to the world. Christ promises that after his departure he will send a "comforter" which is the Holy Spirit. When this happens, at Pentecost, the Spirit is communicated to the disciples as tongues of fire, but thereafter it will only be transmitted through sacramental baptism and unction. By the same token, once it is transmitted sacramentally, from person to person, it no longer appears in corporeal form and ceases to act as an external presence. In the final stage of history it is present in the world and does its work, only through the persons, and the acts, of the faithful.

This communication of the Spirit to the world is effected in a two-part process. The first takes place on earth: when Christ appeared to all the disciples on the evening of Resurrection day, he gave them the power of forgiving sins:

> Late that Sunday evening, when the disciples were together behind locked doors . . . Jesus came and stood among them. . . . Jesus repeated, "Peace be with you," and said, "As the Father sent me, so I send you." Then he breathed on them, saying, "Receive the Holy Spirit. If you forgive any man's sins, they stand forgiven; if you pronounce them unforgiven, they shall remain so."[45]

This marks the moment, as Victor Lossky points out, when the Church as a corporate whole receives the Holy Spirit.[46] But even then the communication of the Spirit is not complete. This is only consummated at Pentecost, when the Holy Spirit appears, resting on each individual present, and "marking each member of the Church with the seal of personal and unique relationship to the Trinity, becoming present in each person."[47]

The Spirit received by the apostles at Pentecost is thus the same Spirit which appeared over Christ at his own baptism. And it is the same unction of the Spirit—charity—that "teaches all things" and effects the salvation of the individual, cleansing the heart from sin (impurity or sickness), thus making it a fit habitation for God.[48]

When charity, the Holy Spirit, comes from God, it brings with it all the virtues, the three theological virtues as well as an innumerable variety of

lesser, "daughter" virtues. In the *Moralia* the seven lesser virtues depicted in the frontispiece are not so much identified with the Gifts as resulting from them: in Gregory's words, they are "raised up in us by the Holy Spirit through the conception of right thinking."[49] Thus, the virtues are the active manifestation of the Spirit in the individual. Man cannot simply "be" virtuous, but must exercise the virtues in order to possess them.

This twofold identification of charity as the comprehensive virtue, on the one hand, and as the unction of the Holy Spirit, on the other, creates a link between the typologically- and exegetically-based imagery of the upper part of the page and the Works of Mercy at the bottom. Works of mercy are, after all, the tangible, visible expression of the working of the Holy Spirit, God's love, in Christian society. Far from being an alien, discordant element in the frontispiece, the Works of Mercy are therefore the logical continuation of the processes described in the upper registers and an integral part of the page's exegetical "statement."

In bringing together within a single pictorial composition Gregory's "allegorical" and "moral" interpretations of the same passage, the designer of the Floreffe frontispiece was able to accomplish what Gregory himself could not within the structure of his commentary. Since the *Moralia* is divided into three sections, and each section interprets the whole text of Job systematically, line by line, the resulting commentary consists of three parallel but distinct interpretations of the whole text. In other words, Gregory goes through the whole text providing a "literal" commentary, and then begins again with the first sentence of Job for his "allegorical" commentary, and again for the "moral" commentary.[50]

As a result, while Gregory gains internal coherence within each of his hermeneutic categories, the various interpretations of each passage are widely separated and dispersed among the three sections. Since all three interpretations go back to a single scriptural text, a latent link obviously exists between them; the designer of the Floreffe frontispiece simply makes this latent link between the moral and allegorical readings of the first lines of Job visually explicit, and in so doing creates a new exegetical statement based on, but not confined to, Gregory's text. In the imagery, Gregory's *Moralia* provides a springboard for a larger and more complex exegetical structure.

In the "allegorical" interpretation, it will be remembered, the seven Gifts were already mentioned as the septiform Holy Spirit with which the apostles were filled at Pentecost. Thus the two interpretations of the seven sons of Job actually mesh in the imagery into a coherent exegetical argument, one which seems to place particular stress on the apostles and their role in the economy of salvation. Job sacrificing represents Christ beseeching his father on behalf of the apostles after they have returned from preaching; the sons' banquet represents the apostles preaching the Gospel to auditors represented by the daughters; the apostles, having received the septiform Holy Spirit at Pentecost, are thereby endowed with the virtues and, so armed, are prepared to engage in their active ministry, communicating that same Holy Spirit to the world. The "works of mercy" at the bottom of the page testify to the continued presence of the Holy Spirit in the community of the faithful after the age of the apostles, bringing the story down through the present day.

Once the links between the various elements are better understood, it becomes possible to read the frontispiece page as a straightforward historical sequence which traces the progress of God's interaction with humanity through a portion of history.[51] The Job scenes begin the sequence in the Old Testament, at a point when God is still acting directly in world affairs. But then, with the incarnation of Christ, the septiform Holy Spirit (God's love, or *caritas*) suddenly bursts into the world, bringing with it all the virtues. From Christ, the Spirit is then passed first to the apostles, and later to the rest of the world. Until the Second Coming brings an end to time, the Spirit will no longer appear as tongues of fire or a dove; it will be seen only in the love that men show their fellows, a love that is not just inspired by the Spirit, but is an actual manifestation of it. Charity is the Holy Spirit, charity is therefore God, and—since God and Christ are consubstantial—charity is also Christ. Of all the figures on the page, only three—the middle daughter of Job (the type of Caritas), Caritas herself, and Christ—appear frontally on the axis, against gold grounds. The three figures are but three ways of alluding to a single reality.

More intensive scrutiny of the seven lesser virtues supports the interpretation of the central roundel as an allusion to the moment of the Incarnation, the arrival of Christ in the world. The specific identities of these Virtues, here named Providence, Temperance, Prudence, Obedience, Humility, Patience, and Benignity, are, like the designation of Caritas as Unctio, not derived from the *Moralia*. When Gregory relates the virtues to the seven Gifts, he assumes that the virtues are but the expression of their respective gifts, and names them accordingly: understanding, counsel, fortitude, knowledge, piety, and fear of the Lord.

The frontispiece designer, on the other hand, has chosen seven different Virtues with which to associate the seven Gifts. Each personification of a virtue holds a banderole inscribed with a scriptural quotation or paraphrase. Clockwise from the lower left, with banderole inscriptions in parentheses, they are:

Spiritus timoris domini—Providentia (*Beatus qui semp[er] est pavidus*)[52]

Spiritus scientiae—Temperantia[53] (*Estote prudentes sic[ut] serpentes*)[54]

Spiritus consilii—Prudentia (*Omnia fac cum consilio*)[55]

Spiritus sapienti[a]e—Obedientia (*Ut iumentu[m] factus sum apud te*)[56]

Spiritus intellectus—Humilitas (*Intellectum dat parvulis*)[57]

Spiritus fortitudinis—Patientia (*Ego in flagella patiens*)[58]

Spiritus pietatis—Benignitas (*Estote invicem benigni*)[59]

It is not always obvious why a particular Virtue is linked to a specific Gift. While the relationship between the "spiritus fortitudinis" and patience is reasonably clear, that between the "spiritus pietatis" and benignity, or between the "spiritus intellectus" and humility is not obvious.

In some cases the inscriptions create connections between the Gifts and their associated Virtues that might not otherwise be readily apparent. For

example, the "spiritus intellectus" is linked to Humilitas through the Psalm verse quoted in the titulus, *Intellectum dat parvulis*.[60] In similar fashion, the phrase held by the Spirit of Wisdom, *Ut iumentum factus sum apud te*, is frequently interpreted in exegetical literature as an allusion to Christ's having been made, for our sakes, obedient "even unto death on the Cross,"[61] and this makes it possible to identify the Spirit of Wisdom with the virtue of obedience through the person of wisdom incarnate, that is, Christ.

Less easily explained, however, is the use of Christ's exhortation to be "prudent as serpents" on the banderole held by Temperance; this phrase might seem to be more appropriately applied to Prudence. Bestiary lore, however, emphasized the snake's "cold-bloodedness," on account of which it was said to be much less dangerous at night than by day, when warmed by the sun.[62] In that sense, the serpent might be considered temperate by nature, just as it was said in Genesis to be naturally cunning or wise (Gen. 3:1).

No textual parallel for the frontispiece's particular set of Virtues has yet been discovered, although the frontispiece designer could easily have found such sets in well-known literary sources. Lists of virtues could, for example, be derived from scriptural enumerations like the Beatitudes (from Christ's Sermon on the Mount) or the fruits of the Holy Spirit (from Paul's letter to the Galatians.)[63] The designer could also have turned to one of the numerous moral tracts featuring lists of virtues or personified virtues, such as Prudentius's *Psychomachia*;[64] Hugh of Saint-Victor's treatise on the "sevens," *De quinque septenis seu septenariis*;[65] the pseudo-Hugonian *De fructibus carnis et spiritus*;[66] or Herrad of Landsberg's *Hortus deliciarum*, in which every conceivable Virtue and Vice joins in the moral battle.[67]

Hugh of Saint-Victor's list, which is based on the Beatitudes, receives a more detailed discussion in a sermon attributed to a Victorine, possibly Richard of Saint-Victor, in which two of the scriptural quotations held by the Floreffe Virtues are cited.[68] But despite this last, tantalizing coincidence, only Herrad of Landsberg's greatly expanded series of Virtues actually contains all seven of those named in the Floreffe set.

Nor did the frontispiece designer follow any of the known pictorial sources for personified virtues. One of these, however, the ivory book cover of the famous Melisende Psalter, dated 1131–43 (Figs. 3, 4), is the only known surviving monument that juxtaposes the theme of personified virtues with that of the works of mercy prior to the Floreffe Bible, and as such it deserves particular attention.[69]

The psalter's front cover depicts a modified "Psychomachia," with the seven battling pairs of Virtues and Vices cited by Prudentius, plus five additional Virtues (and appropriate Vices), giving a total of twelve pairs. The additional Virtues include Benignitas, Beatitudo, Laetitia, Bonitas, and Largitas; of these, Benignitas, Bonitas, and Laetitia (= Gaudium) are already familiar from the Pauline "fruits of the Spirit." Only four of these twelve virtues, however (Benignitas, Patientia, Humilitas, and Fides), overlap with the ten depicted on the Floreffe frontispiece.

In the Melisende Psalter, the combination of Virtues with Works of Mercy seems to serve a different end than the same juxtaposition in the Floreffe frontispiece: the "Psychomachia" of the front cover alludes to the virtues of the author of the Psalms, King David, who functions here not only as the author

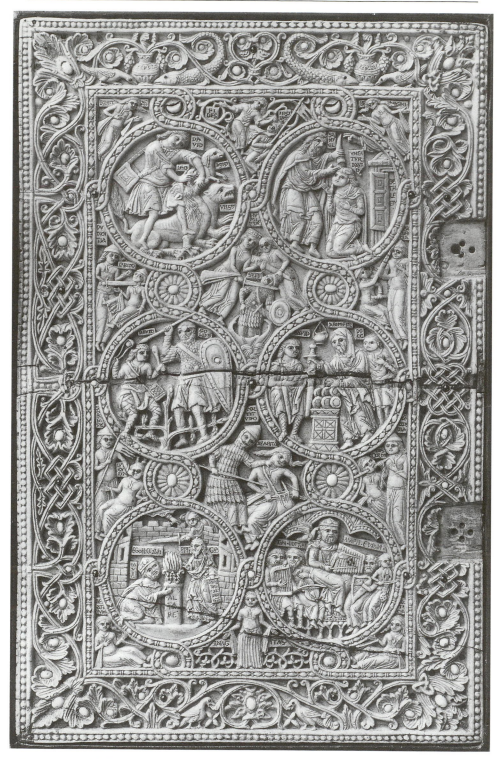

3. London, British Library, Ms. Egerton 1139, Psalter of Queen Melisende, front cover

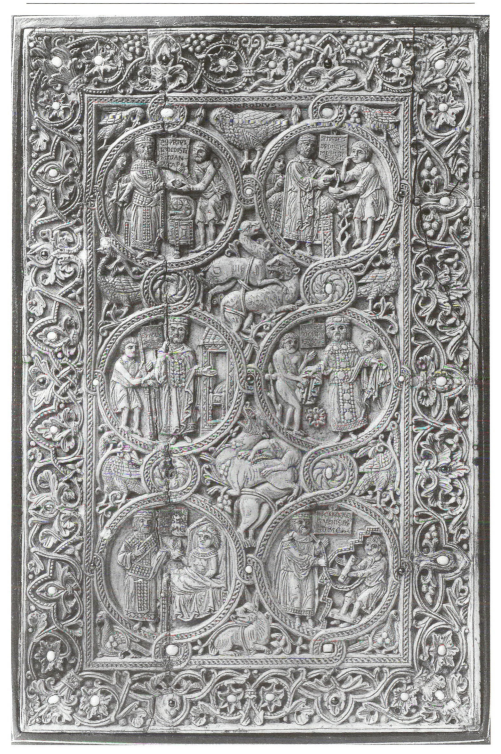

4. London, British Library, Ms. Egerton 1139, Psalter of Queen Melisende, back cover

of the text, but as a prototypical model of sacred kingship for the royal personage who is shown, on the back cover, exhibiting those same kingly virtues by performing works of mercy.

If the frontispiece designer was not drawing directly on an existing source for his group of Virtues, one of two things must be assumed. Either these Floreffe Virtues were picked at random, an unlikely scenario given the careful planning evident elsewhere in the imagery, or the Virtues selected were especially suited to the iconographic program. If the scriptural tituli are examined once again, looking at them as a group this time, it is possible to discern what may be the outlines of a pattern.

Three tituli—*ego in flagella patiens, ut iumentum factus sum apud te,* and *intellectum dat parvulis*—are phrases, drawn from the psalter, that are frequently used to refer to Christ's obedience and patient endurance.[70] "Benignitas" was not only recommended to his disciples by Christ, but is a term frequently used in exegetical rhetoric to describe the extraordinary mercy shown by God towards mankind when, to atone for the sins of the world, he became incarnate as Christ.[71] The rest of the banderole tituli are either exhortations made directly by Christ to his followers or statements that, though drawn from elsewhere in Scripture, are close parallels or analogs to Christ's direct exhortations. If this observation is valid, then it follows that the Virtues of the frontispiece are those especially exhibited (and recommended) by Christ.

This interpretation is supported by an exegetical tradition that linked Christ with the virtues. Paul described Christ as "the power and wisdom of God" (*Dei virtutem et Dei sapientia,* 1 Cor. 1:24). Christ, therefore, is the power, or virtue of God, the agent of God's work,[72] and in his person encompasses all the powers (virtues) of the Father.[73] Indeed, Gregory the Great attributed the plenitude of the Gifts of the Holy Spirit to Christ alone: only in the case of the perfect man can all the Gifts be operational at once.[74]

This Christocentric interpretation of the frontispiece Virtues is confirmed by the presence of the Right Hand of God in the eighth medallion, which completes, and perfects, the octave of the central rosette.[75] This "right hand," according to the Psalm verse inscribed around it, "does great things": *Dextera Domini fecit virtutem.*[76] (The English translation does not quite convey the Latin conflation of the meanings of "virtues" and "great things, mightiness" which gives the psalm verse its particular appropriateness.)

In art-historical literature, the Right Hand of God is generally assumed to refer to God the Father, especially when it extends from the heavens in a gesture of presence or benediction above a terrestrial event.[77] However, the standard patristic explanation of the verse *dextera Domini fecit virtutem,* which is reiterated in various forms throughout the Middle Ages, is that offered by Cassiodorus in his *Expositio psalmorum:* "And so that you might acknowledge whence this joy comes, he [the Psalmist] adds: the Right Hand of the Lord does great works, that is, Christ, through whom the great works of the Father are carried out. . . . "[78]

That the Hand of God continued to be routinely identified with Christ throughout the Middle Ages is clear from comments such as that made by Arno of Reichersberg, who remarks that in pictures Christ is "sometimes represented as a hand, sometimes as a lamb."[79] Patristic exegeses of the *dextera*

Domini as Christ were disseminated both directly, through the works of church fathers such as Jerome, and indirectly through patristic glosses in psalm commentaries such as that of Bruno of Würzburg (d. 1045).[80] In Jerome, as in the frontispiece, the *dextera* is not only associated with Christ, but also more specifically with the idea of virtue or power (*virtus*).[81]

Not infrequently, especially in eucharistic contexts, the identification of the hand with Christ is made explicit by the presence of a cruciform nimbus, as, for example, on the eleventh- or twelfth-century silver-gilt patens in the treasuries of the cathedrals of Cividale and Skara (Sweden).[82] The theological idea behind this use of the *dextera* on a paten is clear: the Eucharist, like the sacrifice on the Cross which it reiterates, is one of those "great works" through which Christ brings about salvation. The giving of the Holy Spirit must also be classified as one of these "great works," at least in the West where the Spirit was held to come from the Son as well as from the Father.

If the Virtues of the frontispiece, together with the *dextera Domini*, refer collectively to Christ, the Gifts of the Holy Spirit provide an additional, temporal dimension, in that they are specifically associated, through the prophesy of Isaiah 11, with Christ's advent on earth in the Incarnation. This temporal aspect, and the pivotal position of the Incarnation within history, are important for understanding the entire frontispiece as an historical sequence. This sequence describes a U-shaped itinerary, from top to bottom on the left-hand page and from bottom to top on the right. It begins in the Old Testament, with Job at the top of folio 3v, then moves downwards, through the key events of the Incarnation of Christ (roundel of the Virtues) and the sending of the Holy Spirit and the inauguration of the apostolic age (Pentecost), into the age of the Church, the present (Works of Mercy) at the bottom of the page.

The sequence continues on the facing page (f. 4r, Fig. 2). At the bottom of the page, a Last Supper evokes the liturgical sacrament of the Eucharist.[83] This is the spiritual Work of Mercy paralleling the corporeal works on the left-hand page; like these, it is a continuously re-enacted gesture, that, though inaugurated in the past, will continue through the present and into the future.

At the top of the page, the itinerary culminates in a Transfiguration, representing here the end point of the historical narrative. Since at least the fourth century, one of the primary meanings attributed to the Transfiguration has been its proleptic allusion to the glorified body in which Christ returns at the end of time. This, for example, is the interpretation of Jerome: "*And he was transfigured in front of them.* As he is to be in the time of judgment, so he appeared to the Apostles. . . . *And his face shone as the sun.* Surely, the Lord was transfigured, showing forth that glory with which afterwards he is to come in his kingdom."[84] The Transfiguration thus stands in place of a representation of the Second Coming, and refers proleptically and symbolically to an event that, because it lies beyond the present, can only be anticipated, not described with any certainty.

The frontispiece thus singles out certain key events in the history of salvation within the historical framework revealed in Scripture, a framework that is characterized by a typological or prophetic relationship between the events of the Old Testament and those of the New. The imagery summarizes only part of the historical process, that beginning with Job, but by selectively

depicting scenes that were interpreted typologically as references to Christ and the disciples it underscores the unity that, according to Christian exegetes, linked the Hebrew Bible with the New Testament.

Why, however, should the sequence begin with Job, rather than with the more logical starting point of the Creation? This was the point that interested Walter Cahn, who tried to interpret the frontispiece as if it were an illustration to the Book of Job.[85] That biblical book does, indeed, immediately follow the frontispiece, since it is the first book in volume two of the Bible. However, the physical proximity of the text of Job to the frontispiece has a different significance.

The frontispiece is an original work of visual exegesis, based, like all exegeses, on a text. In this case, the text in question is that contained in volume two of the Bible. The sequence of imagery begins in Job and ends with an allusion to the Second Coming because volume two of the Floreffe Bible begins with Job and ends with Revelations. It is known that volume one of the Bible also had a frontispiece, now lost, that almost certainly followed a pattern established in earlier Mosan frontispieces, in which a monogrammatic treatment of the first word of Genesis, "In," is combined with Creation scenes.[86] Whether this lost frontispiece also provided some kind of visual summary and exegesis of the entire contents of volume one cannot, unfortunately, be determined, but this is at least a possibility.

Thus, on at least one level, the frontispiece to volume two of the Floreffe Bible functioned as a commentary to the accompanying text, paralleling and interpreting the historical narrative in a way that underscored the main stages of God's involvement with the world, from the Old Dispensation (represented by Job) through the Incarnation (the roundel of the Virtues), the age of the apostles (the *Moralia* typologies), the present (Works of Mercy and the liturgy of the Eucharist, alluded to through the Last Supper), and on into the future (Transfiguration).

The association of the wheel of the Virtues, in the center of the left-hand page, with the Incarnation provides an explanation for the formal emphasis given to it in the overall composition. Just as the Incarnation breaks into the pattern of history and sends it decisively and permanently in a new and improved direction, so too the roundel of the Virtues, representing the incarnation of Christ, bursts into the frontispiece composition with dramatic force. Inserting itself into an arrangement otherwise organized into horizontal registers, it seems to force all the other scenes into the margins. Even the bars that separate the horizontal registers from each other at the top and bottom of the page bow outward, as if in response to a shock wave emanating from the center. This moment, the center point and pivot of history, has repercussions both backwards in time—making the meaning of past historical events suddenly clear—and forwards, as it influences the course of future events. A more felicitous visual metaphor for the irruption of the Holy Spirit into history at the moment of the Incarnation can hardly be imagined.

Far from being a conventional evocation of a well-known *topos*, the Virtues of the Floreffe frontispiece thus represent a startlingly original departure from the usual roles played by such personified virtues in medieval art. They were carefully selected and fitted with tituli so as to participate actively in the

meaning in the frontispiece, going beyond Gregory's *Moralia* in stressing the link between the virtuous acts of individuals and the very source of all virtue, Christ, and underlining the identity of substance between individual virtues, the comprehensive virtue of charity, and the Holy Spirit. Like Gregory's *Moralia*, the frontispiece has both an allegorical/historical message and a moral one: it explains the deep structure and meaning of history, and it models how the individual Christian viewer might insert his- or herself into the historical process of salvation by participating in the substance and nature of Christ through the practice of the virtues.

Had the program's designer simply wanted to transcribe a preexisting text into visual form, these personifications might have looked the same superficially, but their identities would have been different, and their tituli less idiosyncratic. But the frontispiece's creator recognized an opportunity to move beyond the conventional and established set of theological and visual ideas, and to create an original synthesis, a work of exegesis in visual form that provides an extended meditation on the meaning of Scripture, and of life, at the very threshold of the written text.

NOTES

1. All direct citations and paraphrases of the Vulgate text are in italics; non-biblical citations are indicated by quotation marks. All translations into English, unless otherwise indicated, are my own. The recent article by Ulrich Kuder, "Die dem Hiob-buch vorangestellten Bildseiten zu Beginn des 2. Bandes der Bible von Floreffe," in *Per Assiduum Studium Scientiae Adipisci Margaritam: Festgabe für Ursula Nilgen zum 65. Geburtstag,* ed. A. Amberger et al. (St. Ottilien, 1997), 109ff., came to my attention when this volume was already in press. His conclusions, however, do not contradict my interpretation.

2. A. Katzenellenbogen, *Allegories of the Virtues and Vices in Mediaeval Art, from Early Christian Times to the Thirteenth Century* (London, 1939; repr. Toronto, 1989), 37–38.

3. Floreffe is near Namur, in present-day Belgium. On the Bible's date, provenance, and style, see: A. Boeckler, "Beiträge zur romanischen kölner Buchmalerei," in *Mittelalterliche Handschriften: Festgabe zum 60. Geburtstage von Hermann Degering* (Leipzig, 1926), 15–28; S. Collon-Gevaert, "Le Modèle de la Bible de Floreffe: Contribution à l'étude de la miniature mosane du XIIe siècle," *Revue belge d'archéologie et d'histoire de l'art* 5 (1935), 17–24; eadem, "L'Origine de la Bible[!] d'Averbode," *Revue belge d'archéologie et d'histoire de l'art* 5 (1935), 213–19, esp. 215; R. Schilling, "Studien zur deutschen Goldschmiedekunst des 12. und 13. Jahrhunderts," in *Form und Inhalt: Kunstgeschichtliche Studien Otto Schmitt zum 60. Geburtstag am 13. Dezember 1950 dargebracht* (Stuttgart, 1950), 73–88; *Rhein und Maas: Kunst und Kultur, 800–1400,* exh. cat., Schnütgen-Museum (Cologne, 1972), vol. 1, 252, cat. G 13; G. Chapman, "The Bible of Floreffe: A Study of a Twelfth-Century Manuscript" (Ph.D. diss., University of Chicago, 1964); eadem, "The Bible of Floreffe: Redating of a Romanesque Manuscript," *Gesta* 10 (1971), 49–62; eadem, "The Floreffe Bible Revisited," *Manuscripta* 35 (1991), 96–137; H. Köllner, "Ein Annalenfragment und die Datierung der arnsteiner Bibel in London," *Scriptorium* 26 (1972), 34–50. On the manuscripts of Floreffe Abbey in general, see A. C. Fraëys de Veubeke, "Les Manuscrits de l'abbaye de Floreffe: Histoire d'une bibliothèque factice," *Archief-en bibliotheekwezen in België* (= *Archives et bibliothèques de Belgique*) 48 (1977), 601–16.

4. Besides the frontispiece to volume two, the Floreffe Bible also contains a large symbolic-typological composition preceding each of the four Gospels. Volume one also once had a frontispiece, now lost. The rest of the decoration consists of magnificent foliate initials (some fully painted, others drawn in red) without historiated content.

5. For a recent interpretation and contextualization of the frontispiece, the reader is referred to my dissertation, "The Floreffe Bible Frontispiece (London, B.L. add. ms 17738, fol. 3v–4r) and Twelfth-Century Contemplative Theory" (Ph.D. diss., Columbia University, 1997). The iconographical study of the Floreffe Bible was inaugurated by Wilhelm Neuss in *Das Buch Ezechiel in Theologie und Kunst bis zum Ende des XII. Jahrhunderts*, Beiträge zur Geschichte des alten Mönchtums und des Benediktinerordens 1–2 (Münster in Westfalen, 1912). Neuss, however, was only concerned with the frontispiece to the Gospel of John; he did not discuss the volume two frontispiece. Egid Beitz, *Rupertus von Deutz, seine Werke und die bildende Kunst* (Cologne, 1930), suggested a link between Rupert of Deutz's theological writings and the typological imagery of the Gospels frontispieces, but, again, did not address the volume two frontispiece.

6. All references will be to the following edition: *S. Gregorii Magni, Moralia in Iob: Libri I–X*, ed. M. Adriaen, vol. 1, CCSL 143 (Turnholt, 1979).

7. As if, for example, he was working from a photograph. He mentions only elements visible on the left-hand page, and discusses the two poetic inscriptions that frame the imagery as though they were complete, not realizing that he only had the first half of each.

8. W. Cahn, *Romanesque Bible Illumination* (Ithaca, N.Y., 1982), 198–99.

9. H. Köllner, "Zur Datierung der Bibel von Floreffe: Bibelhandschriften als Geschichtsbücher?" in *Rhein und Maas* (as in note 3), vol. 2, 361–76.

10. Job 1:1 and 1:4–5: "Vir erat in terra Hus nomine Iob . . . natique sunt ei septem filii et tres filiae . . . et ibant filii eius et faciebant convivium per domos unusquisque in die suo, et mittentes vocabant tres sorores suas ut comederent et biberent cum eis. Cumque in orbem transissent dies convivii mittebat ad eos Iob et sanctificabat illos, consurgensque diluculo offerebat holocausta per singulos; dicebat enim, ne forte peccaverint filii mei et benedixerint Deo in cordibus suis. Sic faciebat Iob cunctis diebus." Here the curious reading "perhaps my sons have sinned, and have *blessed* God in their hearts," euphemistically substitutes "blessed" for the more logical "blasphemed" so as to avoid applying the verb "to blaspheme" to God. This euphemism was present in the original Hebrew text translated by Jerome. While not explicitly addressing the issue, Gregory simply sidesteps it by stating that to "bless" God means, in this instance, to "curse" God; see *Moralia* I.23 (31), ed. Adriaen (as in note 6), 42: "Deo quippe benedicere est, id est maledicere, de eius munere sibi gloriam praebere."

11. "Lest the sons should sin, they are sanctified by the father, while on behalf of each pious one he offers gifts acceptable to God."

12. *Moralia*, I.14 (19), ed. Adriaen (as in note 6), 33–34. The seven sons are related to the Twelve Apostles through numerology: seven equals 3 + 4, but the same numbers multiplied equal twelve. Gregory also points out that the Twelve Apostles, moreover, were chosen to preach the Trinity to the four corners of the world, again $4 \times 3 = 12$.

13. *Moralia* I.14 (20), ed. Adriaen (as in note 6), 34; ibid., I.19 (27), ed. Adriaen, 39.

14. *Moralia* I.22 (30), ed. Adriaen (as in note 6), 41.

15. John 17:11: "Father, in thy name serve those whom you gave to me"; John 17:20: "I do not ask this so much for their sake, as for the sake of those who, through their preaching, are to believe in me." Although these two citations are separated by several verses in the Gospels, they are quoted in the banderoles as a continuous statement.

16. Katzenellenbogen, *Virtues and Vices* (as in note 2), 38: "Just as at the very top of the picture Job, the prototype of Christ, kneeling beside his burnt-offering, prays God

for mercy on his children . . . so Christ between the apostles pleads with his Father on their behalf."

17. Ps. 117:16, Gallican version: "the right hand of the Lord does great things" [literally, mightily].

18. *Moralia*, I.27 (38), ed. Adriaen (as in note 6), 45–46.

19. Ibid.

20. "Just as the three daughters of Job, together with seven sons, refresh themselves with foods dripping sweetness, so too hope, love, and faith, supported by the sevenfold Gifts, restore strength in the mind of the faithful one."

21. Rom. 1:17: "The just man lives by faith."

22. "Loving, he shall be loved," a paraphrase of John 14:21: *Qui autem diligit me diligetur a Patre meo.*

23. Rom. 5:5: "Hope is not abashed."

24. "Faith founds [i.e., is a foundation for] hearts; Hope lifts [them] up, Unction cleanses [them]."

25. Bede, *In Ezram et Neeiam libri III*, lib. I, cap. 3; *De Tabernaculo; De Templo; In Ezram et Neeiam*, ed. D. Hurst, CCSL 119A (Turnholt, 1969), 272: "Fundatio templi dei illorum hoc in loco typice figuram tenet qui nuper ad fidem conversi locum mansionem que domino in suo corde et corpore praeparant dicente apostolo: *an nescitis quoniam membra vestra templum est spiritus sancti qui in vobis est*; et iterum: *per fidem habitare Christum in cordibus vestris.*"

26. Gregory the Great, *Expositiones in canticum canticorum, in librum primum regum*, ed. P. Verbraken, CCSL 144 (Turnholt, 1963), 426: "Sanctorum praedicatorum exhortatio dies est: quia, dum temptata minorum corda tangit, ad spem victoriae erigit."

27. Cf. the description of the anointing of Aaron in Exodus 29.

28. Cf. Leviticus 14. The cleansing property of unction is reflected in the Christian rites of the unction of the sick and extreme unction; here the oil is effective for both spiritual and physical ills.

29. Rupert of Deutz, *Commentaria in evangelium sancti Johannis*, lib. II, ed. R. Haacke, CCCM 9 (Turnholt, 1969), 60–61.

30. Rupert of Deutz, ibid., lib. II, ed. Haacke, 89: "Ille namque lapis perfusus oleo ipsum significat unctum Spiritu sancto. Unde et singulariter dicitur Christus, quia prae consortibus suis est unctus."

31. 1 John 2:26–27: *Haec scripsi vobis de eis qui seducunt vos, et vos unctionem quam accepistis ab eo manet in vobis. Et non necesse habetis ut aliquis doceat vos, sed sicut unctio eius docet vos de omnibus, et verum est et non est mendacium.*

32. John 14:26–27: *Paracletus autem Spiritus Sanctus quem mittet Pater in nomine meo, ille vos docebit omnia*; John 16:13: *Cum autem venerit ille Spiritus veritatis docebit vos in omnem veritatem.*

33. Rupert of Deutz, *Commentaria in evangelium sancti Johannis*, lib. II, ed. Haacke (as in note 29), 68.

34. Augustine, *In epistolam Joannis ad Parthos*, tract. 3, cap. 12; PL 35, col. 2004.

35. Bede, *De templo libri II*, lib. 1, cap. 2, ed. D. Hurst, CCSL 119A (as in note 25), 149.

36. Rupert of Deutz, *De divinis officiis*, lib. 10, cap. 15, ed. R. Haacke, CCCM 7 (Turnholt, 1967), 349: "Quod tamen mirum non videbitur, si ad memoriam revoces quia proprie uel naturaliter amor est iste Spiritus. Amor, inquam, uel caritas, qua Pater Filium vel Filius diligit Patrem, Spiritus sanctus est, qui et bonitas utriusque dicitur et est. 'Nam si quaeras, inquit Augustinus, quis omnia fecit, respondeo: Deus. Si quaeras per quid? Per Verbum suum. Si quaera: Quare? Quia bonus est, omnia fecit. Et haec Trinitas unus est Deus.' Itaque amor Dei Spiritus sanctus est."

37. Bede, *In epistolas septem catholicas*, lib. 4, cap. 2 (27), ed. D. Hurst, CCSL 121 (Turnholt, 1983), 298: (referring to the first letter of John 2:27, *Et vos unctionem quam accepistis ab eo maneat in vobis, et non necesse habetis et aliquis doceat vos.*) "Potest unctio de qua loquitur ipsa Dei caritas intellegi quae diffundit in cordibus nostris per spiritum sanctum qui datus est nobis, quae citissime ad observanda Dei mandata cor quod implet inflammat."

38. Ps. 132 (iuxta Heb.):

> Ecce quam bonum et quam decorum habitare fratres in uno
> sicut unguentum optimum in capite
> quod descendit in barbam, barbam Aaron
> quod descendit super oram vestimentorum eius.

39. Rupert of Deutz, *De divinis officiis*, lib. I, cap. 22, ed. Haacke (as in note 36), 18–19.

40. Augustine, *De Trinitate*, lib. 15.26.46, ed. W. J. Mountain with the assistance of F. Glorie, CCSL 50A 45 (Turnholt, 1968), 525–27: "Propter hoc et dominus ipse Iesus spiritum sanctum non solum dedit ut deus sed etiam accepit ut homo, propterea dictus est plenus gratia. Et manifestius de illo scriptum est in actibus apostolorum: *Quoniam unxit eum deus spiritu sancto*, non utique oleo visibili sed dono gratiae quod visibili significatur unguento quo baptizatos ungit ecclesia. Nec sane tunc unctus est Christus spiritu sancto quando super eum baptizatum velut columba descendit; tunc enim corpus suum, id est ecclesiam suam, praefigurare dignatus est in qua praecipue baptizati accipiunt spiritum sanctum. Sed ista mystica et invisibili unctione tunc intellegendus est unctus quando *verbum* dei *caro factum est*, id est quando humana natura sine ullis praecedentibus bonorum operum meritis deo verbo est in utero virginis copulata ita ut cum illo fieret una persona."

41. For a clear exposition of the theological issues relating to the temporal mission of the Spirit, described from the standpoint of the Eastern Orthodox church, but in most respects applicable to Western theology as well, see V. Lossky, *The Mystical Theology of the Eastern Church* (London, 1957), esp. chap. 8, 156–73, "The Economy of the Holy Spirit."

42. Isaiah 11:1–3: *Et egredietur virga de radice Iesse, et flos de radice eius ascendet. Et requiescet super eum spiritus Domini, spiritus sapientiae et intellectus, spiritus consilii et fortitudinis, spiritus scientiae et pietatis, et replebit eum spiritus timoris Domini* (A stem shall grow from the root of Jesse, and a flower shall rise from his root. And on him shall rest the spirit of the Lord, the spirit of wisdom and understanding, the spirit of counsel and strength, the spirit of knowedge and piety, and it will fill him with the spirit of fear of the Lord).

43. Lossky, *Mystical Theology* (as in note 41), 157.

44. Rupert of Deutz, *Commentaria in evangelium sancti Johannis*, lib. 2, ed. Haacke (as in note 29), 64–65.

45. John 20:19–23.

46. Lossky, *Mystical Theology* (as in note 41), 167.

47. Ibid., 168.

48. Hugh of Saint-Victor, *De quinque septenis seu septenariis opusculum*, cap. 5, PL 175, cols. 410–11: "Igitur Patrem rogaturus, et Patrem qui in coelis est, coelestia dona quaere, non terrena: non substantiam corporalem, sed gratiam spiritalem. Dabit enim spiritum bonum petentibus se, dabit spiritum suum, ut sanet spiritum tuum: spiritum sanctum dabit, et spiritum peccatorum sanabit. Hic aegrotus est, ille medicina. Si ergo vis sanari istum, quaere illum. Si petis pro spiritu, spiritum pete. Noli timere morbo medicinam apponere; morbus medicinam non corrumpit, sed morbum medicina disrumpit. Non illam inficit, sed ex illa deficit. Igitur noli timere spiritum

Dei sanctum ad spiritum tuum peccatorem invitare, quia peccator es, et indignus consortio illius: non enim hoc fit, quia dignus es, sed ut dignus fias. Venit ad te, ut mansionem faciat in te. Non enim inveniet quando veniet; set veniet, ut faciat. Prius aedificabit, postea habitabit. Primum sanabit: postea illuminabit. Primum ad sanitatem, postea ad jucunditatem."

49. Gregory, *Moralia*, I.27 (38), ed. Adriaen (as in note 6), 45.

50. As Gregory works his way through the Book of Job this ambitious system breaks down to some extent; in later parts of the *Moralia* he does not consistently supply all three interpretations for every passage.

51. Herbert Köllner noted a possible relationship between the three-part structure of the Bible's iconographic program (volume one frontispiece, volume two frontispiece, four Gospel frontispieces) and the trinitarian structure of God's involvement with the history of the world posited by Rupert of Deutz in his treatise *In apocalypsin*. Köllner hypothesized that, since the volume one frontispiece (probably containing Creation imagery) must have embodied the work of God the Father, and the Gospels frontispieces (typological allusions to the four main episodes in Christ's life) the work of God the Son, then the mysterious volume two frontispiece must in some way evoke the work of the Holy Spirit. My investigation, proceeding from entirely independent grounds, confirms this hypothesis and explains how the imagery indeed traces the itinerary of the Holy Spirit in history. See Köllner, "Datierung der Bibel von Floreffe" (as in note 9), vol. 2, 361–76, esp. p. 372.

52. Prov. 28:14: "Blessed is the one who is ever fearful."

53. The inscription has almost entirely flaked off, but Katzenellenbogen identified this Virtue in 1939 (*Virtues and Vices* [as in note 2], 37–38) as "Temperantia," an identification which accords well with the fragmentary remains and which I see no reason to question.

54. Matt. 10:16: "Be ye prudent as serpents."

55. "Do all things with deliberation," possibly a paraphrase of Sirach 32:24, *Fili sine consilio nihil facias et post factum non paeniteberis*.

56. Ps. Gall. 72:23: "I am made like a beast of burden before you."

57. Ps. Gall. 118:130: "He gives understanding to the humble [literally, to the little ones]."

58. "I am suffering under the lash," a paraphrase of Ps. Gall., 37:18: *Quoniam ego in flagella paratus* [sum].

59. Eph. 4:32: "Be kind to one another."

60. E.g., Cassiodorus, *Expositio psalmorum*, Ps. 118, 130; *Opera*, ed. M. Adriaen after the edition of the Maurists, CCSL 98, pt. 2, vol. 2 (Turnhout, 1958), 1117: "Haec declaratio obscuritatem naturae nostrae quae iacebat in tenebris, vi suae potestatis *illuminare* dignata est, *et intellectum dedit parvulis*, id est qui se humiles atque egentes suis viribus agnoverunt. Sed isti *parvuli* non de aetate metiendi sunt, sed de simplicitate conscientiae, de quibus dictum est: *Sinite parvulos venire ad me; talium est enim regnum caelorum*."

61. Phil. 2:8: *Christus factus est pro nobis obediens usque ad mortem, mortem autem crucis.*

62. E.g., in the twelfth-century text (Cambridge, University Library. Ms. II.4.26), translated by T. H. White as *The Book of Beasts* (London, 1954; repr. New York, 1984), 186.

63. Gal. 5:22–23: *Fructus autem Spiritus est caritas, gaudium, pax, patientia, benignitas, bonitas, longanimitas, mansuetudo, fides, modestia, continentia, castitas.*

64. Prudentius, *Aurelii Prudentii Clementis Carmina*, ed. J. Bergman, CSEL 61 (Vienna and Leipzig, 1926), 165ff.; cf. Katzenellenbogen, *Virtues and Vices* (as in note 2), 1–3.

65. Hugh of Saint-Victor, *De quinque septenis seu septenariis opusculum*, cap. 1; PL 175, col. 406.

66. PL 176, cols. 997ff.

67. Katzenellenbogen, *Virtues and Vices* (as in note 2), 10–11.

68. Richard of Saint-Victor(?), *Sermones centum appendix ad hugonis opera mystica*, serm. 35; PL 177, col. 982. For the debate and further bibliography concerning the authorship of this collection of sermons, see the article of Roger Baron, "Hughes de Saint-Victor," in *Dictionnaire de spiritualité*, vol. 7, pt. 1 (Paris, 1969), 906–7.

69. London, British Library, Ms. Egerton 1139. For a recent discussion of the style and iconography of the book covers, see B. Kühnel, *Crusader Art of the Twelfth Century: A Geographical, an Historical, or an Art Historical Notion?* (Berlin, 1994), 67–125; also Katzenellenbogen, *Virtues and Vices* (as in note 2), 9.

70. For Christ's acceptance of the lash, in which he suffered the punishment incurred by Adam, see Augustine, *Enarrationes in Psalmos*, Ps. 37, parag. 23, ed. after the edition of the Maurists by E. Dekkers and I. Fraipont, rev. ed., CCSL 38 (Turnholt, 1990), 397: "*Quoniam ego in flagella paratus sum.* Omnino magnifice, tamquam diceret: ad hoc natus sum, ut flagella sufferam. Non enim nasceretur nisi de Adam, cui flagella debentur."

71. E.g., Bede, *Homeliarum Evangelii libri II*, lib. 2, hom. 7; *Bedae Venerabalis Opera*, pts. 3–4, *Opera Homiletica, Opera Rhytmica*, CCSL 122, ed. D. Hurst (Turnholt, 1955), 229: "O mira pietas salvatoris mira benignitas! Quos ante passionem discipulos et aliquando etiam servos vocare consueverat hos post resurrectionem fratres suos appellat ut eiusdem se humanitatis quam et ante habuerat habitum resurgendo resumpsisse monstraret et illos quoque ad promerendam sperandamque in sua carne coronam inmortalitatis qua ipse preeminebat erigeret."

72. Ambrosiaster, *Quaestiones veteris et novi testamenti*, PL 35, col. 2367: "[Christus] non solum autem Verbum Dei est, sed et virtus et sapientia Dei . . . quantum autem ad operationem, qua per ipsum omnia fecit et facit Deus, Virtus dicitur Dei."

73. Jerome, *Commentariorum in Esaiam libri XVIII*, bk. XII.42; *Commentariorum in Esaiam; In Esaia Parvula Adbreviatio*, vol. 2, ed. M. Adriaen, CCSL 73A (Turnholt, 1963), 482: "Cum enim Christus Dei virtus sit, Deique sapientia, omnes in se virtutes continet Patris."

74. Gregory, *Moralia*, XXIX.31 (74); *Moralia in Iob*, ed. M. Adriaen, vol. 2, CCSL 143A (Turnholt, 1979), 1486: "Nullus vero hominum operationes sancti Spiritus simul omnes habuit, nisi solus Mediator Dei et hominum, cuius est idem Spiritus, qui de Patre ante saecula procedit." St. Bonaventure elaborates on this thought, distinguishing between *possession* of the Gifts—which are inseparable from Grace, and therefore are given to mankind, even sinners, whenever Grace is given—and their full *utilization*, which is possible only for Christ. See J.-Fr. Bonnefoy, *Le Saint-Esprit et ses dons selon Saint Bonaventure* (Paris, 1929), 82.

75. The idea that eight, the diapason, is a perfect number is deeply entrenched in patristic thought, and an essential part of this notion is the movement or transition from the number seven to the perfect number eight. As Emile Mâle puts it in *The Gothic Image* (New York, 1958), 14: "[The number eight] comes after seven which marks the limit assigned to the life of man and to the duration of the world. The number eight is like the octave in music with which all begins once more. It is the symbol of the new life, of the final resurrection and of that anticipated resurrection implied in baptism." The same thinking applies to the treatment of the Beatitudes by patristic and medieval theologians, who assimilate them to the Gifts of the Holy Spirit by considering the eighth as a return to the first, e.g., Augustine, *De sermone Domini in monte*, bk. I, cap. 3–4; PL 35, col. 1234.

76. Ps. Gall. 117:16.

77. For example, Engelbert Kirschbaum, in *LCI*, vol. 2 (1970), cols. 211–14, devotes most of his attention to the Hand as God the Father, and only a few sentences to the

Hand as the second and third persons of the Trinity. This is probably because his examples are taken mainly from monumental art and from narrative images from the Life of Christ, both contexts in which the *dextera* is often depicted as an indication of God the Father's presence at an earthly event.

78. Cassiodorus, *Expositio psalmorum*, ed. after the edition of the Maurists by M. Adriaen, CCSL 98 (Turnholt, 1958), Ps. 117, p. 1053.

79. Arno of Reichersberg, *Scutum canonicorum*, PL 194, col. 1527: "In picturis quoque ecclesiasticis, cum nunc in agni specie, nunc in similitudine manus dexterae fingatur Dominus Jesus, foris quidem in pictura nonnulla diversitas est, sed intus unus atque idem Dominus adoratur."

80. Ps. 97:2, PL 142, col. 355: *Salvavit sibi dextera ejus/Et brachium sanctum ejus*, glossed "H [=Hieronymus] Christus enim, dextera et brachium dicitur. Dextera pro virtute, brachium pro robore hic ponitur," or Ps. 20:8, PL 142, col. 105: "*Dextera tua inveniat omnes qui te oderunt*, glossed "H. Dextera Patris Dominus est Salvator." These glosses are extracted from Jerome, *Tractatus sive homiliae in Psalmos*, ed. G. Morin, rev. ed., CCSL 78 (Turnholt, 1958), who seems to link most of the psalter references to the "hand" or "arm" of God to Christ.

81. Ibid., Psalm 97, 162: "*Salvavit sibi dextera eius*. Quod dicit hoc est: Salvavit homines, non alienum, sed suum opus; hoc est, quod fecerat sibi, sibi ipse salvavit. Fecerat hominem in salutem, qui vitio suo perierat: iste mortuus est, ut salvaret sibi hominem dextera sua. Dextera hic pro virtute ponitur, et brachium pro robore."

82. For the Cividale paten, see A. Santangelo, *Catalogo delle cose d'arte e di antichità d'Italia: Cividale* (Rome, 1936), 38–40. For the Skara paten, see V. H. Elbern, "Der eucharistische Kelch im frühen Mittelalter," *Zeitschrift für Kunstwissenschaft* 17 (1963), 1–76, 117–88, esp. 55–56 and fig. 123, p. 179.

83. That the Last Supper is here used for its more general eucharistic meaning and is not simply a depiction of the historical event is made clear by the inclusion of St. Paul among the twelve disciples present, and by the inscription in the frame above the scene: "Lex vetus impletur ut verum pascha paretur / Vinum fit sanguis, caro panis subruit anguis" (The old law is fulfilled that the true Paschal feast might be prepared. Wine is made blood, flesh of bread overturns the serpent.)

84. Jerome, *Commentariorum in Mattheum libri IV*, lib. 3, cap. 17.2, ed. D. Hurst and M. Adriaen, CCSL 77 (Turnholt, 1969), 147ff.: "*Et transfiguratus est ante eos*. Qualis futures est tempore judicandi talis apostolis apparuit. . . . *Resplenduit facies ejus sicut sol*. Certe transformatus est Dominus in eam gloriam, qua venturus est postea in regno suo."

85. Cahn, *Romanesque Bible Illumination* (as in note 8), 198–99.

86. Köllner, "Datierung der Bibel von Floreffe" (as in note 9), vol. 2, 372.

Good and Evil, Not-So-Good and Not-So-Evil: Marginal Life on Gothic German Sacrament Houses

ACHIM TIMMERMANN

FOLLOWING the formulation of the dogma of transubstantiation during the Fourth Lateran Council (1215), and the foundation of the feast of Corpus Christi (1264/1317), the eucharist became the focus of an increasingly visual cult throughout medieval Europe.[1] Among the many manifestations of this cult, which included the elevation of the host during Mass, as well as various kinds of eucharistic processions, the central European sacrament house occupied an important position.[2] Providing a perpetual residence for the sacramental Christ and offering visual access to him, all sacrament houses comprised a host shrine or *corpus* (in which a monstrance containing the eucharist was placed), and very often towering pyramids which ascended in a succession of tapering storeys and which could serve as the transcendent backdrop for complex iconographic programs. Of christological, typological, or hagiographical emphasis, such pyramids could provide a visual gloss on, and in some ways a rhetorical extension of the eucharist in the host shrine below. (The Early New High German word for a pyramid of this kind is *auszug*, literally meaning an extension, "something which is drawn out.")

After more than three and a half centuries of preserving the host in simple, more or less unadorned walled tabernacles, the first efforts to distinguish the *locus* of the sacrament architecturally were made during the second half of the fourteenth century, mainly under the influence of Parlerian microarchitecture. But it was only during the mid-1400s that the buttressing pyramid was generally viewed as the most appurtenant architectural homage to the eucharistic Christ, and until the Reformation this particular type of church furnishing appeared in almost every large church of the Holy Roman Empire and its peripheral territories. The high points of this development are the sacrament houses of Ulm minster (ca. 1461 and later), which is the largest example of its kind, rising to about one hundred feet (Figs. 1, 2); St. Lorenz in Nuremberg (1493 and later), a work particularly famous for its socle figures of Adam Kraft and his colleagues; and St. George in Haguenau (1523), erected on the eve of the Reformation, and featuring one of the most complex baldachins ever conceived.

Lutheran, and particularly Zwinglian criticism, exposing the eucharistic monopoly of the clergy and insisting on the verbal rather than the visual, dealt a deathblow to the idea of the sacrament house. Despite some attempts to revive the tradition during the Counter-Reformation, the building of free-standing sacrament houses had virtually ceased by the early seventeenth century.

This study focuses on a small group of sacrament houses in the south-western area of the German-speaking lands of the Holy Roman Empire, particularly in Swabia and the Upper Rhine. All of these examples are distinguished by their use of marginal sculpture. Rather than appearing in the pyramid, the carvings are concentrated without exception around the host shrine, the nucleus of the tabernacle, or on those parts leading up to it. Apart from containing the sacrament itself, the principal function of the barred *corpus* was twofold. First, it granted visual, if somewhat veiled access to the sacrament or the vessel within which it was contained, a function of prime importance at a time when the *manducatio per visum* (visual communion) had virtually replaced the *manducatio per gustum* (physical or oral communion). Second, it ensured the safety of the eucharist. The desire for greater security of the sacrament was first expressed in the statutes of Lateran IV. The council decreed that all churches should preserve the chrism and eucharist "in a safe container, making use of keys" ("sub custodia clavibus adhibitis"), in order to prevent the extending of "dastardly hands," which might plot terrible and heretical deeds.[3] Over the next three hundred years or so this stipulation is repeated time and again in the decrees of German and French synods, indicating that despite the greater security provided by sacrament houses, the threat to the host, either through theft and desecration or through heresy, was believed to be far from over.

In many ways, the marginal sculpture clustered around the critical zone of the *custodia* appears to pictorialize and gloss aspects of this anxiety. Apart from a study published at the beginning of this century by the local historian Reiter, no attempts have been made to discuss the subject of "sacrament house marginalia" from a thematic perspective. Reiter's article, which concentrates on a specific type of marginalia, is primarily useful for its listing of monuments, some of which have since disappeared.[4]

Throughout this paper the term "marginalia" will be used in a strictly literal, that is, topographical sense to denote iconographies in the physical margins of a larger visual and semantic ensemble, in this case the sacrament house. It needs to be stressed that the carvings in question do not present anti-programs depicting a world *à l'envers*, which offers in the words of the Russian scholar Mikhail Bakhtin, "a completely different, nonofficial, extraecclesiastical and extrapolitical aspect of the world, of man, and of human relations."[5] Instead we will be investigating images that could be easily accommodated within traditional eucharistic theology and dogma. The first part of this paper will consider the *corpus* sculpture which characterizes a number of sacrament houses in Swabia and the Upper Rhine. One of these works, the tabernacle at Ulm minster, which features an unusual cycle of staircase marginalia, will be discussed in the second part of the paper.

1. Ulm minster, sacrament
house, ca. 1461–mid-1470s, gen-
eral view from southwest

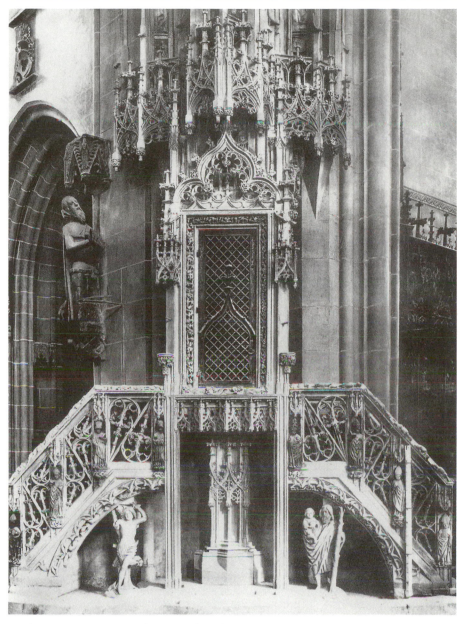

2. Ulm minster, sacrament house, socle and *corpus* zone

I. Guarding and Defending the Eucharist

Over ninety larger sacrament houses and about three hundred wall tabernacles have survived in the former Alemannic territories of Swabia, Baden, the Alsace, and northern Switzerland. With a few exceptions from the time of the Counter-Reformation, most of these date from the late Gothic period. Of these, nine sacrament houses are distinguished through the particular decoration of their host shrines. In each case there are small figures of either lions or dogs, or a combination of both, crouching on the projecting cornice before the barred shrine opening. The number of animals varies from two to eight, depending on how many sides of the shrine were available for decoration.

The monuments in question are the following:

1. The sacrament house in the nave of Ulm minster, erected between ca. 1461 and the mid-1470s under the direction of Moritz Ensinger, with the participation of members of the workshop of Jörg Syrlin the Elder (left cornice: three dogs; right cornice: lion, dog [Fig. 3], lion)[6]
2. The sacrament house of St. George in Dinkelsbühl, dated by an inscription to 1480 (cornice surrounding octagonal *corpus*: dogs alternating with lions)[7]
3. The sacrament house of Chur Cathedral, dated by an inscription to 1484, and, despite its rather remote location in the Swiss canton of Graubünden, stylistically related to sacrament houses in Franconia and Swabia (cornice: two dogs)[8]
4. The sacrament house in the collegiate church of Wimpfen im Tal, datable to ca. 1490 (cornice: three dogs)[9]
5. The sacrament house of Blaubeuren abbey, of the 1490s, surviving only as a series of fragments (cornice: traces of two crouching animals)[10]
6. The sacrament house in the church of the former Dominican nunnery of Hechingen-Stetten, of ca. 1510 (left cornice: lion; right cornice: dog)[11]
7. The sacrament house in the parish church of St. Michael in Oberiflingen, dated by an inscription to 1512 (cornice: lion, dog)[12]
8. The sacrament niche formerly in the abbey church of Offenhausen, and now in the inner courtyard of Liechtenstein castle, of ca. 1515 (dog, lion)[13]
9. The sacrament house in the parish church of St. Lorenz in Hailfingen, of ca. 1515–20, closely related to the tabernacles at Blaubeuren and Offenhausen (left cornice: two lions [Fig. 4]; right cornice: two dogs [Fig. 5]).[14]

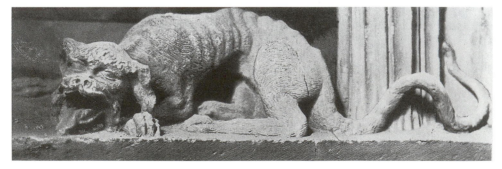

3. Ulm minster, sacrament house, *corpus*, right cornice. Dog

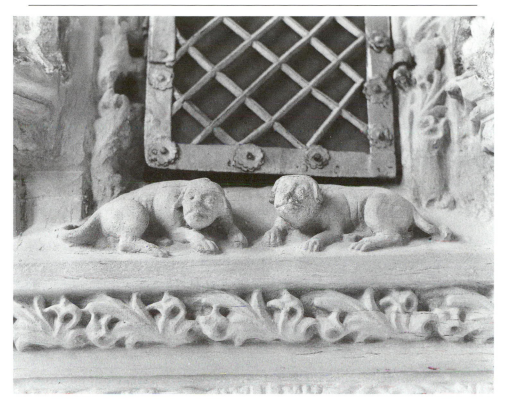

4. Hailfingen, St. Lorenz, sacrament house, ca. 1515–20, *corpus*, right cornice. Two dogs

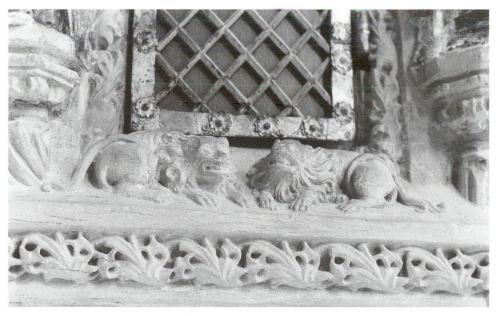

5. Hailfingen, St. Lorenz, sacrament house, *corpus*, left cornice. Two lions

A tenth monument of this kind, the tabernacle in the parish church of Dettingen, is listed by Reiter but has since disappeared.[15] A distant, isolated relative of this group has also survived in the Cathedral of Fürstenwalde (Brandenburg), likewise featuring animal sculpture on the cornice of its host shrine.[16]

Depending on their activities and expressions, three types of animals can be distinguished: those which silently lie in wait, yet are extremely alert (for example, the dogs at Hailfingen); those which threateningly bare their teeth (for instance, the lion and dog at Oberiflingen); and those which bark, howl, roar, and sound alarm (for example, some of the dogs at Ulm minster). All allude to the possible presence of an intruder.

Few areas of medieval iconography are as complex and semantically ambiguous as that of animal allegory, and few have been subject to so much speculation.[17] Where interpretive attempts do not fail altogether, the scholar has to confront the polyvalent nature of animal representations: an animal can mean different, often contradictory things, depending on its context. The symbolism of lions, as well as of dogs, is a case in point. In its negative aspect, the lion appears as a demonic creature in Psalm 90:13, together with the aspes, the basilisk, and the dragon, and, in typological pictorializations of this passage, is often shown being trampled underfoot by Christ or the Virgin Mary.[18] *In bonam partem*, the lion symbolizes Christ himself, and in the *Physiologus* and bestiary tradition becomes an emblem of his resurrection. The dog could equally well have opposite meanings.[19] To stay within the area of eucharistic theology, the dog was often associated with those unworthy of communion, most famously in the Corpus Christi sequence attributed to Thomas Aquinas: "Ecce panis angelorum, / Factus cibus viatorum: / Vere panis filiorum, / Non mittendis canibus" ("This is the bread of angels, / Made as nourishment of pilgrims: / The true bread of the children, / Do not feed it to the dogs").[20] In the story of the Canaanite woman, on the other hand, the dogs which eat the crumbs falling from the table of their lords become symbols of faith in Christ, and, regarded eucharistically, draw attention to the unifying power of the sacrament.[21]

These readings, as symbols of both virtue and vice, certainly seem appropriate within the semantic framework of the sacrament house. However, to apply them to the sculptures in question would ignore an important aspect of the visual evidence: as has already been pointed out, virtually all the animals are characterized as guardians, crouching on the edge of the *corpus*, keeping a lookout, or barking and roaring.

The history of such threshold guardians is almost as old as the history of art itself, and can be traced back to ancient Egypt, Mesopotamia, and Greece, where the beasts guarded the Tree of Life or watched over the entrances to towns and temples (e.g., the Lion Gate at Mycenae). Adapted by Christian art, the motif became popular during the Romanesque period, when it was applied to all sorts of openings and liminal zones within the fabric of the church building. The countless examples include the weathered pair of lions on the east face of Bamberg Cathedral, flanking the Mercy and Adam Portals respectively (ca. 1220–30). Particularly close in position and expression to the beasts on the sacrament houses are the animals carved on the exterior sills of Romanesque windows. Striking comparisons are provided by the east choir

windows of Worms Cathedral (ca. 1150),[22] and the apse window of the Walterichskapelle in Murrhardt, a chapel erected in about 1230 in memory of the Blessed Walterich.[23] While these examples feature pairs of lions, roaring and revealing their sharp teeth, a dog is shown crouching before the sacristy window at St. George in Dinkelsbühl (ca. 1480).[24] This animal may have been carved by the same workshop which executed the cycle of lions and dogs on the sacrament house (see no. 2 above).

In each case, the beasts watch over an aperture of a building part which is of particular liturgical, symbolic, or material significance, such as a choir, a memorial chapel (adjacent to an abbey church), or a sacristy (where the church treasure was kept). The same applies to the sacrament houses, which preserved the most powerful emblem of the Catholic Church and which, thus symbolically enhanced, was in many ways a church within the church itself. Only there the liminal beasts are reduced in scale and are applied to a microarchitectural context. While some beasts merely block the entrance to the host shrine and generally keep a watchful eye, others, especially the dogs, appear to have espied the foe, bared their teeth, and sounded the alarm.

In its discussion of dogs as symbols of virtue, the theological exegesis of animals from Christian antiquity to the Baroque period has often been based on their loud and threatening barking. St. Augustine, for example, compares those who fight until death for the Christian faith to those faithful dogs which bark and defend the house of their lord against the enemy: "Eosdem ipsos qui usque ad sanguinem fuerant certaturi pro fide Evangelica, etiam canes vocant: tanquam pro suo Domino latrantes. . . . Canes laudabiles non detestabiles, fidem sevantes Domino, et pro eius domo contra inimicos latrantes."[25] In a similar vein, Hugh of Saint-Victor likens the barking dog to a preacher who directs his sermons against the wheelings and dealings of the devil: "Cuius [i.e., canis] figuram in rebus quibusdam praedicatores habent, qui semper admonendo atque exsequendo quae recta sunt, insidias diaboli propellunt, ne thesaurum Dei, id est Christianorum animas rapiendo ipse auferat."[26] In the thirteenth and fourteenth centuries the association preacher/dog became particularly popular with the Dominican order, which often referred to its members as *domini canes*, and eventually adopted the dog with a torch in its mouth as its emblem.[27]

Medieval exegesis also commented on the lion's roar, although for different reasons. Rather than being associated with fighting and preaching against the devil and the infidel, the animal was a well-known symbol of Christ's resurrection.[28] But, as in the case of the dog, the lion could be linked to the concept of faithful watchfulness, for instance, in Isaiah 21:6–8: "For thus hath the Lord said unto me, Go, set a watchman, let him declare what he seeth. . . . And he cried, A lion: My lord, I stand continually upon the watchtower in the daytime, and I am set in my ward whole nights."[29]

II. Striving for the Eucharist

By far the most comprehensive cycle of "sacramental marginalia" has survived on the staircases of the Ulm tabernacle (Fig. 2); these are likely to have

been added as an afterthought to the already existing sacrament house at some stage during the mid-1470s, possibly with the participation of sculptors of the workshop of the elder Syrlin.[30] These staircases, which provide access to the *corpus* from both nave and choir, are supported by two sculptures of St. Sebastian and St. Christopher, and show on the banisters four pairs of clergymen, that is, two bishops and two priests, two popes and two bishops, each pair consisting of one reading and one meditating figure. The most unusual feature of the staircases, however, is the micro-program of handrail carvings, comprising seven small figures on each side—animals on the right and humans on the left. Comparable cycles of handrail figures are known only from a handful of monuments, mainly pulpits. Anton Pilgram's pulpit in Vienna Cathedral (ca. 1500), with its zoomorphic marginalia on the staircases, is undoubtedly the best-known example (see below).[31] Likewise, Hans Hammer's pulpit in Strasbourg Cathedral (1484–86) is recorded as having handrail carvings, which were, however, cut away because of pious sentiment in the eighteenth century.[32] A third such staircase might initially also have led to the host shrine of the sacrament house in the abbey church of St. Mary Magdalene in Strasbourg (destroyed). The tabernacle was dated by an inscription to 1488 and is described as "wonderfully and skillfully executed . . . with a lot of strange things above and below, and also cut in the stone of the staircase."[33] Due to the scarcity of comparable works, the question of whether the Ulm sacrament house might in fact have been the first monument to feature such handrail carvings must remain unanswered.

Apart from a few attempts by Vöge,[34] the Ulm program has not been analyzed iconographically. Pfleiderer had dismissed the cycle as "a free expression of artistic arbitrariness, which is an end in itself," a view which was reiterated more recently in Lipp's guide to Ulm minster.[35] On the right handrail (from left to right) are two lions facing each other and showing their teeth, three dragons with their backs turned toward the host shrine, and two dogs facing each other (Fig. 6). What is particularly striking about this succession is the different positions of the animals: while the dogs and lions are paired up, the three dragons all seem to creep away from the host shrine.

The negative allegorical interpretation of the dragon is well known and need not be discussed here at length. Throughout medieval art and literature the dragon is regarded as an embodiment of vice and evil, as a symbol of the Antichrist, death, sin, the devil, hell, paganism, and heresy; no fewer than fifty-five saints fight against him.[36] With such negative associations condensed into one animal, it is often impossible to pinpoint the dragon's exact meaning, especially in the absence of textual sources. Where particular clues are missing, the beast's significance can only be established by approximation, that is, by relating all of its possible connotations to that of the broader visual and semantic context of which it forms a part.

Within the framework of a sacrament house, the dragon might thus denote those evil and heretical forces which seek to undermine and defile the fruits of visual communion, sow the seeds of disbelief, and lead the faithful away from salvation attained by sacrament and into damnation. It is interesting to note that rather than showing the beasts advancing on the real-present Christ, the artists have depicted a procession of retreating animals. The dragons'

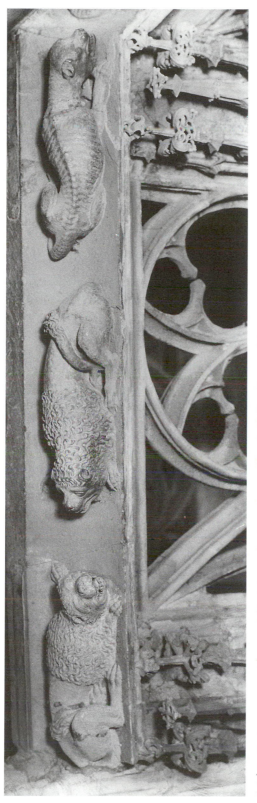

6. Ulm minster, sacrament house, right staircase, horizontal part of handrail. Two lions and dragon

movement away from the host shrine has a counterpart in the majority of beasts (toads, snakes, and lizards) which crawl down the curved handrails of Anton Pilgram's pulpit in Vienna Cathedral. In his analysis of this pulpit's marginalia, Gerhardt has convincingly shown that their withdrawal was due to a barking dog which was strategically placed at the junction of the handrails and banisters surrounding the preacher's platform.[37] The barking dog crouching on the right cornice of the Ulm *corpus* provides a tempting analogy, and might indeed account for the dragons' retreat. However, it should be taken into account that, since the present staircases are likely to have been added to the sacrament house at a later stage, a programmatic connection between shrine and handrail sculpture cannot automatically be assumed.

Less disputable evidence is furnished by the handrail figures themselves: the three dragons are flanked to their left and right by pairs of lions and dogs which face each other like their counterparts on many of the tabernacle shrines discussed above. Of these two animals, the lion in particular, when intended to be read *in bonam partem*, was often depicted as the dragon's mortal enemy. Once again, many instances of this iconography occur in Romanesque art; both beasts are thus shown opposing each other, or fighting, on the banisters of the so-called *Kaiserstuhl* in Goslar (ca. 1150), in the tympanum of the Wechselburg castle chapel (ca. 1170–80), on a nave capital of the collegiate church of Hamersleben (ca. 1120–30),[38] and later on a corbel in the cloister of Maulbronn abbey (fourteenth century).[39] Lecouteux also lists textual examples in which the lion is depicted as the dragon's (victorious) foe.[40]

Given this iconographical tradition, as well as the fact that within the framework of sacrament house shrines both lion and dog have already been encountered as faithful protectors of the eucharist, a positive interpretation for both animal pairs is feasible. In their position on either side of the sequence of dragons they might, for instance, be considered as "counter-animals." As such, they lock the forces of evil between them, symbolically neutralizing that which strives to desecrate the sacrament and disrupt the integrity of the *communitas Christianorum*.

While the choice of these figures is determined by traditional animal allegory, which centers on the fight between good and evil, between virtue and vice, with the ultimate victory of the former over the latter, the iconography of the left handrail is entirely different in character. It draws on sources as diverse as contemporary eucharistic theology and geographical anthropology, with a meaning that is far from clear. As on the right side, the artist has here carved seven figures on the handrail—four on the oblique part, three on the horizontal part. All are shown in recumbent positions, with their heads turned toward the host shrine; some have their legs crossed, others use their left arm as a support for their heads.

Following Vöge, and reading from left to right, the figures on the oblique part of the handrail can be identified as a peasant, a Wild Man, a friar or monk, and a shepherd; all are shown asleep (Fig. 7).[41] As a group, these may be considered to represent "the margins of the city," to use the words of Michael Camille.[42] All live solitary lives away from urban society, dwelling either in the *claustrum* of the monastery or in the rural isolation of field, pasture, and

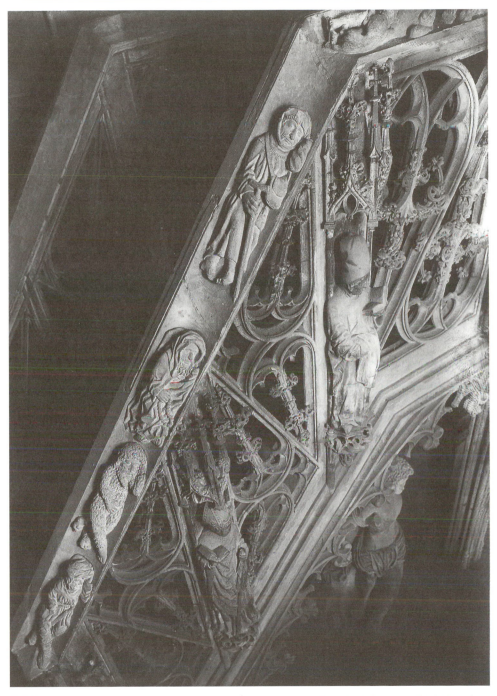

7. Ulm minster, sacrament house, left staircase, oblique part of handrail. Peasant, Wild Man, friar or monk, and shepherd

forest. Medieval attitudes toward the "social" groups represented by each of the figures were, at best, ambiguous.

The depiction of peasants and shepherds became popular during the fifteenth and sixteenth centuries, especially in the new graphic media of woodcut and engraving. Albrecht Dürer himself devoted several engravings to this subject (e.g., Bartsch 83, 86, 89, 90), as did many of his followers, including Erhart Schön and Sebald Beham. Especially close to the carving of the Ulm peasant is the right man in Dürer's engraving *Three Peasants in Conversation* (Bartsch 86): both figures wear a hoodlike cape and a short, belted tunic with a knife at the waist. The curious turban worn by the Ulm figure over his hood has its counterpart in the headdress of the middle peasant in Dürer's engraving. Although representing the principal economic and demographic foundation of medieval Europe, peasants and other rural layfolk were much ridiculed for their hinterland simplicity and ignorance, as well as their coarse and indecent humor, and were the subject of satirical depictions in literature and art. In the early sixteenth century, several humanist scholars, including Aventius and Johannes Agricola, who had become interested in the ethnic and cultural identity of the German people, took a more tolerant stance, appreciating the peasants' role as progenitors of an independent popular culture.[43]

While peasants, and to a lesser degree, shepherds or swineherds, could to some extent still claim to be occasionally exposed to urban culture, the process of alienation from urban society has reached its extreme in the figure of the Wild Man (Fig. 7). Believed by many to dwell in the dense forests surrounding the medieval city, the Wild Man was generally regarded as a fallen human being who had forfeited his place in the network of human relations.[44] In his monumental study on medieval monsters, Claude Lecouteux sums up the position of this creature thus: "L'homme sauvage . . . représente l'homme non cultivé, la brute, et laisse entrevoir ce qui arrive à toute personne exclue de la communauté, de la société, de la civilisation. Le retour à la nature s'accompagne ici d'une opposition à la culture."[45]

The idea of the Wild Man as a fallen human being derived much of its momentum from the biblical story of Nebuchadnezzar.[46] As king of Babylon he fell from grace because of his crimes against the Jews. Alienated from God, he had to live with the animals and turned into a hairy savage: "The same hour was the thing fulfilled upon Nebuchadnezzar: and he was driven from men, and did eat grass as oxen, and his body was wet with the dew of heaven, till his hairs were grown like eagles' feathers, and his nails like birds' claws" (Dan. 4:33). Medieval literature includes many instances in which sinful men, and sometimes even the hero of the story, are subjected to a similar metamorphosis. Cases in point are furnished by Hartmann von Aue's epics *Gregorius* and *Iwein*, in which the main character is temporarily transformed into a hairy savage (lines 3423ff. and 3277ff. respectively).

The presence of the monk or friar in the company of rustics and a Wild Man is something of a surprise, especially since he could have been included in the sequence of fully-carved clergymen (priests, bishops, popes) on the banisters of the staircases. The precise reasons for the monk's marginalization are unknown, but circumstantial evidence suggests that polemical considerations might have played a part. His peripheral position could allude to the long-standing rivalry

between the parish and the mendicant orders in Ulm. By the middle of the fifteenth century the hearing of sermons and attending of Mass in both Franciscan and Dominican churches had become so popular with large sections of the Ulm populace that parish priests, fearing a drastic erosion of their parishioners, began to direct their sermons against the mendicants, a trend which would culminate in the notorious "pulpit war" (*Kanzelkrieg*) of 1516–17.[47]

The most unusual feature of this quartet of figures is undoubtedly the motif of sleep.[48] All of the sleeping figures use their left arms as headrests, and their calm faces, some with half-open mouths, betray a general unawareness of the things which surround them. In light of a recent study by Jonathan Alexander, it is tempting to regard at least two of the handrail figures, the peasant and the shepherd, as exemplars of the vice of laziness. Although chiefly concerned with the depiction of peasants in the calendar cycle of the *Très Riches Heures*, Alexander's article also traces the rare iconography of the *sleeping* peasant or shepherd in medieval manuscript illumination and discusses its significance as an illustration of laziness (*paresse*). In the earliest surviving example of this iconography, an English bestiary of ca. 1200 now in Aberdeen University Library,[49] a shepherd is shown sleeping while two wolves creep up to his flock, thereby dramatically highlighting the consequences of his lack of watchfulness. A later instance, superscribed "paresse," occurs in a copy of the *Somme le Roi*, a treatise on virtues and vices written for the king of France in 1279, in which a sleeping peasant has abandoned his plough and horses.[50] To view the Wild Man, and especially the monk or friar, in the same light, is certainly feasible. Polemics against "slothful monks" abound in medieval literature and art, and need not be recounted here.

Apart from pointing to a particular vice, there is also an eschatological dimension to the figures' sleep and lack of watchfulness. There are numerous examples in the New Testament in which Christ or his disciples exhort the faithful to be vigilant in view of the things to come. In his First Epistle to the Thessalonians, for example, St. Paul writes: "Ye are the children of the light, and the children of the day: we are not of the night, nor of darkness. Therefore let us not sleep, as do others; but let us watch and be sober. For they that sleep sleep at night. . . . But let us, who are of the day, be sober, putting on the breastplate of faith and love; and for an helmet, the hope of salvation. For God hath not appointed us to wrath, but to obtain salvation by our Lord Jesus Christ" (1 Th. 5:5–9). While in some cases those who oversleep the arrival of the Lord are barred forever from the fruits of salvation (as in the parable of the wise and foolish virgins in Matthew 25:1ff.), other passages strike a conciliatory tone, for instance, St. Paul's letter to the Ephesians: "Wherefore he saith, Awake thou that sleepest, and arise from the dead, and Christ shall give thee light" (Eph. 5:14). Both positions, the damnatory and reconciliatory, mark either end of the semantic spectrum within which the meaning of the left handrail cycle appears to oscillate. For the moment it may suffice to point out that while the dwellers in the margins of the city are clearly charged with a neglect of watchfulness, they are on the other hand not caricatures, and indeed their rather sympathetic depiction makes it difficult to conceive of them as purely negative exemplars.

That an "awakening" is certainly possible is suggested by the character of Nebuchadnezzar himself, the biblical "prototype" for the Wild Man, who,

having been cast down the ontological scale and into the state of mental darkness, begins to repent and lift up his eyes to heaven again, whereupon his understanding, reason, and kingdom are restored to him (Dan. 4:34–37). Hartmann von Aue's biographies of Gregorius and Iwein develop along similar lines. That the Ulm characters could potentially remedy their "oversleeping of salvation" is suggested by the eucharist itself, toward which all are turned.

If the figures on the oblique handrail represent the margins of the city, the next group of sculptures is symbolic of the margins of the earth (Fig. 8). Carved on the left horizontal handrail are representatives of the Monstrous Races or "Marvels of the East," fabulous peoples who throughout antiquity and the Middle Ages were believed to dwell in the remotest environments of the *orbis terrarum*. Nowhere was their marginality pictorialized more poignantly than in the many medieval *mappaemundi*, where, far from Jerusalem, the navel of the world, they occupy limited strips of land on the very fringes of the earth.[51] At Ulm their existence is confined to the narrow molding of the handrail. From the immense variety of species the designers of the Ulm staircases chose three examples, only one of which, however, can be identified with absolute certainty. This is the one-eyed Cyclops, who is shown here with a thick coat of hair, his big hands holding a large club. Depending on the source, the *Cyclopes* live in either Sicily or India, and they eat nothing but flesh; in some cases, they are described as cannibals.[52] To his right the Ulm Cyclops is flanked by another hairy, though beardless creature with large ears and prominent facial features, and holding a child on his lap, possibly representing one of the many varieties of hairy peoples found in the literary sources.[53] Vöge was fascinated by the psychological characterization of the elder figure's face, which according to him expresses both "archetypal sloth" (*Urfaulheit*) and "archetypal fear" (*Urfurcht*).[54] The third monstrous being, located to the Cyclops's left, is distinguished by its markedly canine, or, as Vöge puts it, "wolflike" features,[55] and probably represents a Dog-Head or *Cynocephalus*, believed to live in the mountains of India and to communicate by barking.[56] This identification may find support in the figure's association with the dog which he holds on a leash. In contrast to their counterparts on the oblique handrail, the peoples from the edges of the world are depicted with open, even staring, eyes. Once again, their heads are turned toward the host shrine, with the large head of the hairy man seemingly joining the left corner post.

The description and depiction of the *homines monstruosi* is a well-known *topos* from antique and medieval art and literature; by the time the Ulm figures were carved, this geographical and ethnographical genre had already undergone two millennia of unbroken development. The motif has its origins in the works of the Greek authors Herodotus, Ctesias of Knidos, and Megasthenes, and was later taken up by the Romans Solinus (*Collectanea rerum memorabilium*) and especially the elder Pliny (*Historia naturalis*). Knowledge about the Monstrous Races was passed on to the writers of early Christianity, chiefly Macrobius, Martianus Capella, St. Augustine, and Isidore of Seville. Reexamined, glossed, and moralized in the light of the New Testament, the "Matter of the East" was disseminated through a large variety of high and late medieval texts, including encyclopedias, bestiaries, herbals, lapidaries, cosmographical and geographical works, fictitious travel accounts (most

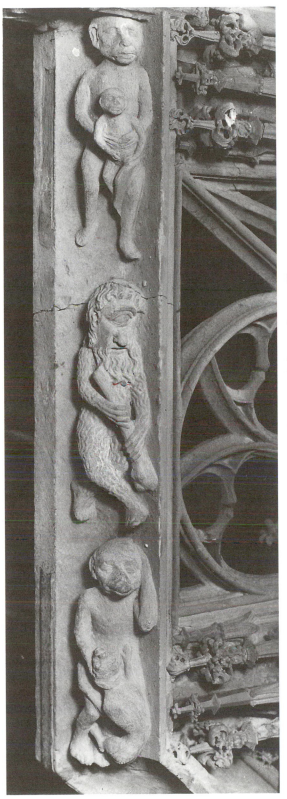

8. Ulm minster, sacrament house, left staircase, horizontal part of handrail. *Cynocephalus*, cyclops, and hairy man

famously those of Sir John Mandeville), and world chronicles. The Monstrous Races feature, for example, in Hartmann Schedel's *Liber chronicarum* of 1493/96, framing the opening page of the second age of the world. Among those twenty-one examples we also find the one-eyed Cyclops (shown beardless and clothed), the Dog-Head (also clothed), and, as a representative of the hairy kind, a woman covered with fur from head to toe.[57]

Medieval attitudes toward the Monstrous Races were equivocal. On the one hand, they were subject to a proselytizing, missionary impulse, which derived its justification from the view that they "were neither an accident in the creation nor indicative of a failure in God's plan. They were part of His creation whose meaning and purposes were, if unclear, still regarded in a positive light."[58] One of the chief authors instrumental in the perpetuation of this notion was St. Augustine, who, presupposing that these races really existed and were human, considered them to be descendants of Adam. If, he continued to argue, they could trace their pedigree to the first father, they must have souls, and if they had souls, they could be saved by grace.[59] The belief in the redeemability of the Monstrous Races is eloquently expressed in the tympanum of the pilgrimage church of St. Madeleine in Vézélay (ca. 1130); representatives from the edges of the world populate eight compartments on the fringe of the tympanum, showing the pentecostal Christ flanked by seated apostles.[60] Though separated from the main scene by a wavy border representing the ocean, they clearly live within the range of Christ's word, "which is about to come to them across the water."[61]

On the other hand, due to their deformity and habitat, the Monstrous Races were also considered perverted and cursed, and were interpreted as a theological warning against disobedience and pride. This school of thought is expressed in three Middle High German poems written in the eleventh and twelfth centuries, and known collectively as the *Wiener Genesis*. The texts present an apocryphal tale in which the children of Adam (chiefly the line of Cain) corrupt their species forever as a result of their disobedience in eating certain kinds of herbs.[62]

Due to the consistent ambiguity of the individual figures, the sequence of handrail carvings on the left side of the Ulm staircase presents obvious problems of interpretation. Were the characters intended to be looked at from the more conciliatory, missionary viewpoint evinced by St. Augustine, or were they designed to function as negative exemplars, typifying the ignorant and unwatchful, the progeny of Cain justly marked by God, the victims of the devil, and ultimately those deemed unworthy of membership in Christian society and sacramentally-attained salvation?

Depending on what is considered to be the figures' immediate iconographic and semantic context, both readings are possible. A number of options can be proposed.

1. Directional interaction with the eucharist. All seven figures clearly have their heads turned toward the residence of the sacramental Christ, a position which may emphasize their potential redeemability and candidacy for a place in the *corpus mysticum*. This peculiar position, which contrasts with that of the dragons on the right handrail, might suggest a reading along positive, sal-

vation-seeking lines. The beings shown on the left handrail live in various states of ignorance, but an opening of their eyes—a *revelatio* not dissimilar from the one Synagogue was sometimes expected to experience in eschatological thought—will eventually assimilate them into the mystic body of Christ.

The belief that the eucharist could unify all strata of human society into one body, the *corpus mysticum*, was a central feature of medieval sacramental theology. Among the most popular sources cited to support this notion were excerpts from the First Letter to the Corinthians. In 1 Corinthians 10, for example, St. Paul writes: "Unus panis et unum corpus multi sumus, omnes qui de uno pane et uno calice participamus." St. Thomas Aquinas deduces from this: "Ex quo patet quod Eucharistia sit sacramentum ecclesiasticae unitatis."[63] Particularly important in the context of the Ulm sacrament house is another quotation from St. Paul, which was used by, among others, the fifteenth-century Swabian theologian Gabriel Biel, in his monumental *Canonis Misse Expositio*, to illustrate the *mirabilium* of the mystic body of Christ. In 1 Corinthians 12:13 St. Paul continues to argue: "Et enim in uno Spiritu omnes nos in unum corpus baptizati sumus sive Iudaei sive gentiles sive servi sive liberi et omnes unum Spiritum potati sumus."[64] In St. Paul's sacramental utopia, margins, whatever their character, simply cease to exist, as all, whether Jews or Gentiles, whether slaves or free men, are "made to drink into one Spirit." This belief in an ultimate cessation of boundaries may certainly have influenced the unique position of the left handrail figures: having assumed almost identical postures, all lie with their heads turned toward the *sacramentum ecclesiasticae unitatis*. To put it frivolously, we seem to be looking at a petrified conveyor belt, which, when set in motion, will deliver one marginal dweller after another into the *corpus mysticum*, where isolation and ignorant sleep are no longer.

2. Interaction with other marginalia on the left side. In their unconscious striving toward the sacrament, the people from the margins of Christian society are seemingly being greeted by three barking dogs crouching on the left *corpus* ledge; their positive significance as threshold animals guarding Christ's residence has been discussed above. Since the dogs clearly sound the alarm, one might regard the seven figures on the left handrail as a latent threat to the eucharistic Christ. In this reading, the dwellers in the liminal zones would represent a group which is to be excluded from, rather than included in, the mystic body of Christ.

It is in fact in this vein that some scholars of marginality have discussed the relationship between social or religious outsiders and the eucharistic Church. In the introduction to his recent study *Other Middle Ages*, for example, Michael Goodrich writes:

> In Western Catholicism, the new stress in the central Middle Ages on the Eucharist as the incarnate body and blood of Christ gave sacramental form to Christian unity. This identification of the body of the faithful as those who took part in the Eucharist service (and thereby shared in the divinity) entailed the ceremonial exclusion of those deemed marginal,

excommunicated, or ideologically incompatible. The communion service, during which believers partook of the body and blood of Christ, thus effectively defined the boundaries of Christian polity.[65]

Without a knowledge of the building history of the sacrament house, it is possible to interpret the visual evidence as a corroboration of Goodrich's argument. However, it has already been pointed out that the present staircases are likely to have been added to the tabernacle as an afterthought, and that therefore the question of whether or not the handrail sculpture was ever intended to tie in with the already-existing carvings around the *corpus* ledge must remain open.

But there is other, disconcerting evidence which could literally undermine the positive reading of the left handrail sculpture. The evidence is difficult to access visually, but nonetheless real. Hidden behind the frieze of quarter-arches underneath the banisters of the left staircase are seven howling and hissing monsters (Fig. 9), their number corresponding to that of the handrail figures. Many have dragonlike features known from some of the beasts on the right handrail. Just as the people from the margins of the city and the edges of the world have their heads turned toward the sacramental Christ, so this procession of demons looks in the same direction. The correspondence between their number and placement with those of the marginal dwellers can hardly be accidental. A possible interpretation of this concurrence might consider the monsters as emblems of the ontological state of the handrail figures, as zoomorphic extrapolations of their souls and bodies, which were, at least as far as some schools of thought were concerned, almost by definition debased, corrupt, prone to Satan's power and the possession of the devil.

3. *The position of both handrail cycles relative to the eucharist.* Considered from the perspective of the sacramental Christ dwelling in the *corpus*, the orientation of both staircases is reversed. The sequence of humans now appears on the *dextera Domini*, while the beasts move to his left side. Throughout medieval art, the polarities of left and right were used fairly consistently. The left side of an iconographical program was reserved for those of secondary importance, and in many cases for those tainted by evil, while the right side had an altogether positive meaning, designating a place of honor and privilege.[66] Examples are provided by Romanesque and Gothic Last Judgment portals, in which the blessed are led toward heaven on Christ's right, while the damned are cast into hell on his left, an orientation which also determined the position of ancillary iconographies of allegorical content, such as Ecclesia and Synagogue, or the wise and foolish virgins. In these examples (as in many others), the *dextera* and *sinistra Domini* are invested with an eschatological significance. To a large extent this interpretation hinges on the importance given to Christ's side wound, which is first shown on his right in the Rabbula Gospels of 586, and thereafter depicted almost exclusively in this position. Medieval exegesis frequently interpreted the wound as a fountain of Grace, from which flowed the life-giving and world-redeeming blood; the blood's sacramental perpetuity is often emphasized in Gothic depictions of angels catching the salvific substance in chalices.[67] For St. Augustine, it is the Church

9. Ulm minster, sacrament house, left staircase, quarter-arch curtain. Monster

itself which emanates from the side wound: "For the Church, the Lord's bride, was created from His side, as Eve was created from the side of Adam."[68]

Given these positive associations of the *dextera Domini* with the origin of the sacrament, and thus with the Church itself, the handrail program of the left side (that is, Christ's right side) can once again be read along the lines of redemption and ultimate salvation—gifts which are attained through a participation in the Eucharist, and through a membership in the *corpus mysticum*. Just how the figures' potentially negative characterization through their zoomorphic "counterparts" was supposed to fit into the picture is unclear. Perhaps it is the pictorialization of a *present* ontological state that will find its elevation in a reconciliatory future, so tangibly promised by the presence of the eucharist itself.

III. Outlook

In medieval Ulm, as elsewhere, there were of course no dragons or *Cyclopes* which would challenge definitions of "eucharistic outsiders and insiders," nor were there any dogs or lions, however well-trained and domesticated, which would effectively ward off unwanted intruders dangerous to the integrity of the sacramental community. It almost goes without saying that the creatures and beasts encountered in the physical margins of the eucharist are symbolic of something else. To define this "something else" exactly is difficult, all the more so since the program's meaning has been shown to fluctuate according to our definition of its immediate, and broader, semantic context. The iconographies discussed are certainly indicative of a real concern with potential challenges and threats to the sacrament and its all-encompassing symbolism. At least two possibilities should be briefly mentioned.

The first relates to the physical safety of the eucharist, which, despite having greatly increased since the use of movable host containers on the altar mensa or hanging tabernacles, was still a main point on the agenda of the Catholic clergy, as is highlighted by the many, and endlessly repeated synodal stipulations dealing with this issue.[69] In part, this angst may have been fostered by the circulation of countless miracle stories in which either lay people (mostly women) or non-Christians (mostly Jews) allegedly tried to take possession of the host; very often these stories seemingly offered suggestions of the appropriate punishment of the culprits. A typical case is that of a woman in the town of Ehingen on the Danube, who was said to have stolen the host container from the altar of the parish church, and then supposedly attempted to sell its contents to the Jews. The theft was discovered, and pogroms against the Jewish community were instigated; a total of eight Jews were executed. Needless to say, the host, upon having been recovered and brought back to the church, immediately began to work miracles.[70]

This story, which also involves the interaction of non-Christians with believers, introduces the second, and probably more important, cause of concern, namely heresy. By the time larger sacrament houses were erected, there was one movement in particular which posed a real threat to the Catholic Church's definition of the sacrament, and, ultimately, to the definition of the Catholic Church itself: Hussitism/Utraquism. The origins of Hussitism can be traced back to late fourteenth-century Prague, a city which had become the forum for the debates of eminent reformers such as Conrad Waldhauser, Jan Milič of Kromříž, and, most importantly, Matthias of Janov.[71] The last of these was the author of the *Regulae veteris et novi testamenti*, which contained one of the first criticisms of the current eucharistic practice. Demanding above all the frequent communion of the laity, Matthias's ideas were quickly condemned by the Prague synod of 1388–89, and he was forced to recant. Nevertheless, together with the influx of Wycliffite writings into Bohemia at the same time, his teachings provided a strong platform for more radical reformers, namely, Jan Hus himself and his follower Jakoubek. Floating "in an atmosphere of anticlericalism," the new movement primarily revolved around the issue of the Eucharist.[72] Looking at what they believed to have been the apostolic practice of the early Church, the reformers not only advo-

cated frequent physical communion, but also demanded the administration of the Eucharist under *both* species ("sub utraque species," hence the name Utraquism). Both the denial of the frequent *manducatio per gustum* and the withdrawal of the lay chalice were considered to be expressions of the clergy's privileged position. The Council of Constance responded swiftly to these threats, and in 1415 not only banned the lay chalice altogether[73] but also burned Hus as a heretic. However, far from being under control, the heresy entered into a new, militant phase, and successful attempts were made to spread Hussitism/Utraquism in Bohemia and in the southern German-speaking lands. In the area under consideration, infiltrations of Hussite ideas are documented, for instance, in the city of Weinsberg in 1425, and in later years in Middle Franconia.[74] One of the most significant Hussite preachers was Friedrich Reiser of Donauwörth, who was particularly active in Bavaria, Swabia, and the Alsace. He was burnt in 1458, three years before the Ulm sacrament house was begun.[75] Though in later years the movement lost much of its initial momentum, for the Church "the Hussites were the main object of concern during the century that followed the Council of Constance."[76]

All this is not to say that any of the marginal figures discussed in this paper is to be specifically identified with the Hussite (or any other heretical) movement or one of its representatives, though clearly the dogs and lions found on the *corpus* cornice can be read as preachers and defenders of the Catholic faith. But it can hardly be coincidental that the programs in question throw into relief issues of acceptance and rejection, or outside and inside, at a time when the Church witnessed the first serious erosion of its eucharistic monopoly.

In some ways the late Gothic sacrament house was probably the most powerful expression of this monopoly. No better place could be chosen as a rhetorical stage for the Church's vision of the sacrament than the perpetual residence of the eucharistic Christ itself. Often prominently positioned in the choir or, as in the case of Ulm, even in the nave, sacrament houses suggested that the eucharist *was to some extent always available* to the laity. However, by shielding the host through a system of doors, grilles, and screens, they also placed the eucharistic God beyond the reach of the congregation. Sacrament houses may thus be considered as "hagioscopes," which, like modern-day television, allowed viewing but denied interactive participation.

NOTES

1. The bibliography on the subject of eucharistic devotion is considerable. It may suffice here to draw attention to the numerous studies written between ca. 1920 and ca. 1950 by the Jesuit scholar P. Browe, in particular *Die Verehrung der Eucharistie im Mittelalter* (Munich, 1933). More recent works include D. Devlin, "Corpus Christi: A Study in Medieval Eucharistic Theory" (Ph.D. diss., University of Chicago, 1975); and M. Rubin, *Corpus Christi: The Eucharist in Late Medieval Culture* (Cambridge, 1991).

2. On the subject of central European sacrament houses, see: J. Hertkens, *Die mittelalterlichen Sakramentshäuschen* (Frankfurt, 1908); F. Raible, *Das Tabernakel einst und jetzt: Eine historische und liturgische Darstellung der Andacht zur Aufbewahrung der Eucharistie* (Freiburg, 1908); E. Baare-Schmidt, *Das spätgotische Tabernakel in Deutschland*, Ph.D. diss., Bonn, 1937 (Düsseldorf, 1937); R. Wesenberg, *Das*

gotische Sakramentshaus: Entstehung und künstlerische Gestaltung dargestellt an Beispielen Hessens und des Mittelrheingebietes, Ph.D. diss., Giessen (Giessen, 1937); R. Klockenbusch, "Sakramentshäuser und -nischen Westfalens" (Ph.D. diss., Münster, 1942); G. Naujoks, "Die Entwicklung des architektonischen Sakramentsbehälters in Franken" (Ph.D. diss., Erlangen, 1948); I. Güttich, "Die rheinischen Sakraments-häuschen und Sakramentsnischen" (Ph.D. diss., Cologne, 1952); H. Weidenhoffer, Sakramentshäuschen in Österreich: Eine Untersuchung zur Typologie und stilisti-schen Entwicklung in der Spätgotik und Renaissance, 2 vols. (Graz, 1992); A. Tim-mermann, "Staging the Eucharist: Late Gothic Sacrament Houses in Swabia and the Upper Rhine. Architecture and Iconography" (Ph.D. diss., University of London, 1996). See also A. Seeliger-Zeiss, Lorenz Lechler von Heidelberg und sein Umkreis: Studien zur Geschichte der spätgotischen Zierarchitektur und Skulptur in der Kurpfalz und in Schwaben, Heidelberger Kunstgeschichtliche Abhandlungen 10 (Heidelberg, 1967), passim; O. Nussbaum, Die Aufbewahrung der Eucharistie, Theophaneia: Beiträge zur Religions- und Kirchengeschichte des Altertums 29 (Bonn, 1979).

3. "Statuimus, ut in cunctis ecclesiis chrisma and eucharistia sub fideli custodia clavibus adhibitis conserventur: ne possit ad illa temeraria manus extendi, ad aliqua horribilia vel nefaria exercenda." Quoted from J. D. Mansi, ed., Sacrorum Conciliorum Nova et Amplissima Collectio, 53 vols. (Florence, Venice, and Paris, 1759–98), vol. 22 (1778), col. 1007.

4. Reiter (no first name given), "Löwe und Hund am Sakramentshäuschen," Archiv für christliche Kunst 6 (1903), 57–60.

5. M. Bakhtin, Rabelais and His World (Bloomington, 1984) (first published in Russian, Moscow, 1965), 6. For the notion of the "bodily lower stratum," see 368ff.

6. R. Pfleiderer, Das Ulmer Münster in Vergangenheit und Gegenwart (Ulm, 1907), 61f.; W. Vöge, Niclas Hagnower: Der Meister des Isenheimer Hochaltars und seine Frühwerke (Freiburg i.Br., 1931), passim, esp. 13–44; Seeliger-Zeiss, Lorenz Lechler (as in note 2), 62ff.; R. Wortmann, Das Ulmer Münster, Grosse Bauten Europas 4 (Stuttgart, 1972), 44ff.; V. Frebel, "Das Ulmer Sakramentshaus und sein Meister," Ulm und Ober-schwaben 44 (1982), 239–52; Timmermann, "Staging the Eucharist" (as in note 2), 94ff., 351ff., cat. no. 81 (with bibliography); D. Gropp, "Der Prophetenzyklus am Sakra-mentshaus des Ulmer Münsters," in Hans Multscher: Bildhauer der Spätgotik in Ulm (Ulm, 1997), 145–65.

7. Seeliger-Zeiss, Lorenz Lechler (as in note 2), 62f.; W. Helmberger, Architektur und Baugeschichte der St. Georgskirche zu Dinkelsbühl, 1448–1499, Bamberger Stu-dien zur Kunstgeschichte und Denkmalpflege 2 (Bamberg, 1984), 82f.; Timmermann, "Staging the Eucharist" (as in note 2), 144ff., 311ff., cat. no. 15 (with bibliography).

8. Vöge, Niclas Hagnower (as in note 6), passim, esp. 44ff.; E. Poeschel, Die Kunst-denkmäler des Kantons Graubünden, vol. 7 (Basel, 1948), 127ff.; A. Klodnicki-Orlowski, Studien zu Jakob Russ, einem spätgotischen Bildschnitzer aus Ravensburg, Ph.D. diss., Heidelberg (Heidelberg, 1990), 17f.; Timmermann, "Staging the Eucharist" (as in note 2), 185ff., 308f., cat. no. 10 (with bibliography).

9. G. Schäfer, Die Kunstdenkmäler des Grossherzogtums Hessen, Provinz Starken-burg: Ehemaliger Kreis Wimpfen (Darmstadt, 1898), 247ff.; Timmermann, "Staging the Eucharist" (as in note 2), 103f., 119, 359, cat. no. 90 (with bibliography).

10. Timmermann, "Staging the Eucharist" (as in note 2), 156f.

11. L. Böhling, Die spätgotische Plastik im württembergischen Neckargebiet, Tübinger Forschungen 10 (Reutlingen, 1932), 150; Timmermann, "Staging the Eucha-rist" (as in note 2), 159, 326f., cat. no. 38.

12. Timmermann, "Staging the Eucharist" (as in note 2), 120, 337, cat. no. 56 (with bibliography).

13. Timmermann, "Staging the Eucharist" (as in note 2), 158, 297.

14. Böhling, *Spätgotische Plastik* (as in note 11), 146f.; H. Koepf, "Das Sakramentshaus in Hailfingen," in *Rottenburger Post*, 17 June 1950; Timmermann, "Staging the Eucharist" (as in note 2), 157ff., 326, cat. no. 37 (with bibliography)

15. Reiter, "Löwe und Hund" (as in note 4), 58. According to Böhling, *Spätgotische Plastik* (as in note 11), 245 n. 238, the piece was sold shortly afterwards to an unidentified collection in Bavaria.

16. Illustrated in *Die Kunstdenkmäler des Kreises Lebus*, Die Kunstdenkmäler der Provinz Brandenburg, vol. 6, pt. 1 (Berlin, 1909), fig. 73; see also Foto Marburg, no. 831706.

17. This is not the place to provide an exhaustive bibliography on the subject. Among the most important publications are: W. von Blankenburg, *Heilige und dämonische Tiere: Die Symbolsprache der deutschen Ornamentik im frühen Mittelalter* (Leipzig, 1943); D. Schmidtke, *Geistliche Tierinterpretationen in der deutschsprachigen Literatur des Mittelalters, 1100–1500*, 2 vols. (Berlin, 1968); F. D. Klingender, *Animals in Art and Thought to the End of the Middle Ages* (London, 1971), esp. 145ff.; P. Michel, *Tiere als Symbol und Ornament: Möglichkeiten und Grenzen der ikonographischen Deutung, gezeigt am Beispiel der Züricher Grossmünsterkreuzgangs* (Wiesbaden, 1979) (semiotic approach, pointing out the pitfalls of interpretation); J. Leibbrand, *Speculum Bestialitatis: Die Tiergestalten der Fastnacht und des Karnevals im Kontext christlicher Allegorese*, Kulturgeschichtliche Forschungen 11 (Munich, 1988). For monstrous animals (and humans) in particular, see C. Lecouteux, *Les Monstres dans la littérature allemande du moyen âge*, Göppinger Arbeiten zur Germanistik 330, 3 vols. (Göppingen, 1982); summarized in C. Lecouteux, *Les Monstres dans la pensée médiévale européenne*, Cultures et civilisations médiévales 10 (Paris, 1993). One of the most comprehensive compendia on animal allegory is H. H. Frey, *Therobiblia: Biblisch Thier-, Vogel- und Fischbuch* (Leipzig, 1595; reprinted, with a foreword by H. Reinitzer, Graz, 1978). Although of post-medieval date, this monumental compilation largely derives its material and arguments from patristic and scholastic sources.

18. As a negative animal the lion is discussed *in extenso* by Frey, *Therobiblia* (as in note 17), 229aff. For examples from the visual arts, see *LCI*, vol. 3 (1971), cols. 115f.

19. See Frey, *Therobiblia* (as in note 17), 210bff.; *LCI*, vol. 2 (1970), cols. 334f.

20. See W. Breuer, *Die lateinische Eucharistiedichtung des Mittelalters von ihren Anfängen bis zum Ende des 13. Jahrhunderts*, supplementary volume to *Mittelalterliches Jahrbuch* 2 (Wuppertal, 1970), 282ff., 293. The quoted passage was often inscribed on the host shrines of sacrament houses, for instance, over the *corpus* opening of the tabernacle in the town church of Donauwörth (1503).

21. "At illa dixit etiam Domine nam et catelli edunt de micis quae cadunt de mensa dominorum suorum. Tunc respondens Iesus ait illi o mulier magna est fides tua. . . . " (Matt. 15:27–28). For interpretations of this passage, see Frey, *Therobiblia* (as in note 17), 211aff.

22. See R. Budde, *Deutsche romanische Skulptur, 1050–1250* (Munich, 1979), 27 no. 20, pl. 20 (esp. top figure).

23. Cf. Blankenburg, *Heilige und dämonische Tiere* (as in note 17), 187, fig. 172; for close-ups of these animals, see Foto Marburg, nos. 754034, 754035. For the chapel, see H. Wischermann, *Romanik in Baden-Württemberg* (Stuttgart, 1987), 287f., figs. 143–45.

24. Helmberger, *Architektur- und Baugeschichte* (as in note 7), 42–43, ill. 30.

25. St. Augustine, *Enarrationes in Psalmos* 68 (PL 36, col. 833). Discussed by Frey, *Therobiblia* (as in note 17), 215a.

26. Hugh of Saint-Victor, *De bestiis et aliis rebus* II.17 (PL 177, col. 65D). The dog as a symbol of the preacher is discussed *in extenso* by C. Gerhardt, "Der Hund, der Eidechsen, Schlangen und Kröten verbellt: Zum Treppenaufgang der Kanzel im Wiener

Stefansdom," *Wiener Jahrbuch für Kunstgeschichte* 38 (1985), 116–32, esp. 118ff. (with bibliography and a wealth of examples).

27. See Gerhardt, "Der Hund" (as in note 26), 120f. nn. 13 and 14, for sources.

28. According to the *Physiologus*, the cubs of the lion are born dead. After three days they would be awakened by the lion's roar.

29. Discussed, with references to the exegetical discourse, by Frey, *Therobiblia* (as in note 17), 239bf.

30. The staircases are of a different material than the sacrament house (limestone instead of sandstone) and also differ stylistically. The unusual tracery patterns on the banisters are nowhere to be found either in the context of the tabernacle architecture or in the overall architectural vocabulary of Ulm minster itself. The tracery consists of two large daggers on the horizontal part of the banisters, as well as of "tumbling" configurations of four small daggers in each of the four rhomboid compartments in the diagonal parts of the staircases. It is clear, however, that for structural reasons and for reasons of accessibility to the host shrine some kind of lateral staircases must always have been projected for the present sacrament house. See Wortmann, *Das Ulmer Münster* (as in note 6), 44; Timmermann, "Staging the Eucharist" (as in note 2), 99f.

31. See Gerhardt, "Der Hund" (as in note 26), passim (for bibliography, see esp. nn. 1, 2, 5).

32. On Hammer's pulpit, see B. Schock-Werner, *Das Strassburger Münster im 15. Jahrhundert: Stilistische Entwicklung und Hüttenorganisation eines Bürger-Doms*, Veröffentlichungen der Abteilung Architektur des Kunsthistorischen Instituts der Universität zu Köln 23 (Cologne, 1984), 176, 186ff., with further bibliography.

33. "Das sacramenthaeuslein ist gar herrlich und koestlich gemacht . . . und vielerley seltzame sachen unten darunter und darüber, und an der stegen in stein und von stein gehauen. . . . " Quoted from L. Daucheux, "La Chronique strasbourgeoise de Jacques Tausch et de Jean Wencker," *Mitteilungen der Gesellschaft für Erhaltung der geschichtlichen Denkmäler im Elsass*, 2d ser., 15 (1897), 109. Also printed, with slightly wrong spelling, by H. Rott, *Der Oberrhein: Baden, Pfalz, Elsass. Quellen I*, Quellen und Forschungen zur südwestdeutschen und schweizerischen Kunstgeschichte im 15. und 16. Jahrhundert 3 (Stuttgart, 1936), 301.

34. Vöge, *Niclas Hagnower* (as in note 6), 40ff.

35. Pfleiderer, *Das Ulmer Münster* (as in note 6), 61; W. Lipp, *Begleiter durch das Ulmer Münster* (Ulm, 1977), 17.

36. See Frey, *Therobiblia* (as in note 17), 304bff., for many examples from biblical and patristic sources. Good summaries of the beast's significance in art and literature, as well as extensive bibliographies, can be found in *RDK*, vol. 4 (1958), cols. 342ff.; *LCI*, vol. 1 (1968), cols. 516ff.; Lecouteux, *Les Monstres dans la littérature* (as in note 17), vol. 2, 183ff.; *Le Dragon dans la culture médiévale*, ed. D. Buschinger and W. Spiewok, Greifswalder Beiträge zum Mittelalter 39 (Greifswald, 1994).

37. Gerhardt, "Der Hund" (as in note 26), passim.

38. Illustrated in Blankenburg, *Heilige und dämonische Tiere* (as in note 17), figs. 41, 70, 84.

39. Foto Marburg, no. 87259.

40. Peter Damien, *Epistola* VI.6; Hartmann von Aue, *Iwein*, 3840ff. See Lecouteux, *Les Monstres dans la littérature* (as in note 17), vol. 2, 187.

41. Vöge, *Niclas Hagnower* (as in note 6), 40 n. 42.

42. M. Camille, *Image on the Edge: The Margins of Medieval Art* (Cambridge, Mass., 1992), 129.

43. Among more recent publications on the peasant in the art of the fifteenth and sixteenth centuries are K. P. F. Moxey, "Sebald Beham's Church Anniversary Holidays: Festive Peasants as Instruments of Repressive Humor," *Simiolus* 12 (1981–82), 107–31

(regards the peasant principally as an object of mockery and social and religious satire); M. D. Carroll, "Peasant Festivity and Political Identity in the Sixteenth Century," *Art History* 10 (1987), 289–314 (analyzes much of Moxey's material in the light of sources more sympathetic to peasant culture). See also R. Mellinkoff, *Outcasts: Signs of Otherness in Northern European Art of the Late Middle Ages*, 2 vols. (Berkeley, 1993), vol. 1, 137ff., 285 nn. 97–98 (with more bibliography on the subject).

44. On the subject of Wild Men, cf. R. Bernheimer, *Wild Men in the Middle Ages* (Cambridge, Mass., 1952); *Die Wilden Leute des Mittelalters*, exh. cat., Hamburg, Museum für Kunst und Gewerbe (Hamburg, 1963); K. Basford, *The Green Man* (Ipswich, 1978); *The Wild Man: Medieval Myth and Symbolism*, exh. cat., New York, The Cloisters, ed. T. Husband (New York, 1980) (reviewed by E. H. Gombrich in *Burlington Magazine* 122 [1981], 57–58); Lecouteux, *Les Monstres dans la littérature* (as in note 17), vol. 1, 15ff.; vol. 2, 98ff. (literary sources and bibliography); C. Gaignebet and J. D. Ladoux, *Art profane et réligion populaire au moyen-âge* (Paris, 1985), 114ff.

45. Lecouteux, *Les Monstres dans la littérature* (as in note 17), vol. 1, 24.

46. For the theological interpretation, see especially Bernheimer, *Wild Men* (as in note 44), passim.

47. G. Geiger, *Die Reichsstadt Ulm vor der Reformation*, Forschungen zur Geschichte der Stadt Ulm 11 (Ulm, 1971), 82, 106, 142f.

48. The iconography of sleep has not been sufficiently researched. For sources and examples from different contexts, see esp. E. Dinkler-von Schubert, *Der Schrein der hl. Elisabeth zu Marburg: Studien zur Schrein-Ikonographie*, Veröffentlichungen des Forschungsinstitutes für Kunstgeschichte, Marburg (Marburg, 1964), 20ff.; *LCI*, vol. 4 (1972), cols. 72–75. See also the essayistic study by M. Covin, *Une Esthéthique du sommeil* (Paris, 1990).

49. Aberdeen, University Library, Ms. 24, f. 16v; N. J. Morgan, *Early Gothic Manuscripts*, vol. 1, *1190–1250* (London and New York, 1982), 63f., no. 17; J. Alexander, "*Labeur et Paresse*: Ideological Representations of Medieval Peasant Labor," *Art Bulletin* 72 (1990), 436–52; esp. 445f., fig. 16.

50. British Library, Ms. Add. 54180, f. 121v; Alexander, "*Labeur et Paresse*" (as in note 49), 446f., fig. 19.

51. The bibliography on this subject is vast. Among the more important studies are: R. Wittkower, "Marvels of the East: A Study in the History of Monsters," *Journal of the Warburg and Courtauld Institutes* 5 (1942), 159–98; *RDK*, vol. 6 (1973), cols. 740–816 (extensive catalogue of different species, bibliography); C. Kappler, *Monstres, démons et merveilles à la fin du Moyen Age* (Paris, 1980), passim; J. B. Friedman, *The Monstrous Races in Medieval Art and Thought* (Cambridge, Mass., and London, 1981); Lecouteux, *Les Monstres dans la littérature* (as in note 17), vols. 1 and 2, passim; M. B. Campbell, *The Witness and the Other World: Exotic European Travel Writing, 400–1600* (Ithaca and London, 1988), esp. 47ff.; H. Kästner, "Kosmographisches Weltbild und sakrale Bilderwelt: Meerwunder und Wundervölker im mittelalterlichen Kirchenraum," in *Mein ganzer Körper ist Gesicht: Groteske Darstellungen in der europäischen Kunst und Literatur des Mittelalters*, ed. K. Kröll and H. Steger (Freiburg i.Br., 1994), 214–37. See also P. Hiloy-Girtz, "Begegnung mit dem Ungeheuer," in *An den Grenzen höfischer Kultur*, ed. G. Kaiser (Munich, 1991), 167–209, esp. 193ff.; A. Grafton, *New Worlds, Ancient Texts: The Power of Tradition and the Shock of Discovery* (Cambridge, Mass., and London, 1992), 35ff.; D. Hassig, "The Icononography of Rejection: Jews and Other Monstrous Races," in *Image and Belief: Studies in Celebration of the Eightieth Anniversary of the Index of Christian Art*, ed. C. Hourihane (Princeton, 1999), 25–46.

52. See Lecouteux, *Les Monstres dans la littérature* (as in note 17), vol. 2 (1982), 18ff., with sources and bibliography.

53. Cf. Friedman, *Monstrous Races* (as in note 51), 15f.

54. Vöge, *Niclas Hagnower* (as in note 6), 41.

55. Ibid. The doglike qualities of the creature only become fully apparent if it is seen in profile.

56. See Lecouteux, *Les Monstres dans la littérature* (as in note 17), vol. 2, 20ff., with sources and bibliography.

57. Hartmann Schedel, *Liber chronicarum*, fol. 12r–v. Schedel mentions Pliny, St. Augustine, and Isidore as his sources.

58. Friedman, *Monstrous Races* (as in note 51), 89.

59. Friedman, *Monstrous Races* (as in note 51), 59. St. Augustine's views on the *homines monstruosi* are chiefly expounded in *De civitate dei*, chapter XVI.8. For an in-depth discussion of this theme, see Lecouteux, *Les Monstres dans la littérature* (as in note 17), vol. 1, 153–62.

60. Discussed at length in J. S. Feldmann, "The Narthex Portal at Vézelay: Art and Monastic Self-Image" (Ph.D. diss., University of Texas at Austin, 1986), 78ff., 95ff. See also Friedman, *Monstrous Races* (as in note 51), 77ff.

61. Friedman, *Monstrous Races* (as in note 51), 79.

62. Cf. R. A. Wisbey, "Marvels of the East in the *Wiener Genesis* and in Wolfram's *Parzival*," in *Essays in German and Dutch Literature*, ed. W. Robson-Scott (London, 1973), 1–41; Friedman, *Monstrous Races* (as in note 51), 87ff. Physical deformity as a stigma of otherness in general is discussed at length by Mellinkoff, *Outcasts* (as in note 43), 121ff.

63. *Summa Theologiae*, 3a, 72, 2.

64. Biel's reading of this passage is discussed *in extenso* by Massa (no first name given), *Die Eucharistiepredigt am Vorabend der Reformation*, Veröffentlichungen des Missionspriesterseminares St. Augustin bei Siegburg 15 (Siegburg, 1966), 149f., 153.

65. M. Goodrich, *Other Middle Ages: Witnesses at the Margins of Medieval Society*, ed. M. Goodrich (Philadelphia, 1998), 7.

66. See *LCI*, vol. 3 (1971), cols. 511–15; M. Lurker, "Die Symbolbedeutung von Rechts und Links und ihr Niederschlag in der abendländisch-christlichen Kunst," *Symbolon*, new ser., 5 (1980), 95–128.

67. Cf. V. Gurevich, "Observations on the Iconography of the Wound in Christ's Side, with Special Reference to Its Position," *Journal of the Warburg and Courtauld Institutes* 20 (1957), 358–62.

68. Ibid.

69. See above, at note 3.

70. The story dates from ca. 1320–30. See R. Bauerreiss, *Pie Jesu: Das Schmerzensmann-Bild und sein Einfluss auf die mittelalterliche Frömmigkeit* (Munich, 1931), 50. See also P. Browe, "Die Hostienschändungen der Juden im Mittelalter," *Römische Quartalschrift für christliche Altertumskunde und Kirchengeschichte* 34 (1926), 167–97 (esp. 173ff., with a list of alleged Jewish host desecrations, many of which took place in southern Germany). See also M. Rubin, *Gentile Tales: The Narrative Assault on Late Medieval Jews* (New Haven and London, 1999).

71. The following is based on M. Lambert, *Medieval Heresy: Popular Movements from Bogomil to Hus*, 2d ed. (London, 1992), 289ff., 316ff., with further literature.

72. Ibid., 317.

73. From the twelfth century onwards the lay chalice had been generally withheld, but until the council's decree this practice had not been universally sanctioned. See Rubin, *Corpus Christi* (as in note 1), 70ff.

74. R. Kieckhefer, *Repression of Heresy in Medieval Germany* (Liverpool, 1979), 87, 90.

75. Lambert, *Medieval Heresy* (as in note 71), 345.

76. Kieckhefer, *Repression of Heresy* (as in note 74), 87.

The Art of the Tongue: Illuminating Speech and Writing in Later Medieval Manuscripts

JESSE M. GELLRICH

SCHOLARSHIP on the history of the book in premodern Europe has presumed, until recently, a familiar assumption concerning the relation of the visual image to the written word. This view was articulated years ago by Emile Mâle, especially in the perspective he established in *The Gothic Image*, that the art of the Middle Ages is "first and foremost a sacred writing [*écriture sacrée*] of which every artist must learn the characters."[1] His statement has roots in many medieval comments about images, one of which is St. Gregory the Great's well-known dictum that pictures offer to those who cannot read what literates are able to understand from writing: pictures are the "books" of the illiterate.[2] Whether or not pictures could be read like texts without an interpretative aid is a contested issue in medieval scholarship. But Gregory's remark bears at least one point in common with Mâle's: a text in sacred Scripture or exegesis takes precedence in understanding the images related to it. The image is the *citation* of writing.

Lately, however, this understanding of the relation of image to text has been the subject of increasing scrutiny.[3] Responding to influences from other disciplines, art historians have focused attention on how pictures may refer not only to the content of a text, but also to the form of written language or to the physical manuscript in which it is contained.[4] Not unlike palinodes in Dante or Chaucer which comment metapoetically on a text, certain pictures may also be "metadiscursive" when they refer to adjacent inscriptions or to the manuscript book itself as objects in their own right.[5] Examination of these characteristics has led to various conclusions. For example, images that cue certain textual passages appear to document the advance of literate skills, the development of silent reading, and the passing of oral customs of reading and thinking.[6] They may serve as mnemonic devices for committing a text to memory.[7] And they may indicate the use of a text as an instrument for meditation and spiritual self-examination.[8] All of these proposals show the vital influence of images on the development of the book, but they also imply a departure from Mâle's and Gregory's concept of the image as a "gloss" or "citation" of a written source.

Images do more than "substitute" for a text when they point to, reflect on, or signify the manuscript in which they appear. This kind of signifying process is not easily explained by the concept of the visual image as "citation."[9] If, for example, a comparison could be made between this process and the metalanguage of poetic texts, we should be prepared to consider how pictures about writing mirror not only an adjacent or prior text, but also mirror themselves as graphic forms of shape and gesture. In such cases, the picture that cites the inscription of its own manuscript can also refer to itself. The image may then be *self-reflexive*, a kind of "writing" like the material form of letters on parchment.

Mâle had used a similar claim, that art is "sacred writing," and before him Gregory had advised the "reading" of pictures as text substitutes. But their perspective is based on an understanding of citation different from the one suggested here.[10] Illuminated manuscripts offer an excellent field for studying these two perspectives on the so-called writing of the image since they constitute such an enormous archive of information on how writing was received before the age of the printed book. In particular, we need to look at images that depict writing in relation to acts of speaking because such images frequently comment on their own form. In such instances, they introduce a noticeable separation between the oral and written registers of communication. This distinction merits attention since it represents a striking departure from the conventional medieval opinion that writing is simply speech written down, the embodiment of the oral word.[11] The images of manuscripts tell a different story about how writing cites its sources. How it carries forward their sense, especially their historical and moral interests, remains to be seen.

The Bohun Psalter, produced in England during the second half of the fourteenth century and now in the Austrian National Library, Vienna, provides a useful starting place in folio 43r (Fig. 1).[12] This is the opening page of Psalm 44, and it contains a historiated initial of the letter E for *Eructavit* in verse 2: "My heart hath uttered a good word: I speak my words to the King. My tongue is the pen of a scrivener that writeth swiftly" (. . . *lingua mea calamus scribae velociter scribentis*).[13] Within the initial a seated male figure with a reed pen issuing from his mouth writes in the open book on his lap (Fig. 2). It is tempting to say that the illuminator responded literally to the metaphor of the tongue as pen, except for the fact that the image suggests an obviously oral sense of the act of writing. If the open text in the initial displays the importance of writing and literacy, the tongue as the pen also indicates the *listening* experience of divine communication, such as the prophets "heard" when they were "called" or St. Paul speaks about when he says (thinking of Isaiah) that "faith . . . cometh by hearing" (Rom. 10:17). Is this image to be regarded as a literal representation of the metaphor in the psalm, or as an interpretation in biblical exegesis, or as a response to the practices of reading and copying manuscript books?

The metaphor in Psalm 44 obviously attracted the interest of commentators, to judge from the number of them who glossed it. But they certainly do not agree on the subject: some believe that the image refers to oral discourse; others, to the act of writing. St. Jerome, for instance, says: "For indeed just as those things that are written are neither light nor easy, but useful and also

1. Vienna, Österreichische Nationalbibliothek, Cod. 1826, psalter of the Bohun family, f. 43r, Psalm 44 (Vulgate): "My tongue is the pen of a scrivener that writeth swiftly"

2. Vienna, Österreichische Nationalbibliothek, Cod. 1826, psalter of the Bohun family, f. 43r (detail), Psalm 44 (Vulgate). The psalmist's tongue as reed pen "speaking" to the page

beneficial, just so is the eloquence of God written, and so is it executed." It occurs "swiftly" (*velociter*), he continues, because "the things that divine eloquence has spoken are not delayed but fulfilled swiftly, and therefore the pen speaks" (*calamus dicit*). It is "compared to Christ," and it pertains to him just as other metaphors do, "the stone, lion, right hand, and other things . . . namely because he is a measurer and a writer," as we know from Ezekiel 40:3. In the phrase *calamus scribae*, Jerome concludes, "the scribe is Christ himself," and he writes swiftly because "no one writes so quickly as the Lord himself writes in the hearts of the saints. What does he write if the word of prophecy does not render his own faith, hope, and charity?"[14]

The familiar view of the image as a citation of text is affirmed if an exegesis as rich as Jerome's is aligned with the details in the Bohun illumination. The reference to Christ in the commentary is not so distant from the seated male figure. He wears a pearl nimbus commonly reserved for special individuals such as members of the holy family, although it lacks the identifying cross of the Christ-logos figure.[15] Speaking through the reed pen, moreover, the image could easily recall Jerome's explanation that "the pen speaks" as the Word made flesh. And finally, one of the most extraordinary statements in the exegesis on this psalm, "I speak to the Word itself" (*Loquor ipsi Verbo*), needs almost no comment if the picture is taken to represent the Word as Christ uttering the word as text.[16] Understood in this way, the image on the Bohun folio conforms to the familiar notion of the picture as a citation or gloss that shows the connection between Old and New Testament *figurae*—persons, events, and situations.

This connection, however, deserves further study in the Bohun illustration. The figure of "speaking to the word itself" refers not only to other texts, such as Jerome's gloss on King and Son, but also to the words written in pseudo-script on the page. This image provides an understanding of "I speak to the word itself" that is not mentioned by Jerome, that the language of the psalm refers back to itself—to the material inscription on the page and the sounds in the mouth. What is more, the image suggests that this reflexivity is a property of both the biblical passage and the visual form, since the image of the book in the picture inevitably mirrors the larger manuscript book in which it is included. The picture, in short, does more than simply cite another text—it cites itself in the process.

Jerome's exegesis, as might be anticipated, was valuable to subsequent commentators on this psalm. It is found, for instance, in the comprehensive coverage offered on the text in both the *Glossa ordinaria* and the *Opera omnia* of Hugh of St. Cher. The illumination in the Bohun Psalter appears to be indebted to both of these sources, and, as in the case of Jerome, it expands their suggestions by the interplay between image and inscription. In the *Glossa* Jerome's name is noted, and his general ideas (though not his exact words) are obvious: *eructavit*, according to the *Glossa*, refers not to an utterance from the body but from "the person of the Father"; it is he who says, "from my plenitude and secret essence I have begotten the word . . . and through him I speak; this is my tongue, this the pen of my scribe; as the scribe is nothing without the pen and the pen without the scribe, so the Father and the Son are compared."[17] The eternal and generative quality of utterance is extended in the commentary from the *Glossa* to clarify the material signification of the word *calamus*: "the pen prepares the word not by sound which passes quickly, but by the written word which endures." The pen writes "swiftly" (*velociter*) because it does not create "one thing after another, but all things simultaneously in one eternal word."[18] Nicholas of Lyra, whose fourteenth-century commentary is included in the Renaissance edition of the *Glossa*, extends this point succinctly when he says that the Holy Spirit "does not need the interval of time for his teaching."[19] The Bohun image responds to several of these details of the "heart" speaking as the "tongue" of the divine *verbum*, but it magnifies and clarifies them by rendering the paradoxical notion of "speaking to the word itself." The suggestion of that paradox in the image of the tongue upon the book "illuminates," in the most basic medieval sense of the term, the word spoken in Genesis: a voice from above speaks the word that is simultaneously the book and the Word made flesh.

Hugh of St. Cher evidently knew the commentary quoted in the *Glossa* because he cites it in his thirteenth-century exegesis to explain the pen that "writes swiftly." But he goes on to list several things that slow down or "impede" the making of *scriptura*. He is manifestly referring to the work of copying books in the medieval scriptorium. But his elucidations are themselves allegorical in more ways than we ordinarily find in other commentators. If the Bohun artist was inspired by the metalanguage of exegesis, Hugh of St. Cher provides abundant illustrations of it. For instance, one "impediment" to *scriptura* is "the lack of ink," without which "indeed no letter can be made: and if it is drawn, the *figura* does not appear." Lest his reader miss

the obvious here, Hugh de-allegorizes his exegesis: "The pen therefore is the tongue of the preacher, the ink the grace of the Holy Spirit, without which no preaching appears nor is fruit born."[20] Another impediment has even more direct bearing on the Bohun folio. It is apparent when "the pen is not held by the hand, but by the mouth alone" (. . . *sed tantum ore*). To understand this contrast, Hugh refers to Paul sending his greetings to the Thessalonians by "my own hand," which is indicated by the "sign" of writing itself, the actual epistle written by the apostle. In contrast, says Hugh, are all of those who send greetings only "by mouth" (*ore*), that is, who "preach salvation to the Gentiles, but do not greet with their hand because they do not perform the work of salvation." Such people do not possess the "sign that Paul has used in all of his epistles," and therefore "they must be judged false apostles" (*pseudo-apostoli*).[21]

Highlighting the contrast in Paul's text between salutation by mouth and by hand, Hugh refers to Psalm 44 within the context of the medieval scriptorium, where impediments to the production of "scriptura" must have included conflicts between those who labored with the pen and those who paid only lip service to that work. The Bohun image betokens a similar conflict, not only because of the contrast between the pen in the mouth versus the writing in the hand, but also because the image within the initial reflects both the writing and the marginalia beyond its borders (Fig. 2). As the image of the tongue offsets the play of voice and script, the reflexivity of visual form is offset further by the marginal art in which two men, one of whom is nude and wears a hood, tug on the ropy vines forming the left marginal bar of the letter and physically tie in knots things above and those below. Here, if anywhere, are Hugh's *pseudoapostoli* who, although they are involved with the medium of the sacred letter, do no beneficial work with their hands nor, for that matter, with their mouths. The artist of the Bohun Psalter has worked in a very different interest. Even if he did not know Hugh's commentary or the others mentioned so far, still he was able to direct the popular notion of the picture as a gloss on New Testament scenes toward the discovery of the self-reflection inherent in the psalm and in his own visual medium. That discovery develops out of the conflict between spoken and written modes of this text, which in turn points to the self-discovery of its spiritual purpose.

The image in the Bohun Psalter is unique. But it is by no means alone in responding to the image of the tongue in Psalm 44:2. Another example is the illumination of this text in the St. Albans Psalter, also produced in England but in the early twelfth century and now in the treasury of St. Godehard's Church at Hildesheim, Germany (Fig. 3).[22] In the initial E for *Eructavit*, David is crowned and seated; he holds a pen in his right hand and with the index finger of his left hand he touches his protruding tongue in response to the verse "my tongue is the pen." The index finger of his left hand not only indicates speech by pointing to the tongue, but reiterates as well the gesture of pointing as an act of oral utterance.

The locus classicus for the "language" of gesture is Quintilian's *Institutio oratoria*. Is it not the case, asks Quintilian, that the gestures of the hands, "in pointing to places and persons take the place of adverbs and pronouns, so that among the great diversity of languages throughout all peoples and nations, the

diffusa est gra inlabirt t
benedixit te di inecernï

3. Hildesheim, St. Godehard's Church, treasury, St. Albans Psalter, f. 80v (detail),
Psalm 44 (Vulgate). David "writing" the speech of his tongue

gestures of the hands seem to me to be the universal speech [*sermo communis*] of all men?"[23] He goes on to remark that this "speech" is so common that even the "index finger" (*index*) is named for it because "it is effective in denouncing and indicating."[24] With or without Quintilian's observations in mind, medieval artists commonly represented the act of speaking through images of the pointing index finger.[25] Representations of the Annunciation, for example, provide typical illustrations of this gesture. As in the Cloisters Apocalypse, Gabriel is frequently shown pointing with his index finger to the Virgin Mary and delivering the words of the Incarnation to her, "Ave, Maria, gratia plena."[26] In the St. Albans Psalter, the text itself provides numerous examples of the pointing finger as an act of speech (Fig. 5).

In the illumination of Psalm 44 (Fig. 3), however, the gesture of David's pointing finger lends force to ideas that were commonly associated with the

figure of the tongue as pen—that through it the Holy Spirit is speaking and that the psalmist "speaks to the Word itself." Here, indeed, as the *Glossa* indicates, the tongue is Christ. Although the image of writing is prominent in this illumination, it tends to be represented as an embodiment of oral language, as speech written down. As David looks up to God, he touches his protruding tongue with the index finger of his left hand, while he holds, in obvious symmetry, a reed pen in his right hand. Hugh of St. Cher, a century later, would describe the meaning of this verse in Psalm 44: "What I speak I do not speak from me myself, but from the Holy Spirit," as Matthew indicates (10:20: "For it is not you that speak, but the spirit of your Father that speaketh in you").[27] The St. Albans illumination apparently anticipates such a reading, since it is based on well-known ideas about the voice of David in the Psalms. The Beatus page of the manuscript states explicitly the most common understanding of that voice. Within an open book held by David, the inscription reads: "Blessed David, the psalmist whom God has chosen, speaks forth the Annunciation of the Holy Spirit."[28] The illumination of Psalm 44 is undoubtedly informed by these textual sources. But the picture is a source in its own right, and it qualifies the belief that voice takes priority over the image.

Once the figure of the tongue as pen is visualized, it begins to exceed its own citation, as in the later Bohun illumination. The pen, the finger, and especially the tongue, if only by virtue of its size, stage a little drama of self-reflexivity, not only in David's pointing to himself, but in the many subtle mirrorings of this initial, such as the right hand balanced with the left, tongue with pen, tongue with finger, David's eye with the eye of the beast figure, and the beast above with the one below. In a scene with so much pictorial subtlety, it seems rather arbitrary to decide which channel of communication, oral or written, is going to have the last word. The picture at once speaks through the conventional gestures of oral language, but they in turn reflect back on the materiality of their own form.

A similar expression of this interplay is found in another folio in the St. Albans Psalter, the illumination of Psalm 80 (Fig. 4).[29] It depicts the initial E for the word *Exsultate* in verse 2, "Rejoice to God our helper." Christ above lifts two figures in answer to the petition of verse 8: "Thou calledst upon me in my affliction and I delivered thee." Below, David holds a rod connecting his open mouth to the open mouth of Christ. Verse 11 reads: "Open thy mouth wide, and I will fill it" (*Dilata os tuum, et implebo illud*). The metaphor of *implebo* ("I will fill") in the scriptural text has been transferred to a new context, but not without being manifestly altered in the process. Whatever "fill" might mean in the psalm, here it recalls Isaiah 11:4: "he shall strike the earth with the rod [*virga*] of his mouth"; or St. Paul's claim that Christians have "tasted" (*gustaverunt*) the word of God (Hebrews 6:5); or the medieval commonplace of the word of the mouth as physical object (in the root sense of *implere*, "to fill" with food and in some cases with semen, "to satisfy," "to make pregnant").[30] And yet it is clearly not speech that has priority in this image. No matter how many references to rod are found among biblical sources, the image will eventually transcend them since it refers back to itself.

If the distinguishing interest of medieval exegesis is the citation of sources, these images are not simply citational. Nor are they text substitutes, despite

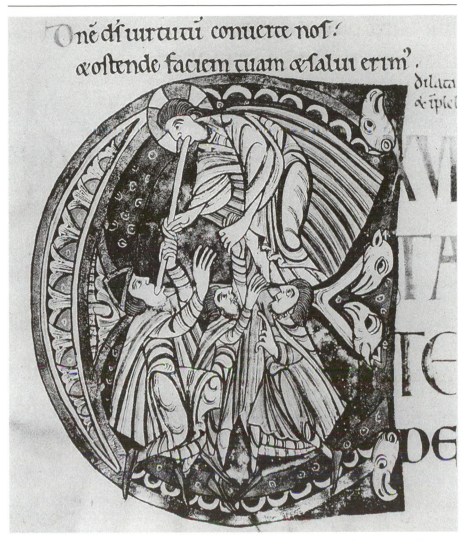

4. Hildesheim, St. Godehard's Church, treasury, St. Albans Psalter, f. 118r (detail), Psalm 80 (Vulgate). David's mouth connected to Christ's by the "rod" of the word

Gregory's dictum about pictures as the "books of the illiterate," which, incidentally, is quoted directly in the St. Albans Psalter.[31] Images in this book have a status that is little different from the inscription surrounding them: they frequently cross the border of picture and enter the space of writing as if a difference between the two media did not exist. Through this emphasis on the materiality of form, both image and text illustrate their separation from the speech they represent.

Among the many illustrations of this departure in the St. Albans Psalter, the illumination of Psalm 48 is particularly noteworthy (Fig. 5).[32] Within the initial A for *Audite* in verse 2 ("Hear these things, all ye nations"), a large figure points with his right index finger directly into the ear of his companion, while with his left hand he reaches outside of the initial to point at the word

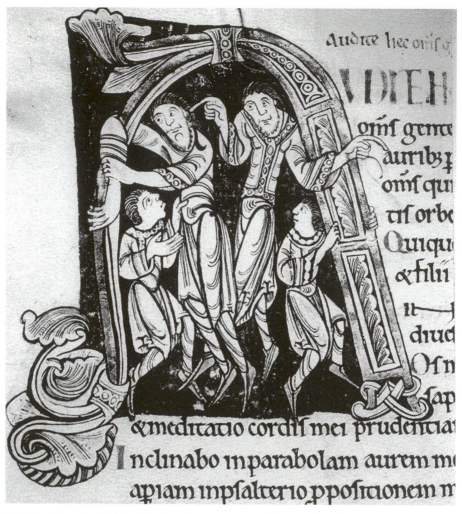

5. Hildesheim, St. Godehard's Church, treasury, St. Albans Psalter, f. 83v (detail), Psalm 48 (Vulgate). Leaning on the "letter alone" and deaf to the oral warning—"give ear"

auribus for the rest of verse 2: "give ear, all ye inhabitants of the world" (*auribus percipite, omnes qui habitatis orbem*). Despite the warning given by the smaller man who tugs on the robes of the slouching figure, the words of entreaty go unheeded. As one of the "inhabitants of the earth," the indifferent listener has ears but hears not, and neither does he see the implication of leaning excessively on the mere physical form of the "letter alone." The point is made by the gesturing figure whose outstretched arms constitute a kind of visual pun on the two completely different senses of *auribus percipite*: on the one hand, "give ear," and on the other, "take hold of" or "grasp by the ears." It is tempting to say, as with the image in the Bohun Psalter, that the artist has rendered an exceedingly "literal" sense of the words by the physical gestures of taking hold of the initial and touching the ear. Thus fixed between text and image, the gesturing figure is a picture of citation itself in comic relief. He does

not "stand for" the voice of the script, nor does the picture "speak" for those who cannot read. In this respect, the reflexivity of images qualifies the traditional subordination of picture to source and writing to voice that marks so much of the formation of the book in the Middle Ages.

For a later example, Psalm 51 of the Luttrell Psalter, a manuscript produced in early fourteenth-century England, shows a historiated initial Q for *Quid gloriarus* in verse 3: "Why dost thou glory in malice" (Fig. 6).[33] A nimbed fig-

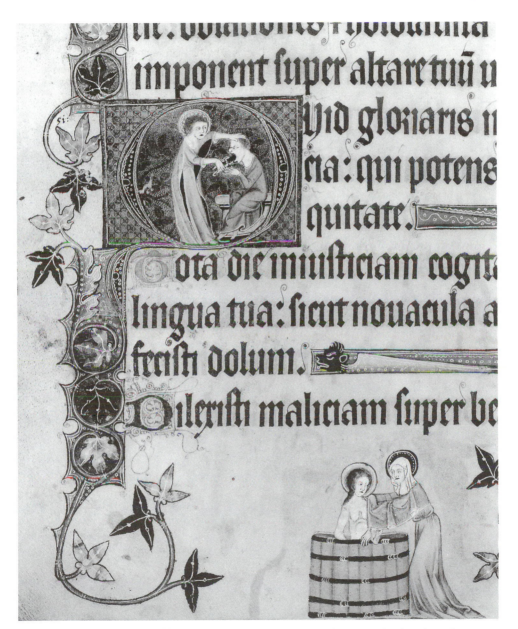

6. London, British Library, Add. Ms. 42130, f. 97v, Psalm 51 (Vulgate). "Why dost thou glory in malice . . . O deceitful tongue?"

ure of David with pincers extracts the tongue of a man seated with hands clasped in prayer. Verses 6–7 read: "Thou has loved all the words of ruin, O deceitful tongue. Therefore will God destroy thee forever. He will pluck thee out and remove thee from thy dwelling place and thy root out of the land of the living."[34] The image reveals the same practice here of citing the metaphor in the text, though the effect is reversed: where the apostrophe to the tongue in the psalm indicts the entire generation of a people, the picture radically contracts the range of reference to the *lingua dolosa* of a single pathetic suppliant (Fig. 7).

This image brings to mind a number of other texts.[35] One of them is the "circumcision of the lips" mentioned by Augustine in the *Confessions*, book 11.2.[36] Pondering when he will be capable of proclaiming "with the tongue of my pen" (*lingua calami*) all of the teachings in sacred scripture, Augustine calls upon God to "circumcise . . . my inner and outer lips"; let the Scriptures alone, he says, "be my chaste delights."[37] Augustine's figure of the *lingua calami* draws directly upon the occurrence of this phrase in Psalm 44:2, but he combines it with the vivid scene in Exodus 6:12, where Moses calls upon God to ask how he will be able to plea for Israel before Pharaoh since he is a "man of uncircumcised lips" (*cum incircumcisus sim labiis*). Augustine's passage, moreover, is informed by at least two other scriptural passages on the mouth. One is the reference to cleansing the tongue in Psalm 38:2: "I will take heed to my ways, that I sin not with my tongue. I have set a guard to my mouth" (*custodiam vias meas, ut non peccem lingua mea*). The other is the

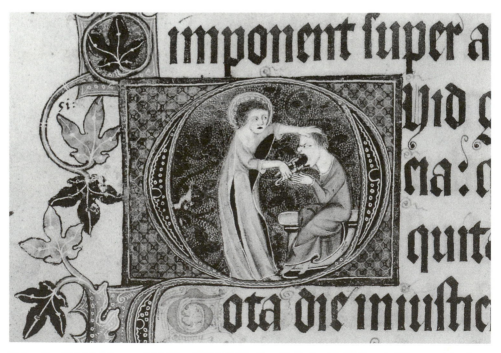

7. London, British Library, Add. Ms. 42130, f. 97v (detail), Psalm 51 (Vulgate). "Circumcising" the deceitful tongue from the root of the living

call of Isaiah in chapter 6, where the prophet berates himself as a "man of unclean lips" (verse 5: *vir pollutus labiis*) who is unfit for the word of God but who is immediately purified when the angel flies to him and touches his lips with a burning coal taken from the altar of the sanctuary. Isaiah surely has the plea of Moses in mind, and Augustine combines both of them with the equally prominent passage on the "circumcision of Christ" (*circumcisione Christi*) described by St. Paul (Col. 2:11–12) as a sign of the purification of the "flesh" and the spiritual life of the New Covenant. The Old Covenant of the flesh, Paul adds, was the "writing" nailed on the Cross like the body of Christ (Col. 2:13–14); it ended with Christ's death, and that is how Augustine is now— after the purification of the burning coal of Isaiah and the crucifixion of Christ—made "sufficient" to speak about Holy Scripture. His ability "to proclaim" (*enuntiare*), let us note, will now prevail over the mere written form of his text.

Manuscript illuminators did not miss the rich possibilities that these passages offered when it came to illustrating references to speaking and writing. Illustrations, for example, of Psalm 38:2, which refers to placing a guard to the mouth, recall the gesture of purifying the lips in Isaiah and perhaps in Augustine as well.[38] This psalm generated something of a commonplace image in manuscript illumination by showing David pointing to his protruding tongue or touching his hand to his lips in a gesture of supplication. The figure was certainly known by the artists of the Luttrell Psalter since it occurs in the historiated initial of Psalm 38.[39] Augustine's association of cleansing the lips and tongue through ritual circumcision follows directly the readings of the psalter passages in light of the purification of Isaiah and Christ, and medieval artists saw the connection immediately. It is made, moreover, in the *bas de page* imagery of Psalm 51 (Fig. 6) showing a scene of bathing, which may suggest the figurative and doctrinal connection between circumcision and baptism made by Paul (Col. 2:12–13).[40]

The historiated initial for Psalm 51, however, depicts torturing the instruments of speech to such an extent that circumcision leans toward castration, as the *lingua dolosa* simulates yet another commonplace element, the phallic form of Satan in Genesis. Satan's phallic power has a long association with the tongue: St. Paul in 2 Corinthians 11:3 warns the "chaste virgin" of the new Christian community to beware of the slick talk of the serpent who "seduced" the first bride, Eve.[41] Isaiah had drawn a similar association when he berated sinful Israel as the "seed" of the adulterer and fornicator: "upon whom have you opened your mouth wide and put out your tongue? Are you not . . . a false seed?"[42] The association of the tongue with the sins of the flesh and the phallic seduction of Satan is nowhere more notoriously drawn than in Milton's description of the Fall in *Paradise Lost*, book 9, which is clearly indebted to medieval sources. The St. Albans Psalter, for example, includes a highly suggestive scene of the Fall with the serpent emerging as a tongue from the mouth of Satan, who is perched as a winged dragon in the Tree of Knowledge, which is exactly how Milton depicts him in the opening of book 9 (Fig. 8).[43]

It is the association of seductive speech, the tongue, and the serpent that lies behind the castration scene in the illumination of Psalm 51 in the Lut-

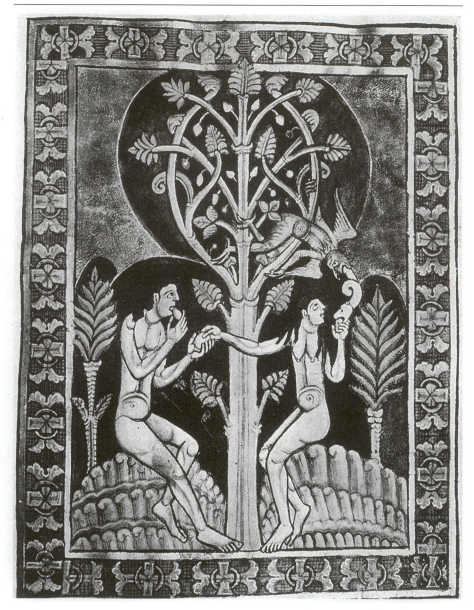

8. Hildesheim, St. Godehard's Church, treasury, St. Albans Psalter, f. 9r. The "bilingual" Satan and the fruit of his "circular" word

trell Psalter. But to describe this image as the citation of the text in Genesis 3, 2 Corinthians 3, or Augustine's *Confessions* does not do justice to such a complex page. On the contrary, the picture overthrows the belief that voice comes first, writing follows, and illumination affirms the whole order of the sequence. That convention is pointedly qualified by a depiction of the sins of the tongue in which the tongue itself is the source of representation. The illumination of this folio of the Luttrell Psalter is as much about image-making as it is about oral circumcision and castration.

The double function of the image, one that indicates both an object as well as itself, is common in representations of language, particularly in images of the mouth. Artists and designers inevitably begin to probe this subject when they suggest the doubling of the image in pictures showing, for example, the double-tongued utterance of the deceiver or liar. The word in the Vulgate for that figure is *bilinguis*, "two-tongued," "double-tongued," and hence "hypocritical," "deceitful," "false." But as the root of modern English "bilingual," the Latin word also means "speaking two languages," and therefore it can also signify "having a double meaning, allegorical."[44] These two basic senses of *bilinguis*, two-tongued and bilingual, accommodate rather strikingly the visual image that represents both the moral status of a sinner as well as the signifying process of images.

The connection of *bilinguis* with the sins of the serpent is self-evident in the notion of speaking with "forked tongue." But this phrase does not occur in Genesis. The serpent is called *callidior*, "more subtle" (Gen. 3:1); and for his deception God condemns the serpent with the term *maledictus*, "accursed" (Gen. 3:14). *Bilinguis*, in fact, is not used anywhere in the Vulgate to describe Satan or the serpent. Though various sinners are called *bilinguis* in scriptural passages, the closest we come to a connection between the serpent and the double-tongued deceiver is in a passage from Ecclesiasticus 28:15, where *bilinguis* occurs in conjunction with the word *maledictus* that is said of the serpent in Genesis: "the whisperer and the double-tongued is accursed" (*susurro et bilinguis maledictus [est]*).

But a description of deceivers as "two-tongued" or "split-tongued" hardly had to wait for references to the serpent in the Bible. The serpent was merely an occasion for exploring the connections between the birth of sin and the creation of pictures. The St. Albans artist took advantage of that occasion, as he demonstrates in his full-page miniature of the Fall (Fig. 8). In it Satan is *bilinguis* not only as the deceiver presenting the fruit to Eve but also as a split figure: he is both the winged dragon in the tree and the *draco* or "worm" issuing as a tongue from the mouth of that bird. Two-tongued himself in form, Satan has a tongue that is also the word for worm in Latin. Moreover, his word of persuasion to Eve is the fruit in his mouth which she accepts and Adam subsequently eats.

The doubling of figures in this picture is unmistakable: the two figures of Satan, his two open mouths, the two naked figures, the fruit in each hand of Eve, and finally the two trees. Such circularity of reference is mirrored also by the shape of the tree and the coiled form of the serpent's body; and that form is continued in the semicircular direction of Satan's speech, which proceeds as the fruit passed from his mouth above, to Eve below, and via her bowed arm over to Adam.[45] The artist has responded to a *bilinguis* Satan with his own form, the image that reflects upon itself as it depicts the doubleness of deception.

The relevance of reflexive form to the imagery of vice is not unique to the St. Albans artist. One of the more enigmatic figures in the Luttrell Psalter is the image of a secular woman in the left margin of Psalm 21 (Fig. 9).[46] She has the pose of a dancer or bagpipe blower. But does she disgorge or engorge the dragon protruding from her mouth as a tongue? Perhaps she conflates a

9. London, British Library, Add. Ms. 42130, f. 43v
(detail), Psalm 21 (Vulgate). Woman dancing to the
tune of her dragon-tongue

response to verse 7, "I am vermin [*virmis*] and not man," or verse 14, "they
have opened their mouth [*os*] against me," or verse 16, "my tongue [*lingua*]
adheres to my jaw." She is not a specific reference to any of these texts any
more than she exemplifies the seduction of the serpent in the Fall or his cas-
tration from her mouth. Though precedents for this image have not been
found, the dragon of the tongue recalls the serpent-dragon image of Satan's

mouth in the miniature of the Fall in the St. Albans Psalter (Fig. 8). As a figure of the death of the soul, the image could equally mean the opposite, the soul liberated from the flesh in death since the dove or bird emerging from the mouth is ubiquitous in medieval pictures of the dying. One such image occurs in the St. Albans illumination of Psalm 147. Christ descends to earth, as a bird (perhaps a dove) emerges from his mouth, representing the tongue of his word, in illustration of verse 15: "Who sending forth his speech [*eloquium suum*] to the earth; his word [*sermo*] runneth swiftly."[47] Here is the direct opposite of the *lingua dolosa* of Satan in other pictures.

The woman with the dragon-tongue in the Luttrell Psalter cannot be specifically linked to any of these sources. She is a split figure, a citation of sin and its expiation. If she suggests the figure of *bilinguis* condemned in Ecclesiasticus 28:15, it cannot be because she is a personification of the *lingua dolosa* in Psalm 51. No sooner has the artist illuminated the sins of the tongue in the conventional figure of the "bilingual" serpent than he has revealed as well the "bilingual" nature of the visual image where the dragon stares back at her.

An even more graphic example of this attribute, though not from manuscript illumination, is Giotto's painting of Invidia (Envy) in the Scrovegni Chapel in Padua, which was probably completed before 1306 (Fig. 10).[48] Invidia is on the north wall and is second in the series of seven Vices leading to the Last Judgment painted on the adjoining west wall. Each sin is paired with a Virtue directly opposite on the south wall, and all the figures are named in Latin above and described below with an inscription also in Latin (though not always legible). Although the ultimate source for such a grouping is Prudentius's *Psychomachia*, Giotto's arrangement varies somewhat from it, and he may not have had that text specifically in mind. The succession of virtues juxtaposed with vices is common in penitential handbooks from the Middle Ages, and Giotto's debt is obviously to them by virtue of his organization of the series.[49]

In the case of Invidia, the written identification is especially pertinent to the form of the painting. *Invidia* is written on the recessed frame of the picture, but the figure stands in front of this frame as if it has stepped outside of its stone enclosure. Giotto is manifestly imitating the convention of framed sculpture, but he is also departing from it. For instance, the flames in which this female figure stands envelop her gown completely at the base; they repeat the image of the river of fire flowing from the left side of Christ in Judgment which is immediately in front of Invidia on the west wall. She not only exists beyond her frame but even faces in the direction of the fire, leaning and gesturing toward it with her right hand. She of course does not desire that fiery judgment, except in *contrapasso*, as Dante would call it, for those sinners who paradoxically seek the same evil they themselves have committed. Invidia, however, leans forward more specifically in greed, which is indicated by the money bag in her left hand and by the grasping fingers of her right hand. She is paired with Caritas on the opposite wall, who receives enough gifts to fill her basket. Although this pairing of Charity with Greed follows the *Psychomachia*, Giotto's figure is as oblivious to greed as she is to the fire at her feet, and this blindness stands out in sharp contrast to the reflexivity of her portrait in relation to its frame.

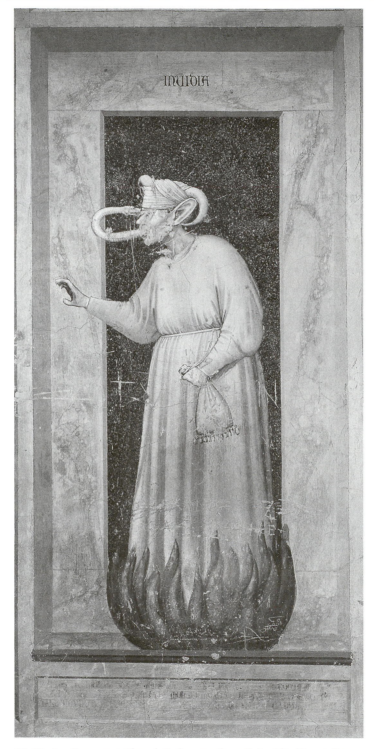

10. Giotto, Scrovegni Chapel, Padua, north wall, Invidia (Envy). Envy standing outside of her frame consumed by her own greed

It stands out even more strikingly in relation to the grotesque distortion of her faculties of speaking and hearing (Fig. 11). She is a horned figure with huge batlike ears and an enormous tongue depicted as a serpent crawling out of her mouth and circling back to her eyes. The mouth of the serpent is open, and his tongue is protruding as if poised to strike, though Invidia looks on blindly, in another *contrapasso*, at this threat to her own language. As an image of the serpent's voice, the tongue of Invidia, like those in the St. Albans Psalter and the Luttrell Psalter, is *bilinguis* in the sense that it signifies deceitful or equivocal utterance, but also because Invidia, without realizing it, is staring straight at her own words. And yet like the ear, which is large enough to hear all but hears nothing, jealous language neither sees nor hears itself. The figure herself is frozen in motion, as unaware of the tongue and ears as she is of the fire beneath. The static form of this figure is one of its compelling virtues; it characterizes envy with the extraordinary insight that it is incapable of reflecting on itself.

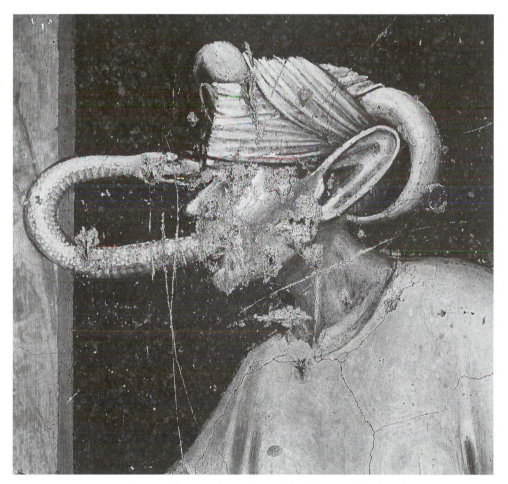

11. Giotto, Scrovegni Chapel, Padua, north wall, Envy (detail). Envy "blind" to her own serpent-tongue

Nowhere in the picture is this self-reflexivity clearer than in the use of the Latin title. *Invidia* is related etymologically to *invidere*, which means "to cast the evil eye upon," a meaning that Giotto knew well for his painting of the evil eye of the snake meeting the eye of the woman.[50] But the Latin infinitive also suggests the direct opposite of sight since it is made up of "in" plus "videre," which suggests "not" being able "to see." The duality of the title, itself a type of *bilinguis*, relates to the two-tongued serpent and the "bilingual" form of the picture: it reflects on itself but creates a figure totally blind to that realization. Like the artists of the Bohun, St. Albans, and Luttrell Psalters, Giotto has qualified the conventional subordination in which writing imitates speech, and both of them are in turn imitated in visual forms. Indeed, the picture of Invidia takes that convention to task, as Giotto imitates it by inscribing his frame with a name.

Perhaps this effect was what prompted Francesco da Barberino to use Giotto's Invidia, in a very rare contemporary reference (1313), as an explanation for one of his own figures, Inimica (the Enemy), in his *Documenti d'amore*. "The Enemy: one is made an enemy, indeed, by bearing out hateful actions, as when the envious person is consumed by envy within and without, which Giotto has painted excellently in the Arena at Padua" (*Inimica: inimicatur enim patientibus eam unde Invidiosus invidia comburitur intus et extra hanc Padue in Arena optime pinsit Giottus*).[51] The Latin shows much more closely than the English translation how Barberino defines the moral category by drawing out *inimica* from *inimicatur* and *invidiosus* from *invidia*. But it is also clear that he reads in this linguistic reflexivity the paradoxical nature of the moral condition he is describing, the soul that makes itself hateful by bearing out hatred. Giotto is called to witness this moral self-contradiction in the figure of Invidia because it is "consumed" by its own fire (*comburitur*) and attacked from "without" (*extra*) by the serpent from "within" (*intus*). The "double-tongued" form of the sinner has obviously left its mark on the deliberate "bilingual" explanation of this historical witness to Giotto's art.

The evidence for self-reflexivity in visual art suggests that manuscript illumination makes a significant contribution to language theory in the Middle Ages when it plays upon the difference between the written and spoken word. A picture that illustrates a text is not simply a citation if it also reflects upon its own graphic form. So too does writing disclose its difference from oral utterance as soon as it mirrors itself as inscription. Citation does not explain adequately this subtle and challenging contribution from art to language. The medieval convention, therefore, that speech comes first, writing is next, and the picture follows last (a mere "illustration") clearly needs renovation when we consider the evidence from art.[52]

But the qualification of this subordination does not imply that the metalanguage of images leaves us in a vague world of reference, like Chaucer's *House of Fame*, where language swirls in a noisy and endless echo of itself. To the contrary, the speech that sees and hears only itself may show, as indicated, how the vices of envy and hatred are motions of a soul utterly incapable of self-reflexivity. That effect is as much the affirmation of an old virtue as it is the creation of new form.

Well-practiced in the familiar structure of citing *auctoritates*, illuminators and designers reverse the very principle on which the illustrated page and the manuscript codex were constructed: reaching back to the past, they cite paradoxically their own form and in the process develop the book against its time-worn currents.[53] The visual art of the book has as much to tell us about the history of language in the Middle Ages as we are likely to find in its written word.

ACKNOWLEDGMENTS

I am grateful to Eric Jager for inviting a preliminary version of this essay for presentation in a special session on "Medieval Myths of Writing" held at the MLA convention in Chicago, 1995. I also acknowledge the support of Jeffrey Hamburger, Steven Nichols, Howard Bloch, Seth Lerer, Derek Pearsall, Brian Stock, Peggy Prenshaw, Lisi Oliver, and Mark Zucker. I have received eager assistance from the research librarians and curators at the J. Pierpont Morgan Library in New York, the J. Paul Getty Museum in Los Angeles, and the Marquand Library and Index of Christian Art at Princeton University. But I am especially grateful for the generous help of the research scholars at the Princeton Index: Adelaide Bennett, Brendan Cassidy, and Lois Drewer. I owe special thanks to Colum Hourihane, current director of the Index, and to Amy Gutman, Dean of the Faculty, for appointing me Visiting Fellow in Art and Archaeology at Princeton during the summer of 1997.

NOTES

1. *The Gothic Image: Religious Art in France of the Thirteenth Century*, trans. D. Nussey (New York, 1958), 1, from the original *L'Art religieux du XIIIᵉ siècle en France: Étude sur l'iconographie du Moyen Age et sur ses sources d'inspiration* (Paris, 1910), 14.

2. Gregory: "Pictures are used in churches so that people who do not know letters may at least read by seeing on the walls what they are unable to read in books. . . . For what writing shows to literates a picture shows to illiterates looking at it . . . in it they who do not know letters read" ("Idcirco enim pictura in ecclesiis adhibetur, ut hi qui litteras nesciunt saltem in parietibus uidendo legant, quae legere in codicibus non ualent. . . . Nam quod legentibus scritura, hoc idiotis praestat pictura cernentibus . . . in ipsa legunt qui litteras nesciunt"). Gregory the Great, *S. Gregorii Magni Registrum Epistularum Libri VIII–XIV*, ed. D. Norberg, CCSL 140A (Turnhout, 1982), IX.209 and XI.10, 768, 873–76. Translations throughout are my own.

On the problem of how the Church accommodated a text-based religion to illiterate congregations (including reliance on the "oral performance" of writing), see H. Y. Gamble, *Books and Readers in the Early Church: A History of Early Christian Texts* (New Haven, 1995). For the diversity of opinion about Gregory's statement, see L. G. Duggan, "Was Art Really the 'Book of the Illiterate'?" *Word and Image* 5 (1989), 227–51. For a fine assessment of the primary evidence, see C. M. Chazelle, "Pictures, Books, and the Illiterate: Pope Gregory I's Letters to Serenus of Marseilles," *Word and Image* 6 (1990), 138–53. On the principle in monumental art, see H. Kessler, "Pictures as

Scripture in Fifth-Century Churches," *Studia Artium Orientalis et Occidentalis* 2, fasc. 1 (1985), 17–35. And on stained glass, see the careful qualifications drawn by M. H. Caviness, "Biblical Stories in Windows: Were They Bibles for the Poor?" in *The Bible in the Middle Ages: Its Influence on Literature and Art*, ed. B. S. Levy (Binghamton, 1992), esp. 124 and 147.

3. Meyer Shapiro signaled the need for reconsidering this relation some time ago: "the correspondence between word and picture is problematic and may be surprisingly vague"; *Words and Pictures: On the Literal and the Symbolic in the Illustration of a Text* (The Hague: 1973), 1.

4. See, e.g., M. Camille, "The Book of Signs: Writing and Visual Difference in Gothic Manuscript Illumination," *Word and Image* 1 (1985), 133–48; idem, "Visual Signs of the Sacred Page: Books in the *Bible Moralisée*," *Word and Image* 5 (1989), 111–30. The same author's *Image on the Edge: The Margins of Medieval Art* (Cambridge, 1992) is concerned throughout with the relation of "marginalia" to the "center" of the text and with the reversibility of these two categories of reference. But see the critique of this concept and other issues raised by this book in Jeffrey Hamburger's pointed review in *Art Bulletin* 75 (1993), 319–27. Questions about the relation of picture to text are especially prominent in the so-called New Art History, which shares many interests with the New Philology in literary and historical studies—too lengthy to summarize here; but see, e.g., J. J. G. Alexander, "Art History, Literary History, and the Study of Medieval Illuminated Manuscripts," *Studies in Iconography* 18 (1997), 51–66. The essays collected in *The New Art History*, ed. A. L. Rees and F. Borzello (London, 1986), do not concern medieval art and reflect theoretical inquiries now bypassed by recent revisions of deconstruction, feminism, and psycholinguistics.

5. Suzanne Lewis uses this term broadly for the study of a representative group of illuminated manuscripts from the Gothic period in England; see *Reading Images: Narrative Discourse and Reception in the Thirteenth-Century Illuminated Apocalypse* (Cambridge, 1995), 3, 15. A related use of this term—to characterize authentication in pictorial narrative—is made by Cynthia Hahn, "Purification, Sacred Action, and the Vision of God: Viewing Medieval Narratives," *Word and Image* 5 (1989), 70–84.

6. See M. Camille, "Seeing and Reading: Some Visual Implications of Medieval Literacy and Illiteracy," *Art History* 8 (1985), 26–49; and R. M. Wright, "Sound in Pictured Silence: The Significance of Writing in the Illustration of the Douce Apocalypse," *Word and Image* 7 (1991), 239–74—Wright refers to pictures in manuscripts as a "metalinguistic system" (p. 239), indicating the increasing reliance on written documents in England during the late thirteenth century. For the practice of silent reading, Lewis presumes a date among lay audiences as early as the 1260s in England on the evidence of the artistic programs of illuminated Apocalypses made in that decade; they create, she argues, "a privileged metadiscursive imagery that finds its special distinction in its inherent silence"; *Reading Images* (as in note 5), 3. Paul Saenger, however, proposes a much later date for silent reading among the laity on the evidence of their books of hours, which assume an oral use of written prayer through the fourteenth and fifteenth centuries; see "Books of Hours and the Reading Habits of the Later Middle Ages," in *The Culture of Print: Power and the Uses of Print in Early Modern Europe*, ed. R. Chartier (Princeton, 1989), 143–73. He holds the same opinion for lay audiences in his more recent study, *Space Between Words: The Origins of Silent Reading* (Stanford, 1997), 256–76; learned audiences (with university training) no doubt practiced silent reading earlier, but exactly when is difficult to establish. Insofar as the practice is understood in relation to the development of word separation and the regularization of Latin word order (pp. 39, 41), it is not until the twelfth century that manuscripts show both of these developments consistently (pp. 44–51)—and even then the production of manuscripts reflects oral customs (pp. 201ff.)

7. See the following studies by Suzanne Lewis: "The Apocalypse of Isabella of France: Paris, Bibl. Nat. Ms. Fr. 13096," *Art Bulletin* 72 (1990), 224–59; "The English Gothic Illuminated Apocalypse, *Lectio Divina*, and the Art of Memory," *Word and Image* 7 (1991), 1–32; "Beyond the Frame: Marginal Figures and Historiated Initials in the Getty Apocalypse," *Gesta* 20 (1992), 53–76; and *Reading Images* (as in note 5), concerned throughout with memory.

8. For the visual image as the occasion of meditation, see J. F. Hamburger, "The Visual and the Visionary: The Image in Late Medieval Monastic Devotions," *Viator* 20 (1989), 161–82; idem, *The Rothschild Canticles: Art and Mysticism in Flanders and the Rhineland ca. 1300* (New Haven, 1990), esp. chap. 7.

9. On the theory and practice of citation in general, see the interesting series of essays collected by Stephen A. Barney, *Annotation and Its Texts* (New York, 1991).

10. Their perspective is exemplified famously in the work of Erwin Panofsky, e.g., *Studies in Iconology: Humanistic Themes in the Art of the Renaissance* (New York, 1939; repr. New York, 1962 and 1972), or in literary studies by D. W. Robertson Jr., *A Preface to Chaucer: Studies in Medieval Perspectives* (Princeton, 1963). For a departure from Mâle, see M. Camille, *The Gothic Idol: Ideology and Image-Making in Medieval Art* (Cambridge, 1989); from Panofsky, see M. Camille, "Mouths and Meanings: Towards an Anti-Iconography of Medieval Art," in *Iconography at the Crossroads*, ed. B. Cassidy (Princeton, 1993), 43–57. For a critique of Robertson's use of art, see V. A. Kolve, *Chaucer and the Imagery of Narrative: The First Five Canterbury Tales* (Stanford, 1984).

11. For an assessment of this notion about language and the departures from it in medieval tradition, see the first chapter of my volume *Discourse and Dominion in the Fourteenth Century: Oral Contexts of Writing in Philosophy, Politics, and Poetry* (Princeton, 1995), 3–36. For similar departures later in the Renaissance, I note Jonathan Goldberg's studies of sixteenth-century handbooks, which, in spite of their intentions, could not account for writing as a replication of speech; see *Writing Matter from the Hands of the English Renaissance* (Stanford, 1990).

12. Vienna, Österreichische Nationalbibliothek, Cod. 1826, f. 43r, Psalm 44 (Vulgate). Facsimile: M. R. James and E. G. Millar, *The Bohun Manuscripts: A Group of Five Manuscripts Executed in England about 1370 for Members of the Bohun Family* (Oxford, 1936), pl. 43e.

13. *Biblia Sacra iuxta Vulgatam Clementinam* (Madrid, 1965). Translations are from the Douay version, *The Holy Bible* (New York, 1943).

14. Jerome, *Breviarum in Psalmos* (PL 26, cols. 1013–14): "Sicut enim quae scribuntur non sunt levia neque facilia, sed utilia atque salubria: sic et Dei eloquium tanquam scribatur, ita perficitur. De velocitate vero, hoc est, quod non tardantur quae dixerit, sed velociter adimplentur, ideo calamus dicit. Et ad quid pertinet calamus? Aut quomodo comparatur calamus Christo? Quia sicut pertinet petra ad Christum, leo, dextra, mons, vel alia his similia: sic pertinet et calamus: scilicet quia mensurator et scriptor est . . . 'Calamus scribae.' Scriba ipse est Christus . . . 'Velociter scribentis.' Quia nullus tam cito scribit, sicut ipse Dominus in cordibus sanctorum scribit. Quid scribit, nisi fidem spem et charitatem suam, verbum praedicationis tribuit?"

15. For this familiar convention, see, e.g., the figure of Christ in the illumination of Psalm 80 from the St. Albans Psalter (Fig. 4).

16. Jerome (PL 26, col. 1013), commenting on *Dico ego* of the previous sentence in verse 2: "Loquor ipsi Verbo, regi, filio, et cuncta perficiuntur."

17. *Biblia Sacra cum Glossa Ordinaria et Postilla Nicholai Lyrami*, 8 vols. (Paris and London, 1590), vol. 3, 741: "*Eructauit:* ex plenitudine mea et secreta essentia genui verbum . . . et per eum loquor, et hoc est lingua mea, et hic est calamus mei scribe, ut scriba nil sine calamo, et calamus sine scriba, sic cooperantur pater et filius."

18. *Glossa* (as in note 17), vol. 3, 742: "*Calamus:* non sono qui transit comparat verbum, sed scripto quod manet. Vel, velociter, quia non aliud post aliud, sed omnia simul in vno verbo aeterno."

19. *Glossa* (as in note 17), vol. 3, 742: "Lingua . . . spiritus sancti, qui in docendo non indibet interuallo temporis."

20. Hugh of St. Cher, *Opera Omnia*, 8 vols. (Venice, 1732), vol. 2, 116R: "Et notandum, quod multa sunt, quae impediunt, ne fiat Scritura. Primum est defectus incausti. Sine incausto enim non fit littera: et si protrahatur, figura non apparet. Calamus igitur est lingua Praedicatoris; incaustum est gratia Spiritus sancti: sine qua nulla praedicatio apparet, nec fructum profert."

21. Hugh, *Opera* (as in note 20), vol. 2, 116R: "Tertium est, si calamus manu non tenetur, sed tantum ore [2 Thess. 3]. 'Salutatio mea manu Pauli, quod est signum in omni Epistola, ita scribo'. Multi salutant ore, qui praedicant salutatem Gentibus, sed non salutant manu sua, quia opera salutis non faciunt. Unde non habentes signum, quod habebat Apostolus in omni Epistola sua, pseudoapostoli judicandi sunt."

22. Hildesheim, St. Godehard's Church, treasury, St. Albans Psalter, f. 80v, Psalm 44 (Vulgate). Facsimile: O. Pächt, C. R. Dodwell, and F. Wormald, *The St. Albans Psalter* (London, 1960), 160, pl. 55b. For an outstanding appreciation of the orality implied in the reading and interpretation of this codex, though from an approach different from the one presented here, see M. Powell, "The Mirror and the Woman: Instruction for Religious Women and the Emergence of Vernacular Poetics, 1120–1250," (Ph.D. diss., Princeton University, 1997), chap. 1, 24–98, esp. 42: "Writing becomes speech and performance" in the pictures of the St. Albans Psalter. On the question of whether the manuscript was written for Christina of Markyate (presumed by Powell) and for other important qualifications about production and date since Pächt's edition, see K. E. Haney, "The St. Albans Psalter: A Reconsideration," *Journal of the Warburg and Courtauld Institutes* 58 (1995), 1–28.

23. Quintilian, *Instituto oratoria*, ed. M. Winterbottom, vol. 2 (Oxford, 1970), bk. 11, ch. 3.87: "non in demonstrandis locis atque personis aduerbiorum atque pronomium optinet uicem? —ut in tanta per omnis gentes nationesque linguae diuersitate hic mihi omnium hominum communis sermo uideatur."

24. *Institutio* (as in note 23), bk. 11, ch. 3.94: "Is in exprobrando et indicando unde ei nomen est ualet."

25. Despite the popularity of the image, it has drawn very little commentary. Emile Beneveniste has remarked in passing that the pointing finger in early art is "the present instance of discourse"—cited in L. Marin, "The Gesture of Looking in Classical History Painting," *History and Anthropology* 1 (1984), 178–81; and Camille remarks briefly on the image in "Seeing and Reading" (as in note 6), 28.

26. See the facsimile of the early fourteenth-century French manuscript, *The Cloisters Apocalypse* (New York, 1971), vol. 1, 32 (f. 1r).

27. Hugh, *Opera* (as in note 20), vol. 2, 115V–116R: "Lingua mea est calamus scribae, id est, Spiritus sanctus, quasi dicat, quod loquor, a memetipso non loquor, sed a Spiritu sancto."

28. "Annuntiationem sancti spiritus eructavit beatus David psalmista quem Deus elegit"; *St. Albans Psalter* (as in note 22), Psalm 1, p. 72, and transcription with commentary, p. 206.

29. Hildesheim, St. Godehard's Church, treasury, St. Albans Psalter, f. 118r, Psalm 80 (Vulgate), in *St. Albans Psalter* (as in note 22), 235, pl. 65c.

30. C. T. Lewis and C. Short, *A Latin Dictionary* (Oxford, 1966), s.v. *impleo*, I.B.1 and 2; *Oxford Latin Dictionary* (Oxford, 1968–82), s.v. *impleo*, 3 (food); 4 (pregnant), citing Ovid, *Metamorphoses* 9.280: "and he filled her womb with generous semen" ("impleveratque uterum generoso semine").

31. The folio is reproduced in facsimile in *St. Albans Psalter* (as in note 22), pl. 37, and discussed by Pächt on pp. 137–38; the scribe copies the gist of Gregory's letter, first in Latin and then in Norman French (Latin cited in note 2 above). Pächt speculates that the letter is cited by the scribe as a "ratio de picturis" in order to justify that a series of full-page miniatures included in the text without any accompanying explanation is nonetheless accessible to those who cannot read.

32. Hildesheim, St. Godehard's Church, treasury, St. Albans Psalter, f. 83v, Psalm 48 (Vulgate), *St. Albans Psalter* (as in note 22), 166, pl. 56b.

33. London, British Library, Add. Ms. 42130, the Luttrell Psalter, f. 97v, Psalm 51 (Vulgate). Facsimile: *The Luttrell Psalter*, ed. E. G. Millar (London, 1932). See the exhaustive recent study of the manuscript by Michael Camille, *Mirror in Parchment: The Luttrell Psalter and the Making of Medieval England* (Chicago, 1998); on the mouth as the "major organ" of the body illustrated in the manuscript, see 335–44.

34. Ps. 51:6–7: "Dilexisti omnia verba praecipitationis, lingua dolosa. Propterea Deus destruet te in finem; Evellet te, et emigrabit te de tabernaculo tuo, Et radicem tuam de terra viventium."

35. For a related consideration of word and image in this psalter, compare L. F. Sandler, "The Word in the Text and the Image in the Margin" *Journal of the Walters Art Gallery* 54 (1996), 97: "If the words give rise to the images, the images disclose the depths of meaning in the text." Camille expands upon Sandler's conclusion in *Mirror in Parchment* (as in note 33), 45, 162–63, 167, 173–74.

36. Cynthia Hahn has noted a similar comparison between torturing the instruments of speech and Augustine's thoughts on the circumcision of the lips in a visual illustration of the passion of Romanus of Antioch; see "Speaking without Tongues: The Martyr Romanus and Augustine's Theory of Language in Illustrations of Bern Burgerbibliothek Codex 264," in *Images of Sainthood in Medieval Europe*, ed. R. Blumenfeld-Kosinski and T. Szell (Ithaca, 1991), 178–79 and fig. 8.10.

37. "Quando autem sufficio lingua calami enuntiare omnia hortamenta tua. . . . Circumcide ab omni temeritate omnique mendacio interiora et exteriora, labia mea. Sint castae delicae meae scripturae tuae"; *Confessionvm Libri XIII*, ed. M. Skutella, rev. L. Verheijen (Turnholt, 1981), XI.2.2–3, 194–95.

38. I am grateful to Jeffrey Hamburger for suggesting to me the connection between David's gesture in illuminations of Psalm 38 and the call of Isaiah.

39. See *Luttrell Psalter*, ed. Millar (as in note 33), Psalm 38 (Vulgate), f. 75v. For the occurrence of the figure in the St. Albans Psalter, see *St. Albans Psalter* (as in note 22), Psalm 38 (Vulgate), 147, pl. 53d. Camille observes of the Luttrell Psalter in general that "performed speech, or prayer spoken out loud, forms the major mode of devotional expression in the psalter," *Mirror in Parchment* (as in note 33), 144; both word and image always refer back "to the spontaneous springs of speech" (p. 174).

40. Millar notes in his commentary on this image (*Luttrell Psalter* [as in note 33], 35) that the artist in all likelihood misunderstood his instructions and put the pearlnimbed woman, who is the Virgin, outside of the bath, whereas she should instead be bathing in preparation for the scene on the following folio (98r), which is a picture of her death. I would say, however, that it is indeed the Virgin inside the bath and that the woman outside is her mother, St. Anne, who attends to her daughter with draped hands, as is befitting a sacred (and nimbed) person. Thus, as a prefiguration of death in the next folio, the allegory of baptism in this image is all the more obvious, since death is the fulfillment of baptism (Rom. 6:3–4). For a different view, see Camille, *Mirror in Parchment* (as in note 33), 141–42.

41. 2 Cor. 11:3: "Timeo autem ne sicut serpens Evam seduxit astutia sua, ita corrumpantur sensus vestri, et excidant." For the suggestion of castration in the visual art of cutting out the tongue, see W. J. T. Mitchell, *Iconology: Image, Text, Ideology*

(Chicago, 1986), 103. On the castration of idols in medieval art as a means of silencing their magical powers (including speech), see Camille, *Gothic Idol* (as in note 10), 69–70.

42. Isaiah 57:3–4: "semen adulteri et fornicariae. . . . Super quem dilatastis os, et eiecistis linguam? Numquid non vos filii scelesti, semen mendax."

43. Hildesheim, St. Godehard's Church, treasury, St. Albans Psalter, f. 9r; facsimile in *St. Albans Psalter* (as in note 22), 17.

44. Lewis and Short, *Latin Dictionary* (as in note 30), s.v. *bilinguis*, I and II; *Oxford Latin Dictionary* (as in note 30), s.v. *bilinguis*, 1, 2, and 3.

45. Eric Jager has pointed out the terms of rhetorical persuasion in Augustine's description of Satan's speech to Eve, e.g., *anfractus* (i.e., "circumlocution"), in *De civitate Dei*, 14.11; see *The Tempter's Voice: Language and the Fall in Medieval Literature* (Ithaca, 1993), 105–15. I am grateful to the author for suggesting the circular path of the fruit in the St. Albans picture of the Fall (Fig. 8).

46. London, British Library, Add. Ms. 42130, f. 43v, Psalm 21 (Vulgate).

47. St. Albans Psalter, Psalm 147 (Vulgate). See *St. Albans Psalter* (as in note 22), 368, pl. 90d.

48. For reproductions of the restoration project, see the magnificent volume by Giuseppe Basile, *Giotto: The Arena Chapel Frescoes* (London, 1993); on the date, 9ff.; on the Virtues and Vices, 319; Invidia is reproduced on pp. 325 and 345. Still very useful for the study of the Arena Chapel Virtues and Vices is S. Pfeiffenberger, "The Iconology of Giotto's Virtues and Vices at Padua" (Ph.D. diss, Bryn Mawr College, 1966).

49. See Pfeiffenberger, "Iconology of Giotto's Virtues and Vices" (as in note 48), IV.1.7–16 and V.45–53. A comparable figure of Envy as a woman standing in flames is also associated with text in an anonymous fifteenth-century Italian engraving; see A. M. Hind, *Early Italian Engraving: A Critical Catalogue with Complete Reproduction of All the Prints Described*, pt. 1, *Florentine Engravings and Anonymous Prints of Other Schools* (London, 1938), vol. 4, pl. 396, no. E.III.3. I am grateful to Mark Zucker for this reference.

50. Lewis and Short, *Latin Dictionary* (as in note 30), s.v. *invideo*, I.A. Cf. *Oxford Latin Dictionary* (as in note 30), s.v. *inuideo*, 1.

51. *I documenti d'amore di Francesco da Barberino*, ed. F. Egidi, Societá filologica Romana, vol. 2 (Rome, 1912), 165.

52. Compare Jonathan Alexander's conclusion about twelfth- and thirteenth-century illumination in *Medieval Illuminators and Their Methods of Work* (New Haven, 1992): "there are opportunities for illuminators to evade or even challenge the authority of the preexisting cycle and the constraints of the text" (p. 118); and about fifteenth-century illumination: the artist "liberated the pictures from the book" (p. 149). More recently he has observed "that medieval illuminators invented rather than copied"—"Art History, Literary History" (as in note 4), 54. Hamburger suggests a similar conclusion for devotional imagery in the early fourteenth century, that "it deliberately breaks down the barrier between . . . example and experience," *Rothschild Canticles* (as in note 8), 167. Caviness argues a related claim about stained glass: "Once independent of a text, the window stands by itself and is open to variant readings and interpretations that need not be 'corrected' in reference to a text"; see "Biblical Stories in Windows" (as in note 2), 146. In a different context, Leo Steinberg has urged a comparable qualification for understanding Renaissance images of the sexuality of Christ: "Treated as illustrations of what is already scripted, they withhold their secrets": *The Sexuality of Christ in Renaissance Art and in Modern Oblivion*, 2nd rev. ed. (Chicago, 1996), 106.

53. In this respect, artists have a good deal in common with medieval Latin poets, as Jan Ziolkowski would understand them. Pointing out that medievalists commonly

assume (with E. R. Curtius) a "one-way" relationship from the Latin Middle Ages to the oral culture of vernacular composition, Ziolkowski urges a salutary reversal—"to document the effect of vernacular languages and oral literatures upon . . . the style [and] content of medieval Latin writings," for "the Latin Middle Ages were neither Latin to the exclusion of the vernaculars, nor literate to the exclusion of the oral"; see "Cultural Diglossia and the Nature of Medieval Latin Literature," in *The Ballad and Oral Literature*, ed. J. Harris, Harvard English Studies 17 (Cambridge, Mass., 1991), 193–213 (quotations from 206–7 and 213).

The Virtuous Pelican in Medieval Irish Art

COLUM HOURIHANE

✦

LATE MEDIEVAL IRISH ART, and in particular the iconography that was used after the arrival of the Anglo-Normans in 1169, has been sadly neglected by scholars. Some studies, such as those by Helen Roe,[1] have attempted to redress this situation and dispel the notion that the creative spirit in Irish art ended at the time of the conquest. While Gothic art in Ireland, by virtue of its close ties with England, is certainly less indigenous than the art of the early Christian period, it nevertheless still shows forms and styles that were not slavishly adopted but were also adapted.

Examination of the iconography of this art can show not only how the spirit of pre-conquest Irish art was kept alive, but also that it is an art which is frequently misunderstood. A prime example of this is the misunderstanding of representations of animals, which abound in all the decorative arts of this period but which have been dismissed as merely interesting details. This paper will investigate the use and meaning of one of these animal motifs, the pelican, which is found in early medieval Irish art in a variety of media ranging from metalwork to wall painting to sculpture. Examination of this motif against its European background demonstrates once again that close ties existed between Ireland and the rest of western Europe in this period, and also shows how the Irish art of this time maintains the creative force of preceding periods.

Despite the fact that the pelican is one of the most popular motifs in the history of art, and one whose symbolism is widely known, no single study in English has fully dealt with its origins and meaning. While this will not be undertaken here, it is nevertheless useful to review briefly the early textual references to this motif before discussing the Irish representations.

Origins

Unlike the owl or the ram, whose antiquity and origins as symbols can be traced to the classical period, no such ancient links can be found for the pelican. The classical and orthodox sources do not attach any particular symbolism to this bird. Classical writers earlier than the *Physiologus*, other than the commentators on the Bible, appear to have contributed little to the legend of

the pelican. Pliny (ca. A.D. 79), for example, gives only a brief description of the bird and its feeding habits, saying that it lives in northern Gaul and resembles a swan, but has two stomachs like a ruminant.[2] In the third century, Aelian (ca. A.D. 220) similarly gives an account that focuses on the natural history of the pelican, particularly its diet.[3]

The description by Horapollo (ca. A.D. 500), on the other hand, attaches some symbolic importance to the pelican but adds little to our understanding of the medieval occurrences of the symbol. In fact, as George Boas points out, this is one of the few emblems in Horapollo which contradicts the descriptions of the *Physiologus*.[4] Horapollo's account of the bird, which essentially agrees with that of Artemidorus (late second century A.D.), gives foolishness as its main characteristic:

> A FOOL: When they draw a pelican they indicate foolishness or imprudence. Though, like other birds, it can lay its eggs in the highest places, it does not. But rather it hollows out a place in the ground, and there places its young. When men observe this, they surround the spot with dry cow-dung to which they set fire. When the pelican sees the smoke, it wishes to put the fire out with its wings, but on the contrary only fans the flames with its motion. When its wings are burned, it is very easily caught by the hunters. For this reason priests are not supposed to eat of it, since it died solely to save its children. But the other Egyptians eat it, saying that the pelican does not do this because of intelligence, as the vulpanser, but from heedlessness.[5]

The essential medieval characteristic of the pelican, however, is the feeding of its own blood to its young, which differs considerably from the characterization of Horapollo. Wellman argues that this discrepancy may have arisen through a misapplication of the vulture's traits to the pelican.[6] Horapollo's description of the vulture is as follows: "When it is at a loss to find food to prepare for its young, it cuts open its own thighs and allows its young to drink its blood, so that it may not lack food to give them."[7] Wellman further believes that the name "crooked beak," which Hermes Koiraniden (3:39) gives to the pelican, was also used to refer to the vulture, suggesting how this confusion may have occurred. It has been argued that it was in fact the theme of resurrection through self-sacrifice that prompted Christian writers, eager to use the nature and behavior of animals for didactic purposes, to see in the pelican a parallel to the sacrifice and Passion of Christ, and to readily accept this account of the bird.[8] This characteristic of the pelican, according to Percy Robin,[9] was elaborated during the first three Christian centuries by commentators on the Septuagint.

The Septuagint makes reference to the pelican (Ps. 102:6) but does not offer any solid foundation for viewing it as a symbol of self-sacrifice. The origin of this symbolism must therefore have occurred between the date of the Septuagint, the third century B.C., and its earliest definite usage in the original Greek version of the *Physiologus*, which may have been written as early as A.D. 200[10] but was probably not in wide circulation until the end of the fourth century A.D.

It is clear that the origins of the pelican motif are as complex and numerous as was its symbolism in the Middle Ages. The *Physiologus* provides the

first definite and clearest description of the medieval symbolism of the bird: "David says in Psalm 101, 'I am like the pelican in the wilderness.' "[11] The *Physiologus* also says of the pelican that it is an exceeding lover of its young:

> If it brings forth young and the little ones grow, they take to striking their parents in the face. The parents, however, hitting back, kill their young ones and then, moved by compassion, they weep over them for three days, lamenting over those whom they killed. On the third day, their mother strikes her side and spills her own blood over their dead bodies (that is, of the chicks) and the blood itself awakens them from death. Thus did our Lord speaking through Isaiah say "I have brought forth sons and have lifted them up, but they have scorned me" [Is. 1:2]. The maker of every creature brought us forth and we struck him. How did we strike him? Because we served the creature rather than the creator. The Lord ascended the height of the cross and the impious one struck his side and opened it, and blood and water came forth for eternal life, blood because it was said "Taking the chalice he gave thanks" [Matt. 26:26, Lk. 22:17] and water because of the baptism of repentance [Mk. 1:4, Lk. 3:3]. The Lord says "They have forsaken me, the fountain of living water and so on" [Jer. 2:13].[12]

This essentially favorable account in the *Physiologus* is the most widely accepted version of the legend of the pelican and is referred to in another *Physiologus* quoted by Vincent of Beauvais.[13] Slightly earlier Greek versions of the *Physiologus*, however, report that the young birds are killed not by their mother, but by a snake which blows venom towards them on the wind. Similarly, in the *Physiologus* ascribed to Epiphanius[14] there is no reference to the young hitting their mother and vice versa—it is simply through excessive caressing of her young that she smothers them.

Different versions of the *Physiologus*, as well as the later bestiaries, record that it is the male bird and not the female which sheds its blood. This last detail emphasized the allegory of Christ's suffering by equating the sex of the bird with that of Christ. The accounts of the pelican in the bestiaries proper contain variations similar to those found in the *Physiologus*. Many of these accounts may have been drawn from earlier writers of natural history and then expanded.

Medieval theologians invested the symbol with a variety of meanings. The moral commentary in the *Physiologus* draws a parallel between the wound of Christ and that of the pelican. This characteristic does not change throughout the life of the legend: God is always directly equated with the pelican, "God who is the true pelican."[15]

The popularity of the pelican as a symbol with the fathers of the Church may have been due to the many aspects of Christ's life which it incorporated, and which were extended with the passage of time. The pelican was used not only as a symbol of resurrection, but also as a short-hand method of depicting the entire Passion and sacrifice of Christ. Schiller has pointed out the late medieval usage of the pelican as a symbol referring specifically to the holy blood, and as a symbol of Longinus, the soldier who thrust his lance into the crucified Christ.[16] The pelican also appears as a symbol of charity from the sixteenth century onwards.[17]

As a general rule the pelican is shown piercing its breast, with its blood nourishing the young beneath. The minor variations that occur may be the result of the differing details which were originally recorded in the *Physiologus*, and which found their way into the later English and French bestiaries. One such depiction of a pelican, in a Latin prose bestiary of the twelfth century (Cambridge, University Library, Ms. 11.4.26), attempts to illustrate the entire legend, showing the young pecking at their mother, the mother in turn biting her young, and finally the rebirth of the young birds. The resurrection in this instance is not brought about by the opening of the pelican's breast, but by what appears to be a regurgitation from the mouth of the mother into that of the young. This depiction shows a certain influence from Pliny's original description of the bird.

The pelican also appears as a motif in manuscripts ranging from psalters to books of hours, and Lilian Randall alone has catalogued some twenty-eight examples as marginalia dating from the late thirteenth to the mid-fourteenth century.[18] Some of these illustrations are similar to the late Irish examples in that they do not depict the nest or the young but identify the bird only by its action of pecking its breast. The pelican was also a most popular bestiary subject with the medieval wood-carver in England, as Anderson has shown.[19] The pelican motif was a common subject for roof bosses in the late medieval period,[20] and it figures prominently as a subject for architectural sculpture (see nos. 4–15 below).

Ireland

Whatever the origins of this symbol, its popularity in Irish medieval art is unquestionable. Motifs such as the pelican, fox, rabbit, etc., are first found in Irish art of the Gothic period. No such animals have been identified in the extensive repertoire of animal motifs from the early Christian period. Even in the Gothic period in Ireland, on the basis of the surviving evidence, animals appear to have been used sparingly in comparison with the rest of Europe, but among the identifiable motifs there is no doubt about the popularity of the pelican. Although Gerhardt recognised only two Irish examples of this motif in his survey of its usage in Europe,[21] there are in fact at least seventeen examples to be found in Ireland, sixteen of which date to the medieval period. The pelican motif is not only popular, but in almost every instance retains the full force of its symbolic meaning. While other animal motifs in Irish art, such as the dragon and the fox, may have been used in specific locations or periods in ways that are entirely decorative and without any symbolic purpose, this cannot be said to apply to the pelican. Only one late example, on the seventeenth-century Sexton tomb in St. Mary's Cathedral, Limerick (no. 17 below), differs in meaning from the other examples.

The following catalogue of medieval Irish depictions of the pelican is arranged by medium: metalwork (nos. 1–3), architectural sculpture (nos. 4–15), and fresco (no. 16). Within each medium the representations are grouped on the basis of monastic affiliation.

1. The Limerick Crozier (Figs. 1, 2)
Bishop of Limerick; on exhibition in the Hunt Museum, Limerick

The earliest dated medieval Irish representation of the pelican is that found on the Limerick Crozier, which has an inscription on the lowest moulding of the head section recording the year of manufacture as 1418.[22] The animated depiction is found on the end of the volute directly below the platform (Fig. 2), "which is also supported by a pelican in her piety, with wings displayed 'vulning herself.' The young pelicans which she is feeding with her blood thrust their heads upwards from a nest made of the cast vine leaves."[23] The pelican's beak is shown piercing its breast, while the eager heads and open

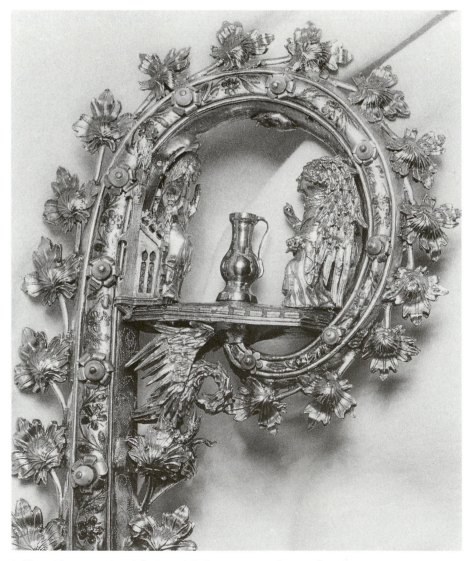

1. Hunt Museum, Limerick. Limerick Crozier, general view of crook

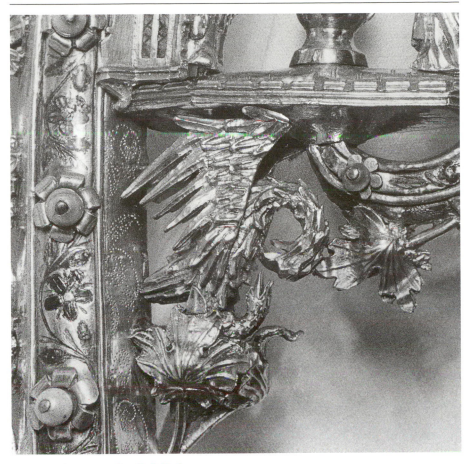

2. Limerick Crozier, detail of platform

mouths of the three young chicks extend from the nest to the wound. The curve of the pelican's neck exaggerates its grief. Unlike the other figures on the crozier, which were cast from one mould with additional and distinguishing features added prior to gilding, the pelican appears to have been entirely cast as one piece.

This representation is one of the most accomplished in Irish metalwork and also one of the most graphic, adhering rigidly to the original bestiary description. The rough yet expertly cast pelican's wings tower above its body as if in flight and contrast with the smooth vine leaves of the nest. The Annunciation is shown in the crook of the crozier (Fig. 1), with the seated and surprised Virgin facing the standing angel. This scene is connected to that of the pelican by the curved crook of the crozier, which surrounds the Annunciation and ends at the pelican's head, thereby linking the birth and resurrection of the Saviour. The two contrasting styles in these scenes, with the tranquility of the Virgin in marked opposition to the power and movement of the bird's and angel's wings, emphasizes the association of a symbol of Christ's suffering and resurrection with a scene from his birth and early life.

This unique surviving example of a Gothic Irish crozier was made, according to its inscription, by an Irish craftsman, Thomas O'Carryd, for an Irish patron, Conor O'Dea, bishop of Limerick. The iconography of the crozier, however, combines Insular and European motifs, and is one of the earliest examples of such a combination from the late medieval period in Ireland. The juxtaposition of the two Sts. Bridgid, one from Sweden, the other from Ireland, may have been an intentional play on their names, but the appearance of local figures such as Munchin and Patrick side by side with Sts. Margaret of Antioch and Catherine of Alexandria indicates the creative powers displayed in this work. The same combination of Irish and European elements is found in the association of the Annunciation (which is found elsewhere) and the pelican (which is not recorded elsewhere) in the crook of the crozier. The Annunciation occurs in this position on several Continental croziers dating to the late thirteenth and early fourteenth centuries, such as those in the Musée du Louvre, Paris,[24] and the Cathedral in Sulmona,[25] where the two figures are shown standing and facing each other. Compositionally, however, these are far removed from the Limerick depiction. Far more frequent in such a position, and much closer to the Limerick Crozier scene, is the adoration of the Virgin Mary and Christ child, usually by the donor, such as on the croziers in Cologne[26] and Haarlem.[27] In nearly all of these examples the Virgin is seated on a throne similar to that found on the Limerick example and holds the Christ child on her knees. The full-length figure of a donor either stands or kneels facing her, a composition that is also closer to the example from Limerick, where the angel would originally have represented Conor O'Dea. The dove and vase are not found in scenes of the Annunciation but appear in representations of the Adoration. It is possible that Conor O'Dea drew on the frequently found Adoration scenes in creating this unusual depiction of the Annunciation but adapted it to his particular needs. Overall, the Limerick Crozier is closer in style and iconography to examples from mainland Europe than to the better-known crozier of William Wyckham now in New College, Oxford.[28]

There are no known parallels for the pelican in this position on a crozier, and the Limerick example may represent a local or Insular adoption of the more common figure of an angel with his broadly sweeping wings, which is similar in composition. There can be little doubt, however, that the bird was chosen not for its form but for its symbolic meaning. Great care seems to have been lavished on this scene, and the standardization found elsewhere on the crozier is not in evidence here. The expression of surprise on the Virgin's face, details of the throne, the vase with its now missing lily, and the Holy Ghost (also now missing) would have added to the power and force of the composition.

2. The Ballylongford Cross (Figs. 3, 4)
National Museum of Ireland (N.M.I. 1889:4)

This cross was found in 1871 in a field in the townland of Ballymacasey, near Ballylongford, approximately two miles from the Franciscan friary of Lis-

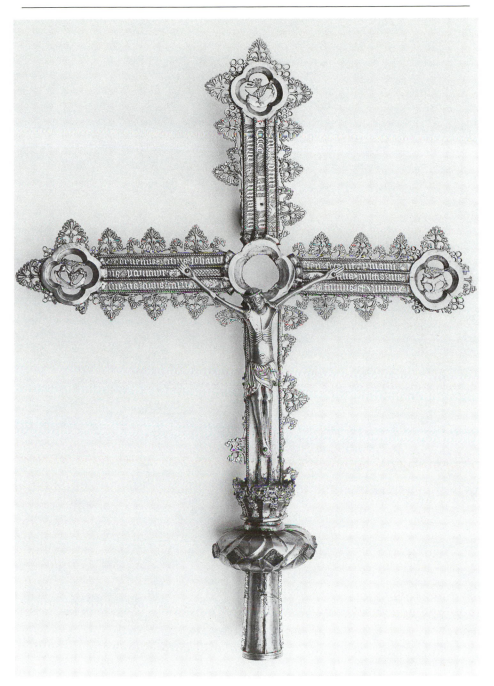

3. National Museum of Ireland, Ballylongford Cross, general view

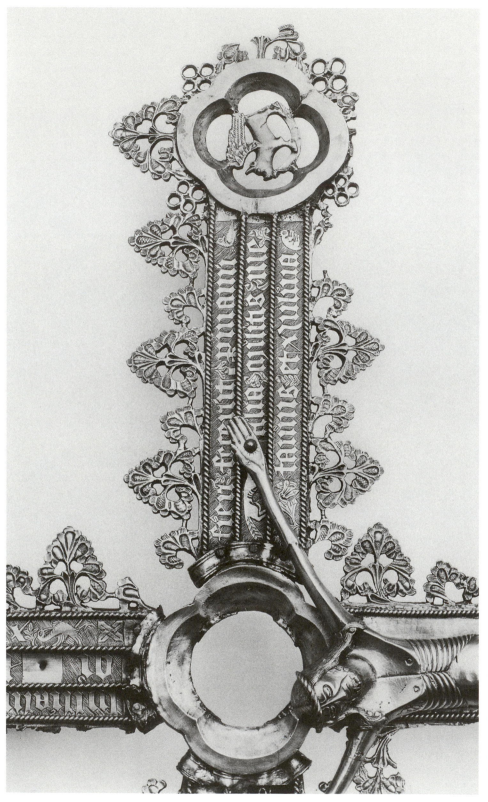

4. Ballylongford Cross, detail of cross showing a pelican in the right-hand register of the vertical shaft above Christ's head

laughtin, County Kerry. According to an inscription on its arms, it was made in 1479 by an Irish craftsman, William O Connor, for an Irish patron, Cornelius son of John O'Connor, head of his sept, and Eibhlin, daughter of the knight. It comes in all probability from the friary at Lislaughtin, near where it was found. The cross was found in a damaged condition and has been reassembled, but it appears that the arms are in their original positions. The arms are divided into registers, as are the majority of processional crosses of this period.[29] These registers usually have lightly incised angular motifs, and the Ballylongford Cross is the only known example to have either an inscription or animal representations. The inscription in Gothic lettering, which is interspersed with four animals, simple interlace patterns, knots, and foliage motifs, reads: ACORNELIUS FILIUS JOHANNIS Y CONCHYR SUE NACONIS CAPITANUS ET AVILINA (rabbit) (fox) FILIA MILITIS ME FIERI FECERUT PER MANU (bird) UILLIAMI CORNELI M. XXI CCCCC (pelican) ANNO DI on the left and right transoms and the upper shaft of the cross.[30]

The only animal symbol on the vertical shaft is the pelican; the other three are located on the right-hand transom (Fig. 4). These animals may be interpreted as independent symbols, but it is more likely that their significance is based on opposing groups of twos. The pelican (virtue) is opposed to the woodpecker-like bird (vice), while the fox (vice) is opposed to the rabbit/hare (virtue). The association of the pelican with these three other animals is closely paralleled in an early sixteenth-century manuscript from Germany (Darmstadt, Hessische Landes- und Hochschulbibliothek, Ms. 1944, Cologne, about 1525, f. 188v), where a rabbit and bird are found together with a pelican. The representation of the pelican on the Ballylongford Cross is naturalistic, unlike the figure of Christ which shows elements of stylization in its depiction of suffering. No nest is shown, and the young birds are not depicted. Instead, the pelican is in a nearly vertical position, as if in flight, with its long beak about to pierce its breast. Directly over the bird's head is a foliage motif which does not bear any relevance to the symbol.

This processional cross, which is considered to be one of the masterpieces of metalworking of the late medieval period, is the only example that can be assigned to an Irish artist and patron with total certainty. Whereas a number of other processional crosses also fall within the mainstream of English style of this period, the Ballylongford Cross is unique in its iconography. Ó Floinn has noted that "small animals such as the fox or the pelican" on metalwork are "typical of Irish art of this period, and similar incidental animals are a feature of Irish friary architecture of the fifteenth and sixteenth centuries."[31] The pelican on the Ballylongford Cross is not a unique occurrence. In fact, pelicans are frequently found on European metalwork crosses of this period, usually processional or altar crosses,[32] and they are always in a similar location, directly above the head of the crucified Christ. On an object such as a cross, the pelican is used to reinforce the general eucharistic nature of the symbolism, and in this position, rising above the head of the dead Christ, immediately brings to mind the Resurrection. The blood of Christ shown on the Ballylongford Cross is thus paralleled symbolically by the pelican. The drama and tension seen in the figure of Christ in this cross are subtly paralleled by the

two opposing pairs of animal symbols, but not by the individual representations, which are merely static depictions. The victory of the pelican is subtly underlined by the presence of vice as represented by the woodpecker and fox. It would have been possible for the artist to have used the pelican simply as an isolated symbol, but by subtly linking it to a symbol of vice he has created a dramatic tension which is also manifest in Christ's body. The association of this cross with the Franciscans in Lislaughtin Friary would have been particularly apposite considering the devotion that order had for Christ's Passion.[33]

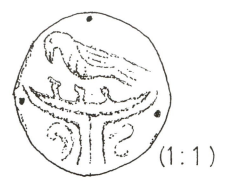

5. National Museum of Ireland, seal matrix (no registration number)

3. Seal Matrix (Fig. 5)
National Museum of Ireland (no inventory number)

The legend on a small seal matrix in the National Museum of Ireland reads + SIC PELICAN * FITM[.] I S'S ANG [. . . .]. The roughly circular seal is pierced by three holes and shows the bird in profile over its three young in the nest. As in the examples from Kilcooly Abbey and Thomastown (nos. 6–8 and 15 below), the nest appears to be a chalice-like cup, the stem of which does not have a base. Slight traces of a scroll pattern are found on either side of the stem. The original provenance or association of this seal is unknown, but it is likely to have been used by a member of the religious community.

4. Shrine Relief (Fig. 6)
Holycross Abbey, County Tipperary

The rebuilding of this abbey may have begun as early as 1430, when protection was granted to the abbot and convent for clergy begging alms "for the works of the aforesaid monastery."[34] Reconstruction was certainly underway by 1431, and the earliest reference to Holycross as a place of pilgrimage was in 1488.[35] Roger Stalley has discussed the unusual presence of two shrines in this abbey.[36] One of these is in the south transept and forms part of the actual

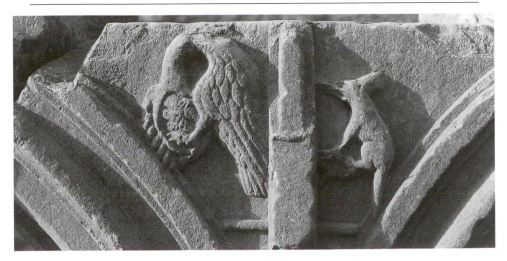

6. Holycross Abbey, County Tipperary. Fragment of shrine

structure, while the second has been damaged, and its parts are presently located in a storeroom at the site. Stalley records the temporary reassembly of this second shrine in the early 1970s and notes that its vaulted canopy was three bays long and one bay wide.[37] He also mentions the possibility that it was a tomb rather than a shrine. It is decorated in a manner similar to that of the intact shrine; of the three complete arches that remain, two have carvings in their spandrels. Even though both works come from the same shrine, they are not similar in style and are the work of two different hands.

The first of these two examples, which is carved in low relief, shows the pelican facing towards the left in the spandrel of an arch fragment. The bird is shown with its curved neck forming a nearly perfect circle, and with its beak piercing its breast. Under the breast is a nest in which unshapely chicks are shown. There is no attempt at depicting the bird in flight. This carving betrays the hand of an experienced and skilled craftsman who was capable of judging his proportions and was not content with merely simple execution but employed distinctive details such as the rough finish on the nest and the angle of the parent bird's head. It is interesting to note that this pelican, the more accomplished of the two examples, is balanced against a fox in the adjacent spandrel, apparently providing another Irish example of the pairing of animal symbols of virtue and vice.

Although the pelican as a symbol of resurrection is found in a post-medieval context in Irish funerary carvings (see no. 17 below), it is not used with this meaning on any funerary monuments prior to the sixteenth century. Stalley has also noted that it is a more appropriate motif for a shrine than for a tomb.[38] The presence of two examples of this symbol on a single shrine, however, is unusual and may have been necessitated by the fact that pilgrims were able to view the monument only from one side or the other, thereby creating the need to replicate the decoration on both sides.

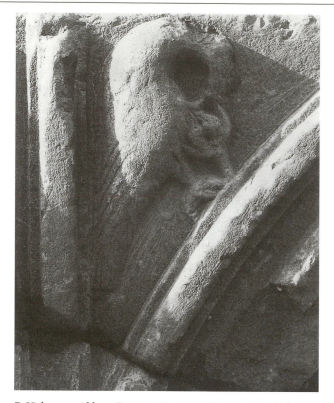

7. Holycross Abbey, County Tipperary. Fragment of shrine

5. Shrine Relief (Fig. 7)
Holycross Abbey, Co. Tipperary

A full account of the shrine and the dating of this panel is given above (no. 4). This panel, which is the less accomplished of the two examples from this shrine, shows the bird facing towards the right. The pelican is placed in the spandrel of the arch fragment and is carved in low relief. Although it is similar to the other example, it does not have the same level of detail. The tail feathers of the bird are all that remains of whatever detail was originally on the carving. The bird's neck curves over its young, which are facing its breast. In this example the nest is not separated from the bird's breast but appears to be part of the bird itself. This panel exhibits a certain lack of judgment of proportion and balance: the bird is awkwardly placed in the spandrel and even the finer details lack balance.

6–8. Portal Reliefs (Fig. 8)
Kilcooly Abbey, County Tipperary

Three examples of the pelican symbol are found in the nearby Cistercian abbey of Kilcooly, County Tipperary. Although research undertaken by the

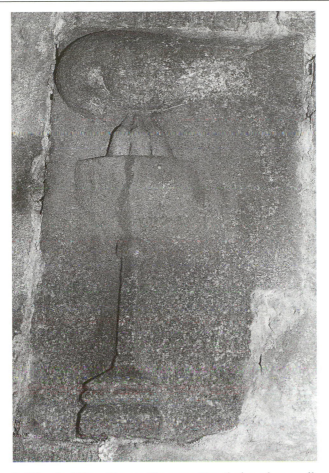

8. Kilcooly Abbey, County Tipperary. Detail of southern wall of sacristy

writer has shown that a considerable number of the workforce employed in the rebuilding of Holycross Abbey were subsequently employed in the rebuilding of Kilcooly Abbey,[39] it is unfortunately impossible to detect any similarities between the pelican carvings at these two sites. The carvings at Kilcooly Abbey are slightly later than those at Holycross Abbey, and date to ca. 1464 when the rebuilding took place, according to Leask,[40] or ca. 1450–1520, according to Stalley.[41] On the present evidence, the dating would seem to be later rather than earlier, ca. 1464 or shortly thereafter.

There are no large-scale sculptural programmes in late medieval Ireland that are comparable to English or Continental examples. The emphasis in Irish sculpture appears to have been on the static or single image, and only very rarely are more than two carvings related in a larger scheme. Rae has discussed the unique surviving example of the clausteral carvings at Jerpoint Abbey, County Kilkenny.[42] This is the largest group of related late medieval

Irish architectural sculpture to have survived relatively intact, and would appear to have been the exception rather than the rule. At other sites where more than one carving is found they tend to be located to the side of or above doorways, as at Clontuskert (see no. 11 below) or Clonmacnoise.

The programme at Kilcooly is similar in context and design to these two sites. Seven carvings are found around the doorway between the south transept and the sacristy. Stalley has described the random sequence of the carvings as a mermaid, abbot, angel, pelican, St. Christopher, Crucifixion with the Virgin and St. John, and two shields with the Ormond arms.[43] Apart from the Crucifixion, which is centrally placed over the opening of the doorway, the carvings are placed asymmetrically around the opening. The mermaid, as a symbol of vice, is placed near the ground to the right of the doorway, directly beneath the fully vested cleric who is framed by an arch and surmounted by a censing angel. Above the arch to the right of the crowning pinnacle is a pelican feeding her young. St. Christopher appears to the right of the Crucifixion scene, while to the left are two shields, the larger of which is supported by two pelicans. An additional carving of a small male head is found on the right-hand moulding of the aumbry. All of the work is inexpertly cut, apart from the mermaid, which shows a competent technique. The other carvings are awkward and disproportionate, and have the quality of folk art.

The single pelican is shown piercing its breast over the three long-necked chicks whose nest is, interestingly, a chalice. This overt equation of the blood of the pelican with the blood of Christ is found on one other fifteenth-century carving in Ireland (the Thomastown font, no. 5 below), and given the location of the carving on the sacristy wall, this is a perfectly apt linkage of symbol and location. This example, like the two other pelican carvings at Kilcooly, is in low relief, and all three may be the work of the same sculptor. The two other pelicans are heraldic in composition and support the larger of the two Butler shields, which is charged with a chief indented within a border of eight roses. The two pelicans are shown in profile, facing in opposite directions, and with their necks curved in the act of piercing their breasts. Healey describes them as "two pelicans adorsed and tails united with beaks in breast, emblematic of their unbroken union and in themselves of the undivided eternity which awaits those who are nurtured on the most precious blood. . . ."[44] No nests are shown, and it is only the characteristic position of the neck on the breast that identifies the birds.

The carvings on this wall appear to be either commemorative or symbolic. Included in the first category is the carving of the cleric, whom Stalley has tentatively identified as Philip O'Molwanayn, the fifteenth-century rebuilder of the monastery.[45] The Ormond shields commemorate the patrons in whose territories the abbey is located. The portrait-like quality of the small head on the aumbry is similar to a number of other heads, such as one in the nave at nearby Hore Abbey. It differs in both location and style from the many larger heads which are found in a variety of other contexts, such as label stops, corbels, and string courses, which were purely decorative. Among the symbolic reliefs, virtuous symbols such as the pelicans, the Crucifixion, and St. Christopher predominate over the isolated representation of vice, the mermaid.

9. Chancel Relief (Fig. 9)

Priory of the Holy Cross, Strade, County Mayo

A relief carving of a pelican is found on the north pier of the chancel arch at the Dominican Priory of the Holy Cross. Like a number of other examples in this catalogue, it dates to the mid-fifteenth century. Documentary sources relate that an indulgence for the restoration of the priory at Strade was granted in 1434,[46] and it is likely that work would have started soon after this date. It is probable that these carvings are contemporary with the rebuilding, ca. 1440–50, the period in which the same mason may have been working at Holycross Abbey, County Tipperary.

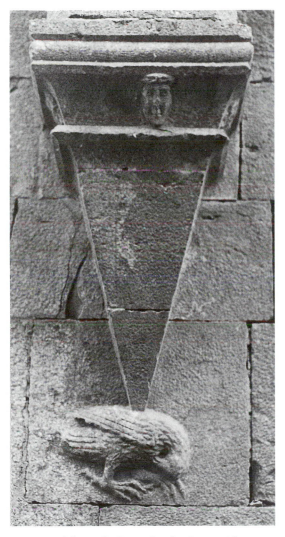

9. Priory of the Holy Cross, Strade, County Mayo.
North pier of chancel arch

The pelican, which is seen in profile and facing towards the right, is about to pierce its breast, and its neck is curved into a nearly circular form. Neither the nest nor the young birds are shown. This carving is one of a pair, the other being an eagle and snake located on the opposite, or south, pier of the chancel arch. Both reliefs are clearly the work of the same sculptor and are of a high standard: the pelican's plumage is well cut, consisting of lozenge-shaped feathers similar to the more accomplished examples from Holycross Abbey, County Tipperary (nos. 4 and 5 above). If the Holy Cross Priory pelican is not the work of the same sculptor, it was at the least influenced by it. The position of the eagle's head at Strade, for example, is exactly the same as that of the pelican at Holycross Abbey. Although the body is shown in profile, the head is depicted as if from the front.

The location of this motif at the entrance to the chancel would have reminded the worshipper of the apposite symbolism of the pelican in relation to the sacrifice of the Mass and Christ's sacrifice which was recreated in the Mass. The eagle and snake show the victory of Christ over his adversary and, like the pelican, would have offered hope.

10. Relief Fragment

Abbey of St. Mary de Pertu Patrum, Annaghdown, County Galway

Only a fragment of this carving now remains. The lozenge-shaped panel is on the left of a simple moulding and shows a bird standing over a nest with the young inside. The stylized bird is shown in profile, with finely lined wings and tail feathers, while the young are placed regularly within the basket-like nest.

11. Portal Relief (Fig. 10)

Priory of St. Mary, Clontuskert, County Galway

One of the most charming of all the medieval Irish depictions of pelicans is found in the Augustinian Priory of St. Mary, Clontuskert, County Galway. The group of carvings surrounding the west or main doorway into the nave is one of the largest sculptural programmes of the period to have survived, and it would have formed an impressive entrance into the church. The carvings are contemporary with the door, which is dated to 1471 by an inscription on its horizontal crown moulding.[47]

Like Kilcooly Abbey (nos. 6–8 above) and the similar portal sculpture at Clonmacnoise Cathedral, the carvings at Clontuskert are grouped around the opening. The nine panels include, on the south side, a bird, two dragons with interlocking necks, a mermaid, and a grotesque animal head, while on the north side are two separate panels showing a pelican and a griffin. On the pinnacles of the doorway are an angel with the "Arma Christi" and three animals. Four larger figures have been incorporated into the walling over the

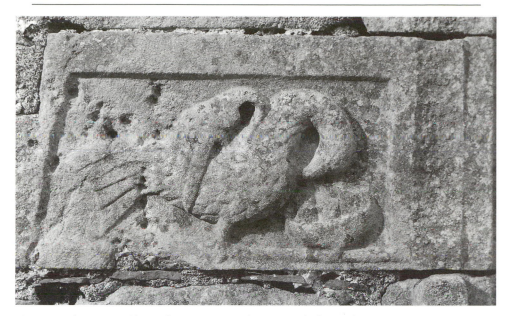

10. Priory of St. Mary, Clontuskert, County Galway. Detail of west door to nave

doorway: an unidentified ecclesiastic, St. Catherine, St. John the Baptist, and St. Michael.

The pelican is in the lower panel on the north side of the doorway. The carving (19.5 cm wide, 33 cm long) shows the bird standing above the basket-like nest, with its beak on its breast and feeding the three young chicks. Its wing is curved upward and falls in a fan-like shape over the rear part of the body. It is interesting to note the similarities between this carving and the other panels. The pelican was originally worked in great detail; traces of its plumage still remain, and they show skillful cutting. The wing of the bird is unusually modelled and resembles the wings of many of the dragons executed in this period, for example, those on the misericords in St. Mary's Cathedral, Limerick.[48]

Although not distributed symmetrically, these carvings are more balanced than other portal sculpture in that an attempt has been made to arrange them as close as possible to the actual opening of the door, and even though there is a different number of panels on the two sides of the doorway, the overall composition does not belie this fact immediately. There also appears to be a symbolic division, with symbols of vice predominating on the south side and symbols of virtue on the north. The doorway has been restored, but there seems no reason to dispute that this was the original layout of these carvings and that they are all contemporary. The sculptor is unknown, but the four figures over the doorway, in particular that of St. John the Baptist, are reminiscent of several funerary monuments of the late fifteenth century in the Cashel-Kilkenny area.[49] The modelling of the drapery, the flared robes of the ecclesiastic, and the pose and emblems of St. John and St. Catherine are more

reminiscent of funerary than architectural sculpture in this period and indicate a sculptor more at home in that medium than in portal sculpture.

12. Hood Moulding (Fig. 11)

Priory of Beatae Mariae Fontis Vivi, Lorrha, County Tipperary

In his survey of carved doorways at Lorrha, Crawford does not mention the example at the nearby priory of the Augustinian Canons Regular, to the northwest of St. Ruadhán's Monastery.[50] The decoration of the west doorway of the church includes a pelican in a position similar to that at St. Ruadhán's, i.e., taking the place of one of the rosettes on the hood moulding. Here it is the second carving from the top, on the south side of the doorway, immediately above a relief carving of a female head, which incidentally is one of the few medieval carvings still in Ireland to retain traces of the original polychrome. The pelican is oval in shape, with its neck curved on top of its body and its beak piercing its breast. Its wings envelop the lower part of its body and form a nest for the young chicks. Despite the small scale of the carving, it shows great detail, and the figure is executed in varying degrees of relief. The doorway with its three moulded orders has a canopy with two pinnacles on either side matching the central one, which also has foliate terminals. The centrally placed female head on the outer moulding of the doorway, which is contemporary, wears a horned headdress with widely flared bejewelled wings and a veil falling onto her shoulders, which is typical of late fifteenth-century headgear. The technique of working on the pelican at Lorrha is closely paralleled on the animal carvings (amphisbaena, swan, and dragon) on the hood moulding of the northern door to the nave at the nearby Clonmacnoise Cathedral, which is the work of the same sculptor and which is accurately dated by an inscription to circa 1460.

13. Hood Moulding (Fig. 12)

Parish Church, Lorrha, County Tipperary

This example is carved in relief on the outer face of the door moulding in the south wall of the nave. This arch moulding was inserted into an earlier, and larger, thirteenth-century doorway. The date at which the arch moulding was added to the older doorway is unknown, but the moulding is clearly of late fifteenth-century date.

On the arch ring Crawford records "fourteen small ornaments in relief, most of which take the form of square rosettes."[51] One of these, however, the sixth from the east end, is a pelican. The small carving shows the pelican with its neck curved, beak on breast, over its nest, which appears to be made of twigs and shows the young birds within. The thirteenth-century doorway had stiff leaf capitals on either side, but the late insertion ends in a simple twist motif. Even though other pelicans, such as those on the Ballylongford Cross

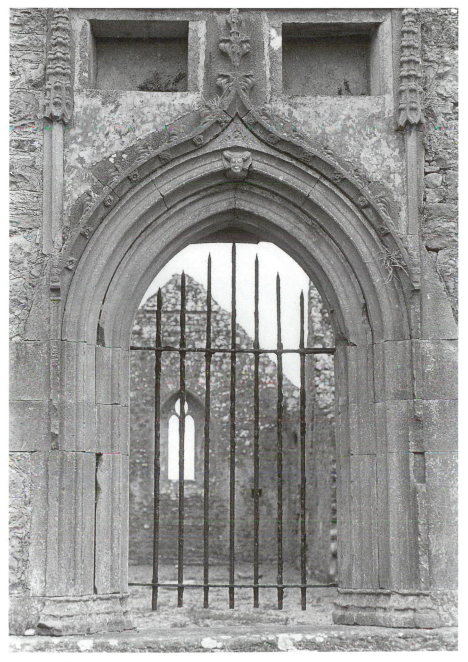

11. Priory of Beatae Mariae Fontis Vivi, Lorrha, County Tipperary. West door to nave

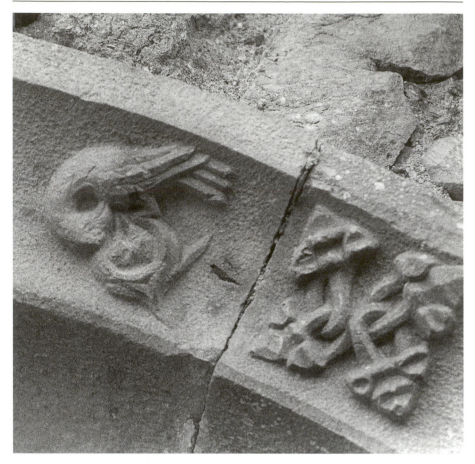

12. Parish church, Lorrha, County Tipperary. South door to nave, with a pelican as the sixth decorative element from the right on the hood moulding

(no. 2 above) and the Dunsany font (no. 14 below), are associated with depictions of foliage, this particular example is unusual in that all of the other rosettes have foliate motifs except for the single example with the pelican.

14. Font Relief

Church of St. Nicholas, Dunsany, County Meath

The decoration of the medieval font in the church of St. Nicholas, Dunsany, County Meath, includes a representation of a pelican. The carving, which is found on the under-stone of the bowl, displays a certain influence from stitchcraft, as Helen Roe has pointed out.[52] The panel shows the pelican with its neck curved in a slightly exaggerated circle, piercing its breast and feeding three young chicks in the plain basket-like nest beneath. The bird is shown in great detail, with its beak and claws portrayed naturalistically. Similarly, the depiction of the three young chicks is highly detailed. The subject is sur-

rounded by "palm-like sprays of foliage" which highlight the central subject.[53] The font dates to the late fifteenth century.

15. Font Relief
Parish Church, Thomastown, County Kilkenny

The final medieval example in stone is a font which is now in the baptistery of the parish church at Thomastown, County Kilkenny. The small carving is on the south face of the font, the decoration of which is divided into three parts. The pelican, which appears to the left of an architectural motif, is shown in profile with its neck curved and its beak on its breast. Its plumage is depicted by a series of deeply cut parallel lines. Three long-beaked chicks are shown in the nest, which resembles that of the example at Kilcooly Abbey, County Tipperary (nos. 6–8 above). The nest is chalice-like, with a long stem that appears not to have a base. The cup of the chalice is decorated in an all-over chevron pattern. This work seems to have been influenced by the relief of the single pelican at Kilcooly Abbey. Not only are the distinctive nests similar, but the use of architectural designs on the other sides of this font are also paralleled on the font in the northern transept at Kilcooly. The use of vaulting as a design element on such pieces of architectural furnishing dates to the late fifteenth–early sixteenth century in Ireland, and it is not widely found there. The heraldic arms of the Butler and Fitzgerald families on the east side of the Thomastown font are again related to those on the sacristy walls at Kilcooly Abbey. McGarry has detected a mason's mark on the bottom right-hand corner of this panel,[54] but unfortunately no other example of this mark has been recorded to date.[55] McGarry dates this font on the basis of its heraldic iconography to ca. 1516–46. The association of the pelican with the sacrament of baptism is unusual and appears to have been introduced towards the end of the fifteenth or the beginning of the sixteenth century.

16. Fresco
Clare Island, County Mayo

Amongst the many subjects depicted on the ceiling of the small Cistercian cell on Clare Island, off the coast of County Mayo, is a possible representation of a pelican.[56] These paintings, some of which are still visible, are distributed over the four bays of the chancel vault. They include a variety of subjects ranging from St. Michael to hunting scenes, the Tree of Life, dragons, and other mythical animals. Stalley has detailed the many colours used in this work and the cleverly executed trompe d'oeil in this remote cell.[57]

This small pelican is found on the south side of the decorated ceiling in area L, according to Westropp's classification.[58] The painting shows a "large yellow conventional bird outlined in red. It has a curved neck, serrated wings, and triangular tail, with a curved red object and some red lines below. It is very probably a pelican."[59] Westropp's sketch of this painting, which now provides the best evidence of what the original looked like, is very similar to the exam-

ples in stone discussed above, and reinforces the belief that the number of examples in the present catalogue may represent only a small proportion of those that once existed. Its position, directly over the chancel arch, would have been particularly suitable for such a symbol.

Few frescoes have survived from medieval Ireland. The largest cycle is to be found at Abbeyknockmoy, which was the parent house of the cell on Clare Island, and this fact may explain the presence of these paintings in such a remote location. Stalley has dated the remains to the fifteenth century and is willing to believe that Luckombe's assertion of a foundation date of circa 1460 is correct.

17. Sexton Tomb (Fig. 13)
St. Mary's Cathedral, Limerick

The popularity of the pelican as a symbol appears not to have ended in the medieval period. A detailed carving of a pelican is found on the Sexton tomb at St. Mary's Cathedral, Limerick, but here it is used as the crest of the Stacpole family.[60] The bird is found over the entrance to the tomb and faces the seven-headed dragon of the Apocalypse. All the work appears to be in one style and dates to the mid-seventeenth century.

Discussion

It is clear from this brief study that the motif of the pelican attained great popularity during the late medieval period in Ireland. Its appearances in Ireland are not too much later than in the rest of Europe, where it is found as early as the sixth century but was widely used only from the thirteenth century onwards. In the early Gothic period in Ireland the majority of animal motifs

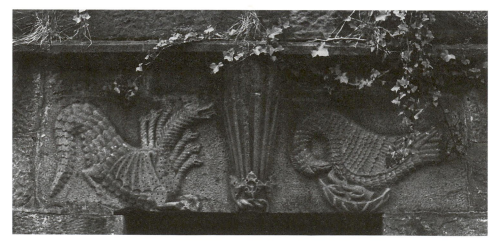

13. St. Mary's Cathedral, Limerick, Sexton Tomb

were purely decorative in nature, and it was not until the fifteenth century that symbolic animals were introduced on a large scale. This period coincided with rebuilding campaigns undertaken in a number of the monastic houses, which allowed the sculptors and metalworkers to introduce new motifs.

The repertoire of animal motifs, on the present evidence, appears to have been relatively narrow. Other animals used symbolically in Irish art of this period include the owl (five examples), the ram (twelve examples), and the fox (five examples). The relative importance of the pelican in this group cannot be judged accurately, as the purpose of some of the other animals found in Irish art does not seem to have been uniform. The dragon, for instance, appears in great numbers and in a variety of media, but the didactic element is clearly lacking in some of these depictions. At Jerpoint Abbey, County Kilkenny, for example, there is what appears to be a caricaturized parody of a dragon on the north face of pier number five.[61]

Klingender believes that the bestiary subjects in general appear more often and later in carvings than in manuscript illuminations.[62] The iconographic influence of the bestiary in Gothic Irish art is first detectable in the fifteenth century, the period of the monastic rebuilding campaigns. While no bestiary texts have survived from Ireland, it is clear that such manuscripts exerted great influence on the choice of subject matter in church decoration. Many of the English and European carvings of the pelican, such as the examples on a misericord at Winchester College[63] and on a roof boss at Sherborne Abbey, are similar to the Irish examples in that the bird is shown in profile only. However, the English sculptors as a general rule employed a greater variety of poses, such as in the carving on a roof boss in the nave at Winchester Cathedral, where the pelican forms the central element and is viewed as if from above, surrounded on all sides by the young chicks.[64]

When the nest is shown in Continental manuscripts, sculpture, tapestry, or painting, there are usually three young chicks. Examples of this common representation include the Aberdeen Bestiary (Aberdeen, University Library, Ms. 24, f. 35r), the Northumberland Bestiary (formerly Alnwick Castle, Ms. 447, f. 41r),[65] the Brussels *Physiologus* (Brussels, Bibliothèque Royale, Ms. 10066-77, f. 143v), the Nuremberg triptych (Germanisches Nationalmuseum, Nuremberg, KG 1),[66] and the fifteenth-century printed bestiary known as the *Libellus de Natura Animalium*.[67] However, the number of young shown does not appear to have been either significant or standardised in Britain or Ireland. In some instances only one chick is shown (Cambridge, University Library, Ms. 11.4.26, f. 38r), in others, two (Cambridge, Gonville and Caius College Library, Ms. 384, f. 191r; silk altar cloth (Brunswick, Städtisches Museum, B no. 56).[68] As we have seen, one Irish representation of the subject, that from Holycross Abbey, County Tipperary (no. 5 above), may have five young in the nest. Another example with five chicks is found on a mid-fourteenth-century Italian painted cross (Staatsgalerie, Stuttgart).[69] The Irish sculptors employed a greater variety of nest forms than is found elsewhere. In Britain and on the Continent, the most common shape of nest is the simple basket-like one, best seen in Ireland on the carving from St. Nicholas's Church, Dunsany. The form of the nest, however, does appear to have been significant in the examples where it takes the shape of a chalice, reinforcing the eucharistic symbolism of the bird's sacrifice. Several examples do not show any nest, and it is the

recognisable pose of the bird alone that would have made it immediately identifiable.

The context of Irish pelican depictions appears to have been important to their meaning as a symbol. Unlike the European examples, which are generally found in the chancel or above the crucifix, the Irish pelicans occur in a wide variety of prominent and conspicuous locations. Their position in highly visible locations, such as on the chancel arch, on the sacristy wall, and around doorways, all normally at eye level, must have been chosen for visual and associative impact, not only within the monastic community but also for lay visitors. These very conspicuous locations reinforce the eucharistic symbolism of the bird, which is also significant on the shaft of the processional cross from Ballymacasey. This is again contrary to the situation in England, "where from the late thirteenth century animal subjects tend to disappear from the more visible parts of the masonry in the interior to lead a secret life on the remote bosses high on the vaults."[70]

Like most other animal carvings in late medieval Ireland, the pelican is found with greatest frequency in Cistercian houses. This order employed decoration on an unparalleled scale in the fifteenth century and was responsible for the most extensive surviving decorative programmes. As a general rule, however, Irish art of this period is more concerned with the static or single image, and does not employ large-scale or complex programmes. The pelican is one of the few animal symbols to be used both independently as well as in programmes linking and contrasting symbols of virtue and vice. It is also interesting that there are few depictions of the actual Passion in Ireland dating from this period, but that a number of symbolic elements of the cycle, such as the "Arma Christi," are found. Similarly, there are few representations of the Resurrection in Gothic Irish art, but that subject is frequently shown symbolically in images of the pelican. This reliance on symbolism and on small-scale representations, whose meaning must have been recognised by laity and clergy alike, implies a relatively sophisticated and learned audience in the remote areas where these Irish pelicans are found.

ACKNOWLEDGEMENTS

My thanks are due to the late Professor M. J. O'Kelly, University College Cork, Ireland, and to Professor George Zarnecki, Courtauld Institute of Art, University of London, for their assistance and helpful comments, as well as to Dr. Elizabeth Twohig for her help in preparing this paper. Thanks are also owed to the National Museum of Ireland for permission to reproduce Figures 1 and 2, and to Dúchas, Irish Heritage Service, for Figures 6, 7, and 12.

NOTES

1. Listed in R. Haworth, "The Published Work of Helen M. Roe," in *Figures from the Past: Studies on Figurative Art in Christian Ireland in Honour of Helen M. Roe*, ed. E. Rynne (Dun Laoghaire, 1987), 20–26.

2. See Pliny the Elder, *Natural History* 10:66, trans. H. Rackham (London, 1942), 377.

3. See Aelian, *On the Characteristics of Animals* III:20, trans. A. F. Scholfield (London, 1958), 179.

4. *The Hieroglyphics of Horapollo*, trans. G. Boas (New York, 1950), 81.

5. Horapollo 1:54, trans. Boas (as in note 4), 81. Cf. Artemidorus, *Onirocriticon* 2:20; *Artemidori Daldiani Onirocriticon Libri V*, ed. R. Hercher (Leipzig, 1864), 114.

6. M. Wellman, "Der Physiologus," in *Philologus Supplementband* 22 (1930), 50.

7. Horapollo 1:11, trans. Boas (as in note 4), 64–65.

8. P. A. Robin, *Animal Lore in English Literature* (London, 1932), 65; F. Sbordone, *Physiologus* (Milan, 1936), xii–xiii.

9. Robin, *Animal Lore* (as in note 8), 65.

10. Sbordone, *Physiologus* (as in note 8).

11. Ps. 102:7; *Physiologus*, trans. M. J. Curley (London, 1979), ix.

12. Trans. Curley, *Physiologus* (as in note 11).

13. *Speculum naturale* 17 (n.p., n.d.), p. 127.

14. J. P. Migne, "Epiphanius Episcopus Constantiensis," PG (Paris, 1959), 41–43.

15. *The Bestiary of Guillaume le Clerc*, trans. G. C. Druce (Ashford, Kent, 1936), 612.

16. G. Schiller, *The Iconography of Christian Art* (London, 1972), 136.

17. J. Hall, *Dictionary of Subjects and Symbols in Art* (London, 1974), 238.

18. L. M. C. Randall, *Images in the Margins of Gothic Manuscripts* (Berkeley, 1966), 197.

19. M. D. Anderson, *Misericords: Medieval Life in English Woodcarving* (London, 1956), 15.

20. C. J. P. Cave, *Roof Bosses in Medieval Churches* (Cambridge, 1948), 73.

21. C. Gerhardt, *Die Metamorphosen des Pelikans* (Frankfurt, 1979).

22. J. Hunt, *The Limerick Crozier and Mitre* (Dublin, n.d. [ca. 1946]), 5; R. Ó Floinn, "Irish Goldsmiths' Work of the Later Middle Ages," *Irish Arts Review Yearbook* 12 (1996), 37.

23. Hunt, *Limerick Crozier* (as in note 22), 17–18.

24. M. Bàràny-Oberschall, "Baculus pastoralis: Keltisch-irische Motive auf mittelalterlichen beeingeschnitzte Bischofsstäben," *Zeitschrift des deutschen Verein für Kunstwissenschaft* 12 (1958), 30.

25. A. Rossi, "L'Art industriel dans les Abruzzes," *Les Arts* 50 (1906), 23, fig. 4; C. Bunt, *The Goldsmiths of Italy: Some Account of Their Guilds, Statutes, and Work* (London, 1926), 124.

26. Cologne, cathedral treasury: F. Witte, *Tausend Jahre deutscher Kunst am Rhein* (Berlin, 1932), vol. 3, pl. 130; M. Gauthier, *Emaux du Moyen Age occidental* (Fribourg, 1972), 251, fig. 200.

27. Haarlem, cathedral: F. Vermeulen, "L'Exposition nationale d'art religieux ancien, à Bois-le-Duc," *Art flamand et hollandais* 20 (1913), 125, fig. 3; Gauthier, *Emaux du Moyen Age* (as in note 26), 273, fig. 226.

28. An illustration and full bibliography are published in *Age of Chivalry: Art in Plantagenet England, 1200–1400*, ed. J. Alexander and P. Binski (London, 1987), 471–73.

29. C. Hourihane, "Hollye Crosses: A Catalogue of Late Medieval Irish Processional, Altar, and Pendant Crosses," *Proceedings of the Royal Irish Academy*, forthcoming.

30. R. Ó Floinn, "Gilt Silver Processional Cross," in *Treasures of Ireland: Irish Art, 3000 B.C.–1500 A.D.*, ed. M. Ryan (Dublin, 1983), 181.

31. Ó Floinn, "Gilt Silver Processional Cross" (as in note 30), 181.

32. Baltimore, Walters Art Gallery, processional cross, inv. 44.120; M. C. Ross,

"Austrian Gothic Enamels and Metalwork," *Journal of the Walters Art Gallery* 1 (1938), 70–83, at 75, figs. 1, 2. Cleveland, Museum of Art, altar cross, inv. 42.1091-93; W. Milliken, "Copper-Gilt Cross in the Cleveland Museum," *Art Quarterly* 6 (1943), 336–37, fig. p. 332. New York, Metropolitan Museum of Art, processional cross, inv. 36.134; P. Harris, "A Processional Cross and Two Roundels," *Bulletin of the Metropolitan Museum of Art* 32 (1937), 95–96, fig. p. 95.

33. A. Derbes, *Picturing the Passion in Late Medieval Italy: Narrative Painting, Franciscan Ideologies, and the Levant* (New York, 1996).

34. *Irish Monastic and Episcopal Deeds, A.D. 1200–1600*, ed. N. B. White (Dublin, 1936), 23–24.

35. On both of these points, see R. Stalley, *The Cistercian Monasteries of Ireland* (New Haven and London, 1987), 115.

36. Stalley, *Cistercian Monasteries* (as in note 35), 115.

37. Stalley, *Cistercian Monasteries* (as in note 35), 117.

38. Stalley, *Cistercian Monasteries* (as in note 35), 117.

39. C. Hourihane, "Masons' Marks in the Medieval Archbishoprics of Cashel and Dublin" (M.A. thesis, University College, Cork, 1979).

40. H. G. Leask, *Irish Churches and Monastic Buildings*, vol. 3, *Medieval Gothic and the Last Phases* (Dundalk, 1971), 69

41. Stalley, *Cistercian Monasteries* (as in note 35), 194.

42. E. C. Rae, "The Sculpture of the Cloister of Jerpoint Abbey," *Journal of the Royal Society of Antiquaries of Ireland* 96 (1966), 59–91.

43. Stalley, *Cistercian Monasteries* (as in note 35), 194–95.

44. W. Healey, "The Cistercian Abbey of Kilcooly," *Journal of the Royal Society of Antiquaries of Ireland* 20 (1890), 224–25.

45. Stalley, *Cistercian Monasteries* (as in note 35), 195.

46. A. Gwynn and N. Hadcock, *Medieval Religious Houses: Ireland* (London, 1970), 230.

47. Leask, *Irish Churches* (as in note 40), 74.

48. J. Hunt, "The Limerick Cathedral Misericords," *Ireland of the Welcomes* 20, no. 3 (Sept.–Oct., 1971), 12–16.

49. J. Hunt, *Irish Medieval Figure Sculpture, 1200–1600: A Study of Irish Tombs with Notes on Costume and Armour* (Dublin, 1974), cat. nos. 294–296, 300.

50. H. S. Crawford, "Notes on the Crosses and Carved Doorways at Lorrha, in North Tipperary," *Journal of the Royal Society of Antiquaries of Ireland* 39 (1909), 127–131.

51. Crawford, "Crosses and Carved Doorways" (as in note 50), 129.

52. H. M. Roe, *Medieval Fonts of Meath* (Longford, 1968), 17.

53. Roe, *Medieval Fonts* (as in note 52), 17.

54. D. McGarry, "Carved Medieval Font at Thomastown," *Old Kilkenny Review*, new series 2, vol. 22 (1980), 35.

55. Hourihane, "Masons' Marks" (as in note 39).

56. T. J. Westropp, "Clare Island Survey, Part 2," *Proceedings of the Royal Irish Academy* 31 (1911), 1–78.

57. Stalley, *Cistercian Monasteries* (as in note 35), 216.

58. Westropp, "Clare Island Survey" (as in note 56), 34–35.

59. Ibid., 35.

60. T. J. Westropp, "Carvings in St. Mary's Cathedral, Limerick," *Journal of the Royal Society of Antiquaries of Ireland* 22 (1892), 73.

61. The classification is based on that adopted by Rae, "Cloister of Jerpoint Abbey" (as in note 42).

62. F. Klingender, *Animals in Art and Thought*, ed. E. Antal and J. Harthan (London, 1971), 433.

63. S. Pitcher, *Medieval Sculpture at Winchester College* (Oxford, 1932), 13–14, pl. 41.

64. Cave, *Roof Bosses* (as in note 20), 73, cat. no. 257.

65. E. G. Millar, *A Thirteenth-Century Bestiary in the Library of Alnwick Castle* (Oxford, 1958), 35, pl. 58.

66. E. Zimmermann, "Die Tafelmalerei," *Anzeiger des Germanischen National-museums* (1930–31), 30–32.

67. *Libellus de Natura Animalium: A Fifteenth-Century Bestiary Reproduced in Facsimile* (London, 1958).

68. R. Kroos, *Niedersächsische Bildstickerein* (Berlin, 1970), 98, 116–17.

69. P. Beye, "Ein unbekanntes Florentiner Kruzifix aus der Zeit um 1330–1340," *Pantheon* 25 (1967), 5–11.

70. Klingender, *Animals in Art* (as in note 62), 433.

PART 2

CATALOGUE OF
VIRTUES AND VICES
IN THE INDEX OF
CHRISTIAN ART

Introduction to the Catalogue

🕭

THE FOLLOWING EXTRACT represents the current files covering all of the personifications of virtue and vice in the Index of Christian Art. These records, which embrace the card files as well as the electronic database, include a total of 227 different personifications. A checklist of these Virtues and Vices follows this introduction. The personifications are presented alphabetically in three sections, the first of which catalogues depictions of 109 Virtues, ranging from Abstinence to Wisdom. Following this is a listing of personifications which appear to be Virtues but which cannot be conclusively identified. Despite extensive research, the precise moral values represented by these figures have not been accurately discerned, and hence they are listed separately. The catalogue of Virtues concludes with a list of representations of the Tree of Virtues and the Cardinal Virtues. The section devoted to the Cardinal Virtues includes works of art in which the four personifications Fortitude, Justice, Prudence, and Temperance are present, even when they are part of a larger ensemble of Virtues. Researchers who are interested in only one of these personifications will also need to look in the general list of Virtues under their respective heading.

The catalogue of 118 Vices follows a pattern similar to that of the catalogue of Virtues, with a list of probable but unidentified Vices following the identified examples. Also included in this section are lists of depictions of the Tree of Vices, the Seven Vices, and the Wheel of Vices.

The third and final section of the catalogue is a list of works of art in which the actual conflict between the Virtues and Vices is the theme. This section includes only works in which the individual Virtues and Vices cannot be identified. When the individual personifications in these battle scenes can be identified, they are catalogued separately in the sections devoted to identified personifications.

The works of art depicting each personification are grouped by medium— fresco, glass, manuscript, sculpture, textile, etc.—following the classification system used by the Index of Christian Art. Within each medium the works of art are listed alphabetically by current location in a four-field record. Not every personification, understandably, is represented in every medium. One revealing feature of this catalogue is that it shows quite clearly how much more commonly some of the personifications were depicted, and that some of them appear with greater frequency in certain media.

The first field in each entry begins with the current geographic location of the object, such as London, Cologne, Paris, Melle-sur-Béronne, and so on. This is followed, on the same line, by an indication of the type of collection in which the work is found, for example, Lib. (library), Mus. (museum),

Ch. (church), Cath. (cathedral), etc. The location is then further refined by the proper name of the institution which houses the work, such as Heribert, Kunstgewerbe, All Saints, etc. In the case of manuscripts, the final element on the first line is the shelf mark or other unique identifier assigned by the holding institution. When a work of art belongs to more than one institution, as is the case with the Gospel Book of Henry the Lion, which is jointly owned by two libraries in Germany (Wolfenbüttel, Herzog August Bibliothek, Cod. Guelf. 105 Noviss. 2°, and Munich, Bayerische Staatsbibliothek, Clm. 30055) the object is entered under both institutions.

The second line of each record gives more detailed information on the object itself. This may refer to the type of object, such as casket or reliquary, or the location of the work within a building, for example, exterior, nave, narthex, or door. Wherever possible, inventory numbers or similarly unique identifying elements are given. For metalwork, the material used, such as bronze, gold, and so on, is given. In manuscript entries, the second line gives the type of manuscript, such as Bible; Bible, Moralized; Psalter; or Apocalypse-Pericope. In a number of instances the actual author of the work can be given, for example, Guillaume de Digulleville, *Pèlerinage*. The final element in the second line of all manuscript entries is the folio or page number on which the personification occurs. There are a few examples where it has not been possible to obtain the actual folio number of the illumination.

The third line generally records the date assigned to the work; this may refer to a century, a range of years or centuries, or, in cases where it is known, a more exact date. In entries where the creator or artist responsible for the work of art is known, however, the attribution occupies the third line, and is followed by the date on the fourth line. As is to be expected, this is not frequently encountered in medieval art, but this information is included whenever possible. Qualifications such as atelier, workshop, or school are added to the artist's or artists' name(s). In the entries for works which have been attributed to more than one artist, the names are listed in no significant order.

In cases where the main subject of the work of art is not the Virtue or Vice being catalogued, a final line, set in italics, records the primary subject, e.g., *Abraham: Battle against Kings* or *Christ and Peter and Paul*. These are some of the more than 26,000 subject terms developed by the Index of Christian art specifically for use within the archive.[1] Because of the complex interrelationships among these personifications, it is common to find that another Virtue or Vice is the primary theme of a work of art.

NOTE

1. These subject terms have been discussed by Helen Woodruff in her pioneering publication, *The Index of Christian Art at Princeton University* (Princeton, 1942).

List of Virtues and Vices
in the Catalogue

❧

THE PERSONIFICATIONS listed here are followed by the various names with which they are identified in medieval sources.

Virtues

Abstinence (*Abstinentia*)
Action (*Praxis*)
Beauty (*Pulchritudo, Venustas*)
Celestial Desire (*Caeleste Desiderium*)
Charity (*Agape, Caritas, Eleemosyne*)
Chastity (*Castitas, Chastee, Pudicitia*)
Chivalry (*Domney*)
Compassion (*Compassio, Sympatheia*)
Compunction (*Compunctio*)
Concord (*Concordia*)
Confession (*Confessio*)
Confidence (*Confidentia*)
Consolation (*Consolatio*)
Constancy (*Constantia*)
Contemplation (*Contemplatio, Theoria*)
Contempt of World (*Contemptus Mundi*)
Continence (*Continentia*)
Contrition (*Contritio*)
Counsel (*Consilium*)
Courage (*Andreia, Bon Coratge*)
Courtliness (*Curtisia*)
Deliberation (*Deliberatio*)
Devotion (*Devotio*)
Diligence (*Solertia*)

Discipline (*Disciplina, Districtionis Rigor*)
Discretion (*Discretio, Discretionis Temperamentum, Retenernen*)
Divine Love (*Amor Caeleste*)
Docility (*Docilitas*)
Eloquence (*Oratio*)
Equity (*Eqite, Equitas, Equité*)
Exhortation (*Paraklesis*)
Faith (*Fides, Pistis*)
Feeling (*Affectus*)
Felicity (*Beatitudo, Félicité*)
Fidelity (*Fidelitas*)
Fortitude (*Fortitudo, Forsse, Force*)
Friendship (*Amicitia, Amistie, Amitié*)
Generosity (*Largesce, Largitas, Largueza, Liberalitas, Liberalité*)
Gentleness (*Dulcedo, Mansuetudo, Praotes*)
Good Behavior (*Ensenham*)
Goodness (*Bonitas*)
Grace (*Gratia*)
Graciousness
Guilelessness (*Akakia*)
Holiness (*Agiosyne, Sanctitas*)
Holy Fear (*Timor Dei, Timor Domini*)
Honesty (*Honestas, Simplicitas*)
Hope (*Elpis, Sperantia, Spes*)

Humility (*Humilitas, Humilité, Tapeinophrosyne*)
Indulgence (*Indulgentia*)
Innocence (*Innocentia*)
Joy (*Gaudium, Laetitia*)
Judgment (*Iudicium*)
Justice (*Dikaiosyne, Iustitia*)
Kindness (*Benignitas*)
Knowledge (*Gnosis, Science, Scientia*)
Lamentation (*Gemitus*)
Law (*Lex*)
Longevity (*Longaevitas*)
Longsuffering (*Longanimitas*)
Love of God (*Dilectio Dei*)
Love of Neighbor (*Dilectio Proximi*)
Loyalty (*Lialta*)
Magnificence (*Magnificentia*)
Memory (*Memoria*)
Mercy (*Misericorde, Misericordia*)
Might (*Dynamis, Ischys*)
Modesty (*Modestia*)
Oath-Keeping (*Iuris Iurandi Observantia*)
Obedience (*Hypakoe, Obedientia*)
Parsimony (*Parcitas, Parsimonia*)
Passionlessness (*Aprospatheia*)
Patience (*Debonereté, Patientia*)
Peace (*Eirene, Pax*)
Perfection (*Perfectio*)
Perseverance (*Perseverantia*)
Piety (*Pietas, Pietatis Affectus*)
Pilgrimage (*Xeniteia*)
Placidity (*Aorgesia*)
Poverty (*Paupertas*)

Prayer (*Oratio, Proseuche*)
Providence (*Providentia*)
Prowess (*Proesse, Provesce*)
Prudence (*Phronesis, Prudence, Prudentia*)
Purity (*Munditia, Puritas*)
Reason (*Ratio*)
Religion (*Religio*)
Repentance (*Metanoia, Poenitentia*)
Resolution (*Parastasis*)
Rest (*Requies*)
Reverence (*Reverentia*)
Righteousness (*Jus*)
Security (*Securitas*)
Severity (*Severitas*)
Shamefacedness (*Verecundia*)
Silence (*Siope, Taciturnitas*)
Simplicity (*Haplotes*)
Sobriety (*Sobrietas, Sobriété, Soubrietez*)
Solitude (*Solitudo*)
Stability (*Stabilitas*)
Suffering (*Carnis Afflictio*)
Temperance (*Atrampance, Sophrosyne, Temperantia*)
Tolerance (*Tolerantia*)
Tranquility (*Apatheia*)
Truth (*Aletheia, Veritas*)
Understanding (*Entendement, Intelligentia*)
Victory (*Victoria*)
Virginity (*Virginitas*)
Wisdom (*Sapience, Sapientia, Sophia*)

Vices

Ambition (*Ambitio, Honoris Appetentia*)
Anger (*Ira, Thymos*)
Anxiety (*Anxietas*)
Arrogance (*Arrogantia*)
Avarice (*Avareza, Avarice, Avaritia*)
Bad Habit (*Synetheia Ponera*)
Bitterness (*Amaritudo*)
Blasphemy (*Blasphemia*)
Boastfulness (*Exultatio, Jactantia*)

Care (*Cura*)
Clamor (*Clamor*)
Contumacy (*Contumacia*)
Contumely (*Contumelia*)
Corporal Beauty (*Venustas*)
Covetousness (*Convoitise, Philargyria*)
Cowardice (*Ignavia*)
Cruelty (*Crudelitas*)
Cupidity (*Cupiditas*)

Curiosity (*Curiositas*)

Deceit (*Dolus, Fallacia, Fraus*)

Delight (*Deliciae*)

Despair (*Desperantia, Desperatio*)

Discord (*Discordia*)

Disobedience (*Disobedientia, Indisciplina, Inobedientia*)

Division (*Divisio*)

Drunkenness (*Crapula, Ebrietas*)

Dullness (*Mentis Hebetudo*)

Envy (*Invidia*)

False Piety (*Pseudeulabeia*)

Falsehood (*Falsitas, Pseudos*)

Fear (*Metus*)

Flattery (*Blandiciae*)

Folly (*Fateza, Paccia, Stultitia*)

Fornication (*Fornicatio*)

Fraud (*Fraus*)

Fury (*Ardor, Furia, Furor*)

Gloating (*Exultatio in Adversis*)

Glory (*Gloria*)

Gluttony (*Gastrimargia, Gloutonnie, Gula, Ventris Ingluvies, Voracitas*)

Greed (*Fames, Fames Acquirendi*)

Grief (*Dolor*)

Harshness (*Malignitas*)

Hate (*Haine, Odium*)

Homicide (*Homicidium*)

Hypocrisy (*Hypocrisis, Ippocrité*)

Idleness (*Accidia, Peresce*)

Idolatry (*Cultura Deorum, Idolatria*)

Ignorance (*Ignorantia*)

Impatience (*Cocha, Impatientia*)

Impiety (*Impietas*)

Imprudence

Impurity (*Immunditia*)

Inconstancy (*Inconstantia*)

Incredulity (*Incredulitas*)

Indignation (*Indignatio*)

Indiscretion (*Desselar, Indiscretione*)

Indocility (*Indocilitas*)

Infidelity (*Infidelitas*)

Infortitude

Ingratitude

Iniquity (*Iniquitas*)

Injustice (*Iniustitia*)

Insensibility (*Anaisthesia*)

Intemperance (*Intemperancia*)

Irascibility (*Iracundia*)

Jest (*Jocus*)

Labor (*Labor*)

Languor (*Languor*)

Loquacity (*Loquacitas, Multiloquium, Polylogia*)

Lust (*Concupiscentia, Lascivia, Libido*)

Luxury (*Luxure, Luxuria*)

Malice (*Malicia, Mnesikakia*)

Mendacity (*Mendacium*)

Mischief (*Dolor*)

Muttering (*Susurratio*)

Negligence (*Negligentia*)

Oblivion (*Oblivio*)

Obscene Speech (*Turpiloquium*)

Obstinacy (*Pertinacia*)

Opulence (*Opulentia*)

Perjury (*Perjurium*)

Petulance (*Petulantia*)

Pillage (*Rapina*)

Pleasure (*Voluptas*)

Pomp (*Pompa*)

Poverty (*Paupertas*)

Power (*Potentia*)

Presumption (*Praesumptio*)

Pride (*Alazoneia, Erguelh, Hyperephania, Iactantia, Orgueil, Superbia*)

Profane Love (*Amor, Amor Seculi*)

Rapacity (*Rapacitas*)

Sadness (*Tristitia*)

Satiety (*Koros*)

Sedition (*Seditio*)

Senility (*Vilhitge*)

Simony

Simulation (*Simulatio*)

Slander (*Calumnia, Detractio, Katalalia, Lanzengos*)

Sleep (*Hypnos*)

Sloth (*Akedia*)

Sordidness (*Sordiditas*)

Stinginess (*Tenacitas*)

Temerity (*Temeritas*)

Thought of Death

Timidity (*Deilia*)

Titubation (*Titubatio*)

Treason (*Proditio, Tradimentum*)

Turpitude (*Turpitudo*)
Tyranny (*Tirania*)
Unbelief (*Apistia*)
Usury (*Usura*)
Vainglory (*Inanis Gloria, Kenodoxia, Vana Gloria*)

Vanity (*Vanitas*)
Vengeance (*Ultio*)
Violence (*Violentia, Vis*)
Weakness (*Debilitas, Fievolezza*)
Wickedness (*Poneria*)
Wrath (*Ira*)

Abbreviations Used in the Catalogue

Arch. Archive
Bibl. Biblioteca, Bibliotheek, Bibiliothek, Bibliothèque
Brev. d'Amor *Le Breviari d'Amor*
Canzone *La Canzone delle Virtù e delle Scienze*
Cath. Cathedral
Cem. Cemetery
Ch. Church
Chap. Chapel
Clédat J. Clédat. *Le Monastère et la nécropole de Baouît*. Cairo, 1904
Coll. Private collection
Comm. *Commentaria super Codices*
Conv. Convent
Gall. Gallery
Germ. Germanisches
Hofbibl. Hofbibliothek
Hort. Delic. *Hortus Deliciarum*
Kupferstichkab. Kupferstichkabinett
Landesbibl. Landesbibliothek
Landesmus. Landesmuseum
Lib. Library
LXX Septuagint
Medit. *Meditations on the Life of Christ*
Miracles N.D. *Miracles de Notre Dame*
Mon. Monastery
Mus. Musée, Museo, Museum
Nat. National, Nationale
Nationalbibl. Nationalbibliothek
Nationalmus. Nationalmuseum
Naz. Nazionale
Novella *Novella super Decretalibus Gregorii IX*
Pal. Palace, Palais, Palazzo
Pèlerinage *Pèlerinage de Vie Humaine*
Pref. Prefecture
Rupert, *Super* Rupert of Deutz, *Commentaria in Canticum Canticorum*
 Cant. Cant.
Samml. Sammlung
Serm. *Sermones de Tempore*
Spec. Hum. *Speculum Humanae Salvationis*
 Salvationis
Staatl. Staatliche
Staatsbibl. Staatsbibliothek
Stadtbibl. Stadtbibliothek

Stiftsbibl.	Stiftsbibliothek
Studienbibl.	Studienbibliothek
Summa	*Summa de Casibus Poenitentiae*
Universitätsbibl.	Universitätsbibliothek
Univ.	Universität, Université, Universiteit, University
Zentralbibl.	Zentralbibliothek

Virtues

❦

ABSTINENCE

GLASS

Strasbourg: Cath., Notre Dame
Windows, southern transept
Date: 13th cent.
Apostle: Matthias

Wels: Church
Windows
Date: Late 14th–15th cent.
Adam and Eve: Fall of Man

MANUSCRIPT

Paris: Lib., Bibl. Nat. de France,
 lat. 8318
Prudentius, *Psychomachia*, fol. 53r
Date: Late 10th cent.
Personification: Vice, Pride

Strasbourg: Lib., Bibl. Municipale
Herradis of Landsberg, *Hort. Delic.,*
 fol. 67v
Date: Second half 12th cent.
Christ

Strasbourg: Lib., Bibl. Municipale
Herradis of Landsberg, *Hort. Delic.,*
 fol. 201r
Date: Second half 12th cent.
Personification: Virtue, Patience

Wiesbaden: Lib., Hessische Landes-
 bibl., I
Hildegardis, *Liber Scivias*, fol. 161v
Date: ca. 1165
Hildegardis of Bingen: Vision

METALWORK

Hildesheim: Cath., Maria
Chandelier, of Hezilo
Date: ca. 1055–1065
Building: City Wall

ACTION

MANUSCRIPT

Melbourne: Gall., National, Felton
 710/5
Gospel Book, fol. 6r
Date: ca. 1100
Personification: Virtue, Wisdom

BEAUTY

MANUSCRIPT

Nuremberg: Mus., Germ. Nat. Bibl.,
 156142
Gospel Book, Echternach, fol. 113v
Date: 10th–11th cent.
Personification: Virtue

CELESTIAL DESIRE

MANUSCRIPT

Heidelberg: Lib., Universitätsbibl.,
 Sal. X.16
Hildegardis, *Liber Scivias*, fol. 111v
Date: 12th cent.
Hildegardis of Bingen: Vision

Wiesbaden: Lib., Hessische
 Landesbibl., I
Hildegardis, *Liber Scivias*, fol. 202v
Date: ca. 1165
Hildegardis of Bingen: Vision

CHARITY

ENAMEL

Baltimore: Gall., Walters
Plaques (44.99–100)
Date: Second half 12th cent.
Personification: Virtue, Justice

Berlin: Mus., Kunstgewerbe
Plaque, from retable (1978,56)
Date: ca. 1150

Berlin: Mus., Kunstgewerbe
Plaque
Date: 12th cent.

Brussels: Lib., Bibl. Royale
Book cover (14970)
Date: Second half 12th cent.
Evangelist: Symbol

Brussels: Mus., Royaux d'Art et
 d'Histoire
Plaque, from reliquary (3141)
Date: ca. 1170
Personification: Virtue, Fortitude

Brussels: Mus., Royaux d'Art et
 d'Histoire
Reliquary, Valentinus of Maastricht
 (1038)
Date: ca. 1160–1170
Personification: Virtue, Hope

Cologne: Coll., Seligmann
Plaque
Date: 12th cent.
Angel

Florence: Mus., Naz. di Bargello
Crozier (Carrand 622)
Date: ca. 1185–1200
David: Slaying Bear

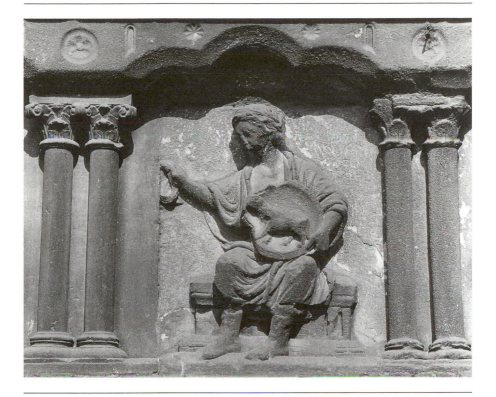

Klosterneuburg: Monastery
Retable
Attribution: Nicolas of Verdun
Date: 1181
Abraham: Entertaining the Angels

London: Mus., Victoria and Albert
Chalice, silver-gilt (4903-1859)
Date: First half 14th cent.
Christ: Crucifixion

London: Mus., Victoria and Albert
Triptych (4757-1858)
Date: ca. 1150
Jonah: Cast Up

Manchester: Lib., Rylands
Book cover (lat. 11)
Date: Second half 12th cent.
Angel

New York: Mus., Metropolitan,
 Cloisters
Triptych, reliquary (L. 1979.143)
Date: ca. 1160
Christ: Last Judgment

Osnabrück: Town Hall, Rathaus
Vessel
Date: First half 14th cent.
Personification: Virtue, Prudence

Saint-Ghislain: Church
Casket, reliquary
Date: Mid-12th cent.
Personification: Virtue, Patience

Troyes: Cath., Pierre, Treasury
Casket
Date: ca. 1200
Personification: Virtue, Faith

FRESCO

Assisi: Ch., Francesco, Lower
Crossing, vault
Date: First half 14th cent.
Allegory: Poverty

Bawît: Mon., Apollo
Chapel III (Clédat)
Date: 6th–7th cent.
Scene, Unidentified

Bawît: Mon., Apollo
Chapel XII (Clédat)
Date: 6th–7th cent.
Malachi

Brioude: Ch., Julien
Porch
Date: 12th–13th cent.
Christ: Last Judgment

Cividale: Ch., Tempietto
Decoration
Date: 12th–13th cent.
Mary Magdalen

Cologne: Cath., Peter und Maria
Chapel, S. Agnes
Date: 14th cent.
Irmgardis of Zutphen: Scene

Copford: Ch., Mary
Nave
Date: ca. 1150
*Christ: Miracle of Raising Daughter
of Jairus*

Florence: Ch., Croce
Chapel, Bardi di Vernio (Silvestro)
Date: First half 14th cent.
Constantine the Great: Scene

Florence: Ch., Croce
Chapel, Baroncelli, back wall
Attribution: Taddeo Gaddi
Date: ca. 1328–1330
Personification: Virtues, Cardinal

Florence: Ch., Croce
Chapel, Baroncelli, side vault
Attribution: Taddeo Gaddi
Date: ca. 1328–1330
Joachim: Offerings Rejected

Florence: Ch., Croce
Sacristy
Date: Late 14th cent.
Christ: Ascension

Florence: Ch., Maria Novella
Chapel, Strozzi, ceiling
Attribution: Giovanni del Biondo,
 Nardo di Cione
Date: ca. 1350–1360
Thomas Aquinas

Gundsømagle: Church
Decoration
Date: ca. 1200
Saint

Gurk: Cath., Maria Himmelfahrt
Gallery, west
Date: 13th cent.
Virgin Mary and Christ Child

Kirkerup: Church
Decoration
Date: ca. 1200

Padua: Chap., Madonna dell'Arena
Decoration
Attribution: Giotto
Date: ca. 1303–1308
Joachim: Offerings Rejected

Padua: Ch., Eremitani
Chapel, S. Agostino
Date: ca. 1370
Personification: Theology

Prufening: Ch., Monastery
Choir
Date: 12th cent.
Personification: Church

Saeby: Church
Decoration
Date: 1150–1175
Christ and Four Beasts

San Galagano: Chap., Rotunda
Sacristy
Date: First half 14th cent.
Virgin Mary and Christ Child

San Miniato: Pal., Municipio
Room, Consiglio
Date: 1393
*Virgin Mary and Christ Child: Type
 Suckling*

Saqqara: Mon., Jeremias
Cell 709
Date: 6th cent. or later
Palm

Siena: Pal., Pubblico
Room, Pace
Attribution: Ambrogio Lorenzetti
Date: 1338–1339
Personification: Virtue, Justice

Tolentino: Ch., Nicola da Tolentino
Chapel, S. Nicola
Date: 13th–14th cent.
Evangelist: Symbol

GLASS

Esslingen: Ch., Dionysius
Windows, choir
Date: Late 13th–14th cent.
Isaiah

Lyons: Cath., Jean
Window, apse
Date: ca. 1220
Magi: Before Herod the Great

Mulhouse: Ch., Etienne
Windows
Date: First half 14th cent.
Personification: Virtue, Sobriety

Paris: Cath., Notre Dame
Window, west rose
Date: First half 13th cent.
Virgin Mary and Christ Child

Strasbourg: Cath., Notre Dame
Windows, nave
Date: 14th cent.
Personification: Virtue, Wisdom

Wienhausen: Convent
Windows
Date: 1330–1340
Christ: Entry into Jerusalem

MANUSCRIPT

Aschaffenburg: Lib., Hofbibl., 15
Breviary, fol. 237r
Date: Second half 14th cent.
Psalm 115 (Vulgate, 114)

Berlin: Mus., Staatl., Kupferstichkab.,
 78.A.9
Hamilton Psalter, fol. 92v
Date: ca. 1300
Psalm 37 (LXX, 36)

Besançon: Lib., Bibl. Municipale, 54
Psalter, fol. 15v
Date: Second half 13th cent.
Psalms: Illustration

Boulogne: Lib., Bibl. Municipale, 46
Augustine, *Confessiones*, fol. 1v
Date: ca. 1125
Lambert of S. Bertin: Scene

Cambridge: Mus., Fitzwilliam, 330
Psalter, W. de Brailes, no. 1
Date: ca. 1240
Psalms: Illustration

Cologne: Arch., Historisches, W 255
Bernard of Clairvaux, *Serm.*, fol. 117v
Date: Late 13th cent.
Christ: Resurrection

Cracow: Mus., Państwowe Zbiory
 Sztuki na Wawelu, 2459
Bible, fol. 391v
Date: Early 14th cent.
Psalm 22 (Vulgate, 21)

Darmstadt: Lib., Hessische Landes-
 bibl., 1640
Gospel Book, Hitda of Meschede,
 fol. 173r
Date: 1000–1020

Engelberg: Lib., Stiftsbibl., 48
Jerome, *In Matthaeum, in Marcum,*
 fol. 103v
Date: 12th cent.
Personification: Church?

Eton: Lib., Eton College, 177
Miscellany, fol. 3r
Date: 13th cent.
Daniel: Vision, Nebuchadnezzar's
Dream

Florence: Lib., Bibl. Laurenziana, Plut.
XLII.19
Brunetto Latini, *Tesoro*, fol. 66r
Date: 14th cent.

Ghent: Lib., Bibl. de l'Université, 92
Lambertus, *Liber Floridus*, fol. 231v
Date: 1120
Tree of Virtues

Kremsmünster: Lib., Stiftsbibl., 243
Spec. Hum. Salvationis, fol. 4r
Date: First half 14th cent.
Tree of Virtues

London: Lib., British, Add. 17737–8
Bible, Floreffe, II, fol. 3v
Date: ca. 1153
Job: Sacrifice for Children

London: Lib., British, Add. 19352
Theodore Psalter, fol. 43v
Date: 1066
Psalm 37 (LXX, 36)

London: Lib., British, Add. 19352
Theodore Psalter, fol. 153v
Date: 1066
Psalm 112 (LXX, 111)

London: Lib., British, Harley 1526–27
Bible, Moralized, II, fol. 28v
Date: First half 13th cent.
Christ: Miracle of Raising Daughter of
Jairus

London: Lib., British, Yates Thompson
11
Miscellany, fol. 1v
Date: ca. 1300
Christ and Four Beasts

Lucca: Lib., Bibl. Capitolare, P †
Passional, fol. 28v
Date: First half 12th cent.
Personification: Virtue, Wisdom

Lucca: Lib., Bibl. Governativa,
lat. 1942
Hildegardis, *Liber Divinorum*,
fol. 132r
Date: ca. 1230
Hildegardis of Bingen: Vision

Lucca: Lib., Bibl. Governativa,
lat. 1942
Hildegardis, *Liber Divinorum*,
fol. 143r
Date: ca. 1230
Hildegardis of Bingen: Vision

Lyons: Lib., Bibl. Municipale, Pal. des
Arts 22
Prudentius, *Psychomachia*, fol. 11v
Date: Last quarter 11th cent.
Personification: Virtue, Faith

Lyons: Lib., Bibl. Municipale, Pal. des
Arts 22
Prudentius, *Psychomachia*, fol. 16v
Date: Last quarter 11th cent.
Personification: Virtue

Lyons: Lib., Bibl. Municipale, Pal. des
Arts 22
Prudentius, *Psychomachia*, fol. 19v
Date: Last quarter 11th cent.
Personification: Virtue, Faith

Madrid: Lib., Bibl. Nacional, 195-6
Bartolus of Sassoferrato, *Comm.*
Date: 14th cent.
Augustine of Hippo

Melbourne: Gall., National, Felton
710/5
Gospel Book, fol. 5v
Date: ca. 1100
Personification: Virtue, Exhortation

Milan: Lib., Bibl. Ambrosiana, B.42
inf.
Giovanni d'Andrea, *Novella*, fol. 1r
Date: 1354
Personification: Virtues, Cardinal

Montecassino: Monastery, 132
Rabanus Maurus, *De Universo*, p. 68
Date: ca. 1023

Moscow: Mus., Historical, gr. 129
Chludoff Psalter, fol. 35r
Date: 9th cent.
Psalm 37 (LXX, 36)

Moscow: Mus., Historical, gr. 129
Chludoff Psalter, fol. 116r
Date: 9th cent.
Psalm 112 (LXX, 111)

Munich: Lib., Staatsbibl., Clm. 13002
Miscellany, fol. 4r
Date: 1158–1165
Joseph: Brethren Begging Forgiveness

Munich: Mus., Staatl. Graphische
 Samml., 39789
Miniature
Date: 12th cent.
Christ: Sermon on Mount

New York: Lib., Morgan, Pierpont,
 M.333
Gospel Book, fol. 51r
Date: Early 11th cent.
Zacharias: Annunciation

New York: Lib., Morgan, Pierpont,
 M.676
Dante, *Divina Commedia*, fol. 83v
Date: Late 14th cent.
Dante: Purgatorio

Oxford: Lib., Bodleian, 270b
Bible, Moralized, fol. 57v
Date: First half 13th cent.
Moses: Teaching

Paris: Lib., Bibl. Nat. de France,
 fr. 9220
Verger de Solas, fol. 2r
Date: 13th–14th cent.
Solomon: Throne

Paris: Lib., Bibl. Nat. de France,
 lat. 1052
Breviary, Charles V, fol. 226r
Date: Second half 14th cent.
Psalm 39 (Vulgate, 38)

Paris: Lib., Bibl. Nat. de France,
 lat. 10483–84
Breviary, Belleville, I, fol. 24v
Date: First half 14th cent.
Psalm 39 (Vulgate, 38)

Paris: Lib., Bibl. Nat. de France,
 lat. 18014
Hours, Duc de Berry, fol. 278v
Date: Late 14th cent.
Solomon: Throne

Rome: Gall., Naz. d'Arte Antica
Bartolomeo di Bartoli, *Canzone*, fol. 8r
Date: 14th cent.

Rome: Lib., Bibl. Vaticana, Barb.
 gr. 372
Psalter, fol. 59v
Date: 11th cent.
Psalm 37 (LXX, 36)

Rome: Lib., Bibl. Vaticana, Barb.
 gr. 372
Psalter, fol. 190r
Date: 11th cent.
Psalm 112 (LXX, 111)

Rome: Lib., Bibl. Vaticana, gr. 394
John Climacus, *Climax*, fol. 71r
Date: Late 11th cent.
John Climacus: Climax, Chapter XI

Rome: Lib., Bibl. Vaticana, gr. 394
John Climacus, *Climax*, fol. 89v
Date: Late 11th cent.
John Climacus: Climax, Chapter XV

Rome: Lib., Bibl. Vaticana, gr. 394
John Climacus, *Climax*, fol. 94r
Date: Late 11th cent.
*John Climacus: Climax, Chapter
 XVIII*

Rome: Lib., Bibl. Vaticana, gr. 394
John Climacus, *Climax*, fol. 151v
Date: Late 11th cent.
*John Climacus: Climax, Chapter
 XXIX*

Rome: Lib., Bibl. Vaticana, gr. 394
John Climacus, *Climax*, fol. 154r
Date: Late 11th cent.
John Climacus: Climax, Chapter XXX

Rome: Lib., Bibl. Vaticana, Urb. gr. 2
Gospel Book, fol. 19v
Date: 1120s
Christ: Crowning

Rome: Lib., Bibl. Vaticana, Urb. gr. 2
Gospel Book, fol. 21r
Date: 1120s
Evangelist: Matthew

Saint-Omer: Lib., Bibl. Municipale, 34
Origen, *Homilies*, fol. 1v
Date: Second quarter 12th cent.
Creation Scene

Salzburg: Lib., Studienbibl., V 1 H 162
Miscellany, fol. 76r
Date: First half 12th cent.
Tree of Virtues

Schauffhausen: Lib., Stadtbibl., Gen. V
Psalter, fol. 10r
Date: First half 13th cent.
Psalms: Illustration

Strasbourg: Lib., Bibl. Municipale
Herradis of Landsberg, *Hort. Delic.*,
 fol. 200r
Date: Second half 12th cent.
Personification: Virtue, Humility

Strasbourg: Lib., Bibl. Municipale
Herradis of Landsberg, *Hort. Delic.*,
 fol. 200v
Date: Second half 12th cent.
Personification: Vice, Wrath

Strasbourg: Lib., Bibl. Municipale
Herradis of Landsberg, *Hort. Delic.*,
 fol. 201r
Date: Second half 12th cent.
Personification: Virtue, Patience

Strasbourg: Lib., Bibl. Municipale
Herradis of Landsberg, *Hort. Delic.*,
 fol. 215v
Date: Second half 12th cent.
Ladder Heavenly

Vienna: Lib., Nationalbibl., 1367
Miscellany, fol. 92v
Date: 12th cent.

Vienna: Lib., Nationalbibl., Ser. Nov.
 2639
Convenevoli de Pratis(?), *Poemata*,
 fol. 2r
Date: Early 14th cent.

Wiesbaden: Lib., Hessische Landes-
 bibl., I
Hildegardis, *Liber Scivias*, fol. 178r
Date: ca. 1165
Hildegardis of Bingen: Vision

METALWORK

Aachen: Cathedral, Treasury
Casket, reliquary, Charlemagne
Date: 1182–1215
Charlemagne: Scene

Berlin: Mus., Staatliche
Bowl, bronze (I.3136)
Date: 13th cent.
Personification: Virtue, Humility

Budapest: Mus., Magyar Nemzeti
 Múzeum
Bowl, bronze
Date: 12th–13th cent.
Personification: Virtue, Humility

Cologne: Cathedral, Treasury
Casket, of Three Kings
Date: 1190–1225
Christ: Last Judgment

Cologne: Ch., Heribert
Casket, S. Heribertus
Date: ca. 1150–1175
Saint

Copenhagen: Mus., National
Altar, copper-gilt (D287)
Date: ca. 1150
Christ

Florence: Baptistery
Door, south, bronze
Attribution: Andrea Pisano
Date: 1330
Zacharias: Annunciation

Hannover: Mus., Kestner
Bowl, bronze-gilt (1894.18)
Date: 12th cent.
Personification: Virtue, Humility

Hildesheim: Cath., Maria
Chandelier, of Hezilo
Date: ca. 1055–1065
Building: City Wall

Leipzig: Mus., Kunsthandwerk
Bowl, bronze-gilt (5011)
Date: ca. 1250
Personification: Virtue, Hope

London: Mus., British
Shrine, silver-gilt (1978,5-2,7)
Date: ca. 1165–1170
Oda of Belgium

Lübeck: Mus., Kunst und Kul-
 turgeschichte
Bowl, copper (130)
Date: 12th–13th cent.
Personification: Virtue, Hope

Lund: Mus., Kulturhistoriska
Bowl (K.M. 10283)
Date: 12th cent.
Personification: Virtue, Hope

Lund: Mus., Kulturhistoriska
Bowl, bronze (25557)
Date: 11th–13th cent.
Personification: Virtue, Humility

Munich: Mus., Bayerisches
 Nationalmus.
Bowl, brass (M.A. 204)
Date: 12th–13th cent.
Personification: Virtue, Humility

Namur: Mus., Archéologique
Reliquary
Date: 12th cent.
Personification: Virtue, Faith

Padua: Mus., Civico
Bowl (664)
Date: 12th cent.

Saint-Gilles: Church
Sarcophagus, gold, of Aegidius
Date: 12th cent.?
Elders, Four and Twenty

Salzburg: Mus., Dom
Bowl, bronze
Date: 12th cent.
Personification: Virtue, Humility

Tallinn: Mus., Institute of History
Bowl, bronze (AI 4143:5)
Date: 12th cent.
Personification: Virtue, Hope

Tallinn: Mus., Institute of History
Bowl, bronze (AI 4143:6)
Date: 12th cent.
Personification: Virtue, Hope

Wrocław: Mus., Archeologiczne
Bowl, bronze
Date: Late 11th–12th cent.
Personification: Virtue, Humility

MISCELLANEOUS

Chantilly: Mus., Condé
Drawing, after Giotto (1)
Date: 14th cent.

MOSAIC

Venice: Ch., Marco
Atrium
Date: Second quarter 13th cent.
Joseph: Dream I

Venice: Ch., Marco
Crossing
Date: Last quarter 12th cent.
Christ: Ascension

PAINTING

Bad Doberan: Ch., Cistercian
Triptych
Date: First half 14th cent.
*Christ: Crucifixion, Nailed to Cross by
 Virtues*

Florence: Ch., Croce
Polyptych
Attribution: Giovanni del Biondo
Date: 1379
Virgin Mary and Christ Child

Florence: Mus., Opera del Duomo
Panel (9152)
Attribution: Bigallo Master
Date: ca. 1240–1250
Zenobius of Florence

Greenwich: Coll., Hyland
Panel
Date: 14th cent.
Virgin Mary and Christ Child

Massa Marittima: Pal., Comunale
Panel
Attribution: Ambrogio Lorenzetti
Date: ca. 1335–1340
Virgin Mary and Christ Child

New York: Coll., Kahn
Panel
Date: 14th cent.
Cosmas of Cilicia

New York: Coll., Wildenstein
Panel
Date: 14th cent.
Virgin Mary and Christ Child

Regensburg: Cath., Peter, Treasury
Casket, reliquary
Date: Second half 13th cent.
Virgin Mary: Death

Rome: Mus., Vaticani, Pinacoteca
Panel (40520)
Date: ca. 1375–1380
Virgin Mary

SCULPTURE

Amiens: Cath., Notre Dame
Exterior, west
Date: 1220–1235
Malachi

Arezzo: Cathedral
Reliquary, S. Donatus
Attribution: Betto di Francesco da
 Firenze, Giovanni di Francesco
 d'Arezzo
Date: After 1362
Christ

Autun: Cath., Lazare
Chapter room
Date: First half 12th cent.
Scene: Ecclesiastic, Donation

Bourg-Argental: Church
Exterior, west
Date: 12th cent.
Christ and Four Beasts

Bruges: Mus., Lapidaire
Brackets
Date: Late 14th cent.
Adam and Eve: Fall of Man

Chartres: Cath., Notre Dame
Exterior, north, central portal
Date: 1205–1210
Virgin Mary: Coronation

Chartres: Cath., Notre Dame
Exterior, north, left portal
Date: ca. 1220
Virgins, Foolish

Chartres: Cath., Notre Dame
Porch, south
Date: ca. 1230–1240
Saint

Clermont-Ferrand: Ch., Notre Dame
 du Port
Choir
Date: 12th cent.
Angel

Cluny: Mus., Farinier
Capitals
Date: Late 11th–early 12th cent.
Personification: Music

Detroit: Mus., Institute of Arts
Statue, marble (43.47)
Attribution: Pacio and Giovanni
 Bertini da Firenze, workshop of
Date: Mid-14th cent.

Florence: Cath., Maria del Fiore
Tomb of Antonio Orso
Attribution: Tino di Camaino
Date: ca. 1321
Antonio Orso

Florence: Ch., Orsanmichele
Tabernacle, marble
Attribution: Orcagna
Date: 1359–1360
Angel: Archangel Michael

Florence: Loggia dei Lanzi
Exterior
Date: 14th cent.
Personification: Virtues, Cardinal

Florence: Mus., Bardini
Statue (12)
Attribution: Tino di Camaino
Date: 14th cent.

Florence: Mus., Opera del Duomo
Relief, marble
Attribution: Tino di Camaino
Date: Early 14th cent.

Florence: Mus., Opera del Duomo
Relief, from bell tower
Attribution: Maestro della Luna
Date: 1337–1341
Personification: Virtue, Faith

Florence: Mus., Opera del Duomo
Relief, possibly eastern door of
 sacristy
Attribution: Master of San Giovanni,
 Giovanni Pisano, Tino di Camaino
Date: 14th cent.

Laon: Cath., Notre Dame
Exterior, west
Date: ca. 1180–1210
Magi: Adoration

Lyons: Mus., Beaux-Arts
Statue, marble (D-613)
Attribution: Pacio and Giovanni
 Bertini da Firenze, workshop of
Date: ca. 1330–1350

Milan: Ch., Eustorgio
Tomb of Peter Martyr
Attribution: Giovanni di Balduccio or
 workshop
Date: 1339
Christ

Monreale: Cath., Maria la Nuova
Cloister
Date: Last quarter 12th cent.
Christ: Parable, Lazarus and Dives

Naples: Ch., Chiara
Tomb of Agnes and Clementia of
 Durazzo
Date: Late 14th cent.
Agnes of Durazzo

Naples: Ch., Chiara
Tomb of Marie of Valois
Attribution: Tino di Camaino or work-
 shop
Date: ca. 1330
Marie of Valois

Naples: Ch., Chiara
Tomb of Robert of Anjou
Attribution: Pacio and Giovanni
 Bertini da Firenze
Date: ca. 1343
Robert of Anjou

Naples: Ch., Domenico Maggiore
Candlestick
Attribution: Pacio and Giovanni
 Bertini da Firenze, workshop of
Date: ca. 1330–1350
Personification: Virtues, Cardinal

Naples: Ch., Lorenzo Maggiore
Tomb of Catherine of Austria
Attribution: Tino di Camaino
Date: ca. 1324
Virgin Mary and Christ Child

Paris: Cath., Notre Dame
Exterior, west
Date: ca. 1220–1230
Christ: Last Judgment

Parma: Baptistery
Exterior
Date: Late 12th–13th cent.
Magi: Adoration

Pavia: Ch., Pietro in Ciel d'Oro
Tomb of Augustine of Hippo
Attribution: Giovanni di Balduccio,
 follower of
Date: Second half 14th cent.
Augustine of Hippo: Scene

Pisa: Baptistery
Pulpit
Attribution: Nicola Pisano
Date: 1260
Virgin Mary: Annunciation

Pisa: Cathedral
Pulpit
Attribution: Giovanni Pisano
Date: 1302–1310
Virgin Mary: Annunciation

Pistoia: Ch., Giovanni Fuorcivitas
Holy water basin
Attribution: Nicola Pisano, work-
 shop of
Date: Late 13th cent.
Personification: Virtues, Cardinal

Poitiers: Cath., Pierre
Choir stalls, wood
Date: Second half 13th–14th cent.
Angel

Puy-en-Velay, Le: Mus., Crozatier
Capital
Date: 12th cent.

Reims: Cath., Notre Dame
Exterior, west
Date: ca. 1230–1240
Virgin Mary: Coronation

Rome: Ch., Francesca Romana
Tomb of Marino Vulcani
Date: 1394–1403
Marino Vulcani

Salisbury: Cathedral, Chapter House
Decoration, vestibule
Date: ca. 1260–1280
*Personification: Virtues and Vices,
 Conflict*

Sens: Cath., Etienne
Exterior, west
Date: Late 12th–13th cent.
Stephen Protomartyr: In Synagogue

Siena: Cath., Assunta
Exterior, south
Date: 13th–14th cent.
Miriam

Siena: Cath., Assunta
Pulpit
Attribution: Nicola Pisano
Date: ca. 1265–1269
Virgin Mary: Visitation

Siena: Cath., Assunta
Statuette
Date: 14th cent.
Figure: Female

Venice: Ch., Giovanni e Paolo
Tomb of Antonio Venier
Attribution: Jacobello and Pierpaolo
 delle Masegne
Date: 1370–1420
Antonio Venier

Venice: Ch., Marco
Exterior, west
Date: 13th cent.
Christ

Verona: Cath., Maria Matricolare
Exterior, west
Date: 12th cent.
Shepherds: Annunciation

Vienna: Coll., Liechtenstein
Relief
Date: 14th cent.

Vienne: Cath., Maurice
Aisles
Date: 12th cent.
Solomon: Judgment

Villeneuve-l'Archêveque: Church
Exterior, north
Date: First half 13th cent.
Virgin Mary: Coronation

Washington: Gall., National Gallery
Relief, marble (1960.5.4)
Attribution: Giovanni di Balduccio
Date: ca. 1330

Worms: Cath., Peter and Paul
Exterior, south
Date: First half 14th cent.
Nicholas of Myra: Scene

CHASTITY

ENAMEL

Brussels: Mus., Royaux d'Art et
 d'Histoire
Plaque, from reliquary (3141)
Date: ca. 1170
Personification: Virtue, Fortitude

Cologne: Ch., Pantaleon
Casket, reliquary, Albanus of Mayence
Date: 1186
Personification: Virtue, Humility

Florence: Mus., Naz. di Bargello
Crozier (Carrand 622)
Date: ca. 1185–1200
David: Slaying Bear

Klosterneuberg: Monastery
Retable
Attribution: Nicolas of Verdun
Date: 1181
Abraham: Entertaining the Angels

Osnabrück: Town Hall, Rathaus
Vessel
Date: First half 14th cent.
Personification: Virtue, Prudence

Saint-Ghislain: Church
Casket, reliquary
Date: Mid-12th cent.
Personification: Virtue, Patience

Troyes: Cath., Pierre, Treasury
Casket
Date: ca. 1200
Personification: Virtue, Faith

FRESCO

Assisi: Ch., Francesco, Lower
Crossing, vault
Date: First half 14th cent.
Allegory: Poverty

Barcelona: Conv., Pedralbes
Chapel, S. Michael
Date: 1345–1346
Christ: In Gethsemane

Bawît: Mon., Apollo
Chapel XII (Clédat)
Date: 6th–7th cent.
Malachi

Florence: Ch., Croce
Chapel, Bardi
Date: First half 14th cent.
Francis of Assisi

Florence: Ch., Croce
Chapel, Baroncelli, back wall
Attribution: Taddeo Gaddi
Date: ca. 1328–1330
Joachim: Offerings Rejected

Florence: Ch., Maria Novella
Chapel, Strozzi, ceiling
Attribution: Giovanni del Biondo,
 Nardo di Cione
Date: ca. 1350–1360
Thomas Aquinas

Gurk: Cath., Maria Himmelfahrt
Gallery, west
Date: 13th cent.
Virgin Mary and Christ Child

Montoire: Ch., Gilles
Crossing
Date: 12th cent.
Lamb of God

Pisa: Ch., Francesco
Choir
Date: 1342
Francis of Assisi

Pistoia: Ch., Francesco
Choir
Date: 1343
Francis of Assisi: Scene

Prufening: Ch., Monastery
Choir
Date: 12th cent.
Personification: Church

Siena: Ch., Francesco
Chapel, Bandini Piccolomini
Date: First half 14th cent.
Louis of Toulouse: Scene

GLASS

Esslingen: Ch., Dionysius
Windows, choir
Date: Late 13th–14th cent.
Isaiah

Lyons: Cath., Jean
Window, apse
Date: ca. 1220
Magi: Before Herod the Great

Niederhaslach: Ch., Florentius
Windows, nave
Date: 1290–1420
Christ: Parable, Prodigal Son

Paris: Cath., Notre Dame
Window, west rose
Date: First half 13th cent.
Virgin Mary and Christ Child

Strasbourg: Cath., Notre Dame
Windows, nave
Date: 14th cent.
Personification: Virtue, Wisdom

Strasbourg: Cath., Notre Dame
Windows, southern transept
Date: 13th cent.
Apostle: Matthias

IVORY

London: Lib., British
Plaques, in book cover (Egerton 1139)
Date: 1131–1143
David: Slaying Lion

MANUSCRIPT

Berne: Lib., Stadtbibl., 264
Prudentius, *Psychomachia*, fol. 35v
Date: Early 10th cent.
Personification: Virtue, Faith

Berne: Lib., Stadtbibl., 264
Prudentius, *Psychomachia*, fol. 36r
Date: Early 10th cent.

Berne: Lib., Stadtbibl., 264
Prudentius, *Psychomachia*, fol. 36v
Date: Early 10th cent.

Berne: Lib., Stadtbibl., 264
Prudentius, *Psychomachia*, fol. 37v
Date: Early 10th cent.

Berne: Lib., Stadtbibl., 264
Prudentius, *Psychomachia*, fol. 38r
Date: Early 10th cent.

Brussels: Lib., Bibl. Royale, 9968-72
Prudentius, *Psychomachia*, fol. 79r
Date: 11th cent.
Personification: Virtue, Faith

Brussels: Lib., Bibl. Royale, 9968-72
Prudentius, *Psychomachia*, fol. 79v
Date: 11th cent.

Brussels: Lib., Bibl. Royale, 9968-72
Prudentius, *Psychomachia*, fol. 80r
Date: 11th cent.

Brussels: Lib., Bibl. Royale, 9968-72
Prudentius, *Psychomachia*, fol. 81r
Date: 11th cent.

Brussels: Lib., Bibl. Royale, 9968-72
Prudentius, *Psychomachia*, fol. 81v
Date: 11th cent.

Brussels: Lib., Bibl. Royale, 9987-91
Prudentius, *Psychomachia*, fol. 100v
Date: 10th cent.

Brussels: Lib., Bibl. Royale, 9987-91
Prudentius, *Psychomachia*, fol. 101r
Date: 10th cent.

Brussels: Lib., Bibl. Royale, 9987-91
Prudentius, *Psychomachia*, fol. 102r
Date: 10th cent.

Brussels: Lib., Bibl. Royale, 9987-91
Prudentius, *Psychomachia*, fol. 102v
Date: 10th cent.

Brussels: Lib., Bibl. Royale, 10066-77
Prudentius, *Psychomachia*, fol. 116r
Date: 10th–first half 11th cent.

Brussels: Lib., Bibl. Royale, 10066-77
Prudentius, *Psychomachia*, fol. 116v
Date: 10th–first half 11th cent.

Brussels: Lib., Bibl. Royale, 10066-77
Prudentius, *Psychomachia*, fol. 117v
Date: 10th–first half 11th cent

Brussels: Lib., Bibl. Royale, 10066-77
Prudentius, *Psychomachia*, fol. 118r
Date: 10th–first half 11th cent.

Cambridge: Lib., Corpus Christi
 College, 23
Prudentius, *Psychomachia*, fol. 8r
Date: Early 11th cent.

Cambridge: Lib., Corpus Christi
 College, 23
Prudentius, *Psychomachia*, fol. 8v
Date: Early 11th cent.

Cambridge: Lib., Corpus Christi
 College, 23
Prudentius, *Psychomachia*, fol. 9r
Date: Early 11th cent.

Cambridge: Lib., Corpus Christi
 College, 23
Prudentius, *Psychomachia*, fol. 10r
Date: Early 11th cent

Cambridge: Lib., Corpus Christi
 College, 23
Prudentius, *Psychomachia*, fol. 10v
Date: Early 11th cent.

Cambridge: Mus., Fitzwilliam, 368
Somme le Roi
Date: ca. 1300

Florence: Lib., Bibl. Laurenziana,
 Plut. XLII.19
Brunetto Latini, *Tesoro*, fol. 47v
Date: 14th cent.

Ghent: Lib., Bibl. de l'Université, 92
Lambertus, *Liber Floridus*, fol. 231v
Date: 1120
Tree of Virtues

Hannover: Lib., Niedersächsische
 Landesbibl., I.82
Somme le Roi, fol. 145r
Date: Early 14th cent.
Personification: Vice, Luxury

Leiden: Lib., Bibl. der Univ., Burm. Q.3
Prudentius, *Psychomachia*, fol. 123v
Date: Second quarter 9th cent.

Leiden: Lib., Bibl. der Univ., Burm. Q.3
Prudentius, *Psychomachia*, fol. 124r
Date: Second quarter 9th cent.

Leiden: Lib., Bibl. der Univ., Burm. Q.3
Prudentius, *Psychomachia*, fol. 125r
Date: Second quarter 9th cent.

Leiden: Lib., Bibl. der Univ., Burm. Q.3
Prudentius, *Psychomachia*, fol. 125v
Date: Second quarter 9th cent.

Leiden: Lib., Bibl. der Univ., Voss. lat.
 oct. 15
Prudentius, *Psychomachia*, fol. 37v
Date: Early 11th cent.
Abraham: Blessed by Melchisedek

Leiden: Lib., Bibl. der Univ., Voss. lat.
 oct. 15
Prudentius, *Psychomachia*, fol. 38r
Date: Early 11th cent.

London: Lib., British, Add. 24199
Prudentius, *Psychomachia*, fol. 5v
Date: Early 11th cent.
Personification: Virtue, Faith

London: Lib., British, Add. 24199
Prudentius, *Psychomachia*, fol. 6r
Date: Early 11th cent.

London: Lib., British, Add. 24199
Prudentius, *Psychomachia*, fol. 6v
Date: Early 11th cent.

London: Lib., British, Add. 24199
Prudentius, *Psychomachia*, fol. 7v
Date: Early 11th cent.

London: Lib., British, Add. 24199
Prudentius, *Psychomachia*, fol. 8r
Date: Early 11th cent.

London: Lib., British, Add. 38120
G. de Degulleville, *Pèlerinage*,
 fol. 103r
Date: ca. 1400
*Guillaume de Degulleville: Pèlerinage
 de Vie Humaine*

London: Lib., British, Cott. Cleo.
 C.VIII
Prudentius, *Psychomachia*, fol. 4v
Date: Early 11th cent.
Personification: Virtue, Faith

London: Lib., British, Cott. Cleo.
 C.VIII
Prudentius, *Psychomachia*, fol. 5r
Date: Early 11th cent.
Personification: Vice, Lust

London: Lib., British, Cott. Cleo.
 C.VIII
Prudentius, *Psychomachia*, fol. 5v
Date: Early 11th cent.

London: Lib., British, Cott. Cleo.
 C.VIII
Prudentius, *Psychomachia*, fol. 6v
Date: Early 11th cent.

London: Lib., British, Cott. Cleo.
 C.VIII
Prudentius, *Psychomachia*, fol. 7r
Date: Early 11th cent.

London: Lib., British, Cott. Titus
 D.XVI
Prudentius, *Psychomachia*, fol. 6v
Date: ca. 1100

London: Lib., British, Cott. Titus
 D.XVI
Prudentius, *Psychomachia*, fol. 7r
Date: ca. 1100

London: Lib., British, Cott. Titus
 D.XVI
Prudentius, *Psychomachia*, fol. 7v
Date: ca. 1100

London: Lib., British, Cott. Titus
 D.XVI
Prudentius, *Psychomachia*, fol. 8v
Date: ca. 1100

London: Lib., British, Harley 1526–27
Bible, Moralized, II, fol. 110v
Date: First half 13th cent.
Apostle: Paul Preaching

London: Lib., British, Roy. 19 C.II
Somme le Roi, fol. 85v
Date: 14th cent.
Personification: Vice, Luxury

Lyons: Lib., Bibl. Municipale, Pal. des
 Arts 22
Prudentius, *Psychomachia*, fol. 6v
Date: Last quarter 11th cent.

Munich: Lib., Staatsbibl., Clm. 30055
Gospel Book, Henry the Lion, fol. 15v
Date: ca. 1175
Apostle: Simon

Nuremberg: Mus., Germ. Nat. Bibl.,
 156142
Gospel Book, Echternach, fol. 114r
Date: 10th–11th cent.
Personification: Virtue, Virginity

Oxford: Lib., Bodleian, 270b
Bible, Moralized, fol. 40r
Date: First half 13th cent.
*Moses and Daughters of Jethro:
 At Well*

Oxford: Lib., Bodleian, 270b
Bible, Moralized, fol. 57v
Date: First half 13th cent.
Moses: Teaching

Oxford: Lib., Bodleian, 270b
Bible, Moralized, fol. 58r
Date: First half 13th cent.
Moses: Law, Meat Offering

Oxford: Lib., Bodleian, 270b
Bible, Moralized, fol. 84r
Date: First half 13th cent.
Moses: Instructing Israelites

Paris: Lib., Bibl. Mazarine, 870
Somme le Roi, fol. 147r
Date: 1295

Paris: Lib., Bibl. Nat. de France,
 fr. 9220
Verger de Solas, fol. 2r
Date: 13th–14th cent.
Solomon: Throne

Paris: Lib., Bibl. Nat. de France,
 fr. 9561
Bible, Moralized, fol. 77r
Date: ca. 1370
Moses: Law, Meat Offering

Paris: Lib., Bibl. Nat. de France,
 lat. 2077
Miscellany, fol. 173r
Date: 10th–11th cent.
Personification: Vice, Luxury

Paris: Lib., Bibl. Nat. de France,
 lat. 8085
Prudentius, *Psychomachia*, fol. 57r
Date: Late 9th cent.
Personification: Virtue, Faith

Paris: Lib., Bibl. Nat. de France,
 lat. 8085
Prudentius, *Psychomachia*, fol. 57v
Date: Late 9th cent.

Paris: Lib., Bibl. Nat. de France,
 lat. 8085
Prudentius, *Psychomachia*, fol. 58r
Date: Late 9th cent.

Paris: Lib., Bibl. Nat. de France,
 lat. 8318
Prudentius, *Psychomachia*, fol. 53v
Date: Late 10th cent.
Personification: Vice, Fornication

Paris: Lib., Bibl. Nat. de France,
 lat. 18554
Prudentius, *Psychomachia*, fol. 142r
Date: 10th cent.

Paris: Lib., Bibl. Nat. de France,
 lat. 18554
Prudentius, *Psychomachia*, fol. 142v
Date: 10th cent.

Saint Gall: Lib., Stiftsbibl., 135
Prudentius, *Psychomachia*, p. 391
Date: First half 11th cent.

Soissons: Coll., Grand Séminaire
Gautier de Coincy, *Miracles N.D.*,
 fol. Aro
Date: 14th cent.
Virgin Mary and Christ Child

Strasbourg: Lib., Bibl. Municipale
Herradis of Landsberg, *Hort. Delic.*,
 fol. 67v
Date: Second half 12th cent.
Christ

Strasbourg: Lib., Bibl. Municipale
Herradis of Landsberg, *Hort. Delic.*,
 fol. 200r
Date: Second half 12th cent.
Personification: Virtue, Humility

Valenciennes: Lib., Bibl. Municipale, 563
Prudentius, *Psychomachia*, fol. 5r
Date: Early 11th cent.
Personification: Virtue, Faith

Valenciennes: Lib., Bibl. Municipale, 563
Prudentius, *Psychomachia*, fol. 5v
Date: Early 11th cent.

Valenciennes: Lib., Bibl. Municipale, 563
Prudentius, *Psychomachia*, fol. 6r
Date: Early 11th cent.

Valenciennes: Lib., Bibl. Municipale, 563
Prudentius, *Psychomachia*, fol. 7r
Date: Early 11th cent.

Valenciennes: Lib., Bibl. Municipale, 563
Prudentius, *Psychomachia*, fol. 7v
Date: Early 11th cent.

Vienna: Lib., Nationalbibl., 1179
Bible, Moralized, fol. 43r
Date: ca. 1215–1230
Moses: Law, Offering of Herd

Vienna: Lib., Nationalbibl., 2554
Bible, Moralized, fol. 27r
Date: ca. 1215–1230
Moses: Law, Offering of Herd

Wiesbaden: Lib., Hessische Landesbibl., I
Hildegardis, *Liber Scivias*, fol. 178r
Date: ca. 1165
Hildegardis of Bingen: Vision

Wolfenbüttel: Lib., Herzog August Bibl., Guelf. 105 Noviss. 2°
Gospel Book, Henry the Lion, fol. 15v
Date: ca. 1175
Apostle: Simon

METALWORK

Cologne: Cathedral, Treasury
Casket, of Three Kings
Date: 1190–1225
Christ: Last Judgment

Hannover: Mus., Kestner
Bowl, bronze-gilt (1894.18)
Date: 12th cent.
Personification: Virtue, Humility

Hildesheim: Cath., Maria
Chandelier, of Hezilo
Date: ca. 1055–1065
Building: City Wall

Leipzig: Mus., Kunsthandwerk
Bowl, bronze-gilt (5011)
Date: ca. 1250
Personification: Virtue, Hope

Lübeck: Mus., Kunst und Kulturgeschichte
Bowl, copper (130)
Date: 12th–13th cent.
Personification: Virtue, Hope

Manchester: Lib., Rylands
Book cover, silver-gilt (lat. 4)
Date: ca. 1150–1175
Saint?

Trier: Ch., Maximin
Font, of Folcardus
Date: Early 12th cent.
Personification: Virtue, Humility

SCULPTURE

Amiens: Cath., Notre Dame
Exterior, west
Date: 1220–1235
Malachi

Argenton-Château: Ch., Gilles
Exterior, west
Date: After 1130
Ornament: Figured

Aulnay-de-Saintonge: Ch., Pierre
Exterior, west
Date: ca. 1130–1150
Month: Occupation

Chartres: Cath., Notre Dame
Porch, south
Date: ca. 1230–1240
Saint

Foussais: Ch., Hilaire
Exterior, west
Date: 12th cent.
Christ and Four Beasts

Laon: Cath., Notre Dame
Exterior, west
Date: ca. 1180–1210
Magi: Adoration

Parma: Baptistery
Exterior
Date: Late 12th–13th cent.
Magi: Adoration

Pavia: Ch., Pietro in Ciel d'Oro
Tomb of Augustine of Hippo
Attribution: Giovanni di Balduccio,
 follower of
Date: Second half 14th cent.
Augustine of Hippo: Scene

Pisa: Baptistery
Pulpit
Attribution: Nicola Pisano
Date: 1260
Virgin Mary: Annunciation

Reims: Cath., Notre Dame
Exterior, west
Date: ca. 1230–1240
Virgin Mary: Coronation

Salisbury: Cathedral, Chapter House
Decoration, vestibule
Date: ca. 1260–1280
*Personification: Virtues and Vices,
 Conflict*

Sens: Cath., Etienne
Exterior, west
Date: Late 12th–13th cent.
Stephen Protomartyr: In Synagogue

Stanton Fitzwarren: Church
Font
Date: ca. 1160
Personification: Church

Strzelno: Ch., Trinity
Nave, column
Date: Last quarter 12th cent.
Christ: Baptism

Tournai: Cath., Notre Dame
Exterior, north
Date: ca. 1140–1170
Ornament: Figured

Vézelay: Ch., Madeleine
Nave
Date: First half 12th cent.
Saint

TEXTILE

Paris: Mus., Moyen Age, Cluny
Purse, embroidery (Cl. 11788)
Date: 14th cent.
Angel

Quedlinburg: Church, Treasury
Hanging, tapestry
Date: 1186–1203

CHIVALRY

MANUSCRIPT

Vienna: Lib., Nationalbibl., 2583*
Matfre Ermengaud, *Brev. d'Amor*,
 fol. 237v
Date: 14th cent.
Personification: Virtue, Generosity

COMPASSION

GLASS

Strasbourg: Cath., Notre Dame
Windows, southern transept
Date: 13th cent.
Apostle: Matthias

MANUSCRIPT

Strasbourg: Lib., Bibl. Municipale
Herradis of Landsberg, *Hort. Delic.*,
 fol. 67v
Date: Second half 12th cent.
Christ

Strasbourg: Lib., Bibl. Municipale
Herradis of Landsberg, *Hort. Delic.*,
 fol. 201r
Date: Second half 12th cent.
Personification: Virtue, Patience

Venice: Lib., Bibl. Marciana, gr. Z. 540
 (557)
Gospel Book, fol. 7r
Date: Early 12th cent.
Personification: Virtue, Gentleness

COMPUNCTION

MANUSCRIPT

Heidelberg: Lib., Universitätsbibl.,
 Sal. X.16
Hildegardis, *Liber Scivias*, fol. 111v
Date: 12th cent.
Hildegardis of Bingen: Vision

Strasbourg: Lib., Bibl. Municipale
Herradis of Landsberg, *Hort. Delic.*,
 fol. 200r
Date: Second half 12th cent.
Personification: Virtue, Humility

Strasbourg: Lib., Bibl. Municipale
Herradis of Landsberg, *Hort. Delic.*,
 fol. 201r
Date: Second half 12th cent.
Personification: Virtue, Patience

Wiesbaden: Lib., Hessische
 Landesbibl., I
Hildegardis, *Liber Scivias*, fol. 202v
Date: ca. 1165
Hildegardis of Bingen: Vision

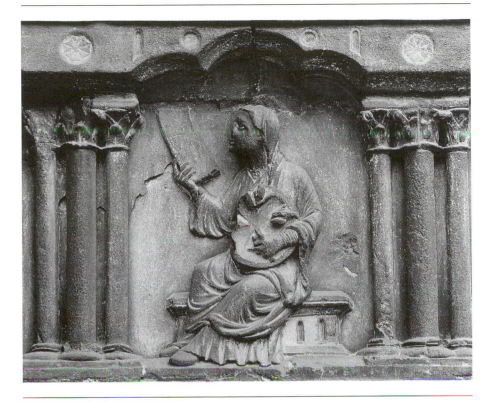

CONCORD

ENAMEL

Brussels: Mus., Royaux d'Art et
 d'Histoire
Plaque, from reliquary (3141)
Date: ca. 1170
Personification: Virtue, Fortitude

Florence: Mus., Naz. di Bargello
Crozier (Carrand 622)
Date: ca. 1185–1200
David: Slaying Bear

Klosterneuberg: Monastery
Retable
Date: 1322–1331
Abraham: Entertaining the Angels

Osnabrück: Town Hall, Rathaus
Vessel
Date: First half 14th cent.
Personification: Virtue, Prudence

Troyes: Cath., Pierre, Treasury
Casket
Date: ca. 1200
Personification: Virtue, Faith

FRESCO

Aquileia: Cathedral
Crypt
Date: 1180s

Brioude: Ch., Julien
Porch
Date: 12th–13th cent.
Christ: Last Judgment

Siena: Pal., Pubblico
Room, Pace
Attribution: Ambrogio Lorenzetti
Date: 1338–1339
Personification: Virtue, Justice

GLASS

Esslingen: Ch., Dionysius
Windows, choir
Date: Late 13th–14th cent.
Isaiah

Paris: Cath., Notre Dame
Window, west rose
Date: First half 13th cent.
Virgin Mary and Christ Child

Strasbourg: Cath., Notre Dame
Windows, nave
Date: 14th cent.
Personification: Virtue, Wisdom

IVORY

London: Lib., British
Plaques, in book cover (Egerton 1139)
Date: 1131–1143
Daniel: Slaying Lion

MANUSCRIPT

Brussels: Lib., Bibl. Royale, 9968-72
Prudentius, *Psychomachia*, fol. 107v
Date: 11th cent.

Brussels: Lib., Bibl. Royale, 9987-91
Prudentius, *Psychomachia*, fol. 119r
Date: 10th cent.
God: Hand

Brussels: Lib., Bibl. Royale, 9987-91
Prudentius, *Psychomachia*, fol. 122r
Date: 10th cent.
Personification: Virtue, Faith

Brussels: Lib., Bibl. Royale, 9987-91
Prudentius, *Psychomachia*, fol. 122v
Date: 10th cent.
Personification: Virtue, Faith

Brussels: Lib., Bibl. Royale, 9987-91
Prudentius, *Psychomachia*, fol. 123v
Date: 10th cent.
Personification: Virtue, Faith

Brussels: Lib., Bibl. Royale, 9987-91
Prudentius, *Psychomachia*, fol. 124r
Date: 10th cent.
Personification: Virtue, Faith

Brussels: Lib., Bibl. Royale, 10066-77
Prudentius, *Psychomachia*, fol. 134r
Date: 10th–first half 11th cent.
Personification: Virtue, Faith

Brussels: Lib., Bibl. Royale, 10066-77
Prudentius, *Psychomachia*, fol. 135v
Date: 10th–first half 11th cent.
Personification: Virtue, Faith

Brussels: Lib., Bibl. Royale, 10066-77
Prudentius, *Psychomachia*, fol. 137r
Date: 10th–first half 11th cent.
Personification: Virtue, Faith

Cambridge: Lib., Corpus Christi
 College, 23
Prudentius, *Psychomachia*, fol. 34r
Date: Early 11th cent.

Cambridge: Lib., Corpus Christi
 College, 23
Prudentius, *Psychomachia*, fol. 35r
Date: Early 11th cent.
Personification: Vice, Discord

Cambridge: Lib., Corpus Christi
 College, 23
Prudentius, *Psychomachia*, fol. 37v
Date: Early 11th cent.
Personification: Virtue, Faith

Cambridge: Lib., Corpus Christi
 College, 23
Prudentius, *Psychomachia*, fol. 38r
Date: Early 11th cent.
Personification: Virtue, Faith

Cambridge: Lib., Corpus Christi
 College, 23
Prudentius, *Psychomachia*, fol. 39v
Date: Early 11th cent.
Personification: Virtue, Faith

Cambridge: Lib., Corpus Christi
 College, 23
Prudentius, *Psychomachia*, fol. 40r
Date: Early 11th cent.
Personification: Virtue, Faith

Heidelberg: Lib., Universitätsbibl.,
 Sal. X.16
Hildegardis, *Liber Scivias*, fol. 111v
Date: 12th cent.
Hildegardis of Bingen: Vision

Leiden: Lib., Bibl. der Univ., Burm. Q.3
Prudentius, *Psychomachia*, fol. 142r
Date: Second quarter 9th cent.
God: Hand

Leiden: Lib., Bibl. der Univ., Burm. Q.3
Prudentius, *Psychomachia*, fol. 143r
Date: Second quarter 9th cent.

Leiden: Lib., Bibl. der Univ., Burm. Q.3
Prudentius, *Psychomachia*, fol. 145r
Date: Second quarter 9th cent.
Personification: Virtue, Faith

Leiden: Lib., Bibl. der Univ., Burm. Q.3
Prudentius, *Psychomachia*, fol. 145v
Date: Second quarter 9th cent.
Personification: Virtue, Faith

Leiden: Lib., Bibl. der Univ., Burm. Q.3
Prudentius, *Psychomachia*, fol. 146v
Date: Second quarter 9th cent.
Personification: Virtue, Faith

Leiden: Lib., Bibl. der Univ., Burm. Q.3
Prudentius, *Psychomachia*, fol. 147r
Date: Second quarter 9th cent.
Personification: Virtue, Faith

Leiden: Lib., Bibl. der Univ., Voss.
 lat. oct. 15
Prudentius, *Psychomachia*, fol. 42r
Date: Early 11th cent.

Leiden: Lib., Bibl. der Univ., Voss.
 lat. oct. 15
Prudentius, *Psychomachia*, fol. 42v
Date: Early 11th cent.
Personification: Vice, Discord

Leiden: Lib., Bibl. der Univ., Voss.
 lat. oct. 15
Prudentius, *Psychomachia*, fol. 43r
Date: Early 11th cent.

London: Lib., British, Add. 24199
Prudentius, *Psychomachia*, fol. 30r
Date: Early 11th cent.

London: Lib., British, Add. 24199
Prudentius, *Psychomachia*, fol. 31r
Date: Early 11th cent.
Personification: Vice, Discord

London: Lib., British, Add. 24199
Prudentius, *Psychomachia*, fol. 33v
Date: Early 11th cent.

London: Lib., British, Cott. Cleo.
 C.VIII
Prudentius, *Psychomachia*, fol. 27v
Date: Early 11th cent.

London: Lib., British, Cott. Cleo.
 C.VIII
Prudentius, *Psychomachia*, fol. 28r
Date: Early 11th cent.

London: Lib., British, Cott. Cleo.
 C.VIII
Prudentius, *Psychomachia*, fol. 28v
Date: Early 11th cent.
Personification: Vice, Discord

London: Lib., British, Cott. Cleo.
 C.VIII
Prudentius, *Psychomachia*, fol. 31v
Date: Early 11th cent.
Personification: Virtue, Faith

London: Lib., British, Cott. Titus
 D.XVI
Prudentius, *Psychomachia*, fol. 26v
Date: ca. 1100

London: Lib., British, Cott. Titus
 D.XVI
Prudentius, *Psychomachia*, fol. 29r
Date: ca. 1100
Personification: Virtue, Faith

London: Lib., British, Cott. Titus
 D.XVI
Prudentius, *Psychomachia*, fol. 29v
Date: ca. 1100
Personification: Virtue, Faith

London: Lib., British, Cott. Titus
 D.XVI
Prudentius, *Psychomachia*, fol. 30r
Date: ca. 1100

Lyons: Lib., Bibl. Municipale, Pal. des
 Arts 22
Prudentius, *Psychomachia*, fol. 11r
Date: Last quarter 11th cent.
Personification: Virtue, Faith

Lyons: Lib., Bibl. Municipale, Pal. des
 Arts 22
Prudentius, *Psychomachia*, fol. 11v
Date: Last quarter 11th cent.
Personification: Virtue, Faith

Lyons: Lib., Bibl. Municipale, Pal. des
 Arts 22
Prudentius, *Psychomachia*, fol. 12v
Date: Last quarter 11th cent.
Personification: Virtue, Faith

Lyons: Lib., Bibl. Municipale, Pal. des
 Arts 22
Prudentius, *Psychomachia*, fol. 16v
Date: Last quarter 11th cent.
Personification: Virtue

Lyons: Lib., Bibl. Municipale, Pal. des
 Arts 22
Prudentius, *Psychomachia*, fol. 18v
Date: Last quarter 11th cent.

Lyons: Lib., Bibl. Municipale, Pal. des
 Arts 22
Prudentius, *Psychomachia*, fol. 19v
Date: Last quarter 11th cent.
Personification: Virtue, Faith

Munich: Lib., Staatsbibl., Clm. 30055
Gospel Book, Henry the Lion, fol. 15v
Date: ca. 1175
Apostle: Simon

Munich: Lib., Staatsbibl., Clm. 30055
Gospel Book, Henry the Lion, fol. 17v
Date: ca. 1175
Evangelist: Luke

Munich: Lib., Staatsbibl., Clm. 30055
Gospel Book, Henry the Lion, fol. 18v
Date: ca. 1175
John Baptist

Paris: Lib., Bibl. Nat. de France,
 lat. 8085
Prudentius, *Psychomachia*, fol. 66r
Date: Late 9th cent.
Personification: Virtue, Generosity

Paris: Lib., Bibl. Nat. de France,
 lat. 8085
Prudentius, *Psychomachia*, fol. 66v
Date: Late 9th cent.

Paris: Lib., Bibl. Nat. de France,
 lat. 8085
Prudentius, *Psychomachia*, fol. 67v
Date: Late 9th cent.
Personification: Vice, Discord

Paris: Lib., Bibl. Nat. de France,
 lat. 8085
Prudentius, *Psychomachia*, fol. 68r
Date: Late 9th cent.
Personification: Virtue, Faith

Paris: Lib., Bibl. Nat. de France,
 lat. 8085
Prudentius, *Psychomachia*, fol. 68v
Date: Late 9th cent.
Personification: Virtue, Faith

Paris: Lib., Bibl. Nat. de France,
 lat. 8318
Prudentius, *Psychomachia*, fol. 62r
Date: Late 10th cent.
Soldier

Paris: Lib., Bibl. Nat. de France,
 lat. 8318
Prudentius, *Psychomachia*, fol. 62v
Date: Late 10th cent.

Paris: Lib., Bibl. Nat. de France,
 lat. 8318
Prudentius, *Psychomachia*, fol. 63r
Date: Late 10th cent.
Personification: Vice, Discord

Paris: Lib., Bibl. Nat. de France,
 lat. 15158
Prudentius, *Psychomachia*, fol. 56v
Date: 1289

Paris: Lib., Bibl. Nat. de France,
 lat. 15158
Prudentius, *Psychomachia*, fol. 57r
Date: 1289

Paris: Lib., Bibl. Nat. de France,
 lat. 15158
Prudentius, *Psychomachia*, fol. 57v
Date: 1289
Personification: Vice, Discord

Paris: Lib., Bibl. Nat. de France,
 lat. 15158
Prudentius, *Psychomachia*, fol. 59r
Date: 1289
Personification: Virtue, Faith

Paris: Lib., Bibl. Nat. de France,
 lat. 15158
Prudentius, *Psychomachia*, fol. 59v
Date: 1289
Personification: Virtue, Faith

Paris: Lib., Bibl. Nat. de France,
 lat. 15158
Prudentius, *Psychomachia*, fol. 60v
Date: 1289
Personification: Virtue, Faith

Paris: Lib., Bibl. Nat. de France,
 lat. 15158
Prudentius, *Psychomachia*, fol. 61v
Date: 1289
Personification: Virtue, Faith

Paris: Lib., Bibl. Nat. de France,
 lat. 15158
Prudentius, *Psychomachia*, fol. 62r
Date: 1289
Personification: Virtue, Faith

Pommersfelden: Coll., Schönborn,
 Library, 215
Miscellany, fol. 161r
Date: 14th cent.
Alanus de Insulis: Text

Rome: Lib., Bibl. Vaticana, Reg.
 lat. 596
Prudentius, *Psychomachia*, fol. 26r
Date: Late 10th cent.

Saint Gall: Lib., Stiftsbibl., 135
Prudentius, *Psychomachia*, p. 426
Date: First half 11th cent.

Saint Gall: Lib., Stiftsbibl., 135
Prudentius, *Psychomachia*, p. 429
Date: First half 11th cent.

Valenciennes: Lib., Bibl. Municipale,
 563
Prudentius, *Psychomachia*, fol. 32r
Date: Early 11th cent.

Valenciennes: Lib., Bibl. Municipale,
 563
Prudentius, *Psychomachia*, fol. 36r
Date: Early 11th cent.
Personification: Virtue, Faith

Valenciennes: Lib., Bibl. Municipale,
 563
Prudentius, *Psychomachia*, fol. 36v
Date: Early 11th cent.
Personification: Virtue, Faith

Valenciennes: Lib., Bibl. Municipale,
 563
Prudentius, *Psychomachia*, fol. 37r
Date: Early 11th cent.
Personification: Virtue, Faith

Valenciennes: Lib., Bibl. Municipale,
 563
Prudentius, *Psychomachia*, fol. 38v
Date: Early 11th cent.
Personification: Virtue, Faith

Valenciennes: Lib., Bibl. Municipale,
 563
Prudentius, *Psychomachia*, fol. 39r
Date: Early 11th cent.
Personification: Virtue, Faith

Wiesbaden: Lib., Hessische
Landesbibl., I
Hildegardis, *Liber Scivias*, fol. 202v
Date: ca. 1165
Hildegardis of Bingen: Vision

Wolfenbüttel: Lib., Herzog August
Bibl., Guelf. 105 Noviss. 2°
Gospel Book, Henry the Lion, fol. 15v
Date: ca. 1175
Apostle: Simon

Wolfenbüttel: Lib., Herzog August
Bibl., Guelf. 105 Noviss. 2°
Gospel Book, Henry the Lion, fol. 17v
Date: ca. 1175
Evangelist: Luke

Wolfenbüttel: Lib., Herzog August
Bibl., Guelf. 105 Noviss. 2°
Gospel Book, Henry the Lion, fol. 18v
Date: ca. 1175
John Baptist

METALWORK

Cologne: Cathedral, Treasury
Casket, of Three Kings
Date: 1190–1225
Christ: Last Judgment

Hannover: Mus., Kestner
Bowl, bronze-gilt (1894.18)
Date: 12th cent.
Personification: Virtue, Humility

Trier: Ch., Maximin
Font, of Folcardus
Date: Early 12th cent.
Personification: Virtue, Humility

SCULPTURE

Amiens: Cath., Notre Dame
Exterior, west
Date: 1220–1235
Malachi

Argenton-Château: Ch., Gilles
Exterior, west
Date: After 1130
Ornament: Figured

Aulnay-de-Saintonge: Ch., Pierre
Exterior, west
Date: ca. 1130–1150
Month: Occupation

Chartres: Cath., Notre Dame
Porch, south
Date: ca. 1230–1240
Saint

Paris: Cath., Notre Dame
Exterior, west
Date: ca. 1220–1230
Christ: Last Judgment

Saint-Pierre-le-Moutier: Church
Decoration
Date: First half 12th cent.

CONFESSION

GLASS

Strasbourg: Cath., Notre Dame
Windows, southern transept
Date: 13th cent.
Apostle: Matthias

MANUSCRIPT

Strasbourg: Lib., Bibl. Municipale
Herradis of Landsberg, *Hort. Delic.*,
fol. 67v
Date: Second half 12th cent.
Christ

Strasbourg: Lib., Bibl. Municipale
Herradis of Landsberg, *Hort. Delic.*,
 fol. 200r
Date: Second half 12th cent.
Personification: Virtue, Humility

CONFIDENCE

MANUSCRIPT

Strasbourg: Lib., Bibl. Municipale
Herradis of Landsberg, *Hort. Delic.*,
 fol. 204r
Date: Second half 12th cent.
Personification: Virtue, Mercy

CONSOLATION

MANUSCRIPT

Strasbourg: Lib., Bibl. Municipale
Herradis of Landsberg, *Hort. Delic.*,
 fol. 201r
Date: Second half 12th cent.
Personification: Virtue, Patience

CONSTANCY

MANUSCRIPT

Florence: Lib., Bibl. Laurenziana,
 Plut. XLII.19
Brunetto Latini, *Tesoro*, fol. 47v
Date: 14th cent.
Personification: Virtue, Chastity

Heidelberg: Lib., Universitätsbibl.,
 Sal. X.16
Hildegardis, *Liber Scivias*, fol. 111v
Date: 12th cent.
Hildegardis of Bingen: Vision

Strasbourg: Lib., Bibl. Municipale
Herradis of Landsberg, *Hort. Delic.*,
 fol. 204r
Date: Second half 12th cent.
Personification: Virtue, Mercy

Wiesbaden: Lib., Hessische
 Landesbibl., I
Hildegardis, *Liber Scivias*, fol. 202v
Date: ca. 1165
Hildegardis of Bingen: Vision

CONTEMPLATION

MANUSCRIPT

Florence: Lib., Bibl. Laurenziana,
 Plut. XLII.19
Brunetto Latini, *Tesoro*, fol. 57r
Date: 14th cent.

Melbourne: Gall., National, Felton
 710/5
Gospel Book, fol. 6r
Date: ca. 1100
Personification: Virtue, Wisdom

Oxford: Lib., Bodleian, 270b
Bible, Moralized, fol. 4r
Date: First half 13th cent.
Creation Scene

Strasbourg: Lib., Bibl. Municipale
Herradis of Landsberg, *Hort. Delic.*,
 fol. 200r
Date: Second half 12th cent.
Personification: Virtue, Humility

Toledo: Lib., Bibl. del Cabildo
Bible, Moralized, I, fol. 4r
Date: First half 13th cent.
Creation Scene

CONTEMPT OF WORLD

MANUSCRIPT

Heidelberg: Lib., Universitätsbibl.,
 Sal. X.16
Hildegardis, *Liber Scivias*, fol. 111v
Date: 12th cent.
Hildegardis of Bingen: Vision

Wiesbaden: Lib., Hessische
 Landesbibl., I
Hildegardis, *Liber Scivias*, fol. 202v
Date: ca. 1165
Hildegardis of Bingen: Vision

METALWORK

Trier: Ch., Maximin
Font, of Folcardus
Date: Early 12th cent.
Personification: Virtue, Humility

CONTINENCE

ENAMEL

Cologne: Ch., Pantaleon
Casket, reliquary, Albanus of Mayence
Date: 1186
Personification: Virtue, Humility

FRESCO

Prufening: Ch., Monastery
Choir
Date: 12th cent.
Personification: Church

MANUSCRIPT

Ghent: Lib., Bibl. de l'Université, 92
Lambertus, *Liber Floridus*, fol. 231v
Date: 1120
Tree of Virtues

Nuremberg: Mus., Germ. Nat. Bibl.,
 156142
Gospel Book, Echternach, fol. 114r
Date: 10th–11th cent.
Personification: Virtue, Virginity

Strasbourg: Lib., Bibl. Municipale
Herradis of Landsberg, *Hort. Delic.*,
 fol. 200r
Date: Second half 12th cent.
Personification: Virtue, Humility

METALWORK

Hildesheim: Cath., Maria
Chandelier, of Hezilo
Date: ca. 1055–1065
Building: City Wall

CONTRITION

GLASS

Niederhaslach: Ch., Florentius
Windows, nave
Date: 1290–1420
Christ: Parable, Prodigal Son

MANUSCRIPT

Strasbourg: Lib., Bibl. Municipale
Herradis of Landsberg, *Hort. Delic.*,
 fol. 202r
Date: Second half 12th cent.
Personification: Virtue, Prudence

COUNSEL

ENAMEL

Brussels: Mus., Royaux d'Art et
 d'Histoire
Reliquary, Alexander (1031)
Date: 1145
Eventius of Rome

MANUSCRIPT

Strasbourg: Lib., Bibl. Municipale
Herradis of Landsberg, *Hort. Delic.*,
 fol. 202r
Date: Second half 12th cent.
Personification: Virtue, Prudence

COURAGE

MANUSCRIPT

Melbourne: Gall., National, Felton
 710/5
Gospel Book, fol. 4r
Date: ca. 1100
Personification: Virtue, Prudence

Vienna: Lib., Nationalbibl., 2583*
Matfre Ermengaud, *Brev. d'Amor*,
 fol. 237v
Date: 14th cent.
Personification: Virtue, Generosity

METALWORK

Venice: Ch., Marco, Treasury
Reliquary, silver (142)
Date: Late 12th cent.
Building

COURTLINESS

MANUSCRIPT

Malines: Lib., Grand Séminaire
Bible, Nicolò de Alifio, p. 1
Date: Mid-14th cent.
Robert of Anjou

Vienna: Lib., Nationalbibl., 2592
Roman de la Rose, fol. 10r
Date: Second half 14th cent.

DELIBERATION

MANUSCRIPT

Strasbourg: Lib., Bibl. Municipale
Herradis of Landsberg, *Hort. Delic.*,
 fol. 202r
Date: Second half 12th cent.
Personification: Virtue, Prudence

DEVOTION

SCULPTURE

Florence: Ch., Orsanmichele
Tabernacle, marble
Attribution: Orcagna
Date: 1359–1360
Angel: Archangel Michael

DILIGENCE

SCULPTURE

Florence: Ch., Orsanmichele
Tabernacle, marble
Attribution: Orcagna
Date: 1359–1360
Angel: Archangel Michael

DISCIPLINE

MANUSCRIPT

Munich: Lib., Staatsbibl., Clm. 13601
Lectionary of Uta, fol. 4v
Date: ca. 1025
Erhardus of Germany: Scene

Wiesbaden: Lib., Hessische
 Landesbibl., I
Hildegardis, *Liber Scivias*, fol. 138v
Date: ca. 1165
Hildegardis of Bingen: Vision

Wiesbaden: Lib., Hessische
 Landesbibl., I
Hildegardis, *Liber Scivias*, fol. 139r
Date: ca. 1165
Hildegardis of Bingen: Vision

SCULPTURE

Bamberg: Cath., Peter und Georg
Tomb of Clement II
Date: ca. 1220–1240
Clement II, Pope: Scene

DISCRETION

MANUSCRIPT

Malines: Lib., Grand Séminaire
Bible, Nicolò de Alifio, p. 1
Date: Mid-14th cent.
Robert of Anjou

Munich: Lib., Staatsbibl., Clm. 13601
Lectionary of Uta, fol. 4v
Date: ca. 1025
Erhardus of Germany: Scene

Vienna: Lib., Nationalbibl., 2583 *
Matfre Ermengaud, *Brev. d'Amor*,
 fol. 237v
Date: 14th cent.
Personification: Virtue, Generosity

Wiesbaden: Lib., Hessische
 Landesbibl., I
Hildegardis, *Liber Scivias*, fol. 161v
Date: ca. 1165
Hildegardis of Bingen: Vision

PAINTING

Berlin: Mus., Staatliche
Panel (1844)
Date: ca. 1360–1370
Fulgentius of Ruspe

DIVINE LOVE

GLASS

Niederhaslach: Ch., Florentius
Windows, nave
Date: 1290–1420
Christ: Parable, Prodigal Son

MANUSCRIPT

Wiesbaden: Lib., Hessische
 Landesbibl., I
Hildegardis, *Liber Scivias*, fol. 138v
Date: ca. 1165
Hildegardis of Bingen: Vision

Wiesbaden: Lib., Hessische
 Landesbibl., I
Hildegardis, *Liber Scivias*, fol. 139r
Date: ca. 1165
Hildegardis of Bingen: Vision

DOCILITY

MANUSCRIPT

Rome: Lib., Bibl. Vaticana, Barb.
 lat. XLVI, 18?
Francesco da Barberino, *Documenti
 d'Amore*, fol. 4v
Date: 14th cent.

SCULPTURE

Chartres: Cath., Notre Dame
Porch, south
Date: ca. 1230–1240
Saint

Florence: Ch., Orsanmichele
Tabernacle, marble
Attribution: Orcagna
Date: 1359–1360
Angel: Archangel Michael

ELOQUENCE

MANUSCRIPT

Oxford: Lib., Bodleian, 270b
Bible, Moralized, fol. 57v
Date: First half 13th cent.
Moses: Teaching

EQUITY

MANUSCRIPT

Cambridge: Lib., St. John's College,
 B.9
Miscellany, fol. 203v
Date: 14th cent.

Cambridge: Mus., Fitzwilliam, 192
Somme le Roi
Date: ca. 1300

London: Lib., British, Add. 28162
Somme le Roi, fol. 7v
Date: ca. 1300

Paris: Lib., Bibl. Mazarine, 870
Somme le Roi, fol. 103r
Date: 1295

Strasbourg: Lib., Bibl. Municipale
Herradis of Landsberg, *Hort. Delic.*,
 fol. 202r
Date: Second half 12th cent.
Personification: Virtue, Prudence

EXHORTATION

MANUSCRIPT

Melbourne: Gall., National, Felton
 710/5
Gospel Book, fol. 5v
Date: ca. 1100

FAITH

ENAMEL

Baltimore: Gall., Walters
Cross (44.98)
Date: Mid-12th cent.
Christ: Crucifixion

Brussels: Lib., Bibl. Royale
Book cover (14970)
Date: Second half 12th cent.
Evangelist: Symbol

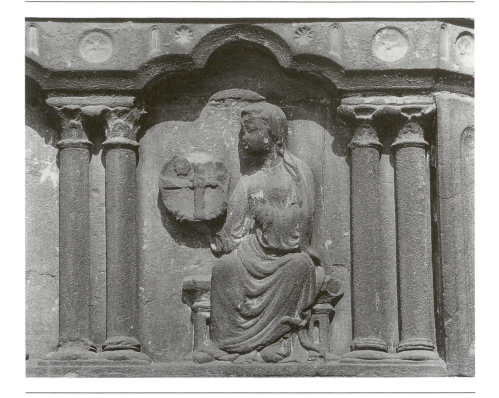

Brussels: Mus., Royaux d'Art et
 d'Histoire
Plaque, from reliquary (3141)
Date: ca. 1170
Personification: Virtue, Fortitude

Brussels: Mus., Royaux d'Art et
 d'Histoire
Reliquary, Valentinus of Maastricht
 (1038)
Date: ca. 1160–1170
Personification: Virtue, Hope

Florence: Mus., Naz. di Bargello
Crozier (Carrand 622)
Date: ca. 1185–1200
David: Slaying Bear

Frankfurt: Mus., Kunsthandwerk
Plaque, from retable (6710)
Date: ca. 1150

Klosterneuberg: Monastery
Retable
Attribution: Nicolas of Verdun
Date: 1181
Abraham: Entertaining the Angels

London: Mus., British
Plaque (78,11-1,16)
Date: ca. 1160–1170

Manchester: Lib., Rylands
Book cover (lat. 11)
Date: Second half 12th cent.
Angel

Osnabrück: Town Hall, Rathaus
Vessel
Date: First half 14th cent.
Personification: Virtue, Prudence

Pistoia: Cath., Zenone
Plaques, on altar frontal
Date: Last quarter 13th cent.
Christ

Troyes: Cath., Pierre, Treasury
Casket
Date: ca. 1200

Troyes: Cath., Pierre, Treasury
Plaques
Date: 12th cent.
*Jacob: Blessing Abraham and
 Manasseh*

FRESCO

Bawît: Mon., Apollo
Chapel III (Clédat)
Date: 6th–7th cent.?
Scene: Unidentified

Bawît: Mon., Apollo
Chapel XII (Clédat)
Date: 6th–7th cent.?
Malachi

Bawît: Mon., Apollo
Chapel XVIII (Clédat)
Date: 6th–7th cent.?
Bird

Bawît: Mon., Apollo
Chapel XXII (Clédat)
Date: 6th–7th cent.?

Brioude: Ch., Julien
Porch
Date: 12th–13th cent.
Christ: Last Judgment

Cairo: Mus., Coptic Museum, 7954
Date: 6th cent. or later
Palm

Cividale: Ch., Tempietto
Decoration
Date: 12th–13th cent.
Mary Magdalen

Cologne: Cath., Peter und Maria
Chapel, S. Agnes
Date: 14th cent.
Irmgardis of Zutphen: Scene

Florence: Ch., Croce
Chapel, Bardi di Vernio (Silvestro)
Date: First half 14th cent.
Constantine the Great: Scene

Florence: Ch., Croce
Chapel, Baroncelli, back wall
Attribution: Taddeo Gaddi
Date: ca. 1328–1330
Personification: Virtues, Cardinal

Florence: Ch., Croce
Chapel, Baroncelli, side vault
Attribution: Taddeo Gaddi
Date: ca. 1328–1330
Joachim: Offerings Rejected

Florence: Ch., Croce
Sacristy
Date: Late 14th cent.
Christ: Ascension

Florence: Ch., Maria Novella
Chapel, Strozzi, ceiling
Attribution: Giovanni del Biondo,
 Nardo di Cione
Date: ca. 1350–1360
Thomas Aquinas

Gundsømagle: Church
Decoration
Date: ca. 1200
Saint

Kirkerup: Church
Decoration
Date: ca. 1200
Personification: Virtue, Charity

Padua: Chap., Madonna dell'Arena
Decoration
Attribution: Giotto
Date: ca. 1303–1308
Joachim: Offerings Rejected

Padua: Ch., Eremitani
Chapel, S. Agostino
Date: ca. 1370
Personification: Theology

Pisa: Ch., Francesco
Choir
Date: 1342
Francis of Assisi

Pistoia: Cath., Zenone
Nave
Date: 1347
Personification: Virtue, Prudence

Prufening: Ch., Monastery
Choir
Date: 12th cent.
Personification: Church

San Miniato: Pal., Municipio
Room, Consiglio
Date: 1393
Virgin Mary and Christ Child:
 Type Suckling

Siena: Pal., Pubblico
Room, Pace
Attribution: Ambrogio Lorenzetti
Date: 1338–1339
Personification: Virtue, Justice

Tolentino: Ch., Nicola da Tolentino
Chapel, S. Nicola
Date: 13th–14th cent.
Evangelist: Symbol

Vicchio di Rimaggio: Ch., Lorenzo
Decoration
Date: 14th–15th cent.
Apostle: Peter, Warden of Paradise

GLASS

Esslingen: Ch., Dionysius
Windows, choir
Date: Late 13th–14th cent.
Isaiah

Niederhaslach: Ch., Florentius
Windows, nave
Date: 1290–1420
Christ: Parable, Prodigal Son

Strasbourg: Cath., Notre Dame
Windows, nave
Date: 14th cent.
Personification: Virtue, Wisdom

IVORY

London: Lib., British
Plaques, in book cover (Egerton 1139)
Date: 1131–1143
David: Slaying Lion

MANUSCRIPT

Berne: Lib., Stadtbibl., 264
Prudentius, *Psychomachia*, fol. 34v
Date: Early 10th cent.

Berne: Lib., Stadtbibl., 264
Prudentius, *Psychomachia*, fol. 35r
Date: Early 10th cent.

Berne: Lib., Stadtbibl., 264
Prudentius, *Psychomachia*, fol. 35v
Date: Early 10th cent.

Brussels: Lib., Bibl. Royale, 9968-72
Prudentius, *Psychomachia*, fol. 78r
Date: 11th cent.
Prudentius: Scene

Brussels: Lib., Bibl. Royale, 9968-72
Prudentius, *Psychomachia*, fol. 78v
Date: 11th cent.

Brussels: Lib., Bibl. Royale, 9968-72
Prudentius, *Psychomachia*, fol. 79r
Date: 11th cent.

Brussels: Lib., Bibl. Royale, 9987-91
Prudentius, *Psychomachia*, fol. 99v
Date: 10th cent.

Brussels: Lib., Bibl. Royale, 9987-91
Prudentius, *Psychomachia*, fol. 100r
Date: 10th cent.

Brussels: Lib., Bibl. Royale, 9987-91
Prudentius, *Psychomachia*, fol. 121r
Date: 10th cent.

Brussels: Lib., Bibl. Royale, 9987-91
Prudentius, *Psychomachia*, fol. 122r
Date: 10th cent.

Brussels: Lib., Bibl. Royale, 9987-91
Prudentius, *Psychomachia*, fol. 122v
Date: 10th cent.

Brussels: Lib., Bibl. Royale, 9987-91
Prudentius, *Psychomachia*, fol. 123v
Date: 10th cent.

Brussels: Lib., Bibl. Royale, 9987-91
Prudentius, *Psychomachia*, fol. 124r
Date: 10th cent.

Brussels: Lib., Bibl. Royale, 10066-77
Prudentius, *Psychomachia*, fol. 115r
Date: 10th–first half 11th cent.

Brussels: Lib., Bibl. Royale, 10066-77
Prudentius, *Psychomachia*, fol. 115v
Date: 10th–first half 11th cent.

Brussels: Lib., Bibl. Royale, 10066-77
Prudentius, *Psychomachia*, fol. 133v
Date: 10th–first half 11th cent.

Brussels: Lib., Bibl. Royale, 10066-77
Prudentius, *Psychomachia*, fol. 134r
Date: 10th–first half 11th cent.

Brussels: Lib., Bibl. Royale, 10066-77
Prudentius, *Psychomachia*, fol. 135v
Date: 10th–first half 11th cent.

Brussels: Lib., Bibl. Royale, 10066-77
Prudentius, *Psychomachia*, fol. 136v
Date: 10th–first half 11th cent.

Brussels: Lib., Bibl. Royale, 10066-77
Prudentius, *Psychomachia*, fol. 137r
Date: 10th–first half 11th cent.

Cambridge: Lib., Corpus Christi
 College, 23
Prudentius, *Psychomachia*, fol. 6v
Date: Early 11th cent.

Cambridge: Lib., Corpus Christi
 College, 23
Prudentius, *Psychomachia*, fol. 7v
Date: Early 11th cent.

Cambridge: Lib., Corpus Christi
 College, 23
Prudentius, *Psychomachia*, fol. 36v
Date: Early 11th cent.

Cambridge: Lib., Corpus Christi
 College, 23
Prudentius, *Psychomachia*, fol. 37v
Date: Early 11th cent.

Cambridge: Lib., Corpus Christi
 College, 23
Prudentius, *Psychomachia*, fol. 38r
Date: Early 11th cent.

Cambridge: Lib., Corpus Christi
 College, 23
Prudentius, *Psychomachia*, fol. 39v
Date: Early 11th cent.

Cambridge: Lib., Corpus Christi
 College, 23
Prudentius, *Psychomachia*, fol. 40r
Date: Early 11th cent.

Darmstadt: Lib., Hessische
 Landesbibl., 1640
Gospel Book, Hitda of Meschede,
 fol. 173r
Date: 1000–1020
Personification: Virtue, Charity

Ghent: Lib., Bibl. de l'Université, 92
Lambertus, *Liber Floridus*, fol. 231v
Date: 1120
Tree of Virtues

Kremsmünster: Lib., Stiftsbibl., 243
Spec. Hum. Salvationis, fol. 4r
Date: First half 14th cent.
Tree of Virtues

Leiden: Lib., Bibl. der Univ., Burm. Q.3
Prudentius, *Psychomachia*, fol. 122v
Date: Second quarter 9th cent.

Leiden: Lib., Bibl. der Univ., Burm. Q.3
Prudentius, *Psychomachia*, fol. 123r
Date: Second quarter 9th cent.

Leiden: Lib., Bibl. der Univ., Burm. Q.3
Prudentius, *Psychomachia*, fol. 144r
Date: Second quarter 9th cent.

Leiden: Lib., Bibl. der Univ., Burm. Q.3
Prudentius, *Psychomachia*, fol. 145r
Date: Second quarter 9th cent.

Leiden: Lib., Bibl. der Univ., Burm. Q.3
Prudentius, *Psychomachia*, fol. 145v
Date: Second quarter 9th cent.

Leiden: Lib., Bibl. der Univ., Burm. Q.3
Prudentius, *Psychomachia*, fol. 146v
Date: Second quarter 9th cent.

Leiden: Lib., Bibl. der Univ., Burm. Q.3
Prudentius, *Psychomachia*, fol. 147r
Date: Second quarter 9th cent.

Leiden: Lib., Bibl. der Univ., Voss.
 lat. oct. 15
Prudentius, *Psychomachia*, fol. 2r
Date: Early 11th cent.

Leiden: Lib., Bibl. der Univ., Voss.
 lat. oct. 15
Prudentius, *Psychomachia*, fol. 37v
Date: Early 11th cent.
Abraham: Blessed by Melchisedek

Leiden: Lib., Bibl. der Univ., Voss.
 lat. oct. 15
Prudentius, *Psychomachia*, fol. 42v
Date: Early 11th cent.
Personification: Vice, Discord

Leiden: Lib., Bibl. der Univ., Voss.
 lat. oct. 15
Prudentius, *Psychomachia*, fol. 43r
Date: Early 11th cent.
Personification: Virtue, Concord

London: Lib., British, Add. 17737–8
Bible, Floreffe, II, fol. 3v
Date: ca. 1153
Job: Sacrifice for Children

London: Lib., British, Add. 24199
Prudentius, *Psychomachia*, fol. 4v
Date: Early 11th cent.

London: Lib., British, Add. 24199
Prudentius, *Psychomachia*, fol. 5r
Date: Early 11th cent.

London: Lib., British, Add. 24199
Prudentius, *Psychomachia*, fol. 5v
Date: Early 11th cent.

London: Lib., British, Add. 24199
Prudentius, *Psychomachia*, fol. 32r
Date: Early 11th cent.
Personification: Vice, Discord

London: Lib., British, Add. 24199
Prudentius, *Psychomachia*, fol. 33r
Date: Early 11th cent.

London: Lib., British, Add. 24199
Prudentius, *Psychomachia*, fol. 33v
Date: Early 11th cent.
Personification: Virtue, Concord

London: Lib., British, Cott. Cleo.
 C.VIII
Prudentius, *Psychomachia*, fol. 4r
Date: Early 11th cent.

London: Lib., British, Cott. Cleo.
 C.VIII
Prudentius, *Psychomachia*, fol. 4v
Date: Early 11th cent.

London: Lib., British, Cott. Cleo.
 C.VIII
Prudentius, *Psychomachia*, fol. 31r
Date: Early 11th cent.

London: Lib., British, Cott. Cleo.
 C.VIII
Prudentius, *Psychomachia*, fol. 31v
Date: Early 11th cent.

London: Lib., British, Cott. Titus
 D.XVI
Prudentius, *Psychomachia*, fol. 5v
Date: ca. 1100

London: Lib., British, Cott. Titus
 D.XVI
Prudentius, *Psychomachia*, fol. 6r
Date: ca. 1100

London: Lib., British, Cott. Titus
 D.XVI
Prudentius, *Psychomachia*, fol. 28v
Date: ca. 1100

London: Lib., British, Cott. Titus
 D.XVI
Prudentius, *Psychomachia*, fol. 29r
Date: ca. 1100

London: Lib., British, Cott. Titus
 D.XVI
Prudentius, *Psychomachia*, fol. 29v
Date: ca. 1100

London: Lib., British, Harley 1526–27
Bible, Moralized, II, fol. 28v
Date: First half 13th cent.
*Christ: Miracle of Raising Daughter of
 Jairus*

Lucca: Lib., Bibl. Capitolare, P †
Passional, fol. 28v
Date: First half 12th cent.
Personification: Virtue, Wisdom

Lyons: Lib., Bibl. Municipale, Pal. des
 Arts 22
Prudentius, *Psychomachia*, fol. 11r
Date: Last quarter 11th cent.

Lyons: Lib., Bibl. Municipale, Pal. des
 Arts 22
Prudentius, *Psychomachia*, fol. 11v
Date: Last quarter 11th cent.

Lyons: Lib., Bibl. Municipale, Pal. des
 Arts 22
Prudentius, *Psychomachia*, fol. 12v
Date: Last quarter 11th cent.

Lyons: Lib., Bibl. Municipale, Pal. des
 Arts 22
Prudentius, *Psychomachia*, fol. 16v
Date: Last quarter 11th cent.
Personification: Virtue

Lyons: Lib., Bibl. Municipale, Pal. des
 Arts 22
Prudentius, *Psychomachia*, fol. 19v
Date: Last quarter 11th cent.

Madrid: Lib., Bibl. Nacional, 195-6
Bartolus of Sassoferrato, *Comm.*
Date: 14th cent.
Augustine of Hippo

Melbourne: Gall., National, Felton
 710/5
Gospel Book, fol. 6v
Date: ca. 1100

Milan: Lib., Bibl. Ambrosiana,
 B.42 inf.
Giovanni d'Andrea, *Novella*, fol. 1r
Date: 1354
Personification: Virtues, Cardinal

Montecassino: Monastery, 132
Rabanus Maurus, *De Universo*, p. 68
Date: ca. 1023
Personification: Virtue, Charity

Munich: Lib., Staatsbibl., Clm. 29031b
Prudentius, *Psychomachia*, recto
Date: 10th cent.

Munich: Lib., Staatsbibl., Clm. 29031b
Prudentius, *Psychomachia*, verso
Date: 10th cent.

Munich: Lib., Staatsbibl., Clm. 30055
Gospel Book, Henry the Lion, fol. 13v
Date: ca. 1175
Apostle: James Minor

Munich: Lib., Staatsbibl., Clm. 30055
Gospel Book, Henry the Lion, fol. 15r
Date: ca. 1175
Evangelist: Matthew

Munich: Lib., Staatsbibl., Clm. 30055
Gospel Book, Henry the Lion, fol. 18r
Date: ca. 1175
Apostle: Paul

Munich: Lib., Staatsbibl., Clm. 30055
Gospel Book, Henry the Lion, fol. 18v
Date: ca. 1175
John Baptist

Munich: Mus., Staatl. Graphische
 Samml., 39789
Miniature
Date: 12th cent.
Christ: Sermon on Mount

New York: Lib., Morgan, Pierpont,
 M.676
Dante: *Divina Commedia*, fol. 83v
Date: Late 14th cent.
Dante: Purgatorio

Oxford: Lib., Keble College, 49
Legendarium, fol. 7r
Date: ca. 1267–1276
Christ: Crucifixion, Nailed to Cross by
* Virtues*

Paris: Lib., Bibl. Nat. de France,
 lat. 8085
Prudentius, *Psychomachia*, fol. 56v
Date: Late 9th cent.
Prudentius: Scene

Paris: Lib., Bibl. Nat. de France,
 lat. 8085
Prudentius, *Psychomachia*, fol. 57r
Date: Late 9th cent.

Paris: Lib., Bibl. Nat. de France,
 lat. 8085
Prudentius, *Psychomachia*, fol. 67r
Date: Late 9th cent.
Personification: Vice, Discord

Paris: Lib., Bibl. Nat. de France,
 lat. 8085
Prudentius, *Psychomachia*, fol. 67v
Date: Late 9th cent.
Personification: Vice, Discord

Paris: Lib., Bibl. Nat. de France,
 lat. 8085
Prudentius, *Psychomachia*, fol. 68r
Date: Late 9th cent.

Paris: Lib., Bibl. Nat. de France,
 lat. 8085
Prudentius, *Psychomachia*, fol. 68v
Date: Late 9th cent.

Paris: Lib., Bibl. Nat. de France,
 lat. 8318
Prudentius, *Psychomachia*, fol. 50v
Date: Late 10th cent.

Paris: Lib., Bibl. Nat. de France,
 lat. 8318
Prudentius, *Psychomachia*, fol. 54v
Date: Late 10th cent.
Personification: Vice, Idleness

Paris: Lib., Bibl. Nat. de France,
 lat. 8318
Prudentius, *Psychomachia*, fol. 63v
Date: Late 10th cent.
Personification: Vice, Discord

Paris: Lib., Bibl. Nat. de France,
 lat. 15158
Prudentius, *Psychomachia*, fol. 58v
Date: 1289

Paris: Lib., Bibl. Nat. de France,
 lat. 15158
Prudentius, *Psychomachia*, fol. 59r
Date: 1289

Paris: Lib., Bibl. Nat. de France,
 lat. 15158
Prudentius, *Psychomachia*, fol. 59v
Date: 1289

Paris: Lib., Bibl. Nat. de France,
 lat. 15158
Prudentius, *Psychomachia*, fol. 60r
Date: 1289

Paris: Lib., Bibl. Nat. de France,
 lat. 15158
Prudentius, *Psychomachia*, fol. 60v
Date: 1289

Paris: Lib., Bibl. Nat. de France,
 lat. 15158
Prudentius, *Psychomachia*, fol. 61v
Date: 1289

Paris: Lib., Bibl. Nat. de France,
 lat. 15158
Prudentius, *Psychomachia*, fol. 62r
Date: 1289

Paris: Lib., Bibl. Nat. de France,
 lat. 18014
Hours, Duc de Berry, fol. 278v
Date: Late 14th cent.
Solomon: Throne

Pommersfelden: Coll., Schönborn,
 Library, 215
Miscellany, fol. 162r
Date: 14th cent.
Alanus de Insulis: Text

Pommersfelden: Coll., Schönborn,
 Library, 215
Miscellany, fol. 162v
Date: 14th cent.
Alanus de Insulis: Text

Rome: Gall., Naz. d'Arte Antica
Bartolomeo di Bartoli, *Canzone*, fol. 6r
Date: 14th cent.

Rome: Lib., Bibl. Vaticana, gr. 394
John Climacus, *Climax*, fol. 94r
Date: Late 11th cent.
John Climacus: Climax,
 Chapter XVIII

Rome: Lib., Bibl. Vaticana, gr. 394
John Climacus, *Climax*, fol. 151v
Date: Late 11th cent.
John Climacus: Climax, Chapter XXIX

Rome: Lib., Bibl. Vaticana, gr. 394
John Climacus, *Climax*, fol. 154r
Date: Late 11th cent.
John Climacus: Climax, Chapter XXX

Rome: Lib., Bibl. Vaticana,
 Reg. lat. 596
Prudentius, *Psychomachia*, fol. 26r
Date: Late 10th cent.
Personification: Virtue, Concord

Saint Gall: Lib., Stiftsbibl., 135
Prudentius, *Psychomachia*, p. 388
Date: First half 11th cent.

Saint Gall: Lib., Stiftsbibl., 135
Prudentius, *Psychomachia*, p. 390
Date: First half 11th cent.

Saint Gall: Lib., Stiftsbibl., 135
Prudentius, *Psychomachia*, p. 429
Date: First half 11th cent.
Personification: Virtue, Concord

Saint-Omer: Lib., Bibl. Municipale, 34
Origen, *Homilies*, fol. 1v
Date: Second quarter 12th cent.
Creation Scene

Salzburg: Lib., Studienbibl., V 1 H 162
Miscellany, fol. 76r
Date: First half 12th cent.
Tree of Virtues

Strasbourg: Lib., Bibl. Municipale
Herradis of Landsberg, *Hort. Delic.*,
 fol. 199v
Date: Second half 12th cent.
Personification: Vice, Pride

Strasbourg: Lib., Bibl. Municipale
Herradis of Landsberg, *Hort. Delic.*,
 fol. 200r
Date: Second half 12th cent.
Personification: Virtue, Humility

Valenciennes: Lib., Bibl. Municipale,
 563
Prudentius, *Psychomachia*, fol. 4r
Date: Early 11th cent.

Valenciennes: Lib., Bibl. Municipale,
 563
Prudentius, *Psychomachia*, fol. 4v
Date: Early 11th cent.

Valenciennes: Lib., Bibl. Municipale,
 563
Prudentius, *Psychomachia*, fol. 5r
Date: Early 11th cent.

Valenciennes: Lib., Bibl. Municipale,
 563
Prudentius, *Psychomachia*, fol. 35r
Date: Early 11th cent.

Valenciennes: Lib., Bibl. Municipale,
 563
Prudentius, *Psychomachia*, fol. 36r
Date: Early 11th cent.

Valenciennes: Lib., Bibl. Municipale,
 563
Prudentius, *Psychomachia*, fol. 36v
Date: Early 11th cent.

Valenciennes: Lib., Bibl. Municipale,
 563
Prudentius, *Psychomachia*, fol. 37r
Date: Early 11th cent.

Valenciennes: Lib., Bibl. Municipale,
 563
Prudentius, *Psychomachia*, fol. 38v
Date: Early 11th cent.

Valenciennes: Lib., Bibl. Municipale,
563
Prudentius, *Psychomachia*, fol. 39r
Date: Early 11th cent.

Vienna: Lib., Nationalbibl., 1367
Miscellany, fol. 92v
Date: 12th cent.
Personification: Virtue, Charity

Vienna: Lib., Nationalbibl., Ser. Nov.
2639
Convenevoli de Pratis(?), *Poemata*,
fol. 2v
Date: Early 14th cent.

Wiesbaden: Lib., Hessische
Landesbibl., I
Hildegardis, *Liber Scivias*, fol. 178r
Date: ca. 1165
Hildegardis of Bingen: Vision

Wolfenbüttel: Lib., Herzog August
Bibl., Guelf. 105 Noviss. 2°
Gospel Book, Henry the Lion, fol. 13v
Date: ca. 1175
Apostle: James Minor

Wolfenbüttel: Lib., Herzog August
Bibl., Guelf. 105 Noviss. 2°
Gospel Book, Henry the Lion, fol. 15r
Date: ca. 1175
Evangelist: Matthew

Wolfenbüttel: Lib., Herzog August
Bibl., Guelf. 105 Noviss. 2°
Gospel Book, Henry the Lion, fol. 18r
Date: ca. 1175
Apostle: Paul

Wolfenbüttel: Lib., Herzog August
Bibl., Guelf. 105 Noviss. 2°
Gospel Book, Henry the Lion, fol. 18v
Date: ca. 1175
John Baptist

Zurich: Lib., Zentralbibl., Rheinau 85
Psalter, fol. 139r
Date: 1253
Psalm 138 (Vulgate, 137)

METALWORK

Aachen: Cathedral, Treasury
Casket, reliquary, Charlemagne
Date: 1182–1215
Charlemagne: Scene

Berlin: Mus., Staatliche
Bowl, bronze (I.3136)
Date: 13th cent.
Personification: Virtue, Humility

Budapest: Mus., Magyar Nemzeti
Múzeum
Bowl, bronze
Date: 12th–13th cent.
Personification: Virtue, Humility

Cologne: Cathedral, Treasury
Casket, of Three Kings
Date: 1190–1225
Christ: Last Judgment

Copenhagen: Mus., National
Altar, copper-gilt (D287)
Date: ca. 1150
Christ

Florence: Baptistery
Door, south, bronze
Attribution: Andrea Pisano
Date: 1330
Zacharias: Annunciation

Hannover: Mus., Kestner
Bowl, bronze-gilt (1894.18)
Date: 12th cent.
Personification: Virtue, Humility

Hildesheim: Cath., Maria
Chandelier, of Hezilo
Date: ca. 1055–1065
Building: Çity Wall

Leipzig: Mus., Kunsthandwerk
Bowl, bronze-gilt (5011)
Date: ca. 1250
Personification: Virtue, Hope

Lund: Mus., Kulturhistoriska
Bowl (K.M. 10283)
Date: 12th cent.
Personification: Virtue, Hope

Lund: Mus., Kulturhistoriska
Bowl, bronze (25557)
Date: 11th–13th cent.
Personification: Virtue, Humility

Munich: Mus., Bayerisches
 Nationalmus.
Bowl, brass (M.A. 204)
Date: 12th–13th cent.
Personification: Virtue, Humility

Namur: Mus., Archéologique
Reliquary
Date: 12th cent.

Padua: Mus., Civico
Bowl (664)
Date: 12th cent.
Personification: Virtue, Charity

Saint-Gilles: Church
Sarcophagus, gold, of Aegidius
Date: 12th cent.?
Elders: Four and Twenty

Salzburg: Mus., Dom
Bowl, bronze
Date: 12th cent.
Personification: Virtue, Humility

Strasbourg: Mus., Historique
Bowl, copper-gilt (700)
Date: 12th–13th cent.
Personification: Virtue, Humility

Tallinn: Mus., Institute of History
Bowl, bronze (AI 4143:5)
Date: 12th cent.
Personification: Virtue, Hope

Tallinn: Mus., Institute of History
Bowl, bronze (AI 4143:6)
Date: 12th cent.
Personification: Virtue, Hope

Tongres: Ch., Notre Dame
Reliquary
Date: ca. 1160–1170

Trier: Ch., Maximin
Font, of Folcardus
Date: Early 12th cent.
Personification: Virtue, Humility

Wrocław: Mus., Archeologiczne
Bowl, bronze
Date: Late 11th–12th cent.
Personification: Virtue, Humility

MOSAIC

Cremona: Cathedral
Pavement
Date: First half 12th cent.
Pagan Type: Satyr

Pavia: Mus., Civico
Pavement (B 378a–e/XI)
Date: Late 11th–early 12th cent.
Personification: Vice, Discord

Venice: Ch., Marco
Crossing
Date: Last quarter 12th cent.
Christ: Ascension

PAINTING

Florence: Ch., Croce
Polyptych
Attribution: Giovanni del Biondo
Date: 1379
Virgin Mary and Christ Child

Greenwich: Coll., Hyland
Panel
Date: 14th cent.
Virgin Mary and Christ Child

Massa Marittima: Pal., Comunale
Panel
Attribution: Ambrogio Lorenzetti
Date: ca. 1335–1340
Virgin Mary and Christ Child

New York: Coll., Wildenstein
Panel
Date: 14th cent.
Virgin Mary and Christ Child

Rome: Mus., Vaticani, Pinacoteca
Panel (40520)
Date: ca. 1375–1380
Virgin Mary

SCULPTURE

Amiens: Cath., Notre Dame
Exterior, west
Date: 1220–1235
Malachi

Arezzo: Cathedral
Reliquary, S. Donatus
Attribution: Betto di Francesco da
 Firenze, Giovanni di Francesco
 d'Arezzo
Date: After 1362
Christ

Argenton-Château: Ch., Gilles
Exterior, west
Date: After 1130
Ornament: Figured

Aulnay-de-Saintonge: Ch., Pierre
Exterior, west
Date: ca. 1130–1150
Month: Occupation

Bergamo: Street, Arena
Relief
Date: 14th cent.

Boston: Mus., Gardner
Statue, marble (S12e2)
Date: Last quarter 14th cent.

Bremen: Cath., Peter
Reliefs, from choir stalls
Date: 14th–15th cent.
Apostles

Chartres: Cath., Notre Dame
Exterior, north, central portal
Date: 1205–1210
Virgin Mary: Coronation

Chartres: Cath., Notre Dame
Exterior, north, left portal
Date: ca. 1220
Virgins, Foolish

Chartres: Cath., Notre Dame
Porch, south
Date: ca. 1230–1240
Saint

Cluny: Mus., Farinier
Capitals
Date: Late 11th–early 12th cent.
Personification: Music

Florence: Cath., Maria del Fiore
Tomb of Antonio Orso
Attribution: Tino di Camaino
Date: ca. 1321
Antonio Orso

Florence: Ch., Orsanmichele
Tabernacle, marble
Attribution: Orcagna
Date: 1359–1360
Angel: Archangel Michael

Florence: Loggia dei Lanzi
Exterior
Date: 14th cent.
Personification: Virtues, Cardinal

Florence: Mus., Opera del Duomo
Relief, from bell tower
Attribution: Gino Micheli da
 Chastello
Date: 1337–1341

Florence: Mus., Opera del Duomo
Statues
Date: 14th cent.
Figure: Female

Laon: Cath., Notre Dame
Exterior, west
Date: ca. 1180–1210
Magi: Adoration

Milan: Ch., Eustorgio
Tomb of Peter Martyr
Attribution: Giovanni di Balduccio or
 workshop
Date: 1339
Christ

Monreale: Cath., Maria la Nuova
Cloister
Date: Last quarter 12th cent.
Christ: Parable, Lazarus and Dives

Naples: Ch., Chiara
Statue, from tomb
Attribution: Tino di Camaino or
 workshop
Date: ca. 1330

Naples: Ch., Chiara
Tomb of Marie, Princess of Calabria
Date: ca. 1328
Marie, Princess of Calabria

Naples: Ch., Chiara
Tomb of Robert of Anjou
Attribution: Pacio and Giovanni
 Bertini da Firenze
Date: ca. 1343
Robert of Anjou

Naples: Ch., Domenico Maggiore
Candlestick
Attribution: Pacio and Giovanni
 Bertini da Firenze, workshop of
Date: ca. 1330–1350
Personification: Virtues, Cardinal

Nazareth: Mus., Franciscan Convent
Capital
Date: Second half 12th cent.

Paris: Cath., Notre Dame
Exterior, west
Date: ca. 1220–1230
Christ: Last Judgment

Paris: Mus., Louvre
Statue, marble
Attribution: Nicola Pisano
Date: 1264–1267
Angel?

Parma: Baptistery
Exterior
Date: Late 12th–13th cent.
Magi: Adoration

Pavia: Ch., Pietro in Ciel d'Oro
Tomb of Augustine of Hippo
Attribution: Giovanni di Balduccio,
 follower of
Date: Second half 14th cent.
Augustine of Hippo: Scene

Pisa: Baptistery
Pulpit
Attribution: Nicola Pisano
Date: 1260
Virgin Mary: Annunciation

Pisa: Cathedral
Pulpit
Attribution: Giovanni Pisano
Date: 1302–1310
Virgin Mary: Annunciation

Pistoia: Ch., Giovanni Fuorcivitas
Holy water basin
Attribution: Nicola Pisano,
 workshop of
Date: Late 13th cent.
Personification: Virtues, Cardinal

Reims: Cath., Notre Dame
Exterior, west
Date: ca. 1230–1240
Virgin Mary: Coronation

Rome: Ch., Francesca Romana
Tomb of Marino Vulcani
Date: 1394–1403
Marino Vulcani

Salisbury: Cathedral, Chapter House
Decoration, vestibule
Date: ca. 1260–1280
Personification: Virtues and Vices,
 Conflict

Siena: Cath., Assunta
Exterior, south
Date: 13th–14th cent.
Miriam

Siena: Cath., Assunta
Pulpit
Attribution: Nicola Pisano
Date: ca. 1265–1269
Virgin Mary: Visitation

Strzelno: Ch., Trinity
Nave, column
Date: Last quarter 12th cent.
Christ: Baptism

Tebessa: Ch., Catholic
Sarcophagus
Date: 4th–6th cent.
Personification: City of Rome

Venice: Ch., Marco
Exterior, west
Date: 13th cent.
Christ

Verona: Cath., Maria Matricolare
Exterior, west
Date: 12th cent.
Shepherds: Annunciation

Worms: Cath., Peter and Paul
Exterior, south
Date: First half 14th cent.
Nicholas of Myra: Scene

FEELING

MANUSCRIPT

Strasbourg: Lib., Bibl. Municipale
Herradis of Landsberg, *Hort. Delic.*,
 fol. 200r
Date: Second half 12th cent.
Personification: Virtue, Humility

FELICITY

IVORY

London: Lib., British
Plaques, in book cover (Egerton 1139)
Date: 1131–1143
David: Slaying Lion

MANUSCRIPT

Brussels: Lib., Bibl. Royale, 9505-6
Aristotle, *Ethiques*, fol. 198v
Date: 1372

Chantilly: Mus., Condé, 1327
Aristotle, *Ethiques*, fol. 3r
Date: 1397–1398
Charles the Wise

Hague: Mus., Meermanno-
 Westreenianum, 10 D 1
Aristotle, *Ethiques*, fol. 5r
Date: 1376
Charles the Wise

Hague: Mus., Meermanno-
 Westreenianum, 10 D 1
Aristotle, *Ethiques*, fol. 193r
Date: 1376

FIDELITY

ENAMEL

Brussels: Coll., Stoclet
Plaque
Date: Second half 12th cent.
Personification: Virtue

SCULPTURE

Bremen: Cath., Peter
Reliefs, from choir stalls
Date: 14th–15th cent.
Apostles

Naples: Ch., Domenico Maggiore
Candlestick
Attribution: Pacio and Giovanni
 Bertini da Firenze, workshop of
Date: ca. 1330–1350
Personification: Virtues, Cardinal

Pisa: Baptistery
Pulpit
Attribution: Nicola Pisano
Date: 1260
Virgin Mary: Annunciation

FORTITUDE

ENAMEL

Brussels: Mus., Royaux d'Art et
 d'Histoire
Plaque, from reliquary (3141)
Date: ca. 1170

Brussels: Mus., Royaux d'Art et
 d'Histoire
Reliquary, Alexander (1031)
Date: 1145
Eventius of Rome

Darmstadt: Mus., Hessisches
 Landesmus.
Plaque, copper-gilt (Kg 54:246a)
Date: ca. 1170
Ecclesiasticus: Illustration

Klosterneuberg: Monastery
Retable
Attribution: Nicolas of Verdun
Date: 1181
Abraham: Entertaining the Angels

Langres: Museum
Plaques, on reliquary
Date: Third quarter 12th cent.

Liège: Mus., Curtius
Book cover (12/1)
Date: ca. 1160–1170
Personification: River of Paradise

Pistoia: Cath., Zenone
Plaques, on altar frontal
Date: Last quarter 13th cent.
Christ

Troyes: Cath., Pierre, Treasury
Plaques
Date: 12th cent.
*Jacob: Blessing Ephraim and
 Manasseh*

FRESCO

Assisi: Ch., Francesco, Lower
Crossing, vault
Date: First half 14th cent.
Allegory: Poverty

Cologne: Ch., Maria Lyskirchen
Nave
Date: 13th cent.
Daniel?

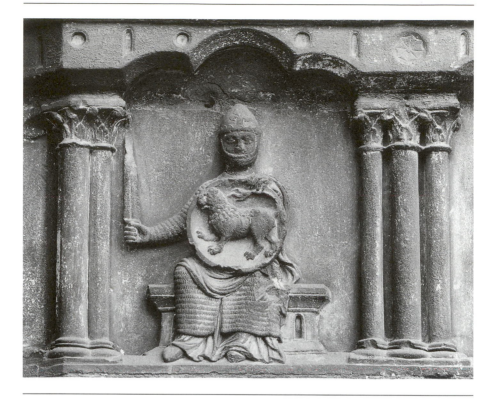

Florence: Ch., Croce
Chapel, Bardi di Vernio (Silvestro)
Date: First half 14th cent.
Constantine the Great: Scene

Florence: Ch., Croce
Chapel, Baroncelli, back wall
Attribution: Taddeo Gaddi
Date: ca. 1328–1330
Joachim: Offerings Rejected

Florence: Ch., Croce
Sacristy
Date: Late 14th cent.
Christ: Ascension

Florence: Ch., Maria Novella
Chapel, Strozzi, ceiling
Attribution: Giovanni del Biondo,
 Nardo di Cione
Date: ca. 1350–1360
Thomas Aquinas

London: Pal., Westminster
Painted Chamber
Date: Late 13th cent.
Maccabees: Battle

Padua: Chap., Madonna dell'Arena
Decoration
Attribution: Giotto
Date: ca. 1303–1308
Joachim: Offerings Rejected

Padua: Ch., Antonio
Chapel, S. Felice
Date: Second half 14th cent.
Apostle: James Major, Scene

Pisa: Ch., Francesco
Choir
Date: 1342
Francis of Assisi

Siena: Pal., Pubblico
Room, Pace
Attribution: Ambrogio Lorenzetti
Date: 1338–1339
Personification: Virtue, Justice

Soest: Cath., Patrokli
Chapel, S. Nikolaus
Date: Mid-13th cent.
Christ and Four Beasts

Tolentino: Ch., Nicola da Tolentino
Chapel, S. Nicola
Date: 13th–14th cent.
Evangelist: Symbol

GLASS

Mulhouse: Ch., Etienne
Windows
Date: First half 14th cent.
Personification: Virtue, Sobriety

Paris: Cath., Notre Dame
Window, west rose
Date: First half 13th cent.
Virgin Mary and Christ Child

Strasbourg: Cath., Notre Dame
Windows, nave
Date: 14th cent.
Personification: Virtue, Wisdom

IVORY

London: Lib., British
Plaques, in book cover (Egerton 1139)
Date: 1131–1143
David: Slaying Lion

MANUSCRIPT

Admont: Lib., Stiftsbibl., lat. 128
Miscellany, fol. 13r
Date: Mid-13th cent.
Personification: Ethics

Berne: Lib., Stadtbibl., 120 II
Peter of Eboli, *De Rebus Siculis*,
 fol. 146r
Date: 1195–1197
Henry VI

Brussels: Lib., Bibl. Royale, 9505-6
Aristotle, *Ethiques*, fol. 39r
Date: 1372

Brussels: Lib., Bibl. Royale, 9505-6
Aristotle, *Ethiques*, fol. 89r
Date: 1372
Personification: Virtue, Justice

Florence: Lib., Bibl. Laurenziana,
 Plut. XLII.19
Brunetto Latini, *Tesoro*, fol. 60r
Date: 14th cent.

Florence: Lib., Bibl. Laurenziana,
 Plut. XLII.19
Brunetto Latini, *Tesoro*, fol. 62v
Date: 14th cent.

Malines: Lib., Grand Séminaire
Bible, Nicolò de Alifio, p. 1
Date: Mid-14th cent.
Robert of Anjou

Munich: Lib., Staatsbibl., Clm. 30055
Gospel Book, Henry the Lion, fol. 14r
Date: ca. 1175
Apostle: Philip

Munich: Mus., Staatl. Graphische
 Samml., 39789
Miniature
Date: 12th cent.
Christ: Sermon on Mount

Rome: Gall., Naz. d'Arte Antica
Bartolomeo di Bartoli, *Canzone*, fol. 3r
Date: 14th cent.
Judith: Slaying Holofernes

Salzburg: Lib., Studienbibl., V 1 H 162
Miscellany, fol. 76r
Date: First half 12th cent.
Tree of Virtues

Strasbourg: Lib., Bibl. Municipale
Herradis of Landsberg, *Hort. Delic.*,
 fol. 200r
Date: Second half 12th cent.
Personification: Virtue, Humility

Strasbourg: Lib., Bibl. Municipale
Herradis of Landsberg, *Hort. Delic.*,
 fol. 204r
Date: Second half 12th cent.
Personification: Virtue, Mercy

Valenciennes: Lib., Bibl. Municipale, 512
Miscellany, fol. 4v
Date: 12th cent.
Gregory the Great

Vienna: Lib., Nationalbibl., Ser. Nov. 2639
Convenevoli de Pratis(?), *Poemata*, fol. 1r
Date: Early 14th cent.
Personification: Virtue, Justice

Wolfenbüttel: Lib., Herzog August Bibl., Guelf. 105 Noviss. 2°
Gospel Book, Henry the Lion, fol. 14r
Date: ca. 1175
Apostle: Philip

METALWORK

Florence: Baptistery
Door, south, bronze
Attribution: Andrea Pisano
Date: 1330
Zacharias: Annunciation

Hildesheim: Cath., Maria
Chandelier, of Hezilo
Date: ca. 1055–1065
Building: City Wall

London: Mus., Victoria and Albert
Aquamanile (4054-56)
Date: 1240–1260
Animal Vessel

Manchester: Lib., Rylands
Book cover, silver-gilt (lat. 4)
Date: ca. 1150–1175
Saint?

Saint-Symphorien: Church
Casket, S. Symphorien
Date: 12th–13th cent.
Christ and Apostles

Verona: Ch., Zeno
Door, bronze
Date: Second–fourth quarter 12th cent.
Virgin Mary: Annunciation

PAINTING

Florence: Ch., Croce
Polyptych
Attribution: Giovanni del Biondo
Date: 1379
Virgin Mary and Christ Child

Greenwich: Coll., Hyland
Panel
Date: 14th cent.
Virgin Mary and Christ Child

New York: Coll., Wildenstein
Panel
Date: 14th cent.
Virgin Mary and Christ Child

Rome: Mus., Vaticani, Pinacoteca
Panel (40520)
Date: ca. 1375–1380
Virgin Mary

SCULPTURE

Amiens: Cath., Notre Dame
Exterior, west
Date: 1220–1235
Malachi

Arezzo: Cathedral
Reliquary, S. Donatus
Attribution: Betto di Francesco da Firenze, Giovanni di Francesco d'Arezzo
Date: After 1362
Christ

Bamberg: Cath., Peter und Georg
Tomb of Clement II
Date: ca. 1220–1240
Clement II, Pope: Scene

Chartres: Cath., Notre Dame
Exterior, north, central portal
Date: 1205–1210
Virgin Mary: Coronation

Chartres: Cath., Notre Dame
Exterior, north, left portal
Date: ca. 1220
Virgins, Foolish

Chartres: Cath., Notre Dame
Porch, north
Date: ca. 1220–1230
Creation Scene

Chartres: Cath., Notre Dame
Porch, south
Date: ca. 1230–1240
Saint

Florence: Cath., Maria del Fiore
Exterior, north
Attribution: Giovanni d'Ambrogio,
 Piero di Giovanni Tedesco
Date: Late 14th cent.
Prophet

Florence: Ch., Croce
Baroncelli tomb
Date: First half 14th cent.
Angel

Florence: Ch., Orsanmichele
Tabernacle, marble
Attribution: Orcagna
Date: 1359–1360
Angel: Archangel Michael

Florence: Loggia del Bigallo
Exterior, east and north
Date: 1352–1358
Christ: Of Sorrows

Genoa: Mus., S. Agostino
Tomb of Margaret of Brabant
Attribution: Giovanni Pisano
Date: ca. 1313

Milan: Mus., Castello Sforzesco
Tomb of Bernabò Visconti (287)
Attribution: Bonino da Campione
Date: ca. 1363
Bernabò Visconti

Naples: Ch., Chiara
Tomb of Robert of Anjou
Attribution: Pacio and Giovanni
 Bertini da Firenze
Date: ca. 1343
Robert of Anjou

Padua: Ch., Giustina
Reliefs
Date: Late 12th cent.
Justina of Padua?

Paris: Cath., Notre Dame
Exterior, west
Date: ca. 1220–1230
Christ: Last Judgment

Pisa: Baptistery
Pulpit
Attribution: Nicola Pisano
Date: 1260
Virgin Mary: Annunciation

Reims: Cath., Notre Dame
Exterior, west
Date: ca. 1230–1240
Virgin Mary: Coronation

Salisbury: Cathedral, Chapter House
Decoration, vestibule
Date: ca. 1260–1280
Personification: Virtues and Vices,
 Conflict

Siena: Cath., Assunta
Pulpit
Attribution: Nicola Pisano
Date: ca. 1265–1269
Virgin Mary: Visitation

Venice: Ch., Marco
Exterior, west
Date: 13th cent.
Christ

TEXTILE

Quedlinburg: Church, Treasury
Hanging, tapestry
Date: 1186–1203
Personification: Virtue, Chastity

FRIENDSHIP

FRESCO

Florence: Ch., Croce
Chapel, Baroncelli, back wall
Attribution: Taddeo Gaddi
Date: ca. 1328–1330
Joachim: Offerings Rejected

MANUSCRIPT

Brussels: Lib., Bibl. Royale, 9505-6
Aristotle, *Ethiques*, fol. 157r
Date: 1372

Cambridge: Lib., St. John's College, B.9
Miscellany, fol. 201v
Date: 14th cent.

London: Lib., British, Add. 28162
Somme le Roi, fol. 6v
Date: ca. 1300

London: Lib., British, Add. 54180
Somme le Roi, fol. 107r
Date: ca. 1300

Paris: Lib., Bibl. de l'Arsenal, 6329
Somme le Roi, fol. 112v
Date: 1311

Paris: Lib., Bibl. Nat. de France, fr.
 14939
Somme le Roi, fol. 105v
Date: 1373

Strasbourg: Lib., Bibl. Municipale
Herradis of Landsberg, *Hort. Delic.*,
 fol. 201r
Date: Second half 12th cent.
Personification: Virtue, Patience

GENEROSITY

ENAMEL

Cologne: Ch., Pantaleon
Casket, reliquary, Albanus of Mayence
Date: 1186
Personification: Virtue, Humility

Florence: Mus., Naz. di Bargello
Crozier (Carrand 622)
Date: ca. 1185–1200
David: Slaying Bear

Klosterneuberg: Monastery
Retable
Date: 1322–1331
Abraham: Entertaining the Angels

Troyes: Cath., Pierre, Treasury
Casket
Date: ca. 1200
Personification: Virtue, Faith

FRESCO

London: Pal., Westminster
Painted Chamber
Date: Late 13th cent.
Maccabees: Battle

Siena: Pal., Pubblico
Room, Pace
Attribution: Ambrogio Lorenzetti
Date: 1338–1339
Personification: Virtue, Justice

GLASS

Lyons: Cath., Jean
Window, apse
Date: ca. 1220
Magi: Before Herod the Great

Mulhouse: Ch., Etienne
Windows
Date: First half 14th cent.
Personification: Virtue, Sobriety

Niederhaslach: Ch., Florentius
Windows, nave
Date: 1290–1420
Christ: Parable, Prodigal Son

Strasbourg: Cath., Notre Dame
Windows, nave
Date: 14th cent.
Personification: Virtue, Wisdom

Strasbourg: Cath., Notre Dame
Windows, southern transept
Date: 13th cent.
Apostle: Matthias

IVORY

London: Lib., British
Plaques, in book cover (Egerton 1139)
Date: 1131–1143
David: Slaying Lion

MANUSCRIPT

Brussels: Lib., Bibl. Royale, 9505-6
Aristotle, *Ethiques*, fol. 66r
Date: 1372

Brussels: Lib., Bibl. Royale, 9968-72
Prudentius, *Psychomachia*, fol. 105r
Date: 11th cent.

Brussels: Lib., Bibl. Royale, 9987-91
Prudentius, *Psychomachia*, fol. 116v
Date: 10th cent.
Personification: Vice, Avarice

Brussels: Lib., Bibl. Royale, 9987-91
Prudentius, *Psychomachia*, fol. 117r
Date: 10th cent.

Brussels: Lib., Bibl. Royale, 9987-91
Prudentius, *Psychomachia*, fol. 118r
Date: 10th cent.
Personification: Vice, Avarice

Brussels: Lib., Bibl. Royale, 9987-91
Prudentius, *Psychomachia*, fol. 118v
Date: 10th cent.

Brussels: Lib., Bibl. Royale, 10066-77
Prudentius, *Psychomachia*, fol. 130v
Date: 10th–first half 11th cent.

Cambridge: Lib., Corpus Christi
College, 23
Prudentius, *Psychomachia*, fol. 30v
Date: Early 11th cent.
Personification: Vice, Avarice

Cambridge: Lib., Corpus Christi
College, 23
Prudentius, *Psychomachia*, fol. 31v
Date: Early 11th cent.
Personification: Vice, Avarice

Cambridge: Lib., Corpus Christi
College, 23
Prudentius, *Psychomachia*, fol. 32r
Date: Early 11th cent.

Cambridge: Lib., Corpus Christi
College, 23
Prudentius, *Psychomachia*, fol. 32v
Date: Early 11th cent.

Florence: Lib., Bibl. Laurenziana,
Plut. XLII.19
Brunetto Latini, *Tesoro*, fol. 63v
Date: 14th cent.

Leiden: Lib., Bibl. der Univ., Burm. Q.3
Prudentius, *Psychomachia*, fol. 139v
Date: Second quarter 9th cent.
Personification: Vice, Avarice

Leiden: Lib., Bibl. der Univ., Burm. Q.3
Prudentius, *Psychomachia*, fol. 140r
Date: Second quarter 9th cent.
Personification: Vice, Avarice

Leiden: Lib., Bibl. der Univ., Burm. Q.3
Prudentius, *Psychomachia*, fol. 140v
Date: Second quarter 9th cent.

Leiden: Lib., Bibl. der Univ., Burm. Q.3
Prudentius, *Psychomachia*, fol. 141r
Date: Second quarter 9th cent.

Leiden: Lib., Bibl. der Univ., Voss. lat.
 oct. 15
Prudentius, *Psychomachia*, fol. 41r
Date: Early 11th cent.
Personification: Vice, Avarice

Leiden: Lib., Bibl. der Univ., Voss. lat.
 oct. 15
Prudentius, *Psychomachia*, fol. 41v
Date: Early 11th cent.
Personification: Vice, Avarice

London: Lib., British, Add. 24199
Prudentius, *Psychomachia*, fol. 27r
Date: Early 11th cent.

London: Lib., British, Add. 24199
Prudentius, *Psychomachia*, fol. 27v
Date: Early 11th cent.
Personification: Vice, Avarice

London: Lib., British, Add. 24199
Prudentius, *Psychomachia*, fol. 28r
Date: Early 11th cent.

London: Lib., British, Add. 24199
Prudentius, *Psychomachia*, fol. 28v
Date: Early 11th cent.

London: Lib., British, Cott. Cleo.
 C.VIII
Prudentius, *Psychomachia*, fol. 24v
Date: Early 11th cent.
Personification: Vice, Avarice

London: Lib., British, Cott. Cleo.
 C.VIII
Prudentius, *Psychomachia*, fol. 25v
Date: Early 11th cent.

London: Lib., British, Cott. Cleo.
 C.VIII
Prudentius, *Psychomachia*, fol. 26r
Date: Early 11th cent.

London: Lib., British, Cott. Titus
 D.XVI
Prudentius, *Psychomachia*, fol. 24v
Date: ca. 1100

London: Lib., British, Cott. Titus
 D.XVI
Prudentius, *Psychomachia*, fol. 25r
Date: ca. 1100

Lyons: Lib., Bibl. Municipale, Pal. des
 Arts 22
Prudentius, *Psychomachia*, fol. 9v
Date: Last quarter 11th cent.
Personification: Vice, Avarice

Lyons: Lib., Bibl. Municipale, Pal. des
 Arts 22
Prudentius, *Psychomachia*, fol. 13r
Date: Last quarter 11th cent.
Personification: Vice, Avarice

Lyons: Lib., Bibl. Municipale, Pal. des
 Arts 22
Prudentius, *Psychomachia*, fol. 13v
Date: Last quarter 11th cent.

Lyons: Lib., Bibl. Municipale, Pal. des
 Arts 22
Prudentius, *Psychomachia*, fol. 15r
Date: Last quarter 11th cent.

Paris: Lib., Bibl. Nat. de France,
 lat. 8085
Prudentius, *Psychomachia*, fol. 65r
Date: Late 9th cent.
Personification: Vice, Avarice

Paris: Lib., Bibl. Nat. de France,
 lat. 8085
Prudentius, *Psychomachia*, fol. 65v
Date: Late 9th cent.
Personification: Virtue, Peace

Paris: Lib., Bibl. Nat. de France,
 lat. 8085
Prudentius, *Psychomachia*, fol. 66r
Date: Late 9th cent.

Paris: Lib., Bibl. Nat. de France,
 lat. 8318
Prudentius, *Psychomachia*, fol. 53v
Date: Late 10th cent.
Personification: Vice, Fornication

Paris: Lib., Bibl. Nat. de France,
lat. 8318
Prudentius, *Psychomachia*, fol. 60v
Date: Late 10th cent.
Personification: Vice, Avarice

Paris: Lib., Bibl. Nat. de France,
lat. 8318
Prudentius, *Psychomachia*, fol. 61r
Date: Late 10th cent.
Personification: Vice, Avarice

Paris: Lib., Bibl. Nat. de France,
lat. 8318
Prudentius, *Psychomachia*, fol. 61v
Date: Late 10th cent.

Paris: Lib., Bibl. Nat. de France,
lat. 15158
Prudentius, *Psychomachia*, fol. 53v
Date: 1289
Personification: Vice, Avarice

Paris: Lib., Bibl. Nat. de France,
lat. 15158
Prudentius, *Psychomachia*, fol. 54r
Date: 1289
Personification: Vice, Avarice

Paris: Lib., Bibl. Nat. de France,
lat. 15158
Prudentius, *Psychomachia*, fol. 54v
Date: 1289
Personification: Vice, Avarice

Paris: Lib., Bibl. Nat. de France,
lat. 15158
Prudentius, *Psychomachia*, fol. 55r
Date: 1289

Saint Gall: Lib., Stiftsbibl., 135
Prudentius, *Psychomachia*, p. 406
Date: First half 11th cent.

Strasbourg: Lib., Bibl. Municipale
Herradis of Landsberg, *Hort. Delic.*,
fol. 67v
Date: Second half 12th cent.
Christ

Strasbourg: Lib., Bibl. Municipale
Herradis of Landsberg, *Hort. Delic.*,
fol. 201r
Date: Second half 12th cent.
Personification: Virtue, Patience

Strasbourg: Lib., Bibl. Municipale
Herradis of Landsberg, *Hort. Delic.*,
fol. 203r
Date: Second half 12th cent.
Personification: Vice, Pillage

Valenciennes: Lib., Bibl. Municipale,
563
Prudentius, *Psychomachia*, fol. 31r
Date: Early 11th cent.

Vienna: Lib., Nationalbibl., 2583*
Matfre Ermengaud, *Brev. d'Amor*,
fol. 237v
Date: 14th cent.

Vienna: Lib., Nationalbibl., 2592
Roman de la Rose, fol. 9r
Date: Second half 14th cent.

Wiesbaden: Lib., Hessische
Landesbibl., I
Hildegardis, *Liber Scivias*, fol. 161v
Date: ca. 1165
Hildegardis of Bingen: Vision

METALWORK

Cologne: Cathedral, Treasury
Casket, of Three Kings
Date: 1190–1225
Christ: Last Judgment

SCULPTURE

Argenton-Château: Ch., Gilles
Exterior, west
Date: After 1130
Ornament: Figured

Aulnay-de-Saintonge: Ch., Pierre
Exterior, west
Date: ca. 1130–1150
Month: Occupation

Clermont-Ferrand: Ch., Notre Dame
 du Port
Choir
Date: 12th cent.
Angel

Laon: Cath., Notre Dame
Exterior, west
Date: ca. 1180–1210
Magi: Adoration

Mozac: Church
Nave
Date: 12th cent.
Tobias: Taking Fish

Salisbury: Cathedral, Chapter House
Decoration, vestibule
Date: ca. 1260–1280
Personification: Virtues and Vices,
 Conflict

Sens: Cath., Etienne
Exterior, west
Date: Late 12th–13th cent.
Stephen Protomartyr: In Synagogue

Southrop: Church
Font
Date: ca. 1160
Personification: Church and
 Synagogue

Stanton Fitzwarren: Church
Font
Date: ca. 1160
Personification: Church

GENTLENESS

ENAMEL

Troyes: Cath., Pierre, Treasury
Casket
Date: ca. 1200
Personification: Virtue, Faith

FRESCO

Prufening: Ch., Monastery
Choir
Date: 12th cent.
Personification: Church

GLASS

Paris: Cath., Notre Dame
Window, west rose
Date: First half 13th cent.
Virgin Mary and Christ Child

MANUSCRIPT

Brussels: Lib., Bibl. Royale, 9505-6
Aristotle, *Ethiques*, fol. 89r
Date: 1372
Personification: Virtue, Justice

Cambridge: Lib., Trinity College,
 R.17.1
Psalter, Canterbury, fol. 78v
Date: ca. 1145–1170
Psalm 45 (Vulgate, 44)

Ghent: Lib., Bibl. de l'Université, 92
Lambertus, *Liber Floridus*, fol. 231v
Date: 1120
Tree of Virtues

London: Lib., British, Harley 603
Psalter, fol. 26r
Date: ca. 1000–12th cent.
Psalm 45 (Vulgate, 44)

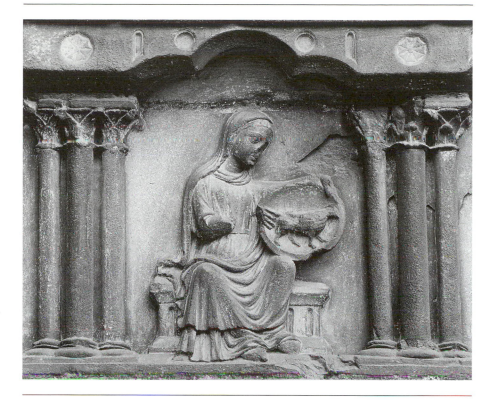

Munich: Lib., Staatsbibl., Clm. 13002
Miscellany, fol. 4r
Date: 1158–1165
Joseph: Brethren Begging Forgiveness

Paris: Lib., Bibl. Nat. de France, gr. 139
Psalter, fol. 3v
Date: 10th cent.
Psalms: Illustration

Rome: Lib., Bibl. Vaticana, gr. 333
Kings, fol. 22v
Date: 11th cent.
David: Anointed

Rome: Lib., Bibl. Vaticana, gr. 394
John Climacus, *Climax*, fol. 62r
Date: Late 11th cent.
John Climacus: Climax, Chapter VII

Rome: Lib., Bibl. Vaticana, gr. 394
John Climacus, *Climax*, fol. 107r
Date: Late 11th cent.
John Climacus: Climax, Chapter XXIII, Part 2

Rome: Lib., Bibl. Vaticana, Reg. gr. 1
Bible of Leo, fol. 263r
Date: Mid-10th cent.
David: Anointed

Strasbourg: Lib., Bibl. Municipale
Herradis of Landsberg, *Hort. Delic.*,
 fol. 201r
Date: Second half 12th cent.
Personification: Virtue, Patience

Utrecht: Lib., Bibl. der Universiteit, 32
Psalter, fol. 26r
Date: ca. 820–830
Psalm 45 (Vulgate, 44)

Venice: Lib., Bibl. Marciana, gr. Z. 540
 (557)
Gospel Book, fol. 7r
Date: Early 12th cent.

Vienna: Lib., Nationalbibl., 2554
Bible, Moralized, fol. 27r
Date: ca. 1215–1230
Moses: Law, Offering of Herd

Washington: Coll., Dumbarton
 Oaks, 3
Psalter-New Testament, fol. 5r
Date: Late 11th cent.
David: Birth

METALWORK

Cologne: Cathedral, Treasury
Casket, of Three Kings
Date: 1190–1225
Christ: Last Judgment

Hildesheim: Cath., Maria
Chandelier, of Hezilo
Date: ca. 1055–1065
Building: City Wall

Saint-Gilles: Church
Sarcophagus, gold, of Aegidius
Date: 12th cent.?
Elders, Four and Twenty

SCULPTURE

Amiens: Cath., Notre Dame
Exterior, west
Date: 1220–1235
Malachi

Chartres: Cath., Notre Dame
Porch, south
Date: ca. 1230–1240
Saint

Laon: Cath., Notre Dame
Exterior, west
Date: ca. 1180–1210
Magi: Adoration

Nuremberg: Ch., Sebaldus
Exterior, north
Date: 14th cent.
Virgins: Wise and Foolish

Paris: Cath., Notre Dame
Exterior, west
Date: ca. 1220–1230
Christ: Last Judgment

Pavia: Ch., Pietro in Ciel d'Oro
Tomb of Augustine of Hippo
Attribution: Giovanni di Balduccio,
 follower of
Date: Second half 14th cent.
Augustine of Hippo: Scene

TEXTILE

Vienna: Coll., Wilczek
Hanging, tapestry
Date: 1186–1203

GOOD BEHAVIOR

MANUSCRIPT

Vienna: Lib., Nationalbibl., 2583*
Matfre Ermengaud, *Brev. d'Amor*,
 fol. 237v
Date: 14th cent.
Personification: Virtue, Generosity

GOODNESS

ENAMEL

Cologne: Ch., Pantaleon
Casket, reliquary, Albanus of Mayence
Date: 1186
Personification: Virtue, Humility

FRESCO

Bawît: Mon., Apollo
Chapel III (Clédat)
Date: 6th–7th cent.?
Scene: Unidentified

IVORY

London: Lib., British
Plaques, in book cover (Egerton 1139)
Date: 1131–1143
David: Slaying Lion

MANUSCRIPT

Brussels: Lib., Bibl. Royale, 9505-6
Aristotle, *Ethiques*, fol. 24r
Date: 1372

Ghent: Lib., Bibl. de l'Université, 92
Lambertus, *Liber Floridus*, fol. 231v
Date: 1120
Tree of Virtues

Paris: Lib., Bibl. Nat. de France,
 lat. 6734
Honorius of Autun, *Clavis Physicae*,
 fol. 3v
Date: 12th cent.

METALWORK

Cologne: Cathedral, Treasury
Casket, of Three Kings
Date: 1190–1225
Christ: Last Judgment

GRACE

FRESCO

Cologne: Ch., Maria Lyskirchen
Nave
Date: Mid-13th cent.
Balaam: Prophesying Star of Jacob

MANUSCRIPT

Eton: Lib., Eton College, 177
Miscellany, fol. 7v
Date: 13th cent.

Paris: Lib., Bibl. Nat. de France,
 lat. 15670
Cassianus, *De Institutis*, fol. 5r
Date: 12th cent.
Cassianus the Theologian

Strasbourg: Lib., Bibl. Municipale
Herradis of Landsberg, *Hort. Delic.*,
 fol. 201r
Date: Second half 12th cent.
Personification: Virtue, Patience

METALWORK	**TEXTILE**
Hildesheim: Cath., Maria Chandelier, of Hezilo Date: ca. 1055–1065 *Building: City Wall*	Augsburg: Ch., Ulric and Afra Tapestries Date: 12th cent. *Personification: New Testament*

GRACIOUSNESS

FRESCO

Bawît: Mon., Apollo
Chapel III (Clédat)
Date: 6th–7th cent.?
Scene: Unidentified

GUILELESSNESS

MANUSCRIPT

Rome: Lib., Bibl. Vaticana, gr. 394
John Climacus, *Climax*, fol. 107r
Date: Late 11th cent.
John Climacus: Climax, Chapter XXIII, Part 2

Venice: Lib., Bibl. Marciana, gr. Z. 540 (557)
Gospel Book, fol. 7r
Date: Early 12th cent.
Personification: Virtue, Gentleness

HOLINESS

MANUSCRIPT

Venice: Lib., Bibl. Marciana, gr. Z. 540 (557)
Gospel Book, fol. 6v
Date: Early 12th cent.
Personification: Virtue, Truth

Wiesbaden: Lib., Hessische Landesbibl., I
Hildegardis, *Liber Scivias*, fol. 192r
Date: ca. 1165
Hildegardis of Bingen: Vision

METALWORK

Hildesheim: Cath., Maria Chandelier, of Hezilo
Date: ca. 1055–1065
Building: City Wall

HOLY FEAR

ENAMEL

Klosterneuberg: Monastery
Retable
Attribution: Nicolas of Verdun
Date: 1181
Abraham: Entertaining the Angels

MANUSCRIPT

London: Lib., British, Add. 38120
G. de Degulleville, *Pèlerinage*,
 fol. 101v
Date: ca. 1400
*Guillaume de Degulleville: Pèlerinage
 de Vie Humaine*

Paris: Lib., Bibl. Nat. de France,
 lat. 2077
Miscellany, fol. 165v
Date: 10th–11th cent.
Personification: Vice, Vainglory

Strasbourg: Lib., Bibl. Municipale
Herradis of Landsberg, *Hort. Delic.*,
 fol. 202r
Date: Second half 12th cent.
Personification: Virtue, Prudence

Wiesbaden: Lib., Hessische
 Landesbibl., I
Hildegardis, *Liber Scivias*, fol. 2r
Date: ca. 1165
Hildegardis of Bingen: Vision

Wiesbaden: Lib., Hessische
 Landesbibl., I
Hildegardis, *Liber Scivias*, fol. 178r
Date: ca. 1165
Hildegardis of Bingen: Vision

HONESTY

GLASS

Niederhaslach: Ch., Florentius
Windows, nave
Date: 1290–1420
Christ: Parable, Prodigal Son

Strasbourg: Cath., Notre Dame
Windows, nave
Date: 14th cent.
Personification: Virtue, Wisdom

MANUSCRIPT

London: Lib., British, Yates
 Thompson 11
Miscellany, fol. 1v
Date: ca. 1300
Christ and Four Beasts

Nuremberg: Mus., Germ. Nat. Bibl.,
 156142
Gospel Book, Echternach, fol. 113v
Date: 10th–11th cent.
Personification: Virtue

Strasbourg: Lib., Bibl. Municipale
Herradis of Landsberg, *Hort. Delic.*,
 fol. 201r
Date: Second half 12th cent.
Personification: Virtue, Patience

METALWORK

Trier: Ch., Maximin
Font, of Folcardus
Date: Early 12th cent.
Personification: Virtue, Humility

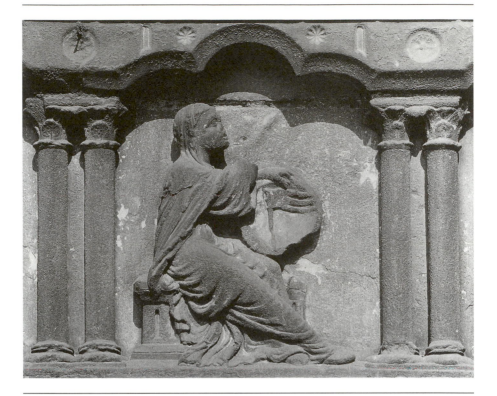

HOPE

ENAMEL

Baltimore: Gall., Walters
Cross (44.98)
Date: Mid-12th cent.
Christ: Crucifixion

Brussels: Lib., Bibl. Royale
Book cover (14970)
Date: Second half 12th cent.
Evangelist: Symbol

Brussels: Mus., Royaux d'Art et
 d'Histoire
Plaque, from reliquary (3141)
Date: ca. 1170
Personification: Virtue, Fortitude

Brussels: Mus., Royaux d'Art et
 d'Histoire
Reliquary, Valentinus of Maastricht
 (1038)
Date: ca. 1160–1170

Chicago: Mus., Art Institute
Plaque (43.75)
Date: Second half 12th cent.

Klosterneuberg: Monastery
Retable
Attribution: Nicolas of Verdun
Date: 1181
Abraham: Entertaining the Angels

Manchester: Lib., Rylands
Book cover (lat. 11)
Date: Second half 12th cent.
Angel

Saint-Ghislain: Church
Casket, reliquary
Date: Mid-12th cent.
Personification: Virtue, Patience

FRESCO

Assisi: Ch., Francesco, Lower
Crossing, vault
Date: First half 14th cent.
Allegory: Poverty

Bawît: Mon., Apollo
Chapel III (Clédat)
Date: 6th–7th cent.?
Scene: Unidentified

Bawît: Mon., Apollo
Chapel XII (Clédat)
Date: 6th–7th cent.?
Malachi

Bawît: Mon., Apollo
Chapel XVIII (Clédat)
Date: 6th–7th cent.?
Bird

Bawît: Mon., Apollo
Chapel XXII (Clédat)
Date: 6th–7th cent.?
Personification: Virtue, Faith

Brioude: Ch., Julien
Porch
Date: 12th–13th cent.
Christ: Last Judgment

Cairo: Mus., Coptic Museum, 7954
Date: 6th cent. or later
Palm

Cividale: Ch., Tempietto
Decoration
Date: 12th–13th cent.
Mary Magdalen

Cologne: Cath., Peter und Maria
Chapel, S. Agnes
Date: 14th cent.
Irmgardis of Zutphen: Scene

Florence: Ch., Croce
Chapel, Bardi di Vernio (Silvestro)
Date: First half 14th cent.
Constantine the Great: Scene

Florence: Ch., Croce
Chapel, Baroncelli, back wall
Attribution: Taddeo Gaddi
Date: ca. 1328–1330
Personification: Virtues, Cardinal

Florence: Ch., Croce
Chapel, Baroncelli, side vault
Attribution: Taddeo Gaddi
Date: ca. 1328–1330
Joachim: Offerings Rejected

Florence: Ch., Croce
Sacristy
Date: Late 14th cent.
Christ: Ascension

Florence: Ch., Maria Novella
Chapel, Spanish
Date: ca. 1355
Peter Martyr: Scene

Florence: Ch., Maria Novella
Chapel, Strozzi, ceiling
Attribution: Giovanni del Biondo,
 Nardo di Cione
Date: ca. 1350–1360
Thomas Aquinas

Gundsømagle: Church
Decoration
Date: ca. 1200
Saint

Kirkerup: Church
Decoration
Date: ca. 1200
Personification: Virtue, Charity

Padua: Chap., Madonna dell'Arena
Decoration
Attribution: Giotto
Date: ca. 1303–1308
Joachim: Offerings Rejected

Padua: Ch., Eremitani
Chapel, S. Agostino
Date: ca. 1370
Personification: Theology

Paganico: Ch., Michele
Choir
Date: 14th cent.
Magi: Adoration

Pisa: Ch., Francesco
Choir
Date: 1342
Francis of Assisi

Pistoia: Cath., Zenone
Nave
Date: 1347
Personification: Virtue, Prudence

Prufening: Ch., Monastery
Choir
Date: 12th cent.
Personification: Church

San Miniato: Pal., Municipio
Room, Consiglio
Date: 1393
Virgin Mary and Christ Child:
 Type Suckling

Siena: Pal., Pubblico
Room, Pace
Attribution: Ambrogio Lorenzetti
Date: 1338–1339
Personification: Virtue, Justice

Tolentino: Ch., Nicola da Tolentino
Chapel, S. Nicola
Date: 13th–14th cent.
Evangelist: Symbol

GLASS

Esslingen: Ch., Dionysius
Windows, choir
Date: Late 13th–14th cent.
Isaiah

Niederhaslach: Ch., Florentius
Windows, nave
Date: 1290–1420
Christ: Parable, Prodigal Son

Strasbourg: Cath., Notre Dame
Windows, nave
Date: 14th cent.
Personification: Virtue, Wisdom

IVORY

London: Lib., British
Plaques, in book cover (Egerton 1139)
Date: 1131–1143
David: Slaying Lion

MANUSCRIPT

Berne: Lib., Stadtbibl., 264
Prudentius, *Psychomachia*, fol. 43v
Date: Early 10th cent.
Personification: Vice, Fraud

Berne: Lib., Stadtbibl., 264
Prudentius, *Psychomachia*, fol. 44r
Date: Early 10th cent.
Personification: Virtue, Humility

Berne: Lib., Stadtbibl., 264
Prudentius, *Psychomachia*, fol. 44v
Date: Early 10th cent.
Personification: Vice, Pride

Berne: Lib., Stadtbibl., 264
Prudentius, *Psychomachia*, fol. 45r
Date: Early 10th cent.
Personification: Vice, Pride

Berne: Lib., Stadtbibl., 264
Prudentius, *Psychomachia*, fol. 45v
Date: Early 10th cent.
Personification: Virtue, Humility

Brussels: Lib., Bibl. Royale, 9968-72
Prudentius, *Psychomachia*, fol. 86r
Date: 11th cent.
Personification: Vice, Pride

Brussels: Lib., Bibl. Royale, 9968-72
Prudentius, *Psychomachia*, fol. 87r
Date: 11th cent.
Personification: Virtue, Humility

Brussels: Lib., Bibl. Royale, 9968-72
Prudentius, *Psychomachia*, fol. 90r
Date: 11th cent.

Brussels: Lib., Bibl. Royale, 9968-72
Prudentius, *Psychomachia*, fol. 90v
Date: 11th cent.
Personification: Virtue, Humility

Brussels: Lib., Bibl. Royale, 9987-91
Prudentius, *Psychomachia*, fol. 106r
Date: 10th cent.
Personification: Vice, Pride

Brussels: Lib., Bibl. Royale, 9987-91
Prudentius, *Psychomachia*, fol. 107r
Date: 10th cent.
Personification: Vice, Pride

Brussels: Lib., Bibl. Royale, 9987-91
Prudentius, *Psychomachia*, fol. 107v
Date: 10th cent.
Personification: Vice, Pride

Brussels: Lib., Bibl. Royale, 9987-91
Prudentius, *Psychomachia*, fol. 108r
Date: 10th cent.

Brussels: Lib., Bibl. Royale, 9987-91
Prudentius, *Psychomachia*, fol. 108v
Date: 10th cent.

Brussels: Lib., Bibl. Royale, 9987-91
Prudentius, *Psychomachia*, fol. 109r
Date: 10th cent.

Brussels: Lib., Bibl. Royale, 10066-77
Prudentius, *Psychomachia*, fol. 122r
Date: 10th–first half 11th cent.
Personification: Vice, Pride

Brussels: Lib., Bibl. Royale, 10066-77
Prudentius, *Psychomachia*, fol. 123v
Date: 10th–first half 11th cent.
Personification: Vice, Pride

Brussels: Lib., Bibl. Royale, 10066-77
Prudentius, *Psychomachia*, fol. 124r
Date: 10th–first half 11th cent.
Personification: Virtue, Humility

Brussels: Lib., Bibl. Royale, 10066-77
Prudentius, *Psychomachia*, fol. 124v
Date: 10th–first half 11th cent.

Cambridge: Lib., Corpus Christi
 College, 23
Prudentius, *Psychomachia*, fol. 15r
Date: Early 11th cent.
Personification: Vice, Pride

Cambridge: Lib., Corpus Christi
 College, 23
Prudentius, *Psychomachia*, fol. 16v
Date: Early 11th cent.
Personification: Vice, Pride

Cambridge: Lib., Corpus Christi
 College, 23
Prudentius, *Psychomachia*, fol. 17v
Date: Early 11th cent.
Personification: Vice, Pride

Cambridge: Lib., Corpus Christi
 College, 23
Prudentius, *Psychomachia*, fol. 18r
Date: Early 11th cent.

Cambridge: Lib., Corpus Christi
 College, 23
Prudentius, *Psychomachia*, fol. 18v
Date: Early 11th cent.

Cambridge: Lib., Corpus Christi
 College, 23
Prudentius, *Psychomachia*, fol. 19v
Date: Early 11th cent.

Darmstadt: Lib., Hessische
 Landesbibl., 1640
Gospel Book, Hitda of Meschede, fol.
 173r
Date: 1000–1020
Personification: Virtue, Charity

Ghent: Lib., Bibl. de l'Université, 92
Lambertus, *Liber Floridus*, fol. 231v
Date: 1120
Tree of Virtues

Kremsmünster: Lib., Stiftsbibl., 243
Spec. Hum. Salvationis, fol. 4r
Date: First half 14th cent.
Tree of Virtues

Leiden: Lib., Bibl. der Univ., Burm. Q.3
Prudentius, *Psychomachia*, fol. 129r
Date: Second quarter 9th cent.
Personification: Vice, Pride

Leiden: Lib., Bibl. der Univ., Burm. Q.3
Prudentius, *Psychomachia*, fol. 130r
Date: Second quarter 9th cent.
Personification: Vice, Pride

Leiden: Lib., Bibl. der Univ., Burm. Q.3
Prudentius, *Psychomachia*, fol. 130v
Date: Second quarter 9th cent.
Personification: Virtue, Humility

Leiden: Lib., Bibl. der Univ., Burm. Q.3
Prudentius, *Psychomachia*, fol. 131r
Date: Second quarter 9th cent.

Leiden: Lib., Bibl. der Univ., Burm. Q.3
Prudentius, *Psychomachia*, fol. 131v
Date: Second quarter 9th cent.

Leiden: Lib., Bibl. der Univ., Burm. Q.3
Prudentius, *Psychomachia*, fol. 132r
Date: Second quarter 9th cent.

Leiden: Lib., Bibl. der Univ., Voss.
 lat. oct. 15
Prudentius, *Psychomachia*, fol. 39r
Date: Early 11th cent.
Personification: Vice, Pride

Leiden: Lib., Bibl. der Univ., Voss.
 lat. oct. 15
Prudentius, *Psychomachia*, fol. 39v
Date: Early 11th cent.

London: Lib., British, Add. 17737–8
Bible, Floreffe, II, fol. 3v
Date: ca. 1153
Job: Sacrifice for Children

London: Lib., British, Add. 24199
Prudentius, *Psychomachia*, fol. 12v
Date: Early 11th cent.
Personification: Vice, Pride

London: Lib., British, Add. 24199
Prudentius, *Psychomachia*, fol. 14r
Date: Early 11th cent.
Personification: Vice, Pride

London: Lib., British, Add. 24199
Prudentius, *Psychomachia*, fol. 14v
Date: Early 11th cent.
Personification: Virtue, Humility

London: Lib., British, Add. 24199
Prudentius, *Psychomachia*, fol. 15r
Date: Early 11th cent.

London: Lib., British, Add. 24199
Prudentius, *Psychomachia*, fol. 15v
Date: Early 11th cent.
Personification: Virtue, Humility

London: Lib., British, Add. 24199
Prudentius, *Psychomachia*, fol. 16r
Date: Early 11th cent.

London: Lib., British, Cott. Cleo.
 C.VIII
Prudentius, *Psychomachia*, fol. 11r
Date: Early 11th cent.
Personification: Vice, Pride

London: Lib., British, Cott. Cleo.
 C.VIII
Prudentius, *Psychomachia*, fol. 12v
Date: Early 11th cent.
Personification: Vice, Pride

London: Lib., British, Cott. Cleo.
 C.VIII
Prudentius, *Psychomachia*, fol. 13v
Date: Early 11th cent.

London: Lib., British, Cott. Cleo.
 C.VIII
Prudentius, *Psychomachia*, fol. 14r
Date: Early 11th cent.

London: Lib., British, Cott. Cleo.
 C.VIII
Prudentius, *Psychomachia*, fol. 14v
Date: Early 11th cent.

London: Lib., British, Cott. Titus
 D.XVI
Prudentius, *Psychomachia*, fol. 12v
Date: ca. 1100
Personification: Vice, Pride

London: Lib., British, Cott. Titus
 D.XVI
Prudentius, *Psychomachia*, fol. 16r
Date: ca. 1100

London: Lib., British, Harley 1526–27
Bible, Moralized, II, fol. 28v
Date: First half 13th cent.
*Christ: Miracle of Raising Daughter of
 Jairus*

Lucca: Lib., Bibl. Capitolare, P †
Passional, fol. 28v
Date: First half 12th cent.
Personification: Virtue, Wisdom

Madrid: Lib., Bibl. Nacional, 195-6
Bartolus of Sassoferrato, *Comm.*
Date: 14th cent.
Augustine of Hippo

Melbourne: Gall., National, Felton
 710/5
Gospel Book, fol. 6v
Date: ca. 1100
Personification: Virtue, Faith

Milan: Lib., Bibl. Ambrosiana,
 B.42 inf.
Giovanni d'Andrea, *Novella,* fol. 1r
Date: 1354
Personification: Virtues, Cardinal

Montecassino: Monastery, 132
Rabanus Maurus, *De Universo*, p. 68
Date: ca. 1023
Personification: Virtue, Charity

Munich: Lib., Staatsbibl., Clm. 30055
Gospel Book, Henry the Lion, fol. 13v
Date: ca. 1175
Apostle: James Minor

Munich: Mus., Staatl. Graphische
 Samml., 39789
Miniature
Date: 12th cent.
Christ: Sermon on Mount

New York: Lib., Morgan, Pierpont,
 M.676
Dante, *Divina Commedia*, fol. 83v
Date: Late 14th cent.
Dante: Purgatorio

Paris: Lib., Bibl. Nat. de France,
 lat. 1052
Breviary, Charles V, fol. 217r
Date: Second half 14th cent.
Psalm 27 (Vulgate, 26)

Paris: Lib., Bibl. Nat. de France,
 lat. 8085
Prudentius, *Psychomachia*, fol. 60r
Date: Late 9th cent.
Personification: Vice, Pride

Paris: Lib., Bibl. Nat. de France,
 lat. 8085
Prudentius, *Psychomachia*, fol. 60v
Date: Late 9th cent.
Personification: Vice, Pride

Paris: Lib., Bibl. Nat. de France,
 lat. 8085
Prudentius, *Psychomachia*, fol. 61r
Date: Late 9th cent.
Personification: Virtue, Humility

Paris: Lib., Bibl. Nat. de France,
 lat. 8318
Prudentius, *Psychomachia*, fol. 51r
Date: Late 10th cent.
Personification: Vice, Pride

Paris: Lib., Bibl. Nat. de France,
 lat. 8318
Prudentius, *Psychomachia*, fol. 51v
Date: Late 10th cent.
Personification: Vice, Pride

Paris: Lib., Bibl. Nat. de France,
 lat. 10483–84
Breviary, Belleville, I, fol. 12v
Date: First half 14th cent.
Psalm 27 (Vulgate, 26)

Paris: Lib., Bibl. Nat. de France,
 lat. 10483–84
Breviary, Belleville, I, fol. 17v
Date: First half 14th cent.
Psalm 27 (Vulgate, 26)

Paris: Lib., Bibl. Nat. de France,
 lat. 18014
Hours, Duc de Berry, fol. 278v
Date: Late 14th cent.
Solomon: Throne

Rome: Gall., Naz. d'Arte Antica
Bartolomeo di Bartoli, *Canzone*, fol. 7r
Date: 14th cent.

Rome: Lib., Bibl. Vaticana, gr. 394
John Climacus, *Climax*, fol. 94r
Date: Late 11th cent.
*John Climacus: Climax, Chapter
 XVIII*

Rome: Lib., Bibl. Vaticana, gr. 394
John Climacus, *Climax*, fol. 151v
Date: Late 11th cent.
*John Climacus: Climax, Chapter
 XXIX*

Rome: Lib., Bibl. Vaticana, gr. 394
John Climacus, *Climax*, fol. 154r
Date: Late 11th cent.
John Climacus: Climax, Chapter XXX

Saint Gall: Lib., Stiftsbibl., 135
Prudentius, *Psychomachia*, p. 399
Date: First half 11th cent.

Saint Gall: Lib., Stiftsbibl., 135
Prudentius, *Psychomachia*, p. 400
Date: First half 11th cent.
Personification: Vice, Fraud

Salzburg: Lib., Studienbibl., V 1 H 162
Miscellany, fol. 76r
Date: First half 12th cent.
Tree of Virtues

Strasbourg: Lib., Bibl. Municipale
Herradis of Landsberg, *Hort. Delic.*,
 fol. 199v
Date: Second half 12th cent.
Personification: Vice, Pride

Strasbourg: Lib., Bibl. Municipale
Herradis of Landsberg, *Hort. Delic.*,
 fol. 200r
Date: Second half 12th cent.
Personification: Virtue, Humility

Valenciennes: Lib., Bibl. Municipale,
 563
Prudentius, *Psychomachia*, fol. 13r
Date: Early 11th cent.
Personification: Vice, Pride

Valenciennes: Lib., Bibl. Municipale,
 563
Prudentius, *Psychomachia*, fol. 14v
Date: Early 11th cent.
Personification: Vice, Pride

Valenciennes: Lib., Bibl. Municipale,
 563
Prudentius, *Psychomachia*, fol. 15r
Date: Early 11th cent.
Personification: Vice, Pride

Valenciennes: Lib., Bibl. Municipale,
 563
Prudentius, *Psychomachia*, fol. 15v
Date: Early 11th cent.
Personification: Vice, Pride

Valenciennes: Lib., Bibl. Municipale,
 563
Prudentius, *Psychomachia*, fol. 16r
Date: Early 11th cent.
Personification: Virtue, Humility

Valenciennes: Lib., Bibl. Municipale,
 563
Prudentius, *Psychomachia*, fol. 16v
Date: Early 11th cent.

Valenciennes: Lib., Bibl. Municipale,
 563
Prudentius, *Psychomachia*, fol. 17r
Date: Early 11th cent.

Vienna: Lib., Nationalbibl., 1367
Miscellany, fol. 92v
Date: 12th cent.
Personification: Virtue, Charity

Vienna: Lib., Nationalbibl., Ser. Nov.
 2639
Convenevoli de Pratis(?), *Poemata*,
 fol. 2r
Date: Early 14th cent.
Personification: Virtue, Charity

Wiesbaden: Lib., Hessische
 Landesbibl., I
Hildegardis, *Liber Scivias*, fol. 178r
Date: ca. 1165
Hildegardis of Bingen: Vision

Wolfenbüttel: Lib., Herzog August
 Bibl., Guelf. 105 Noviss. 2°
Gospel Book, Henry the Lion, fol. 13v
Date: ca. 1175
Apostle: James Minor

METALWORK

Aachen: Cathedral, Treasury
Casket, reliquary, Charlemagne
Date: 1182–1215
Charlemagne: Scene

Berlin: Mus., Staatliche
Bowl, bronze (I.3136)
Date: 13th cent.
Personification: Virtue, Humility

Budapest: Mus., Magyar Nemzeti
 Múzeum
Bowl, bronze
Date: 12th–13th cent.
Personification: Virtue, Humility

Cologne: Cathedral, Treasury
Casket, of Three Kings
Date: 1190–1225
Christ: Last Judgment

Copenhagen: Mus., National
Altar, copper-gilt (D287)
Date: ca. 1150
Christ

Florence: Baptistery
Door, south, bronze
Attribution: Andrea Pisano
Date: 1330
Zacharias: Annunciation

Hannover: Mus., Kestner
Bowl, bronze-gilt (1894.18)
Date: 12th cent.
Personification: Virtue, Humility

Hildesheim: Cath., Maria
Chandelier, of Hezilo
Date: ca. 1055–1065
Building: City Wall

Leipzig: Mus., Kunsthandwerk
Bowl, bronze-gilt (5011)
Date: ca. 1250

Lübeck: Mus., Kunst und
 Kulturgeschichte
Bowl, copper (130)
Date: 12th–13th cent.

Lund: Mus., Kulturhistoriska
Bowl (K.M. 10283)
Date: 12th cent.

Lund: Mus., Kulturhistoriska
Bowl, bronze (25557)
Date: 11th–13th cent.
Personification: Virtue, Humility

Manchester: Lib., Rylands
Book cover, silver-gilt (lat. 4)
Date: ca. 1150–1175
Saint?

Munich: Mus., Bayerisches
 Nationalmus.
Bowl, brass (M.A. 204)
Date: 12th–13th cent.
Personification: Virtue, Humility

Namur: Mus., Archéologique
Reliquary
Date: 12th cent.
Personification: Virtue, Faith

Padua: Mus., Civico
Bowl (664)
Date: 12th cent.
Personification: Virtue, Charity

Saint-Gilles: Church
Sarcophagus, gold, of Aegidius
Date: 12th cent.?
Elders, Four and Twenty

Salzburg: Mus., Dom
Bowl, bronze
Date: 12th cent.
Personification: Virtue, Humility

Tallinn: Mus., Institute of History
Bowl, bronze (AI 4143:5)
Date: 12th cent.

Tallinn: Mus., Institute of History
Bowl, bronze (AI 4143:6)
Date: 12th cent.

Trier: Ch., Maximin
Font, of Folcardus
Date: Early 12th cent.
Personification: Virtue, Humility

Wrocław: Mus., Archeologiczne
Bowl, bronze
Date: Late 11th–12th cent.
Personification: Virtue, Humility

MOSAIC

Venice: Ch., Marco
Atrium
Date: ca. 1260
Joseph: Sold to Potiphar

Venice: Ch., Marco
Crossing
Date: Last quarter 12th cent.
Christ: Ascension

PAINTING

Florence: Ch., Croce
Polyptych
Attribution: Giovanni del Biondo
Date: 1379
Virgin Mary and Christ Child

Greenwich: Coll., Hyland
Panel
Date: 14th cent.
Virgin Mary and Christ Child

Massa Marittima: Pal., Comunale
Panel
Attribution: Ambrogio Lorenzetti
Date: ca. 1335–1340
Virgin Mary and Christ Child

New York: Coll., Wildenstein
Panel
Date: 14th cent.
Virgin Mary and Christ Child

Rome: Mus., Vaticani, Pinacoteca
Panel (40520)
Date: ca. 1375–1380
Virgin Mary

SCULPTURE

Amiens: Cath., Notre Dame
Exterior, west
Date: 1220–1235
Malachi

Chartres: Cath., Notre Dame
Exterior, north, central portal
Date: 1205–1210
Virgin Mary: Coronation

Chartres: Cath., Notre Dame
Exterior, north, left portal
Date: ca. 1220
Virgins, Foolish

Chartres: Cath., Notre Dame
Porch, south
Date: ca. 1230–1240
Saint

Cluny: Mus., Farinier
Capitals
Date: Late 11th–early 12th cent.
Personification: Music

Florence: Cath., Maria del Fiore
Tomb of Antonio Orso
Date: ca. 1321
Antonio Orso

Florence: Ch., Orsanmichele
Tabernacle, marble
Attribution: Orcagna
Date: 1359–1360
Angel: Archangel Michael

Florence: Loggia dei Lanzi
Exterior
Date: 14th cent.
Personification: Virtues, Cardinal

Florence: Mus., Opera del Duomo
Relief, from bell tower
Attribution: Maestro della Luna
Date: 1337–1341
Personification: Virtue, Faith

Florence: Mus., Opera del Duomo
Statues
Date: 14th cent.
Figure: Female

Milan: Ch., Eustorgio
Tomb of Peter Martyr
Attribution: Giovanni di Balduccio or
 workshop of
Date: 1339
Christ

Monreale: Cath., Maria la Nuova
Cloister
Date: Last quarter 12th cent.
Christ: Parable, Lazarus and Dives

Naples: Ch., Chiara
Tomb of Marie of Valois
Attribution: Tino di Camaino or
 workshop
Date: ca. 1330
Marie of Valois

Naples: Ch., Chiara
Tomb of Marie, Princess of Calabria
Date: ca. 1328
Marie, Princess of Calabria

Naples: Ch., Domenico Maggiore
Candlestick
Attribution: Pacio and Giovanni
 Bertini da Firenze, workshop of
Date: ca. 1330–1350
Personification: Virtues, Cardinal

Naples: Ch., Lorenzo Maggiore
Tomb of Catherine of Austria
Attribution: Tino di Camaino
Date: ca. 1324
Virgin Mary and Christ Child

Paris: Cath., Notre Dame
Exterior, west
Date: ca. 1220–1230
Christ: Last Judgment

Parma: Baptistery
Exterior
Date: Late 12th–13th cent.
Magi: Adoration

Pavia: Ch., Pietro in Ciel d'Oro
Tomb of Augustine of Hippo
Attribution: Giovanni di Balduccio,
 follower of
Date: Second half 14th cent.
Augustine of Hippo: Scene

Pisa: Cathedral
Pulpit
Attribution: Giovanni Pisano
Date: 1302–1310
Virgin Mary: Annunciation

Pistoia: Ch., Giovanni Fuorcivitas
Holy water basin
Attribution: Nicola Pisano,
 workshop of
Date: Late 13th cent.
Personification: Virtues, Cardinal

Reims: Cath., Notre Dame
Exterior, west
Date: ca. 1230–1240
Virgin Mary: Coronation

Rome: Ch., Francesca Romana
Tomb of Marino Vulcani
Date: 1394–1403
Marino Vulcani

Salisbury: Cathedral, Chapter House
Decoration, vestibule
Date: ca. 1260–1280
*Personification: Virtues and Vices,
 Conflict*

Siena: Cath., Assunta
Pulpit
Attribution: Nicola Pisano
Date: ca. 1265–1269
Virgin Mary: Visitation

Venice: Ch., Marco
Exterior, west
Date: 13th cent.
Christ

Verona: Cath., Maria Matricolare
Exterior, west
Date: 12th cent.
Shepherds: Annunciation

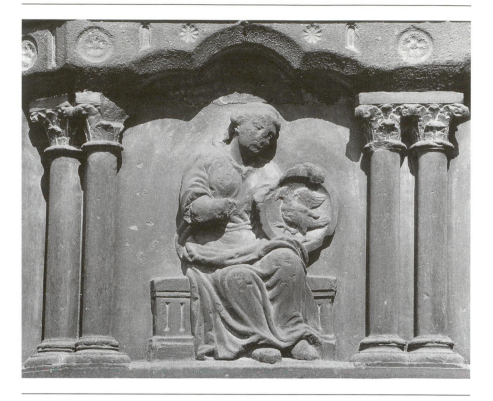

HUMILITY

ENAMEL

Brussels: Coll., Stoclet
Plaque
Date: Second half 12th cent.
Personification: Virtue

Brussels: Lib., Bibl. Royale
Book cover (14970)
Date: Second half 12th cent.
Evangelist: Symbol

Brussels: Mus., Royaux d'Art et
 d'Histoire
Plaque, from reliquary (3141)
Date: ca. 1170
Personification: Virtue, Fortitude

Brussels: Mus., Royaux d'Art et
 d'Histoire
Reliquary, Alexander (1031)
Date: 1145
Eventius of Rome

Budapest: Mus., Magyar Nemzeti
 Múzeum
Crown of Constantine IX
 Monomachos
Date: 1042–1050
Constantine Monomacus

Cleveland: Museum of Art
Pendant, reliquary (26.428)
Date: ca. 1160
Virgin Mary and Christ Child

Cologne: Ch., Pantaleon
Casket, reliquary, Albanus of Mayence
Date: 1186

Darmstadt: Mus., Hessisches
 Landesmus.
Plaque, copper-gilt (Kg 54:246f)
Date: ca. 1170
Ecclesiasticus: Illustration

Klosterneuberg: Monastery
Retable
Attribution: Nicolas of Verdun
Date: 1181
Abraham: Entertaining the Angels

Langres: Museum
Plaques, on reliquary
Date: Third quarter 12th cent.
Personification: Virtue, Fortitude

Manchester: Lib., Rylands
Book cover (lat. 11)
Date: Second half 12th cent.
Angel

Osnabrück: Town Hall, Rathaus
Vessel
Date: First half 14th cent.
Personification: Virtue, Prudence

Troyes: Cath., Pierre, Treasury
Casket
Date: ca. 1200
Personification: Virtue, Faith

Troyes: Cath., Pierre, Treasury
Plaques
Date: 12th cent.
*Jacob: Blessing Ephraim and
 Manasseh*

FRESCO

Assisi: Ch., Francesco, Lower
Crossing, vault
Date: First half 14th cent.
Allegory: Poverty

Bawît: Mon., Apollo
Chapel III (Clédat)
Date: 6th–7th cent.?
Scene: Unidentified

Brioude: Ch., Julien
Porch
Date: 12th–13th cent.
Christ: Last Judgment

Florence: Ch., Croce
Chapel, Baroncelli, back wall
Attribution: Taddeo Gaddi
Date: ca. 1328–1330
Personification: Virtues, Cardinal

Florence: Ch., Croce
Chapel, Baroncelli, side vault
Attribution: Taddeo Gaddi
Date: ca. 1328–1330
Joachim: Offerings Rejected

Gurk: Cath., Maria Himmelfahrt
Gallery, west
Date: 13th cent.
Virgin Mary and Christ Child

Pisa: Ch., Francesco
Choir
Date: 1342
Francis of Assisi

Purgg: Ch., Johannis
Decoration
Date: 12th–13th cent.
Cain and Abel: Bringing Offerings

Saeby: Church
Decoration
Date: 1150–1175
Christ and Four Beasts

GLASS

Esslingen: Ch., Dionysius
Windows, choir
Date: Late 13th–14th cent.
Isaiah

Freiburg: Cath., Unsere Liebe Frau
Window, tower
Date: 14th cent.
Month: Occupation

Lyons: Cath., Jean
Window, apse
Date: ca. 1220
Magi: Before Herod the Great

Niederhaslach: Ch., Florentius
Windows, nave
Date: 1290–1420
Christ: Parable, Prodigal Son

Paris: Cath., Notre Dame
Window, west rose
Date: First half 13th cent.
Virgin Mary and Christ Child

Strasbourg: Cath., Notre Dame
Windows, nave
Date: 14th cent.
Personification: Virtue, Wisdom

Wels: Church
Windows
Date: Late 14th–15th cent.
Adam and Eve: Fall of Man

IVORY

London: Lib., British
Plaques, in book cover (Egerton 1139)
Date: 1131–1143
David: Slaying Lion

MANUSCRIPT

Baltimore: Gall., Walters, W. 72
Speculum Virginum, fol. 26r
Date: First half 13th cent.

Baltimore: Gall., Walters, W. 72
Speculum Virginum, fol. 31r
Date: First half 13th cent.

Berlin: Lib., Staatsbibl., Phill. 1701
Speculum Virginum, fol. 43r
Date: Early 13th cent.

Berne: Lib., Stadtbibl., 264
Prudentius, *Psychomachia*, fol. 43v
Date: Early 10th cent.
Personification: Vice, Fraud

Berne: Lib., Stadtbibl., 264
Prudentius, *Psychomachia*, fol. 44r
Date: Early 10th cent.

Berne: Lib., Stadtbibl., 264
Prudentius, *Psychomachia*, fol. 44v
Date: Early 10th cent.
Personification: Vice, Pride

Berne: Lib., Stadtbibl., 264
Prudentius, *Psychomachia*, fol. 45r
Date: Early 10th cent.
Personification: Vice, Pride

Berne: Lib., Stadtbibl., 264
Prudentius, *Psychomachia*, fol. 45v
Date: Early 10th cent.

Besançon: Lib., Bibl. Municipale, 54
Psalter, fol. 15v
Date: Second half 13th cent.
Psalms: Illustration

Brussels: Lib., Bibl. Royale, 9968-72
Prudentius, *Psychomachia*, fol. 86r
Date: 11th cent.
Personification: Vice, Pride

Brussels: Lib., Bibl. Royale, 9968-72
Prudentius, *Psychomachia*, fol. 87r
Date: 11th cent.

Brussels: Lib., Bibl. Royale, 9968-72
Prudentius, *Psychomachia*, fol. 90r
Date: 11th cent.
Personification: Virtue, Hope

Brussels: Lib., Bibl. Royale, 9968-72
Prudentius, *Psychomachia*, fol. 90v
Date: 11th cent.

Brussels: Lib., Bibl. Royale, 9987-91
Prudentius, *Psychomachia*, fol. 106r
Date: 10th cent.
Personification: Vice, Pride

Brussels: Lib., Bibl. Royale, 9987-91
Prudentius, *Psychomachia*, fol. 107r
Date: 10th cent.
Personification: Vice, Pride

Brussels: Lib., Bibl. Royale, 9987-91
Prudentius, *Psychomachia*, fol. 107v
Date: 10th cent.
Personification: Vice, Pride

Brussels: Lib., Bibl. Royale, 9987-91
Prudentius, *Psychomachia*, fol. 108r
Date: 10th cent.
Personification: Virtue, Hope

Brussels: Lib., Bibl. Royale, 10066-77
Prudentius, *Psychomachia*, fol. 122r
Date: 10th–first half 11th cent.
Personification: Vice, Pride

Brussels: Lib., Bibl. Royale, 10066-77
Prudentius, *Psychomachia*, fol. 123v
Date: 10th–first half 11th cent.
Personification: Vice, Pride

Brussels: Lib., Bibl. Royale, 10066-77
Prudentius, *Psychomachia*, fol. 124r
Date: 10th–first half 11th cent.

Brussels: Lib., Bibl. Royale, 10066-77
Prudentius, *Psychomachia*, fol. 124v
Date: 10th–first half 11th cent.
Personification: Virtue, Hope

Cambridge: Lib., Corpus Christi
 College, 23
Prudentius, *Psychomachia*, fol. 15r
Date: Early 11th cent.
Personification: Vice, Pride

Cambridge: Lib., Corpus Christi
 College, 23
Prudentius, *Psychomachia*, fol. 16v
Date: Early 11th cent.
Personification: Vice, Pride

Cambridge: Lib., Corpus Christi
 College, 23
Prudentius, *Psychomachia*, fol. 17v
Date: Early 11th cent.
Personification: Vice, Pride

Cambridge: Lib., Corpus Christi
 College, 23
Prudentius, *Psychomachia*, fol. 18r
Date: Early 11th cent.
Personification: Virtue, Hope

Cambridge: Lib., Corpus Christi
 College, 23
Prudentius, *Psychomachia*, fol. 18v
Date: Early 11th cent.
Personification: Virtue, Hope

Cambridge: Mus., Fitzwilliam, 330
Psalter, W. de Brailes, no. 1
Date: ca. 1240
Psalms: Illustration

Cologne: Arch., Historisches, W 276a
Speculum Virginum, fol. 12r
Date: Mid-12th cent.

Cracow: Mus., Państwowe Zbiory
 Sztuki na Wawelu, 2459
Bible, fol. 391v
Date: Early 14th cent.
Psalm 22 (Vulgate, 21)

Darmstadt: Lib., Hessische
 Landesbibl., 1640
Gospel Book, Hitda of Meschede,
 fol. 173r
Date: 1000–1020
Personification: Virtue, Charity

Eton: Lib., Eton College, 177
Miscellany, fol. 4r
Date: 13th cent.
Moses: Crossing Red Sea

Hannover: Mus., Kestner, 3984
Speculum Virginum, single leaf from
 Trier, Bistumsarchiv 132
Date: ca. 1180

Kremsmünster: Lib., Stiftsbibl., 243
Spec. Hum. Salvationis, fol. 4r
Date: First half 14th cent.
Tree of Virtues

Leiden: Lib., Bibl. der Univ., Burm. Q.3
Prudentius, *Psychomachia*, fol. 129r
Date: Second quarter 9th cent.
Personification: Vice, Pride

Leiden: Lib., Bibl. der Univ., Burm. Q.3
Prudentius, *Psychomachia*, fol. 130r
Date: Second quarter 9th cent.
Personification: Vice, Pride

Leiden: Lib., Bibl. der Univ., Burm. Q.3
Prudentius, *Psychomachia*, fol. 130v
Date: Second quarter 9th cent.

Leiden: Lib., Bibl. der Univ., Burm. Q.3
Prudentius, *Psychomachia*, fol. 131r
Date: Second quarter 9th cent.
Personification: Virtue, Hope

Leiden: Lib., Bibl. der Univ., Burm. Q.3
Prudentius, *Psychomachia*, fol. 131v
Date: Second quarter 9th cent.
Personification: Virtue, Hope

Leiden: Lib., Bibl. der Univ., Voss.
 lat. oct. 15
Prudentius, *Psychomachia*, fol. 39r
Date: Early 11th cent.
Personification: Vice, Pride

Leiden: Lib., Bibl. der Univ., Voss.
 lat. oct. 15
Prudentius, *Psychomachia*, fol. 39v
Date: Early 11th cent.
Personification: Virtue, Hope

Leipzig: Lib., Universitätsbibl., 148
Miscellany, fol. 114r
Date: 1133
Tree of Virtues

Leipzig: Lib., Universitätsbibl., 305
Miscellany, fol. 151v
Date: 13th cent.

Leipzig: Lib., Universitätsbibl., 665
Speculum Virginum, fol. 49v
Date: Mid-14th cent.

London: Lib., British, Add. 24199
Prudentius, *Psychomachia*, fol. 12v
Date: Early 11th cent.
Personification: Vice, Pride

London: Lib., British, Add. 24199
Prudentius, *Psychomachia*, fol. 14r
Date: Early 11th cent.
Personification: Vice, Pride

London: Lib., British, Add. 24199
Prudentius, *Psychomachia*, fol. 14v
Date: Early 11th cent.

London: Lib., British, Add. 24199
Prudentius, *Psychomachia*, fol. 15r
Date: Early 11th cent.
Personification: Virtue, Hope

London: Lib., British, Add. 24199
Prudentius, *Psychomachia*, fol. 15v
Date: Early 11th cent.

London: Lib., British, Add. 28162
Somme le Roi, fol. 5v
Date: ca. 1300

London: Lib., British, Add. 54180
Somme le Roi, fol. 97v
Date: ca. 1300

London: Lib., British, Arundel 44
Speculum Virginum, fol. 29r
Date: ca. 1140–1150

London: Lib., British, Arundel 44
Speculum Virginum, fol. 34v
Date: ca. 1140–1150

London: Lib., British, Cott. Cleo.
 C.VIII
Prudentius, *Psychomachia*, fol. 11r
Date: Early 11th cent.
Personification: Vice, Pride

London: Lib., British, Cott. Cleo.
 C.VIII
Prudentius, *Psychomachia*, fol. 12v
Date: Early 11th cent.
Personification: Vice, Pride

London: Lib., British, Cott. Cleo.
 C.VIII
Prudentius, *Psychomachia*, fol. 13r
Date: Early 11th cent.

London: Lib., British, Cott. Cleo.
 C.VIII
Prudentius, *Psychomachia*, fol. 13v
Date: Early 11th cent.
Personification: Virtue, Hope

London: Lib., British, Cott. Cleo.
 C.VIII
Prudentius, *Psychomachia*, fol. 14r
Date: Early 11th cent.
Personification: Virtue, Hope

London: Lib., British, Cott. Titus
 D.XVI
Prudentius, *Psychomachia*, fol. 12v
Date: ca. 1100
Personification: Vice, Pride

London: Lib., British, Cott. Titus
 D.XVI
Prudentius, *Psychomachia*, fol. 14r
Date: ca. 1100
Personification: Vice, Pride

London: Lib., British, Cott. Titus
 D.XVI
Prudentius, *Psychomachia*, fol. 15r
Date: ca. 1100

Lucca: Lib., Bibl. Governativa,
 lat. 1942
Hildegardis, *Liber Divinorum*,
 fol. 132r
Date: ca. 1230
Hildegardis of Bingen: Vision

Melk: Lib., Stiftsbibl., 388
Raymond of Pennafort, *Summa*,
 fol. 150r
Date: ca. 1220–1230
Tree of Virtues

Milan: Lib., Bibl. Ambrosiana,
 H.106 sup.
Somme le Roi, fol. XLIVr
Date: ca. 1300

Munich: Lib., Staatsbibl., Clm. 13002
Miscellany, fol. 4r
Date: 1158–1165
Joseph: Brethren Begging Forgiveness

Munich: Lib., Staatsbibl., Clm. 14159
Dialogus Cruce Christi, fol. 5r
Date: ca. 1170–1185
Christ: Bearing Cross

Munich: Lib., Staatsbibl., Clm. 30055
Gospel Book, Henry the Lion, fol. 16v
Date: ca. 1175
Apostle: Matthias

Munich: Mus., Staatl. Graphische
 Samml., 39789
Miniature
Date: 12th cent.
Christ: Sermon on Mount

Paris: Lib., Bibl. de l'Arsenal, 6329
Somme le Roi, fol. 102v
Date: 1311

Paris: Lib., Bibl. Mazarine, 870
Somme le Roi, fol. 89v
Date: 1295

Paris: Lib., Bibl. Nat. de France,
 fr. 9220
Verger de Solas, fol. 2r
Date: 13th–14th cent.
Solomon: Throne

Paris: Lib., Bibl. Nat. de France,
 fr. 14939
Somme le Roi, fol. 100v
Date: 1373

Paris: Lib., Bibl. Nat. de France,
 fr. 19093
Sketchbook, Villard de Honnecourt,
 fol. 3v
Date: Mid-13th cent.
Personification: Vice, Pride

Paris: Lib., Bibl. Nat. de France,
 lat. 2077
Miscellany, fol. 163r
Date: 10th–11th cent.
Personification: Vice, Pride

Paris: Lib., Bibl. Nat. de France,
 lat. 2077
Miscellany, fol. 164v
Date: 10th–11th cent.

Paris: Lib., Bibl. Nat. de France,
 lat. 8085
Prudentius, *Psychomachia*, fol. 60r
Date: Late 9th cent.
Personification: Vice, Pride

Paris: Lib., Bibl. Nat. de France,
 lat. 8085
Prudentius, *Psychomachia*, fol. 60v
Date: Late 9th cent.
Personification: Vice, Pride

Paris: Lib., Bibl. Nat. de France,
 lat. 8085
Prudentius, *Psychomachia*, fol. 61r
Date: Late 9th cent.

Paris: Lib., Bibl. Nat. de France,
 lat. 8318
Prudentius, *Psychomachia*, fol. 51r
Date: Late 10th cent.
Personification: Vice, Pride

Paris: Lib., Bibl. Nat. de France,
 lat. 8318
Prudentius, *Psychomachia*, fol. 51v
Date: Late 10th cent.
Personification: Vice, Pride

Paris: Lib., Bibl. Nat. de France,
 lat. 8318
Prudentius, *Psychomachia*, fol. 53r
Date: Late 10th cent.
Personification: Vice, Pride

Paris: Lib., Bibl. Nat. de France, nouv.
 acq. fr. 24541
Gautier de Coincy, *Miracles N.D.*,
 fol. Av
Attribution: Jean Pucelle, workshop of
Date: ca. 1327
Virgin Mary and Christ Child

Rome: Lib., Bibl. Vaticana, gr. 394
John Climacus, *Climax*, fol. 66r
Date: Late 11th cent.
John Climacus: Climax, Chapter VIII

Rome: Lib., Bibl. Vaticana, gr. 394
John Climacus, *Climax*, fol. 109v
Date: Late 11th cent.
John Climacus: Climax,
 Chapter XXIV

Rome: Lib., Bibl. Vaticana, Pal.
 lat. 565
Speculum Virginum, fol. 32r
Date: ca. 1155

Saint Gall: Lib., Stiftsbibl., 135
Prudentius, *Psychomachia*, p. 399
Date: First half 11th cent.
Personification: Virtue, Hope

Saint Gall: Lib., Stiftsbibl., 135
Prudentius, *Psychomachia*, p. 400
Date: First half 11th cent.
Personification: Vice, Fraud

Salzburg: Lib., Studienbibl., V 1 H 162
Miscellany, fol. 76r
Date: First half 12th cent.
Tree of Virtues

Soissons: Coll., Grand Séminaire
Gautier de Coincy, *Miracles N.D.*,
 fol. Ar
Date: 14th cent.
Virgin Mary and Christ Child

Strasbourg: Lib., Bibl. Municipale
Herradis of Landsberg, *Hort. Delic.*,
 fol. 199v
Date: Second half 12th cent.
Personification: Vice, Pride

Strasbourg: Lib., Bibl. Municipale
Herradis of Landsberg, *Hort. Delic.*,
 fol. 200r
Date: Second half 12th cent.

Troyes: Lib., Bibl. Municipale, 252
Speculum Virginum, fol. 30r
Date: ca. 1190

Troyes: Lib., Bibl. Municipale, 252
Speculum Virginum, fol. 37v
Date: ca. 1190

Valenciennes: Lib., Bibl. Municipale,
 563
Prudentius, *Psychomachia*, fol. 13r
Date: Early 11th cent.
Personification: Vice, Pride

Valenciennes: Lib., Bibl. Municipale,
 563
Prudentius, *Psychomachia*, fol. 14v
Date: Early 11th cent.
Personification: Vice, Pride

Valenciennes: Lib., Bibl. Municipale,
 563
Prudentius, *Psychomachia*, fol. 15r
Date: Early 11th cent.
Personification: Vice, Pride

Valenciennes: Lib., Bibl. Municipale,
 563
Prudentius, *Psychomachia*, fol. 15v
Date: Early 11th cent.
Personification: Vice, Pride

Valenciennes: Lib., Bibl. Municipale,
 563
Prudentius, *Psychomachia*, fol. 16r
Date: Early 11th cent.

Vienna: Lib., Nationalbibl., 2583*
Matfre Ermengaud, *Brev. d'Amor*, fol.
 237v
Date: 14th cent.
Personification: Virtue, Generosity

Vorau: Lib., Stiftsbibl., lat. 130
G. of Vorau, *Lumen Animae*, fol. 109r
Date: 1332

Wiesbaden: Lib., Hessische
 Landesbibl., I
Hildegardis, *Liber Scivias*, fol. 2r
Date: ca. 1165
Hildegardis of Bingen: Vision

Wiesbaden: Lib., Hessische
 Landesbibl., I
Hildegardis, *Liber Scivias*, fol. 178r
Date: ca. 1165
Hildegardis of Bingen: Vision

Wolfenbüttel: Lib., Herzog August
 Bibl., Guelf. 105 Noviss. 2°
Gospel Book, Henry the Lion, fol. 16v
Date: ca. 1175
Apostle: Matthias

Zwettl: Monastery, 180
Speculum Virginum, fol. 45v
Date: First third 13th cent.

METALWORK

Berlin: Mus., Staatliche
Bowl, bronze (I.3136)
Date: 13th cent.

Brussels: Mus., Royaux d'Art et
 d'Histoire
Bowl, bronze-gilt (2879)
Date: 12th–13th cent.

Budapest: Mus., Magyar Nemzeti
 Múzeum
Bowl, bronze
Date: 12th–13th cent.

Cologne: Cathedral, Treasury
Casket, of Three Kings
Date: 1190–1225
Christ: Last Judgment

Cologne: Ch., Heribert
Casket, S. Heribertus
Date: ca. 1150–1175
Saint

Florence: Baptistery
Door, south, bronze
Attribution: Andrea Pisano
Date: 1330
Zacharias: Annunciation

Ghent: Mus., Archéologie
Bowl, bronze (1284)
Date: 12th–13th cent.

Hannover: Mus., Kestner
Bowl, bronze-gilt (1894.18)
Date: 12th cent.

Hildesheim: Cath., Maria
Chandelier, of Hezilo
Date: ca. 1055–1065
Building: City Wall

Kaliningrad: Mus., Regional
Bowl (fragment)
Date: 12th–13th cent.

Lund: Mus., Kulturhistoriska
Bowl, bronze (25557)
Date: 11th–13th cent.

Munich: Mus., Bayerisches
 Nationalmus.
Bowl, brass (M.A. 204)
Date: 12th–13th cent.

Namur: Mus., Archéologique
Reliquary
Date: 12th cent.
Personification: Virtue, Faith

New York: Lib., Morgan, Pierpont
Book cover (710)
Date: Early 13th cent.
Virgin Mary and Christ Child

Rome: Mus., Capitoline
Bowl, bronze-gilt
Date: 12th–13th cent.

Salzburg: Mus., Dom
Bowl, bronze
Date: 12th cent.

Strasbourg: Mus., Historique
Bowl, copper-gilt (700)
Date: 12th–13th cent.

Trier: Ch., Maximin
Font, of Folcardus
Date: Early 12th cent.

Wrocław: Mus., Archeologiczne
Bowl, bronze
Date: Late 11th–12th cent.

PAINTING

Bad Doberan: Ch., Cistercian
Triptych
Date: First half 14th cent.
*Christ: Crucifixion, Nailed to Cross by
 Virtues*

Berlin: Mus., Staatliche
Panel (1844)
Date: ca. 1360–1370
Gregory the Great

Florence: Mus., Opera del Duomo
Panel (9152)
Attribution: Bigallo Master
Date: ca. 1240–1250
Zenobius of Florence

Greenwich: Coll., Hyland
Panel
Date: 14th cent.
Virgin Mary and Christ Child

New York: Coll., Wildenstein
Panel
Date: 14th cent.
Virgin Mary and Christ Child

Rome: Mus., Vaticani, Pinacoteca
Panel (40520)
Date: ca. 1375–1380
Virgin Mary

Stuttgart: Gall., Staatl. Gemäldegalerie
Panel (1140)
Date: ca. 1335
Solomon: Throne

SCULPTURE

Amiens: Cath., Notre Dame
Exterior, west
Date: 1220–1235
Malachi

Argenton-Château: Ch., Gilles
Exterior, west
Date: After 1130
Ornament: Figured

Aulnay-de-Saintonge: Ch., Pierre
Exterior, west
Date: ca. 1130–1150
Month: Occupation

Berlin: Mus., Staatliche
Statuette, marble (6742)
Date: 14th cent.
Personification

Bremen: Cath., Peter
Reliefs, from choir stalls
Date: 14th–15th cent.
Apostles

Chartres: Cath., Notre Dame
Exterior, north, central portal
Date: 1205–1210
Virgin Mary: Coronation

Chartres: Cath., Notre Dame
Exterior, north, left portal
Date: ca. 1220
Virgins, Foolish

Chartres: Cath., Notre Dame
Porch, south
Date: ca. 1230–1240
Saint

Florence: Ch., Orsanmichele
Tabernacle, marble
Attribution: Orcagna
Date: 1359–1360
Angel: Archangel Michael

Laon: Cath., Notre Dame
Exterior, west
Date: ca. 1180–1210
Magi: Adoration

Munich: Mus., Bayerisches
 Nationalmus.
Tympanum, sandstone (72)
Date: Second half 13th cent.
Christ: Washing of Feet

Paris: Cath., Notre Dame
Exterior, west
Date: ca. 1220–1230
Christ: Last Judgment

Parma: Baptistery
Exterior
Date: Late 12th–13th cent.
Magi: Adoration

Piacenza: Cath., Assunta
Exterior, west, central portal
Date: ca. second quarter 12th cent.
Personification: Vice, Avarice

Pisa: Baptistery
Pulpit
Attribution: Nicola Pisano
Date: 1260
Virgin Mary: Annunciation

Salisbury: Cathedral, Chapter House
Decoration, vestibule
Date: ca. 1260–1280
Personification: Virtues and Vices,
 Conflict

Sens: Cath., Etienne
Exterior, west
Date: Late 12th–13th cent.
Stephen Protomartyr: In Synagogue

Siena: Cath., Assunta
Pulpit
Attribution: Nicola Pisano
Date: ca. 1265–1269
Virgin Mary: Visitation

Stanton Fitzwarren: Church
Font
Date: ca. 1160
Personification: Church

Strzelno: Ch., Trinity
Nave, column
Date: Last quarter 12th cent.
Christ: Baptism

Tournai: Cath., Notre Dame
Exterior, north
Date: ca. 1140–1170
Ornament: Figured

Worms: Cath., Peter and Paul
Exterior, south
Date: First half 14th cent.
Nicholas of Myra: Scene

INDULGENCE

MANUSCRIPT

Strasbourg: Lib., Bibl. Municipale
Herradis of Landsberg, *Hort. Delic.*,
 fol. 201r
Date: Second half 12th cent.
Personification: Virtue, Patience

INNOCENCE

ENAMEL

Baltimore: Gall., Walters
Cross (44.98)
Date: Mid-12th cent.
Christ: Crucifixion

MANUSCRIPT

Wiesbaden: Lib., Hessische
 Landesbibl., I
Hildegardis, *Liber Scivias*, fol. 178r
Date: ca. 1165
Hildegardis of Bingen: Vision

JOY

ENAMEL

Klosterneuburg: Monastery
Retable
Attribution: Nicolas of Verdun
Date: 1181
Abraham: Entertaining the Angels

GLASS

Lyons: Cath., Jean
Window, apse
Date: ca. 1220
Magi: Before Herod the Great

IVORY

London: Lib., British
Plaques, in book cover (Egerton 1139)
Date: 1131–1143
David: Slaying Lion

MANUSCRIPT

Ghent: Lib., Bibl. de l'Université, 92
Lambertus, *Liber Floridus*, fol. 231v
Date: 1120
Tree of Virtues

New York: Lib., Morgan, Pierpont,
 M.333
Gospel Book, fol. 51r
Date: Early 11th cent.
Zacharias: Annunciation

Paris: Lib., Bibl. Nat. de France,
 lat. 8318
Prudentius, *Psychomachia*, fol. 54r
Date: Late 10th cent.
Personification: Vice, Anger

Strasbourg: Lib., Bibl. Municipale
Herradis of Landsberg, *Hort. Delic.*,
 fol. 200r
Date: Second half 12th cent.
Personification: Virtue, Humility

SCULPTURE

Salisbury: Cathedral, Chapter House
Decoration, vestibule
Date: ca. 1260–1280
*Personification: Virtues and Vices,
 Conflict*

Strzelno: Ch., Trinity
Nave, column
Date: Last quarter 12th cent.
Christ: Baptism

JUDGMENT

ENAMEL

New York: Mus., Metropolitan,
 Cloisters
Triptych, reliquary (L. 1979.143)
Date: ca. 1160
Christ: Last Judgment

MANUSCRIPT

Strasbourg: Lib., Bibl. Municipale
Herradis of Landsberg, *Hort. Delic.*,
 fol. 202r
Date: Second half 12th cent.
Personification: Virtue, Prudence

METALWORK

Liège: Ch., Croix
Triptych, reliquary, copper-gilt
Date: ca. 1160–1170
Apostle: Peter

TEXTILE

Augsburg: Ch., Ulric and Afra
Tapestries
Date: 12th cent.
Personification: New Testament

JUSTICE

ENAMEL

Aachen: Cathedral, Treasury
Reliquary, silver-gilt
Date: ca. 1250–1260
Christ: Flagellation

Baltimore: Gall., Walters
Plaques (44.99–100)
Date: Second half 12th cent.

Brussels: Mus., Royaux d'Art et
 d'Histoire
Plaque, from reliquary (3141)
Date: ca. 1170
Personification: Virtue, Fortitude

Brussels: Mus., Royaux d'Art et
 d'Histoire
Reliquary, Valentinus of Maastricht
 (1038)
Date: ca. 1160–1170
Personification: Virtue, Hope

Klosterneuberg: Monastery
Retable
Attribution: Nicolas of Verdun
Date: 1181
Abraham: Entertaining the Angels

Langres: Museum
Plaques, on reliquary
Date: Third quarter 12th cent.
Personification: Virtue, Fortitude

Liège: Mus., Curtius
Book cover (12/1)
Date: ca. 1160–1170
Personification: River of Paradise

London: Mus., Victoria and Albert
Chalice, silver-gilt (4903-1859)
Date: First half 14th cent.
Christ: Crucifixion

London: Mus., Victoria and Albert
Triptych (4757-1858)
Date: ca. 1150
Jonah: Cast Up

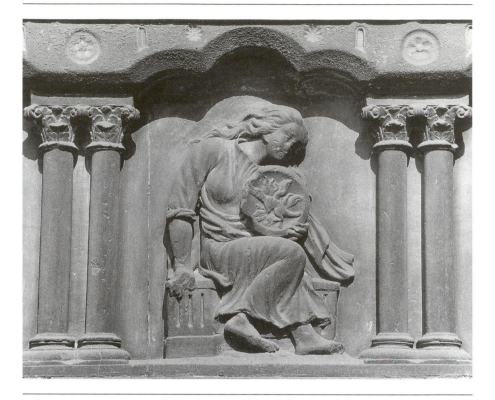

New York: Mus., Metropolitan,
 Cloisters
Triptych, reliquary (L. 1979.143)
Date: ca. 1160
Christ: Last Judgment

Pistoia: Cath., Zenone
Plaques, on altar frontal
Date: Last quarter 13th cent.
Christ

Saint Petersburg: Mus., Hermitage
Plaque (Ø 1425)
Date: Second half 12th cent.

Vienna: Mus., Erzbischöfliches
 Dommuseum
Plaques (L 3)
Date: Late 12th cent.
Abraham: Sacrificing Isaac

FRESCO

Brixen: Ch., Johannes
Decoration
Date: 13th cent.
*Christopher of Lycia: Carrying Christ
 Child*

Bury Saint Edmunds: Ch., Abbey
Decoration?
Date: 13th cent.?
Personification: Synagogue

Cologne: Ch., Maria Lyskirchen
Nave
Date: 13th cent.
Daniel?

El-Bagaouat: Necropolis
Chapel with Personifications
Date: 4th cent.
Vine

Florence: Ch., Croce
Chapel, Bardi di Vernio (Silvestro)
Date: First half 14th cent.
Constantine the Great: Scene

Florence: Ch., Maria Novella
Chapel, Strozzi, ceiling
Attribution: Giovanni del Biondo,
 Nardo di Cione
Date: ca. 1350–1360
Thomas Aquinas

Padua: Chap., Madonna dell'Arena
Decoration
Attribution: Giotto
Date: ca. 1303–1308
Joachim: Offerings Rejected

Padua: Ch., Antonio
Chapel, S. Felice
Date: Second half 14th cent.
Apostle: James Major, Scene

Peterborough: Cath., Peter, Paul, and
 Andrew
Decoration, on choir screen
Date: 12th cent.
Isaiah

Siena: Ch., Francesco
Chapel, Bandini Piccolomini
Date: First half 14th cent.
Louis of Toulouse: Scene

Siena: Coll., Franci
Panel
Attribution: Sano di Pietro, School of
 Simone Martini, Simone Martini
Date: 14th–15th cent.

Siena: Pal., Pubblico
Room, Pace
Attribution: Ambrogio Lorenzetti
Date: 1338–1339

Soest: Cath., Patrokli
Chapel, S. Nikolaus
Date: Mid-13th cent.
Christ and Four Beasts

Tolentino: Ch., Nicola da Tolentino
Chapel, S. Nicola
Date: 13th–14th cent.
Evangelist: Symbol

Worcester: Cathedral, Chapter House
Decoration
Date: 13th cent.?
Christ: Nativity

GLASS

Canterbury: Cath., Christ
Windows, choir
Date: 1180–1220
Moses: Burning Bush

Esslingen: Ch., Dionysius
Windows, choir
Date: Late 13th–14th cent.
Isaiah

Niederhaslach: Ch., Florentius
Windows, nave
Date: 1290–1420
Christ: Parable, Prodigal Son

Strasbourg: Cath., Notre Dame
Windows, nave
Date: 14th cent.
Personification: Virtue, Wisdom

Strasbourg: Cath., Notre Dame
Windows, southern transept
Date: 13th cent.
Apostle: Matthias

Wels: Church
Windows
Date: Late 14th–15th cent.
Adam and Eve: Fall of Man

Wienhausen: Convent
Windows
Date: 1330–1340
Christ: Entry into Jerusalem

LEATHER

Valenciennes: Lib., Bibl. Municipale
Book cover (24)
Date: 12th cent.
Christ and Four Beasts

MANUSCRIPT

Admont: Lib., Stiftsbibl., lat. 128
Miscellany, fol. 13r
Date: Mid-13th cent.
Personification: Ethics

Berne: Lib., Stadtbibl., 120 II
Peter of Eboli, *De Rebus Siculis*,
 fol. 146r
Date: 1195–1197
Henry VI

Brussels: Lib., Bibl. Royale, 9505-6
Aristotle, *Ethiques*, fol. 89r
Date: 1372

Brussels: Lib., Bibl. Royale, 9961-2
Psalter, fol. 10r
Date: 13th cent.
Jeremiah

Cambridge: Lib., Trinity College,
 R.17.1
Psalter, Canterbury, fol. 78v
Date: ca. 1145–1170
Psalm 45 (Vulgate, 44)

Cambridge: Lib., Trinity College,
 R.17.1
Psalter, Canterbury, fol. 150v
Date: ca. 1145–1170
Psalm 85 (Vulgate, 84)

Cambridge: Lib., Trinity College,
 R.17.1
Psalter, Canterbury, fol. 167r
Date: ca. 1145–1170
Psalm 94 (Vulgate, 93)

Cambridge: Lib., Trinity College,
 R.17.1
Psalter, Canterbury, fol. 170v
Date: ca. 1145–1170
Psalm 96 (Vulgate, 95)

Cambridge: Lib., Trinity College,
 R.17.1
Psalter, Canterbury, fol. 172r
Date: ca. 1145–1170
Psalm 97 (Vulgate, 96)

Cleveland: Museum of Art, 33.445
Miniature, recto
Date: Late 12th cent.
Christ: Nativity

Eton: Lib., Eton College, 177
Miscellany, fol. 7v
Date: 13th cent.
Personification: Virtue, Grace

Florence: Lib., Bibl. Laurenziana,
 Plut. XLII.19
Brunetto Latini, *Tesoro*, fol. 45r
Date: 14th cent.

Florence: Lib., Bibl. Laurenziana,
 Plut. XLII.19
Brunetto Latini, *Tesoro*, fol. 62v
Date: 14th cent.
Personification: Virtue, Fortitude

Florence: Lib., Bibl. Laurenziana,
 Plut. XLII.19
Brunetto Latini, *Tesoro*, fol. 68r
Date: 14th cent.
Personification: Vice, Negligence

Florence: Lib., Bibl. Laurenziana,
 Tempi 1
Dante, *Divina Commedia*, fol. 2r
Date: 1398
Dante: Inferno

Florence: Lib., Bibl. Naz. Centrale,
 Banco Rari 397
Hours, Giangaleazzo Visconti,
 fol. 108v
Attribution: Giovannino and
 Salomone dei Grassi
Date: ca. 1389–1391
Psalm 116 (Vulgate, 114)

Florence: Lib., Bibl. Naz. Centrale,
 Landau-Finaly 22
Hours, Giangaleazzo Visconti, fol. 17r
Attribution: Giovannino and
 Salomone dei Grassi
Date: ca. 1395
Ambrose of Milan

Leipzig: Lib., Universitätsbibl., 878
Digestum Vetus, fol. 6r
Date: 14th cent.

London: Coll., Murray
Dante, *Divina Commedia*, fol. 1r
Date: 14th cent.

London: Lib., British, Add. 74236
Missal, Sherborne, p. 380
Date: ca. 1400
Christ: Crucifixion

London: Lib., British, Harley 603
Psalter, fol. 26r
Date: ca. 1000–12th cent.
Psalm 45 (Vulgate 44)

London: Lib., British, Roy. 6 E.IX
Convenevoli de Pratis(?), *Poemata*,
 fol. 21r
Date: ca. 1335–1340
Personification: Virtue, Prudence

London: Pal., Lambeth, 3
Bible, I, fol. 198r
Date: Mid-12th cent.
Jesse: Tree

Malines: Lib., Grand Séminaire
Bible, Nicolò de Alifio, p. 1
Date: Mid-14th cent.
Robert of Anjou

Malvern: Coll., Dyson Perrins, 57
Dante, *Divina Commedia*, fol. 1r
Date: Late 14th cent.
Dante: Inferno

Munich: Lib., Staatsbibl., Clm. 30055
Gospel Book, Henry the Lion, fol. 14v
Date: ca. 1175
Apostle: Bartholomew

Munich: Lib., Staatsbibl., Clm. 30055
Gospel Book, Henry the Lion,
 fol. 110v
Date: ca. 1175
Virgin Mary: Annunciation

Munich: Mus., Staatl. Graphische
 Samml., 39789
Miniature
Date: 12th cent.
Christ: Sermon on Mount

Paris: Lib., Bibl. Nat. de France,
 Coislin gr. 79
John Chrysostom, *Homilies*, fol. 2r
Date: ca. 1078
Nicephorus III

Paris: Lib., Bibl. Nat. de France, fr. 377
G. de Degulleville, *Pèlerinage*,
 fol. 148v
Date: 14th cent.

Paris: Lib., Bibl. Nat. de France,
 fr. 12465
G. de Degulleville, *Pèlerinage*,
 fol. 152r
Date: 14th cent.

Paris: Lib., Bibl. Nat. de France,
 ital. 115
Pseudo-Bonaventura, *Medit.*, fol. 4r
Date: 14th cent.
Christ: In Mandorla

Paris: Lib., Bibl. Nat. de France,
 lat. 819
Sacramentary, S. Bertin, fol. 13r
Date: 11th cent.
Psalm 85 (Vulgate, 84)

Paris: Lib., Bibl. Nat. de France,
 lat. 6734
Honorius of Autun, *Clavis Physicae*,
 fol. 3v
Date: 12th cent.
Personification: Virtue, Goodness

Paris: Lib., Bibl. Nat. de France,
 lat. 11535-34
Bible, II, fol. 105r
Date: Late 12th cent.

Paris: Lib., Bibl. Nat. de France,
 lat. 18014
Hours, Duc de Berry, fol. 278v
Date: Late 14th cent.
Solomon: Throne

Paris: Lib., Bibl. Sainte-Geneviève,
 1130
G. de Degulleville, *Pèlerinage*,
 fol. 104r
Date: Second half 14th cent.

Pisa: Lib., Bibl. Universitaria, 536
Commentary on Gospel Book, Acts,
 and Epistles, fol. 2v
Date: 13th–14th cent.
Christ

Rome: Gall., Naz. d'Arte Antica
Bartolomeo di Bartoli, *Canzone*, fol. 5r
Date: 14th cent.

Rome: Lib., Bibl. Vaticana, gr. 1927
Psalter, fol. 156r
Date: 11th–12th cent.
Psalm 85 (LXX, 84)

Rome: Lib., Bibl. Vaticana, lat. 4776
Dante, *Divina Commedia*, fol. 1r
Date: 14th–15th cent.

Rome: Lib., Bibl. Vaticana, Ottob.
 lat. 74
Lectionary, Henry II, fol. 193v
Date: 11th cent.
Henry II

Rome: Lib., Bibl. Vaticana, Reg. lat. 12
Psalter, fol. 92r
Date: Early 11th cent.
Psalm 85 (Vulgate, 84)

Rome: Lib., Bibl. Vaticana, Urb. gr. 2
Gospel Book, fol. 19v
Date: 1120s
Christ: Crowning

Salzburg: Lib., Studienbibl., V 1 H 162
Miscellany, fol. 76r
Date: First half 12th cent.
Tree of Virtues

Strasbourg: Lib., Bibl. Municipale
Herradis of Landsberg, *Hort. Delic.*,
 fol. 67v
Date: Second half 12th cent.
Christ

Strasbourg: Lib., Bibl. Municipale
Herradis of Landsberg, *Hort. Delic.*,
 fol. 200r
Date: Second half 12th cent.
Personification: Virtue, Humility

Strasbourg: Lib., Bibl. Municipale
Herradis of Landsberg, *Hort. Delic.*,
 fol. 202r
Date: Second half 12th cent.
Personification: Virtue, Prudence

Stuttgart: Lib., Landesbibl., Bibl.
 fol. 20
Missal, fol. 80v
Date: 12th cent.
Christ: Nativity

Trieste: Lib., Bibl. Civica
Statuta of Trieste, fol. 3r
Date: 1365

Utrecht: Lib., Bibl. der Universiteit, 32
Psalter, fol. 26r
Date: ca. 820–830
Psalm 45 (Vulgate, 44)

Utrecht: Lib., Bibl. der Universiteit, 32
Psalter, fol. 49v
Date: ca. 820–830
Psalm 85 (Vulgate, 84)

Utrecht: Lib., Bibl. der Universiteit, 32
Psalter, fol. 56r
Date: ca. 820–830
Psalm 96 (Vulgate, 95)

Utrecht: Lib., Bibl. der Universiteit, 32
Psalter, fol. 56v
Date: ca. 820–830
Psalm 97 (Vulgate, 96)

Valenciennes: Lib., Bibl. Municipale,
 512
Miscellany, fol. 4v
Date: 12th cent.
Gregory the Great

Venice: Lib., Bibl. Marciana, gr. Z. 540
 (557)
Gospel Book, fol. 6v
Date: Early 12th cent.
Personification: Virtue, Truth

Vienna: Lib., Nationalbibl., Ser. Nov.
 2639
Convenevoli de Pratis(?), *Poemata*,
 fol. 1r
Date: Early 14th cent.

Wiesbaden: Lib., Hessische
 Landesbibl., I
Hildegardis, *Liber Scivias*, fol. 192r
Date: ca. 1165
Hildegardis of Bingen: Vision

Wolfenbüttel: Lib., Herzog August
 Bibl., Guelf. 105 Noviss. 2°
Gospel Book, Henry the Lion, fol. 14v
Date: ca. 1175
Apostle: Bartholomew

Wolfenbüttel: Lib., Herzog August
 Bibl., Guelf. 105 Noviss. 2°
Gospel Book, Henry the Lion,
 fol. 110v
Date: ca. 1175
Virgin Mary: Annunciation

METALWORK

Cologne: Cathedral, Treasury
Casket, of Three Kings
Date: 1190–1225
Christ: Last Judgment

Florence: Baptistery
Door, south, bronze
Attribution: Andrea Pisano
Date: 1330
Zacharias: Annunciation

Hildesheim: Cath., Maria
Chandelier, of Hezilo
Date: ca. 1055–1065
Building: City Wall

Manchester: Lib., Rylands
Book cover, silver-gilt (lat. 4)
Date: ca. 1150–1175
Saint?

Saint-Symphorien: Church
Casket, S. Symphorien
Date: 12th–13th cent.
Christ and Apostles

Salzburg: Mus., Dom
Bowl, bronze
Date: 12th cent.
Personification: Virtue, Humility

Trier: Ch., Maximin
Font, of Folcardus
Date: Early 12th cent.
Personification: Virtue, Humility

Verona: Ch., Zeno
Door, bronze
Date: Second–fourth quarter 12th cent.
Virgin Mary: Annunciation

MOSAIC

Reims: Ch., Remi
Choir
Date: After 1090
David: As Musician

Venice: Ch., Marco
Atrium
Date: Second quarter 13th cent.
Abraham: Communicating with God

PAINTING

Bad Doberan: Ch., Cistercian
Triptych
Date: First half 14th cent.
*Christ: Crucifixion, Nailed to Cross by
 Virtues*

Florence: Ch., Croce
Polyptych
Attribution: Giovanni del Biondo
Date: 1379
Virgin Mary and Christ Child

Greenwich: Coll., Hyland
Panel
Date: 14th cent.
Virgin Mary and Christ Child

Regensburg: Cath., Peter, treasury
Casket, reliquary
Date: Second half 13th cent.
Virgin Mary: Death

Rome: Mus., Vaticani, Pinacoteca
Panel (40520)
Date: ca. 1375–1380
Virgin Mary

SCULPTURE

Arezzo: Cathedral
Reliquary, S. Donatus
Attribution: Betto di Francesco da
 Firenze, Giovanni di Francesco
 d'Arezzo
Date: After 1362
Christ

Bamberg: Cath., Peter und Georg
Tomb of Clement II
Date: ca. 1220–1240
Clement II, Pope: Scene

Bologna: Pal., Mercanzia
Statues
Date: Late 14th cent.

Chartres: Cath., Notre Dame
Exterior, north, central portal
Date: 1205–1210
Virgin Mary: Coronation

Chartres: Cath., Notre Dame
Exterior, north, left portal
Date: ca. 1220
Virgins, Foolish

Chartres: Cath., Notre Dame
Porch, north
Date: ca. 1220–1230
Creation Scene

Città di Castello: Cath., SS. Florido e
 Amanzio
Exterior, north
Date: Mid-14th cent.

Cluny: Mus., Farinier
Capitals
Date: Late 11th–early 12th cent.
Personification: Music

Detroit: Mus., Institute of Arts
Statue, marble (43.53)
Attribution: Tino da Camaino,
 workshop of
Date: 1330s

Florence: Cath., Maria del Fiore
Exterior, north
Attribution: Giovanni d'Ambrogio,
 Piero di Giovanni Tedesco
Date: Late 14th cent.
Prophet

Florence: Ch., Orsanmichele
Tabernacle, marble
Attribution: Orcagna
Date: 1359–1360
Angel: Archangel Michael

Florence: Loggia del Bigallo
Exterior, east and north
Date: 1352–1358
Christ: Of Sorrows

Genoa: Gall., Naz. di Palazzo Spinola
Statue
Attribution: Giovanni Pisano
Date: 1313

León: Cath., Maria de Regla
Exterior, west
Date: Second half 13th cent.
Innocents: Massacre

Milan: Mus., Castello Sforzesco
Tomb of Bernabò Visconti (287)
Attribution: Bonino da Campione
Date: ca. 1363
Bernabò Visconti

Monreale: Cath., Maria la Nuova
Cloister
Date: Last quarter 12th cent.
Christ: Parable, Lazarus and Dives

Naples: Ch., Chiara
Statue, from tomb
Attribution: Pacio and Giovanni
 Bertini da Firenze
Date: ca. 1330–1350

Naples: Ch., Chiara
Tomb of Charles of Calabria
Attribution: Tino di Camaino
Date: 1333
Charles of Calabria

Naples: Ch., Chiara
Tomb of Robert of Anjou
Attribution: Pacio and Giovanni
 Bertini da Firenze
Date: ca. 1343
Robert of Anjou

Paris: Cath., Notre Dame
Exterior, west
Date: ca. 1220–1230
Christ: Last Judgment

Parma: Baptistery
Exterior
Date: Late 12th–13th cent.
Magi: Adoration

Pavia: Ch., Michele
Decoration
Date: 12th cent.
Ornament: Figured

Salisbury: Cathedral, Chapter House
Decoration, vestibule
Date: ca. 1260–1280
Personification: Virtues and Vices,
 Conflict

Siena: Cath., Assunta
Exterior, south
Date: 13th–14th cent.
Miriam

Siena: Cath., Assunta
Pulpit
Attribution: Nicola Pisano
Date: ca. 1265–1269
Virgin Mary: Visitation

Strzelno: Ch., Trinity
Nave, column
Date: Last quarter 12th cent.
Christ: Baptism

Venice: Ch., Frari
Tomb of Duccio degli Alberti
Date: 1336
Lamb of God

Venice: Ch., Marco
Exterior, west
Date: 13th cent.
Christ

Vézelay: Ch., Madeleine, Nave
Date: First half 12th cent.
Saint

TEXTILE

Augsburg: Ch., Ulric and Afra
Tapestries
Date: 12th cent.
Personification: New Testament

Bamberg: Cathedral, Treasury
Vestment, rational, embroidery
Date: 11th cent.
Apocalypse: Christ and Four Beasts

Quedlinburg: Church, Treasury
Hanging, tapestry
Date: 1186–1203
Personification: Virtue, Chastity

Regensburg: Cath., Peter, Treasury
Vestment, rational, embroidery
Date: 1314–1328
Apocalypse: Christ and Four Beasts

KINDNESS

IVORY

London: Lib., British
Plaques, in book cover (Egerton 1139)
Date: 1131–1143
David: Slaying Lion

MANUSCRIPT

Strasbourg: Lib., Bibl. Municipale
Herradis of Landsberg, *Hort. Delic.*,
 fol. 201r
Date: Second half 12th cent.
Personification: Virtue, Patience

METALWORK

Cologne: Cathedral, Treasury
Casket, of Three Kings
Date: 1190–1225
Christ: Last Judgment

Hildesheim: Cath., Maria
Chandelier, of Hezilo
Date: ca. 1055–1065
Building: City Wall

Saint-Gilles: Church
Sarcophagus, gold, of Aegidius
Date: 12th cent.?
Elders, Four and Twenty

KNOWLEDGE

ENAMEL

Brussels: Mus., Royaux d'Art et
 d'Histoire
Reliquary, Alexander (1031)
Date: 1145
Eventius of Rome

Darmstadt: Mus., Hessisches
 Landesmus.
Plaque, copper-gilt (Kg 54:246b)
Date: ca. 1170
Ecclesiasticus: Illustration

London: Mus., Victoria and Albert
Casket (7955-1862)
Date: 12th–13th cent.
Personification: Grammar

MANUSCRIPT

Hague: Mus., Meermanno-
 Westreenianum, 10 D 1
Aristotle, *Ethiques*, fol. 110r
Date: 1376

Oxford: Lib., Bodleian, 270b
Bible, Moralized, fol. 53v
Date: First half 13th cent.
Moses: Instrument, Candelabrum

LAMENTATION

MANUSCRIPT

Wiesbaden: Lib., Hessische
 Landesbibl., I
Hildegardis, *Liber Scivias*, fol. 138v
Date: ca. 1165
Hildegardis of Bingen: Vision

LAW

MANUSCRIPT

Eton: Lib., Eton College, 177
Miscellany, fol. 7v
Date: 13th cent.
Personification: Virtue, Grace

Strasbourg: Lib., Bibl. Municipale
Herradis of Landsberg, *Hort. Delic.*,
 fol. 202r
Date: Second half 12th cent.
Personification: Virtue, Prudence

LONGSUFFERING

FRESCO

Cairo: Mus., Coptic Museum, 7952
Date: 6th cent. or later

MANUSCRIPT

Ghent: Lib., Bibl. de l'Université, 92
Lambertus, *Liber Floridus*, fol. 231v
Date: 1120
Tree of Virtues

Munich: Lib., Staatsbibl., Clm. 13002
Miscellany, fol. 4r
Date: 1158–1165
Joseph: Brethren Begging Forgiveness

Strasbourg: Lib., Bibl. Municipale
Herradis of Landsberg, *Hort. Delic.*,
 fol. 200r
Date: Second half 12th cent.
Personification: Virtue, Humility

Strasbourg: Lib., Bibl. Municipale
Herradis of Landsberg, *Hort. Delic.*,
 fol. 201r
Date: Second half 12th cent.
Personification: Virtue, Patience

LOVE OF GOD

MANUSCRIPT

Valenciennes: Lib., Bibl. Municipale,
 500
Vitae Sanctorum, fol. 68r
Date: ca. 1180
Amandus of Maastricht: Scene

Valenciennes: Lib., Bibl. Municipale,
 501
Vita S. Amandi, fol. 31r
Date: Mid-12th cent.
Amandus of Maastricht: Scene

LOVE OF NEIGHBOR

MANUSCRIPT

Valenciennes: Lib., Bibl. Municipale,
 500
Vitae Sanctorum, fol. 68r
Date: ca. 1180
Amandus of Maastricht: Scene

Valenciennes: Lib., Bibl. Municipale,
 501
Vita S. Amandi, fol. 31r
Date: Mid-12th cent.
Amandus of Maastricht: Scene

LOYALTY

MANUSCRIPT

Malines: Lib., Grand Séminaire
Bible, Nicolò de Alifio, p. 1
Date: Mid-14th cent.
Robert of Anjou

SCULPTURE

Strzelno: Ch., Trinity
Nave, column
Date: Last quarter 12th cent.
Christ: Baptism

MAGNIFICENCE

MANUSCRIPT

Brussels: Lib., Bibl. Royale, 9505-6
Aristotle, *Ethiques*, fol. 66r
Date: 1372
Personification: Virtue, Generosity

Florence: Lib., Bibl. Laurenziana,
 Plut. XLII.19
Brunetto Latini, *Tesoro*, fol. 61v
Date: 14th cent.

Strasbourg: Lib., Bibl. Municipale
Herradis of Landsberg, *Hort. Delic.*,
 fol. 204r
Date: Second half 12th cent.
Personification: Virtue, Mercy

MEMORY

MANUSCRIPT

Strasbourg: Lib., Bibl. Municipale
Herradis of Landsberg, *Hort. Delic.*,
 fol. 202ᵥ
Date: Second half 12th cent.
Personification: Virtue, Prudence

MERCY

ENAMEL

Cleveland: Museum of Art
Pendant, reliquary (26.428)
Date: ca. 1160
Virgin Mary and Christ Child

Klosterneuburg: Monastery
Retable
Attribution: Nicolas of Verdun
Date: 1181
Abraham: Entertaining the Angels

Liège: Ch., Croix
Triptych, reliquary
Date: ca. 1160–1170
Angel

New York: Mus., Metropolitan,
 Cloisters
Triptych, reliquary (L. 1979.143)
Date: ca. 1160
Christ: Last Judgment

Troyes: Cath., Pierre, Treasury
Casket
Date: ca. 1200
Personification: Virtue, Faith

FRESCO

Brixen: Ch., Johannes
Decoration
Date: 13th cent.
*Christopher of Lycia: Carrying Christ
 Child*

Florence: Ch., Croce
Chapel, Baroncelli, back wall
Attribution: Taddeo Gaddi
Date: ca. 1328–1330
Joachim: Offerings Rejected

Florence: Loggia del Bigallo
Room, Consiglio
Date: 1342
Mercy Acts: Corporal

Hoxne: Ch., Peter and Paul
Nave
Date: Late 14th cent.
Tree of Vices

Peterborough: Cath., Peter, Paul, and
 Andrew
Decoration, on choir screen
Date: 12th cent.
Isaiah

Purgg: Ch., Johannis
Decoration
Date: 12th–13th cent.
Cain and Abel: Bringing Offerings

Soest: Cath., Patrokli
Chapel, S. Nikolaus
Date: Mid-13th cent.
Christ and Four Beasts

Worcester: Cathedral, Chapter House
Decoration
Date: 13th cent.?
Christ: Nativity

GLASS

Canterbury: Cath., Christ
Windows, choir
Date: 1180–1220
Moses: Burning Bush

Wienhausen: Convent
Windows
Date: 1330–1340
Christ: Entry into Jerusalem

MANUSCRIPT

Besançon: Lib., Bibl. Municipale, 54
Psalter, fol. 15v
Date: Second half 13th cent.
Psalms: Illustration

Brussels: Lib., Bibl. Royale, 9961-2
Psalter, fol. 10r
Date: 13th cent.
Jeremiah

Cambridge: Lib., Trinity College,
R.17.1
Psalter, Canterbury, fol. 70r
Date: ca. 1145–1170
Psalm 90 (Vulgate, 89)

Cambridge: Lib., Trinity College,
R.17.1
Psalter, Canterbury, fol. 73v
Date: ca. 1145–1170
Psalm 42 (Vulgate, 41)

Cambridge: Lib., Trinity College,
R.17.1
Psalter, Canterbury, fol. 150v
Date: ca. 1145–1170
Psalm 85 (Vulgate, 84)

Cambridge: Lib., Trinity College,
R.17.1
Psalter, Canterbury, fol. 156v
Date: ca. 1145–1170
Psalm 89 (Vulgate, 88)

Cambridge: Lib., Trinity College,
R.17.1
Psalter, Canterbury, fol. 164v
Date: ca. 1145–1170
Psalm 92 (Vulgate, 91)

Cambridge: Lib., Trinity College,
R.17.1
Psalter, Canterbury, fol. 167r
Date: ca. 1145–1170
Psalm 94 (Vulgate, 93)

Cambridge: Lib., Trinity College,
R.17.1
Psalter, Canterbury, fol. 207v
Date: ca. 1145–1170
Psalm 97 (Vulgate, 96)

Cambridge: Lib., Trinity College,
R.17.1
Psalter, Canterbury, fol. 244v
Date: ca. 1145–1170
Psalm 138 (Vulgate, 137)

Hildesheim: Ch., Godehard, Treasury
Psalter of S. Albans, fol. 91r
Date: Early 12th cent.
Psalm 57 (Vulgate, 56)

London: Lib., British, Add. 28162
Somme le Roi, fol. 9v
Date: ca. 1300

London: Lib., British, Add. 54180
Somme le Roi, fol. 136v
Date: ca. 1300

London: Lib., British, Harley 603
Psalter, fol. 23r
Date: ca. 1000–12th cent.
Psalm 40 (Vulgate, 39)

London: Lib., British, Harley 603
Psalter, fol. 24v
Date: ca. 1000–12th cent.
Psalm 42 (Vulgate, 41)

London: Lib., British, Roy. 19 C.II
Somme le Roi, fol. 73v
Date: 14th cent.
Lot: Entertaining Angels

London: Pal., Lambeth, 3
Bible, I, fol. 198r
Date: Mid-12th cent.
Jesse: Tree

Madrid: Lib., Bibl. Nacional, 6422
Psalter, fol. 7r
Date: ca. 1250–1260
Psalm

Milan: Lib., Bibl. Ambrosiana,
 H.106 sup.
Somme le Roi, fol. LXIv
Date: ca. 1300

Oxford: Lib., Keble College, 49
Legendarium, fol. 7r
Date: ca. 1267–1276
Christ: Crucifixion, Nailed to Cross by
 Virtues

Paris: Lib., Bibl. Nat. de France,
 ital. 115
Pseudo-Bonaventura, *Medit.*, fol. 4r
Date: 14th cent.
Christ: In Mandorla

Rome: Lib., Bibl. Vaticana, gr. 1927
Psalter, fol. 61v
Date: 11th–12th cent.
Psalm 37 (LXX, 36)

Rome: Lib., Bibl. Vaticana, gr. 1927
Psalter, fol. 156r
Date: 11th–12th cent.
Psalm 85 (LXX, 84)

Rome: Lib., Bibl. Vaticana, Reg. lat. 12
Psalter, fol. 92r
Date: Early 11th cent.
Psalm 85 (Vulgate, 84)

Strasbourg: Lib., Bibl. Municipale
Herradis of Landsberg, *Hort. Delic.*,
 fol. 201r
Date: Second half 12th cent.
Personification: Virtue, Patience

Strasbourg: Lib., Bibl. Municipale
Herradis of Landsberg, *Hort. Delic.*,
 fol. 204r
Date: Second half 12th cent.

Stuttgart: Lib., Landesbibl., Bibl.
 fol. 20
Missal, fol. 80v
Date: 12th cent.
Christ: Nativity

Utrecht: Lib., Bibl. der Universiteit, 32
Psalter, fol. 23r
Date: ca. 820–830
Psalm 40 (Vulgate, 39)

Utrecht: Lib., Bibl. der Universiteit, 32
Psalter, fol. 24v
Date: ca. 820–830
Psalm 42 (Vulgate, 41)

Utrecht: Lib., Bibl. der Universiteit, 32
Psalter, fol. 49v
Date: ca. 820–830
Psalm 85 (Vulgate, 84)

Utrecht: Lib., Bibl. der Universiteit, 32
Psalter, fol. 51v
Date: ca. 820–830
Psalm 89 (Vulgate, 88)

Utrecht: Lib., Bibl. der Universiteit, 32
Psalter, fol. 54r
Date: ca. 820–830
Psalm 92 (Vulgate, 91)

Utrecht: Lib., Bibl. der Universiteit, 32
Psalter, fol. 55r
Date: ca. 820–830
Psalm 94 (Vulgate, 93)

Utrecht: Lib., Bibl. der Universiteit, 32
Psalter, fol. 67v
Date: ca. 820–830
Psalm 97 (Vulgate, 96)

Utrecht: Lib., Bibl. der Universiteit, 32
Psalter, fol. 77v
Date: ca. 820–830
Psalm 138 (Vulgate, 137)

Wiesbaden: Lib., Hessische
 Landesbibl., I
Hildegardis, *Liber Scivias*, fol. 138v
Date: ca. 1165
Hildegardis of Bingen: Vision

Wiesbaden: Lib., Hessische
 Landesbibl., I
Hildegardis, *Liber Scivias*, fol. 139r
Date: ca. 1165
Hildegardis of Bingen: Vision

METALWORK

Cologne: Cathedral, Treasury
Casket, of Three Kings
Date: 1190–1225
Christ: Last Judgment

Hildesheim: Cath., Maria
Chandelier, of Hezilo
Date: ca. 1055–1065
Building: City Wall

Hildesheim: Cath., Maria
Font, bronze
Date: ca. 1220–1225
Virgin Mary and Christ Child

PAINTING

Regensburg: Cath., Peter, Treasury
Casket, reliquary
Date: Second half 13th cent.
Virgin Mary: Death

Stuttgart: Gall., Staatl. Gemäldegalerie
Panel (1140)
Date: ca. 1335
Solomon: Throne

SCULPTURE

Città di Castello: Cath., SS. Florido e
 Amanzio
Exterior, north
Date: Mid-14th cent.
Personification: Virtue, Justice

Clermont-Ferrand: Ch., Notre Dame
 du Port
Choir
Date: 12th cent.
Angel

Salisbury: Cathedral, Chapter House
Decoration, vestibule
Date: ca. 1260–1280
*Personification: Virtues and Vices,
 Conflict*

Southrop: Church
Font
Date: ca. 1160
*Personification: Church and
 Synagogue*

Stanton Fitzwarren: Church
Font
Date: ca. 1160
Personification: Church

TEXTILE

Augsburg: Ch., Ulric and Afra
Tapestries
Date: 12th cent.
Personification: New Testament

Bamberg: Cathedral, Treasury
Vestment, rational, embroidery
Date: 11th cent.
Apocalypse: Christ and Four Beasts

Regensburg: Cath., Peter, Treasury
Vestment, rational, embroidery
Date: 1314–1328
Apocalypse: Christ and Four Beasts

MIGHT

FRESCO

Saqqara: Mon., Jeremias
Cell 709
Date: 6th cent. or later
Palm

MANUSCRIPT

London: Lib., British, Add. 40731
Bristol Psalter, fol. 231v
Date: First half 11th cent.
Psalm 144 (LXX, 143)

Paris: Lib., Bibl. Nat. de France,
 gr. 139
Psalter, fol. 2v
Date: 10th cent.
Psalms: Illustration

Paris: Lib., Bibl. Nat. de France,
 gr. 139
Psalter, fol. 4v
Date: 10th cent.
Psalms: Illustration

Paris: Lib., Bibl. Nat. de France,
 lat. 1052
Breviary, Charles V, fol. 238r
Date: Second half 14th cent.
Psalm 69 (Vulgate, 68)

Paris: Lib., Bibl. Nat. de France,
 lat. 10483–84
Breviary, Belleville, I, fol. 37r
Date: First half 14th cent.
Psalm 69 (Vulgate, 68)

Wiesbaden: Lib., Hessische Landes-
 bibl., I
Hildegardis, *Liber Scivias*, fol. 192r
Date: ca. 1165
Hildegardis of Bingen: Vision

METALWORK

Novgorod: Cath., Sophia
Door, bronze
Attribution: Riquinus of Magdeburg
Date: 1152–1156
Christ and Peter and Paul

MOSAIC

Reims: Ch., Remi
Choir
Date: After 1090
David: As Musician

SCULPTURE

Rouen: Cath., Notre Dame
Exterior, north
Date: Late 13th–14th cent.
Creation Scene

MODESTY

ENAMEL

Saint-Ghislain: Church
Casket, reliquary
Date: Mid-12th cent.
Personification: Virtue, Patience

FRESCO

Tours: Ch., Martin
Tower, Charlemagne
Date: Second half 11th cent.
Florentius of Bavaria

MANUSCRIPT

Ghent: Lib., Bibl. de l'Université, 92
Lambertus, *Liber Floridus*, fol. 231v
Date: 1120
Tree of Virtues

Strasbourg: Lib., Bibl. Municipale
Herradis of Landsberg, *Hort. Delic.*,
 fol. 200r
Date: Second half 12th cent.
Personification: Virtue, Humility

Wiesbaden: Lib., Hessische
 Landesbibl., I
Hildegardis, *Liber Scivias*, fol. 138v
Date: ca. 1165
Hildegardis of Bingen: Vision

Wiesbaden: Lib., Hessische
 Landesbibl., I
Hildegardis, *Liber Scivias*, fol. 139r
Date: ca. 1165
Hildegardis of Bingen: Vision

METALWORK

Copenhagen: Mus., National
Altar, copper-gilt (D287)
Date: ca. 1150
Christ

Hildesheim: Cath., Maria
Chandelier, of Hezilo
Date: ca. 1055–1065
Building: City Wall

PAINTING

Stuttgart: Gall., Staatl. Gemäldegalerie
Panel (1140)
Date: ca. 1335
Solomon: Throne

SCULPTURE

Parma: Baptistery
Exterior
Date: Late 12th–13th cent.
Magi: Adoration

Southrop: Church
Font
Date: ca. 1160
*Personification: Church and
 Synagogue*

Stanton Fitzwarren: Church
Font
Date: ca. 1160
Personification: Church

TEXTILE

Paris: Mus., Moyen Age, Cluny
Purse, embroidery (Cl. 11788)
Date: 14th cent.
Angel

OATH-KEEPING

MANUSCRIPT

Strasbourg: Lib., Bibl. Municipale
Herradis of Landsberg, *Hort. Delic.*,
 fol. 202r
Date: Second half 12th cent.
Personification: Virtue, Prudence

OBEDIENCE

ENAMEL

Baltimore: Gall., Walters
Cross (44.98)
Date: Mid-12th cent.
Christ: Crucifixion

Brussels: Mus., Royaux d'Art et
 d'Histoire
Plaque, from reliquary (3141)
Date: ca. 1170
Personification: Virtue, Fortitude

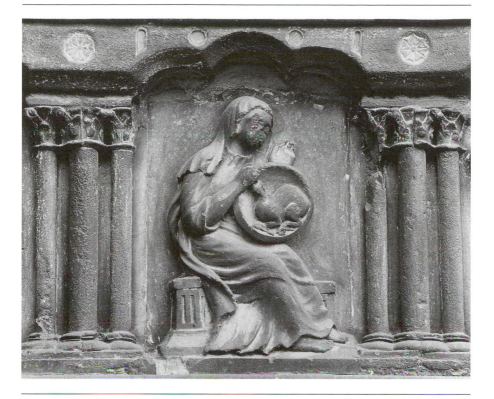

Klosterneuberg: Monastery
Retable
Attribution: Nicolas of Verdun
Date: 1181
Abraham: Entertaining the Angels

FRESCO

Assisi: Ch., Francesco, Lower
Crossing, vault
Date: First half 14th cent.
Allegory: Poverty

Barcelona: Conv., Pedralbes
Chapel, S. Michael
Date: 1345–1346
Christ: In Gethsemane

Florence: Ch., Croce
Chapel, Bardi
Date: First half 14th cent.
Francis of Assisi

Florence: Ch., Croce
Chapel, Baroncelli, back wall
Attribution: Taddeo Gaddi
Date: ca. 1328–1330
Joachim: Offerings Rejected

Florence: Ch., Maria Novella
Chapel, Strozzi, ceiling
Attribution: Giovanni del Biondo,
 Nardo di Cione
Date: ca. 1350–1360
Thomas Aquinas

Gurk: Cath., Maria Himmelfahrt
Gallery, west
Date: 13th cent.
Virgin Mary and Christ Child

Pistoia: Ch., Francesco
Choir
Date: 1343
Francis of Assisi: Scene

GLASS

Esslingen: Ch., Dionysius
Windows, choir
Date: Late 13th–14th cent.
Isaiah

Freiburg: Cath., Unsere Liebe Frau
Window, tower
Date: 14th cent.
Month: Occupation

Paris: Cath., Notre Dame
Window, west rose
Date: First half 13th cent.
Virgin Mary and Christ Child

Strasbourg: Cath., Notre Dame
Windows, southern transept
Date: 13th cent.
Apostle: Matthias

MANUSCRIPT

Bamberg: Lib., Staatsbibl., Bibl. 140
Apocalypse-Pericope, fol. 60r
Date: Early 11th cent.

Besançon: Lib., Bibl. Municipale, 54
Psalter, fol. 15v
Date: Second half 13th cent.
Psalms: Illustration

Cracow: Mus., Państwowe Zbiory
 Sztuki na Wawelu, 2459
Bible, fol. 391v
Date: Early 14th cent.
Psalm 22 (Vulgate, 21)

Eton: Lib., Eton College, 177
Miscellany, fol. 5r
Date: 13th cent.
Abraham: Sacrificing Isaac

Oxford: Lib., Keble College, 49
Legendarium, fol. 7r
Date: ca. 1267–1276
*Christ: Crucifixion, Nailed to Cross
 by Virtues*

Paris: Lib., Bibl. Nat. de France,
 fr. 9220
Verger de Solas, fol. 2r
Date: 13th–14th cent.
Solomon: Throne

Rome: Lib., Bibl. Vaticana, gr. 394
John Climacus, *Climax*, fol. 19r
Date: Late 11th cent.
John Climacus: Climax, Chapter IV

Soissons: Coll., Grand Séminaire
Gautier de Coincy, *Miracles N.D.*,
 fol. Ar
Date: 14th cent.
Virgin Mary and Christ Child

Strasbourg: Lib., Bibl. Municipale
Herradis of Landsberg, *Hort. Delic.*,
 fol. 67v
Date: Second half 12th cent.
Christ

Strasbourg: Lib., Bibl. Municipale
Herradis of Landsberg, *Hort. Delic.*,
 fol. 200r
Date: Second half 12th cent.
Personification: Virtue, Humility

Wiesbaden: Lib., Hessische
 Landesbibl., I
Hildegardis, *Liber Scivias*, fol. 178r
Date: ca. 1165
Hildegardis of Bingen: Vision

METALWORK

Cologne: Cathedral, Treasury
Casket, of Three Kings
Date: 1190–1225
Christ: Last Judgment

PAINTING

Bad Doberan: Ch., Cistercian
Triptych
Date: First half 14th cent.
*Christ: Crucifixion, Nailed to Cross
 by Virtues*

Berlin: Mus., Staatliche
Panel (1844)
Date: ca. 1360–1370
Gregory the Great

New York: Coll., Wildenstein
Panel
Date: 14th cent.
Virgin Mary and Christ Child

Regensburg: Cath., Peter, Treasury
Casket, reliquary
Date: Second half 13th cent.
Virgin Mary: Death

Stuttgart: Gall., Staatl. Gemäldegalerie
Panel (1140)
Date: ca. 1335
Solomon: Throne

SCULPTURE

Amiens: Cath., Notre Dame
Exterior, west
Date: 1220–1235
Malachi

Chartres: Cath., Notre Dame
Porch, south
Date: ca. 1230–1240
Saint

Florence: Ch., Orsanmichele
Tabernacle, marble
Attribution: Orcagna
Date: 1359–1360
Angel: Archangel Michael

Milan: Ch., Eustorgio
Tomb of Peter Martyr
Attribution: Giovanni di Balduccio or
 workshop
Date: 1339
Christ

Nuremberg: Ch., Sebaldus
Exterior, north
Date: 14th cent.
Virgins: Wise and Foolish

Paris: Cath., Notre Dame
Exterior, west
Date: ca. 1220–1230
Christ: Last Judgment

Pavia: Ch., Pietro in Ciel d'Oro
Tomb of Augustine of Hippo
Attribution: Giovanni di Balduccio,
 follower of
Date: Second half 14th cent.
Augustine of Hippo: Scene

Strzelno: Ch., Trinity
Nave, column
Date: Last quarter 12th cent.
Christ: Baptism

Worms: Cath., Peter and Paul
Exterior, south
Date: First half 14th cent.
Nicholas of Myra: Scene

PARSIMONY

ENAMEL

Troyes: Cath., Pierre, Treasury
Casket
Date: ca. 1200
Personification: Virtue, Faith

METALWORK

Cologne: Cathedral, Treasury
Casket, of Three Kings
Date: 1190–1225
Christ: Last Judgment

PASSIONLESSNESS

MANUSCRIPT

Rome: Lib., Bibl. Vaticana, gr. 394
John Climacus, *Climax*, fol. 7r
Date: Late 11th cent.
John Climacus: Climax, Chapter I

Rome: Lib., Bibl. Vaticana, gr. 394
John Climacus, *Climax*, fol. 12r
Date: Late 11th cent.
John Climacus: Climax, Chapter I

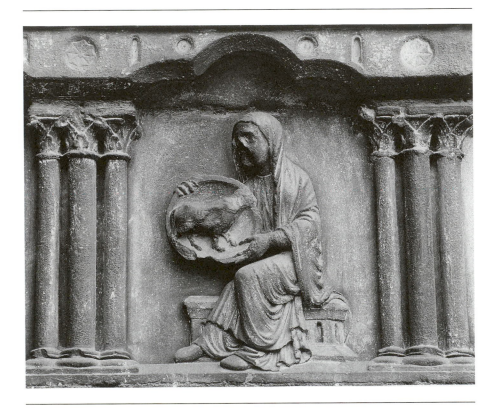

PATIENCE

ENAMEL

Brussels: Mus., Royaux d'Art et
 d'Histoire
Plaque, from reliquary (3141)
Date: ca. 1170
Personification: Virtue, Fortitude

Cologne: Ch., Pantaleon
Casket, reliquary, Albanus of Mayence
Date: 1186
Personification: Virtue, Humility

Klosterneuberg: Monastery
Retable
Attribution: Nicolas of Verdun
Date: 1181
Abraham: Entertaining the Angels

München-Gladbach: Ch.,
 Klosterkirche
Altar, portable
Date: 12th cent.
*Melchisedek: Represented with
 Chalice*

Saint-Ghislain: Church
Casket, reliquary
Date: Mid-12th cent.

Troyes: Cath., Pierre, Treasury
Casket
Date: ca. 1200
Personification: Virtue, Faith

FRESCO

Bawît: Mon., Apollo
Chapel III (Clédat)
Date: 6th–7th cent.?
Scene: Unidentified

Bawît: Mon., Apollo
Chapel XII (Clédat)
Date: 6th–7th cent.?
Malachi

Brioude: Ch., Julien
Porch
Date: 12th–13th cent.
Christ: Last Judgment

Cairo: Mus.: Coptic Museum, 8443
Date: 6th cent. or later
Palm

London: Pal., Westminster
Painted Chamber
Date: Late 13th cent.
Maccabees: Battle

Montoire: Ch., Gilles
Crossing
Date: 12th cent.
Lamb of God

Saeby: Church
Decoration
Date: 1150–1175
Christ and Four Beasts

Tours: Ch., Martin
Tower, Charlemagne
Date: Second half 11th cent.
Florentius of Bavaria

GLASS

Esslingen: Ch., Dionysius
Windows, choir
Date: Late 13th–14th cent.
Isaiah

Lyons: Cath., Jean
Window, apse
Date: ca. 1220
Magi: Before Herod the Great

Mulhouse: Ch., Etienne
Windows
Date: First half 14th cent.
Personification: Virtue, Sobriety

Niederhaslach: Ch., Florentius
Windows, nave
Date: 1290–1420
Christ: Parable, Prodigal Son

Paris: Cath., Notre Dame
Window, west rose
Date: First half 13th cent.
Virgin Mary and Christ Child

IVORY

London: Lib., British
Plaques, in book cover (Egerton 1139)
Date: 1131–1143
David: Slaying Lion

MANUSCRIPT

Bamberg: Lib., Staatsbibl., Bibl. 140
Apocalypse-Pericope, fol. 60r
Date: Early 11th cent.
Personification: Virtue, Obedience

Berne: Lib., Stadtbibl., 264
Prudentius, *Psychomachia*, fol. 38r
Date: Early 10th cent.
Personification: Virtue, Chastity

Berne: Lib., Stadtbibl., 264
Prudentius, *Psychomachia*, fol. 38v
Date: Early 10th cent.
Personification: Vice, Wrath

Berne: Lib., Stadtbibl., 264
Prudentius, *Psychomachia*, fol. 39r
Date: Early 10th cent.

Berne: Lib., Stadtbibl., 264
Prudentius, *Psychomachia*, fol. 39v
Date: Early 10th cent.

Berne: Lib., Stadtbibl., 264
Prudentius, *Psychomachia*, fol. 40r
Date: Early 10th cent.
Personification: Vice, Wrath

Berne: Lib., Stadtbibl., 264
Prudentius, *Psychomachia*, fol. 40v
Date: Early 10th cent.

Berne: Lib., Stadtbibl., 264
Prudentius, *Psychomachia*, fol. 41r
Date: Early 10th cent.

Boulogne: Lib., Bibl. Municipale, 46
Augustine, *Confessiones*, fol. 1v
Date: ca. 1125
Lambert of S. Bertin: Scene

Brussels: Lib., Bibl. Royale, 9968-72
Prudentius, *Psychomachia*, fol. 82r
Date: 11th cent.

Brussels: Lib., Bibl. Royale, 9968-72
Prudentius, *Psychomachia*, fol. 82v
Date: 11th cent.

Brussels: Lib., Bibl. Royale, 9968-72
Prudentius, *Psychomachia*, fol. 83r
Date: 11th cent.

Brussels: Lib., Bibl. Royale, 9968-72
Prudentius, *Psychomachia*, fol. 83v
Date: 11th cent.

Brussels: Lib., Bibl. Royale, 9968-72
Prudentius, *Psychomachia*, fol. 84v
Date: 11th cent.

Brussels: Lib., Bibl. Royale, 9968-72
Prudentius, *Psychomachia*, fol. 85r
Date: 11th cent.

Brussels: Lib., Bibl. Royale, 9968-72
Prudentius, *Psychomachia*, fol. 85v
Date: 11th cent.

Brussels: Lib., Bibl. Royale, 9987-91
Prudentius, *Psychomachia*, fol. 103r
Date: 10th cent.

Brussels: Lib., Bibl. Royale, 9987-91
Prudentius, *Psychomachia*, fol. 103v
Date: 10th cent.
Personification: Vice, Wrath

Brussels: Lib., Bibl. Royale, 9987-91
Prudentius, *Psychomachia*, fol. 104r
Date: 10th cent.

Brussels: Lib., Bibl. Royale, 9987-91
Prudentius, *Psychomachia*, fol. 104v
Date: 10th cent.

Brussels: Lib., Bibl. Royale, 9987-91
Prudentius, *Psychomachia*, fol. 105r
Date: 10th cent.

Brussels: Lib., Bibl. Royale, 10066-77
Prudentius, *Psychomachia*, fol. 118r
Date: 10th–first half 11th cent.
Personification: Virtue, Chastity

Brussels: Lib., Bibl. Royale, 10066-77
Prudentius, *Psychomachia*, fol. 118v
Date: 10th–first half 11th cent.
Personification: Vice, Wrath

Brussels: Lib., Bibl. Royale, 10066-77
Prudentius, *Psychomachia*, fol. 119r
Date: 10th–first half 11th cent.
Personification: Vice, Wrath

Brussels: Lib., Bibl. Royale, 10066-77
Prudentius, *Psychomachia*, fol. 119v
Date: 10th–first half 11th cent.

Brussels: Lib., Bibl. Royale, 10066-77
Prudentius, *Psychomachia*, fol. 120r
Date: 10th–first half 11th cent.

Brussels: Lib., Bibl. Royale, 10066-77
Prudentius, *Psychomachia*, fol. 120v
Date: 10th–first half 11th cent.

Cambridge: Lib., Corpus Christi
 College, 23
Prudentius, *Psychomachia*, fol. 10v
Date: Early 11th cent.
Personification: Virtue, Chastity

Cambridge: Lib., Corpus Christi
 College, 23
Prudentius, *Psychomachia*, fol. 11r
Date: Early 11th cent.

Cambridge: Lib., Corpus Christi
 College, 23
Prudentius, *Psychomachia*, fol. 11v
Date: Early 11th cent.
Personification: Vice, Wrath

Cambridge: Lib., Corpus Christi
 College, 23
Prudentius, *Psychomachia*, fol. 12r
Date: Early 11th cent.
Personification: Vice, Wrath

Cambridge: Lib., Corpus Christi
 College, 23
Prudentius, *Psychomachia*, fol. 12v
Date: Early 11th cent.
Personification: Vice, Wrath

Cambridge: Lib., Corpus Christi
 College, 23
Prudentius, *Psychomachia*, fol. 13r
Date: Early 11th cent.
Personification: Vice, Wrath

Cambridge: Lib., Corpus Christi
 College, 23
Prudentius, *Psychomachia*, fol. 13v
Date: Early 11th cent.

Cambridge: Lib., Corpus Christi
 College, 23
Prudentius, *Psychomachia*, fol. 14r
Date: Early 11th cent.

Cambridge: Mus., Fitzwilliam, 330
Psalter, W. de Brailes, no. 1
Date: ca. 1240
Psalms: Illustration

Cracow: Mus., Państwowe Zbiory
 Sztuki na Wawelu, 2459
Bible, fol. 391v
Date: Early 14th cent.
Psalm 22 (Vulgate, 21)

Eton: Lib., Eton College, 177
Miscellany, fol. 4v
Date: 13th cent.
Elijah: Meeting Widow of Zarephath

Ghent: Lib., Bibl. de l'Université, 92
Lambertus, *Liber Floridus*, fol. 231v
Date: 1120
Tree of Virtues

Leiden: Lib., Bibl. der Univ., Burm. Q.3
Prudentius, *Psychomachia*, fol. 125v
Date: Second quarter 9th cent.
Personification: Virtue, Chastity

Leiden: Lib., Bibl. der Univ., Burm. Q.3
Prudentius, *Psychomachia*, fol. 126r
Date: Second quarter 9th cent.

Leiden: Lib., Bibl. der Univ., Burm. Q.3
Prudentius, *Psychomachia*, fol. 126v
Date: Second quarter 9th cent.

Leiden: Lib., Bibl. der Univ., Burm. Q.3
Prudentius, *Psychomachia*, fol. 127r
Date: Second quarter 9th cent.
Personification: Vice, Wrath

Leiden: Lib., Bibl. der Univ., Burm. Q.3
Prudentius, *Psychomachia*, fol. 127v
Date: Second quarter 9th cent.

Leiden: Lib., Bibl. der Univ., Burm. Q.3
Prudentius, *Psychomachia*, fol. 128r
Date: Second quarter 9th cent.

Leiden: Lib., Bibl. der Univ., Voss.
 lat. oct. 15
Prudentius, *Psychomachia*, fol. 38r
Date: Early 11th cent.
Personification: Virtue, Chastity

Leiden: Lib., Bibl. der Univ., Voss.
 lat. oct. 15
Prudentius, *Psychomachia*, fol. 38v
Date: Early 11th cent.
Personification: Vice, Wrath

London: Coll., Beatty, 29
Job, fol. 1v
Date: 12th cent.
Adam and Eve: Fall of Man

London: Lib., British, Add. 24199
Prudentius, *Psychomachia*, fol. 8r
Date: Early 11th cent.
Personification: Virtue, Chastity

London: Lib., British, Add. 24199
Prudentius, *Psychomachia*, fol. 8v
Date: Early 11th cent.

London: Lib., British, Add. 24199
Prudentius, *Psychomachia*, fol. 9r
Date: Early 11th cent.

London: Lib., British, Add. 24199
Prudentius, *Psychomachia*, fol. 9v
Date: Early 11th cent.
Personification: Vice, Wrath

London: Lib., British, Add. 24199
Prudentius, *Psychomachia*, fol. 10r
Date: Early 11th cent.
Personification: Vice, Wrath

London: Lib., British, Add. 24199
Prudentius, *Psychomachia*, fol. 10v
Date: Early 11th cent.
Personification: Vice, Wrath

London: Lib., British, Add. 24199
Prudentius, *Psychomachia*, fol. 11r
Date: Early 11th cent.

London: Lib., British, Add. 24199
Prudentius, *Psychomachia*, fol. 11v
Date: Early 11th cent.

London: Lib., British, Cott. Cleo.
 C.VIII
Prudentius, *Psychomachia*, fol. 7r
Date: Early 11th cent.
Personification: Virtue, Chastity

London: Lib., British, Cott. Cleo.
 C.VIII
Prudentius, *Psychomachia*, fol. 7v
Date: Early 11th cent.

London: Lib., British, Cott. Cleo.
 C.VIII
Prudentius, *Psychomachia*, fol. 8r
Date: Early 11th cent.
Personification: Vice, Wrath

London: Lib., British, Cott. Cleo.
 C.VIII
Prudentius, *Psychomachia*, fol. 8v
Date: Early 11th cent.
Personification: Vice, Wrath

London: Lib., British, Cott. Cleo.
 C.VIII
Prudentius, *Psychomachia*, fol. 9r
Date: Early 11th cent.
Personification: Vice, Wrath

London: Lib., British, Cott. Cleo.
 C.VIII
Prudentius, *Psychomachia*, fol. 9v
Date: Early 11th cent.

London: Lib., British, Cott. Cleo.
 C.VIII
Prudentius, *Psychomachia*, fol. 10r
Date: Early 11th cent.

London: Lib., British, Cott. Titus
 D.XVI
Prudentius, *Psychomachia*, fol. 9r
Date: ca. 1100

London: Lib., British, Cott. Titus
 D.XVI
Prudentius, *Psychomachia*, fol. 9v
Date: ca. 1100

Lyons: Lib., Bibl. Municipale, Pal. des
 Arts 22
Prudentius, *Psychomachia*, fol. 4r
Date: Last quarter 11th cent.

Lyons: Lib., Bibl. Municipale, Pal. des
 Arts 22
Prudentius, *Psychomachia*, fol. 4v
Date: Last quarter 11th cent.

Lyons: Lib., Bibl. Municipale, Pal. des
　Arts 22
Prudentius, *Psychomachia*, fol. 7r
Date: Last quarter 11th cent.

Lyons: Lib., Bibl. Municipale, Pal. des
　Arts 22
Prudentius, *Psychomachia*, fol. 7v
Date: Last quarter 11th cent.

Munich: Lib., Staatsbibl., Clm. 30055
Gospel Book, Henry the Lion, fol. 16r
Date: ca. 1175
Apostle: Jude

Munich: Mus., Staatl. Graphische
　Samml., 39789
Miniature
Date: 12th cent.
Christ: Sermon on Mount

Paris: Lib., Bibl. Nat. de France,
　lat. 2077
Miscellany, fol. 168r
Date: 10th–11th cent.
Personification: Vice, Wrath

Paris: Lib., Bibl. Nat. de France,
　lat. 8085
Prudentius, *Psychomachia*, fol. 58r
Date: Late 9th cent.
Personification: Virtue, Chastity

Paris: Lib., Bibl. Nat. de France,
　lat. 8085
Prudentius, *Psychomachia*, fol. 58v
Date: Late 9th cent.

Paris: Lib., Bibl. Nat. de France,
　lat. 8085
Prudentius, *Psychomachia*, fol. 59r
Date: Late 9th cent.

Paris: Lib., Bibl. Nat. de France,
　lat. 8085
Prudentius, *Psychomachia*, fol. 59v
Date: Late 9th cent.

Paris: Lib., Bibl. Nat. de France,
　lat. 8318
Prudentius, *Psychomachia*, fol. 54r
Date: Late 10th cent.
Personification: Vice, Anger

Saint Gall: Lib., Stiftsbibl., 135
Prudentius, *Psychomachia*, p. 395
Date: First half 11th cent.

Saint-Omer: Lib., Bibl. Municipale, 34
Origen, *Homilies*, fol. 1v
Date: Second quarter 12th cent.
Creation Scene

Strasbourg: Lib., Bibl. Municipale
Herradis of Landsberg, *Hort. Delic.*,
　fol. 200r
Date: Second half 12th cent.
Personification: Virtue, Humility

Strasbourg: Lib., Bibl. Municipale
Herradis of Landsberg, *Hort. Delic.*,
　fol. 201r
Date: Second half 12th cent.

Valenciennes: Lib., Bibl. Municipale,
　563
Prudentius, *Psychomachia*, fol. 8r
Date: Early 11th cent.

Valenciennes: Lib., Bibl. Municipale,
　563
Prudentius, *Psychomachia*, fol. 8v
Date: Early 11th cent.

Valenciennes: Lib., Bibl. Municipale,
　563
Prudentius, *Psychomachia*, fol. 9r
Date: Early 11th cent.

Valenciennes: Lib., Bibl. Municipale,
　563
Prudentius, *Psychomachia*, fol. 10r
Date: Early 11th cent.

Valenciennes: Lib., Bibl. Municipale,
　563
Prudentius, *Psychomachia*, fol. 11r
Date: Early 11th cent.

Valenciennes: Lib., Bibl. Municipale,
　563
Prudentius, *Psychomachia*, fol. 11v
Date: Early 11th cent.

Valenciennes: Lib., Bibl. Municipale,
 563
Prudentius, *Psychomachia*, fol. 12r
Date: Early 11th cent.

Vienna: Lib., Nationalbibl., 2583*
Matfre Ermengaud, *Brev. d'Amor*,
 fol. 237v
Date: 14th cent.
Personification: Virtue, Generosity

Vorau: Lib., Stiftsbibl., lat. 130
G. of Vorau, *Lumen Animae*, fol. 110r
Date: 1332

Wiesbaden: Lib., Hessische
 Landesbibl., I
Hildegardis, *Liber Scivias*, fol. 138v
Date: ca. 1165
Hildegardis of Bingen: Vision

Wolfenbüttel: Lib., Herzog August
 Bibl., Guelf. 105 Noviss. 2°
Gospel Book, Henry the Lion, fol. 16r
Date: ca. 1175
Apostle: Jude

METALWORK

Berlin: Mus., Staatliche
Bowl, bronze (I.3136)
Date: 13th cent.
Personification: Virtue, Humility

Budapest: Mus., Magyar Nemzeti
 Múzeum
Bowl, bronze
Date: 12th–13th cent.
Personification: Virtue, Humility

Cologne: Cathedral, Treasury
Casket, of Three Kings
Date: 1190–1225
Christ: Last Judgment

Copenhagen: Mus., National
Altar, copper-gilt (D287)
Date: ca. 1150
Christ

Hannover: Mus., Kestner
Bowl, bronze-gilt (1894.18)
Date: 12th cent.
Personification: Virtue, Humility

Hildesheim: Cath., Maria
Chandelier, of Hezilo
Date: ca. 1055–1065
Building: City Wall

Lund: Mus., Kulturhistoriska
Bowl, fragment (19488)
Date: 11th–13th cent.

Lund: Mus., Kulturhistoriska
Bowl, bronze (25557)
Date: 11th–13th cent.
Personification: Virtue, Humility

Munich: Mus., Bayerisches
 Nationalmus.
Bowl, brass (M.A. 204)
Date: 12th–13th cent.
Personification: Virtue, Humility

Tallinn: Mus., Institute of History
Bowl, bronze (AI 4143:5)
Date: 12th cent.
Personification: Virtue, Hope

Tallinn: Mus., Institute of History
Bowl, bronze (AI 4143:6)
Date: 12th cent.
Personification: Virtue, Hope

Trier: Ch., Maximin
Font, of Folcardus
Date: Early 12th cent.
Personification: Virtue, Humility

Wrocław: Mus., Archeologiczne
Bowl, bronze
Date: Late 11th–12th cent.
Personification: Virtue, Humility

PAINTING

Florence: Ch., Croce
Polyptych
Attribution: Giovanni del Biondo
Date: 1379
Virgin Mary and Christ Child

SCULPTURE

Amiens: Cath., Notre Dame
Exterior, west
Date: 1220–1235
Malachi

Argenton-Château: Ch., Gilles
Exterior, west
Date: After 1130
Ornament: Figured

Aulnay-de-Saintonge: Ch., Pierre
Exterior, west
Date: ca. 1130–1150
Month: Occupation

Autun: Cath., Lazare
Chapter room
Date: First half 12th cent.
Scene: Ecclesiastic, Donation

Clermont-Ferrand: Ch., Notre Dame
 du Port
Choir
Date: 12th cent.
Angel

Florence: Ch., Orsanmichele
Tabernacle, marble
Attribution: Orcagna
Date: 1359–1360
Angel: Archangel Michael

Laon: Cath., Notre Dame
Exterior, west
Date: ca. 1180–1210
Magi: Adoration

Nuremberg: Ch., Sebaldus
Exterior, north
Date: 14th cent.
Virgins: Wise and Foolish

Paris: Cath., Notre Dame
Exterior, west
Date: ca. 1220–1230
Christ: Last Judgment

Parma: Baptistery
Exterior
Date: Late 12th–13th cent.
Magi: Adoration

Piacenza: Cath., Assunta
Exterior, west, central portal
Date: ca. second quarter 12th cent.
Personification: Vice, Avarice

Salisbury: Cathedral, Chapter House
Decoration, vestibule
Date: ca. 1260–1280
Personification: Virtues and Vices,
 Conflict

Southrop: Church
Font
Date: ca. 1160
Personification: Church and
 Synagogue

Stanton Fitzwarren: Church
Font
Date: ca. 1160
Personification: Church

Strzelno: Ch., Trinity
Nave, column
Date: Last quarter 12th cent.
Christ: Baptism

PEACE

ENAMEL

Cologne: Ch., Pantaleon
Casket, reliquary, Albanus of Mayence
Date: 1186
Personification: Virtue, Humility

Klosterneuburg: Monastery
Retable
Attribution: Nicolas of Verdun
Date: 1181
Abraham: Entertaining the Angels

FRESCO

Brixen: Ch., Johannes
Decoration
Date: 13th cent.
*Christopher of Lycia: Carrying Christ
 Child*

Bury Saint Edmunds: Ch., Abbey
Decoration?
Date: 13th cent.?
Personification: Synagogue

El-Bagaouat: Necropolis
Chapel with Personifications
Date: 4th cent.
Vine

Florence: Ch., Maria Novella
Chapel, Strozzi, ceiling
Attribution: Giovanni del Biondo,
 Nardo di Cione
Date: ca. 1350–1360
Thomas Aquinas

Peterborough: Cath., Peter, Paul, and
 Andrew
Decoration, on choir screen
Date: 12th cent.
Isaiah

Purgg: Ch., Johannis
Decoration
Date: 12th–13th cent.
Cain and Abel: Bringing Offerings

Rome: Cem., Petrus and Marcellinus
Arcosolium
Date: Mid-4th cent.
Jonah: Cast Up

Rome: Cem., Petrus and Marcellinus
Arcosolium near Cubiculum XI
Date: First half 4th cent.
Putto

Rome: Cem., Petrus and Marcellinus
Cubiculum of Gaudentia
Date: Mid-4th cent.
Putto

Rome: Cem., Petrus and Marcellinus
Cubiculum with the Tricliniarch
Date: First half 4th cent.
Figure: Male

Siena: Pal., Pubblico
Room, Pace
Attribution: Ambrogio Lorenzetti
Date: 1338–1339
Personification: Virtue, Justice

Soest: Cath., Patrokli
Chapel, S. Nikolaus
Date: Mid-13th cent.
Christ and Four Beasts

Worcester: Cathedral, Chapter House
Decoration
Date: 13th cent.?
Christ: Nativity

GLASS

Canterbury: Cath., Christ
Windows, choir
Date: 1180–1220
Moses: Burning Bush

Paris: Cath., Notre Dame
Window, west rose
Date: First half 13th cent.
Virgin Mary and Christ Child

Wienhausen: Convent
Windows
Date: 1330–1340
Christ: Entry into Jerusalem

LEATHER

Valenciennes: Lib., Bibl. Municipale
Book cover (24)
Date: 12th cent.
Christ and Four Beasts

MANUSCRIPT

Basel: Lib., Bibl. der Univ. Basel,
 A.N.I.8
Elias of Crete, *In Serm. Gregorii*, fol. I
Date: 11th–14th cent.
Gregory Nazianzen: Scene

Brussels: Lib., Bibl. Royale, 9961-2
Psalter, fol. 10r
Date: 13th cent.
Jeremiah

Brussels: Lib., Bibl. Royale, 9968-72
Prudentius, *Psychomachia*, fol. 106v
Date: 11th cent.

Brussels: Lib., Bibl. Royale, 9987-91
Prudentius, *Psychomachia*, fol. 117v
Date: 10th cent.

Cambridge: Lib., Corpus Christi
 College, 23
Prudentius, *Psychomachia*, fol. 33r
Date: Early 11th cent.

Cambridge: Lib., Trinity College,
 R.17.1
Psalter, Canterbury, fol. 150v
Date: ca. 1145–1170
Psalm 85 (Vulgate, 84)

Eton: Lib., Eton College, 177
Miscellany, fol. 7v
Date: 13th cent.
Personification: Virtue, Grace

Ghent: Lib., Bibl. de l'Université, 92
Lambertus, *Liber Floridus*, fol. 231v
Date: 1120
Tree of Virtues

Leiden: Lib., Bibl. der Univ., Burm. Q.3
Prudentius, *Psychomachia*, fol. 141v
Date: Second quarter 9th cent.

Leiden: Lib., Bibl. der Univ., Voss.
 lat. oct. 15
Prudentius, *Psychomachia*, fol. 41v
Date: Early 11th cent.
Personification: Vice, Avarice

London: Lib., British, Add. 24199
Prudentius, *Psychomachia*, fol. 29r
Date: Early 11th cent.

London: Lib., British, Add. 74236
Missal, Sherborne, p. 380
Date: ca. 1400
Christ: Crucifixion

London: Lib., British, Cott. Cleo.
 C.VIII
Prudentius, *Psychomachia*, fol. 27r
Date: Early 11th cent.

London: Pal., Lambeth, 3
Bible, I, fol. 198r
Date: Mid-12th cent.
Jesse: Tree

Lucca: Lib., Bibl. Governativa,
 lat. 1942
Hildegardis, *Liber Divinorum*,
 fol. 132r
Date: ca. 1230
Hildegardis of Bingen: Vision

Lyons: Lib., Bibl. Municipale, Pal. des
 Arts 22
Prudentius, *Psychomachia*, fol. 15r
Date: Last quarter 11th cent.
Personification: Virtue, Generosity

Lyons: Lib., Bibl. Municipale, Pal. des
 Arts 22
Prudentius, *Psychomachia*, fol. 18r
Date: Last quarter 11th cent.

Munich: Lib., Staatsbibl., Clm. 30055
Gospel Book, Henry the Lion,
 fol. 110v
Date: ca. 1175
Virgin Mary: Annunciation

Paris: Lib., Bibl. Nat. de France,
 ital. 115
Pseudo-Bonaventura, *Medit.*, fol. 4r
Date: 14th cent.
Christ: In Mandorla

Paris: Lib., Bibl. Nat. de France,
 lat. 8085
Prudentius, *Psychomachia*, fol. 65v
Date: Late 9th cent.

Paris: Lib., Bibl. Nat. de France,
 lat. 8318
Prudentius, *Psychomachia*, fol. 61v
Date: Late 10th cent.
Personification: Virtue, Generosity

Paris: Lib., Bibl. Nat. de France,
 lat. 15158
Prudentius, *Psychomachia*, fol. 55v
Date: 1289

Paris: Lib., Bibl. Nat. de France,
 lat. 15158
Prudentius, *Psychomachia*, fol. 56r
Date: 1289

Rome: Lib., Bibl. Vaticana, gr. 1927
Psalter, fol. 156r
Date: 11th–12th cent.
Psalm 85 (LXX, 84)

Rome: Lib., Bibl. Vaticana, Reg. lat. 12
Psalter, fol. 92r
Date: Early 11th cent.
Psalm 85 (Vulgate, 84)

Stuttgart: Lib., Landesbibl., Bibl.
 fol. 20
Missal, fol. 80v
Date: 12th cent.
Christ: Nativity

Utrecht: Lib., Bibl. der Universiteit, 32
Psalter, fol. 49v
Date: ca. 820–830
Psalm 85 (Vulgate, 84)

Wiesbaden: Lib., Hessische
 Landesbibl., I
Hildegardis, *Liber Scivias*, fol. 161v
Date: ca. 1165
Hildegardis of Bingen: Vision

Wolfenbüttel: Lib., Herzog August
 Bibl., Guelf. 105 Noviss. 2°
Gospel Book, Henry the Lion, fol. 110v
Date: ca. 1175
Virgin Mary: Annunciation

METALWORK

Cologne: Cathedral, Treasury
Casket, of Three Kings
Date: 1190–1225
Christ: Last Judgment

Copenhagen: Mus., National
Altar, copper-gilt (D287)
Date: ca. 1150
Christ

Hildesheim: Cath., Maria
Chandelier, of Hezilo
Date: ca. 1055–1065
Building: City Wall

PAINTING

Bad Doberan: Ch., Cistercian
Triptych
Date: First half 14th cent.
Christ: Crucifixion, Nailed to Cross
 by Virtues

SCULPTURE

Parma: Baptistery
Exterior
Date: Late 12th–13th cent.
Magi: Adoration

TEXTILE

Bamberg: Cathedral, Treasury
Vestment, rational, embroidery
Date: 11th cent.
Apocalypse: Christ and Four Beasts

Regensburg: Cath., Peter, Treasury
Vestment, rational, embroidery
Date: 1314–1328
Apocalypse: Christ and Four Beasts

PERFECTION

ENAMEL

Brussels: Mus., Royaux d'Art et
 d'Histoire
Reliquary, Alexander (1031)
Date: 1145
Eventius of Rome

PERSEVERANCE

GLASS

Paris: Cath., Notre Dame
Window, west rose
Date: First half 13th cent.
Virgin Mary and Christ Child

MANUSCRIPT

Cracow: Mus., Państwowe Zbiory
 Sztuki na Wawelu, 2459
Bible, fol. 391v
Date: Early 14th cent.
Psalm 22 (Vulgate, 21)

Strasbourg: Lib., Bibl. Municipale
Herradis of Landsberg, *Hort. Delic.,*
 fol. 204r
Date: Second half 12th cent.
Personification: Virtue, Mercy

METALWORK

Hildesheim: Cath., Maria
Chandelier, of Hezilo
Date: ca. 1055–1065
Building: City Wall

PAINTING

Bad Doberan: Ch., Cistercian
Triptych
Date: First half 14th cent.
*Christ: Crucifixion, Nailed to Cross
 by Virtues*

SCULPTURE

Amiens: Cath., Notre Dame
Exterior, west
Date: 1220–1235
Malachi

Chartres: Cath., Notre Dame
Porch, south
Date: ca. 1230–1240
Saint

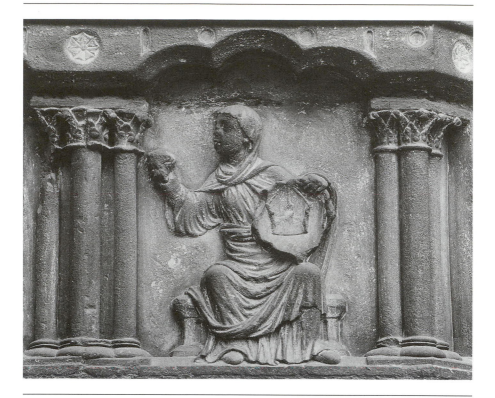

Florence: Ch., Orsanmichele
Tabernacle, marble
Attribution: Orcagna
Date: 1359–1360
Angel: Archangel Michael

Paris: Cath., Notre Dame
Exterior, west
Date: ca. 1220–1230
Christ: Last Judgment

PIETY

ENAMEL

Brussels: Lib., Bibl. Royale
Book cover (14970)
Date: Second half 12th cent.
Evangelist: Symbol

Brussels: Mus., Royaux d'Art et
 d'Histoire
Reliquary, Alexander (1031)
Date: 1145
Eventius of Rome

Cleveland: Museum of Art
Pendant, reliquary (26.428)
Date: ca. 1160
Virgin Mary and Christ Child

Darmstadt: Mus., Hessisches
 Landesmus.
Plaque, copper-gilt (Kg 54:246e)
Date: ca. 1170
Ecclesiasticus: Illustration

Klosterneuberg: Monastery
Retable
Date: 1322–1331
Abraham: Entertaining the Angels

New York: Mus., Metropolitan,
Cloisters
Triptych, reliquary (L. 1979.143)
Date: ca. 1160
Christ: Last Judgment

Vienna: Mus., Erzbischöfliches
Dommuseum
Plaques (L 3)
Date: Late 12th cent.
Abraham: Sacrificing Isaac

GLASS

Freiburg: Cath., Unsere Liebe Frau
Window, tower
Date: 14th cent.
Month: Occupation

MANUSCRIPT

Munich: Lib., Staatsbibl., Clm. 13601
Lectionary of Uta, fol. 4v
Date: ca. 1025
Erhardus of Germany: Scene

Rome: Lib., Bibl. Vaticana, Ottob.
lat. 74
Lectionary, Henry II, fol. 193v
Date: 11th cent.
Henry II

Strasbourg: Lib., Bibl. Municipale
Herradis of Landsberg, *Hort. Delic.*,
fol. 201r
Date: Second half 12th cent.
Personification: Virtue, Patience

Wiesbaden: Lib., Hessische
Landesbibl., I
Hildegardis, *Liber Scivias*, fol. 161v
Date: ca. 1165
Hildegardis of Bingen: Vision

METALWORK

Hildesheim: Cath., Maria
Chandelier, of Hezilo
Date: ca. 1055–1065
Building: City Wall

SCULPTURE

Parma: Baptistery
Exterior
Date: Late 12th–13th cent.
Magi: Adoration

Stanton Fitzwarren: Church
Font
Date: ca. 1160
Personification: Church

Tebessa: Ch., Catholic
Sarcophagus
Date: 4th–6th cent.
Personification: City of Rome

TEXTILE

Quedlinburg: Church, Treasury
Hanging, tapestry
Date: 1186–1203
Personification: Virtue, Chastity

PILGRIMAGE

MANUSCRIPT

Rome: Lib., Bibl. Vaticana, gr. 394
John Climacus, *Climax*, fol. 14v
Date: Late 11th cent.
John Climacus: Climax, Chapter II

Rome: Lib., Bibl. Vaticana, gr. 394
John Climacus, *Climax*, fol. 17v
Date: Late 11th cent.
*John Climacus: Climax, Chapter III,
 Part 1*

Rome: Lib., Bibl. Vaticana, gr. 394
John Climacus, *Climax*, fol. 19r
Date: Late 11th cent.
John Climacus: Climax, Chapter IV

PLACIDITY

MANUSCRIPT

Rome: Lib., Bibl. Vaticana, gr. 394
John Climacus, *Climax*, fol. 62r
Date: Late 11th cent.
John Climacus: Climax, Chapter VII

POVERTY

FRESCO

Assisi: Ch., Francesco, Lower
Crossing, vault
Date: First half 14th cent.
Allegory: Poverty

Budapest: Mus., Szépmüvészeti
 Múzeum
Panel
Date: 14th cent.
Figure: Female

Florence: Ch., Croce
Chapel, Bardi
Date: First half 14th cent.
Francis of Assisi

Florence: Ch., Croce
Chapel, Baroncelli, back wall
Attribution: Taddeo Gaddi
Date: ca. 1328–1330
Joachim: Offerings Rejected

Pistoia: Ch., Francesco
Choir
Date: 1343
Francis of Assisi: Scene

GLASS

Strasbourg: Cath., Notre Dame
Windows, southern transept
Date: 13th cent.
Apostle: Matthias

MANUSCRIPT

Florence: Lib., Bibl. Riccardiana, 1489
Miscellany, fol. 3v
Date: 14th cent.
Christ: Crucifixion

Strasbourg: Lib., Bibl. Municipale
Herradis of Landsberg, *Hort. Delic.,*
 fol. 67v
Date: Second half 12th cent.
Christ

PAINTING

Florence: Ch., Croce
Polyptych
Attribution: Giovanni del Biondo
Date: 1379
Virgin Mary and Christ Child

SCULPTURE

Florence: Mus., Naz. di Bargello
Relief
Attribution: Giovanni di Balduccio
Date: 1318–1349

Pavia: Ch., Pietro in Ciel d'Oro
Tomb of Augustine of Hippo
Attribution: Giovanni di Balduccio,
 follower of
Date: Second half 14th cent.
Augustine of Hippo: Scene

Reims: Cath., Notre Dame
Exterior, west
Date: ca. 1230–1240
Virgin Mary: Coronation

PRAYER

ENAMEL

New York: Mus., Metropolitan,
 Cloisters
Triptych, reliquary (L. 1979.143)
Date: ca. 1160
Christ: Last Judgment

MANUSCRIPT

Paris: Lib., Bibl. Nat. de France,
 lat. 18014
Hours, Duc de Berry, fol. 278v
Date: Late 14th cent.
Solomon: Throne

Rome: Lib., Bibl. Vaticana, gr. 394
John Climacus, *Climax*, fol. 94r
Date: Late 11th cent.
John Climacus: Climax,
 Chapter XVIII

Rome: Lib., Bibl. Vaticana, gr. 394
John Climacus, *Climax*, fol. 95r
Date: Late 11th cent.
John Climacus: Climax, Chapter XIX

Rome: Lib., Bibl. Vaticana, gr. 394
John Climacus, *Climax*, fol. 144r
Date: Late 11th cent.
John Climacus: Climax,
 Chapter XXVIII

Rome: Lib., Bibl. Vaticana, gr. 394
John Climacus, *Climax*, fol. 149r
Date: Late 11th cent.
John Climacus: Climax,
 Chapter XXVIII

PROVIDENCE

MANUSCRIPT

Florence: Lib., Bibl. Laurenziana,
 Plut. XLII.19
Brunetto Latini, *Tesoro*, fol. 53r
Date: 14th cent.

Strasbourg: Lib., Bibl. Municipale
Herradis of Landsberg, *Hort. Delic.*,
 fol. 202r
Date: Second half 12th cent.
Personification: Virtue, Prudence

PROWESS

MANUSCRIPT

Florence: Lib., Bibl. Laurenziana,
 Plut. XLII.19
Brunetto Latini, *Tesoro*, fol. 45v
Date: 14th cent.

London: Lib., British, Add. 28162
Somme le Roi, fol. 8v
Date: ca. 1300

London: Lib., British, Add. 54180
Somme le Roi, fol. 121v
Date: ca. 1300

Paris: Lib., Bibl. de l'Arsenal, 6329
Somme le Roi, fol. 128v
Date: 1311

Paris: Lib., Bibl. Mazarine, 870
Somme le Roi, fol. 111v
Date: 1295

Paris: Lib., Bibl. Nat. de France,
 fr. 14939
Somme le Roi, fol. 112v
Date: 1373

PRUDENCE

ENAMEL

Brussels: Mus., Royaux d'Art et
 d'Histoire
Plaque, from reliquary (3141)
Date: ca. 1170
Personification: Virtue, Fortitude

Cleveland: Museum of Art
Plaque (52.229)
Date: Third quarter 12th cent.

Klosterneuberg: Monastery
Retable
Attribution: Nicolas of Verdun
Date: 1181
Abraham: Entertaining the Angels

Osnabrück: Town Hall, Rathaus
Vessel
Date: First half 14th cent.

Troyes: Cath., Pierre, Treasury
Plaques
Date: 12th cent.
*Jacob: Blessing Ephraim and
 Manasseh*

Vienna: Mus., Erzbischöfliches
 Dommuseum
Plaques (L 3)
Date: Late 12th cent.
Abraham: Sacrificing Isaac

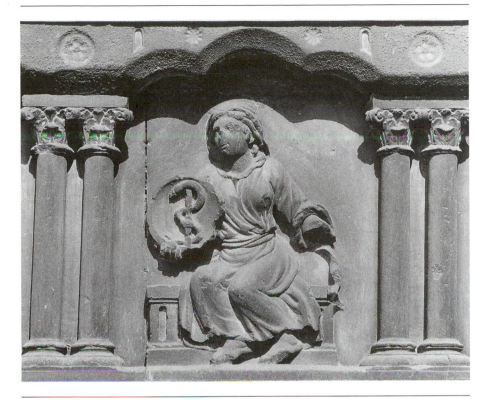

FRESCO

Assisi: Ch., Francesco, Lower
Crossing, vault
Date: First half 14th cent.
Allegory: Poverty

Cologne: Ch., Maria Lyskirchen
Nave
Date: 13th cent.
Daniel?

Florence: Ch., Croce
Chapel, Bardi di Vernio (Silvestro)
Date: First half 14th cent.
Constantine the Great: Scene

Florence: Ch., Croce
Chapel, Baroncelli, back wall
Attribution: Taddeo Gaddi
Date: ca. 1328–1330
Joachim: Offerings Rejected

Florence: Ch., Croce
Sacristy
Date: Late 14th cent.
Christ: Ascension

Gurk: Cath., Maria Himmelfahrt
Gallery, west
Date: 13th cent.
Virgin Mary and Christ Child

Padua: Chap., Madonna dell'Arena
Decoration
Attribution: Giotto
Date: ca. 1303–1308
Joachim: Offerings Rejected

Pistoia: Cath., Zenone
Nave
Date: 1347

Saqqara: Mon., Jeremias
Cell 709
Date: 6th cent. or later
Palm

Siena: Pal., Pubblico
Room, Pace
Attribution: Ambrogio Lorenzetti
Date: 1338–1339
Personification: Virtue, Justice

Tolentino: Ch., Nicola da Tolentino
Chapel, S. Nicola
Date: 13th–14th cent.
Evangelist: Symbol

GLASS

Freiburg: Cath., Unsere Liebe Frau
Window, tower
Date: 14th cent.
Month: Occupation

Paris: Cath., Notre Dame
Window, west rose
Date: First half 13th cent.
Virgin Mary and Christ Child

MANUSCRIPT

Chantilly: Mus., Condé, 1426
Bartolomeo di Bartoli, *Canzone*
Attribution: Andrea da Bologna
Date: ca. 1350–1360

Florence: Lib., Bibl. Laurenziana,
 Plut. XLII.19
Brunetto Latini, *Tesoro*, fol. 52v
Date: 14th cent.

Florence: Lib., Bibl. Naz. Centrale,
 Landau-Finaly 22
Hours, Giangaleazzo Visconti, fol. 17r
Attribution: Giovannino and
 Salomone dei Grassi
Date: ca. 1395
Ambrose of Milan

Hague: Mus., Meermanno-
 Westreenianum, 10 D 1
Aristotle, *Ethiques*, fol. 110r
Date: 1376
Personification: Virtue, Knowledge

London: Lib., British, Roy. 6 E.IX
Convenevoli de Pratis(?), *Poemata*,
 fol. 21r
Date: ca. 1335–1340

Malines: Lib., Grand Séminaire
Bible, Nicolò de Alifio, p. 1
Date: Mid-14th cent.
Robert of Anjou

Melbourne: Gall., National, Felton
 710/5
Gospel Book, fol. 4r
Date: ca. 1100

Munich: Lib., Staatsbibl., Clm. 13002
Miscellany, fol. 4r
Date: 1158–1165
Joseph: Brethren Begging Forgiveness

Munich: Lib., Staatsbibl., Clm. 30055
Gospel Book, Henry the Lion, fol. 14r
Date: ca. 1175
Apostle: Philip

Paris: Lib., Bibl. Nat. de France, fr.
 9220
Verger de Solas, fol. 2r
Date: 13th–14th cent.
Solomon: Throne

Paris: Lib., Bibl. Nat. de France,
 lat. 1052
Breviary, Charles V, fol. 232r
Date: Second half 14th cent.
Psalm 53 (Vulgate, 52)

Paris: Lib., Bibl. Nat. de France,
 lat. 10483–84
Breviary, Belleville, I, fol. 25v
Date: First half 14th cent.
Psalm 53 (Vulgate, 52)

Paris: Lib., Bibl. Nat. de France,
 lat. 10483–84
Breviary, Belleville, I, fol. 31r
Date: First half 14th cent.
Psalm 53 (Vulgate, 52)

Rome: Gall., Naz. d'Arte Antica
Bartolomeo di Bartoli, *Canzone*, fol. 2r
Date: 14th cent.

Rome: Lib., Bibl. Vaticana, Ottob.
 lat. 74
Lectionary, Henry II, fol. 193v
Date: 11th cent.
Henry II

Saint-Omer: Lib., Bibl. Municipale, 34
Origen, *Homilies*, fol. 1v
Date: Second quarter 12th cent.
Creation Scene

Salzburg: Lib., Studienbibl., V 1 H 162
Miscellany, fol. 76r
Date: First half 12th cent.
Tree of Virtues

Soissons: Coll., Grand Séminaire
Gautier de Coincy, *Miracles N.D.*,
 fol. Ar
Date: 14th cent.
Virgin Mary and Christ Child

Strasbourg: Lib., Bibl. Municipale
Herradis of Landsberg, *Hort. Delic.*,
 fol. 200r
Date: Second half 12th cent.
Personification: Virtue, Humility

Strasbourg: Lib., Bibl. Municipale
Herradis of Landsberg, *Hort. Delic.*,
 fol. 201v
Date: Second half 12th cent.
Personification: Vice, Obstinacy

Strasbourg: Lib., Bibl. Municipale
Herradis of Landsberg, *Hort. Delic.*,
 fol. 202r
Date: Second half 12th cent.

Vienna: Lib., Nationalbibl., Ser. Nov.
 2639
Convenevoli de Pratis(?), *Poemata*,
 fol. 1v
Date: Early 14th cent.
Personification: Virtue, Temperance

Wolfenbüttel: Lib., Herzog August
 Bibl., Guelf. 105 Noviss. 2°
Gospel Book, Henry the Lion, fol. 14r
Date: ca. 1175
Apostle: Philip

METALWORK

Baltimore: Gall., Walters
Statuette, bronze (54.52)
Date: 12th cent.
Angel

Cologne: Cathedral, Treasury
Casket, of Three Kings
Date: 1190–1225
Christ: Last Judgment

Florence: Baptistery
Door, south, bronze
Attribution: Andrea Pisano
Date: 1330
Zacharias: Annunciation

Hildesheim: Cath., Maria
Chandelier, of Hezilo
Date: ca. 1055–1065
Building: City Wall

Manchester: Lib., Rylands
Book cover, silver-gilt (lat. 4)
Date: ca. 1150–1175
Saint?

Paris: Mus., Louvre
Statuette, bronze-gilt (OA 5908)
Date: Second half 12th cent.

Saint-Symphorien: Church
Casket, S. Symphorien
Date: 12th–13th cent.
Christ and Apostles

Susteren: Church
Reliquary, Amalaberga
Date: ca. 1160–1170

Venice: Ch., Marco, Treasury
Reliquary, silver (142)
Date: Late 12th cent.
Building

MOSAIC

Reims: Ch., Remi
Choir
Date: After 1090
David: As Musician

PAINTING

Florence: Ch., Croce
Polyptych
Attribution: Giovanni del Biondo
Date: 1379
Virgin Mary and Christ Child

Greenwich: Coll., Hyland
Panel
Date: 14th cent.
Virgin Mary and Christ Child

Rome: Mus., Vaticani, Pinacoteca
Panel (40520)
Date: ca. 1375–1380
Virgin Mary

Stuttgart: Gall., Staatl. Gemäldegalerie
Panel (1140)
Date: ca. 1335
Solomon: Throne

SCULPTURE

Amiens: Cath., Notre Dame
Exterior, west
Date: 1220–1235
Malachi

Bamberg: Cath., Peter und Georg
Tomb of Clement II
Date: ca. 1220–1240
Clement II, Pope: Scene

Chartres: Cath., Notre Dame
Exterior, north, central portal
Date: 1205–1210
Virgin Mary: Coronation

Chartres: Cath., Notre Dame
Exterior, north, left portal
Date: ca. 1220
Virgins, Foolish

Chartres: Cath., Notre Dame
Porch, south
Date: ca. 1230–1240
Saint

Cluny: Mus., Farinier
Capitals
Date: Late 11th–early 12th cent.
Personification: Music

Detroit: Mus., Institute of Arts
Statue (38.72)
Attribution: Pacio and Giovanni
 Bertini da Firenze
Date: Mid-14th cent.

Florence: Cath., Maria del Fiore
Exterior, north
Attribution: Niccolò di Pietro
 Lamberti and Jacopo di Piero Guidi
Date: Late 14th cent.
Prophet

Florence: Ch., Orsanmichele
Tabernacle, marble
Attribution: Orcagna
Date: 1359–1360
Angel: Archangel Michael

Florence: Loggia del Bigallo
Exterior, east and north
Date: 1352–1358
Christ: Of Sorrows

Jaca: Ch., Domingo
Capital
Date: 11th cent.
Figure: Female

Naples: Ch., Chiara
Statue, from tomb
Attribution: Pacio and Giovanni
 Bertini da Firenze
Date: ca. 1330–1350

Naples: Ch., Chiara
Tomb of Robert of Anjou
Attribution: Pacio and Giovanni
 Bertini da Firenze
Date: ca. 1343
Robert of Anjou

Paris: Cath., Notre Dame
Exterior, west
Date: ca. 1220–1230
Christ: Last Judgment

Parma: Baptistery
Exterior
Date: Late 12th–13th cent.
Magi: Adoration

Reims: Cath., Notre Dame
Exterior, west
Date: ca. 1230–1240
Virgin Mary: Coronation

Salisbury: Cathedral, Chapter House
Decoration, vestibule
Date: ca. 1260–1280
*Personification: Virtues and Vices,
 Conflict*

Siena: Cath., Assunta
Exterior, south
Date: 13th–14th cent.
Miriam

Siena: Cath., Assunta
Pulpit
Attribution: Nicola Pisano
Date: ca. 1265–1269
Virgin Mary: Visitation

Strzelno: Ch., Trinity
Nave, column
Date: Last quarter 12th cent.
Christ: Baptism

Venice: Ch., Marco
Exterior, west
Date: 13th cent.
Christ

TEXTILE

Quedlinburg: Church, Treasury
Hanging, tapestry
Date: 1186–1203
Personification: Virtue, Chastity

PURITY

FRESCO

Assisi: Ch., Francesco, Lower
Crossing, vault
Date: First half 14th cent.
Allegory: Poverty

GLASS

Lyons: Cath., Jean
Window, apse
Date: ca. 1220
Magi: Before Herod the Great

MANUSCRIPT

Malines: Lib., Grand Séminaire
Bible, Nicolò de Alifio, p. 1
Date: Mid-14th cent.
Robert of Anjou

Strasbourg: Lib., Bibl. Municipale
Herradis of Landsberg, *Hort. Delic.*,
 fol. 200r
Date: Second half 12th cent.
Personification: Virtue, Humility

REASON

MANUSCRIPT

Baltimore: Gall., Walters, W. 72
Speculum Virginum, fol. 73r
Date: First half 13th cent.
Speculum Virginum: Text

Brussels: Lib., Bibl. Royale, 9505-6
Aristotle, *Ethiques*, fol. 132r
Date: 1372

Cologne: Arch., Historisches, W 276a
Speculum Virginum, fol. 68r
Date: Mid-12th cent.
Speculum Virginum: Text

Hague: Mus., Meermanno-
 Westreenianum, 10 D 1
Aristotle, *Ethiques*, fol. 126r
Date: 1376

Heidelberg: Lib., Universitätsbibl.,
 Pal. lat. 1969
G. de Degulleville, *Pèlerinage*, fol. 10v
Date: ca. 1370–1380
Guillaume de Degulleville: Pèlerinage
 de Vie Humaine

Madrid: Lib., Bibl. Nacional, 195-6
Bartolus of Sassoferrato, *Comm.*
Date: 14th cent.
Augustine of Hippo

Munich: Lib., Staatsbibl., Clm. 14159
Dialogus Cruce Christi, fol. 6r
Date: ca. 1170–1185
Christ

Paris: Lib., Bibl. Nat. de France,
 lat. 6734
Honorius of Autun, *Clavis Physicae*,
 fol. 3v
Date: 12th cent.
Personification: Virtue, Goodness

Paris: Lib., Bibl. Sainte-Geneviève,
 1130
G. de Degulleville, *Pèlerinage*, fol. 35v
Date: Second half 14th cent.

Paris: Lib., Bibl. Sainte-Geneviève,
 1130
G. de Degulleville, *Pèlerinage*,
 fol. 104r
Date: Second half 14th cent.
Personification: Virtue, Justice

Pommersfelden: Coll., Schönborn,
 Library, 215
Miscellany, fol. 161r
Date: 14th cent.
Alanus de Insulis: Text

Pommersfelden: Coll., Schönborn,
 Library, 215
Miscellany, fol. 161v
Date: 14th cent.
Alanus de Insulis: Text

Pommersfelden: Coll., Schönborn,
 Library, 215
Miscellany, fol. 162r
Date: 14th cent.
Alanus de Insulis: Text

Pommersfelden: Coll., Schönborn,
 Library, 215
Miscellany, fol. 162v
Date: 14th cent.
Alanus de Insulis: Text

Saint Gall: Lib., Stiftsbibl., 135
Prudentius, *Psychomachia*, p. 420
Date: First half 11th cent.

Strasbourg: Lib., Bibl. Municipale
Herradis of Landsberg, *Hort. Delic.*,
 fol. 202r
Date: Second half 12th cent.
Personification: Virtue, Prudence

Troyes: Lib., Bibl. Municipale, 252
Speculum Virginum, fol. 82r
Date: ca. 1190
Speculum Virginum: Text

RELIGION

ENAMEL

Brussels: Lib., Bibl. Royale
Book cover (14970)
Date: Second half 12th cent.
Evangelist: Symbol

MANUSCRIPT

Montecassino: Monastery, 132
Rabanus Maurus, *De Universo*, p. 68
Date: ca. 1023
Personification: Virtue, Charity

Princeton: Lib., Univ., Garrett 114
Miscellany, fol. 88r
Date: ca. 1200
Figure: Male

Strasbourg: Lib., Bibl. Municipale
Herradis of Landsberg, *Hort. Delic.*,
 fol. 200r
Date: Second half 12th cent.
Personification: Virtue, Humility

METALWORK

London: Mus., British
Shrine, silver-gilt (1978,5-2,7)
Date: ca. 1165–1170
Oda of Belgium

REPENTANCE

FRESCO

Assisi: Ch., Francesco, Lower
Crossing, vault
Date: First half 14th cent.
Allegory: Poverty

Florence: Ch., Croce
Chapel, Baroncelli, back wall
Attribution: Taddeo Gaddi
Date: ca. 1328–1330
Joachim: Offerings Rejected

Pisa: Ch., Francesco
Choir
Date: 1342
Francis of Assisi

GLASS

Strasbourg: Cath., Notre Dame
Windows, southern transept
Date: 13th cent.
Apostle: Matthias

MANUSCRIPT

Bamberg: Lib., Staatsbibl., Bibl. 140
Apocalypse-Pericope, fol. 60r
Date: Early 11th cent.
Personification: Virtue, Obedience

Jerusalem: Lib., Greek Patriarchate,
 Taphou 51
Psalter, fol. 108v
Date: 12th–13th cent.
David: Rebuked by Nathan

London: Lib., British, Add. 40731
Bristol Psalter, fol. 82v
Date: First half 11th cent.
Psalm 51 (LXX, 50)

London: Pal., Lambeth, 209
De Quincey Apocalypse, fol. 53r
Date: Late 13th cent.
Allegory: Repentance

Melbourne: Gall., National, Felton
 710/5
Gospel Book, fol. 5v
Date: ca. 1100
Personification: Virtue, Exhortation

Oxford: Lib., Bodleian, 270b
Bible, Moralized, fol. 40r
Date: First half 13th cent.
*Moses and Daughters of Jethro:
 At Well*

Oxford: Lib., Bodleian, 270b
Bible, Moralized, fol. 53v
Date: First half 13th cent.
Moses: Instrument, Candelabrum

Paris: Lib., Bibl. de l'Arsenal, 5211
Bible, fol. 154v
Date: 13th cent.
David: Proclaimed King

Paris: Lib., Bibl. Nat. de France,
 gr. 139
Psalter, fol. 136v
Date: 10th cent.
Psalms: Illustration

Paris: Lib., Bibl. Nat. de France,
 lat. 18014
Hours, Duc de Berry, fol. 278v
Date: Late 14th cent.
Solomon: Throne

Strasbourg: Lib., Bibl. Municipale
Herradis of Landsberg, *Hort. Delic.*,
 fol. 67v
Date: Second half 12th cent.
Christ

Venice: Lib., Bibl. Marciana, gr. Z. 17
 (421)
Psalter, Basil II, fol. Bv
Date: 976–1025
David: Anointed

Vienna: Lib., Nationalbibl., Theol.
 gr. 31
Genesis, fol. 1v
Date: 5th–6th cent.
Adam and Eve: Reproved by God

RESOLUTION

MANUSCRIPT

Rome: Lib., Bibl. Vaticana, gr. 394
John Climacus, *Climax*, fol. 144r
Date: Late 11th cent.
John Climacus: Climax,
 Chapter XXVIII

REST

MANUSCRIPT

Strasbourg: Lib., Bibl. Municipale
Herradis of Landsberg, *Hort. Delic.*,
 fol. 204r
Date: Second half 12th cent.
Personification: Virtue, Mercy

REVERENCE

MANUSCRIPT

Strasbourg: Lib., Bibl. Municipale
Herradis of Landsberg, *Hort. Delic.*,
 fol. 200r
Date: Second half 12th cent.
Personification: Virtue, Humility

RIGHTEOUSNESS

MANUSCRIPT

Rome: Lib., Bibl. Vaticana, Ottob.
 lat. 74
Lectionary, Henry II, fol. 193v
Date: 11th cent.
Henry II

SECURITY

FRESCO

Siena: Pal., Pubblico
Room, Pace
Attribution: Ambrogio Lorenzetti
Date: 1338–1339
Personification: Virtue, Justice

MANUSCRIPT

Florence: Lib., Bibl. Laurenziana, Plut.
 XLII.19
Brunetto Latini, *Tesoro*, fol. 60v
Date: 14th cent.
Personification: Death

SEVERITY

GLASS

Esslingen: Ch., Dionysius
Windows, choir
Date: Late 13th–14th cent.
Isaiah

MANUSCRIPT

Strasbourg: Lib., Bibl. Municipale
Herradis of Landsberg, *Hort. Delic.*,
 fol. 202r
Date: Second half 12th cent.
Personification: Virtue, Prudence

SHAMEFACEDNESS

FRESCO

Gurk: Cath., Maria Himmelfahrt
Gallery, west
Date: 13th cent.
Virgin Mary and Christ Child

MANUSCRIPT

Paris: Lib., Bibl. Nat. de France,
 fr. 9220
Verger de Solas, fol. 2r
Date: 13th–14th cent.
Solomon: Throne

PAINTING

Berlin: Mus., Staatliche
Panel (1844)
Date: ca. 1360–1370
Fulgentius of Ruspe

SILENCE

GLASS

Niederhaslach: Ch., Florentius
Windows, nave
Date: 1290–1420
Christ: Parable, Prodigal Son

MANUSCRIPT

Rome: Lib., Bibl. Vaticana, gr. 394
John Climacus, *Climax*, fol. 54v
Date: Late 11th cent.
John Climacus: Climax, Chapter VI

Rome: Lib., Bibl. Vaticana, gr. 394
John Climacus, *Climax*, fol. 71r
Date: Late 11th cent.
John Climacus: Climax, Chapter XI

SIMPLICITY

MANUSCRIPT

Melbourne: Gall., National, Felton
 710/5
Gospel Book, fol. 6v
Date: ca. 1100
Personification: Virtue, Faith

Oxford: Lib., Bodleian, 270b
Bible, Moralized, fol. 57v
Date: First half 13th cent.
Moses: Teaching

Rome: Lib., Bibl. Vaticana, gr. 394
John Climacus, *Climax*, fol. 107r
Date: Late 11th cent.
*John Climacus: Climax, Chapter
 XXIII, Part 2*

Vienna: Lib., Nationalbibl., 1179
Bible, Moralized, fol. 43r
Date: ca. 1215–1230
Moses: Law, Offering of Herd

Vienna: Lib., Nationalbibl., 2554
Bible, Moralized, fol. 27r
Date: ca. 1215–1230
Moses: Law, Offering of Herd

SOBRIETY

ENAMEL

Florence: Mus., Naz. di Bargello
Crozier (Carrand 622)
Date: ca. 1185–1200
David: Slaying Bear

Klosterneuberg: Monastery
Retable
Date: 1322–1331
Abraham: Entertaining the Angels

Troyes: Cath., Pierre, Treasury
Casket
Date: ca. 1200
Personification: Virtue, Faith

GLASS

Mulhouse: Ch., Etienne
Windows
Date: First half 14th cent.

Strasbourg: Cath., Notre Dame
Windows, southern transept
Date: 13th cent.
Apostle: Matthias

IVORY

London: Lib., British
Plaques, in book cover (Egerton 1139)
Date: 1131–1143
David: Slaying Lion

MANUSCRIPT

Brussels: Lib., Bibl. Royale, 9968-72
Prudentius, *Psychomachia*, fol. 96r
Date: 11th cent.
Personification: Vice, Luxury

Brussels: Lib., Bibl. Royale, 9968-72
Prudentius, *Psychomachia*, fol. 96v
Date: 11th cent.

Brussels: Lib., Bibl. Royale, 9987-91
Prudentius, *Psychomachia*, fol. 110v
Date: 10th cent.

Brussels: Lib., Bibl. Royale, 9987-91
Prudentius, *Psychomachia*, fol. 111v
Date: 10th cent.

Brussels: Lib., Bibl. Royale, 9987-91
Prudentius, *Psychomachia*, fol. 112r
Date: 10th cent.

Brussels: Lib., Bibl. Royale, 9987-91
Prudentius, *Psychomachia*, fol. 113r
Date: 10th cent.
Personification: Vice, Pleasure

Brussels: Lib., Bibl. Royale, 10066-77
Prudentius, *Psychomachia*, fol. 126r
Date: 10th–first half 11th cent.

Cambridge: Lib., Corpus Christi
College, 23
Prudentius, *Psychomachia*, fol. 21v
Date: Early 11th cent.

Cambridge: Lib., Corpus Christi
College, 23
Prudentius, *Psychomachia*, fol. 23r
Date: Early 11th cent.

Cambridge: Lib., Corpus Christi
College, 23
Prudentius, *Psychomachia*, fol. 23v
Date: Early 11th cent.

Cambridge: Lib., Corpus Christi
College, 23
Prudentius, *Psychomachia*, fol. 24r
Date: Early 11th cent.

Cambridge: Lib., Corpus Christi
College, 23
Prudentius, *Psychomachia*, fol. 25v
Date: Early 11th cent.

Ghent: Lib., Bibl. de l'Université, 92
Lambertus, *Liber Floridus*, fol. 231v
Date: 1120
Tree of Virtues

Leiden: Lib., Bibl. der Univ., Burm. Q.3
Prudentius, *Psychomachia*, fol. 133v
Date: Second quarter 9th cent.

Leiden: Lib., Bibl. der Univ., Burm. Q.3
Prudentius, *Psychomachia*, fol. 134v
Date: Second quarter 9th cent.

Leiden: Lib., Bibl. der Univ., Burm. Q.3
Prudentius, *Psychomachia*, fol. 135r
Date: Second quarter 9th cent.

Leiden: Lib., Bibl. der Univ., Burm. Q.3
Prudentius, *Psychomachia*, fol. 136r
Date: Second quarter 9th cent.
Personification: Vice, Pleasure

Leiden: Lib., Bibl. der Univ., Voss.
 lat. oct. 15
Prudentius, *Psychomachia*, fol. 40r
Date: Early 11th cent.
Personification: Vice, Luxury

Leiden: Lib., Bibl. der Univ., Voss.
 lat. oct. 15
Prudentius, *Psychomachia*, fol. 40v
Date: Early 11th cent.
Personification: Vice, Luxury

London: Lib., British, Add. 24199
Prudentius, *Psychomachia*, fol. 18v
Date: Early 11th cent.

London: Lib., British, Add. 24199
Prudentius, *Psychomachia*, fol. 19v
Date: Early 11th cent.

London: Lib., British, Add. 24199
Prudentius, *Psychomachia*, fol. 20r
Date: Early 11th cent.
Personification: Vice, Luxury

London: Lib., British, Add. 24199
Prudentius, *Psychomachia*, fol. 20v
Date: Early 11th cent.

London: Lib., British, Add. 24199
Prudentius, *Psychomachia*, fol. 22v
Date: Early 11th cent.

London: Lib., British, Add. 28162
Somme le Roi, fol. 10v
Date: ca. 1300

London: Lib., British, Add. 38120
G. de Degulleville, *Pèlerinage*,
 fol. 103r
Date: ca. 1400
*Guillaume de Degulleville: Pèlerinage
 de Vie Humaine*

London: Lib., British, Add. 54180
Somme le Roi, fol. 188v
Date: ca. 1300

London: Lib., British, Cott. Cleo.
 C.VIII
Prudentius, *Psychomachia*, fol. 16v
Date: Early 11th cent.

London: Lib., British, Cott. Cleo.
 C.VIII
Prudentius, *Psychomachia*, fol. 18v
Date: Early 11th cent.
Personification: Vice, Luxury

London: Lib., British, Cott. Cleo.
 C.VIII
Prudentius, *Psychomachia*, fol. 19r
Date: Early 11th cent.

London: Lib., British, Cott. Cleo.
 C.VIII
Prudentius, *Psychomachia*, fol. 20r
Date: Early 11th cent.
Personification: Vice, Pleasure

London: Lib., British, Cott. Titus
 D.XVI
Prudentius, *Psychomachia*, fol. 17v
Date: ca. 1100

London: Lib., British, Cott. Titus
 D.XVI
Prudentius, *Psychomachia*, fol. 19r
Date: ca. 1100

London: Lib., British, Cott. Titus
 D.XVI
Prudentius, *Psychomachia*, fol. 19v
Date: ca. 1100

Lyons: Lib., Bibl. Municipale, Pal. des
 Arts 22
Prudentius, *Psychomachia*, fol. 14r
Date: Last quarter 11th cent.

Lyons: Lib., Bibl. Municipale, Pal. des
　　Arts 22
Prudentius, *Psychomachia*, fol. 17r
Date: Last quarter 11th cent.

Milan: Lib., Bibl. Ambrosiana,
　　H.106 sup.
Somme le Roi, fol. LXXXIIIr
Date: ca. 1300

Munich: Lib., Staatsbibl., Clm. 13002
Miscellany, fol. 4r
Date: 1158–1165
Joseph: Brethren Begging Forgiveness

Munich: Lib., Staatsbibl., Clm. 30055
Gospel Book, Henry the Lion, fol. 17r
Date: ca. 1175
Evangelist: Mark

Nuremberg: Mus., Germ. Nat. Bibl.,
　　156142
Gospel Book, Echternach, fol. 114r
Date: 10th–11th cent.
Personification: Virtue, Virginity

Paris: Lib., Bibl. Mazarine, 870
Somme le Roi, fol. 179r
Date: 1295

Paris: Lib., Bibl. Nat. de France,
　　lat. 8085
Prudentius, *Psychomachia*, fol. 62r
Date: Late 9th cent.
Personification: Vice, Luxury

Paris: Lib., Bibl. Nat. de France,
　　lat. 8085
Prudentius, *Psychomachia*, fol. 62v
Date: Late 9th cent.

Paris: Lib., Bibl. Nat. de France,
　　lat. 8085
Prudentius, *Psychomachia*, fol. 63r
Date: Late 9th cent.

Paris: Lib., Bibl. Nat. de France,
　　lat. 8085
Prudentius, *Psychomachia*, fol. 63v
Date: Late 9th cent.

Paris: Lib., Bibl. Nat. de France,
　　lat. 8318
Prudentius, *Psychomachia*, fol. 54v
Date: Late 10th cent.
Personification: Vice, Idleness

Paris: Lib., Bibl. Nat. de France,
　　lat. 8318
Prudentius, *Psychomachia*, fol. 58r
Date: Late 10th cent.
Personification: Vice, Luxury

Paris: Lib., Bibl. Nat. de France,
　　lat. 8318
Prudentius, *Psychomachia*, fol. 58v
Date: Late 10th cent.
Personification: Vice, Profane Love

Paris: Lib., Bibl. Nat. de France,
　　lat. 15158
Prudentius, *Psychomachia*, fol. 48r
Date: 1289

Paris: Lib., Bibl. Nat. de France,
　　lat. 15158
Prudentius, *Psychomachia*, fol. 49v
Date: 1289

Saint Gall: Lib., Stiftsbibl., 135
Prudentius, *Psychomachia*, p. 411
Date: First half 11th cent.

Strasbourg: Lib., Bibl. Municipale
Herradis of Landsberg, *Hort. Delic.*,
　　fol. 67v
Date: Second half 12th cent.
Christ

Strasbourg: Lib., Bibl. Municipale
Herradis of Landsberg, *Hort. Delic.*,
　　fol. 201r
Date: Second half 12th cent.
Personification: Virtue, Patience

Valenciennes: Lib., Bibl. Municipale,
　　563
Prudentius, *Psychomachia*, fol. 19v
Date: Early 11th cent.

Valenciennes: Lib., Bibl. Municipale,
　　563
Prudentius, *Psychomachia*, fol. 21r
Date: Early 11th cent.

Valenciennes: Lib., Bibl. Municipale,
563
Prudentius, *Psychomachia*, fol. 21v
Date: Early 11th cent.

Valenciennes: Lib., Bibl. Municipale,
563
Prudentius, *Psychomachia*, fol. 22r
Date: Early 11th cent.

Valenciennes: Lib., Bibl. Municipale,
563
Prudentius, *Psychomachia*, fol. 23v
Date: Early 11th cent.

Wolfenbüttel: Lib., Herzog August
Bibl., Guelf. 105 Noviss. 2°
Gospel Book, Henry the Lion, fol. 17r
Date: ca. 1175
Evangelist: Mark

METALWORK

Berlin: Mus., Staatliche
Bowl, bronze (I.3136)
Date: 13th cent.
Personification: Virtue, Humility

Cologne: Cathedral, Treasury
Casket, of Three Kings
Date: 1190–1225
Christ: Last Judgment

Hannover: Mus., Kestner
Bowl, bronze-gilt (1894.18)
Date: 12th cent.
Personification: Virtue, Humility

Hildesheim: Cath., Maria
Chandelier, of Hezilo
Date: ca. 1055–1065
Building: City Wall

Salzburg: Mus., Dom
Bowl, bronze
Date: 12th cent.
Personification: Virtue, Humility

Wrocław: Mus., Archeologiczne
Bowl, bronze
Date: Late 11th–12th cent.
Personification: Virtue, Humility

SCULPTURE

Ivry-la-Bataille: Ch., Abbey
Exterior, west
Date: 12th cent.
Angel

Laon: Cath., Notre Dame
Exterior, west
Date: ca. 1180–1210
Magi: Adoration

Salisbury: Cathedral, Chapter House
Decoration, vestibule
Date: ca. 1260–1280
*Personification: Virtues and Vices,
Conflict*

SOLITUDE

FRESCO

Gurk: Cath., Maria Himmelfahrt
Gallery, west
Date: 13th cent.
Virgin Mary and Christ Child

MANUSCRIPT

Paris: Lib., Bibl. Nat. de France,
fr. 9220
Verger de Solas, fol. 2r
Date: 13th–14th cent.
Solomon: Throne

Soissons: Coll., Grand Séminaire
Gautier de Coincy, *Miracles N.D.*,
　　fol. Ar
Date: 14th cent.
Virgin Mary and Christ Child

PAINTING

Stuttgart: Gall., Staatl. Gemäldegalerie
Panel (1140)
Date: ca. 1335
Solomon: Throne

STABILITY

MANUSCRIPT

Strasbourg: Lib., Bibl. Municipale
Herradis of Landsberg, *Hort. Delic.*,
　　fol. 204r
Date: Second half 12th cent.
Personification: Virtue, Mercy

SUFFERING

MANUSCRIPT

Strasbourg: Lib., Bibl. Municipale
Herradis of Landsberg, *Hort. Delic.*,
　　fol. 201r
Date: Second half 12th cent.
Personification: Virtue, Patience

TEMPERANCE

ENAMEL

Brussels: Mus., Royaux d'Art et
　　d'Histoire
Plaque, from reliquary (3141)
Date: ca. 1170
Personification: Virtue, Fortitude

Cologne: Mus., Schnütgen
Plaque
Date: ca. 1160

Darmstadt: Mus., Hessisches
　　Landesmus.
Plaque, copper-gilt (Kg 54:246c)
Date: ca. 1170
Ecclesiasticus: Illustration

Klosterneuberg: Monastery
Retable
Attribution: Nicolas of Verdun
Date: 1181
Abraham: Entertaining the Angels

Langres: Museum
Plaques, on reliquary
Date: Third quarter 12th cent.
Personification: Virtue, Fortitude

Liège: Mus., Curtius
Book cover (12/1)
Date: ca. 1160–1170
Personification: River of Paradise

Saint-Ghislain: Church
Casket, reliquary
Date: Mid-12th cent.
Personification: Virtue, Patience

Saint Petersburg: Mus., Hermitage
Plaque (Ø 1426)
Date: Second half 12th cent.

Vienna: Mus., Erzbischöfliches
 Dommuseum
Plaques (L 3)
Date: Late 12th cent.
Abraham: Sacrificing Isaac

FRESCO

Cologne: Ch., Maria Lyskirchen
Nave
Date: 13th cent.
Daniel?

Florence: Ch., Croce
Chapel, Baroncelli, back wall
Attribution: Taddeo Gaddi
Date: ca. 1328–1330
Joachim: Offerings Rejected

Florence: Ch., Croce
Sacristy
Date: Late 14th cent.
Christ: Ascension

Padua: Chap., Madonna dell'Arena
Decoration
Attribution: Giotto
Date: ca. 1303–1308
Joachim: Offerings Rejected

Pisa: Ch., Francesco
Choir
Date: 1342
Francis of Assisi

Pistoia: Cath., Zenone
Nave
Date: 1347
Personification: Virtue, Prudence

Siena: Ch., Francesco
Chapel, Bandini Piccolomini
Date: First half 14th cent.
Louis of Toulouse: Scene

Siena: Pal., Pubblico
Room, Pace
Attribution: Ambrogio Lorenzetti
Date: 1338–1339
Personification: Virtue, Justice

Summaga: Ch., Maria Assunta
Decoration
Date: 11th cent.
Virgin Mary and Christ Child

Tolentino: Ch., Nicola da Tolentino
Chapel, S. Nicola
Date: 13th–14th cent.
Evangelist: Symbol

GLASS

Esslingen: Ch., Dionysius
Windows, choir
Date: Late 13th–14th cent.
Isaiah

Strasbourg: Cath., Notre Dame
Windows, nave
Date: 14th cent.
Personification: Virtue, Wisdom

IVORY

New York: Mus., Metropolitan
Crozier, handle
Date: 13th cent.

MANUSCRIPT

Admont: Lib., Stiftsbibl., lat. 128
Miscellany, fol. 13r
Date: Mid-13th cent.
Personification: Ethics

Brussels: Lib., Bibl. Royale, 9505-6
Aristotle, *Ethiques*, fol. 39r
Date: 1372
Personification: Virtue, Fortitude

Florence: Lib., Bibl. Naz. Centrale,
 Banco Rari 397
Hours, Giangaleazzo Visconti, fol
 108v
Attribution: Giovannino and
 Salomone dei Grassi
Date: ca. 1389–1391
Psalm 116 (Vulgate, 114)

Malines: Lib., Grand Séminaire
Bible, Nicolò de Alifio, p. 1
Date: Mid-14th cent.
Robert of Anjou

Melbourne: Gall., National, Felton
 710/5
Gospel Book, fol. 4r
Date: ca. 1100
Personification: Virtue, Prudence

Mount Athos: Mon., Stauronikita, 50
John Climacus, *Climax*, fol. 109r
Date: 13th–14th cent.
John Climacus: Climax, Chapter XV

Munich: Lib., Staatsbibl., Clm. 30055
Gospel Book, Henry the Lion, fol. 14v
Date: ca. 1175
Apostle: Bartholomew

Munich: Lib., Staatsbibl., gall. 30
G. de Degulleville, *Pèlerinage*, fol. 95v
Date: 14th cent.
Guillaume de Degulleville: Pèlerinage
 de Vie Humaine

Munich: Mus., Staatl. Graphische
 Samml., 39789
Miniature
Date: 12th cent.
Christ: Sermon on Mount

Paris: Lib., Bibl. Nat. de France,
 lat. 10483–84
Breviary, Belleville, II, fol. 40r
Date: First half 14th cent.
Psalm 81 (Vulgate, 80)

Paris: Lib., Bibl. Nat. de France,
 lat. 10483–84
Breviary, Belleville, II, fol. 45v
Date: First half 14th cent.
Psalm 81 (Vulgate, 80)

Rome: Gall., Naz. d'Arte Antica
Bartolomeo di Bartoli, *Canzone*, fol. 4r
Date: 14th cent.

Rome: Lib., Bibl. Vaticana, gr. 394
John Climacus, *Climax*, fol. 78v
Date: Late 11th cent.
John Climacus: Climax, Chapter XIV

Salzburg: Lib., Studienbibl., V 1 H 162
Miscellany, fol. 76r
Date: First half 12th cent.
Tree of Virtues

Strasbourg: Lib., Bibl. Municipale
Herradis of Landsberg, *Hort. Delic.*,
 fol. 200r
Date: Second half 12th cent.
Personification: Virtue, Humility

Strasbourg: Lib., Bibl. Municipale
Herradis of Landsberg, *Hort. Delic.*,
 fol. 202v
Date: Second half 12th cent.

Valenciennes: Lib., Bibl. Municipale,
 512
Miscellany, fol. 4v
Date: 12th cent.
Gregory the Great

Vienna: Lib., Nationalbibl., Ser. Nov.
 2639
Convenevoli de Pratis(?), *Poemata*,
 fol. 1v
Date: Early 14th cent.

Wolfenbüttel: Lib., Herzog August
 Bibl., Guelf. 105 Noviss. 2°
Gospel Book, Henry the Lion, fol. 14v
Date: ca. 1175
Apostle: Bartholomew

METALWORK

Cologne: Cathedral, Treasury
Casket, of Three Kings
Date: 1190–1225
Christ: Last Judgment

Florence: Baptistery
Door, south, bronze
Attribution: Andrea Pisano
Date: 1330
Zacharias: Annunciation

Hildesheim: Cath., Maria
Chandelier, of Hezilo
Date: ca. 1055–1065
Building: City Wall

Verona: Ch., Zeno
Door, bronze
Date: Second–fourth quarter 12th cent.
Virgin Mary: Annunciation

MISCELLANEOUS

Berlin: Mus., Staatl., Kupferstichkab.
Drawing (61)
Attribution: Giovanni da Milano
Date: ca. 1365–1370
Christ: Crucifixion

MOSAIC

Reims: Ch., Remi
Choir
Date: After 1090
David: As Musician

PAINTING

Florence: Ch., Croce
Polyptych
Attribution: Giovanni del Biondo
Date: 1379
Virgin Mary and Christ Child

Greenwich: Coll., Hyland
Panel
Date: 14th cent.
Virgin Mary and Christ Child

New York: Coll., Wildenstein
Panel
Date: 14th cent.
Virgin Mary and Christ Child

Rome: Mus., Vaticani, Pinacoteca
Panel (40520)
Date: ca. 1375–1380
Virgin Mary

SCULPTURE

Bamberg: Cath., Peter und Georg
Tomb of Clement II
Date: ca. 1220–1240
Clement II, Pope: Scene

Chartres: Cath., Notre Dame
Exterior, north, central portal
Date: 1205–1210
Virgin Mary: Coronation

Chartres: Cath., Notre Dame
Exterior, north, left portal
Date: ca. 1220
Virgins, Foolish

Chartres: Cath., Notre Dame
Porch, south
Date: ca. 1230–1240
Saint

Florence: Cath., Maria del Fiore
Exterior, north
Attribution: Niccolò di Pietro
 Lamberti and Jacopo di Piero Guidi
Date: Late 14th cent.
Prophet

Florence: Ch., Orsanmichele
Tabernacle, marble
Attribution: Orcagna
Date: 1359–1360
Angel: Archangel Michael

Florence: Loggia del Bigallo
Exterior, east and north
Date: 1352–1358
Christ: Of Sorrows

Florence: Mus., Opera del Duomo
Statues
Date: 14th cent.
Figure: Female

Naples: Ch., Chiara
Tomb of Robert of Anjou
Attribution: Pacio and Giovanni
 Bertini da Firenze
Date: ca. 1343
Robert of Anjou

Salisbury: Cathedral, Chapter House
Decoration, vestibule
Date: ca. 1260–1280
Personification: Virtues and Vices,
 Conflict

Siena: Cath., Assunta
Exterior, south
Date: 13th–14th cent.
Miriam

Siena: Cath., Assunta
Pulpit
Attribution: Nicola Pisano
Date: ca. 1265–1269
Virgin Mary: Visitation

Southrop: Church
Font
Date: ca. 1160
Personification: Church and
 Synagogue

Stanton Fitzwarren: Church
Font
Date: ca. 1160
Personification: Church

Strzelno: Ch., Trinity
Nave, column
Date: Last quarter 12th cent.
Christ: Baptism

Tournai: Cath., Notre Dame
Reliefs
Date: ca. 1140–1170
Zodiac Sign!

Venice: Ch., Frari
Tomb of Duccio degli Alberti
Date: 1336
Lamb of God

Venice: Ch., Giovanni e Paolo
Tomb of Antonio Venier
Attribution: Jacobello and Pierpaolo
 delle Masegne
Date: 1370–1420
Antonio Venier

Venice: Ch., Marco
Exterior, west
Date: 13th cent.
Christ

Volvic: Ch., Priest
Choir, capital
Date: 12th cent.

TEXTILE

Quedlinburg: Church, Treasury
Hanging, tapestry
Date: 1186–1203
Personification: Virtue, Charity

TOLERANCE

MANUSCRIPT

Strasbourg: Lib., Bibl. Municipale
Herradis of Landsberg, *Hort. Delic.*,
 fol. 204r
Date: Second half 12th cent.
Personification: Virtue, Mercy

TRANQUILITY

MANUSCRIPT

Mount Athos: Mon., Stauronikita, 50
John Climacus, *Climax*, fol. 109r
Date: 13th–14th cent.
John Climacus: Climax, Chapter XV

Rome: Lib., Bibl. Vaticana, gr. 394
John Climacus, *Climax*, fol. 78v
Date: Late 11th cent.
John Climacus: Climax, Chapter XIV

Rome: Lib., Bibl. Vaticana, gr. 394
John Climacus, *Climax*, fol. 149v
Date: Late 11th cent.
John Climacus: Climax,
 Chapter XXIX

Rome: Lib., Bibl. Vaticana, gr. 394
John Climacus, *Climax*, fol. 151v
Date: Late 11th cent.
John Climacus: Climax,
 Chapter XXIX

TRUTH

ENAMEL

Brussels: Mus., Royaux d'Art et
 d'Histoire
Reliquary, Valentinus of Maastricht
 (1038)
Date: ca. 1160–1170
Personification: Virtue, Hope

Budapest: Mus., Magyar Nemzeti
 Múzeum
Crown of Constantine IX
 Monomachos
Date: 1042–1050
Constantine Monomacus

Klosterneuberg: Monastery
Retable
Attribution: Nicolas of Verdun
Date: 1181
Abraham: Entertaining the Angels

New York: Mus., Metropolitan,
 Cloisters
Triptych, reliquary (L. 1979.143)
Date: ca. 1160
Christ: Last Judgment

Troyes: Cath., Pierre, Treasury
Casket
Date: ca. 1200
Personification: Virtue, Faith

FRESCO

Brixen: Ch., Johannes
Decoration
Date: 13th cent.
*Christopher of Lycia: Carrying Christ
Child*

London: Pal., Westminster
Painted Chamber
Date: Late 13th cent.
Maccabees: Battle

Peterborough: Cath., Peter, Paul, and
Andrew
Decoration, on choir screen
Date: 12th cent.
Isaiah

Purgg: Ch., Johannis
Decoration
Date: 12th–13th cent.
Cain and Abel: Bringing Offerings

Worcester: Cathedral, Chapter House
Decoration
Date: 13th cent.?
Christ: Nativity

GLASS

Canterbury: Cath., Christ
Windows, choir
Date: 1180–1220
Moses: Burning Bush

Esslingen: Ch., Dionysius
Windows, choir
Date: Late 13th–14th cent.
Isaiah

Wienhausen: Convent
Windows
Date: 1330–1340
Christ: Entry into Jerusalem

MANUSCRIPT

Brussels: Lib., Bibl. Royale, 9961-2
Psalter, fol. 10r
Date: 13th cent.
Jeremiah

Cambridge: Lib., Trinity College,
R.17.1
Psalter, Canterbury, fol. 70r
Date: ca. 1145–1170
Psalm 40 (Vulgate, 39)

Cambridge: Lib., Trinity College,
R.17.1
Psalter, Canterbury, fol. 75r
Date: ca. 1145–1170
Psalm 43 (Vulgate, 42)

Cambridge: Lib., Trinity College,
R.17.1
Psalter, Canterbury, fol. 78v
Date: ca. 1145–1170
Psalm 45 (Vulgate, 44)

Cambridge: Lib., Trinity College,
R.17.1
Psalter, Canterbury, fol. 150v
Date: ca. 1145–1170
Psalm 85 (Vulgate, 84)

Cambridge: Lib., Trinity College,
R.17.1
Psalter, Canterbury, fol. 156v
Date: ca. 1145–1170
Psalm 89 (Vulgate, 88)

Cambridge: Lib., Trinity College,
R.17.1
Psalter, Canterbury, fol. 164v
Date: ca. 1145–1170
Psalm 92 (Vulgate, 91)

Cambridge: Lib., Trinity College,
R.17.1
Psalter, Canterbury, fol. 207v
Date: ca. 1145–1170
Psalm 117 (Vulgate, 116)

Cambridge: Lib., Trinity College,
R.17.1
Psalter, Canterbury, fol. 244v
Date: ca. 1145–1170
Psalm 138 (Vulgate, 137)

Cleveland: Museum of Art, 33.445
Miniature, recto
Date: Late 12th cent.
Christ: Nativity

Hildesheim: Ch., Godehard, Treasury
Psalter of S. Albans, fol. 91r
Date: Early 12th cent.
Psalm 57 (Vulgate, 56)

London: Lib., British, Harley 603
Psalter, fol. 23r
Date: ca. 1000–12th cent.
Psalm 40 (Vulgate, 39)

London: Lib., British, Harley 603
Psalter, fol. 25r
Date: ca. 1000–12th cent.
Psalm 43 (Vulgate, 42)

London: Lib., British, Harley 603
Psalter, fol. 26r
Date: ca. 1000–12th cent.
Psalm 45 (Vulgate, 44)

London: Pal., Lambeth, 3
Bible, I, fol. 198r
Date: Mid-12th cent.
Jesse: Tree

Madrid: Lib., Bibl. Nacional, 6422
Psalter, fol. 7r
Date: ca. 1250–1260
Psalm

Munich: Lib., Staatsbibl., Clm. 30055
Gospel Book, Henry the Lion,
 fol. 110v
Date: ca. 1175
Virgin Mary: Annunciation

Paris: Lib., Bibl. Nat. de France,
 Coislin gr. 79
John Chrysostom, *Homilies*, fol. 2r
Date: ca. 1078
Nicephorus III

Paris: Lib., Bibl. Nat. de France,
 ital. 115
Pseudo-Bonaventura, *Medit.*, fol. 4r
Date: 14th cent.
Christ: In Mandorla

Paris: Lib., Bibl. Nat. de France,
 lat. 819
Sacramentary, S. Bertin, fol. 13r
Date: 11th cent.
Psalm 85 (Vulgate, 84)

Paris: Lib., Bibl. Nat. de France,
 lat. 6734
Honorius of Autun, *Clavis Physicae*,
 fol. 3v
Date: 12th cent.
Personification: Virtue, Goodness

Paris: Lib., Bibl. Sainte-Geneviève,
 1130
G. de Degulleville, *Pèlerinage*,
 fol. 104r
Date: Second half 14th cent.
Personification: Virtue, Justice

Rome: Lib., Bibl. Vaticana, gr. 1927
Psalter, fol. 156r
Date: 11th–12th cent.
Psalm 85 (LXX, 84)

Rome: Lib., Bibl. Vaticana, Reg. lat. 12
Psalter, fol. 92r
Date: Early 11th cent.
Psalm 85 (Vulgate, 84)

Strasbourg: Lib., Bibl. Municipale
Herradis of Landsberg, *Hort. Delic.*,
 fol. 202r
Date: Second half 12th cent.
Personification: Virtue, Prudence

Stuttgart: Lib., Landesbibl., Bibl.
 fol. 20
Missal, fol. 80v
Date: 12th cent.
Christ: Nativity

Utrecht: Lib., Bibl. der Universiteit, 32
Psalter, fol. 23r
Date: ca. 820–830
Psalm 40 (Vulgate, 38)

Utrecht: Lib., Bibl. der Universiteit, 32
Psalter, fol. 25r
Date: ca. 820–830
Psalm 43 (Vulgate, 42)

Utrecht: Lib., Bibl. der Universiteit, 32
Psalter, fol. 26r
Date: ca. 820–830
Psalm 45 (Vulgate, 44)

Utrecht: Lib., Bibl. der Universiteit, 32
Psalter, fol. 49v
Date: ca. 820–830
Psalm 85 (Vulgate, 84)

Utrecht: Lib., Bibl. der Universiteit, 32
Psalter, fol. 51v
Date: ca. 820–830
Psalm 89 (Vulgate, 88)

Utrecht: Lib., Bibl. der Universiteit, 32
Psalter, fol. 54r
Date: ca. 820–830
Psalm 93 (Vulgate, 92)

Utrecht: Lib., Bibl. der Universiteit, 32
Psalter, fol. 67v
Date: ca. 820–830
Psalm 117 (Vulgate, 116)

Utrecht: Lib., Bibl. der Universiteit, 32
Psalter, fol. 77v
Date: ca. 820–830
Psalm 138 (Vulgate, 137)

Venice: Lib., Bibl. Marciana, gr. Z. 540
(557)
Gospel Book, fol. 6v
Date: Early 12th cent.

Wiesbaden: Lib., Hessische
Landesbibl., I
Hildegardis, *Liber Scivias*, fol. 161v
Date: ca. 1165
Hildegardis of Bingen: Vision

Wolfenbüttel: Lib., Herzog August
Bibl., Guelf. 105 Noviss. 2°
Gospel Book, Henry the Lion,
fol. 110v
Date: ca. 1175
Virgin Mary: Annunciation

METALWORK

Hildesheim: Cath., Maria
Chandelier, of Hezilo
Date: ca. 1055–1065
Building: City Wall

Liège: Ch., Croix
Triptych, reliquary, copper-gilt
Date: ca. 1160–1170
Apostle: Peter

Maastricht: Cath., Servatius, Treasury
Casket, of Servatius
Date: ca. 1165
Christ: Last Judgment

Trier: Ch., Maximin
Font, of Folcardus
Date: Early 12th cent.
Personification: Virtue, Humility

PAINTING

Bad Doberan: Ch., Cistercian
Triptych
Date: First half 14th cent.
*Christ: Crucifixion, Nailed to Cross by
Virtues*

Stuttgart: Gall., Staatl. Gemäldegalerie
Panel (1140)
Date: ca. 1335
Solomon: Throne

SCULPTURE

Modena: Cath., Geminiano
Relief
Date: 12th cent.
Jacob: Wrestling with Angel

Venice: Ch., Marco
Exterior, west
Date: 13th cent.
Christ

TEXTILE

Augsburg: Ch., Ulric and Afra
Tapestries
Date: 12th cent.
Personification: New Testament

Bamberg: Cathedral, Treasury
Vestment, rational, embroidery
Date: 11th cent.
Apocalypse: Christ and Four Beasts

Regensburg: Cath., Peter, Treasury
Vestment, rational, embroidery
Date: 1314–1328
Apocalypse: Christ and Four Beasts

UNDERSTANDING

ENAMEL

Brussels: Mus., Royaux d'Art et
 d'Histoire
Reliquary, Alexander (1031)
Date: 1145
Eventius of Rome

MANUSCRIPT

Hague: Mus., Meermanno-
 Westreenianum, 10 D 1
Aristotle, *Ethiques*, fol. 110r
Date: 1376
Personification: Virtue, Knowledge

Strasbourg: Lib., Bibl. Municipale
Herradis of Landsberg, *Hort. Delic.*,
 fol. 202r
Date: Second half 12th cent.
Personification: Virtue, Prudence

VICTORY

MANUSCRIPT

New York: Lib., Morgan, Pierpont,
 M.333
Gospel Book, fol. 51r
Date: Early 11th cent.
Zacharias: Annunciation

Wiesbaden: Lib., Hessische
 Landesbibl., I
Hildegardis, *Liber Scivias*, fol. 138v
Date: ca. 1165
Hildegardis of Bingen: Vision

Wiesbaden: Lib., Hessische
 Landesbibl., I
Hildegardis, *Liber Scivias*, fol. 139r
Date: ca. 1165
Hildegardis of Bingen: Vision

VIRGINITY

ENAMEL

Cleveland: Museum of Art
Pendant, reliquary (26.428)
Date: ca. 1160
Virgin Mary and Christ Child

FRESCO

Gurk: Cath., Maria Himmelfahrt
Gallery, west
Date: 13th cent.
Virgin Mary and Christ Child

MANUSCRIPT

Nuremberg: Mus., Germ. Nat. Bibl.,
 156142
Gospel Book, Echternach, fol. 114r
Date: 10th–11th cent.

Paris: Lib., Bibl. Nat. de France,
 fr. 9220
Verger de Solas, fol. 2r
Date: 13th–14th cent.
Solomon: Throne

Soissons: Coll., Grand Séminaire
Gautier de Coincy, *Miracles N.D.*,
 fol. Ar
Date: 14th cent.
Virgin Mary and Christ Child

Wiesbaden: Lib., Hessische
 Landesbibl., I
Hildegardis, *Liber Scivias*, fol. 66r
Date: ca. 1165
Hildegardis of Bingen: Vision

METALWORK

New York: Lib., Morgan, Pierpont
Book cover (710)
Date: Early 13th cent.
Virgin Mary and Christ Child

PAINTING

Berlin: Mus., Staatliche
Panel (1844)
Date: ca. 1360–1370
Gregory the Great

Stuttgart: Gall., Staatl. Gemäldegalerie
Panel (1140)
Date: ca. 1335
Solomon: Throne

SCULPTURE

Florence: Ch., Orsanmichele
Tabernacle, marble
Attribution: Orcagna
Date: 1359–1360
Angel: Archangel Michael

WISDOM

ENAMEL

Brussels: Mus., Royaux d'Art et
 d'Histoire
Reliquary, Alexander (1031)
Date: 1145
Eventius of Rome

Darmstadt: Mus., Hessisches
 Landesmus.
Plaque, copper-gilt (Kg 54:246d)
Date: ca. 1170
Ecclesiasticus: Illustration

Klosterneuberg: Monastery
Retable
Attribution: Nicolas of Verdun
Date: 1181
Abraham: Entertaining the Angels

Osnabrück: Town Hall, Rathaus
Vessel
Date: First half 14th cent.
Personification: Virtue, Prudence

FRESCO

Brixen: Ch., Johannes
Decoration
Date: 13th cent.
*Christopher of Lycia: Carrying Christ
 Child*

Cairo: Mus., Coptic Museum, 8443
Date: 6th cent. or later

Pisa: Ch., Francesco
Choir
Date: 1342
Francis of Assisi

Qarabach Kilisse: Church
Chapel III
Date: Late 9th–10th cent.
Cross

Rome: Cem., Trebius Justus
Cubiculum
Date: 3rd–4th cent.
Scene: Occupational, Building

Saint Gall
Decoration
Date: 9th cent.
Christ

Siena: Ch., Francesco
Chapel, Bandini Piccolomini
Date: First half 14th cent.
Louis of Toulouse: Scene

Siena: Pal., Pubblico
Room, Pace
Attribution: Ambrogio Lorenzetti
Date: 1338–1339
Personification: Virtue, Justice

GLASS

Niederhaslach: Ch., Florentius
Windows, nave
Date: 1290–1420
Christ: Parable, Prodigal Son

Strasbourg: Cath., Notre Dame
Windows, nave
Date: 13th cent., 14th cent.

MANUSCRIPT

Admont: Lib., Stiftsbibl., lat. 128
Miscellany, fol. 13r
Date: Mid-13th cent.
Personification: Ethics

Admont: Lib., Stiftsbibl., lat. 549
Rupert, *Super Cant. Cant.*, fol. 4r
Date: Mid-12th cent.
Virgin Mary and Christ Child

Athens: Lib., National, 7
Psalter, fol. 1v
Date: 10th–12th cent.
Psalms: Illustration

Baltimore: Gall., Walters, W. 72
Speculum Virginum, fol. 73r
Date: First half 13th cent.
Speculum Virginum: Text

Bamberg: Lib., Staatsbibl., Bibl. 1
Bible, fol. 260v
Date: First half 9th cent.

Berlin: Lib., Staatsbibl., Theol. lat.
 fol. 379
Bible of Heisterbach, fol. 264v
Date: ca. 1240
Ecclesiasticus: Illustration

Berlin: Lib., Staatsbibl., Theol. lat.
 fol. 379
Bible of Heisterbach, fol. 275v
Date: ca. 1240
Ecclesiasticus: Illustration

Berne: Lib., Stadtbibl., 120 II
Peter of Eboli, *De Rebus Siculis*,
 fol. 140r
Date: 1195–1197

Berne: Lib., Stadtbibl., 120 II
Peter of Eboli, *De Rebus Siculis*,
 fol. 147r
Date: 1195–1197
Henry VI

Bordeaux: Lib., Bibl. Municipale, 1
Bible, fol. 301r
Date: Second half 11th cent.

Boulogne: Lib., Bibl. Municipale, 4
Bible, fol. 1r
Date: Second half 13th cent.
Ecclesiasticus: Illustration

Brussels: Lib., Bibl. Royale, 9505-6
Aristotle, *Ethiques*, fol. 115v
Date: 1372
Personification: Arts, Mechanical

Brussels: Lib., Bibl. Royale, 9987-91
Prudentius, *Psychomachia*, fol. 125v
Date: 10th cent.

Brussels: Lib., Bibl. Royale, 10066-77
Prudentius, *Psychomachia*, fol. 137v
Date: 10th–first half 11th cent.

Brussels: Lib., Bibl. Royale, 10066-77
Prudentius, *Psychomachia*, fol. 139v
Date: 10th–first half 11th cent.

Brussels: Lib., Bibl. Royale, II.2560
Libri Sapientiae, fol. 118r
Date: 13th cent.
Virgin Mary(?): Coronation

Cambrai: Lib., Bibl. Municipale,
 345, 346
Bible, II, fol. 30v
Date: 13th cent.
Ecclesiasticus: Illustration

Cambridge: Lib., Corpus Christi
 College, 23
Prudentius, *Psychomachia*, fol. 41r
Date: Early 11th cent.

Cambridge: Lib., Corpus Christi
 College, 66
Imago Mundi, p. 66
Date: 12th cent.
Wheel of Fortune

Cologne: Arch., Historisches, W 276a
Speculum Virginum, fol. 68r
Date: Mid-12th cent.
Speculum Virginum: Text

Dijon: Lib., Bibl. Communale, 2
Bible, S. Benigne, fol. 308v
Date: 11th–12th cent.

Erlangen: Lib., Universitätsbibl., 2
Bible, II, fol. 33v
Date: Second half 12th cent.

Erlangen: Lib., Universitätsbibl., 121
Gumpert Bible, fol. 129v
Date: Before 1195
Proverbs: Illustration

Erlangen: Lib., Universitätsbibl., 121
Gumpert Bible, fol. 136v
Date: Before 1195
Ecclesiasticus: Illustration

Erlangen: Lib., Universitätsbibl., 121
Gumpert Bible, fol. 141r
Date: Before 1195
Wisdom of Solomon: Illustration

Erlangen: Lib., Universitätsbibl., 121
Gumpert Bible, fol. 146v
Date: Before 1195
Ecclesiasticus: Illustration

Florence: Lib., Bibl. Laurenziana,
 Mugellano 2
Bible, fol. 189r
Date: 12th cent.

Hague: Mus., Meermanno-
 Westreenianum, 10 D 1
Aristotle, *Ethiques*, fol. 110r
Date: 1376
Personification: Virtue, Knowledge

Jerusalem: Lib., Greek Patriarchate,
 Taphou 53
Psalter, fol. 16v
Date: 1053–1054
David

Klosterneuberg: Lib., Stiftsbibl., 650 A
Bible, fol. 13r
Date: First half 14th cent.

Leiden: Lib., Bibl. der Univ., Burm. Q.3
Prudentius, *Psychomachia*, fol. 148v
Date: Second quarter 9th cent.

Leiden: Lib., Bibl. der Univ., Voss.
 lat. oct. 15
Prudentius, *Psychomachia*, fol. 43r
Date: Early 11th cent.
Personification: Virtue, Concord

London: Lib., British, Add. 10546
Bible, Moutier Grandval, fol. 262v
Date: 9th cent.

London: Lib., British, Add. 15452
Bible, fol. 233v
Date: Early 13th cent.

London: Lib., British, Add. 24199
Prudentius, *Psychomachia*, fol. 37r
Date: Early 11th cent.

London: Lib., British, Arundel 44
Speculum Virginum, fol. 83v
Date: ca. 1140–1150
Speculum Virginum: Text

London: Lib., British, Cott. Cleo.
 C.VIII
Prudentius, *Psychomachia*, fol. 33r
Date: Early 11th cent.

London: Lib., British, Cott. Titus
 D.XVI
Prudentius, *Psychomachia*, fol. 33v
Date: ca. 1100

London: Lib., British, Harley 2798-9
Bible, II, fol. 57v
Date: Late 12th cent.
Solomon

London: Lib., British, Yates Thompson
 11
Miscellany, fol. 1v
Date: ca. 1300
Christ and Four Beasts

Los Angeles: Mus., Getty, 64
Missal, Stammheim, fol. 11r
Date: 12th–13th cent.

Lucca: Lib., Bibl. Capitolare, P †
Passional, fol. 28v
Date: First half 12th cent.

Maihingen: Lib., Wallerstein, I.2.qu.3
Boethius, *De Consolatione
 Philosophiae*
Date: 10th cent.
Boethius

Melbourne: Gall., National, Felton
 710/5
Gospel Book, fol. 6r
Date: ca. 1100

Mount Athos: Mon., Kutlumusi, 283
Gospel Book, fol. 9v
Date: 14th cent.
Evangelist: Matthew

Munich: Lib., Staatsbibl., Clm. 14159
Dialogus Cruce Christi, fol. 6r
Date: ca. 1170–1185
Christ

Munich: Lib., Staatsbibl., Clm. 30055
Gospel Book, Henry the Lion, fol. 18v
Date: ca. 1175
John Baptist

New York: Lib., Morgan, Pierpont,
 M.791
Bible, fol. 288r
Date: ca. 1220
Proverbs: Illustration

Oxford: Lib., Bodleian, 270b
Bible, Moralized, fol. 57v
Date: First half 13th cent.
Moses: Teaching

Oxford: Lib., Bodleian, Auct. D.4.8
Bible, fol. 366v
Date: Third quarter 13th cent.
Wisdom of Solomon: Illustration

Oxford: Lib., Bodleian, Laud Misc. 752
Bible, fol. 265v
Date: Late 12th–early 13th cent.
Ecclesiasticus: Illustration

Oxford: Lib., Keble College, 49
Legendarium, fol. 7r
Date: ca. 1267–1276
*Christ: Crucifixion, Nailed to Cross
 by Virtues*

Paris: Lib., Bibl. Chambre des
 Députés, 2
Bible, fol. 200v
Date: First half 12th cent.

Paris: Lib., Bibl. de l'Arsenal, 5211
Bible, fol. 307v
Date: 13th cent.
Solomon

Paris: Lib., Bibl. Nat. de France, fr. 938
Somme le Roi, fol. 69r
Date: 13th cent.

Paris: Lib., Bibl. Nat. de France,
 gr. 139
Psalter, fol. 7v
Date: 10th cent.
Psalms: Illustration

Paris: Lib., Bibl. Nat. de France, lat. 6
Roda Bible, II, fol. 91r
Date: First half 11th cent.
Solomon

Paris: Lib., Bibl. Nat. de France, lat. 8
Bible, Martial of Limoges, II, fol. 74v
Date: Late 11th cent.
Ecclesiasticus: Illustration

Paris: Lib., Bibl. Nat. de France, lat. 10
Bible, fol. 215r
Date: Second half 12th cent.

Paris: Lib., Bibl. Nat. de France, lat. 15
Bible, fol. 253v
Date: First half 13th cent.
Wisdom of Solomon: Illustration

Paris: Lib., Bibl. Nat. de France,
 lat. 3110
Miscellany, fol. 60r
Date: Late 11th cent.

Paris: Lib., Bibl. Nat. de France,
 lat. 6734
Honorius of Autun, *Clavis Physicae*,
 fol. 3v
Date: 12th cent.
Personification: Virtue, Goodness

Paris: Lib., Bibl. Nat. de France,
 lat. 8085
Prudentius, *Psychomachia*, fol. 69v
Date: Late 9th cent.

Paris: Lib., Bibl. Nat. de France,
 lat. 11560
Bible, Moralized, fol. 40r
Date: First half 13th cent.
Solomon: Scene

Paris: Lib., Bibl. Nat. de France,
 lat. 11560
Bible, Moralized, fol. 42r
Date: First half 13th cent.
Solomon: Scene

Paris: Lib., Bibl. Nat. de France,
 lat. 11560
Bible, Moralized, fol. 43v
Date: First half 13th cent.
Proverbs: Illustration

Paris: Lib., Bibl. Nat. de France,
 lat. 11560
Bible, Moralized, fol. 46r
Date: First half 13th cent.
Proverbs: Illustration

Paris: Lib., Bibl. Nat. de France,
 lat. 11560
Bible, Moralized, fol. 47v
Date: First half 13th cent.
Proverbs: Illustration

Paris: Lib., Bibl. Nat. de France,
 lat. 11560
Bible, Moralized, fol. 50r
Date: First half 13th cent.
Proverbs: Illustration

Paris: Lib., Bibl. Nat. de France,
 lat. 11560
Bible, Moralized, fol. 93v
Date: First half 13th cent.
Song of Solomon: Illustration

Paris: Lib., Bibl. Nat. de France,
 lat. 13142
Bible, fol. 350r
Date: 13th cent.

Paris: Lib., Bibl. Nat. de France,
 lat. 15158
Prudentius, *Psychomachia*, fol. 63r
Date: 1289

Paris: Lib., Bibl. Nat. de France,
 lat. 16719-22
Bible, III, fol. 27r
Date: Mid-13th cent.
Wisdom of Solomon: Illustration

Paris: Lib., Bibl. Nat. de France,
 lat. 16719-22
Bible, III, fol. 39r
Date: Mid-13th cent.
Ecclesiasticus: Illustration

Paris: Lib., Bibl. Nat. de France,
 syr. 341
Bible, fol. 118r
Date: 7th–8th cent.
Virgin Mary and Christ Child

Paris: Lib., Bibl. Sainte-Geneviève,
8-10
Bible, II, fol. 262r
Date: Late 12th cent.

Paris: Lib., Bibl. Sainte-Geneviève,
1029
Barthélemy l'Anglais, *Propriétés*,
fol. 8v
Date: 14th cent.

Paris: Lib., Bibl. Sainte-Geneviève,
1029
Barthélemy l'Anglais, *Propriétés*,
fol. 9r
Date: 14th cent.

Paris: Lib., Bibl. Sainte-Geneviève,
1029
Barthélemy l'Anglais, *Propriétés*,
fol. 9v
Date: 14th cent.

Prague: Lib., Metropolit. Kapituly,
A.VII
Augustine, *De Civitate Dei*, fol. 1v
Date: 12th–13th cent.
Christ and Four Beasts

Reims: Lib., Bibl. Municipale, 19-21
Bible, III, fol. 176r
Date: 11th–12th cent.

Reims: Lib., Bibl. Municipale, 22-23
Bible, II, fol. 18r
Date: 11th–12th cent.

Reims: Lib., Bibl. Municipale, 34-36
Bible, II, fol. 169v
Date: First half 13th cent.
Ecclesiasticus: Illustration

Rome: Lib., Bibl. Vaticana, Ottob.
lat. 74
Lectionary, Henry II, fol. 193v
Date: 11th cent.
Henry II

Rome: Lib., Bibl. Vaticana, Pal. gr. 381
Psalter, fol. 2r
Date: 12th–13th cent.
Psalms: Illustration

Rome: Lib., Bibl. Vaticana, Pal.
lat. 1993
Opicinus de Canistris, *Atlas*, fol. 9v
Date: 1335–1342
Christ

Rouen: Lib., Bibl. Publique, 8
Bible, fol. 221v
Date: 11th cent.

Saint Gall: Lib., Stiftsbibl., 135
Prudentius, *Psychomachia*, p. 438
Date: First half 11th cent.

Saint Petersburg: Lib., Public, 269
Miniatures, fol. 3r
Date: 11th–12th cent.
David

Saint-Yrieix: Lib., Bibl. Municipale
Bible, fol. 228r
Date: 11th–12th cent.

Troyes: Lib., Bibl. Municipale, 252
Speculum Virginum, fol. 82r
Date: ca. 1190
Speculum Virginum: Text

Valenciennes: Lib., Bibl. Municipale,
164
Augustine, *Varia*, fol. 52r
Date: 12th cent.
Augustine of Hippo

Valenciennes: Lib., Bibl. Municipale,
512
Miscellany, fol. 4v
Date: 12th cent.
Gregory the Great

Valenciennes: Lib., Bibl. Municipale,
563
Prudentius, *Psychomachia*, fol. 40v
Date: Early 11th cent.

Vienna: Lib., Nationalbibl., 677
Gregory, *Moralia*, fol. 46r
Date: 11th cent.

Wiesbaden: Lib., Hessische
 Landesbibl., I
Hildegardis, *Liber Scivias*, fol. 192r
Date: ca. 1165
Hildegardis of Bingen: Vision

Winchester: Lib., Cathedral
Bible, III, fol. 278v
Date: Second half 12th cent.
Ecclesiasticus: Illustration

Wolfenbüttel: Lib., Herzog August
 Bibl., Guelf. 105 Noviss. 2°
Gospel Book, Henry the Lion, fol. 18v
Date: ca. 1175
John Baptist

METALWORK

Cologne: Cathedral, Treasury
Casket, of Three Kings
Date: 1190–1225
Christ: Last Judgment

Xanten: Cath., Victor
Bowl, bronze
Date: 12th cent.

MOSAIC

Reims: Ch., Remi
Choir
Date: After 1090
David: As Musician

SCULPTURE

Reims: Cath., Notre Dame
Exterior, west
Date: ca. 1230–1240
Virgin Mary: Coronation

Vézelay: Ch., Madeleine
Nave
Date: First half 12th cent.
Saint

TEXTILE

Bamberg: Cathedral, Treasury
Vestment, chasuble, embroidery
Date: 11th–12th cent.
Christ: Nativity

UNIDENTIFIED VIRTUES

ENAMEL

Arezzo: Ch., Pieve di S. Maria
Reliquary
Date: 1346
Christ

Brussels: Coll., Stoclet
Plaque
Date: Second half 12th cent.

Klosterneuburg: Monastery
Retable
Attribution: Nicolas of Verdun
Date: 1181
Abraham: Entertaining the Angels

Liège: Mus., Curtius
Book cover (12/1)
Date: Mid-12th cent.
Personification: River of Paradise

Nancy: Coll., Bretagne
Cross
Date: 12th cent.

FRESCO

Brioude: Ch., Julien
Porch
Date: 12th–13th cent.
Christ: Last Judgment

Brixen: Ch., Johannes
Decoration
Date: 13th cent.
Christopher of Lycia: Carrying Christ
 Child

Cairo: Mus., Coptic Museum
Fragment (13-1:21-5)
Date: 5th cent.
Christ

Cairo: Mus., Coptic Museum
Fragment (13-1:21-9)
Date: 6th cent.
Christ and Four Beasts

Cairo: Mus., Coptic Museum
Fragment (18-1:21-7)
Date: 5th cent.
Virgin Mary and Christ Child:
 Type Suckling

Cairo, Mus., Coptic Museum
Fragment (7987)
Date: Before 700
Virgin Mary and Christ Child:
 Type Suckling

Cairo, Mus., Coptic Museum
Date: 6th cent. or later
Palm

Claverly: Ch., All Saints
Nave
Date: ca. 1200
Scene: Battle

Copford: Ch., Mary
Nave
Date: ca. 1150
Christ: Miracle of Raising Daughter
 of Jairus

Florence: Ch., Croce
Chapel, Bardi di Vernio (Silvestro)
Date: First half 14th cent.
Constantine the Great: Scene

Florence: Ch., Croce
Chapel, Baroncelli, back wall
Attribution: Taddeo Gaddi
Date: ca. 1328–1330
Joachim: Offerings Rejected

Florence: Ch., Maria Novella
Chapel, Spanish
Date: ca. 1355
Peter Martyr: Scene

Florence: Ch., Maria Novella
Chapel, Strozzi, ceiling
Attribution: Giovanni del Biondo,
 Nardo di Cione
Date: ca. 1350–1360
Thomas Aquinas

Idensen: Church
Decoration
Date: 12th cent.
Christ and Four Beasts

Laval: Ch., Martin
Crossing
Date: 12th cent.
Personification: Virtues and Vices,
 Conflict

Limburg: Cath., Georg
Decoration
Date: First half 13th cent.
Personification: Ocean and Earth

London: Pal., Westminster
Painted Chamber
Date: Late 13th cent.
Maccabees: Battle

Padua: Ch., Eremitani
Tomb of Diamante Dotti
Date: 14th cent.
Virgin Mary: Annunciation

Pisa: Ch., Francesco
Choir
Date: 1342
Francis of Assisi

Saeby: Church
Decoration
Date: 1150–1175
Christ and Four Beasts

Santiago de Compostela: Cathedral
Altar canopy
Date: Before 1135
Lamb of God

Schwarzrheindorf: Ch., Pfarrkirche,
 Upper
Choir
Date: 1176–1193
Apocalypse: John, Calling

Vicq: Church
Nave, east wall
Date: Second quarter 12th cent.

GLASS

Paris: Cath., Notre Dame
Window, west rose
Date: First half 13th cent.
Virgin Mary and Christ Child

Schwäbisch Hall: Ch., Katharina
Window
Date: 1343

IVORY

Ascoli Piceno: Cath., Emidio, Treasury
Casket
Date: 14th cent.

Cologne: Ch., Maria Lyskirchen
Plaque, in book cover
Date: Mid-11th cent.
Christ: Crucifixion

Florence: Mus., Naz. di Bargello
Plaque, from book cover? (30 C)
Date: 9th cent.
Personification: Virtues and Vices,
 Conflict

MANUSCRIPT

Berlin: Lib., Staatsbibl., Theol. lat.
 fol. 2
Sacramentary, fol. 9r
Date: First half 11th cent.
Sigebertus of Minden: Scene

Berne: Lib., Stadtbibl., 120 II
Peter of Eboli, *De Rebus Siculis*,
 fol. 146r
Date: 1195–1197
Henry VI

Berne: Lib., Stadtbibl., 264
Prudentius, *Psychomachia*, fol. 41r
Date: Early 10th cent.
Personification: Virtue, Patience

Brussels: Lib., Bibl. Royale, 9505-6
Aristotle, *Ethiques*, fol. 89r
Date: 1372
Personification: Virtue, Justice

Brussels: Lib., Bibl. Royale, 9968-72
Prudentius, *Psychomachia*, fol. 79r
Date: 11th cent.
Personification: Virtue, Faith

Brussels: Lib., Bibl. Royale, 9968-72
Prudentius, *Psychomachia*, fol. 85v
Date: 11th cent.
Personification: Virtue, Patience

Brussels: Lib., Bibl. Royale, 9968-72
Prudentius, *Psychomachia*, fol. 97v
Date: 11th cent.
Personification: Vice, Pleasure?

Brussels: Lib., Bibl. Royale, 9987-91
Prudentius, *Psychomachia*, fol. 100r
Date: 10th cent.
Personification: Virtue, Faith

Brussels: Lib., Bibl. Royale, 9987-91
Prudentius, *Psychomachia*, fol. 105r
Date: 10th cent.
Personification: Virtue, Patience

Brussels: Lib., Bibl. Royale, 9987-91
Prudentius, *Psychomachia*, fol. 109r
Date: 10th cent.
Personification: Virtue, Hope

Brussels: Lib., Bibl. Royale, 9987-91
Prudentius, *Psychomachia*, fol. 113r
Date: 10th cent.
Personification: Vice, Pleasure

Brussels: Lib., Bibl. Royale, 9987-91
Prudentius, *Psychomachia*, fol. 119r
Date: 10th cent.
God: Hand

Brussels: Lib., Bibl. Royale, 9987-91
Prudentius, *Psychomachia*, fol. 119v
Date: 10th cent.

Brussels: Lib., Bibl. Royale, 9987-91
Prudentius, *Psychomachia*, fol. 120r
Date: 10th cent.
Personification: Vice, Discord

Brussels: Lib., Bibl. Royale, 9987-91
Prudentius, *Psychomachia*, fol. 120v
Date: 10th cent.
Personification: Vice, Discord

Brussels: Lib., Bibl. Royale, 9987-91
Prudentius, *Psychomachia*, fol. 121r
Date: 10th cent.
Personification: Virtue, Faith

Brussels: Lib., Bibl. Royale, 9987-91
Prudentius, *Psychomachia*, fol. 121v
Date: 10th cent.

Brussels: Lib., Bibl. Royale, 9987-91
Prudentius, *Psychomachia*, fol. 122r
Date: 10th cent.
Personification: Virtue, Faith

Brussels: Lib., Bibl. Royale, 9987-91
Prudentius, *Psychomachia*, fol. 122v
Date: 10th cent.
Personification: Virtue, Faith

Brussels: Lib., Bibl. Royale, 9987-91
Prudentius, *Psychomachia*, fol. 123v
Date: 10th cent.
Personification: Virtue, Faith

Brussels: Lib., Bibl. Royale, 10066-77
Prudentius, *Psychomachia*, fol. 115v
Date: 10th–first half 11th cent.
Personification: Virtue, Faith

Brussels: Lib., Bibl. Royale, 10066-77
Prudentius, *Psychomachia*, fol. 133r
Date: 10th–first half 11th cent.
Personification: Vice, Discord

Brussels: Lib., Bibl. Royale, 10066-77
Prudentius, *Psychomachia*, fol. 133v
Date: 10th–first half 11th cent.
Personification: Virtue, Faith

Brussels: Lib., Bibl. Royale, 10066-77
Prudentius, *Psychomachia*, fol. 135v
Date: 10th–first half 11th cent.
Personification: Virtue, Faith

Brussels: Lib., Bibl. Royale, 10066-77
Prudentius, *Psychomachia*, fol. 136v
Date: 10th–first half 11th cent.
Personification: Virtue, Faith

Brussels: Mus., Royaux d'Art et
 d'Histoire
Miniature, recto
Date: ca. 1175
Christ: Miracle of Raising Lazarus

Budapest: Mus., Szépmüvészeti
 Múzeum
Miscellany
Date: First half 14th cent.
Virgin Mary and Christ Child

Cambridge: Lib., Corpus Christi
 College, 23
Prudentius, *Psychomachia*, fol. 7v
Date: Early 11th cent.
Personification: Virtue, Faith

Cambridge: Lib., Corpus Christi
 College, 23
Prudentius, *Psychomachia*, fol. 14r
Date: Early 11th cent.
Personification: Virtue, Patience

Cambridge: Lib., Corpus Christi
 College, 23
Prudentius, *Psychomachia*, fol. 19v
Date: Early 11th cent.
Personification: Virtue, Hope

Cambridge: Lib., Corpus Christi
 College, 23
Prudentius, *Psychomachia*, fol. 20v
Date: Early 11th cent.
Personification: Vice, Luxury

Cambridge: Lib., Corpus Christi
 College, 23
Prudentius, *Psychomachia*, fol. 25v
Date: Early 11th cent.
Personification: Virtue, Sobriety

Cambridge: Lib., Corpus Christi
 College, 23
Prudentius, *Psychomachia*, fol. 30v
Date: Early 11th cent.
Personification: Vice, Avarice

Cambridge: Lib., Corpus Christi
 College, 23
Prudentius, *Psychomachia*, fol. 33v
Date: Early 11th cent.
Soldier

Cambridge: Lib., Corpus Christi
 College, 23
Prudentius, *Psychomachia*, fol. 34r
Date: Early 11th cent.
Personification: Virtue, Concord

Cambridge: Lib., Corpus Christi
 College, 23
Prudentius, *Psychomachia*, fol. 35r
Date: Early 11th cent.
Personification: Vice, Discord

Cambridge: Lib., Corpus Christi
 College, 23
Prudentius, *Psychomachia*, fol. 35v
Date: Early 11th cent.
Personification: Vice, Discord

Cambridge: Lib., Corpus Christi
 College, 23
Prudentius, *Psychomachia*, fol. 36r
Date: Early 11th cent.
Personification: Vice, Discord

Cambridge: Lib., Corpus Christi
 College, 23
Prudentius, *Psychomachia*, fol. 37r
Date: Early 11th cent.
Personification: Vice, Discord

Cambridge: Lib., Corpus Christi
 College, 23
Prudentius, *Psychomachia*, fol. 38r
Date: Early 11th cent.
Personification: Virtue, Faith

Cambridge: Lib., Corpus Christi
 College, 23
Prudentius, *Psychomachia*, fol. 39v
Date: Early 11th cent.
Personification: Virtue, Faith

Cologne: Arch., Historisches, W 255
Bernard of Clairvaux, *Serm.*, fol. 117v
Date: Late 13th cent.
Christ: Resurrection

Douai: Lib., Bibl. Municipale, 301
Gregory, *Moralia in Job*, fol. 1v
Date: 12th cent.
Job: Smitten by Satan

Düsseldorf: Lib., Landesbibl., B. 31
Bernard of Clairvaux, *Serm.*, fol. 122v
Date: Second half 13th cent.
Christ: Resurrection

Engelberg: Lib., Stiftsbibl., 61
Psalter, fol. 5v
Date: Second half 13th cent.
Psalms: Illustration

Eton: Lib., Eton College, 177
Miscellany, fol. 3v
Date: 13th cent.
*Abraham: Giving Tithes to
 Melchisedek*

Eton: Lib., Eton College, 177
Miscellany, fol. 5v
Date: 13th cent.
Jonah: Cast Up

Eton: Lib., Eton College, 177
Miscellany, fol. 6r
Date: 13th cent.
David: Slaying Bear

Eton: Lib., Eton College, 177
Miscellany, fol. 6v
Date: 13th cent.
Enoch, Son of Jared: Translation

Eton: Lib., Eton College, 177
Miscellany, fol. 7r
Date: 13th cent.
Ezekiel: Vision of Shekinah

Eton: Lib., Eton College, 177
Miscellany, fol. 7v
Date: 13th cent.
Personification: Virtue, Grace

Florence: Lib., Bibl. Naz. Centrale,
 Banco Rari 397
Hours, Giangaleazzo Visconti
Attribution: Giovannino and
 Salomone dei Grassi
Date: ca. 1389–1391
Psalms: Illustration

Heidelberg: Lib., Universitätsbibl.,
 Sal. X.16
Hildegardis, *Liber Scivias*, fol. 156r
Date: 12th cent.
Hildegardis of Bingen: Vision

Karlsruhe: Lib., Landesbibl.,
 S. Peter 139
Psalter, fol. 8r
Date: Second half 13th cent.
Psalms: Illustration

Leiden: Lib., Bibl. der Univ., Burm. Q.3
Prudentius, *Psychomachia*, fol. 123r
Date: Second quarter 9th cent.
Personification: Virtue, Faith

Leiden: Lib., Bibl. der Univ., Burm. Q.3
Prudentius, *Psychomachia*, fol. 128r
Date: Second quarter 9th cent.
Personification: Virtue, Patience

Leiden: Lib., Bibl. der Univ., Burm. Q.3
Prudentius, *Psychomachia*, fol. 132r
Date: Second quarter 9th cent.
Personification: Virtue, Hope

Leiden: Lib., Bibl. der Univ., Burm. Q.3
Prudentius, *Psychomachia*, fol. 136r
Date: Second quarter 9th cent.
Personification: Vice, Pleasure

Leiden: Lib., Bibl. der Univ., Burm. Q.3
Prudentius, *Psychomachia*, fol. 142r
Date: Second quarter 9th cent.
God: Hand

Leiden: Lib., Bibl. der Univ., Burm. Q.3
Prudentius, *Psychomachia*, fol. 142v
Date: Second quarter 9th cent.

Leiden: Lib., Bibl. der Univ., Burm. Q.3
Prudentius, *Psychomachia*, fol. 143r
Date: Second quarter 9th cent.
Personification: Virtue, Concord

Leiden: Lib., Bibl. der Univ., Burm. Q.3
Prudentius, *Psychomachia*, fol. 143v
Date: Second quarter 9th cent.
Personification: Vice, Discord

Leiden: Lib., Bibl. der Univ., Burm. Q.3
Prudentius, *Psychomachia*, fol. 144r
Date: Second quarter 9th cent.
Personification: Virtue, Faith

Leiden: Lib., Bibl. der Univ., Burm. Q.3
Prudentius, *Psychomachia*, fol. 144v
Date: Second quarter 9th cent.

Leiden: Lib., Bibl. der Univ., Burm. Q.3
Prudentius, *Psychomachia*, fol. 145r
Date: Second quarter 9th cent.
Personification: Virtue, Faith

Leiden: Lib., Bibl. der Univ., Burm. Q.3
Prudentius, *Psychomachia*, fol. 145v
Date: Second quarter 9th cent.
Personification: Virtue, Faith

Leiden: Lib., Bibl. der Univ., Burm. Q.3
Prudentius, *Psychomachia*, fol. 146v
Date: Second quarter 9th cent.
Personification: Virtue, Faith

Leiden: Lib., Bibl. der Univ., Voss.
 lat. oct. 15
Prudentius, *Psychomachia*, fol. 37v
Date: Early 11th cent.
Abraham: Blessed by Melchisedek

Leiden: Lib., Bibl. der Univ., Voss.
 lat. oct. 15
Prudentius, *Psychomachia*, fol. 38v
Date: Early 11th cent.
Personification: Vice, Wrath

Leiden: Lib., Bibl. der Univ., Voss.
 lat. oct. 15
Prudentius, *Psychomachia*, fol. 39v
Date: Early 11th cent.
Personification: Virtue, Hope

Leiden: Lib., Bibl. der Univ., Voss.
 lat. oct. 15
Prudentius, *Psychomachia*, fol. 40r
Date: Early 11th cent.
Personification: Vice, Luxury

Leiden: Lib., Bibl. der Univ., Voss.
 lat. oct. 15
Prudentius, *Psychomachia*, fol. 40v
Date: Early 11th cent.
Personification: Vice, Luxury

Leiden: Lib., Bibl. der Univ., Voss.
 lat. oct. 15
Prudentius, *Psychomachia*, fol. 41r
Date: Early 11th cent.
Personification: Vice, Avarice

Leiden: Lib., Bibl. der Univ., Voss.
 lat. oct. 15
Prudentius, *Psychomachia*, fol. 41v
Date: Early 11th cent.
Personification: Vice, Avarice

Leiden: Lib., Bibl. der Univ., Voss.
 lat. oct. 15
Prudentius, *Psychomachia*, fol. 42r
Date: Early 11th cent.
Personification: Virtue, Concord

Leiden: Lib., Bibl. der Univ., Voss.
 lat. oct. 15
Prudentius, *Psychomachia*, fol. 42v
Date: Early 11th cent.
Personification: Vice, Discord

Leiden: Lib., Bibl. der Univ., Voss.
 lat. oct. 15
Prudentius, *Psychomachia*, fol. 43r
Date: Early 11th cent.
Personification: Virtue, Concord

London: Lib., British, Add. 18719
Bible, Moralized, fol. 224r
Date: Early 14th cent.
Zechariah: Prophecy

London: Lib., British, Add. 24199
Prudentius, *Psychomachia*, fol. 5v
Date: Early 11th cent.
Personification: Virtue, Faith

London: Lib., British, Add. 24199
Prudentius, *Psychomachia*, fol. 11v
Date: Early 11th cent.
Personification: Virtue, Patience

London: Lib., British, Add. 24199
Prudentius, *Psychomachia*, fol. 16r
Date: Early 11th cent.
Personification: Virtue, Hope

London: Lib., British, Add. 24199
Prudentius, *Psychomachia*, fol. 17v
Date: Early 11th cent.
Personification: Vice, Luxury

London: Lib., British, Add. 24199
Prudentius, *Psychomachia*, fol. 22v
Date: Early 11th cent.
Personification: Virtue, Sobriety

London: Lib., British, Add. 24199
Prudentius, *Psychomachia*, fol. 26v
Date: Early 11th cent.
Personification: Vice, Avarice

London: Lib., British, Add. 24199
Prudentius, *Psychomachia*, fol. 29v
Date: Early 11th cent.
Soldier

London: Lib., British, Add. 24199
Prudentius, *Psychomachia*, fol. 30v
Date: Early 11th cent.

London: Lib., British, Add. 24199
Prudentius, *Psychomachia*, fol. 31v
Date: Early 11th cent.
Personification: Vice, Discord

London: Lib., British, Add. 24199
Prudentius, *Psychomachia*, fol. 32v
Date: Early 11th cent.
Personification: Vice, Discord

London: Lib., British, Cott. Cleo.
 C.VIII
Prudentius, *Psychomachia*, fol. 4v
Date: Early 11th cent.
Personification: Virtue, Faith

London: Lib., British, Cott. Cleo.
 C.VIII
Prudentius, *Psychomachia*, fol. 10r
Date: Early 11th cent.
Personification: Virtue, Patience

London: Lib., British, Cott. Cleo.
 C.VIII
Prudentius, *Psychomachia*, fol. 14v
Date: Early 11th cent.
Personification: Virtue, Hope

London: Lib., British, Cott. Cleo.
 C.VIII
Prudentius, *Psychomachia*, fol. 16r
Date: Early 11th cent.
Personification: Vice, Luxury

London: Lib., British, Cott. Cleo.
 C.VIII
Prudentius, *Psychomachia*, fol. 20r
Date: Early 11th cent.
Personification: Vice, Pleasure

London: Lib., British, Cott. Cleo.
 C.VIII
Prudentius, *Psychomachia*, fol. 24v
Date: Early 11th cent.
Personification: Vice, Avarice

London: Lib., British, Cott. Cleo.
 C.VIII
Prudentius, *Psychomachia*, fol. 27v
Date: Early 11th cent.
Personification: Virtue, Concord

London: Lib., British, Cott. Cleo.
 C.VIII
Prudentius, *Psychomachia*, fol. 28r
Date: Early 11th cent.
Personification: Virtue, Concord

London: Lib., British, Cott. Cleo.
 C.VIII
Prudentius, *Psychomachia*, fol. 29r
Date: Early 11th cent.
Personification: Vice, Discord

London: Lib., British, Cott. Cleo.
 C.VIII
Prudentius, *Psychomachia*, fol. 31r
Date: Early 11th cent.
Personification: Virtue, Faith

London: Lib., British, Cott. Titus
 D.XVI
Prudentius, *Psychomachia*, fol. 9r
Date: ca. 1100
Personification: Virtue, Patience

London: Lib., British, Cott. Titus
 D.XVI
Prudentius, *Psychomachia*, fol. 16r
Date: ca. 1100
Personification: Virtue, Hope

London: Lib., British, Cott. Titus
 D.XVI
Prudentius, *Psychomachia*, fol. 28r
Date: ca. 1100
Personification: Vice, Discord

London: Lib., British, Cott. Titus
 D.XVI
Prudentius, *Psychomachia*, fol. 28v
Date: ca. 1100
Personification: Virtue, Faith

London: Lib., British, Cott. Titus
 D.XVI
Prudentius, *Psychomachia*, fol. 30r
Date: ca. 1100
Personification: Virtue, Concord?

Lyons: Lib., Bibl. Municipale, Pal. des
 Arts 22
Prudentius, *Psychomachia*, fol. 9v
Date: Last quarter 11th cent.
Personification: Vice, Avarice

Lyons: Lib., Bibl. Municipale, Pal. des
 Arts 22
Prudentius, *Psychomachia*, fol. 11r
Date: Last quarter 11th cent.
Personification: Virtue, Faith

Lyons: Lib., Bibl. Municipale, Pal. des
 Arts 22
Prudentius, *Psychomachia*, fol. 11v
Date: Last quarter 11th cent.
Personification: Virtue, Faith

Lyons: Lib., Bibl. Municipale, Pal. des
 Arts 22
Prudentius, *Psychomachia*, fol. 12v
Date: Last quarter 11th cent.
Personification: Virtue, Faith

Lyons: Lib., Bibl. Municipale, Pal. des
 Arts 22
Prudentius, *Psychomachia*, fol. 14r
Date: Last quarter 11th cent.
Personification: Virtue, Sobriety

Lyons: Lib., Bibl. Municipale, Pal. des
 Arts 22
Prudentius, *Psychomachia*, fol. 16r
Date: Last quarter 11th cent.
Personification: Vice, Discord

Lyons: Lib., Bibl. Municipale, Pal. des
 Arts 22
Prudentius, *Psychomachia*, fol. 16v
Date: Last quarter 11th cent.

Lyons: Lib., Bibl. Municipale, Pal. des
 Arts 22
Prudentius, *Psychomachia*, fol. 18r
Date: Last quarter 11th cent.
Personification: Virtue, Peace

Lyons: Lib., Bibl. Municipale, Pal. des
 Arts 22
Prudentius, *Psychomachia*, fol. 18v
Date: Last quarter 11th cent.
Personification: Virtue, Concord

Lyons: Lib., Bibl. Municipale, Pal. des
 Arts 22
Prudentius, *Psychomachia*, fol. 19r
Date: Last quarter 11th cent.

Munich: Lib., Staatsbibl., Clm. 13601
Lectionary of Uta, fol. 1v
Date: ca. 1025
God: Hand

Munich: Lib., Staatsbibl., Clm. 13601
Lectionary of Uta, fol. 2r
Date: ca. 1025
Virgin Mary and Christ Child

Munich: Lib., Staatsbibl., Clm. 29031b
Prudentius, *Psychomachia*, verso
Date: 10th cent.
Personification: Virtue, Faith

Munich: Lib., Staatsbibl., Clm. 30055
Gospel Book, Henry the Lion, fol. 16r
Date: ca. 1175
Apostle: Jude

Munich: Lib., Staatsbibl., Clm. 30055
Gospel Book, Henry the Lion, fol. 16v
Date: ca. 1175
Apostle: Matthias

Munich: Lib., Staatsbibl., Clm. 30055
Gospel Book, Henry the Lion, fol. 17v
Date: ca. 1175
Evangelist: Luke

Munich: Lib., Staatsbibl., Clm. 30055
Gospel Book, Henry the Lion, fol. 18r
Date: ca. 1175
Apostle: Paul

Munich: Lib., Staatsbibl., Clm. 30055
Gospel Book, Henry the Lion, fol. 113r
Date: ca. 1175
Evangelist: Luke

Nuremberg: Mus., Germ. Nat. Bibl.,
 156142
Gospel Book, Echternach, fol. 113v
Date: 10th–11th cent.

Oxford: Lib., Bodleian, 270b
Bible, Moralized, fol. 13v
Date: First half 13th cent.
Abraham: Battle against Kings

Oxford: Lib., Bodleian, 270b
Bible, Moralized, fol. 18r
Date: First half 13th cent.
*Jacob: Choosing between Leah and
 Rachel*

Oxford: Lib., Bodleian, 270b
Bible, Moralized, fol. 39v
Date: First half 13th cent.
Moses: Rebuking Two Israelites

Oxford: Lib., Bodleian, 270b
Bible, Moralized, fol. 83v
Date: First half 13th cent.
Israelite: With Daughters of Moab

Oxford: Lib., Bodleian, 270b
Bible, Moralized, fol. 102r
Date: First half 13th cent.
Joshua: Distribution of Land

Paris: Lib., Bibl. Nat. de France,
 fr. 9561
Bible, Moralized, fol. 77r
Date: ca. 1370
Moses: Law, Meat Offering

Paris: Lib., Bibl. Nat. de France,
 lat. 2077
Miscellany, fol. 168r
Date: 10th–11th cent.
Personification: Vice, Wrath

Paris: Lib., Bibl. Nat. de France,
 lat. 6734
Honorius of Autun, *Clavis Physicae*,
 fol. 3v
Date: 12th cent.
Personification: Virtue, Goodness

Paris: Lib., Bibl. Nat. de France,
 lat. 8085
Prudentius, *Psychomachia*, fol. 57r
Date: Late 9th cent.
Personification: Virtue, Faith

Paris: Lib., Bibl. Nat. de France,
 lat. 8085
Prudentius, *Psychomachia*, fol. 59v
Date: Late 9th cent.
Personification: Virtue, Patience

Paris: Lib., Bibl. Nat. de France,
 lat. 8085
Prudentius, *Psychomachia*, fol. 61r
Date: Late 9th cent.
Personification: Virtue, Humility

Paris: Lib., Bibl. Nat. de France,
 lat. 8085
Prudentius, *Psychomachia*, fol. 63v
Date: Late 9th cent.
Personification: Virtue, Sobriety

Paris: Lib., Bibl. Nat. de France,
 lat. 8085
Prudentius, *Psychomachia*, fol. 66r
Date: Late 9th cent.
Personification: Virtue, Generosity

Paris: Lib., Bibl. Nat. de France,
 lat. 8085
Prudentius, *Psychomachia*, fol. 66v
Date: Late 9th cent.
Personification: Virtue, Concord

Paris: Lib., Bibl. Nat. de France,
 lat. 8085
Prudentius, *Psychomachia*, fol. 67r
Date: Late 9th cent.
Personification: Vice, Discord

Paris: Lib., Bibl. Nat. de France,
 lat. 8085
Prudentius, *Psychomachia*, fol. 67v
Date: Late 9th cent.
Personification: Vice, Discord

Paris: Lib., Bibl. Nat. de France,
 lat. 8085
Prudentius, *Psychomachia*, fol. 68r
Date: Late 9th cent.
Personification: Virtue, Faith

Paris: Lib., Bibl. Nat. de France,
 lat. 8085
Prudentius, *Psychomachia*, fol. 68v
Date: Late 9th cent.
Personification: Virtue, Faith

Paris: Lib., Bibl. Nat. de France,
 lat. 8318
Prudentius, *Psychomachia*, fol. 52r
Date: Late 10th cent.
Personification: Vice, Luxury

Paris: Lib., Bibl. Nat. de France,
 lat. 8318
Prudentius, *Psychomachia*, fol. 60v
Date: Late 10th cent.
Personification: Vice, Avarice

Paris: Lib., Bibl. Nat. de France,
 lat. 8318
Prudentius, *Psychomachia*, fol. 62r
Date: Late 10th cent.
Soldier

Paris: Lib., Bibl. Nat. de France,
 lat. 8318
Prudentius, *Psychomachia*, fol. 62v
Date: Late 10th cent.
Personification: Virtue, Concord

Paris: Lib., Bibl. Nat. de France,
 lat. 8318
Prudentius, *Psychomachia*, fol. 63r
Date: Late 10th cent.
Personification: Vice, Discord

Paris: Lib., Bibl. Nat. de France,
 lat. 8318
Prudentius, *Psychomachia*, fol. 63v
Date: Late 10th cent.
Personification: Vice, Discord

Paris: Lib., Bibl. Nat. de France,
 lat. 11560
Bible, Moralized, fol. 222r
Date: First half 13th cent.
*Zechariah: Prophecy, Two Parts
 Shall Die*

Paris: Lib., Bibl. Nat. de France,
 lat. 15158
Prudentius, *Psychomachia*, fol. 49v
Date: 1289
Personification: Virtue, Sobriety

Paris: Lib., Bibl. Nat. de France,
 lat. 15158
Prudentius, *Psychomachia*, fol. 53v
Date: 1289
Personification: Vice, Avarice

Paris: Lib., Bibl. Nat. de France,
 lat. 15158
Prudentius, *Psychomachia*, fol. 56r
Date: 1289
Personification: Virtue, Peace

Paris: Lib., Bibl. Nat. de France,
 lat. 15158
Prudentius, *Psychomachia*, fol. 56v
Date: 1289
Personification: Virtue, Concord

Paris: Lib., Bibl. Nat. de France,
 lat. 15158
Prudentius, *Psychomachia*, fol. 58v
Date: 1289
Personification: Virtue, Faith

Paris: Lib., Bibl. Nat. de France,
 lat. 15158
Prudentius, *Psychomachia*, fol. 59r
Date: 1289
Personification: Virtue, Faith

Paris: Lib., Bibl. Nat. de France,
 lat. 15158
Prudentius, *Psychomachia*, fol. 60v
Date: 1289
Personification: Virtue, Faith

Paris: Lib., Bibl. Nat. de France,
 lat. 15158
Prudentius, *Psychomachia*, fol. 61v
Date: 1289
Personification: Virtue, Faith

Pommersfelden: Coll., Schönborn,
 Library, 215
Miscellany, fol. 161r
Date: 14th cent.
Alanus de Insulis: Text

Pommersfelden: Coll., Schönborn,
 Library, 215
Miscellany, fol. 161v
Date: 14th cent.
Alanus de Insulis: Text

Pommersfelden: Coll., Schönborn,
 Library, 215
Miscellany, fol. 162v
Date: 14th cent.
Alanus de Insulis: Text

Rome: Lib., Bibl. Vaticana, gr. 394
John Climacus, *Climax*, fol. 94r
Date: Late 11th cent.
*John Climacus: Climax, Chapter
 XVIII*

Rome: Lib., Bibl. Vaticana, gr. 394
John Climacus, *Climax*, fol. 149v
Date: Late 11th cent.
*John Climacus: Climax, Chapter
 XXIX*

Rome: Lib., Bibl. Vaticana, Reg.
 lat. 596
Prudentius, *Psychomachia*, fol. 26r
Date: Late 10th cent.
Personification: Virtue, Concord

Saint Gall: Lib., Stiftsbibl., 135
Prudentius, *Psychomachia*, p. 395
Date: First half 11th cent.
Personification: Virtue, Patience

Saint Gall: Lib., Stiftsbibl., 135
Prudentius, *Psychomachia*, p. 434
Date: First half 11th cent.
Scene: Occupational, Building

Saint Gall: Lib., Stiftsbibl., 135
Prudentius, *Psychomachia*, p. 435
Date: First half 11th cent.
Scene: Occupational, Building

Saint Gall: Lib., Stiftsbibl., 135
Prudentius, *Psychomachia*, p. 439
Date: First half 11th cent.
God: Hand

Saint-Omer: Lib., Bibl. Municipale, 34
Origen, *Homilies*, fol. 1v
Date: Second quarter 12th cent.
Creation Scene

Strasbourg: Lib., Bibl. Municipale
Herradis of Landsberg, *Hort. Delic.*,
 fol. 202r
Date: Second half 12th cent.
Personification: Virtue, Prudence

Toledo: Lib., Bibl. del Cabildo
Bible, Moralized, II, fol. 224r
Date: First half 13th cent.
Zechariah: Prophecy

Valenciennes: Lib., Bibl. Municipale,
 563
Prudentius, *Psychomachia*, fol. 5r
Date: Early 11th cent.
Personification: Virtue, Faith

Valenciennes: Lib., Bibl. Municipale,
 563
Prudentius, *Psychomachia*, fol. 12r
Date: Early 11th cent.
Personification: Virtue, Patience

Valenciennes: Lib., Bibl. Municipale,
 563
Prudentius, *Psychomachia*, fol. 17r
Date: Early 11th cent.
Personification: Virtue, Hope

Valenciennes: Lib., Bibl. Municipale,
 563
Prudentius, *Psychomachia*, fol. 23v
Date: Early 11th cent.
Personification: Virtue, Sobriety

Valenciennes: Lib., Bibl. Municipale,
 563
Prudentius, *Psychomachia*, fol. 31v
Date: Early 11th cent.
God: Hand

Valenciennes: Lib., Bibl. Municipale,
 563
Prudentius, *Psychomachia*, fol. 32r
Date: Early 11th cent.
Personification: Virtue, Concord

Valenciennes: Lib., Bibl. Municipale,
 563
Prudentius, *Psychomachia*, fol. 33r
Date: Early 11th cent.

Valenciennes: Lib., Bibl. Municipale,
 563
Prudentius, *Psychomachia*, fol. 33v
Date: Early 11th cent.
Personification: Vice, Discord

Valenciennes: Lib., Bibl. Municipale,
 563
Prudentius, *Psychomachia*, fol. 34v
Date: Early 11th cent.
Personification: Vice, Discord

Valenciennes: Lib., Bibl. Municipale,
 563
Prudentius, *Psychomachia*, fol. 35r
Date: Early 11th cent.
Personification: Virtue, Faith

Valenciennes: Lib., Bibl. Municipale,
 563
Prudentius, *Psychomachia*, fol. 35v
Date: Early 11th cent.

Valenciennes: Lib., Bibl. Municipale,
 563
Prudentius, *Psychomachia*, fol. 36r
Date: Early 11th cent.
Personification: Virtue, Faith

Valenciennes: Lib., Bibl. Municipale,
 563
Prudentius, *Psychomachia*, fol. 37r
Date: Early 11th cent.
Personification: Virtue, Faith

Valenciennes: Lib., Bibl. Municipale,
 563
Prudentius, *Psychomachia*, fol. 38v
Date: Early 11th cent.
Personification: Virtue, Faith

Vienna: Lib., Nationalbibl., 1179
Bible, Moralized, fol. 43r
Date: ca. 1215–1230
Moses: Law, Offering of Herd

Wiesbaden: Lib., Hessische
 Landesbibl., I
Hildegardis, *Liber Scivias*, fol. 130v
Date: ca. 1165
Hildegardis of Bingen: Vision

Wolfenbüttel: Lib., Herzog August
 Bibl., Guelf. 105 Noviss. 2°
Gospel Book, Henry the Lion, fol. 16r
Date: ca. 1175
Apostle: Jude

Wolfenbüttel: Lib., Herzog August
 Bibl., Guelf. 105 Noviss. 2°
Gospel Book, Henry the Lion, fol. 16v
Date: ca. 1175
Apostle: Matthias

Wolfenbüttel: Lib., Herzog August
 Bibl., Guelf. 105 Noviss. 2°
Gospel Book, Henry the Lion, fol. 17v
Date: ca. 1175
Evangelist: Luke

Wolfenbüttel: Lib., Herzog August
 Bibl., Guelf. 105 Noviss. 2°
Gospel Book, Henry the Lion, fol. 18r
Date: ca. 1175
Apostle: Paul

Wolfenbüttel: Lib., Herzog August
 Bibl., Guelf. 105 Noviss. 2°
Gospel Book, Henry the Lion, fol. 113r
Date: ca. 1175
Evangelist: Luke

METALWORK

Aachen: Coll., Wangemann
Bowl, copper-gilt
Date: 12th–13th cent.
Personification

Boston: Mus., Fine Arts
Bowl, copper-gilt (49.481)
Date: 11th–13th cent.
Personification

Cologne: Coll., Seligmann
Bowl
Date: 12th cent.
Personification

Cologne: Mus., Erzbischöfliches
Cross, processional
Date: 11th cent.
Christ: Crucifixion

Copenhagen: Mus., National
Altar, copper-gilt (D287)
Date: ca. 1150
Christ

Hildesheim: Cath., Maria, Treasury
Altar, portable, niello
Date: 12th cent.
Lamb of God and Four Beasts

Kappenberg: Ch., Klosterkirche
Reliquary of Evangelist John
Date: Second half 12th cent.
Frederick Barbarossa

London: Mus., Victoria and Albert
Relief, bronze-gilt
Date: First half 14th cent.

Manchester: Lib., Rylands
Book cover, silver-gilt (lat. 4)
Date: ca. 1150–1175
Saint?

Manchester: Lib., Rylands
Book cover, silver-gilt (lat. 5)
Date: ca. 1150–1175

Munich: Lib., Staatsbibl.
Book cover (lat. 21585)
Date: 13th cent.
Virgin Mary and Christ Child

Munich: Mus., Residenz
Reliquary, of Henry II (9 WL)
Date: ca. 1010–1020
Evangelist: John

MOSAIC

Hildesheim: Cath., Maria
Pavement
Date: 1153–1161
Ages of Man

Lyons: Ch., Irénée
Pavement
Date: 12th cent.
Zodiac Sign

PAINTING

Bamberg: Lib., Staatsbibl.
Book cover (Bibl. 48)
Date: Early 13th cent.
Christ: Crucifixion

Greenwich: Coll., Hyland
Panel
Date: 14th cent.
Virgin Mary and Christ Child

SCULPTURE

Angers: Préfecture
Cloister
Date: First half 12th cent.
Ornament: Figured

Arezzo: Cathedral
Reliquary, S. Donatus
Attribution: Betto di Francesco da
 Firenze, Giovanni di Francesco
 d'Arezzo
Date: After 1362
Christ

Clermont-Ferrand: Ch., Notre Dame
 du Port
Choir
Date: 12th cent.
Angel

Corcumello: Ch., Pietro
Pulpit
Date: 1267
Beasts of Apocalypse

Florence: Cath., Maria del Fiore
Holy water basin
Attribution: Giotto
Date: 13th cent.

León: Cath., Maria de Regla
Exterior, west
Date: Late 13th cent.
Virgin Mary: Coronation

Loches: Ch., Ours
Exterior, west
Date: ca. 1150
Angel

Lübeck: Cathedral
Triptych
Date: 14th cent.
Virgin Mary: Annunciation

Magdeburg: Cath., Mauritius und
 Katharina
Choir
Date: First half 13th cent.
Apostle: Andrew

Magdeburg: Mus., Kulturhistorisches
Statue, sandstone
Date: ca. 1250
Horseman: King

Naples: Cath., Gennaro
Statuette, marble
Attribution: Tino da Camaino
Date: 14th cent.

Naples: Ch., Chiara
Tomb of Charles of Calabria
Attribution: Tino da Camaino
Date: 1333
Charles of Calabria

Naples: Ch., Domenico Maggiore
Candlestick
Attribution: Pacio and Giovanni
 Bertini da Firenze, workshop of
Date: ca. 1330–1350
Personification: Virtues, Cardinal

Nuremberg: Ch., Sebaldus
Exterior, north
Date: 14th cent.
Virgins: Wise and Foolish

Paris: Cath., Notre Dame
Exterior, north
Date: ca. 1250–1260
Church Fathers

Parma: Baptistery
Exterior
Date: Late 12th–13th cent.
Magi: Adoration

Piacenza: Cath., Assunta
Exterior, west, central portal
Date: ca. second quarter 12th cent.
Personification: Vice, Avarice

Reims: Cath., Notre Dame
Exterior, west
Date: ca. 1230–1240
Virgin Mary: Coronation

Saint-Junien: Church
Sarcophagus
Date: 12th cent.
Christ and Four Beasts

Santiago de Compostela: Cathedral
Narthex
Date: 1188
Christ: Last Judgment

Sens: Cath., Etienne
Exterior, west
Date: Late 12th–13th cent.
Stephen Protomartyr: In Synagogue

Siena: Cath., Assunta
Exterior, south
Date: 13th–14th cent.
Miriam

Strzelno: Ch., Trinity
Nave, column
Date: Last quarter 12th cent.
Christ: Baptism

Treviso: Lib., Bibl. Capitolare
Relief, from tomb of Pietro Alighieri
Date: Second half 14th cent.

Venice: Ch., Giovanni e Paolo
Tomb of Antonio Venier
Attribution: Jacobello and Pierpaolo
 delle Masegne
Date: 1370–1420
Antonio Venier

Wells: Cath., Andrew
Exterior, west
Date: 13th cent.
Virgin Mary and Christ Child

Winchester: Cathedral
Statue
Date: Second half 13th cent.
Figure: Female

TREE OF VIRTUES

MANUSCRIPT

Baltimore: Gall., Walters, W. 72
Speculum Virginum, fol. 26r
Date: First half 13th cent.
Personification: Virtue, Humility

Cologne: Arch., Historisches, W 276a
Speculum Virginum, fol. 12r
Date: Mid-12th cent.
Personification: Virtue, Humility

Ghent: Lib., Bibl. de l'Université, 92
Lambertus, *Liber Floridus*, fol. 231v
Date: 1120

Kremsmünster: Lib., Stiftsbibl., 243
Spec. Hum. Salvationis, fol. 4r
Date: First half 14th cent.

Leipzig: Lib., Universitätsbibl., 148
Miscellany, fol. 114r
Date: 1133

Leipzig: Lib., Universitätsbibl., 305
Miscellany, fol. 151v
Date: 13th cent.
Personification: Virtue, Humility

London: Lib., British, Arundel 44
Speculum Virginum, fol. 29r
Date: ca. 1140–1150
Personification: Virtue, Humility

London: Lib., British, Arundel 83
Psalter, fol. 129r
Date: First half 14th cent.
Psalms: Illustration

Melk: Lib., Stiftsbibl., 388
Raymond of Pennafort, *Summa*,
 fol. 150r
Date: ca. 1220–1230

Paris: Lib., Bibl. Nat. de France,
 lat. 10630
De Fructus Carnis et Spiritus, fol. 65r
Date: Late 13th cent.

Rome: Gall., Naz. d'Arte Antica
Bartolomeo di Bartoli, *Canzone*, fol. 4r
Date: 14th cent.
Personification: Virtue, Temperance

Rome: Lib., Bibl. Vaticana, Pal.
 lat. 565
Speculum Virginum, fol. 32r
Date: ca. 1155
Personification: Virtue, Humility

Salzburg: Lib., Studienbibl., V 1 H 162
Miscellany, fol. 76r
Date: First half 12th cent.

Troyes: Lib., Bibl. Municipale, 252
Speculum Virginum, fol. 30r
Date: ca. 1190
Personification: Virtue, Humility

Vienna: Lib., Nationalbibl., Ser. Nov.
 2639
Convenevoli de Pratis(?), *Poemata*,
 fol. 1v
Date: Early 14th cent.
Personification: Virtue, Temperance

CARDINAL VIRTUES

ENAMEL

Augsburg: Mus., Diocesan
Altar, portable
Date: ca. 1160–13th cent.
Abel: Represented as Lamb

Berlin: Mus., Kunstgewerbe
Base of crucifix
Date: ca. 1160

Berlin: Mus., Staatliche
Altar, portable (W 12)
Date: ca. 1160

Darmstadt: Mus., Hessisches
 Landesmus.
Book cover (Kg 54:2121a–b)
Date: ca. 1160
Evangelist: Matthew

Stavelot: Monastery
Retable, of S. Remaclus
Date: ca. 1150
Christ and Four Beasts

FRESCO

Allinges: Chapel
Apse
Date: 11th cent.
Christ and Four Beasts

Brixen: Ch., Frauenkirche
Nave
Date: First half 13th cent.
Saint

Florence: Ch., Croce
Chapel, Baroncelli, main vault
Attribution: Taddeo Gaddi
Date: ca. 1328–1330

Florence: Loggia del Bigallo
Room, Consiglio
Date: 1342
Mercy Acts: Corporal

Hildesheim: Ch., Michael
Nave
Date: Late 12th–13th cent.
Jesse: Tree

Padua: Ch., Eremitani
Chapel, S. Agostino
Date: ca. 1370
Personification: Theology

Perugia: Ch., Domenico
Chapel, S. Caterina
Date: 14th cent.
Evangelist: Mark

San Miniato: Pal., Municipio
Room, Consiglio
Date: 1393
*Virgin Mary and Christ Child:
 Type Suckling*

Trier: Ch., Maximin
Crypt
Date: ca. 880–900
Christ: Crucifixion, Nailed to Cross

GLASS

Canterbury: Cath., Christ
Window, north, northeast transept
Date: 1180–1220
Moses

IVORY

London: Gall., Courtauld Institute
Plaques, from portable altar
Date: Late 11th cent.
Christ and Four Beasts

MANUSCRIPT

Arras: Lib., Bibl. Municipale, 559
Bible, S. Vaast, III, fol. 1r
Date: 10th–11th cent.
Ecclesiasticus: Illustration

Autun: Lib., Bibl. Municipale, 19bis
Sacramentary of Marmoutier, fol. 173v
Date: Mid-9th cent.
Ragnaldus of Marmoutier: Scene

Baltimore: Gall., Walters, W. 72
Speculum Virginum, fol. 12r
Date: First half 13th cent.
Virgin Mary and Christ Child

Berlin: Lib., Staatsbibl., lat. fol. I
Gratian, *Decretum,* fol. 1r
Date: ca. 1170

Berlin: Lib., Staatsbibl., Phill. 1701
Speculum Virginum, fol. 17r
Date: Early 13th cent.
Virgin Mary and Christ Child

Cambrai: Lib., Bibl. Municipale, 327
Gospel Book, fol. 16v
Date: Second half 9th–10th cent.
Personification: Church

Cologne: Cathedral, Library, Fol. 59
Jerome, *Epistolae-Opera*, fol. 1r
Date: 11th cent.

Darmstadt: Lib., Hessische
 Landesbibl., 1640
Gospel Book, Hitda of Meschede,
 fol. 25r
Date: 1000–1020

Escorial: Lib., Real Biblioteca, Vit. 17
Gospel Book, Henry III, fol. 3r
Date: 1043–1045
Henry III

Hannover: Lib., Niedersächsische
 Landesbibl., I.82
Somme le Roi, fol. 86v
Date: Early 14th cent.

Hildesheim: Cath., Maria,
 Treasury, 37
Missal, Ratmann, fol. 118v
Date: 1159

Karlsruhe: Lib., Landesbibl.,
 S. Peter 92
Thomas of Arras, *Breviculum*, fol. 5r
Date: Early 14th cent.
Thomas of Arras: Breviculum

Kremsmünster: Lib., Stiftsbibl., 243
Spec. Hum. Salvationis, fol. 4r
Date: First half 14th cent.
Tree of Virtues

Leipzig: Lib., Universitätsbibl., 665
Speculum Virginum, fol. 19v
Date: Mid-14th cent.
Virgin Mary and Christ Child

London: Lib., British, Add. 22399
Gilles of Paris, *Carolinus*, fol. 3r
Date: 13th cent.?

London: Lib., British, Add. 28162
Somme le Roi, fol. 4v
Date: ca. 1300

London: Lib., British, Add. 54180
Somme le Roi, fol. 91v
Date: ca. 1300

London: Lib., British, Arundel 44
Speculum Virginum, fol. 13r
Date: ca. 1140–1150
Virgin Mary and Christ Child

London: Lib., British, Arundel 83
Psalter, fol. 129r
Date: First half 14th cent.
Psalms: Illustration

London: Lib., British, Arundel 83
Psalter, fol. 135r
Date: First half 14th cent.
Psalms: Illustration

London: Lib., British, Harley 2798-9
Bible, II, fol. 57v
Date: Late 12th cent.
Solomon

Los Angeles: Mus., Getty, 64
Missal, Stammheim, fol. 84v
Date: 12th–13th cent.

Madrid: Lib., Bibl. Nacional, 195-6
Bartolus of Sassoferrato, *Comm.*
Date: 14th cent.
Augustine of Hippo

Milan: Lib., Bibl. Ambrosiana,
 B.42 inf.
Giovanni d'Andrea, *Novella*, fol. 1r
Date: 1354

Milan: Lib., Bibl. Ambrosiana,
 H.106 sup.
Somme le Roi, fol. XLIVv
Date: ca. 1300

Munich: Lib., Staatsbibl., Clm. 2655
Thomas of Cantimpré, *De Natura
 Rerum*, fol. 105v
Date: 13th–14th cent.

Munich: Lib., Staatsbibl., Clm. 13002
Miscellany, fol. 4r
Date: 1158–1165
Joseph: Brethren Begging Forgiveness

Munich: Lib., Staatsbibl., Clm. 13601
Lectionary of Uta, fol. 1v
Date: ca. 1025
God: Hand

Munich: Lib., Staatsbibl., Clm. 14000
Gospel Book of S. Emmeram, fol. 1v
Date: Last quarter 10th cent.
Romualdus of Regensburg

Munich: Lib., Staatsbibl., Clm. 14159
Dialogus Cruce Christi, fol. 5v
Date: ca. 1170–1185
Christ in Mandorla

Munich: Lib., Staatsbibl., Clm. 30055
Gospel Book, Henry the Lion,
 fol. 172v
Date: ca. 1175
Evangelist: John

New York: Lib., Morgan, Pierpont,
 M.676
Dante, *Divina Commedia*, fol. 83v
Date: Late 14th cent.
Dante: Purgatorio

Nuremberg: Mus., Germ. Nat. Bibl.,
 156142
Gospel Book, Echternach, fol. 3r
Date: 10th–11th cent.

Oxford: Lib., Bodleian, 270b
Bible, Moralized, fol. 5v
Date: First half 13th cent.
Adam: Creation

Oxford: Lib., Bodleian, 270b
Bible, Moralized, fol. 13v
Date: First half 13th cent.
Abraham: Battle against Kings

Paris: Lib., Bibl. de l'Arsenal, 6329
Somme le Roi, fol. 96v
Date: 1311

Paris: Lib., Bibl. Mazarine, 870
Somme le Roi, fol. 83v
Date: 1295

Paris: Lib., Bibl. Nat. de France, lat. 1
Bible, Charles the Bald, fol. 215v
Date: First half 9th cent.
David and Musicians

Paris: Lib., Bibl. Nat. de France,
 lat. 817
Sacramentary, S. Gereon, fol. 77v
Date: 10th–11th cent.

Paris: Lib., Bibl. Nat. de France,
 lat. 8851
Gospel Book, S. Chapelle, fol. 16v
Date: 10th–11th cent.
Evangelist: Symbol

Paris: Lib., Bibl. Nat. de France,
 lat. 9436
Missal, S. Denis, fol. 106v
Date: 11th cent.
*Dionysius the Areopagite: Last
 Sacrament*

Rome: Mon., Paolo fuori le mura
Bible, S. Callisto, fol. 1r
Date: ca. 870
Charles the Bald?

Stuttgart: Lib., Landesbibl., Brev. 128
Lectionary, fol. 10r
Date: Mid-12th cent.
Lamb of God

Toledo: Lib., Bibl. del Cabildo
Bible, Moralized, I, fol. 5v
Date: First half 13th cent.
Adam: Creation

Troyes: Lib., Bibl. Municipale, 252
Speculum Virginum, fol. 14r
Date: ca. 1190
Virgin Mary and Christ Child

Wolfenbüttel: Lib., Herzog August
 Bibl., Guelf. 105 Noviss. 2°
Gospel Book, Henry the Lion,
 fol. 172v
Date: ca. 1175
Evangelist: John

Wolfenbüttel: Lib., Herzog August
 Bibl., Helmst 65
Gospel Book, fol. 62r
Date: 1194

Zwettl: Monastery, 180
Speculum Virginum, fol. 18r
Date: First third 13th cent.
Virgin Mary and Christ Child

METALWORK

Bamberg: Lib., Staatsbibl.
Book cover, silver (Lit. 1)
Date: 11th–12th cent.
Saint

Budapest: Mus., Magyar Nemzeti
 Múzeum
Aquamanile, bronze (Falke N. 329)
Date: ca. 1130

Cleveland: Museum of Art
Paten, S. Bernwardus (30.505)
Attribution: Master of the Oswald
 Reliquary
Date: Third quarter 12th cent.
Christ: Last Judgment

Cologne: Ch., Pantaleon
Casket, reliquary, Maurinus
Date: ca. 1180
Vincent of Saragossa: Scene

Fritzlar: Ch., Petrikirche
Cross, copper-gilt
Date: 10th–12th cent.
Lamb of God and Four Beasts

Gniezno: Mus., Archidiecezjalne
Chalice, of Trzemeszno, silver-gilt
Date: ca. 1160
Virgin Mary: Annunciation

Hildesheim: Cath., Maria
Font, bronze
Date: ca. 1220–1225
Virgin Mary and Christ Child

Lüneburg: Mon., Michael
Cross, reliquary, silver-gilt
Date: 12th–13th cent.
Christ: Crucifixion

Munich: Lib., Staatsbibl.
Book cover (Clm. 4452)
Date: ca. 1007–1012
Lamb of God

Munich: Mus., Bayerisches
 Nationalmus.
Altar, portable
Date: Early 11th cent.
Christ

Paris: Mus., Moyen Age, Cluny
Altar, portable, silver-gilt (Cl. 13072)
Date: First third 11th cent.
Blasius of Sebaste

Paris: Mus., Moyen Age, Cluny
Altar frontal, gold (Cl. 2350)
Date: Second or early third decade
 11th cent.
Christ

Sassoferrato: Pal., Comunale
Cross, silver-gilt
Date: 14th–15th cent.
Christ: Crucifixion

Vienna: Mus., Kunsthistorisches
Chalice, silver-gilt (8924)
Date: ca. 1160–1170
Personification: River of Paradise

MOSAIC

San Benedetto Po: Mon., Polirone
Pavement
Date: 1151–1152

Venice: Ch., Marco
Crossing
Date: Last quarter 12th cent.
Christ: Ascension

PAINTING

Florence: Mus., Opera del Duomo
Panel (9152)
Attribution: Bigallo Master
Date: ca. 1240–1250
Zenobius of Florence

Riggisberg: Coll., Abegg
Candlestick, wood
Attribution: Lippo Vanni
Date: Third quarter 14th cent.
Ansanus of Siena

SCULPTURE

Arezzo: Cathedral
Exterior, south
Date: 14th cent.
Virgin Mary: Annunciation

Bergamo: Baptistery
Exterior
Date: 14th cent.

Exeter: Cath., Peter
Exterior, west
Date: 14th–15th cent.
Angel

Florence: Ch., Croce
Tomb of Francesco and Simone
 de'Pazzi
Attribution: Alberto Arnoldi, Tino di
 Camaino, Gino Micheli
Date: Second quarter 14th cent.
Christ: Of Sorrows

Florence: Loggia dei Lanzi
Exterior
Date: 14th cent.

Florence: Mus., Opera del Duomo
Relief, from bell tower
Attribution: Maestro dell'Armatura,
 Maestro della Luna, Maestro di
 Saturno
Date: 1337–1341
Personification: Virtue, Faith

Genoa: Ch., Maria Maddalena
Exterior, west
Date: 14th cent.
Virgin Mary and Christ Child

Genoa: Mus., S. Agostino
Tomb of Margaret of Brabant
Attribution: Giovanni Pisano
Date: ca. 1313
Personification: Virtue, Fortitude

Mainz: Mus., Dom
Reliefs
Date: 13th cent.
Figure: Male

Milan: Ch., Eustorgio
Tomb of Peter Martyr
Attribution: Giovanni di Balduccio
Date: 1339
Christ

Milan: Mus., Archeologico
Relief, sarcophagus, of Vieri da
 Bassignana (291)
Date: Second half 14th cent.

Murbach: Ch., Abbey
Sarcophagus
Date: 11th cent.
Figure

Naples: Ch., Domenico Maggiore
Candlestick
Attribution: Pacio and Giovanni
 Bertini da Firenze, workshop of
Date: ca. 1330–1350

Naples: Ch., Maria di Donna Regina
Tomb of Maria of Hungary
Attribution: Tino di Camaino
Date: 1325–1326
Angel: Archangel Michael

Pavia: Ch., Pietro in Ciel d'Oro
Tomb of Augustine of Hippo
Attribution: Giovanni di Balduccio,
 follower of
Date: Second half 14th cent.
Augustine of Hippo: Scene

Pisa: Cathedral
Pulpit
Attribution: Giovanni Pisano
Date: 1302–1310
Virgin Mary: Annunciation

Pistoia: Ch., Giovanni Fuorcivitas
Holy water basin
Attribution: Nicola Pisano,
 workshop of
Date: Late 13th cent.

Tournai: Cath., Notre Dame
Exterior, south
Date: ca. 1140–1170
Christ: Last Judgment

Vices

❦

AMBITION

MANUSCRIPT

Munich: Lib., Staatsbibl., Clm. 13002
Miscellany, fol. 3v
Date: 1158–1165
Apocalypse: Scarlet Woman Drunk

Strasbourg: Lib., Bibl. Municipale
Herradis of Landsberg, *Hort. Delic.*,
 fol. 202v
Date: Second half 12th cent.
Personification: Virtue, Temperance

Strasbourg: Lib., Bibl. Municipale
Herradis of Landsberg, *Hort. Delic.*,
 fol. 203v
Date: Second half 12th cent.
Personification: Vice, Avarice

ANGER

ENAMEL

Troyes: Cath., Pierre, Treasury
Casket
Date: ca. 1200
Personification: Virtue, Faith

FRESCO

Hoxne: Ch., Peter and Paul
Nave
Date: Late 14th cent.
Tree of Vices

Ingatestone: Ch., Mary and Edmund
Decoration
Date: Late 14th cent.
Wheel of Vices

GLASS

Esslingen: Ch., Dionysius
Windows, choir
Date: Late 13th–14th cent.
Isaiah

MANUSCRIPT

Cambridge: Lib., University, Mm. 5.31
Alexander Laicus, *In Apocalipsin*, fol.
 115v
Date: 13th cent.
Personification: Vice, Lust

Paris: Lib., Bibl. Nat. de France, lat.
 8318
Prudentius, *Psychomachia*, fol. 54r
Date: Late 10th cent.

Rome: Lib., Bibl. Vaticana, gr. 394
John Climacus, *Climax*, fol. 94r
Date: Late 11th cent.
John Climacus: Climax, Chapter
 XVIII

METALWORK

Bergen: Mus., Historisk
Bowl, copper-gilt (BM 8566)
Date: 12th cent.
Personification: Vice, Pride

Berlin: Mus., Staatliche
Bowl, bronze (1471)
Date: 12th cent.
Personification: Vice, Discord

Berlin: Mus., Staatliche
Bowl, brass (K 4480)
Date: 12th cent.
Personification: Vice, Pride

Eger: Mus., Dobó István
Bowl
Date: 12th cent.
Personification: Vice, Pride

Halle: Mus., Landesmus. für
 Vorgeschichte
Bowl, bronze (HK 34.862)
Date: 12th cent.
Personification: Vice, Pride

Hannover: Mus., Kestner
Bowl, copper-gilt (IV.75)
Date: 12th–13th cent.
Personification: Vice, Pride

Kaliningrad: Mus., Regional
Bowl, bronze (18832)
Date: 12th cent.
Personification: Vice, Pride

Minden: Mus., Geschichte
Bowl, copper-gilt (E 454)
Date: 12th cent.
Personification: Vice, Pride

Orvieto: Mus., Civico
Bowl, bronze
Date: 12th cent.
Personification: Vice, Pride

Riga: Mus., Latvian Historical
Bowl, brass (23156?)
Date: 12th cent.
Personification: Vice, Pride

Strasbourg: Mus., Historique
Bowl, copper-gilt (700)
Date: 12th–13th cent.
Personification: Virtue, Humility

Strasbourg: Mus., Historique
Bowl (19336)
Date: 12th–13th cent.
Personification: Vice, Pride

Tallinn: Mus., Institute of History
Bowl, bronze (AI 4143:1)
Date: 12th cent.
Personification: Vice, Pride

Tallinn: Mus., Institute of History
Bowl (AI 4143:2)
Date: 12th cent.
Personification: Vice, Pride

Tallinn: Mus., Institute of History
Bowl, bronze (AI 4143:3)
Date: 12th cent.
Personification: Vice, Pride

Tallinn: Mus., Institute of History
Bowl (AI 4143:4)
Date: 12th cent.
Personification: Vice, Pride

SCULPTURE

Amiens: Cath., Notre Dame
Exterior, west
Date: 1220–1235
Malachi

Freiburg: Cath., Unsere Liebe Frau
Tower
Date: 13th–14th cent.
Virgin Mary: Coronation

Laon: Cath., Notre Dame
Exterior, west
Date: ca. 1180–1210
Magi: Adoration

Lincoln: Cathedral
Cloisters
Date: Late 13th cent.
Clergy: Bishop

Salisbury: Cathedral, Chapter House
Decoration, vestibule
Date: ca. 1260–1280
Personification: Virtues and Vices,
 Conflict

Strzelno: Ch., Trinity
Nave, column
Date: Last quarter 12th cent.
Christ: Baptism

ANXIETY

MANUSCRIPT

Strasbourg: Lib., Bibl. Municipale
Herradis of Landsberg, *Hort. Delic.*,
 fol. 202v
Date: Second half 12th cent.
Personification: Virtue, Temperance

ARROGANCE

MANUSCRIPT

Strasbourg: Lib., Bibl. Municipale
Herradis of Landsberg, *Hort. Delic.*,
 fol. 201v
Date: Second half 12th cent.
Personification: Vice, Obstinacy

AVARICE

ENAMEL

Florence: Mus., Naz. di Bargello
Crozier (Carrand 622)
Date: ca. 1185–1200
David: Slaying Bear

Osnabrück: Town Hall, Rathaus
Vessel
Date: First half 14th cent.
Personification: Virtue, Prudence

Troyes: Cath., Pierre, Treasury
Casket
Date: ca. 1200
Personification: Virtue, Faith

FRESCO

Assisi: Ch., Francesco, Lower
Crossing, vault
Date: First half 14th cent.
Allegory: Poverty

Bardwell: Ch., Peter and Paul
Nave
Date: Late 14th cent.
Tree of Vices

Felstead: Ch., Holy Cross
Nave
Date: Mid-14th cent.
Tree of Vices

Hoxne: Ch., Peter and Paul
Nave
Date: Late 14th cent.
Tree of Vices

Ingatestone: Ch., Mary and Edmund
Decoration
Date: Late 14th cent.
Wheel of Vices

Kastoria: Mon., Mavriotissa, Church
Decoration
Date: Late 11th–early 13th cent.
Virgin Mary and Christ Child

Kouvaras: Ch., George
Choir screen
Date: First half 13th cent.
Christ: Last Judgment

Kouvaras: Ch., Peter
Narthex
Date: 1232
Christ: Last Judgment

Siena: Ch., Francesco
Chapel, Bandini Piccolomini
Date: First half 14th cent.
Louis of Toulouse: Scene

Siena: Pal., Pubblico
Room, Pace
Attribution: Ambrogio Lorenzetti
Date: 1338–1339
Personification: Virtue, Justice

Summaga: Ch., Maria Assunta
Decoration
Date: 11th cent.
Virgin Mary and Christ Child

GLASS

Lyons: Cath., Jean
Window, apse
Date: ca. 1220
Magi: Before Herod the Great

Mulhouse: Ch., Etienne
Windows
Date: First half 14th cent.
Personification: Virtue, Sobriety

Niederhaslach: Ch., Florentius
Windows, nave
Date: 1290–1420
Christ: Parable, Prodigal Son

Paris: Cath., Notre Dame
Window, west rose
Date: First half 13th cent.
Virgin Mary and Christ Child

Strasbourg: Cath., Notre Dame
Windows, nave
Date: 14th cent.
Personification: Virtue, Wisdom

IVORY

London: Lib., British
Plaques, in book cover (Egerton 1139)
Date: 1131–1143
David: Slaying Lion

MANUSCRIPT

Albenga: Lib., Bibl. Capitolare, A.4
Psalter, fol. 72v
Date: 1220–1229
Personification: Vice, Iniquity

Brussels: Lib., Bibl. Royale, 9576
Roman de la Rose, fol. 2v
Date: 14th cent.

Brussels: Lib., Bibl. Royale, 9968-72
Prudentius, *Psychomachia*, fol. 98v
Date: 11th cent.

Brussels: Lib., Bibl. Royale, 9968-72
Prudentius, *Psychomachia*, fol. 105r
Date: 11th cent.
Personification: Virtue, Generosity

Brussels: Lib., Bibl. Royale, 9987-91
Prudentius, *Psychomachia*, fol. 113v
Date: 10th cent.

Brussels: Lib., Bibl. Royale, 9987-91
Prudentius, *Psychomachia*, fol. 114r
Date: 10th cent.

Brussels: Lib., Bibl. Royale, 9987-91
Prudentius, *Psychomachia*, fol. 114v
Date: 10th cent.

Brussels: Lib., Bibl. Royale, 9987-91
Prudentius, *Psychomachia*, fol. 116r
Date: 10th cent.

Brussels: Lib., Bibl. Royale, 9987-91
Prudentius, *Psychomachia*, fol. 116v
Date: 10th cent.

Brussels: Lib., Bibl. Royale, 9987-91
Prudentius, *Psychomachia*, fol. 118r
Date: 10th cent.

Brussels: Lib., Bibl. Royale, 9987-91
Prudentius, *Psychomachia*, fol. 118v
Date: 10th cent.
Personification: Virtue, Generosity

Brussels: Lib., Bibl. Royale, 10066-77
Prudentius, *Psychomachia*, fol. 127r
Date: 10th–first half 11th cent.

Brussels: Lib., Bibl. Royale, 10066-77
Prudentius, *Psychomachia*, fol. 128r
Date: 10th–first half 11th cent.

Brussels: Lib., Bibl. Royale, 10066-77
Prudentius, *Psychomachia*, fol. 130v
Date: 10th–first half 11th cent.
Personification: Virtue, Generosity

Brussels: Lib., Bibl. Royale, 11187
Roman de la Rose, fol. 4v
Date: Second half 14th cent.
Personification: Vice, Covetousness

Cambrai: Lib., Bibl. Municipale, 559
Augustine, *Varia*, fol. 69v
Date: 12th cent.
Personification: Vice, Luxury

Cambridge: Lib., Corpus Christi
College, 23
Prudentius, *Psychomachia*, fol. 26r
Date: Early 11th cent.

Cambridge: Lib., Corpus Christi
College, 23
Prudentius, *Psychomachia*, fol. 26v
Date: Early 11th cent.

Cambridge: Lib., Corpus Christi
College, 23
Prudentius, *Psychomachia*, fol. 27r
Date: Early 11th cent.

Cambridge: Lib., Corpus Christi
College, 23
Prudentius, *Psychomachia*, fol. 27v
Date: Early 11th cent.

Cambridge: Lib., Corpus Christi
College, 23
Prudentius, *Psychomachia*, fol. 29v
Date: Early 11th cent.

Cambridge: Lib., Corpus Christi
College, 23
Prudentius, *Psychomachia*, fol. 30r
Date: Early 11th cent.

Cambridge: Lib., Corpus Christi
College, 23
Prudentius, *Psychomachia*, fol. 30v
Date: Early 11th cent.

Cambridge: Lib., Corpus Christi
College, 23
Prudentius, *Psychomachia*, fol. 31r
Date: Early 11th cent.

Cambridge: Lib., Corpus Christi
College, 23
Prudentius, *Psychomachia*, fol. 31v
Date: Early 11th cent.

Cambridge: Mus., Fitzwilliam, 330
Psalter, W. de Brailes, no. 1
Date: ca. 1240
Psalms: Illustration

Kremsmünster: Lib., Stiftsbibl., 243
Spec. Hum. Salvationis, fol. 3r
Date: First half 14th cent.
Tree of Vices

Leiden: Lib., Bibl. der Univ., Burm. Q.3
Prudentius, *Psychomachia*, fol. 136v
Date: Second quarter 9th cent.

Leiden: Lib., Bibl. der Univ., Burm. Q.3
Prudentius, *Psychomachia*, fol. 137r
Date: Second quarter 9th cent.

Leiden: Lib., Bibl. der Univ., Burm. Q.3
Prudentius, *Psychomachia*, fol. 137v
Date: Second quarter 9th cent.

Leiden: Lib., Bibl. der Univ., Burm. Q.3
Prudentius, *Psychomachia*, fol. 138v
Date: Second quarter 9th cent.

Leiden: Lib., Bibl. der Univ., Burm. Q.3
Prudentius, *Psychomachia*, fol. 139r
Date: Second quarter 9th cent.

Leiden: Lib., Bibl. der Univ., Burm. Q.3
Prudentius, *Psychomachia*, fol. 139v
Date: Second quarter 9th cent.

Leiden: Lib., Bibl. der Univ., Burm. Q.3
Prudentius, *Psychomachia*, fol. 140r
Date: Second quarter 9th cent.

Leiden: Lib., Bibl. der Univ., Burm. Q.3
Prudentius, *Psychomachia*, fol. 140v
Date: Second quarter 9th cent.
Personification: Virtue, Generosity

Leiden: Lib., Bibl. der Univ., Voss. lat.
oct. 15
Prudentius, *Psychomachia*, fol. 41r
Date: Early 11th cent.

Leiden: Lib., Bibl. der Univ., Voss. lat.
oct. 15
Prudentius, *Psychomachia*, fol. 41v
Date: Early 11th cent.

London: Lib., British, Add. 18719
Bible, Moralized, fol. 228r
Date: Early 14th cent.
Judas Maccabaeus: Capture of Bosora

London: Lib., British, Add. 24199
Prudentius, *Psychomachia*, fol. 22v
Date: Early 11th cent.
Personification: Virtue, Sobriety

London: Lib., British, Add. 24199
Prudentius, *Psychomachia*, fol. 23r
Date: Early 11th cent.

London: Lib., British, Add. 24199
Prudentius, *Psychomachia*, fol. 23r
Date: Early 11th cent.

London: Lib., British, Add. 24199
Prudentius, *Psychomachia*, fol. 23v
Date: Early 11th cent.

London: Lib., British, Add. 24199
Prudentius, *Psychomachia*, fol. 24r
Date: Early 11th cent.

London: Lib., British, Add. 24199
Prudentius, *Psychomachia*, fol. 24v
Date: Early 11th cent.

London: Lib., British, Add. 24199
Prudentius, *Psychomachia*, fol. 25v
Date: Early 11th cent.

London: Lib., British, Add. 24199
Prudentius, *Psychomachia*, fol. 26r
Date: Early 11th cent.

London: Lib., British, Add. 24199
Prudentius, *Psychomachia*, fol. 26v
Date: Early 11th cent.

London: Lib., British, Add. 24199
Prudentius, *Psychomachia*, fol. 27r
Date: Early 11th cent.
Personification: Virtue, Generosity

London: Lib., British, Add. 24199
Prudentius, *Psychomachia*, fol. 27v
Date: Early 11th cent.

London: Lib., British, Add. 24199
Prudentius, *Psychomachia*, fol. 28r
Date: Early 11th cent.
Personification: Virtue, Generosity

London: Lib., British, Add. 28162
Somme le Roi, fol. 9v
Date: ca. 1300
Personification: Virtue, Mercy

London: Lib., British, Add. 54180
Somme le Roi, fol. 136r
Date: ca. 1300
Personification: Virtue, Mercy

London: Lib., British, Arundel 83
Psalter, fol. 128v
Date: First half 14th cent.
Psalms: Illustration

London: Lib., British, Cott. Cleo.
 C.VIII
Prudentius, *Psychomachia*, fol. 20v
Date: Early 11th cent.

London: Lib., British, Cott. Cleo.
 C.VIII
Prudentius, *Psychomachia*, fol. 21r
Date: Early 11th cent.

London: Lib., British, Cott. Cleo.
 C.VIII
Prudentius, *Psychomachia*, fol. 21v
Date: Early 11th cent.

London: Lib., British, Cott. Cleo.
 C.VIII
Prudentius, *Psychomachia*, fol. 22r
Date: Early 11th cent.

London: Lib., British, Cott. Cleo.
 C.VIII
Prudentius, *Psychomachia*, fol. 23r
Date: Early 11th cent.

London: Lib., British, Cott. Cleo.
 C.VIII
Prudentius, *Psychomachia*, fol. 23v
Date: Early 11th cent.

London: Lib., British, Cott. Cleo.
 C.VIII
Prudentius, *Psychomachia*, fol. 24v
Date: Early 11th cent.

London: Lib., British, Cott. Cleo.
 C.VIII
Prudentius, *Psychomachia*, fol. 25r
Date: Early 11th cent.

London: Lib., British, Cott. Cleo.
 C.VIII
Prudentius, *Psychomachia*, fol. 25v
Date: Early 11th cent.
Personification: Virtue, Generosity

London: Lib., British, Cott. Titus
 D.XVI
Prudentius, *Psychomachia*, fol. 20v
Date: ca. 1100

London: Lib., British, Cott. Titus
 D.XVI
Prudentius, *Psychomachia*, fol. 23r
Date: ca. 1100

London: Lib., British, Cott. Titus
 D.XVI
Prudentius, *Psychomachia*, fol. 24v
Date: ca. 1100
Personification: Virtue, Generosity

London: Lib., British, Roy. 19 C.II
Somme le Roi, fol. 73v
Date: 14th cent.
Lot: Entertaining Angels

Lyons: Lib., Bibl. Municipale, Pal. des
 Arts 22
Prudentius, *Psychomachia*, fol. 8v
Date: Last quarter 11th cent.

Lyons: Lib., Bibl. Municipale, Pal. des
 Arts 22
Prudentius, *Psychomachia*, fol. 9r
Date: Last quarter 11th cent.

Lyons: Lib., Bibl. Municipale, Pal. des
 Arts 22
Prudentius, *Psychomachia*, fol. 9v
Date: Last quarter 11th cent.

Lyons: Lib., Bibl. Municipale, Pal. des
 Arts 22
Prudentius, *Psychomachia*, fol. 10r
Date: Last quarter 11th cent.

Lyons: Lib., Bibl. Municipale, Pal. des
 Arts 22
Prudentius, *Psychomachia*, fol. 10v
Date: Last quarter 11th cent.

Lyons: Lib., Bibl. Municipale, Pal. des
 Arts 22
Prudentius, *Psychomachia*, fol. 13r
Date: Last quarter 11th cent.

Lyons: Lib., Bibl. Municipale, Pal. des
 Arts 22
Prudentius, *Psychomachia*, fol. 13v
Date: Last quarter 11th cent.
Personification: Virtue, Generosity

Lyons: Lib., Bibl. Municipale, Pal. des
 Arts 22
Prudentius, *Psychomachia*, fol. 14v
Date: Last quarter 11th cent.

Lyons: Lib., Bibl. Municipale, Pal. des
 Arts 22
Prudentius, *Psychomachia*, fol. 15r
Date: Last quarter 11th cent.
Personification: Virtue, Generosity

Malines: Lib., Grand Séminaire
Bible, Nicolò de Alifio, p. 1
Date: Mid-14th cent.
Robert of Anjou

Milan: Lib., Bibl. Ambrosiana,
 H.106 sup.
Somme le Roi, fol. LXIv
Date: ca. 1300
Personification: Virtue, Mercy

Milan: Lib., Bibl. Naz. Braidense,
 A.D. XIII.48
Pietro da Barsegapè, *Sermons*, fol. 8r
Date: 13th–14th cent.

Munich: Lib., Staatsbibl., Clm. 30055
Gospel Book, Henry the Lion, fol. 17v
Date: ca. 1175
Evangelist: Luke

Oxford: Lib., Bodleian, 270b
Bible, Moralized, fol. 26r
Date: First half 13th cent.
Joseph: As Interpreter of Dreams

Oxford: Lib., Bodleian, 270b
Bible, Moralized, fol. 36r
Date: First half 13th cent.
*Pharaoh: Commanding Affliction of
 Israelites*

Oxford: Lib., Bodleian, 270b
Bible, Moralized, fol. 37v
Date: First half 13th cent.
Pharaoh: Command Disobeyed

Oxford: Lib., Bodleian, 270b
Bible, Moralized, fol. 64r
Date: First half 13th cent.
Moses: Law, Priests without Blemish

Paris: Lib., Bibl. Nat. de France, fr. 167
Bible, Moralized, fol. 59r
Date: ca. 1350
Samson: Delilah Bribed by Philistines

Paris: Lib., Bibl. Nat. de France,
 lat. 2077
Miscellany, fol. 163r
Date: 10th–11th cent.
Personification: Vice, Pride

Paris: Lib., Bibl. Nat. de France,
 lat. 8085
Prudentius, *Psychomachia*, fol. 63v
Date: Late 9th cent.
Personification: Virtue, Sobriety

Paris: Lib., Bibl. Nat. de France,
 lat. 8085
Prudentius, *Psychomachia*, fol. 64r
Date: Late 9th cent.

Paris: Lib., Bibl. Nat. de France,
 lat. 8085
Prudentius, *Psychomachia*, fol. 64v
Date: Late 9th cent.

Paris: Lib., Bibl. Nat. de France,
 lat. 8085
Prudentius, *Psychomachia*, fol. 65r
Date: Late 9th cent.

Paris: Lib., Bibl. Nat. de France,
 lat. 8085
Prudentius, *Psychomachia*, fol. 66r
Date: Late 9th cent.
Personification: Virtue, Generosity

Paris: Lib., Bibl. Nat. de France,
 lat. 8318
Prudentius, *Psychomachia*, fol. 53v
Date: Late 10th cent.
Personification: Vice, Fornication

Paris: Lib., Bibl. Nat. de France,
 lat. 8318
Prudentius, *Psychomachia*, fol. 58v
Date: Late 10th cent.
Personification: Vice, Profane Love

Paris: Lib., Bibl. Nat. de France,
 lat. 8318
Prudentius, *Psychomachia*, fol. 59r
Date: Late 10th cent.

Paris: Lib., Bibl. Nat. de France,
 lat. 8318
Prudentius, *Psychomachia*, fol. 59v
Date: Late 10th cent.

Paris: Lib., Bibl. Nat. de France,
 lat. 8318
Prudentius, *Psychomachia*, fol. 60r
Date: Late 10th cent.

Paris: Lib., Bibl. Nat. de France,
 lat. 8318
Prudentius, *Psychomachia*, fol. 60v
Date: Late 10th cent.

Paris: Lib., Bibl. Nat. de France,
 lat. 8318
Prudentius, *Psychomachia*, fol. 61r
Date: Late 10th cent.

Paris: Lib., Bibl. Nat. de France,
 lat. 15158
Prudentius, *Psychomachia*, fol. 49v
Date: 1289
Personification: Virtue, Sobriety

Paris: Lib., Bibl. Nat. de France,
 lat. 15158
Prudentius, *Psychomachia*, fol. 50r
Date: 1289

Paris: Lib., Bibl. Nat. de France,
 lat. 15158
Prudentius, *Psychomachia*, fol. 50v
Date: 1289

Paris: Lib., Bibl. Nat. de France,
 lat. 15158
Prudentius, *Psychomachia*, fol. 51r
Date: 1289

Paris: Lib., Bibl. Nat. de France,
 lat. 15158
Prudentius, *Psychomachia,* fol. 51v
Date: 1289

Paris: Lib., Bibl. Nat. de France,
 lat. 15158
Prudentius, *Psychomachia*, fol. 52v
Date: 1289

Paris: Lib., Bibl. Nat. de France,
 lat. 15158
Prudentius, *Psychomachia*, fol. 53r
Date: 1289

Paris: Lib., Bibl. Nat. de France,
 lat. 15158
Prudentius, *Psychomachia*, fol. 53v
Date: 1289

Paris: Lib., Bibl. Nat. de France,
 lat. 15158
Prudentius, *Psychomachia*, fol. 54r
Date: 1289

Paris: Lib., Bibl. Nat. de France,
 lat. 15158
Prudentius, *Psychomachia*, fol. 54v
Date: 1289

Rome: Lib., Bibl. Vaticana, gr. 394
John Climacus, *Climax*, fol. 89v
Date: Late 11th cent.
John Climacus: Climax, Chapter XV

Saint Gall: Lib., Stiftsbibl., 135
Prudentius, *Psychomachia*, p. 405
Date: First half 11th cent.

Saint Gall: Lib., Stiftsbibl., 135
Prudentius, *Psychomachia*, p. 406
Date: First half 11th cent.
Personification: Virtue, Generosity

Saint Gall: Lib., Stiftsbibl., 135
Prudentius, *Psychomachia*, p. 419
Date: First half 11th cent.

Saint Gall: Lib., Stiftsbibl., 135
Prudentius, *Psychomachia*, p. 420
Date: First half 11th cent.
Personification: Virtue, Reason

Salzburg: Lib., Studienbibl., V 1 H 162
Miscellany, fol. 75v
Date: First half 12th cent.
Tree of Vices

Strasbourg: Lib., Bibl. Municipale
Herradis of Landsberg, *Hort. Delic.,*
 fol. 199v
Date: Second half 12th cent.
Personification: Vice, Pride

Strasbourg: Lib., Bibl. Municipale
Herradis of Landsberg, *Hort. Delic.,*
 fol. 202v
Date: Second half 12th cent.
Personification: Virtue, Temperance

Strasbourg: Lib., Bibl. Municipale
Herradis of Landsberg, *Hort. Delic.,*
 fol. 203r
Date: Second half 12th cent.
Personification: Vice, Pillage

Strasbourg: Lib., Bibl. Municipale
Herradis of Landsberg, *Hort. Delic.,*
 fol. 203v
Date: Second half 12th cent.

Toledo: Lib., Bibl. del Cabildo
Bible, Moralized, II, fol. 221v
Date: First half 13th cent.
Zachariah: Vision, Ephah and Talent

Toledo: Lib., Bibl. del Cabildo
Bible, Moralized, III, fol. 188r
Date: First half 13th cent.
Apocalypse: Lamb, Victory over Kings

Valenciennes: Lib., Bibl. Municipale,
 563
Prudentius, *Psychomachia*, fol. 24r
Date: Early 11th cent.

Valenciennes: Lib., Bibl. Municipale,
 563
Prudentius, *Psychomachia*, fol. 24v
Date: Early 11th cent.

Valenciennes: Lib., Bibl. Municipale,
 563
Prudentius, *Psychomachia*, fol. 25r
Date: Early 11th cent.

Valenciennes: Lib., Bibl. Municipale,
 563
Prudentius, *Psychomachia*, fol. 25v
Date: Early 11th cent.

Valenciennes: Lib., Bibl. Municipale,
 563
Prudentius, *Psychomachia*, fol. 31r
Date: Early 11th cent.
Personification: Virtue, Generosity

Vienna: Lib., Nationalbibl., 1179
Bible, Moralized, fol. 196r
Date: ca. 1215–1230
*Judas Maccabaeus: Cleansing of
 Sanctuary*

Vienna: Lib., Nationalbibl., 2583*
Matfre Ermengaud, *Brev. d'Amor*,
 fol. 237v
Date: 14th cent.
Personification: Virtue, Generosity

Vienna: Lib., Nationalbibl., 2592
Roman de la Rose, fol. 2v
Date: Second half 14th cent.

Vorau: Lib., Stiftsbibl., lat. 130
G. of Vorau, *Lumen Animae*, fol. 107r
Date: 1332

Wolfenbüttel: Lib., Herzog August
 Bibl., Guelf. 105 Noviss. 2°
Gospel Book, Henry the Lion, fol. 17v
Date: ca. 1175
Evangelist: Luke

METALWORK

Berlin: Mus., Staatliche
Bowl, bronze (1471)
Date: 12th cent.
Personification: Vice, Discord

Hamburg: Mus., Kunst und Gewerbe
Aquamanile, bronze
Date: 1200–1230
Animal: Vessel

Trier: Ch., Maximin
Font, of Folcardus
Date: Early 12th cent.
Personification: Virtue, Humility

MISCELLANEOUS

Chantilly: Mus., Condé
Drawing, after Giotto (1)
Date: 14th cent.
Personification: Virtue, Charity

PAINTING

Florence: Gall., Uffizi
Panel (P752)
Attribution: Giovanni del Biondo
Date: ca. 1380
Evangelist: John

SCULPTURE

Amiens: Cath., Notre Dame
Exterior, west
Date: 1220–1235
Malachi

Aulnay-de-Saintonge: Ch., Pierre
Exterior, west
Date: ca. 1130–1150
Month: Occupation

Autun: Cath., Lazare
Chapter room
Date: First half 12th cent.
Scene: Ecclesiastic, Donation

Autun: Cath., Lazare
Exterior, west
Date: First half 12th cent.
Christ: Last Judgment

Beaulieu: Ch., Pierre
Exterior, south
Date: 12th cent.
Christ: Last Judgment

Blesle: Ch., Pierre
Exterior, east
Date: 12th cent.
Personification: Vice, Luxury

Bordeaux: Ch., Croix
Exterior, west
Date: ca. 1130–1140
Angel

Chanteuges: Ch., Marcellin
Capital, south wall
Date: 12th cent.

Chartres: Cath., Notre Dame
Exterior, north, buttress
Date: ca. 1220
Clergy, Bishop

Chartres: Cath., Notre Dame
Exterior, north, central portal
Date: 1205–1210
Virgin Mary: Coronation

Chartres: Cath., Notre Dame
Exterior, north, left portal
Date: ca. 1220
Virgins, Foolish

Chartres: Cath., Notre Dame
Porch, south
Date: ca. 1230–1240
Saint

Clermont-Ferrand: Ch., Notre Dame
 du Port
Choir
Date: 12th cent.
Angel

Cologne: Cath., Peter und Maria
Choir stalls, south side
Date: First half 14th cent.
Scene: Secular

Conques: Ch., Foy
Exterior, west
Date: First half 12th cent.
Christ: Last Judgment

Conques: Ch., Foy
Transept, north
Date: Late 11th–12th cent.
Devil

Ennezat: Ch., Victor et Ste. Couronne
Nave
Date: Second half 11th–12th cent.
Figure: Male, Usurer

Fornovo di Taro: Ch., Maria Assunta
Exterior, west
Date: ca. 1200
Animal: Fantastic, Centaur

Freiburg: Cath., Unsere Liebe Frau
Tower
Date: 13th–14th cent.
Virgin Mary: Coronation

Frómista: Ch., Martin
Exterior, north
Date: 11th–12th cent.

Guebwiller: Ch., Léger
Exterior
Date: Late 12th cent.
Ornament: Figured

Laon: Cath., Notre Dame
Exterior, west
Date: ca. 1180–1210
Magi: Adoration

Lasvaux: Church
Capital
Date: 12th cent.
Virgin Mary: Annunciation

Lavaudieu: Ch., Abbey, Cloister
Capital
Date: 12th cent.

León: Ch., Isidoro
Gallery
Date: Second half 11th cent.

Lucheux: Church
Decoration
Date: 12th cent.
Ornament: Figured

Moissac: Ch., Pierre
Exterior, south
Date: First half 12th cent.
*Apocalypse: Christ, Adoration by
 Elders*

Mozac: Church
Nave
Date: 12th cent.
Tobias: Taking Fish

Orcival: Church
Capitals
Date: 12th cent.
Ornament: Figured

Paris: Cath., Notre Dame
Exterior, west
Date: ca. 1220–1230
Christ: Last Judgment

Philadelphia (Penn.): Mus., Museum
 of Art
Capital, sandstone (45.25.47)
Date: Late 12th cent.
Personification: Vice

Piacenza: Cath., Assunta
Exterior, west, central portal
Date: ca. second quarter 12th cent.

Poitiers: Cath., Pierre
Choir stalls, wood
Date: Second half 13th–14th cent.
Angel

Regensburg: Ch., Jakob
Exterior, north
Date: Second half 12th cent.
Christ

Reims: Cath., Notre Dame
Exterior, west
Date: ca. 1230–1250
Virgin Mary: Coronation

Saint-Parize-le-Châtel: Church
Crypt
Date: ca. 1113
Figure: Male, Fabulous Type

Saint-Pons: Pref., Sous-Préfecture
Capital
Date: Second half 11th cent.
Personification: Vice, Luxury

Salisbury: Cathedral, Chapter House
Decoration, vestibule
Date: ca. 1260–1280
*Personification: Virtues and Vices,
 Conflict*

Sens: Cath., Etienne
Exterior, west
Date: Late 12th–13th cent.
Stephen Protomartyr: In Synagogue

Southrop: Church
Font
Date: ca. 1160
*Personification: Church and
 Synagogue*

Stanton Fitzwarren: Church
Font
Date: ca. 1160
Personification: Church

Toulouse: Ch., Sernin
Exterior, south
Date: Late 11th–12th cent.
Christ: Ascension

Venice: Ch., Marco
Reliefs
Date: 12th–13th cent.

Vézelay: Ch., Madeleine
Nave
Date: First half 12th cent.
Saint

Villeneuve-l'Archêveque: Church
Exterior, north
Date: First half 13th cent.
Virgin Mary: Coronation

BAD HABIT

MANUSCRIPT

Rome: Lib., Bibl. Vaticana, gr. 394
John Climacus, *Climax*, fol. 94r
Date: Late 11th cent.
John Climacus: Climax, Chapter
 XVIII

BITTERNESS

MANUSCRIPT

Strasbourg: Lib., Bibl. Municipale
Herradis of Landsberg, *Hort. Delic.*,
 fol. 200v
Date: Second half 12th cent.
Personification: Vice, Wrath

BLASPHEMY

MANUSCRIPT

Rome: Lib., Bibl. Vaticana, gr. 394
John Climacus, *Climax*, fol. 105r
Date: Late 11th cent.
John Climacus: Climax, Chapter
 XXIII, Part 1

Strasbourg: Lib., Bibl. Municipale
Herradis of Landsberg, *Hort. Delic.*,
 fol. 200v
Date: Second half 12th cent.
Personification: Vice, Wrath

Strasbourg: Lib., Bibl. Municipale
Herradis of Landsberg, *Hort. Delic.*,
 fol. 203v
Date: Second half 12th cent.
Personification: Vice, Avarice

SCULPTURE

Philadelphia (Penn.): Mus., Museum
 of Art
Capital, sandstone (45.25.47)
Date: Late 12th cent.
Personification: Vice

BOASTFULNESS

MANUSCRIPT

Paris: Lib., Bibl. Nat. de France,
 lat. 2077
Miscellany, fol. 164v
Date: 10th–11th cent.
Personification: Virtue, Humility

Strasbourg: Lib., Bibl. Municipale
Herradis of Landsberg, *Hort. Delic.*,
 fol. 210v
Date: Second half 12th cent.
Personification: Vice, Obstinacy

CARE

MANUSCRIPT

Strasbourg: Lib., Bibl. Municipale
Herradis of Landsberg, *Hort. Delic.*,
 fol. 202v
Date: Second half 12th cent.
Personification: Virtue, Temperance

CLAMOR

MANUSCRIPT

Strasbourg: Lib., Bibl. Municipale
Herradis of Landsberg, *Hort. Delic.*,
 fol. 200v
Date: Second half 12th cent.
Personification: Vice, Wrath

CONTUMACY

GLASS

Paris: Cath., Notre Dame
Window, west rose
Date: First half 13th cent.
Virgin Mary and Christ Child

SCULPTURE

Amiens: Cath., Notre Dame
Exterior, west
Date: 1220–1235
Malachi

Magdeburg: Cath., Mauritius und
 Katharina
Choir
Date: First half 13th cent.
Apostle: Andrew

Paris: Cath., Notre Dame
Exterior, west
Date: ca. 1220–1230
Christ: Last Judgment

CONTUMELY

MANUSCRIPT

Strasbourg: Lib., Bibl. Municipale
Herradis of Landsberg, *Hort. Delic.*,
 fol. 200v
Date: Second half 12th cent.
Personification: Vice, Wrath

CORPORAL BEAUTY

MANUSCRIPT

Florence: Lib., Bibl. Naz. Centrale,
 Palat. 600
Bartholomew of S. Concordio,
 Ammaestramenti, fol. 5v
Date: 14th cent.

Strasbourg: Lib., Bibl. Municipale
Herradis of Landsberg, *Hort. Delic.*,
 fol. 202v
Date: Second half 12th cent.
Personification: Virtue, Temperance

COVETOUSNESS

FRESCO

London: Pal., Westminster
Painted Chamber
Date: Late 13th cent.
Maccabees: Battle

MANUSCRIPT

Brussels: Lib., Bibl. Royale, 11187
Roman de la Rose, fol. 4v
Date: Second half 14th cent.

Strasbourg: Lib., Bibl. Municipale
Herradis of Landsberg, *Hort. Delic.*,
 fol. 202v
Date: Second half 12th cent.
Personification: Virtue, Temperance

Strasbourg: Lib., Bibl. Municipale
Herradis of Landsberg, *Hort. Delic.*,
 fol. 203v
Date: Second half 12th cent.
Personification: Vice, Avarice

Vienna: Lib., Nationalbibl., 2554
Bible, Moralized, fol. 2r
Date: ca. 1215–1230
Eve: Given to Adam by God

COWARDICE

GLASS

Paris: Cath., Notre Dame
Window, west rose
Date: First half 13th cent.
Virgin Mary and Christ Child

MANUSCRIPT

Strasbourg: Lib., Bibl. Municipale
Herradis of Landsberg, *Hort. Delic.*,
 fol. 210v
Date: Second half 12th cent.
Personification: Vice, Obstinacy

SCULPTURE

Amiens: Cath., Notre Dame
Exterior, west
Date: 1220–1235
Malachi

Chartres: Cath., Notre Dame
Exterior, north, central portal
Date: 1205–1210
Virgin Mary: Coronation

Chartres: Cath., Notre Dame
Exterior, north, left portal
Date: ca. 1220
Virgins, Foolish

Chartres: Cath., Notre Dame
Porch, south
Date: ca. 1230–1240
Saint

Lyons: Cath., Jean
Exterior, west
Date: First half 14th cent.
Weighing of Soul

Magdeburg: Cath., Mauritius und
 Katharina
Choir
Date: First half 13th cent.
Apostle: Andrew

Paris: Cath., Notre Dame
Exterior, west
Date: ca. 1220–1230
Christ: Last Judgment

Reims: Cath., Notre Dame
Exterior, west
Date: ca. 1230–1240
Virgin Mary: Coronation

Rouen: Cath., Notre Dame
Exterior, north
Date: Late 13th–14th cent.
Creation Scene

CRUELTY

FRESCO

Siena: Pal., Pubblico
Room, Pace
Attribution: Ambrogio Lorenzetti
Date: 1338–1339
Personification: Virtue, Justice

MOSAIC

Cremona: Cathedral
Pavement
Date: First half 12th cent.
Pagan Type: Satyr

SCULPTURE

Chartres: Cath., Notre Dame
Porch, north
Date: ca. 1205–1210
Creation Scene

CUPIDITY

FRESCO

Assisi: Ch., Francesco, Lower
Crossing, vault
Date: First half 14th cent.
Allegory: Poverty

Brioude: Ch., Julien
Porch
Date: 12th–13th cent.
Christ: Last Judgment

GLASS

Lyons: Cath., Jean
Window, apse
Date: ca. 1220
Magi: Before Herod the Great

MANUSCRIPT

Munich: Lib., Staatsbibl., Clm. 13002
Miscellany, fol. 3v
Date: 1158–1165
Apocalypse: Scarlet Woman Drunk

Oxford: Lib., Bodleian, 270b
Bible, Moralized, fol. 36r
Date: First half 13th cent.
*Pharaoh: Commanding Affliction of
 Israelites*

MISCELLANEOUS

Chantilly: Mus., Condé
Drawing, after Giotto (1)
Date: 14th cent.
Personification: Virtue, Charity

CURIOSITY

SCULPTURE

Chartres: Cath., Notre Dame
Porch, north
Date: ca. 1205–1210
Creation Scene

DECEIT

FRESCO

Siena: Pal., Pubblico
Room, Pace
Attribution: Ambrogio Lorenzetti
Date: 1338–1339
Personification: Virtue, Justice

GLASS

Esslingen: Ch., Dionysius
Windows, choir
Date: Late 13th–14th cent.
Isaiah

Niederhaslach: Ch., Florentius
Windows, nave
Date: 1290–1420
Christ: Parable, Prodigal Son

Strasbourg: Cath., Notre Dame
Windows, nave
Date: 14th cent.
Personification: Virtue, Wisdom

MANUSCRIPT

Cambridge: Lib., Trinity College,
R.17.1
Psalter, Canterbury, fol. 12v
Date: ca. 1145–1170
Psalm 7

Cambridge: Lib., University, Mm. 5.31
Alexander Laicus, *In Apocalipsin*, fol.
115v
Date: 13th cent.
Personification: Vice, Lust

London: Lib., British, Add. 19352
Theodore Psalter, fol. 182v
Date: 1066
Psalm 164 (LXX, 163)

London: Lib., British, Harley 603
Psalter, fol. 4r
Date: ca. 1000–12th cent.
Psalm 7

Paris: Lib., Bibl. Nat. de France,
lat. 8846
Psalter, fol. 12v
Date: 12th–13th cent.
Psalm 7

Rome: Lib., Bibl. Vaticana, Barb.
gr. 372
Psalter, fol. 231v
Date: 11th cent.
Psalm 144 (LXX, 143)

Rome: Lib., Bibl. Vaticana, Reg. lat. 12
Psalter, fol. 25r
Date: Early 11th cent.
Psalm 7

Strasbourg: Lib., Bibl. Municipale
Herradis of Landsberg, *Hort. Delic.*,
 fol. 201v
Date: Second half 12th cent.
Personification: Vice, Obstinacy

Strasbourg: Lib., Bibl. Municipale
Herradis of Landsberg, *Hort. Delic.*,
 fol. 202v
Date: Second half 12th cent.
Personification: Virtue, Temperance

Utrecht: Lib., Bibl. der Universiteit, 32
Psalter, fol. 4r
Date: ca. 820–830
Psalm 7

METALWORK

Trier: Ch., Maximin
Font, of Folcardus
Date: Early 12th cent.
Personification: Virtue, Humility

DELIGHT

MANUSCRIPT

Strasbourg: Lib., Bibl. Municipale
Herradis of Landsberg, *Hort. Delic.*,
 fol. 201v
Date: Second half 12th cent.
Personification: Vice, Obstinacy

DESPAIR

FRESCO

Padua: Chap., Madonna dell'Arena
Decoration
Attribution: Giotto
Date: ca. 1303–1308
Virgin Mary: Birth

Summaga: Ch., Maria Assunta
Decoration
Date: 11th cent.
Virgin Mary and Christ Child

Tavant: Ch., Nicolas
Crypt
Date: 11th–13th cent.
Adam and Eve: Fall of Man

GLASS

Esslingen: Ch., Dionysius
Windows, choir
Date: Late 13th–14th cent.
Isaiah

Niederhaslach: Ch., Florentius
Windows, nave
Date: 1290–1420
Christ: Parable, Prodigal Son

Paris: Cath., Notre Dame
Window, west rose
Date: First half 13th cent.
Virgin Mary and Christ Child

Strasbourg: Cath., Notre Dame
Windows, nave
Date: 14th cent.
Personification: Virtue, Wisdom

MANUSCRIPT

Paris: Lib., Bibl. Nat. de France,
 lat. 8318
Prudentius, *Psychomachia*, fol. 54r
Date: Late 10th cent.
Personification: Vice, Anger

METALWORK

Trier: Ch., Maximin
Font, of Folcardus
Date: Early 12th cent.
Personification: Virtue, Humility

SCULPTURE

Amiens: Cath., Notre Dame
Exterior, west
Date: 1220–1235
Malachi

Chartres: Cath., Notre Dame
Exterior, north, central portal
Date: 1205–1210
Virgin Mary: Coronation

Chartres: Cath., Notre Dame
Exterior, north, left portal
Date: ca. 1220
Virgins, Foolish

Chartres: Cath., Notre Dame
Porch, south
Date: ca. 1230–1240
Saint

Paris: Cath., Notre Dame
Exterior, west
Date: ca. 1220–1230
Christ: Last Judgment

Regensburg: Ch., Jakob
Exterior, north
Date: Second half 12th cent.
Christ

Reims: Cath., Notre Dame
Exterior, west
Date: ca. 1230–1240
Virgin Mary: Coronation

Rouen: Cath., Notre Dame
Exterior, north
Date: Late 13th–14th cent.
Angel

Salisbury: Cathedral, Chapter House
Decoration, vestibule
Date: ca. 1260–1280
Personification: Virtues and Vices,
 Conflict

Uppsala: Cathedral
Choir
Date: Late 13th–14th cent.
Virgin Mary: Death

Vézelay: Ch., Madeleine
Nave
Date: First half 12th cent.
Saint

DISCORD

ENAMEL

Florence: Mus., Naz. di Bargello
Crozier (Carrand 622)
Date: ca. 1185–1200
David: Slaying Bear

Osnabrück: Town Hall, Rathaus
Vessel
Date: First half 14th cent.
Personification: Virtue, Prudence

Troyes: Cath., Pierre, Treasury
Casket
Date: ca. 1200
Personification: Virtue, Faith

FRESCO

Aquileia: Cathedral
Crypt
Date: 1180s
Personification: Virtue, Concord

GLASS

Paris: Cath., Notre Dame
Window, west rose
Date: First half 13th cent.
Virgin Mary and Christ Child

Strasbourg: Cath., Notre Dame
Windows, nave
Date: 14th cent.
Personification: Virtue, Wisdom

IVORY

London: Lib., British
Plaques, in book cover (Egerton 1139)
Date: 1131–1143
David: Slaying Lion

MANUSCRIPT

Brussels: Lib., Bibl. Royale, 9987-91
Prudentius, *Psychomachia*, fol. 120r
Date: 10th cent.

Brussels: Lib., Bibl. Royale, 9987-91
Prudentius, *Psychomachia*, fol. 120v
Date: 10th cent.

Brussels: Lib., Bibl. Royale, 9987-91
Prudentius, *Psychomachia*, fol. 121r
Date: 10th cent.
Personification: Virtue, Faith

Brussels: Lib., Bibl. Royale, 10066-77
Prudentius, *Psychomachia*, fol. 132v
Date: 10th–first half 11th cent.

Brussels: Lib., Bibl. Royale, 10066-77
Prudentius, *Psychomachia*, fol. 133r
Date: 10th–first half 11th cent.

Brussels: Lib., Bibl. Royale, 10066-77
Prudentius, *Psychomachia*, fol. 133v
Date: 10th–first half 11th cent.
Personification: Virtue, Faith

Cambridge: Lib., Corpus Christi
College, 23
Prudentius, *Psychomachia*, fol. 35r
Date: Early 11th cent.

Cambridge: Lib., Corpus Christi
College, 23
Prudentius, *Psychomachia*, fol. 35v
Date: Early 11th cent.

Cambridge: Lib., Corpus Christi
College, 23
Prudentius, *Psychomachia*, fol. 36r
Date: Early 11th cent.

Cambridge: Lib., Corpus Christi
College, 23
Prudentius, *Psychomachia*, fol. 36v
Date: Early 11th cent.
Personification: Virtue, Faith

Cambridge: Lib., Corpus Christi
College, 23
Prudentius, *Psychomachia*, fol. 37r
Date: Early 11th cent.

Leiden: Lib., Bibl. der Univ., Burm. Q.3
Prudentius, *Psychomachia*, fol. 143r
Date: Second quarter 9th cent.
Personification: Virtue, Concord

Leiden: Lib., Bibl. der Univ., Burm. Q.3
Prudentius, *Psychomachia*, fol. 143v
Date: Second quarter 9th cent.

Leiden: Lib., Bibl. der Univ., Burm. Q.3
Prudentius, *Psychomachia*, fol. 144r
Date: Second quarter 9th cent.
Personification: Virtue, Faith

Leiden: Lib., Bibl. der Univ., Voss. lat.
oct. 15
Prudentius, *Psychomachia*, fol. 42r
Date: Early 11th cent.
Personification: Virtue, Concord

Leiden: Lib., Bibl. der Univ., Voss. lat.
 oct. 15
Prudentius, *Psychomachia*, fol. 42v
Date: Early 11th cent.

London: Lib., British, Add. 24199
Prudentius, *Psychomachia*, fol. 31r
Date: Early 11th cent.

London: Lib., British, Add. 24199
Prudentius, *Psychomachia*, fol. 31v
Date: Early 11th cent.

London: Lib., British, Add. 24199
Prudentius, *Psychomachia*, fol. 32r
Date: Early 11th cent.

London: Lib., British, Add. 24199
Prudentius, *Psychomachia*, fol. 32v
Date: Early 11th cent.

London: Lib., British, Cott. Cleo.
 C.VIII
Prudentius, *Psychomachia*, fol. 28v
Date: Early 11th cent.

London: Lib., British, Cott. Cleo.
 C.VIII
Prudentius, *Psychomachia*, fol. 29r
Date: Early 11th cent.

London: Lib., British, Cott. Titus
 D.XVI
Prudentius, *Psychomachia*, fol. 26v
Date: ca. 1100
Personification: Virtue, Concord

London: Lib., British, Cott. Titus
 D.XVI
Prudentius, *Psychomachia*, fol. 28r
Date: ca. 1100

London: Lib., British, Cott. Titus
 D.XVI
Prudentius, *Psychomachia*, fol. 28v
Date: ca. 1100
Personification: Virtue, Faith

Lyons: Lib., Bibl. Municipale, Pal. des
 Arts 22
Prudentius, *Psychomachia*, fol. 16r
Date: Last quarter 11th cent.

Munich: Lib., Staatsbibl., Clm. 30055
Gospel Book, Henry the Lion, fol. 17v
Date: ca. 1175
Evangelist: Luke

Munich: Lib., Staatsbibl., Clm. 30055
Gospel Book, Henry the Lion, fol. 18r
Date: ca. 1175
Apostle: Paul

Paris: Lib., Bibl. Nat. de France, fr.
 19093
Sketchbook, Villard de Honnecourt,
 fol. 8v
Date: Mid-13th cent.

Paris: Lib., Bibl. Nat. de France, lat.
 8085
Prudentius, *Psychomachia*, fol. 66v
Date: Late 9th cent.
Personification: Virtue, Concord

Paris: Lib., Bibl. Nat. de France, lat.
 8085
Prudentius, *Psychomachia*, fol. 67r
Date: Late 9th cent.

Paris: Lib., Bibl. Nat. de France, lat.
 8085
Prudentius, *Psychomachia*, fol. 67v
Date: Late 9th cent.

Paris: Lib., Bibl. Nat. de France, lat.
 8318
Prudentius, *Psychomachia*, fol. 63r
Date: Late 10th cent.

Paris: Lib., Bibl. Nat. de France, lat.
 8318
Prudentius, *Psychomachia*, fol. 63v
Date: Late 10th cent.

Paris: Lib., Bibl. Nat. de France, lat.
 15158
Prudentius, *Psychomachia*, fol. 57v
Date: 1289

Paris: Lib., Bibl. Nat. de France, lat.
 15158
Prudentius, *Psychomachia*, fol. 58v
Date: 1289
Personification: Virtue, Faith

Valenciennes: Lib., Bibl. Municipale,
 563
Prudentius, *Psychomachia*, fol. 33r
Date: Early 11th cent.
Personification: Virtue

Valenciennes: Lib., Bibl. Municipale,
 563
Prudentius, *Psychomachia*, fol. 33v
Date: Early 11th cent.

Valenciennes: Lib., Bibl. Municipale,
 563
Prudentius, *Psychomachia*, fol. 34v
Date: Early 11th cent.

Valenciennes: Lib., Bibl. Municipale,
 563
Prudentius, *Psychomachia*, fol. 35r
Date: Early 11th cent.
Personification: Virtue, Faith

Wolfenbüttel: Lib., Herzog August
 Bibl., Guelf. 105 Noviss. 2°
Gospel Book, Henry the Lion, fol. 17v
Date: ca. 1175
Evangelist: Luke

Wolfenbüttel: Lib., Herzog August
 Bibl., Guelf. 105 Noviss. 2°
Gospel Book, Henry the Lion, fol. 18r
Date: ca. 1175
Apostle: Paul

METALWORK

Berlin: Mus., Staatliche
Bowl, bronze (1471)
Date: 12th cent.

MOSAIC

Cremona: Cathedral
Pavement
Date: First half 12th cent.
Pagan Type: Satyr

Pavia: Mus., Civico
Pavement (B 378a–e/XI)
Date: Late 11th–early 12th cent.

SCULPTURE

Amiens: Cath., Notre Dame
Exterior, west
Date: 1220–1235
Malachi

Anzy-le-Duc: Church
Nave
Date: Late 11th–first half 12th cent.
Personification: River of Paradise

Argenton-Château: Ch., Gilles
Exterior, west
Date: After 1130
Ornament: Figured

Aulnay-de-Saintonge: Ch., Pierre
Exterior, west
Date: ca. 1130–1150
Month: Occupation

Chartres: Cath., Notre Dame
Porch, south
Date: ca. 1230–1240
Saint

Fidenza: Cath., Donnino
Bell tower, southwest
Date: Late 12th–early 13th cent.
Alexander the Great: Celestial Journey

Fornovo di Taro: Ch., Maria Assunta
Exterior, west
Date: ca. 1200
Animal: Fantastic, Centaur

Genoa: Cath., Lorenzo
Exterior, west
Date: 13th cent.
Christ and Four Beasts

León: Ch., Isidoro
Nave
Date: 11th–12th cent.
Samson: Slaying Lion

Magdeburg: Cath., Mauritius und
 Katharina
Choir
Date: First half 13th cent.
Apostle: Andrew

Nevers: Mus., Archéologique
Capital (0098)
Date: 12th cent.
*Apostle: Peter, Miracle of Healing
 Lame Man*

Paris: Cath., Notre Dame
Exterior, west
Date: ca. 1200–1230
Christ: Last Judgment

Poitiers: Ch., Notre Dame la Grande
Exterior, west
Date: Mid-12th cent.
Christ and Four Beasts

Sagra di San Michele: Ch., Abbey
Decoration
Date: Second half 12th cent.
Ornament: Figured

Saint-Pierre-le-Moutier: Church
Decoration
Date: First half 12th cent.
Personification: Virtue, Concord

Souillac: Ch., Abbey
Portal
Date: 12th cent.
Theophilus the Penitent: Scene

Stanton Fitzwarren: Church
Font
Date: ca. 1160
Personification: Church

Teverga: Ch., Pedro
Decoration
Date: 12th cent.

Uppsala: Cathedral
Choir
Date: Late 13th–14th cent.
Virgin Mary: Death

Vézelay: Ch., Madeleine
Nave
Date: First half 12th cent.
Saint

Williamstown: Mus., Williams College
Capital, limestone (49.8)
Date: First half 12th cent.
Scene: Sports and Games, Wrestling(?)

DISOBEDIENCE

GLASS

Esslingen: Ch., Dionysius
Windows, choir
Date: Late 13th–14th cent.
Isaiah

MANUSCRIPT

Bamberg: Lib., Staatsbibl., Bibl. 140
Apocalypse-Pericope, fol. 60r
Date: Early 11th cent.
Personification: Virtue, Obedience

Strasbourg: Lib., Bibl. Municipale
Herradis of Landsberg, *Hort. Delic.*,
 fol. 201v
Date: Second half 12th cent.
Personification: Vice, Obstinacy

SCULPTURE

Amiens: Cath., Notre Dame
Exterior, west
Date: 1220–1235
Malachi

Chartres: Cath., Notre Dame
Porch, south
Date: ca. 1230–1240
Saint

Worms: Cath., Peter and Paul
Exterior, south
Date: First half 14th cent.
Nicholas of Myra: Scene

DIVISION

FRESCO

Siena: Pal., Pubblico
Room, Pace
Attribution: Ambrogio Lorenzetti
Date: 1338–1339
Personification: Virtue, Justice

METALWORK

Trier: Ch., Maximin
Font, of Folcardus
Date: Early 12th cent.
Personification: Virtue, Humility

DRUNKENNESS

ENAMEL

Troyes: Cath., Pierre, Treasury
Casket
Date: ca. 1200
Personification: Virtue, Faith

GLASS

Lyons: Cath., Jean
Window, apse
Date: ca. 1220
Magi: Before Herod the Great

MANUSCRIPT

Forlì: Lib., Bibl. Comunale, 853
Office, S. Mariae, fol. 161r
Date: Late 14th–15th cent.
Scene: Liturgical, Confession

Strasbourg: Lib., Bibl. Municipale
Herradis of Landsberg, *Hort. Delic.*, fol.
 200v
Date: Second half 12th cent.
Personification: Vice, Wrath

SCULPTURE

Autun: Cath., Lazare
Exterior, west
Date: First half 12th cent.
Christ: Last Judgment

Chartres: Cath., Notre Dame
Porch, south
Date: ca. 1230–1240
Saint

Guebwiller: Ch., Léger
Exterior
Date: Late 12th cent.
Ornament: Figured

Lucheux: Church
Decoration
Date: 12th cent.
Ornament: Figured

Southrop: Church
Font
Date: ca. 1160
*Personification: Church and
 Synagogue*

Stanton Fitzwarren: Church
Font
Date: ca. 1160
Personification: Church

Uppsala: Cathedral
Choir
Date: Late 13th–14th cent.
Virgin Mary: Death

Ventouse: Ch., Martin
Exterior, west
Date: Second half 12th cent.
Month: Occupation

DULLNESS

MANUSCRIPT

Strasbourg: Lib., Bibl. Municipale
Herradis of Landsberg, *Hort. Delic.*, fol.
 200v
Date: Second half 12th cent.
Personification: Vice, Wrath

SCULPTURE

Laon: Cath., Notre Dame
Exterior, west
Date: ca. 1180–1210
Magi: Adoration

ENVY

ENAMEL

Florence: Mus., Naz. di Bargello
Crozier (Carrand 622)
Date: ca. 1185–1200
David: Slaying Bear

FRESCO

Bardwell: Ch., Peter and Paul
Nave
Date: Late 14th cent.
Tree of Vices

Hoxne: Ch., Peter and Paul
Nave
Date: Late 14th cent.
Tree of Vices

Ingatestone: Ch., Mary and Edmund
Decoration
Date: Late 14th cent.
Wheel of Vices

Padua: Chap., Madonna dell'Arena
Decoration
Attribution: Giotto
Date: ca. 1303–1308
Virgin Mary: Birth

Siena: Ch., Francesco
Chapel, Bandini Piccolomini
Date: First half 14th cent.
Louis of Toulouse: Scene

GLASS

Mulhouse: Ch., Etienne
Windows
Date: First half 14th cent.
Personification: Virtue, Sobriety

Strasbourg: Cath., Notre Dame
Windows, nave
Date: 14th cent.
Personification: Virtue, Wisdom

MANUSCRIPT

Brussels: Lib., Bibl. Royale, 10176-78
G. de Degulleville, *Pèlerinage*, fol. 68r
Date: 14th–15th cent.
Personification: Vice, Slander

Kremsmünster: Lib., Stiftsbibl., 243
Spec. Hum. Salvationis, fol. 3r
Date: First half 14th cent.
Tree of Vices

Paris: Lib., Bibl. Nat. de France, lat. 6
Roda Bible, III, fol. 45v
Date: First half 11th cent.
*Ezekiel: Prophesying against
 Mountains*

Paris: Lib., Bibl. Nat. de France, lat.
 2077
Miscellany, fol. 163r
Date: 10th–11th cent.
Personification: Vice, Pride

Salzburg: Lib., Studienbibl., V 1 H 162
Miscellany, fol. 75v
Date: First half 12th cent.
Tree of Vices

Strasbourg: Lib., Bibl. Municipale
Herradis of Landsberg, *Hort. Delic.*, fol.
 199v
Date: Second half 12th cent.
Personification: Vice, Pride

Strasbourg: Lib., Bibl. Municipale
Herradis of Landsberg, *Hort. Delic.*, fol.
 200v
Date: Second half 12th cent.
Personification: Vice, Wrath

Vienna: Lib., Nationalbibl., 2592
Roman de la Rose, fol. 3r
Date: Second half 14th cent.

METALWORK

Bergen: Mus., Historisk
Bowl, copper-gilt (BM 8566)
Date: 12th cent.
Personification: Vice, Pride

Berlin: Mus., Staatliche
Bowl, bronze (1471)
Date: 12th cent.
Personification: Vice, Discord

Berlin: Mus., Staatliche
Bowl, brass (K 4480)
Date: 12th cent.
Personification: Vice, Pride

Eger: Mus., Dobó István
Bowl
Date: 12th cent.
Personification: Vice, Pride

Guben: Museum
Bowl, bronze-gilt
Date: 12th cent.

Halle: Mus., Landesmus. für
 Vorgeschichte
Bowl, bronze (HK 34.862)
Date: 12th cent.
Personification: Vice, Pride

Hannover: Mus., Kestner
Bowl, copper-gilt (IV.75)
Date: 12th–13th cent.
Personification: Vice, Pride

Kaliningrad: Mus., Regional
Bowl, bronze (18832)
Date: 12th cent.
Personification: Vice, Pride

Minden: Mus., Geschichte
Bowl, copper-gilt (E 454)
Date: 12th cent.
Personification: Vice, Pride

New York: Mus., Metropolitan,
 Cloisters
Bowl, copper-gilt (N.65.89)
Date: First half 12th cent.
Personification: Vice, Pride

Nuremberg: Mus., Germ.
 Nationalmus.
Bowl, copper-gilt (KG 1183)
Date: First half 13th cent.
Personification: Vice, Pride

Orvieto: Mus., Civico
Bowl, bronze
Date: 12th cent.
Personification: Vice, Pride

Riga: Mus., Latvian Historical
Bowl, brass (23156?)
Date: 12th cent.
Personification: Vice, Pride

Strasbourg: Mus., Historique
Bowl, copper-gilt (700)
Date: 12th–13th cent.
Personification: Virtue, Humility

Strasbourg: Mus., Historique
Bowl (19336)
Date: 12th–13th cent.
Personification: Vice, Pride

Tallinn: Mus., Institute of History
Bowl, bronze (AI 4143:1)
Date: 12th cent.
Personification: Vice, Pride

Tallinn: Mus., Institute of History
Bowl (AI 4143:2)
Date: 12th cent.
Personification: Vice, Pride

Tallinn: Mus., Institute of History
Bowl, bronze (AI 4143:3)
Date: 12th cent.
Personification: Vice, Pride

Tallinn: Mus., Institute of History
Bowl (AI 4143:4)
Date: 12th cent.
Personification: Vice, Pride

SCULPTURE

Piacenza: Cath., Assunta
Exterior, west, central portal
Date: ca. second quarter 12th cent.
Personification: Vice, Avarice

Reims: Cath., Notre Dame
Exterior, west
Date: ca. 1230–1240
Virgin Mary: Coronation

Salisbury: Cathedral, Chapter House
Decoration, vestibule
Date: ca. 1260–1280
Personification: Virtues and Vices,
 Conflict

Southrop: Church
Font
Date: ca. 1160
Personification: Church and
 Synagogue

Stanton Fitzwarren: Church
Font
Date: ca. 1160
Personification: Church

Strzelno: Ch., Trinity
Nave, column
Date: Last quarter 12th cent.
Christ: Baptism

Troyes: Museum
Statues
Date: Late 13th cent.
Moses

Uppsala: Cathedral
Choir
Date: Late 13th–14th cent.
Virgin Mary: Death

FALSE PIETY

MANUSCRIPT

Rome: Lib., Bibl. Vaticana, gr. 394
John Climacus, *Climax*, fol. 94r
Date: Late 11th cent.
John Climacus: Climax, Chapter XVIII

FALSEHOOD

ENAMEL

Troyes: Cath., Pierre, Treasury
Casket
Date: ca. 1200
Personification: Virtue, Faith

FRESCO

Kastoria: Mon., Mavriotissa, Church
Decoration
Date: Late 11th–early 13th cent.
Virgin Mary and Christ Child

Kastoria: Mon., Mavriotissa, Church
Narthex, south wall
Date: Late 11th–early 13th cent.
Christ: Last Judgment

GLASS

Esslingen: Ch., Dionysius
Windows, choir
Date: Late 13th–14th cent.
Isaiah

MANUSCRIPT

Rome: Lib., Bibl. Vaticana, gr. 394
John Climacus, *Climax*, fol. 72r
Date: Late 11th cent.
John Climacus: Climax, Chapter XII

SCULPTURE

Philadelphia: Mus., Museum of Art
Capital, sandstone (45.25.47)
Date: Late 12th cent.
Personification: Vice

FEAR

MANUSCRIPT

Brussels: Lib., Bibl. Royale, 9968-72
Prudentius, *Psychomachia*, fol. 106v
Date: 11th cent.
Personification: Virtue, Peace

Brussels: Lib., Bibl. Royale, 9987-91
Prudentius, *Psychomachia*, fol. 117v
Date: 10th cent.
Personification: Virtue, Peace

Cambridge: Lib., Corpus Christi
College, 23
Prudentius, *Psychomachia*, fol. 33r
Date: Early 11th cent.
Personification: Virtue, Peace

Leiden: Lib., Bibl. der Univ., Burm. Q.3
Prudentius, *Psychomachia*, fol. 141v
Date: Second quarter 9th cent.
Personification: Virtue, Peace

Leiden: Lib., Bibl. der Univ., Voss. lat.
　　oct. 15
Prudentius, *Psychomachia*, fol. 41v
Date: Early 11th cent.
Personification: Vice, Avarice

London: Lib., British, Add. 24199
Prudentius, *Psychomachia*, fol. 29r
Date: Early 11th cent.
Personification: Virtue, Peace

London: Lib., British, Cott. Cleo.
　　C.VIII
Prudentius, *Psychomachia*, fol. 27r
Date: Early 11th cent.
Personification: Virtue, Peace

Lyons: Lib., Bibl. Municipale, Pal. des
　　Arts 22
Prudentius, *Psychomachia*, fol. 15v
Date: Last quarter 11th cent.

Paris: Lib., Bibl. Nat. de France,
　　lat. 8085
Prudentius, *Psychomachia*, fol. 65v
Date: Late 9th cent.
Personification: Virtue, Peace

Paris: Lib., Bibl. Nat. de France,
　　lat. 8318
Prudentius, *Psychomachia*, fol. 61v
Date: Late 10th cent.
Personification: Virtue, Generosity

Paris: Lib., Bibl. Nat. de France,
　　lat. 15158
Prudentius, *Psychomachia*, fol. 55v
Date: 1289
Personification: Virtue, Peace

Strasbourg: Lib., Bibl. Municipale
Herradis of Landsberg, *Hort. Delic.*,
　　fol. 202v
Date: Second half 12th cent.
Personification: Virtue, Temperance

FLATTERY

MANUSCRIPT

Strasbourg: Lib., Bibl. Municipale
Herradis of Landsberg, *Hort. Delic.*,
　　fol. 201v
Date: Second half 12th cent.
Personification: Vice, Obstinacy

FOLLY

ENAMEL

Osnabrück: Town Hall, Rathaus
Vessel
Date: First half 14th cent.
Personification: Virtue, Prudence

FRESCO

Padua: Chap., Madonna dell'Arena
Decoration
Attribution: Giotto
Date: ca. 1303–1308
Virgin Mary: Birth

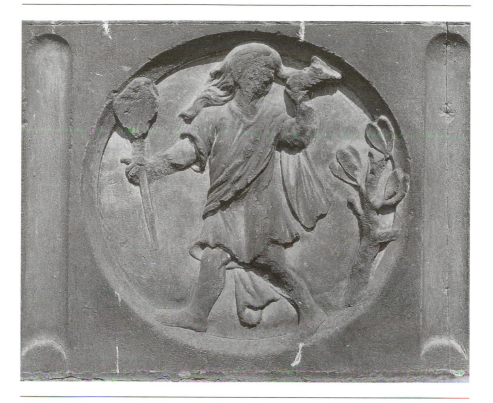

GLASS

Niederhaslach: Ch., Florentius
Windows, nave
Date: 1290–1420
Christ: Parable, Prodigal Son

Strasbourg: Cath., Notre Dame
Windows, nave
Date: 14th cent.
Personification: Virtue, Wisdom

MANUSCRIPT

Malines: Lib., Grand Séminaire
Bible, Nicolò de Alifio, p. 1
Date: Mid-14th cent.
Robert of Anjou

Vienna: Lib., Nationalbibl., 2583*
Matfre Ermengaud, *Brev. d'Amor*,
 fol. 237v
Date: 14th cent.
Personification: Virtue, Generosity

SCULPTURE

Amiens: Cath., Notre Dame
Exterior, west
Date: 1220–1235
Malachi

Chartres: Cath., Notre Dame
Exterior, north, central portal
Date: 1205–1210
Virgin Mary: Coronation

Chartres: Cath., Notre Dame
Exterior, north, left portal
Date: ca. 1220
Virgins, Foolish

Chartres: Cath., Notre Dame
Porch, south
Date: ca. 1230–1240
Saint

Paris: Cath., Notre Dame
Exterior, west
Date: ca. 1220–1230
Christ: Last Judgment

Reims: Cath., Notre Dame
Exterior, west
Date: ca. 1230–1240
Virgin Mary: Coronation

FORNICATION

MANUSCRIPT

Paris: Lib., Bibl. Nat. de France,
 lat. 8318
Prudentius, *Psychomachia*, fol. 53v
Date: Late 10th cent.

Strasbourg: Lib., Bibl. Municipale
Herradis of Landsberg, *Hort. Delic.*,
 fol. 201v
Date: Second half 12th cent.
Personification: Vice, Obstinacy

FRAUD

MANUSCRIPT

Berne: Lib., Stadtbibl., 264
Prudentius, *Psychomachia*, fol. 43v
Date: Early 10th cent.

Paris: Lib., Bibl. Nat. de France,
 lat. 2077
Miscellany, fol. 163r
Date: 10th–11th cent.
Personification: Vice, Pride

Saint Gall: Lib., Stiftsbibl., 135
Prudentius, *Psychomachia*, p. 400
Date: First half 11th cent.

Strasbourg: Lib., Bibl. Municipale
Herradis of Landsberg, *Hort. Delic.*,
 fol. 199v
Date: Second half 12th cent.
Personification: Vice, Pride

Strasbourg: Lib., Bibl. Municipale
Herradis of Landsberg, *Hort. Delic.*,
 fol. 201v
Date: Second half 12th cent.
Personification: Vice, Obstinacy

Strasbourg: Lib., Bibl. Municipale
Herradis of Landsberg, *Hort. Delic.*,
 fol. 202r
Date: Second half 12th cent.
Personification: Virtue, Prudence

Strasbourg: Lib., Bibl. Municipale
Herradis of Landsberg, *Hort. Delic.*,
 fol. 202v
Date: Second half 12th cent.
Personification: Virtue, Temperance

Strasbourg: Lib., Bibl. Municipale
Herradis of Landsberg, *Hort. Delic.*,
 fol. 203v
Date: Second half 12th cent.
Personification: Vice, Avarice

METALWORK

Trier: Ch., Maximin
Font, of Folcardus
Date: Early 12th cent.
Personification: Virtue, Humility

SCULPTURE

Modena: Cath., Geminiano
Relief
Date: 12th cent.
Jacob: Wrestling with Angel

FURY

FRESCO

Assisi: Ch., Francesco, Lower
Crossing, vault
Date: First half 14th cent.
Allegory: Poverty

Siena: Pal., Pubblico
Room, Pace
Attribution: Ambrogio Lorenzetti
Date: 1338–1139
Personification: Virtue, Justice

MANUSCRIPT

Malines: Lib., Grand Séminaire
Bible, Nicolò de Alifio, p. 1
Date: Mid-14th cent.
Robert of Anjou

Strasbourg: Lib., Bibl. Municipale
Herradis of Landsberg, *Hort. Delic.*,
 fol. 200v
Date: Second half 12th cent.
Personification: Vice, Wrath

Strasbourg: Lib., Bibl. Municipale
Herradis of Landsberg, *Hort. Delic.*,
 fol. 203v
Date: Second half 12th cent.
Personification: Vice, Avarice

GLOATING

MANUSCRIPT

Strasbourg: Lib., Bibl. Municipale
Herradis of Landsberg, *Hort. Delic.*,
 fol. 200v
Date: Second half 12th cent.
Personification: Vice, Wrath

GLORY

MANUSCRIPT

Munich: Lib., Staatsbibl., Clm. 13002
Miscellany, fol. 3v
Date: 1158–1165
Apocalypse: Scarlet Woman Drunk

GLUTTONY

FRESCO

Bardwell: Ch., Peter and Paul
Nave
Date: Late 14th cent.
Tree of Vices

Hoxne: Ch., Peter and Paul
Nave
Date: Late 14th cent.
Tree of Vices

Ingatestone: Ch., Mary and Edmund
Decoration
Date: Late 14th cent.
Wheel of Vices

Siena: Ch., Francesco
Chapel, Bandini Piccolomini
Date: First half 14th cent.
Louis of Toulouse: Scene

GLASS

Esslingen: Ch., Dionysius
Windows, choir
Date: Late 13th–14th cent.
Isaiah

Mulhouse: Ch., Etienne
Windows
Date: First half 14th cent.
Personification: Virtue, Sobriety

Strasbourg: Cath., Notre Dame
Windows, nave
Date: 14th cent.
Personification: Virtue, Wisdom

MANUSCRIPT

Kremsmünster: Lib., Stiftsbibl., 243
Spec. Hum. Salvationis, fol. 3r
Date: First half 14th cent.
Tree of Vices

London: Lib., British, Add. 27695,
 28841
Cocharelli, *Tractatus de Septem Vitiis*,
 fol. 13r
Date: Late 14th cent.

London: Lib., British, Add. 28162
Somme le Roi, fol. 10v
Date: ca. 1300
Personification: Virtue, Sobriety

London: Lib., British, Add. 54180
Somme le Roi, fol. 188v
Date: ca. 1300
Personification: Virtue, Sobriety

London: Lib., British, Roy. 1 B.XI
Gospel Book, fol. 6v
Date: 12th cent.

Milan: Lib., Bibl. Ambrosiana,
 H.106 sup.
Somme le Roi, fol. LXXXIIIr
Date: ca. 1300
Personification: Virtue, Sobriety

Oxford: Lib., Bodleian, 270b
Bible, Moralized, fol. 60r
Date: First half 13th cent.
*Moses: Law, Meat Offering of First
 Fruits*

Paris: Lib., Bibl. Mazarine, 870
Somme le Roi, fol. 179r
Date: 1295
Personification: Virtue, Sobriety

Paris: Lib., Bibl. Nat. de France,
 lat. 2077
Miscellany, fol. 163r
Date: 10th–11th cent.
Personification: Vice, Pride

Paris: Lib., Bibl. Nat. de France,
 lat. 8318
Prudentius, *Psychomachia*, fol. 53r
Date: Late 10th cent.
Personification: Vice, Pride

Rome: Lib., Bibl. Vaticana, gr. 394
John Climacus, *Climax*, fol. 74r
Date: Late 11th cent.
John Climacus: Climax, Chapter XIII

Rome: Lib., Bibl. Vaticana, gr. 394
John Climacus, *Climax*, fol. 94r
Date: Late 11th cent.
*John Climacus: Climax, Chapter
 XVIII*

Salzburg: Lib., Studienbibl., V 1 H 162
Miscellany, fol. 75v
Date: First half 12th cent.
Tree of Vices

Soissons: Lib., Bibl. Municipale, 221
Somme le Roi, fol. 57r
Date: 14th cent.

Strasbourg: Lib., Bibl. Municipale
Herradis of Landsberg, *Hort. Delic.*,
 fol. 199v
Date: Second half 12th cent.
Personification: Vice, Pride

Strasbourg: Lib., Bibl. Municipale
Herradis of Landsberg, *Hort. Delic.*,
 fol. 200v
Date: Second half 12th cent.
Personification: Vice, Wrath

Strasbourg: Lib., Bibl. Municipale
Herradis of Landsberg, *Hort. Delic.*,
 fol. 201r
Date: Second half 12th cent.
Personification: Virtue, Patience

Vorau: Lib., Stiftsbibl., lat. 130
G. of Vorau, *Lumen Animae*, fol. 108v
Date: 1332

SCULPTURE

Beaulieu: Ch., Pierre
Exterior, south
Date: 12th cent.
Christ: Last Judgment

Freiburg: Cath., Unsere Liebe Frau
Tower
Date: 13th–14th cent.
Virgin Mary: Coronation

Philadelphia (Penn.): Mus., Museum
 of Art
Capital, sandstone (45.25.47)
Date: Late 12th cent.
Personification: Vice

Regensburg: Ch., Jakob
Exterior, north
Date: Second half 12th cent.
Christ

Reims: Cath., Notre Dame
Exterior, west
Date: ca. 1230–1240
Virgin Mary: Coronation

Salisbury: Cathedral, Chapter House
Decoration, vestibule
Date: ca. 1260–1280
*Personification: Virtues and Vices,
 Conflict*

Strzelno: Ch., Trinity
Nave, column
Date: Last quarter 12th cent.
Christ: Baptism

Ventouse: Ch., Martin
Exterior, west
Date: Second half 12th cent.
Month: Occupation

GREED

MANUSCRIPT

Strasbourg: Lib., Bibl. Municipale
Herradis of Landsberg, *Hort. Delic.*,
 fol. 202v
Date: Second half 12th cent.
Personification: Virtue, Temperance

Strasbourg: Lib., Bibl. Municipale
Herradis of Landsberg, *Hort. Delic.*,
 fol. 203v
Date: Second half 12th cent.
Personification: Vice, Avarice

GRIEF

GLASS

Lyons: Cath., Jean
Window, apse
Date: ca. 1220
Magi: Before Herod the Great

MANUSCRIPT

Vienna: Lib., Nationalbibl., 2592
Roman de la Rose, fol. 3v
Date: Second half 14th cent.

HARSHNESS

GLASS

Paris: Cath., Notre Dame
Window, west rose
Date: First half 13th cent.
Virgin Mary and Christ Child

MANUSCRIPT

Paris: Lib., Bibl. Nat. de France,
 lat. 2077
Miscellany, fol. 163r
Date: 10th–11th cent.
Personification: Vice, Pride

Vienna: Lib., Nationalbibl., 2592
Roman de la Rose, fol. 2r
Date: Second half 14th cent.
Personification: Vice, Hate

SCULPTURE

Amiens: Cath., Notre Dame
Exterior, west
Date: 1220–1235
Malachi

Chartres: Cath., Notre Dame
Porch, south
Date: ca. 1230–1240
Saint

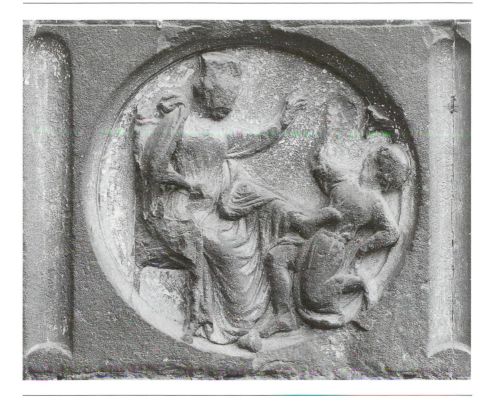

Magdeburg: Cath., Mauritius und
 Katharina
Choir
Date: First half 13th cent.
Apostle: Andrew

Paris: Cath., Notre Dame
Exterior, west
Date: ca. 1220–1230
Christ: Last Judgment

HATE

ENAMEL

Troyes: Cath., Pierre, Treasury
Casket
Date: ca. 1200
Personification: Virtue, Faith

MANUSCRIPT

Brussels: Lib., Bibl. Royale, 9574-75
Roman de la Rose, fol. 1v
Date: First half 14th cent.

Cambridge: Lib., St. John's College, B.9
Miscellany, fol. 201v
Date: 14th cent.
Personification: Virtue, Friendship

London: Lib., British, Add. 28162
Somme le Roi, fol. 6v
Date: ca. 1300
Personification: Virtue, Friendship

London: Lib., British, Add. 54180
Somme le Roi, fol. 107r
Date: ca. 1300
Personification: Virtue, Friendship

Paris: Lib., Bibl. de l'Arsenal, 6329
Somme le Roi, fol. 112v
Date: 1311
Personification: Virtue, Friendship

Paris: Lib., Bibl. Nat. de France,
 fr. 14939
Somme le Roi, fol. 105v
Date: 1373
Personification: Virtue, Friendship

Strasbourg: Lib., Bibl. Municipale
Herradis of Landsberg, *Hort. Delic.*,
 fol. 200v
Date: Second half 12th cent.
Personification: Vice, Wrath

Vienna: Lib., Nationalbibl., 2592
Roman de la Rose, fol. 2r
Date: Second half 14th cent.

HOMICIDE

MANUSCRIPT

Paris: Lib., Bibl. Nat. de France,
 lat. 2077
Miscellany, fol. 163r
Date: 10th–11th cent.
Personification: Vice, Pride

SCULPTURE

Strzelno: Ch., Trinity
Nave, column
Date: Last quarter 12th cent.
Christ: Baptism

HYPOCRISY

MANUSCRIPT

Strasbourg: Lib., Bibl. Municipale
Herradis of Landsberg, *Hort. Delic.*,
 fol. 201v
Date: Second half 12th cent.
Personification: Vice, Obstinacy

Vienna: Lib., Nationalbibl., 2592
Roman de la Rose, fol. 4r
Date: Second half 14th cent.

IDLENESS

GLASS

Mulhouse: Ch., Etienne
Windows
Date: First half 14th cent.
Personification: Virtue, Sobriety

Strasbourg: Cath., Notre Dame
Windows, nave
Date: 14th cent.
Personification: Virtue, Wisdom

MANUSCRIPT

Cleveland: Museum of Art, 53.512
Miniature, recto
Date: Late 14th cent.

Paris: Lib., Bibl. Nat. de France,
 fr. 14939
Somme le Roi, fol. 112v
Date: 1373
Personification: Virtue, Prowess

Paris: Lib., Bibl. Nat. de France,
 lat. 8318
Prudentius, *Psychomachia*, fol. 54v
Date: Late 10th cent.

Vienna: Lib., Nationalbibl., 2592
Roman de la Rose, fol. 10v
Date: Second half 14th cent.

MOSAIC

Reims: Ch., Remi
Choir
Date: After 1090
David: As Musician

SCULPTURE

Regensburg: Ch., Jakob
Exterior, north
Date: Second half 12th cent.
Christ

Reims: Cath., Notre Dame
Exterior, west
Date: ca. 1230–1240
Virgin Mary: Coronation

IDOLATRY

ENAMEL

Florence: Mus., Naz. di Bargello
Crozier (Carrand 622)
Date: ca. 1185–1200
David: Slaying Bear

Osnabrück: Town Hall, Rathaus
Vessel
Date: First half 14th cent.
Personification: Virtue, Prudence

Troyes: Cath., Pierre, Treasury
Casket
Date: ca. 1200
Personification: Virtue, Faith

GLASS

Esslingen: Ch., Dionysius
Windows, choir
Date: Late 13th–14th cent.
Isaiah

Paris: Cath., Notre Dame
Window, west rose
Date: First half 13th cent.
Virgin Mary and Christ Child

Strasbourg: Cath., Notre Dame
Windows, nave
Date: 14th cent.
Personification: Virtue, Wisdom

IVORY

London: Lib., British
Plaques, in book cover (Egerton 1139)
Date: 1131–1143
David: Slaying Lion

MANUSCRIPT

Berne: Lib., Stadtbibl., 264
Prudentius, *Psychomachia*, fol. 34v
Date: Early 10th cent.
Personification: Virtue, Faith

Berne: Lib., Stadtbibl., 264
Prudentius, *Psychomachia*, fol. 35r
Date: Early 10th cent.
Personification: Virtue, Faith

Berne: Lib., Stadtbibl., 264
Prudentius, *Psychomachia*, fol. 35v
Date: Early 10th cent.
Personification: Virtue, Faith

Brussels: Lib., Bibl. Royale, 9968-72
Prudentius, *Psychomachia*, fol. 78r
Date: 11th cent.
Prudentius: Scene

Brussels: Lib., Bibl. Royale, 9968-72
Prudentius, *Psychomachia*, fol. 78v
Date: 11th cent.
Personification: Virtue, Faith

Brussels: Lib., Bibl. Royale, 9968-72
Prudentius, *Psychomachia*, fol. 79r
Date: 11th cent.
Personification: Virtue, Faith

Brussels: Lib., Bibl. Royale, 9987-91
Prudentius, *Psychomachia*, fol. 99v
Date: 10th cent.
Personification: Virtue, Faith

Brussels: Lib., Bibl. Royale, 9987-91
Prudentius, *Psychomachia*, fol. 100r
Date: 10th cent.
Personification: Virtue, Faith

Brussels: Lib., Bibl. Royale, 10066-77
Prudentius, *Psychomachia*, fol. 115r
Date: 10th–first half 11th cent.
Personification: Virtue, Faith

Brussels: Lib., Bibl. Royale, 10066-77
Prudentius, *Psychomachia*, fol. 115v
Date: 10th–first half 11th cent.
Personification: Virtue, Faith

Brussels: Lib., Bibl. Royale, 10066-77
Prudentius, *Psychomachia*, fol. 116v
Date: 10th–first half 11th cent.
Personification: Virtue, Chastity

Cambridge: Lib., Corpus Christi
 College, 23
Prudentius, *Psychomachia*, fol. 6v
Date: Early 11th cent.
Personification: Virtue, Faith

Cambridge (Mass.): Lib., Harvard
 College, Typ 201 H
Augustine, *Cité de Dieu*, fol. 162r
Date: Second half 14th cent.

Jena: Lib., Thüringer Universitätsbibl.,
 M. Gallica f. 87
Simon de Hesdin, *Faits Romains*,
 frontispiece
Date: Late 14th cent.
Simon de Hesdin

Leiden: Lib., Bibl. der Univ., Burm. Q.3
Prudentius, *Psychomachia*, fol. 122v
Date: Second quarter 9th cent.
Personification: Virtue, Faith

Leiden: Lib., Bibl. der Univ., Burm. Q.3
Prudentius, *Psychomachia*, fol. 123r
Date: Second quarter 9th cent.
Personification: Virtue, Faith

Leiden: Lib., Bibl. der Univ., Burm. Q.3
Prudentius, *Psychomachia*, fol. 123v
Date: Second quarter 9th cent.
Personification: Virtue, Chastity

Leiden: Lib., Bibl. der Univ., Voss. lat.
 oct. 15
Prudentius, *Psychomachia*, fol. 2r
Date: Early 11th cent.
Personification: Virtue, Faith

Leiden: Lib., Bibl. der Univ., Voss. lat.
 oct. 15
Prudentius, *Psychomachia*, fol. 37v
Date: Early 11th cent.
Abraham: Blessed by Melchisedek

London: Lib., British, Add. 24199
Prudentius, *Psychomachia*, fol. 4v
Date: Early 11th cent.
Personification: Virtue, Faith

London: Lib., British, Add. 24199
Prudentius, *Psychomachia*, fol. 5r
Date: Early 11th cent.
Personification: Virtue, Faith

London: Lib., British, Cott. Cleo.
 C.VIII
Prudentius, *Psychomachia*, fol. 4r
Date: Early 11th cent.
Personification: Virtue, Faith

London: Lib., British, Cott. Titus
 D.XVI
Prudentius, *Psychomachia*, fol. 5v
Date: ca. 1100
Personification: Virtue, Faith

London: Lib., British, Cott. Titus
 D.XVI
Prudentius, *Psychomachia*, fol. 6r
Date: ca. 1100
Personification: Virtue, Faith

Munich: Lib., Staatsbibl., Clm. 29031b
Prudentius, *Psychomachia*, recto
Date: 10th cent.
Personification: Virtue, Faith

Munich: Lib., Staatsbibl., Clm. 29031b
Prudentius, *Psychomachia*, verso
Date: 10th cent.
Personification: Virtue, Faith

Munich: Lib., Staatsbibl., Clm. 30055
Gospel Book, Henry the Lion, fol. 15r
Date: ca. 1175
Evangelist: Matthew

Paris: Lib., Bibl. Nat. de France,
 lat. 8085
Prudentius, *Psychomachia*, fol. 56v
Date: Late 9th cent.
Prudentius: Scene

Paris: Lib., Bibl. Nat. de France,
 lat. 8085
Prudentius, *Psychomachia*, fol. 57r
Date: Late 9th cent.
Personification: Virtue, Faith

Paris: Lib., Bibl. Nat. de France,
 lat. 8318
Prudentius, *Psychomachia*, fol. 50v
Date: Late 10th cent.
Personification: Virtue, Faith

Saint Gall: Lib., Stiftsbibl., 135
Prudentius, *Psychomachia*, p. 388
Date: First half 11th cent.
Personification: Virtue, Faith

Saint Gall: Lib., Stiftsbibl., 135
Prudentius, *Psychomachia*, p. 390
Date: First half 11th cent.
Personification: Virtue, Faith

Strasbourg: Lib., Bibl. Municipale
Herradis of Landsberg, *Hort. Delic.,*
 fol. 199v
Date: Second half 12th cent.
Personification: Vice, Pride

Strasbourg: Lib., Bibl. Municipale
Herradis of Landsberg, *Hort. Delic.,*
 fol. 200r
Date: Second half 12th cent.
Personification: Virtue, Humility

Valenciennes: Lib., Bibl. Municipale,
 563
Prudentius, *Psychomachia*, fol. 4r
Date: Early 11th cent.
Personification: Virtue, Faith

Valenciennes: Lib., Bibl. Municipale,
 563
Prudentius, *Psychomachia*, fol. 4v
Date: Early 11th cent.
Personification: Virtue, Faith

Wolfenbüttel: Lib., Herzog August
 Bibl., Guelf. 105 Noviss. 2°
Gospel Book, Henry the Lion, fol. 15r
Date: ca. 1175
Evangelist: Matthew

METALWORK

Bergen: Mus., Historisk
Bowl, copper-gilt (BM 8566)
Date: 12th cent.
Personification: Vice, Pride

Berlin: Mus., Staatliche
Bowl, bronze (1471)
Date: 12th cent.
Personification: Vice, Discord

Berlin: Mus., Staatliche
Bowl, brass (K 4480)
Date: 12th cent.
Personification: Vice, Pride

Eger: Mus., Dobó István
Bowl
Date: 12th cent.
Personification: Vice, Pride

Halle: Mus., Landesmus. für
 Vorgeschichte
Bowl, bronze (HK 34.862)
Date: 12th cent.
Personification: Vice, Pride

Hannover: Mus., Kestner
Bowl, copper-gilt (IV.75)
Date: 12th–13th cent.
Personification: Vice, Pride

Kaliningrad: Mus., Regional
Bowl, bronze (18832)
Date: 12th cent.
Personification: Vice, Pride

Minden: Mus., Geschichte
Bowl, copper-gilt (E 454)
Date: 12th cent.
Personification: Vice, Pride

New York: Mus., Metropolitan,
 Cloisters
Bowl, copper-gilt (N.65.89)
Date: First half 12th cent.
Personification: Vice, Pride

Nuremberg: Mus., Germ.
 Nationalmus.
Bowl, copper-gilt (KG 1183)
Date: First half 13th cent.
Personification: Vice, Pride

Orvieto: Mus., Civico
Bowl, bronze
Date: 12th cent.
Personification: Vice, Pride

Riga: Mus., Latvian Historical
Bowl, brass (23156?)
Date: 12th cent.
Personification: Vice, Pride

Strasbourg: Mus., Historique
Bowl (19336)
Date: 12th–13th cent.
Personification: Vice, Pride

Tallinn: Mus., Institute of History
Bowl, bronze (AI 4143:1)
Date: 12th cent.
Personification: Vice, Pride

Tallinn: Mus., Institute of History
Bowl (AI 4143:2)
Date: 12th cent.
Personification: Vice, Pride

Tallinn: Mus., Institute of History
Bowl, bronze (AI 4143:3)
Date: 12th cent.
Personification: Vice, Pride

Tallinn: Mus., Institute of History
Bowl (AI 4143:4)
Date: 12th cent.
Personification: Vice, Pride

Trier: Ch., Maximin
Font, of Folcardus
Date: Early 12th cent.
Personification: Virtue, Humility

SCULPTURE

Amiens: Cath., Notre Dame
Exterior, west
Date: 1220–1235
Malachi

Argenton-Château: Ch., Gilles
Exterior, west
Date: After 1130
Ornament: Figured

Arles: Ch., Trophime
Cloister
Date: 12th cent.
Evangelist: Matthew

Armentia: Ch., Andrés
Reliefs
Date: 12th cent.
Virgin Mary: Annunciation

Aulnay-de-Saintonge: Ch., Pierre
Exterior, west
Date: ca. 1130–1150
Month: Occupation

Autun: Cath., Lazare
Choir
Date: First half 12th cent.
Christ: On Road to Emmaus

Caen: Ch., Etienne-le-Vieux
Exterior
Date: 12th cent.
*Constantine the Great(?): As
 Horseman*

Chadenac: Ch., Martin
Exterior, west
Date: 12th cent.
Saint

Chartres: Cath., Notre Dame
Porch, south
Date: ca. 1230–1240
Saint

Châteauneuf-sur-Charente: Ch., Pierre
Exterior, west
Date: 12th cent.
Constantine the Great: As Horseman

Laon: Cath., Notre Dame
Exterior, west
Date: ca. 1180–1210
Magi: Adoration

Magdeburg: Cath., Mauritius und
 Katharina
Choir
Date: First half 13th cent.
Apostle: Andrew

Melle-sur-Béronne: Ch., Hilaire
Exterior, north
Date: 12th cent.
Month: Occupation

Oloron-Sainte-Marie: Ch., Marie
Exterior, west
Date: 12th cent.
Lamb of God

Paris: Cath., Notre Dame
Exterior, west
Date: ca. 1220–1230
Christ: Last Judgment

Paris: Mus., Louvre
Capital, marble (RF 1994)
Date: Mid-12th cent.
Constantine the Great: Scene

Parthenay-le-Vieux: Ch., Abbey
Exterior, west
Date: First half 12th cent.
Constantine the Great: As Horseman

Reims: Cath., Notre Dame
Exterior, west
Date: ca. 1230–1240
Virgin Mary: Coronation

Saint-Jouin-de-Marnes: Church
Exterior, west
Date: First half 12th cent.
Christ: Last Judgment

Strzelno: Ch., Trinity
Nave, column
Date: Last quarter 12th cent.
Christ: Baptism

Surgères: Church
Exterior, west
Date: 12th cent.
Constantine the Great: As Horseman

Troyes: Museum
Statues
Date: Late 13th cent.
Moses

IGNORANCE

MANUSCRIPT

London: Lib., British, Add. 38120
G. de Degulleville, *Pèlerinage*, fol. 223v
Date: ca. 1400
Guillaume de Degulleville: Pèlerinage Jhesucrist

Princeton: Lib., Univ., Garrett 114
Miscellany, fol. 88r
Date: ca. 1200
Figure: Male

Rome: Lib., Bibl. Vaticana, gr. 394
John Climacus, *Climax*, fol. 94r
Date: Late 11th cent.
John Climacus: Climax, Chapter XVIII

MOSAIC

Reims: Ch., Remi
Choir
Date: After 1090
David: As Musician

IMPATIENCE

GLASS

Niederhaslach: Ch., Florentius
Windows, nave
Date: 1290–1420
Christ: Parable, Prodigal Son

MANUSCRIPT

Paris: Lib., Bibl. Nat. de France, lat. 2077
Miscellany, fol. 163r
Date: 10th–11th cent.
Personification: Vice, Pride

Vienna: Lib., Nationalbibl., 2583*
Matfre Ermengaud, *Brev. d'Amor*,
 fol. 237v
Date: 14th cent.
Personification: Virtue, Generosity

IMPIETY

ENAMEL

Troyes: Cath., Pierre, Treasury
Casket
Date: ca. 1200
Personification: Virtue, Faith

METALWORK

Trier: Ch., Maximin
Font, of Folcardus
Date: Early 12th cent.
Personification: Virtue, Humility

MOSAIC

Cremona: Cathedral
Pavement
Date: First half 12th cent.
Pagan Type: Satyr

SCULPTURE

Strzelno: Ch., Trinity
Nave, column
Date: Last quarter 12th cent.
Christ: Baptism

IMPRUDENCE

SCULPTURE

Salisbury: Cathedral, Chapter House
Decoration, vestibule
Date: ca. 1260–1280
*Personification: Virtues and Vices,
 Conflict*

IMPURITY

FRESCO

Assisi: Ch., Francesco, Lower
Crossing, vault
Date: First half 14th cent.
Allegory: Poverty

MANUSCRIPT

Malines: Lib., Grand Séminaire
Bible, Nicolò de Alifio, p. 1
Date: Mid-14th cent.
Robert of Anjou

Strasbourg: Lib., Bibl. Municipale
Herradis of Landsberg, *Hort. Delic.,*
 fol. 201v
Date: Second half 12th cent.
Personification: Vice, Obstinacy

SCULPTURE

Moissac: Ch., Pierre
Exterior, south
Date: First half 12th cent.
Apocalypse: Christ, Adoration by
 Elders

INCONSTANCY

FRESCO

Padua: Chap., Madonna dell'Arena
Decoration
Attribution: Giotto
Date: ca. 1303–1308
Virgin Mary: Birth

SCULPTURE

Amiens: Cath., Notre Dame
Exterior, west
Date: 1220–1235
Malachi

Chartres: Cath., Notre Dame
Porch, south
Date: ca. 1230–1240
Saint

Cologne: Cath., Peter und Maria
Choir stalls, north side
Date: First half 14th cent.
Scene: Liturgical, Confession

Magdeburg: Cath., Mauritius und
 Katharina
Choir
Date: First half 13th cent.
Apostle: Andrew

Paris: Cath., Notre Dame
Exterior, west
Date: ca. 1220–1230
Christ: Last Judgment

INCREDULITY

GLASS

Niederhaslach: Ch., Florentius
Windows, nave
Date: 1290–1420
Christ: Parable, Prodigal Son

INDIGNATION

MANUSCRIPT

Strasbourg: Lib., Bibl. Municipale
Herradis of Landsberg, *Hort. Delic.*,
 fol. 200v
Date: Second half 12th cent.
Personification: Vice, Wrath

INDISCRETION

MANUSCRIPT

Malines: Lib., Grand Séminaire
Bible, Nicolò de Alifio, p. 1
Date: Mid-14th cent.
Robert of Anjou

Vienna: Lib., Nationalbibl., 2583*
Matfre Ermengaud, *Brev. d'Amor*,
 fol. 237v
Date: 14th cent.
Personification: Virtue, Generosity

INDOCILITY

SCULPTURE

Amiens: Cath., Notre Dame
Exterior, west
Date: 1220–1235
Malachi

Chartres: Cath., Notre Dame
Porch, south
Date: ca. 1230–1240
Saint

Reims: Cath., Notre Dame
Exterior, west
Date: ca. 1230–1240
Virgin Mary: Coronation

INFIDELITY

FRESCO

Padua: Chap., Madonna dell'Arena
Decoration
Attribution: Giotto
Date: ca. 1303–1308
Virgin Mary: Birth

SCULPTURE

Bremen: Cath., Peter
Reliefs, from choir stalls
Date: 14th–15th cent.
Apostles

Chartres: Cath., Notre Dame
Exterior, north, central portal
Date: 1205–1210
Virgin Mary: Coronation

Chartres: Cath., Notre Dame
Exterior, north, left portal
Date: ca. 1220
Virgins, Foolish

Salisbury: Cathedral, Chapter House
Decoration, vestibule
Date: ca. 1260–1280
*Personification: Virtues and Vices,
 Conflict*

INFORTITUDE

SCULPTURE

Salisbury: Cathedral, Chapter House
Decoration, vestibule
Date: ca. 1260–1280
*Personification: Virtues and Vices,
 Conflict*

INGRATITUDE

GLASS

Paris: Cath., Notre Dame
Window, west rose
Date: First half 13th cent.
Virgin Mary and Christ Child

INIQUITY

GLASS

Niederhaslach: Ch., Florentius
Windows, nave
Date: 1290–1420
Christ: Parable, Prodigal Son

Strasbourg: Cath., Notre Dame
Windows, nave
Date: 14th cent.
Personification: Virtue, Wisdom

MANUSCRIPT

Albenga: Lib., Bibl. Capitolare, A.4
Psalter, fol. 72v
Date: 1220–1229

Cambridge: Lib., Trinity College,
 R.17.1
Psalter, Canterbury, fol. 12v
Date: ca. 1145–1170
Psalm 7

Cambridge: Lib., Trinity College,
 R.17.1
Psalter, Canterbury, fol. 66r
Date: ca. 1145–1170
Psalm 38 (Vulgate, 37)

London: Lib., British, Harley 603
Psalter, fol. 4r
Date: ca. 1000–12th cent.
Psalm 7

London: Lib., British, Harley 603
Psalter, fol. 22r
Date: ca. 1000–12th cent.
Psalm 38 (Vulgate, 37)

Paris: Lib., Bibl. Nat. de France, lat.
 8846
Psalter, fol. 12v
Date: 12th–13th cent.
Psalm 7

Paris: Lib., Bibl. Nat. de France, lat.
 8846
Psalter, fol. 66r
Date: 12th–13th cent.
Psalm 38 (Vulgate, 37)

Rome: Lib., Bibl. Vaticana, Reg. lat. 12
Psalter, fol. 25r
Date: Early 11th cent.
Psalm 7

Utrecht: Lib., Bibl. der Universiteit, 32
Psalter, fol. 4r
Date: ca. 820–830
Psalm 7

Utrecht: Lib., Bibl. der Universiteit, 32
Psalter, fol. 22r
Date: ca. 820–830
Psalm 38 (Vulgate, 37)

SCULPTURE

Città di Castello: Cath., SS. Florido e
 Amanzio
Exterior, north
Date: Mid-14th cent.
Personification: Virtue, Justice

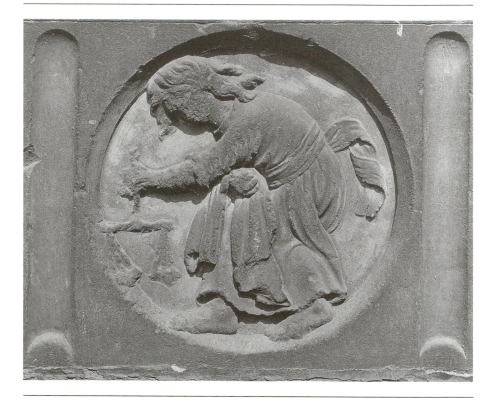

INJUSTICE

ENAMEL

Langres: Museum
Plaques, on reliquary
Date: Third quarter 12th cent.
Personification: Virtue, Fortitude

FRESCO

Padua: Chap., Madonna dell'Arena
Decoration
Attribution: Giotto
Date: ca. 1303–1308
Virgin Mary: Birth

Tolentino: Ch., Nicola da Tolentino
Chapel, S. Nicola
Date: 13th–14th cent.
Evangelist: Symbol

GLASS

Esslingen: Ch., Dionysius
Windows, choir
Date: Late 13th–14th cent.
Isaiah

SCULPTURE

Chartres: Cath., Notre Dame
Exterior, north, central portal
Date: 1205–1210
Virgin Mary: Coronation

Chartres: Cath., Notre Dame
Exterior, north, left portal
Date: ca. 1220
Virgins, Foolish

Paris: Cath., Notre Dame
Exterior, west
Date: ca. 1220–1230
Christ: Last Judgment

Salisbury: Cathedral, Chapter House
Decoration, vestibule
Date: ca. 1260–1280
Personification: Virtues and Vices,
 Conflict

INSENSIBILITY

MANUSCRIPT

Rome: Lib., Bibl. Vaticana, gr. 394
John Climacus, *Climax*, fol. 92r
Date: Late 11th cent.
John Climacus: Climax, Chapter XVII

INTEMPERANCE

ENAMEL

Langres: Museum
Plaques, on reliquary
Date: Third quarter 12th cent.
Personification: Virtue, Fortitude

SCULPTURE

Providence: Mus., Rhode Island School
 of Design
Corbel, limestone (51.316)
Date: First half 12th cent.
Utensil: Container

Salisbury: Cathedral, Chapter House
Decoration, vestibule
Date: ca. 1260–1280
Personification: Virtues and Vices,
 Conflict

IRASCIBILITY

ENAMEL

Troyes: Cath., Pierre, Treasury
Casket
Date: ca. 1200
Personification: Virtue, Faith

JEST

MANUSCRIPT

Brussels: Lib., Bibl. Royale, 9968-72
Prudentius, *Psychomachia*, fol. 97r
Date: 11th cent.

Brussels: Lib., Bibl. Royale, 9987-91
Prudentius, *Psychomachia*, fol. 112v
Date: 10th cent.

Cambridge: Lib., Corpus Christi
College, 23
Prudentius, *Psychomachia*, fol. 24r
Date: Early 11th cent.
Personification: Virtue, Sobriety

Leiden: Lib., Bibl. der Univ., Burm. Q.3
Prudentius, *Psychomachia*, fol. 135v
Date: Second quarter 9th cent.

Leiden: Lib., Bibl. der Univ., Voss. lat.
oct. 15
Prudentius, *Psychomachia*, fol. 40v
Date: Early 11th cent.
Personification: Vice, Luxury

London: Lib., British, Add. 24199
Prudentius, *Psychomachia*, fol. 21r
Date: Early 11th cent.

London: Lib., British, Cott. Cleo.
C.VIII
Prudentius, *Psychomachia*, fol. 19r
Date: Early 11th cent.
Personification: Virtue, Sobriety

Lyons: Lib., Bibl. Municipale, Pal. des
Arts 22
Prudentius, *Psychomachia*, fol. 17r
Date: Last quarter 11th cent.
Personification: Virtue, Sobriety

Paris: Lib., Bibl. Nat. de France,
lat. 8085
Prudentius, *Psychomachia*, fol. 63r
Date: Late 9th cent.
Personification: Virtue, Sobriety

Paris: Lib., Bibl. Nat. de France,
lat. 8318
Prudentius, *Psychomachia*, fol. 58r
Date: Late 10th cent.
Personification: Vice, Luxury

Paris: Lib., Bibl. Nat. de France,
lat. 15158
Prudentius, *Psychomachia*, fol. 48v
Date: 1289

Strasbourg: Lib., Bibl. Municipale
Herradis of Landsberg, *Hort. Delic.*,
fol. 201v
Date: Second half 12th cent.
Personification: Vice, Obstinacy

Strasbourg: Lib., Bibl. Municipale
Herradis of Landsberg, *Hort. Delic.*,
fol. 202v
Date: Second half 12th cent.
Personification: Virtue, Temperance

Valenciennes: Lib., Bibl. Municipale,
563
Prudentius, *Psychomachia*, fol. 22r
Date: Early 11th cent.
Personification: Virtue, Sobriety

LABOR

MANUSCRIPT

Brussels: Lib., Bibl. Royale, 9968-72
Prudentius, *Psychomachia*, fol. 106v
Date: 11th cent.
Personification: Virtue, Peace

Brussels: Lib., Bibl. Royale, 9987-91
Prudentius, *Psychomachia*, fol. 117v
Date: 10th cent.
Personification: Virtue, Peace

Cambridge: Lib., Corpus Christi
College, 23
Prudentius, *Psychomachia*, fol. 33r
Date: Early 11th cent.
Personification: Virtue, Peace

Leiden: Lib., Bibl. der Univ., Burm. Q.3
Prudentius, *Psychomachia*, fol. 141v
Date: Second quarter 9th cent.
Personification: Virtue, Peace

Leiden: Lib., Bibl. der Univ., Voss. lat.
oct. 15
Prudentius, *Psychomachia*, fol. 41v
Date: Early 11th cent.
Personification: Vice, Avarice

London: Lib., British, Add. 24199
Prudentius, *Psychomachia*, fol. 29r
Date: Early 11th cent.
Personification: Virtue, Peace

London: Lib., British, Cott. Cleo.
C.VIII
Prudentius, *Psychomachia*, fol. 27r
Date: Early 11th cent.
Personification: Virtue, Peace

Lyons: Lib., Bibl. Municipale, Pal. des
Arts 22
Prudentius, *Psychomachia*, fol. 15v
Date: Last quarter 11th cent.
Personification: Vice, Fear

Paris: Lib., Bibl. Nat. de France,
lat. 8085
Prudentius, *Psychomachia*, fol. 65v
Date: Late 9th cent.
Personification: Virtue, Peace

Paris: Lib., Bibl. Nat. de France,
lat. 8318
Prudentius, *Psychomachia*, fol. 61v
Date: Late 10th cent.
Personification: Virtue, Generosity

Paris: Lib., Bibl. Nat. de France,
lat. 15158
Prudentius, *Psychomachia*, fol. 55v
Date: 1289
Personification: Virtue, Peace

LANGUOR

MANUSCRIPT

Strasbourg: Lib., Bibl. Municipale
Herradis of Landsberg, *Hort. Delic.,*
 fol. 200v
Date: Second half 12th cent.
Personification: Vice, Wrath

LOQUACITY

GLASS

Niederhaslach: Ch., Florentius
Windows, nave
Date: 1290–1420
Christ: Parable, Prodigal Son

MANUSCRIPT

Rome: Lib., Bibl. Vaticana, gr. 394
John Climacus, *Climax,* fol. 69v
Date: Late 11th cent.
John Climacus: Climax, Chapter X

Strasbourg: Lib., Bibl. Municipale
Herradis of Landsberg, *Hort. Delic.,*
 fol. 201v
Date: Second half 12th cent.
Personification: Vice, Obstinacy

LUST

ENAMEL

Florence: Mus., Naz. di Bargello
Crozier (Carrand 622)
Date: ca. 1185–1200
David: Slaying Bear

Osnabrück: Town Hall, Rathaus
Vessel
Date: First half 14th cent.
Personification: Virtue, Prudence

FRESCO

Hoxne: Ch., Peter and Paul
Nave
Date: Late 14th cent.
Tree of Vices

Ingatestone: Ch., Mary and Edmund
Decoration
Date: Late 14th cent.
Wheel of Vices

Siena: Ch., Francesco
Chapel, Bandini Piccolomini
Date: First half 14th cent.
Louis of Toulouse: Scene

IVORY

London: Lib., British
Plaques, in book cover (Egerton 1139)
Date: 1131–1143
David: Slaying Lion

MANUSCRIPT

Berne: Lib., Stadtbibl., 264
Prudentius, *Psychomachia*, fol. 35v
Date: Early 10th cent.
Personification: Virtue, Faith

Berne: Lib., Stadtbibl., 264
Prudentius, *Psychomachia*, fol. 36r
Date: Early 10th cent.
Personification: Virtue, Chastity

Berne: Lib., Stadtbibl., 264
Prudentius, *Psychomachia*, fol. 36v
Date: Early 10th cent.
Personification: Virtue, Chastity

Brussels: Lib., Bibl. Royale, 9505-6
Aristotle, *Ethiques*, fol. 132r
Date: 1372
Personification: Virtue, Reason

Brussels: Lib., Bibl. Royale, 9968-72
Prudentius, *Psychomachia*, fol. 79r
Date: 11th cent.
Personification: Virtue, Faith

Brussels: Lib., Bibl. Royale, 9968-72
Prudentius, *Psychomachia*, fol. 79v
Date: 11th cent.
Personification: Virtue, Chastity

Brussels: Lib., Bibl. Royale, 9968-72
Prudentius, *Psychomachia*, fol. 80r
Date: 11th cent.
Personification: Virtue, Chastity

Brussels: Lib., Bibl. Royale, 9987-91
Prudentius, *Psychomachia*, fol. 100v
Date: 10th cent.
Personification: Virtue, Chastity

Brussels: Lib., Bibl. Royale, 9987-91
Prudentius, *Psychomachia*, fol. 101r
Date: 10th cent.
Personification: Virtue, Chastity

Brussels: Lib., Bibl. Royale, 10066-77
Prudentius, *Psychomachia*, fol. 116r
Date: 10th–first half 11th cent.
Personification: Virtue, Chastity

Brussels: Lib., Bibl. Royale, 10066-77
Prudentius, *Psychomachia*, fol. 116v
Date: 10th–first half 11th cent.
Personification: Virtue, Chastity

Cambridge: Lib., Corpus Christi
 College, 23
Prudentius, *Psychomachia*, fol. 8r
Date: Early 11th cent.
Personification: Virtue, Chastity

Cambridge: Lib., Corpus Christi
 College, 23
Prudentius, *Psychomachia*, fol. 8v
Date: Early 11th cent.
Personification: Virtue, Chastity

Cambridge: Lib., Corpus Christi
 College, 23
Prudentius, *Psychomachia*, fol. 9r
Date: Early 11th cent.
Personification: Virtue, Chastity

Cambridge: Lib., University, Mm. 5.31
Alexander Laicus, *In Apocalipsin*,
 fol. 115v
Date: 13th cent.

Hague: Mus., Meermanno-
 Westreenianum, 10 D 1
Aristotle, *Ethiques*, fol. 126r
Date: 1376
Personification: Virtue, Reason

Leiden: Lib., Bibl. der Univ., Burm. Q.3
Prudentius, *Psychomachia*, fol. 123v
Date: Second quarter 9th cent.
Personification: Virtue, Chastity

Leiden: Lib., Bibl. der Univ., Burm. Q.3
Prudentius, *Psychomachia*, fol. 124r
Date: Second quarter 9th cent.
Personification: Virtue, Chastity

Leiden: Lib., Bibl. der Univ., Voss. lat.
 oct. 15
Prudentius, *Psychomachia*, fol. 37v
Date: Early 11th cent.
Abraham: Blessed by Melchisedek

Leiden: Lib., Bibl. der Univ., Voss. lat.
 oct. 15
Prudentius, *Psychomachia*, fol. 38r
Date: Early 11th cent.
Personification: Virtue, Chastity

London: Lib., British, Add. 24199
Prudentius, *Psychomachia*, fol. 5v
Date: Early 11th cent.
Personification: Virtue, Faith

London: Lib., British, Add. 24199
Prudentius, *Psychomachia*, fol. 6r
Date: Early 11th cent.
Personification: Virtue, Chastity

London: Lib., British, Add. 24199
Prudentius, *Psychomachia*, fol. 6v
Date: Early 11th cent.
Personification: Virtue, Chastity

London: Lib., British, Cott. Cleo.
 C.VIII
Prudentius, *Psychomachia*, fol. 4v
Date: Early 11th cent.
Personification: Virtue, Faith

London: Lib., British, Cott. Cleo.
 C.VIII
Prudentius, *Psychomachia*, fol. 5r
Date: Early 11th cent.

London: Lib., British, Cott. Cleo.
 C.VIII
Prudentius, *Psychomachia*, fol. 5v
Date: Early 11th cent.
Personification: Virtue, Chastity

London: Lib., British, Cott. Titus
 D.XVI
Prudentius, *Psychomachia*, fol. 6v
Date: ca. 1100
Personification: Virtue, Chastity

London: Lib., British, Cott. Titus
 D.XVI
Prudentius, *Psychomachia*, fol. 7r
Date: ca. 1100
Personification: Virtue, Chastity

London: Lib., British, Cott. Titus
 D.XVI
Prudentius, *Psychomachia*, fol. 7v
Date: ca. 1100
Personification: Virtue, Chastity

Munich: Lib., Staatsbibl., Clm. 30055
Gospel Book, Henry the Lion, fol. 15v
Date: ca. 1175
Apostle: Simon

New York: Lib., Morgan, Pierpont,
 M.729
Yolanda de Soissons Psalter-Hours,
 fol. 273r
Date: Last quarter 13th cent.
Pentecost

Paris: Lib., Bibl. Nat. de France,
 lat. 2077
Miscellany, fol. 163r
Date: 10th–11th cent.
Personification: Vice, Pride

Paris: Lib., Bibl. Nat. de France,
 lat. 8085
Prudentius, *Psychomachia*, fol. 57r
Date: Late 9th cent.
Personification: Virtue, Faith

Paris: Lib., Bibl. Nat. de France,
 lat. 8085
Prudentius, *Psychomachia*, fol. 57v
Date: Late 9th cent.
Personification: Virtue, Chastity

Paris: Lib., Bibl. Nat. de France,
 lat. 18554
Prudentius, *Psychomachia*, fol. 142r
Date: 10th cent.
Personification: Virtue, Chastity

Saint Gall: Lib., Stiftsbibl., 135
Prudentius, *Psychomachia*, p. 391
Date: First half 11th cent.
Personification: Virtue, Chastity

Strasbourg: Lib., Bibl. Municipale
Herradis of Landsberg, *Hort. Delic.*,
 fol. 201v
Date: Second half 12th cent.
Personification: Vice, Obstinacy

Valenciennes: Lib., Bibl. Municipale, 563
Prudentius, *Psychomachia*, fol. 5v
Date: Early 11th cent.
Personification: Virtue, Chastity

Valenciennes: Lib., Bibl. Municipale, 563
Prudentius, *Psychomachia*, fol. 6r
Date: Early 11th cent.
Personification: Virtue, Chastity

Wolfenbüttel: Lib., Herzog August Bibl., Guelf. 105 Noviss. 2°
Gospel Book, Henry the Lion, fol. 15v
Date: ca. 1175
Apostle: Simon

METALWORK

Bergen: Mus., Historisk
Bowl, copper-gilt (BM 8566)
Date: 12th cent.
Personification: Vice, Pride

Berlin: Mus., Staatliche
Bowl, bronze (1471)
Date: 12th cent.
Personification: Vice, Discord

Berlin: Mus., Staatliche
Bowl, brass (K 4480)
Date: 12th cent.
Personification: Vice, Pride

Halle: Mus., Landesmus. für Vorgeschichte
Bowl, bronze (HK 34.862)
Date: 12th cent.
Personification: Vice, Pride

Minden: Mus., Geschichte
Bowl, copper-gilt (E 454)
Date: 12th cent.
Personification: Vice, Pride

New York: Mus., Metropolitan, Cloisters
Bowl, copper-gilt (N.65.89)
Date: First half 12th cent.
Personification: Vice, Pride

Nuremberg: Mus., Germ. Nationalmus.
Bowl, copper-gilt (KG 1183)
Date: First half 13th cent.
Personification: Vice, Pride

Riga: Mus., Latvian Historical
Bowl, brass (23156?)
Date: 12th cent.
Personification: Vice, Pride

Strasbourg: Mus., Historique
Bowl, copper-gilt (700)
Date: 12th–13th cent.
Personification: Virtue, Humility

Strasbourg: Mus., Historique
Bowl (19336)
Date: 12th–13th cent.
Personification: Vice, Pride

Tallinn: Mus., Institute of History
Bowl, bronze (AI 4143:1)
Date: 12th cent.
Personification: Vice, Pride

Trier: Ch., Maximin
Font, of Folcardus
Date: Early 12th cent.
Personification: Virtue, Humility

SCULPTURE

Argenton-Château: Ch., Gilles
Exterior, west
Date: After 1130
Ornament: Figured

Chartres: Cath., Notre Dame
Exterior, north, central portal
Date: 1205–1210
Virgin Mary: Coronation

Chartres: Cath., Notre Dame
Exterior, north, left portal
Date: ca. 1220
Virgins, Foolish

Cologne: Cath., Peter und Maria
Choir stalls, north side
Date: First half 14th cent.
Scene: Liturgical, Confession

Los Angeles: Mus., County
Capital, sandstone (49.23.15a)
Date: ca. 1175–1200
Personification: Vice, Luxury

Regensburg: Ch., Jakob
Exterior, north
Date: Second half 12th cent.
Christ

Stanton Fitzwarren: Church
Font
Date: ca. 1160
Personification: Church

Vézelay: Ch., Madeleine
Aisles
Date: First half 12th cent.
Ornament: Figured

LUXURY

ENAMEL

Florence: Mus., Naz. di Bargello
Crozier (Carrand 622)
Date: ca. 1185–1200
David: Slaying Bear

Osnabrück: Town Hall, Rathaus
Vessel
Date: First half 14th cent.
Personification: Virtue, Prudence

Troyes: Cath., Pierre, Treasury
Casket
Date: ca. 1200
Personification: Virtue, Faith

FRESCO

Bardwell: Ch., Peter and Paul
Nave
Date: Late 14th cent.
Tree of Vices

Montoire: Ch., Gilles
Crossing
Date: 12th cent.
Lamb of God

Peterborough: Cath., Peter, Paul, and
 Andrew
Nave, ceiling
Date: 12th–13th cent.
Lamb of God

Tarrasa: Mus., Municipal
Fragments
Date: 12th cent.

Tavant: Ch., Nicolas
Crypt
Date: 11th–13th cent.
Adam and Eve: Fall of Man

GLASS

Esslingen: Ch., Dionysius
Windows, choir
Date: Late 13th–14th cent.
Isaiah

Lyons: Cath., Jean
Windows, apse
Date: ca. 1220
Magi: Before Herod the Great

Niederhaslach: Ch., Florentius
Windows, nave
Date: 1290–1420
Christ: Parable, Prodigal Son

Paris: Cath., Notre Dame
Window, west rose
Date: First half 13th cent.
Virgin Mary and Christ Child

Strasbourg: Cath., Notre Dame
Windows, nave
Date: 14th cent.
Personification: Virtue, Wisdom

IVORY

London: Lib., British
Plaques, in book cover (Egerton 1139)
Date: 1131–1143
David: Slaying Lion

MANUSCRIPT

Brussels: Lib., Bibl. Royale, 9968-72
Prudentius, *Psychomachia*, fol. 91v
Date: 11th cent.

Brussels: Lib., Bibl. Royale, 9968-72
Prudentius, *Psychomachia*, fol. 92v
Date: 11th cent.

Brussels: Lib., Bibl. Royale, 9968-72
Prudentius, *Psychomachia*, fol. 93r
Date: 11th cent.

Brussels: Lib., Bibl. Royale, 9968-72
Prudentius, *Psychomachia*, fol. 93v
Date: 11th cent.

Brussels: Lib., Bibl. Royale, 9968-72
Prudentius, *Psychomachia*, fol. 96r
Date: 11th cent.

Brussels: Lib., Bibl. Royale, 9968-72
Prudentius, *Psychomachia*, fol. 96v
Date: 11th cent.
Personification: Virtue, Sobriety

Brussels: Lib., Bibl. Royale, 9987-91
Prudentius, *Psychomachia*, fol. 109r
Date: 10th cent.
Personification: Virtue, Hope

Brussels: Lib., Bibl. Royale, 9987-91
Prudentius, *Psychomachia*, fol. 109v
Date: 10th cent.

Brussels: Lib., Bibl. Royale, 9987-91
Prudentius, *Psychomachia*, fol. 110r
Date: 10th cent.

Brussels: Lib., Bibl. Royale, 9987-91
Prudentius, *Psychomachia*, fol. 111v
Date: 10th cent.
Personification: Virtue, Sobriety

Brussels: Lib., Bibl. Royale, 9987-91
Prudentius, *Psychomachia*, fol. 112r
Date: 10th cent.
Personification: Virtue, Sobriety

Cambrai: Lib., Bibl. Municipale, 559
Augustine, *Varia*, fol. 69v
Date: 12th cent.

Cambridge: Lib., Corpus Christi
 College, 23
Prudentius, *Psychomachia*, fol. 19v
Date: Early 11th cent.
Personification: Virtue, Hope

Cambridge: Lib., Corpus Christi
 College, 23
Prudentius, *Psychomachia*, fol. 20r
Date: Early 11th cent.

Cambridge: Lib., Corpus Christi
 College, 23
Prudentius, *Psychomachia*, fol. 20v
Date: Early 11th cent.

Cambridge: Lib., Corpus Christi
 College, 23
Prudentius, *Psychomachia*, fol. 21r
Date: Early 11th cent.

Cambridge: Lib., Corpus Christi
 College, 23
Prudentius, *Psychomachia*, fol. 23v
Date: Early 11th cent.
Personification: Virtue, Sobriety

Cambridge: Lib., Corpus Christi
 College, 23
Prudentius, *Psychomachia*, fol. 24r
Date: Early 11th cent.
Personification: Virtue, Sobriety

Cambridge: Lib., University, Mm. 5.31
Alexander Laicus, *In Apocalipsin*,
 fol. 115v
Date: 13th cent.
Personification: Vice, Lust

Cambridge: Mus., Fitzwilliam, 368
Somme le Roi
Date: ca. 1300
Personification: Virtue, Chastity

Hannover: Lib., Niedersächsische
 Landesbibl., I.82
Somme le Roi, fol. 145r
Date: Early 14th cent.

Kremsmünster: Lib., Stiftsbibl., 243
Spec. Hum. Salvationis, fol. 3r
Date: First half 14th cent.
Tree of Vices

Leiden: Lib., Bibl. der Univ., Burm. Q.3
Prudentius, *Psychomachia*, fol. 132r
Date: Second quarter 9th cent.
Personification: Virtue, Hope

Leiden: Lib., Bibl. der Univ., Burm. Q.3
Prudentius, *Psychomachia*, fol. 132v
Date: Second quarter 9th cent.

Leiden: Lib., Bibl. der Univ., Burm. Q.3
Prudentius, *Psychomachia*, fol. 133r
Date: Second quarter 9th cent.

Leiden: Lib., Bibl. der Univ., Burm. Q.3
Prudentius, *Psychomachia*, fol. 134v
Date: Second quarter 9th cent.
Personification: Virtue, Sobriety

Leiden: Lib., Bibl. der Univ., Burm. Q.3
Prudentius, *Psychomachia*, fol. 135r
Date: Second quarter 9th cent.
Personification: Virtue, Sobriety

Leiden: Lib., Bibl. der Univ., Voss. lat.
 oct. 15
Prudentius, *Psychomachia*, fol. 39v
Date: Early 11th cent.
Personification: Virtue, Hope

Leiden: Lib., Bibl. der Univ., Voss. lat.
 oct. 15
Prudentius, *Psychomachia*, fol. 40r
Date: Early 11th cent.

Leiden: Lib., Bibl. der Univ., Voss. lat.
 oct. 15
Prudentius, *Psychomachia*, fol. 40v
Date: Early 11th cent.

Lilienfeld: Lib., Stiftsbibl., 151
Ulrich of Lilienfeld, *Concordantiae
 Caritatis*, fol. 16v
Date: Mid-14th cent.
Christ: Flight into Egypt, Fall of Idols

London: Lib., British, Add. 19352
Theodore Psalter, fol. 182v
Date: 1066
Psalm 144 (LXX, 143)

London: Lib., British, Add. 24199
Prudentius, *Psychomachia*, fol. 16v
Date: Early 11th cent.

London: Lib., British, Add. 24199
Prudentius, *Psychomachia*, fol. 17r
Date: Early 11th cent.

London: Lib., British, Add. 24199
Prudentius, *Psychomachia*, fol. 17v
Date: Early 11th cent.

London: Lib., British, Add. 24199
Prudentius, *Psychomachia*, fol. 18r
Date: Early 11th cent.

London: Lib., British, Add. 24199
Prudentius, *Psychomachia*, fol. 19v
Date: Early 11th cent.
Personification: Virtue, Sobriety

London: Lib., British, Add. 24199
Prudentius, *Psychomachia*, fol. 20r
Date: Early 11th cent.

London: Lib., British, Add. 24199
Prudentius, *Psychomachia*, fol. 20v
Date: Early 11th cent.
Personification: Virtue, Sobriety

London: Lib., British, Cott. Cleo.
 C.VIII
Prudentius, *Psychomachia*, fol. 15r
Date: Early 11th cent.

London: Lib., British, Cott. Cleo.
 C.VIII
Prudentius, *Psychomachia*, fol. 15v
Date: Early 11th cent.

London: Lib., British, Cott. Cleo.
 C.VIII
Prudentius, *Psychomachia*, fol. 16r
Date: Early 11th cent.

London: Lib., British, Cott. Cleo.
C.VIII
Prudentius, *Psychomachia*, fol. 18r
Date: Early 11th cent.

London: Lib., British, Cott. Cleo.
C.VIII
Prudentius, *Psychomachia*, fol. 18v
Date: Early 11th cent.

London: Lib., British, Cott. Cleo.
C.VIII
Prudentius, *Psychomachia*, fol. 19r
Date: Early 11th cent.
Personification: Virtue, Sobriety

London: Lib., British, Cott. Titus
D.XVI
Prudentius, *Psychomachia*, fol. 16r
Date: ca. 1100
Personification: Virtue, Hope

London: Lib., British, Cott. Titus
D.XVI
Prudentius, *Psychomachia*, fol. 17r
Date: ca. 1100

London: Lib., British, Cott. Titus
D.XVI
Prudentius, *Psychomachia*, fol. 19r
Date: ca. 1100
Personification: Virtue, Sobriety

London: Lib., British, Cott. Titus
D.XVI
Prudentius, *Psychomachia*, fol. 19v
Date: ca. 1100
Personification: Virtue, Sobriety

London: Lib., British, Roy. 19 C.II
Somme le Roi, fol. 85v
Date: 14th cent.

Lyons: Lib., Bibl. Municipale, Pal. des
Arts 22
Prudentius, *Psychomachia*, fol. 17r
Date: Last quarter 11th cent.
Personification: Virtue, Sobriety

Munich: Lib., Staatsbibl., Clm. 30055
Gospel Book, Henry the Lion, fol. 17r
Date: ca. 1175
Evangelist: Mark

Oxford: Lib., Bodleian, 270b
Bible, Moralized, fol. 26r
Date: First half 13th cent.
Joseph: As Interpreter of Dreams

Oxford: Lib., Bodleian, 270b
Bible, Moralized, fol. 36r
Date: First half 13th cent.
*Pharaoh: Commanding Affliction of
Israelites*

Oxford: Lib., Bodleian, 270b
Bible, Moralized, fol. 37v
Date: First half 13th cent.
Pharaoh: Command Disobeyed

Oxford: Lib., Bodleian, 270b
Bible, Moralized, fol. 63v
Date: First half 13th cent.
Moses: Law, Purification of Women

Paris: Lib., Bibl. Mazarine, 870
Somme le Roi, fol. 147r
Date: 1295
Personification: Virtue, Chastity

Paris: Lib., Bibl. Nat. de France,
lat. 2077
Miscellany, fol. 163r
Date: 10th–11th cent.
Personification: Vice, Pride

Paris: Lib., Bibl. Nat. de France,
lat. 2077
Miscellany, fol. 173r
Date: 10th–11th cent.

Paris: Lib., Bibl. Nat. de France,
lat. 8085
Prudentius, *Psychomachia*, fol. 61v
Date: Late 9th cent.

Paris: Lib., Bibl. Nat. de France,
lat. 8085
Prudentius, *Psychomachia*, fol. 62r
Date: Late 9th cent.

Paris: Lib., Bibl. Nat. de France,
lat. 8085
Prudentius, *Psychomachia*, fol. 62v
Date: Late 9th cent.
Personification: Virtue, Sobriety

Paris: Lib., Bibl. Nat. de France,
 lat. 8318
Prudentius, *Psychomachia*, fol. 52r
Date: Late 10th cent.

Paris: Lib., Bibl. Nat. de France,
 lat. 8318
Prudentius, *Psychomachia*, fol. 52v
Date: Late 10th cent.

Paris: Lib., Bibl. Nat. de France, lat.
 8318
Prudentius, *Psychomachia*, fol. 58r
Date: Late 10th cent.

Paris: Lib., Bibl. Nat. de France,
 lat. 15158
Prudentius, *Psychomachia*, fol. 48r
Date: 1289
Personification: Virtue, Sobriety

Rome: Lib., Bibl. Vaticana, Barb.
 gr. 372
Psalter, fol. 231v
Date: 11th cent.
Psalm 144 (LXX, 143)

Saint Gall: Lib., Stiftsbibl., 135
Prudentius, *Psychomachia*, p. 411
Date: First half 11th cent.
Personification: Virtue, Sobriety

Salzburg: Lib., Studienbibl., V 1 H 162
Miscellany, fol. 75v
Date: First half 12th cent.
Tree of Vices

Strasbourg: Lib., Bibl. Municipale
Herradis of Landsberg, *Hort. Delic.*,
 fol. 199v
Date: Second half 12th cent.
Personification: Vice, Pride

Strasbourg: Lib., Bibl. Municipale
Herradis of Landsberg, *Hort. Delic.*,
 fol. 201v
Date: Second half 12th cent.
Personification: Vice, Obstinacy

Strasbourg: Lib., Bibl. Municipale
Herradis of Landsberg, *Hort. Delic.*,
 fol. 202v
Date: Second half 12th cent.
Personification: Virtue, Temperance

Toledo: Lib., Bibl. del Cabildo
Bible, Moralized, III, fol. 188r
Date: First half 13th cent.
Apocalypse: Lamb, Victory over Kings

Valenciennes: Lib., Bibl. Municipale,
 563
Prudentius, *Psychomachia*, fol. 17v
Date: Early 11th cent.

Valenciennes: Lib., Bibl. Municipale,
 563
Prudentius, *Psychomachia*, fol. 18r
Date: Early 11th cent.

Valenciennes: Lib., Bibl. Municipale,
 563
Prudentius, *Psychomachia*, fol. 18v
Date: Early 11th cent.

Valenciennes: Lib., Bibl. Municipale,
 563
Prudentius, *Psychomachia*, fol. 19r
Date: Early 11th cent.

Valenciennes: Lib., Bibl. Municipale,
 563
Prudentius, *Psychomachia*, fol. 21r
Date: Early 11th cent.
Personification: Virtue, Sobriety

Valenciennes: Lib., Bibl. Municipale,
 563
Prudentius, *Psychomachia*, fol. 21v
Date: Early 11th cent.
Personification: Virtue, Sobriety

Valenciennes: Lib., Bibl. Municipale,
 563
Prudentius, *Psychomachia*, fol. 22r
Date: Early 11th cent.
Personification: Virtue, Sobriety

Vienna: Lib., Nationalbibl., 2554
Bible, Moralized, fol. 2r
Date: ca. 1215–1230
Eve: Given to Adam by God

Wolfenbüttel: Lib., Herzog August
 Bibl., Guelf. 105 Noviss. 2°
Gospel Book, Henry the Lion, fol. 17r
Date: ca. 1175
Evangelist: Mark

METALWORK

Bergen: Mus., Historisk
Bowl, copper-gilt (BM 8566)
Date: 12th cent.
Personification: Vice, Pride

Berlin: Mus., Staatliche
Bowl, bronze (1471)
Date: 12th cent.
Personification: Vice, Discord

Eger: Mus., Dobó István
Bowl
Date: 12th cent.
Personification: Vice, Pride

Hannover: Mus., Kestner
Bowl, copper-gilt (IV.75)
Date: 12th–13th cent.
Personification: Vice, Pride

Hannover: Mus., Kestner
Bowl
Date: 12th cent.

Kaliningrad: Mus., Regional
Bowl, bronze (18832)
Date: 12th cent.
Personification: Vice, Pride

Minden: Mus., Geschichte
Bowl, copper-gilt (E 454)
Date: 12th cent.
Personification: Vice, Pride

New York: Mus., Metropolitan,
 Cloisters
Bowl, copper-gilt (N.65.89)
Date: First half 12th cent.
Personification: Vice, Pride

Nuremberg: Mus., Germ.
 Nationalmus.
Bowl, copper-gilt (KG 1183)
Date: First half 13th cent.
Personification: Vice, Pride

Orvieto: Mus., Civico
Bowl, bronze
Date: 12th cent.
Personification: Vice, Pride

Riga: Mus., Latvian Historical
Bowl, brass (23156?)
Date: 12th cent.
Personification: Vice, Pride

Strasbourg: Mus., Historique
Bowl, copper-gilt (700)
Date: 12th–13th cent.
Personification: Virtue, Humility

Strasbourg: Mus., Historique
Bowl (19336)
Date: 12th–13th cent.
Personification: Vice, Pride

Tallinn: Mus., Institute of History
Bowl (AI 4143:2)
Date: 12th cent.
Personification: Vice, Pride

Tallinn: Mus., Institute of History
Bowl, bronze (AI 4143:3)
Date: 12th cent.
Personification: Vice, Pride

Tallinn: Mus., Institute of History
Bowl (AI 4143:4)
Date: 12th cent.
Personification: Vice, Pride

PAINTING

Frankfurt: Coll., Oppenheim
Retable
Date: Second half 14th cent.
Anthony Abbot the Great

SCULPTURE

Agen: Cath., Caprais
Chapter house
Date: 12th cent.

Amiens: Cath., Notre Dame
Exterior, west
Date: 1220–1235
Malachi

Angers: Ch., Nicolas
Decoration
Date: 12th cent.

Arroyo de la Encomienda: Ch., Juan
Apse
Date: Second half 12th cent.

Aulnay-de-Saintonge: Ch., Pierre
Exterior, west
Date: ca. 1130–1150
Month: Occupation

Autun: Cath., Lazare
Choir
Date: First half 12th cent.
Christ: On Road to Emmaus

Autun: Cath., Lazare
Exterior, west
Date: First half 12th cent.
Christ: Last Judgment

Auxerre: Cath., Etienne
Exterior, west, soccle
Date: ca. 1270
Apostle: Scene

Auxerre: Cath., Etienne
Transept, south
Date: 14th cent.
Ornament: Figured

Barcelona: Cath., Cruz
Exterior
Date: 12th cent.

Beaulieu: Ch., Pierre
Exterior, south
Date: 12th cent.
Christ: Last Judgment

Beaumont-sur-Grosne: Church
Exterior, west
Date: Early 12th cent.

Blesle: Ch., Pierre
Exterior, east
Date: 12th cent.

Bordeaux: Ch., Croix
Exterior, west
Date: ca. 1130–1140
Angel

Bourg-Argental: Church
Exterior, west
Date: 12th cent.
Christ and Four Beasts

Bourges: Cath., Etienne
Exterior, west
Date: Second half 13th cent.
Christ: Last Judgment

Brives-sur-Charente: Church
Font
Date: 12th cent.
Christ and Four Beasts

Charité-sur-Loire, La: Ch., Croix
Ambulatory
Date: 12th cent.
Daniel: In Lions' Den

Charlieu: Ch., Fortunatus
Exterior, north
Date: Mid-12th cent.
Lamb of God

Chartres: Cath., Notre Dame
Porch, south
Date: ca. 1230–1240
Saint

Cleveland: Museum of Art
Capitals (30.17,18)
Date: Mid-12th cent.
Virgin Mary: Annunciation

Cologne: Cath., Peter und Maria
Choir stalls, north side
Date: First half 14th cent.
Scene: Liturgical, Confession

Dinan: Ch., Sauveur
Decoration
Date: 12th cent.

Essen: Cath., Maria, Cosmas, und
 Damien
Choir and transept
Date: 11th cent.
Personification: River of Paradise

Fidenza: Cath., Donnino
Bell tower, southwest
Date: Late 12th–early 13th cent.
Alexander the Great: Celestial Journey

Foussais: Ch., Hilaire
Exterior, west
Date: 12th cent.
Christ and Four Beasts

Freiburg: Cath., Unsere Liebe Frau
Narthex
Date: 13th–14th cent.
Personification: Medicine

Freiburg: Cath., Unsere Liebe Frau
Tower
Date: 13th–14th cent.
Virgin Mary: Coronation

Gerona: Cathedral
Cloister
Date: 12th cent.
Eve: Creation

Gourdon: Church
Decoration
Date: 12th cent.

Huesca: Ch., Pedro el Viejo
Cloister
Date: 12th cent.
Cain and Abel: Bringing Offerings

Issoire: Ch., Austremoine
Transept
Date: 12th cent.
Damned

Laon: Cath., Notre Dame
Exterior, west
Date: ca. 1180–1210
Magi: Adoration

Lausanne: Cath., Notre Dame
Exterior, north
Date: 12th cent.
Ornament: Figured

Lavaudieu: Ch., Abbey, Cloister
Capital
Date: 12th cent.

León: Ch., Isidoro
Gallery
Date: Second half 11th cent.
Personification: Vice, Avarice

León: Ch., Isidoro
Nave
Date: 11th–12th cent.
Samson: Slaying Lion

London: Ch., Westminster Abbey
Capitals
Date: 12th cent.
Solomon: Judgment

London: Mus., Victoria and Albert
Capital, marble (A.161-1920)
Date: ca. 1125–1150

Los Angeles: Mus., County
Capital, sandstone (49.23.15a)
Date: ca. 1175–1200

Lund: Cathedral
Transept, north
Date: Mid-12th cent.
Angel: Seraph

Lyngsjö: Church
Font
Date: First quarter 13th cent.
Thomas à Becket: Scene

Lyons: Cath., Jean
Exterior, west
Date: First half 14th cent.
Weighing of Soul

Melle-sur-Béronne: Ch., Hilaire
Exterior, north
Date: 12th cent.
Month: Occupation

Moissac: Ch., Pierre
Exterior, south
Date: First half 12th cent.
*Apocalypse: Christ, Adoration by
 Elders*

Monopoli: Cathedral
Reliefs
Date: ca. 1107
Angel

Montmorillon: Chap., Octogone
Exterior
Date: 12th cent.

Mozac: Church
Nave
Date: 12th cent.
Tobias: Taking Fish

Paris: Cath., Notre Dame
Exterior, west
Date: ca. 1220–1230
Christ: Last Judgment

Perrecy-les-Forges: Church
Exterior, west
Date: ca. 1125
Christ: In Mandorla

Provins: Ch., Ayoul
Exterior, west
Date: Second half 12th cent.
*Apocalypse: Christ, Adoration by
 Elders*

Reims: Cath., Notre Dame
Exterior, north
Date: 13th cent.
Saint

Reims: Cath., Notre Dame
Exterior, west
Date: ca. 1230–1240
Virgin Mary: Coronation

Riom-ès-Montagnes: Ch., Georges
Exterior, east
Date: 11th cent.

Romans: Ch., Barnard
Exterior, west
Date: Second half 12th cent.
Apostle: Peter

Rouen: Cath., Notre Dame
Exterior, north
Date: Late 13th–14th cent.
Angel

Sagra di San Michele: Ch., Abbey
Decoration
Date: Second half 12th cent.
Ornament: Figured

Saint-Jouin-de-Marnes: Church
Exterior, west
Date: First half 12th cent.
Christ: Last Judgment

Saint-Nectaire: Church
Nave and aisles
Date: Mid-12th cent.
Ornament: Figured

Saint-Pons: Pref., Sous-Préfecture
Capital
Date: Second half 11th cent.

Salisbury: Cathedral, Chapter House
Decoration, vestibule
Date: ca. 1260–1280
*Personification: Virtues and Vices,
 Conflict*

Santiago de Compostela: Cathedral
Ambulatory
Date: Late 11th cent.

Santiago de Compostela: Cathedral
Exterior, south
Date: Early 12th cent.
Apostles

Schöngrabern: Church
Exterior, east
Date: First half 13th cent.
Weighing of Souls

Sebustiyeh: Ch., John Baptist
Exterior
Date: Second half 12th cent.
Figure: Male

Sémelay: Church
Nave
Date: 12th cent.

Semur-en-Auxois: Ch., Notre Dame
Decoration
Date: Second half 13th cent.

Soissons: Mus., Municipal
Tympanum
Date: First half 13th cent.
Christ: Harrowing of Hell

Southrop: Church
Font
Date: ca. 1160
*Personification: Church and
 Synagogue*

Stanton Fitzwarren: Church
Font
Date: ca. 1160
Personification: Church

Strzelno: Ch., Trinity
Nave, column
Date: Last quarter 12th cent.
Christ: Baptism

Tarragona: Cathedral
Cloister
Date: 13th cent.
Abraham: Entertaining the Angels

Toledo (Ohio): Mus., Museum of Art
Capital (29.208)
Date: ca. 1220–1225
Weighing of Soul

Toulouse: Ch., Sernin
Exterior, south
Date: Late 11th–12th cent.
Christ: Ascension

Toulouse: Mus., Augustins
Relief, marble (823)
Date: 12th cent.

Tournai: Cath., Notre Dame
Exterior, north
Date: Late 12th–13th cent.
Ornament: Figured

Tudela: Ch., Collegiata
Exterior, west
Date: 12th–13th cent.
Christ: Last Judgment

Uppsala: Cathedral
Choir
Date: Late 13th–14th cent.
Virgin Mary: Death

Vézelay: Ch., Madeleine
Nave
Date: First half 12th cent.
Saint

Vienne: Cath., Maurice
Aisles
Date: 12th cent.
Solomon: Judgment

TEXTILE

Paris: Mus., Moyen-Age, Cluny
Purse, embroidery (Cl. 11788)
Date: 14th cent.
Angel

MALICE

MANUSCRIPT

Hildesheim: Ch., Godehard, Treasury
Psalter of S. Albans, fol. 87r
Date: Early 12th cent.
Psalm 52 (Vulgate, 51)

Rome: Lib., Bibl. Vaticana, gr. 394
John Climacus, *Climax*, fol. 66r
Date: Late 11th cent.
John Climacus: Climax, Chapter VIII

Rome: Lib., Bibl. Vaticana, gr. 394
John Climacus, *Climax*, fol. 67v
Date: Late 11th cent.
John Climacus: Climax, Chapter IX

Rome: Lib., Bibl. Vaticana, gr. 394
John Climacus, *Climax*, fol. 71r
Date: Late 11th cent.
John Climacus: Climax, Chapter XI

Strasbourg: Lib., Bibl. Municipale
Herradis of Landsberg, *Hort. Delic.*,
 fol. 200v
Date: Second half 12th cent.
Personification: Vice, Wrath

METALWORK

Trier: Ch., Maximin
Font, of Folcardus
Date: Early 12th cent.
Personification: Virtue, Humility

MENDACITY

MANUSCRIPT

Cambrai: Lib., Bibl. Municipale, 559
Augustine, *Varia*, fol. 73v
Date: 12th cent.

MISCHIEF

MANUSCRIPT

Cambridge: Lib., Trinity College,
 R.17.1
Psalter, Canterbury, fol. 12v
Date: ca. 1145–1170
Psalm 7

London: Lib., British, Harley 603
Psalter, fol. 4r
Date: ca. 1000–12th cent.
Psalm 7

Paris: Lib., Bibl. Nat. de France,
 lat. 8846
Psalter, fol. 12v
Date: 12th–13th cent.
Psalm 7

Rome: Lib., Bibl. Vaticana, Reg. lat. 12
Psalter, fol. 25r
Date: Early 11th cent.
Psalm 7

Utrecht: Lib., Bibl. der Universiteit, 32
Psalter, fol. 4r
Date: ca. 820–830
Psalm 7

MUTTERING

MANUSCRIPT

Strasbourg: Lib., Bibl. Municipale
Herradis of Landsberg, *Hort. Delic.*,
 fol. 200v
Date: Second half 12th cent.
Personification: Vice, Wrath

NEGLIGENCE

MANUSCRIPT

Florence: Lib., Bibl. Laurenziana, Plut.
 XLII.19
Brunetto Latini, *Tesoro*, fol. 68r
Date: 14th cent.

Vienna: Lib., Nationalbibl., 2563
Matfre Ermengaud, *Brev. d'Amor*,
 fol. 11v
Date: 1354
Matfre Ermengaud: Tree of Love

OBLIVION

MANUSCRIPT

Strasbourg: Lib., Bibl. Municipale
Herradis of Landsberg, *Hort. Delic.*,
 fol. 200v
Date: Second half 12th cent.
Personification: Vice, Wrath

OBSCENE SPEECH

MANUSCRIPT

Strasbourg: Lib., Bibl. Municipale
Herradis of Landsberg, *Hort. Delic.*,
 fol. 201v
Date: Second half 12th cent.
Personification: Vice, Obstinacy

OBSTINACY

MANUSCRIPT

Strasbourg: Lib., Bibl. Municipale
Herradis of Landsberg, *Hort. Delic.*,
 fol. 201v
Date: Second half 12th cent.

OPULENCE

MANUSCRIPT

Munich: Lib., Staatsbibl., Clm. 13002
Miscellany, fol. 3v
Date: 1158–1165
Apocalypse: Scarlet Woman Drunk

PERJURY

FRESCO

Ingatestone: Ch., Mary and Edmund
Decoration
Date: Late 14th cent.
Wheel of Vices

Strasbourg: Lib., Bibl. Municipale
Herradis of Landsberg, *Hort. Delic.*,
 fol. 202v
Date: Second half 12th cent.
Personification: Virtue, Temperance

SCULPTURE

Strzelno: Ch., Trinity
Nave, column
Date: Last quarter 12th cent.
Christ: Baptism

PETULANCE

GLASS

Esslingen: Ch., Dionysius
Windows, choir
Date: Late 13th–14th cent.
Isaiah

MANUSCRIPT

Strasbourg: Lib., Bibl. Municipale
Herradis of Landsberg, *Hort. Delic.*,
 fol. 201v
Date: Second half 12th cent.
Personification: Vice, Obstinacy

Strasbourg: Lib., Bibl. Municipale
Herradis of Landsberg, *Hort. Delic.,*
 fol. 202v
Date: Second half 12th cent.
Personification: Virtue, Temperance

SCULPTURE

Strzelno: Ch., Trinity
Nave, column
Date: Last quarter 12th cent.
Christ: Baptism

PILLAGE

MANUSCRIPT

Paris: Lib., Bibl. Nat. de France,
 lat. 2077
Miscellany, fol. 163r
Date: 10th–11th cent.
Personification: Vice, Pride

Strasbourg: Lib., Bibl. Municipale
Herradis of Landsberg, *Hort. Delic.,*
 fol. 201v
Date: Second half 12th cent.
Personification: Vice, Obstinacy

Strasbourg: Lib., Bibl. Municipale
Herradis of Landsberg, *Hort. Delic.,*
 fol. 202v
Date: Second half 12th cent.
Personification: Virtue, Temperance

Strasbourg: Lib., Bibl. Municipale
Herradis of Landsberg, *Hort. Delic.,*
 fol. 203r
Date: Second half 12th cent.

PLEASURE

MANUSCRIPT

Brussels: Lib., Bibl. Royale, 9968-72
Prudentius, *Psychomachia*, fol. 97v
Date: 11th cent.

Brussels: Lib., Bibl. Royale, 9987-91
Prudentius, *Psychomachia*, fol. 113r
Date: 10th cent.

Cambridge: Lib., Corpus Christi
 College, 23
Prudentius, *Psychomachia*, fol. 25r
Date: Early 11th cent.
Personification: Vice, Pomp

Leiden: Lib., Bibl. der Univ., Burm. Q.3
Prudentius, *Psychomachia*, fol. 136r
Date: Second quarter 9th cent.

Leiden: Lib., Bibl. der Univ., Voss. lat.
 oct. 15
Prudentius, *Psychomachia*, fol. 40v
Date: Early 11th cent.
Personification: Vice, Luxury

London: Lib., British, Add. 24199
Prudentius, *Psychomachia*, fol. 22r
Date: Early 11th cent.

London: Lib., British, Cott. Cleo.
 C.VIII
Prudentius, *Psychomachia*, fol. 20r
Date: Early 11th cent.

Lyons: Lib., Bibl. Municipale, Pal. des
 Arts 22
Prudentius, *Psychomachia*, fol. 17v
Date: Last quarter 11th cent.
Personification: Vice, Profane Love

Munich: Lib., Staatsbibl., Clm. 13002
Miscellany, fol. 3v
Date: 1158–1165
Apocalypse: Scarlet Woman Drunk

Paris: Lib., Bibl. Nat. de France,
 lat. 8085
Prudentius, *Psychomachia*, fol. 63r
Date: Late 9th cent.
Personification: Virtue, Sobriety

Paris: Lib., Bibl. Nat. de France,
 lat. 8318
Prudentius, *Psychomachia*, fol. 58v
Date: Late 10th cent.
Personification: Vice, Profane Love

Paris: Lib., Bibl. Nat. de France,
 lat. 15158
Prudentius, *Psychomachia*, fol. 49r
Date: 1289
Personification: Vice, Pomp

Saint Gall: Lib., Stiftsbibl., 135
Prudentius, *Psychomachia*, p. 412
Date: First half 11th cent.

Strasbourg: Lib., Bibl. Municipale
Herradis of Landsberg, *Hort. Delic.*,
 fol. 201v
Date: Second half 12th cent.
Personification: Vice, Obstinacy

Strasbourg: Lib., Bibl. Municipale
Herradis of Landsberg, *Hort. Delic.*,
 fol. 202v
Date: Second half 12th cent.
Personification: Virtue, Temperance

Valenciennes: Lib., Bibl. Municipale,
 563
Prudentius, *Psychomachia*, fol. 23r
Date: Early 11th cent.

POMP

MANUSCRIPT

Brussels: Lib., Bibl. Royale, 9987-91
Prudentius, *Psychomachia*, fol. 112v
Date: 10th cent.
Personification: Vice, Jest

Cambridge: Lib., Corpus Christi
 College, 23
Prudentius, *Psychomachia*, fol. 25r
Date: Early 11th cent.
Personification: Vice, Pleasure

Leiden: Lib., Bibl. der Univ., Burm. Q.3
Prudentius, *Psychomachia*, fol. 135v
Date: Second quarter 9th cent.
Personification: Vice, Jest

Leiden: Lib., Bibl. der Univ., Voss. lat.
 oct. 15
Prudentius, *Psychomachia*, fol. 40v
Date: Early 11th cent.
Personification: Vice, Luxury

London: Lib., British, Add. 24199
Prudentius, *Psychomachia*, fol. 21v
Date: Early 11th cent.

London: Lib., British, Cott. Cleo.
 C.VIII
Prudentius, *Psychomachia*, fol. 19v
Date: Early 11th cent.
Personification: Vice, Profane Love

Lyons: Lib., Bibl. Municipale, Pal. des
 Arts 22
Prudentius, *Psychomachia*, fol. 17v
Date: Last quarter 11th cent.
Personification: Vice, Profane Love

Paris: Lib., Bibl. Nat. de France, lat.
 8085
Prudentius, *Psychomachia*, fol. 63r
Date: Late 9th cent.
Personification: Virtue, Sobriety

Paris: Lib., Bibl. Nat. de France, lat.
 8318
Prudentius, *Psychomachia*, fol. 58v
Date: Late 10th cent.
Personification: Vice, Profane Love

Paris: Lib., Bibl. Nat. de France, lat.
 15158
Prudentius, *Psychomachia*, fol. 49r
Date: 1289

Strasbourg: Lib., Bibl. Municipale
Herradis of Landsberg, *Hort. Delic.*,
 fol. 201v
Date: Second half 12th cent.
Personification: Vice, Obstinacy

Strasbourg: Lib., Bibl. Municipale
Herradis of Landsberg, *Hort. Delic.*,
 fol. 202v
Date: Second half 12th cent.
Personification: Virtue, Temperance

POVERTY

MANUSCRIPT

Vienna: Lib., Nationalbibl., 2592
Roman de la Rose, fol. 4v
Date: Second half 14th cent.

METALWORK

Novgorod: Cath., Sophia
Door, bronze
Attribution: Riquinus of Magdeburg
Date: 1152–1156
Christ and Peter and Paul

SCULPTURE

Laon: Cath., Notre Dame
Exterior, west
Date: ca. 1180–1210
Magi: Adoration

Salisbury: Cathedral, Chapter House
Decoration, vestibule
Date: ca. 1260–1280
*Personification: Virtues and Vices,
 Conflict*

POWER

MANUSCRIPT

Munich: Lib., Staatsbibl., Clm. 13002
Miscellany, fol. 3v
Date: 1158–1165
Apocalypse: Scarlet Woman Drunk

PRESUMPTION

MANUSCRIPT

Strasbourg: Lib., Bibl. Municipale
Herradis of Landsberg, *Hort. Delic.*,
 fol. 201v
Date: Second half 12th cent.
Personification: Vice, Obstinacy

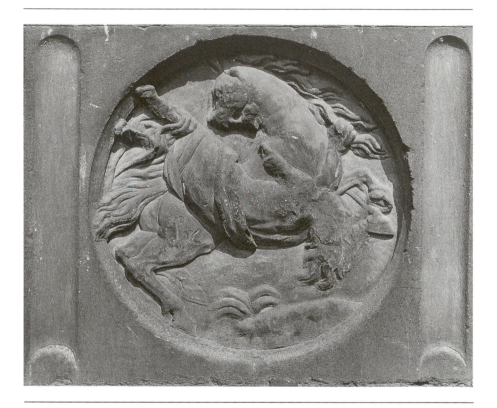

PRIDE

ENAMEL

Langres: Museum
Plaques, on reliquary
Date: Third quarter 12th cent.
Personification: Virtue, Fortitude

Osnabrück: Town Hall, Rathaus
Vessel
Date: First half 14th cent.
Personification: Virtue, Prudence

Troyes: Cath., Pierre, Treasury
Casket
Date: ca. 1200
Personification: Virtue, Faith

FRESCO

Aquileia: Cathedral
Crypt
Date: 1180s
Virgin Mary: Death

Bardwell: Ch., Peter and Paul
Nave
Date: Late 14th cent.
Tree of Vices

Brioude: Ch., Julien
Porch
Date: 12th–13th cent.
Christ: Last Judgment

Hoxne: Ch., Peter and Paul
Nave
Date: Late 14th cent.
Tree of Vices

Ingatestone: Ch., Mary and Edmund
Decoration
Date: Late 14th cent.
Wheel of Vices

Saint-Jacques-des-Guérets: Church
Decoration
Date: 12th cent.
Christ and Four Beasts

Siena: Ch., Francesco
Chapel, Bandini Piccolomini
Date: First half 14th cent.
Louis of Toulouse: Scene

Siena: Pal., Pubblico
Room, Pace
Attribution: Ambrogio Lorenzetti
Date: 1338–1339
Personification: Virtue, Justice

GLASS

Auxerre: Cath., Etienne
Choir, left
Date: ca. 1230–1250

Esslingen: Ch., Dionysius
Windows, choir
Date: Late 13th–14th cent.
Isaiah

Lyons: Cath., Jean
Windows, apse
Date: ca. 1220
Magi: Before Herod the Great

Niederhaslach: Ch., Florentius
Windows, nave
Date: 1290–1420
Christ: Parable, Prodigal Son

Strasbourg: Cath., Notre Dame
Windows, nave
Date: 14th cent.
Personification: Virtue, Wisdom

Wels: Church
Windows
Date: Late 14th–15th cent.
Adam and Eve: Fall of Man

IVORY

London: Lib., British
Plaques, in book cover (Egerton 1139)
Date: 1131–1143
David: Slaying Lion

MANUSCRIPT

Baltimore: Gall., Walters, W. 72
Speculum Virginum, fol. 25v
Date: First half 13th cent.

Baltimore: Gall., Walters, W. 72
Speculum Virginum, fol. 31r
Date: First half 13th cent.
Personification: Virtue, Humility

Berlin: Lib., Staatsbibl., germ. qu. 978
Miniature from Thomasin von
 Zerclaere, *Der wälsche Gast*
Date: Second half 13th–14th cent.

Berlin: Lib., Staatsbibl., Phill. 1701
Speculum Virginum, fol. 43r
Date: Early 13th cent.
Personification: Virtue, Humility

Berne: Lib., Stadtbibl., 264
Prudentius, *Psychomachia*, fol. 41v
Date: Early 10th cent.

Berne: Lib., Stadtbibl., 264
Prudentius, *Psychomachia*, fol. 42r
Date: Early 10th cent.

Berne: Lib., Stadtbibl., 264
Prudentius, *Psychomachia*, fol. 43v
Date: Early 10th cent.
Personification: Vice, Fraud

Berne: Lib., Stadtbibl., 264
Prudentius, *Psychomachia*, fol. 44r
Date: Early 10th cent.
Personification: Virtue, Humility

Berne: Lib., Stadtbibl., 264
Prudentius, *Psychomachia*, fol. 45r
Date: Early 10th cent.

Brussels: Lib., Bibl. Royale, 9968-72
Prudentius, *Psychomachia*, fol. 86r
Date: 11th cent.

Brussels: Lib., Bibl. Royale, 9968-72
Prudentius, *Psychomachia*, fol. 86v
Date: 11th cent.

Brussels: Lib., Bibl. Royale, 9968-72
Prudentius, *Psychomachia*, fol. 90v
Date: 11th cent.
Personification: Virtue, Humility

Brussels: Lib., Bibl. Royale, 9987-91
Prudentius, *Psychomachia*, fol. 105v
Date: 10th cent.

Brussels: Lib., Bibl. Royale, 9987-91
Prudentius, *Psychomachia*, fol. 106r
Date: 10th cent.

Brussels: Lib., Bibl. Royale, 9987-91
Prudentius, *Psychomachia*, fol. 107r
Date: 10th cent.

Brussels: Lib., Bibl. Royale, 9987-91
Prudentius, *Psychomachia*, fol. 107v
Date: 10th cent.

Brussels: Lib., Bibl. Royale, 9987-91
Prudentius, *Psychomachia*, fol. 108v
Date: 10th cent.
Personification: Virtue, Hope

Brussels: Lib., Bibl. Royale, 10066-77
Prudentius, *Psychomachia*, fol. 122r
Date: 10th–first half 11th cent.

Brussels: Lib., Bibl. Royale, 10066-77
Prudentius, *Psychomachia*, fol. 123v
Date: 10th–first half 11th cent.

Brussels: Lib., Bibl. Royale, 10066-77
Prudentius, *Psychomachia*, fol. 124r
Date: 10th–first half 11th cent.
Personification: Virtue, Humility

Brussels: Lib., Bibl. Royale, 10066-77
Prudentius, *Psychomachia*, fol. 124v
Date: 10th–first half 11th cent.
Personification: Virtue, Hope

Cambridge: Lib., Corpus Christi
 College, 23
Prudentius, *Psychomachia*, fol. 14r
Date: Early 11th cent.
Personification: Virtue, Patience

Cambridge: Lib., Corpus Christi
 College, 23
Prudentius, *Psychomachia*, fol. 14v
Date: Early 11th cent.

Cambridge: Lib., Corpus Christi
 College, 23
Prudentius, *Psychomachia*, fol. 15r
Date: Early 11th cent.

Cambridge: Lib., Corpus Christi
 College, 23
Prudentius, *Psychomachia*, fol. 16v
Date: Early 11th cent.

Cambridge: Lib., Corpus Christi
 College, 23
Prudentius, *Psychomachia*, fol. 17r
Date: Early 11th cent.

Cambridge: Lib., Corpus Christi
 College, 23
Prudentius, *Psychomachia*, fol. 17v
Date: Early 11th cent.

Cambridge: Lib., Corpus Christi
 College, 23
Prudentius, *Psychomachia*, fol. 18r
Date: Early 11th cent.
Personification: Virtue, Hope

Cambridge: Lib., Corpus Christi
 College, 23
Prudentius, *Psychomachia*, fol. 18v
Date: Early 11th cent.
Personification: Virtue, Hope

Cologne: Arch., Historisches, W 276a
Speculum Virginum, fol. 11v
Date: Mid-12th cent.

Hamburg: Mus., Kunst und Gewerbe
Prudentius, *Psychomachia*, recto
Date: 10th cent.

Hamburg: Mus., Kunst und Gewerbe
Prudentius, *Psychomachia*, verso
Date: 10th cent.

Kremsmünster: Lib., Stiftsbibl., 243
Spec. Hum. Salvationis, fol. 3r
Date: First half 14th cent.
Tree of Vices

Leiden: Lib., Bibl. der Univ., Burm. Q.3
Prudentius, *Psychomachia*, fol. 128v
Date: Second quarter 9th cent.

Leiden: Lib., Bibl. der Univ., Burm. Q.3
Prudentius, *Psychomachia*, fol. 129r
Date: Second quarter 9th cent.

Leiden: Lib., Bibl. der Univ., Burm. Q.3
Prudentius, *Psychomachia*, fol. 130r
Date: Second quarter 9th cent.

Leiden: Lib., Bibl. der Univ., Burm. Q.3
Prudentius, *Psychomachia*, fol. 130v
Date: Second quarter 9th cent.
Personification: Virtue, Humility

Leiden: Lib., Bibl. der Univ., Burm. Q.3
Prudentius, *Psychomachia*, fol. 131r
Date: Second quarter 9th cent.
Personification: Virtue, Hope

Leiden: Lib., Bibl. der Univ., Burm. Q.3
Prudentius, *Psychomachia*, fol. 131v
Date: Second quarter 9th cent.
Personification: Virtue, Hope

Leiden: Lib., Bibl. der Univ., Voss. lat.
 oct. 15
Prudentius, *Psychomachia*, fol. 39r
Date: Early 11th cent.

Leiden: Lib., Bibl. der Univ., Voss. lat.
 oct. 15
Prudentius, *Psychomachia*, fol. 39v
Date: Early 11th cent.
Personification: Virtue, Hope

Leipzig: Lib., Universitätsbibl., 148
Miscellany, fol. 113v
Date: 1133
Tree of Vices

Leipzig: Lib., Universitätsbibl., 305
Miscellany, fol. 151r
Date: 13th cent.

Leipzig: Lib., Universitätsbibl., 665
Speculum Virginum, fol. 39v
Date: Mid-14th cent.

Leipzig: Lib., Universitätsbibl., 665
Speculum Virginum, fol. 49v
Date: Mid-14th cent.
Personification: Virtue, Humility

London: Lib., British, Add. 18719
Bible, Moralized, fol. 228r
Date: Early 14th cent.
Judas Maccabaeus: Capture of Bosora

London: Lib., British, Add. 24199
Prudentius, *Psychomachia*, fol. 12r
Date: Early 11th cent.

London: Lib., British, Add. 24199
Prudentius, *Psychomachia*, fol. 12v
Date: Early 11th cent.

London: Lib., British, Add. 24199
Prudentius, *Psychomachia*, fol. 14r
Date: Early 11th cent.

London: Lib., British, Add. 24199
Prudentius, *Psychomachia*, fol. 14v
Date: Early 11th cent.
Personification: Virtue, Humility

London: Lib., British, Add. 24199
Prudentius, *Psychomachia*, fol. 15r
Date: Early 11th cent.
Personification: Virtue, Hope

London: Lib., British, Add. 24199
Prudentius, *Psychomachia*, fol. 15v
Date: Early 11th cent.
Personification: Virtue, Humility

London: Lib., British, Add. 28162
Somme le Roi, fol. 5v
Date: ca. 1300
Personification: Virtue, Humility

London: Lib., British, Add. 40731
Bristol Psalter, fol. 231v
Date: First half 11th cent.
Psalm 144 (LXX, 143)

London: Lib., British, Add. 42130
Luttrell Psalter, fol. 53r
Date: ca. 1340
Helena, Empress

London: Lib., British, Add. 54180
Somme le Roi, fol. 97v
Date: ca. 1300
Personification: Virtue, Humility

London: Lib., British, Arundel 44
Speculum Virginum, fol. 28v
Date: ca. 1140–1150

London: Lib., British, Arundel 44
Speculum Virginum, fol. 34v
Date: ca. 1140–1150
Personification: Virtue, Humility

London: Lib., British, Arundel 83
Psalter, fol. 128v
Date: First half 14th cent.
Psalms: Illustration

London: Lib., British, Cott. Cleo.
 C.VIII
Prudentius, *Psychomachia*, fol. 10v
Date: Early 11th cent.

London: Lib., British, Cott. Cleo.
 C.VIII
Prudentius, *Psychomachia*, fol. 11r
Date: Early 11th cent.

London: Lib., British, Cott. Cleo.
 C.VIII
Prudentius, *Psychomachia*, fol. 12v
Date: Early 11th cent.

London: Lib., British, Cott. Cleo.
 C.VIII
Prudentius, *Psychomachia*, fol. 13r
Date: Early 11th cent.
Personification: Virtue, Humility

London: Lib., British, Cott. Cleo.
 C.VIII
Prudentius, *Psychomachia*, fol. 13v
Date: Early 11th cent.
Personification: Virtue, Hope

London: Lib., British, Cott. Cleo.
 C.VIII
Prudentius, *Psychomachia*, fol. 14r
Date: Early 11th cent.
Personification: Virtue, Hope

London: Lib., British, Cott. Titus
 D.XVI
Prudentius, *Psychomachia*, fol. 12r
Date: ca. 1100

London: Lib., British, Cott. Titus
 D.XVI
Prudentius, *Psychomachia*, fol. 12v
Date: ca. 1100

London: Lib., British, Cott. Titus
 D.XVI
Prudentius, *Psychomachia*, fol. 14r
Date: ca. 1100

London: Lib., British, Cott. Titus
 D.XVI
Prudentius, *Psychomachia*, fol. 14v
Date: ca. 1100

London: Lib., British, Cott. Titus
 D.XVI
Prudentius, *Psychomachia*, fol. 15r
Date: ca. 1100
Personification: Virtue, Humility

Milan: Lib., Bibl. Ambrosiana, H.106
 sup.
Somme le Roi, fol. XLIVr
Date: ca. 1300
Personification: Virtue, Humility

Munich: Lib., Staatsbibl., Clm. 14159
Dialogus Cruce Christi, fol. 5r
Date: ca. 1170–1185
Christ: Bearing Cross

Munich: Lib., Staatsbibl., Clm. 30055
Gospel Book, Henry the Lion, fol. 16v
Date: ca. 1175
Apostle: Matthias

Oxford: Lib., Bodleian, 270b
Bible, Moralized, fol. 26r
Date: First half 13th cent.
Joseph: As Interpreter of Dreams

Oxford: Lib., Bodleian, 270b
Bible, Moralized, fol. 36r
Date: First half 13th cent.
Pharaoh: Commanding Affliction of
 Israelites

Oxford: Lib., Bodleian, 270b
Bible, Moralized, fol. 64r
Date: First half 13th cent.
Moses: Law, Priests without Blemish

Paris: Lib., Bibl. de l'Arsenal, 6329
Somme le Roi, fol. 102v
Date: 1311
Personification: Virtue, Humility

Paris: Lib., Bibl. Nat. de France,
 fr. 14939
Somme le Roi, fol. 100v
Date: 1373
Personification: Virtue, Humility

Paris: Lib., Bibl. Nat. de France,
 fr. 19093
Sketchbook, Villard de Honnecourt,
 fol. 3v
Date: Mid-13th cent.

Paris: Lib., Bibl. Nat. de France, gr. 139
Psalter, fol. 4v
Date: 10th cent.
Psalms: Illustration

Paris: Lib., Bibl. Nat. de France,
 lat. 2077
Miscellany, fol. 163r
Date: 10th–11th cent.

Paris: Lib., Bibl. Nat. de France,
 lat. 8085
Prudentius, *Psychomachia*, fol. 59v
Date: Late 9th cent.
Personification: Virtue, Patience

Paris: Lib., Bibl. Nat. de France,
 lat. 8085
Prudentius, *Psychomachia*, fol. 60r
Date: Late 9th cent.

Paris: Lib., Bibl. Nat. de France, lat.
 8085
Prudentius, *Psychomachia*, fol. 60v
Date: Late 9th cent.

Paris: Lib., Bibl. Nat. de France,
 lat. 8085
Prudentius, *Psychomachia*, fol. 61r
Date: Late 9th cent.
Personification: Virtue, Humility

Paris: Lib., Bibl. Nat. de France,
 lat. 8318
Prudentius, *Psychomachia*, fol. 51r
Date: Late 10th cent.

Paris: Lib., Bibl. Nat. de France,
 lat. 8318
Prudentius, *Psychomachia*, fol. 51v
Date: Late 10th cent.

Paris: Lib., Bibl. Nat. de France,
 lat. 8318
Prudentius, *Psychomachia*, fol. 53r
Date: Late 10th cent.

Rome: Lib., Bibl. Vaticana, gr. 394
John Climacus, *Climax*, fol. 94r
Date: Late 11th cent.
John Climacus: Climax, Chapter
 XVIII

Rome: Lib., Bibl. Vaticana, gr. 394
John Climacus, *Climax*, fol. 98r
Date: Late 11th cent.
John Climacus: Climax, Chapter XXI

Rome: Lib., Bibl. Vaticana, gr. 394
John Climacus, *Climax*, fol. 102r
Date: Late 11th cent.
John Climacus: Climax, Chapter XVII

Rome: Lib., Bibl. Vaticana, gr. 394
John Climacus, *Climax*, fol. 105r
Date: Late 11th cent.
John Climacus: Climax, Chapter XXIII, Part 1

Saint Gall: Lib., Stiftsbibl., 135
Prudentius, *Psychomachia*, p. 399
Date: First half 11th cent.
Personification: Virtue, Hope

Saint Gall: Lib., Stiftsbibl., 135
Prudentius, *Psychomachia*, p. 400
Date: First half 11th cent.
Personification: Vice, Fraud

Salzburg: Lib., Studienbibl., V 1 H 162
Miscellany, fol. 75v
Date: First half 12th cent.
Tree of Vices

Strasbourg: Lib., Bibl. Municipale
Herradis of Landsberg, *Hort. Delic.*,
 fol. 199v
Date: Second half 12th cent.

Toledo: Lib., Bibl. del Cabildo
Bible, Moralized, III, fol. 188r
Date: First half 13th cent.
Apocalypse: Lamb, Victory over Kings

Troyes: Lib., Bibl. Municipale, 252
Speculum Virginum, fol. 29v
Date: ca. 1190

Troyes: Lib., Bibl. Municipale, 252
Speculum Virginum, fol. 37v
Date: ca. 1190
Personification: Virtue, Humility

Valenciennes: Lib., Bibl. Municipale,
 563
Prudentius, *Psychomachia*, fol. 12v
Date: Early 11th cent.

Valenciennes: Lib., Bibl. Municipale,
 563
Prudentius, *Psychomachia*, fol. 13r
Date: Early 11th cent.

Valenciennes: Lib., Bibl. Municipale,
 563
Prudentius, *Psychomachia*, fol. 14v
Date: Early 11th cent.

Valenciennes: Lib., Bibl. Municipale,
 563
Prudentius, *Psychomachia*, fol. 15r
Date: Early 11th cent.

Valenciennes: Lib., Bibl. Municipale,
 563
Prudentius, *Psychomachia*, fol. 15v
Date: Early 11th cent.

Valenciennes: Lib., Bibl. Municipale,
 563
Prudentius, *Psychomachia*, fol. 16r
Date: Early 11th cent.
Personification: Virtue, Humility

Valenciennes: Lib., Bibl. Municipale,
 563
Prudentius, *Psychomachia*, fol. 16v
Date: Early 11th cent.
Personification: Virtue, Hope

Vienna: Lib., Nationalbibl., 1179
Bible, Moralized, fol. 160r
Date: ca. 1215–1230
Job: God's Speech

Vienna: Lib., Nationalbibl., 1179
Bible, Moralized, fol. 196r
Date: ca. 1215–1230
*Judas Maccabaeus: Cleansing of
 Sanctuary*

Vienna: Lib., Nationalbibl., 2563
Matfre Ermengaud, *Brev. d'Amor*,
 fol. 11v
Date: 1354
Matfre Ermengaud: Tree of Love

Vienna: Lib., Nationalbibl., 2583*
Matfre Ermengaud, *Brev. d'Amor*,
 fol. 237v
Date: 14th cent.
Personification: Virtue, Generosity

Wolfenbüttel: Lib., Herzog August
 Bibl., Guelf. 105 Noviss. 2°
Gospel Book, Henry the Lion, fol. 16v
Date: ca. 1175
Apostle: Matthias

Zwettl: Monastery, 180
Speculum Virginum, fol. 45v
Date: First third 13th cent.
Personification: Virtue, Humility

METALWORK

Arnhem: Mus., Gemeentemuseum
Bowl (GM 206 13)
Date: 12th cent.

Bergen: Mus., Historisk
Bowl, copper-gilt (BM 8566)
Date: 12th cent.

Berlin: Mus., Staatliche
Bowl, brass (K 4480)
Date: 12th cent.

Budapest: Mus., Magyar Nemzeti
 Múzeum
Bowl, bronze, fragment
Date: 12th–13th cent.

Copenhagen: Mus., National
Bowl, bronze (D 865)
Date: 12th cent.

Copenhagen: Mus., National
Bowl (9204)
Date: 12th cent.

Eger: Mus., Dobó István
Bowl
Date: 12th cent.

Groningen: Mus., Groninger
Bowl, copper (538)
Date: 12th–13th cent.

Halle: Mus., Landesmus. für
 Vorgeschichte
Bowl, bronze (HK 34.862)
Date: 12th cent.

Hamburg: Mus., Kunst und Gewerbe
Bowl, bronze, fragment (1929.139)
Date: 12th cent.

Hannover: Mus., Kestner
Bowl, copper-gilt (IV.75)
Date: 12th–13th cent.

Kaliningrad: Mus., Regional
Bowl, bronze (18832)
Date: 12th cent.

London: Mus., British
Bowl, bronze (1855.6-25.23)
Date: ca. first half 12th cent.

Minden: Mus., Geschichte
Bowl, copper-gilt (E 454)
Date: 12th cent.

Münster: Mus., Westfälisches
 Landesmus.
Bowl, bronze (M 234)
Date: 12th cent.

New York: Mus., Metropolitan,
 Cloisters
Bowl, copper-gilt (N.65.89)
Date: First half 12th cent.

Nuremberg: Mus., Germ.
 Nationalmus.
Bowl, copper-gilt (KG 1183)
Date: First half 13th cent.

Orvieto: Mus., Civico
Bowl, bronze
Date: 12th cent.

Riga: Mus., Latvian Historical
Bowl, brass (23156?)
Date: 12th cent.

Strasbourg: Mus., Historique
Bowl (19336)
Date: 12th–13th cent.

Tallinn: Mus., Institute of History
Bowl, bronze (AI 4143:1)
Date: 12th cent.

Tallinn: Mus., Institute of History
Bowl (AI 4143:2)
Date: 12th cent.

Tallinn: Mus., Institute of History
Bowl, bronze (AI 4143:3)
Date: 12th cent.

Tallinn: Mus., Institute of History
Bowl (AI 4143:4)
Date: 12th cent.

Trier: Ch., Maximin
Font, of Folcardus
Date: Early 12th cent.
Personification: Virtue, Humility

PAINTING

Florence: Gall., Uffizi
Panel (P752)
Attribution: Giovanni del Biondo
Date: ca. 1380
Evangelist: John

Florence: Mus., Opera del Duomo
Panel (9152)
Attribution: Bigallo Master
Date: ca. 1240–1250
Zenobius of Florence

SCULPTURE

Amiens: Cath., Notre Dame
Exterior, west
Date: 1220–1235
Malachi

Argenton-Château: Ch., Gilles
Exterior, west
Date: After 1130
Ornament: Figured

Aulnay-de-Saintonge: Ch., Pierre
Exterior, west
Date: ca. 1130–1150
Month: Occupation

Autun: Cath., Lazare
Choir
Date: First half 12th cent.
Christ: On Road to Emmaus

Bremen: Cath., Peter
Reliefs, from choir stalls
Date: 14th–15th cent.
Apostles

Chartres: Cath., Notre Dame
Exterior, north, central portal
Date: 1205–1210
Virgin Mary: Coronation

Chartres: Cath., Notre Dame
Exterior, north, left portal
Date: ca. 1220
Virgins, Foolish

Chartres: Cath., Notre Dame
Porch, south
Date: ca. 1230–1240
Saint

Cologne: Cath., Peter und Maria
Choir stalls, south side
Date: First half 14th cent.
Scene: Secular

Conques: Ch., Foy
Exterior, west
Date: First half 12th cent.
Christ: Last Judgment

Freiburg: Cath., Unsere Liebe Frau
Tower
Date: 13th–14th cent.
Virgin Mary: Coronation

Guebwiller: Ch., Léger
Exterior
Date: Late 12th cent.
Ornament: Figured

Laon: Cath., Notre Dame
Exterior, west
Date: ca. 1180–1210
Magi: Adoration

Lucheux: Church
Decoration
Date: 12th cent.
Ornament: Figured

Magdeburg: Cath., Mauritius und
 Katharina
Choir
Date: First half 13th cent.
Apostle: Andrew

Paris: Cath., Notre Dame
Exterior, west
Date: ca. 1220–1230
Christ: Last Judgment

Poitiers: Cath., Pierre
Choir stalls, wood
Date: Second half 13th–14th cent.
Angel

Regensburg: Ch., Jakob
Exterior, north
Date: Second half 12th cent.
Christ

Reims: Cath., Notre Dame
Exterior, west
Date: ca. 1230–1240
Virgin Mary: Coronation

Rouen: Cath., Notre Dame
Exterior, north
Date: Late 13th–14th cent.
Angel

Salisbury: Cathedral, Chapter House
Decoration, vestibule
Date: ca. 1260–1280
Personification: Virtues and Vices,
 Conflict

Stanton Fitzwarren: Church
Font
Date: ca. 1160
Personification: Church

Strzelno: Ch., Trinity
Nave, column
Date: Last quarter 12th cent.
Christ: Baptism

Tournai: Cath., Notre Dame
Exterior, north
Date: Late 12th–13th cent.
Ornament: Figured

Tournai: Cath., Notre Dame
Nave
Date: 12th cent.
Ornament: Figured

Uppsala: Cathedral
Choir
Date: Late 13th–14th cent.
Virgin Mary: Death

Worms: Cath., Peter and Paul
Exterior, south
Date: First half 14th cent.
Nicholas of Myra: Scene

PROFANE LOVE

ENAMEL

Osnabrück: Town Hall, Rathaus
Vessel
Date: First half 14th cent.
Personification: Virtue, Prudence

FRESCO

Assisi: Ch., Francesco, Lower
Crossing, vault
Date: First half 14th cent.
Allegory: Poverty

GLASS

Niederhaslach: Ch., Florentius
Windows, nave
Date: 1290–1420
Christ: Parable, Prodigal Son

MANUSCRIPT

Brussels: Lib., Bibl. Royale, 9968-72
Prudentius, *Psychomachia*, fol. 97r
Date: 11th cent.
Personification: Vice, Jest

Brussels: Lib., Bibl. Royale, 9987-91
Prudentius, *Psychomachia*, fol. 112v
Date: 10th cent.
Personification: Vice, Jest

Cambridge: Lib., Corpus Christi
 College, 23
Prudentius, *Psychomachia*, fol. 24v
Date: Early 11th cent.

Leiden: Lib., Bibl. der Univ., Burm. Q.3
Prudentius, *Psychomachia*, fol. 135v
Date: Second quarter 9th cent.
Personification: Vice, Jest

Leiden: Lib., Bibl. der Univ., Voss. lat.
 oct. 15
Prudentius, *Psychomachia*, fol. 40v
Date: Early 11th cent.
Personification: Vice, Luxury

London: Lib., British, Add. 24199
Prudentius, *Psychomachia*, fol. 21r
Date: Early 11th cent.
Personification: Vice, Jest

London: Lib., British, Cott. Cleo.
 C.VIII
Prudentius, *Psychomachia*, fol. 19v
Date: Early 11th cent.

Lyons: Lib., Bibl. Municipale, Pal. des
 Arts 22
Prudentius, *Psychomachia*, fol. 17v
Date: Last quarter 11th cent.

Munich: Lib., Staatsbibl., Clm. 30055
Gospel Book, Henry the Lion, fol. 17r
Date: ca. 1175
Evangelist: Mark

Paris: Lib., Bibl. Nat. de France,
 lat. 8085
Prudentius, *Psychomachia*, fol. 63r
Date: Late 9th cent.
Personification: Virtue, Sobriety

Paris: Lib., Bibl. Nat. de France,
 lat. 8318
Prudentius, *Psychomachia*, fol. 58v
Date: Late 10th cent.

Paris: Lib., Bibl. Nat. de France,
 lat. 15158
Prudentius, *Psychomachia*, fol. 48v
Date: 1289
Personification: Vice, Jest

Strasbourg: Lib., Bibl. Municipale
Herradis of Landsberg, *Hort. Delic.*,
 fol. 201v
Date: Second half 12th cent.
Personification: Vice, Obstinacy

Strasbourg: Lib., Bibl. Municipale
Herradis of Landsberg, *Hort. Delic.*,
 fol. 202v
Date: Second half 12th cent.
Personification: Virtue, Temperance

Valenciennes: Lib., Bibl. Municipale,
 563
Prudentius, *Psychomachia*, fol. 22v
Date: Early 11th cent.

Wolfenbüttel: Lib., Herzog August
 Bibl., Guelf. 105 Noviss. 2°
Gospel Book, Henry the Lion, fol. 17r
Date: ca. 1175
Evangelist: Mark

SCULPTURE

Strzelno: Ch., Trinity
Nave, column
Date: Last quarter 12th cent.
Christ: Baptism

RAPACITY

MANUSCRIPT

Strasbourg: Lib., Bibl. Municipale
Herradis of Landsberg, *Hort. Delic.*,
 fol. 203v
Date: Second half 12th cent.
Personification: Vice, Avarice

SADNESS

MANUSCRIPT

Kremsmünster: Lib., Stiftsbibl., 243
Spec. Hum. Salvationis, fol. 3r
Date: First half 14th cent.
Tree of Vices

Paris: Lib., Bibl. Nat. de France,
 lat. 2077
Miscellany, fol. 163r
Date: 10th–11th cent.
Personification: Vice, Pride

Salzburg: Lib., Studienbibl., V 1 H 162
Miscellany, fol. 75v
Date: First half 12th cent.
Tree of Vices

Strasbourg: Lib., Bibl. Municipale
Herradis of Landsberg, *Hort. Delic.*,
 fol. 199v
Date: Second half 12th cent.
Personification: Vice, Pride

Strasbourg: Lib., Bibl. Municipale
Herradis of Landsberg, *Hort. Delic.*,
 fol. 200r
Date: Second half 12th cent.
Personification: Virtue, Humility

SATIETY

MANUSCRIPT

Rome: Lib., Bibl. Vaticana, gr. 394
John Climacus, *Climax*, fol. 94r
Date: Late 11th cent.
John Climacus: Climax, Chapter
 XVIII

SEDITION

GLASS

Esslingen: Ch., Dionysius
Windows, choir
Date: Late 13th–14th cent.
Isaiah

SENILITY

MANUSCRIPT

Vienna: Lib., Nationalbibl., 2583*
Matfre Ermengaud, *Brev. d'Amor*,
 fol. 237v
Date: 14th cent.
Personification: Virtue, Generosity

Vienna: Lib., Nationalbibl., 2592
Roman de la Rose, fol. 3v
Date: Second half 14th cent.
Personification: Vice, Grief

SIMONY

MANUSCRIPT

Oxford: Lib., Bodleian, 270b
Bible, Moralized, fol. 60r
Date: First half 13th cent.
*Moses: Law, Meat Offering of First
 Fruits*

Oxford: Lib., Bodleian, 270b
Bible, Moralized, fol. 63v
Date: First half 13th cent.
Moses: Law, Purification of Women

SIMULATION

MANUSCRIPT

Strasbourg: Lib., Bibl. Municipale
Herradis of Landsberg, *Hort. Delic.*, fol.
 202v
Date: Second half 12th cent.
Personification: Virtue, Temperance

SLANDER

FRESCO

Kastoria: Mon., Mavriotissa, Church
Decoration
Date: Late 11th–early 13th cent.
Virgin Mary and Christ Child

Kastoria: Mon., Mavriotissa, Church
Narthex, south wall
Date: Late 11th–early 13th cent.
Christ: Last Judgment

GLASS

Niederhaslach: Ch., Florentius
Windows, nave
Date: 1290–1420
Christ: Parable, Prodigal Son

MANUSCRIPT

Brussels: Lib., Bibl. Royale, 10176-78
G. de Degulleville, *Pèlerinage*, fol. 68r
Date: 14th–15th cent.

Paris: Lib., Bibl. Nat. de France,
 lat. 2077
Miscellany, fol. 164v
Date: 10th–11th cent.
Personification: Virtue, Humility

Rome: Lib., Bibl. Vaticana, gr. 394
John Climacus, *Climax*, fol. 67v
Date: Late 11th cent.
John Climacus: Climax, Chapter IX

Rome: Lib., Bibl. Vaticana, gr. 394
John Climacus, *Climax*, fol. 69v
Date: Late 11th cent.
John Climacus: Climax, Chapter X

Rome: Lib., Bibl. Vaticana, gr. 394
John Climacus, *Climax*, fol. 71r
Date: Late 11th cent.
John Climacus: Climax, Chapter XI

Strasbourg: Lib., Bibl. Municipale
Herradis of Landsberg, *Hort. Delic.*,
 fol. 200v
Date: Second half 12th cent.
Personification: Vice, Wrath

Vienna: Lib., Nationalbibl., 2563
Matfre Ermengaud, *Brev. d'Amor*,
 fol. 11v
Date: 1354
Matfre Ermengaud: Tree of Love

Vienna: Lib., Nationalbibl., 2583*
Matfre Ermengaud, *Brev. d'Amor*,
 fol. 237v
Date: 14th cent.
Personification: Virtue, Generosity

SCULPTURE

Autun: Cath., Lazare
Exterior, west
Date: First half 12th cent.
Christ: Last Judgment

Conques: Ch., Foy
Exterior, west
Date: First half 12th cent.
Christ: Last Judgment

Freiburg: Cath., Unsere Liebe Frau
Narthex
Date: 13th–14th cent.
Personification: Medicine

Nuaillé-sur-Boutonne: Ch., Notre
 Dame
Exterior, west
Date: Late 12th cent.
Angel

Philadelphia (Penn.): Mus., Museum
 of Art
Capital, sandstone (45.25.47)
Date: Late 12th cent.
Personification: Vice

Poitiers: Cath., Pierre
Choir
Date: Second half 12th cent.
Ornament: Figured

Saint-André-de-Bagé: Church
Apse
Date: ca. 1100
Daniel: In Lions' Den

Soissons: Mus., Municipal
Tympanum
Date: First half 13th cent.
Christ: Harrowing of Hell

Tournus: Ch., Philibert
Decoration
Date: Early 12th cent.
Ornament: Figured

Vézelay: Ch., Madeleine
Nave
Date: First half 12th cent.
Saint

SLEEP

MANUSCRIPT

Rome: Lib., Bibl. Vaticana, gr. 394
John Climacus, *Climax*, fol. 94r
Date: Late 11th cent.
*John Climacus: Climax, Chapter
 XVIII*

SLOTH

FRESCO

Bardwell: Ch., Peter and Paul
Nave
Date: Late 14th cent.
Tree of Vices

Hoxne: Ch., Peter and Paul
Nave
Date: Late 14th cent.
Tree of Vices

Ingatestone: Ch., Mary and Edmund
Decoration
Date: Late 14th cent.
Wheel of Vices

Siena: Ch., Francesco
Chapel, Bandini Piccolomini
Date: First half 14th cent.
Louis of Toulouse: Scene

MANUSCRIPT

New York: Lib., Morgan, Pierpont,
 M.729
Yolanda de Soissons Psalter-Hours,
 fol. 16r
Date: Last quarter 13th cent.
Psalm 50

Rome: Lib., Bibl. Vaticana, gr. 394
John Climacus, *Climax*, fol. 72r
Date: Late 11th cent.
John Climacus: Climax, Chapter XII

Rome: Lib., Bibl. Vaticana, gr. 394
John Climacus, *Climax*, fol. 74r
Date: Late 11th cent.
John Climacus: Climax, Chapter XIII

SCULPTURE

Boston: Mus., Fine Arts
Corbel, limestone (55.9)
Date: 13th cent.
Figure: Male

Salisbury: Cathedral, Chapter House
Decoration, vestibule
Date: ca. 1260–1280
Personification: Virtues and Vices,
Conflict

SORDIDNESS

MANUSCRIPT

Strasbourg: Lib., Bibl. Municipale
Herradis of Landsberg, *Hort. Delic.*,
fol. 202v
Date: Second half 12th cent.
Personification: Virtue, Temperance

Strasbourg: Lib., Bibl. Municipale
Herradis of Landsberg, *Hort. Delic.*,
fol. 203v
Date: Second half 12th cent.
Personification: Vice, Avarice

STINGINESS

ENAMEL

Troyes: Cath., Pierre, Treasury
Casket
Date: ca. 1200
Personification: Virtue, Faith

MANUSCRIPT

Strasbourg: Lib., Bibl. Municipale
Herradis of Landsberg, *Hort. Delic.*,
fol. 202v
Date: Second half 12th cent.
Personification: Virtue, Temperance

Strasbourg: Lib., Bibl. Municipale
Herradis of Landsberg, *Hort. Delic.*,
fol. 203v
Date: Second half 12th cent.
Personification: Vice, Avarice

TEMERITY

MANUSCRIPT

Strasbourg: Lib., Bibl. Municipale
Herradis of Landsberg, *Hort. Delic.*,
 fol. 200v
Date: Second half 12th cent.
Personification: Vice, Wrath

Strasbourg: Lib., Bibl. Municipale
Herradis of Landsberg, *Hort. Delic.*,
 fol. 203v
Date: Second half 12th cent.
Personification: Vice, Avarice

THOUGHT OF DEATH

MANUSCRIPT

Vienna: Lib., Nationalbibl., 2563
Matfre Ermengaud, *Brev. d'Amor*,
 fol. 11v
Date: 1354
Matfre Ermengaud: Tree of Love

TIMIDITY

MANUSCRIPT

Rome: Lib., Bibl. Vaticana, gr. 394
John Climacus, *Climax*, fol. 97r
Date: Late 11th cent.
John Climacus: Climax, Chapter XX

TITUBATION

MANUSCRIPT

Strasbourg: Lib., Bibl. Municipale
Herradis of Landsberg, *Hort. Delic.*,
 fol. 201v
Date: Second half 12th cent.
Personification: Vice, Obstinacy

TREASON

FRESCO

Siena: Pal., Pubblico
Room, Pace
Attribution: Ambrogio Lorenzetti
Date: 1338–1339
Personification: Virtue, Justice

MANUSCRIPT

Brussels: Lib., Bibl. Royale, 10176-78
G. de Degulleville, *Pèlerinage*, fol. 68r
Date: 14th–15th cent.
Personification: Vice, Slander

Malines: Lib., Grand Séminaire
Bible, Nicolò de Alifio, p. 1
Date: Mid-14th cent.
Robert of Anjou

TURPITUDE

MANUSCRIPT

Strasbourg: Lib., Bibl. Municipale
Herradis of Landsberg, *Hort. Delic.*,
 fol. 201v
Date: Second half 12th cent.
Personification: Vice, Obstinacy

TYRANNY

FRESCO

Siena: Pal., Pubblico
Room, Pace
Attribution: Ambrogio Lorenzetti
Date: 1338–1339
Personification: Virtue, Justice

MANUSCRIPT

Malines: Lib., Grand Séminaire
Bible, Nicolò de Alifio, p. 1
Date: Mid-14th cent.
Robert of Anjou

UNBELIEF

MANUSCRIPT

Rome: Lib., Bibl. Vaticana, gr. 394
John Climacus, *Climax*, fol. 97r
Date: Late 11th cent.
John Climacus: Climax, Chapter XX

USURY

MANUSCRIPT

Strasbourg: Lib., Bibl. Municipale
Herradis of Landsberg, *Hort. Delic.*,
 fol. 202v
Date: Second half 12th cent.
Personification: Virtue, Temperance

SCULPTURE

Piacenza: Cath., Assunta
Exterior, west, central portal
Date: ca. second quarter 12th cent.
Personification: Vice, Avarice

VAINGLORY

FRESCO

Siena: Pal., Pubblico
Room, Pace
Attribution: Ambrogio Lorenzetti
Date: 1338–1339
Personification: Virtue, Justice

MANUSCRIPT

Kremsmünster: Lib., Stiftsbibl., 243
Spec. Hum. Salvationis, fol. 3r
Date: First half 14th cent.
Tree of Vices

Paris: Lib., Bibl. Nat. de France,
 lat. 2077
Miscellany, fol. 163r
Date: 10th–11th cent.
Personification: Vice, Pride

Paris: Lib., Bibl. Nat. de France,
 lat. 2077
Miscellany, fol. 165v
Date: 10th–11th cent.

Paris: Lib., Bibl. Nat. de France,
 lat. 8318
Prudentius, *Psychomachia*, fol. 54v
Date: Late 10th cent.
Personification: Vice, Idleness

Patmos: Lib., Mon. Giovanni, 122
John Climacus, *Climax*, fol. Bro
Date: 11th cent.
*John Climacus: Climax, Table of
 Contents I*

Rome: Lib., Bibl. Vaticana, gr. 394
John Climacus, *Climax*, fol. 94r
Date: Late 11th cent.
*John Climacus: Climax, Chapter
 XVIII*

Rome: Lib., Bibl. Vaticana, gr. 394
John Climacus, *Climax*, fol. 97r
Date: Late 11th cent.
John Climacus: Climax, Chapter XX

Rome: Lib., Bibl. Vaticana, gr. 394
John Climacus, *Climax*, fol. 98r
Date: Late 11th cent.
John Climacus: Climax, Chapter XXI

Rome: Lib., Bibl. Vaticana, gr. 394
John Climacus, *Climax*, fol. 102r
Date: Late 11th cent.
John Climacus: Climax, Chapter XXII

Rome: Lib., Bibl. Vaticana, gr. 394
John Climacus, *Climax*, fol. 105r
Date: Late 11th cent.
*John Climacus: Climax, Chapter
 XXIII, Part 1*

Rome: Lib., Bibl. Vaticana, gr. 1754
John Climacus, *Climax*, fol. 1v
Date: 12th cent.
*John Climacus: Climax, Table of
 Contents I*

Salzburg: Lib., Studienbibl., V 1 H 162
Miscellany, fol. 75v
Date: First half 12th cent.
Tree of Vices

Strasbourg: Lib., Bibl. Municipale
Herradis of Landsberg, *Hort. Delic.*,
 fol. 199v
Date: Second half 12th cent.
Personification: Vice, Pride

Strasbourg: Lib., Bibl. Municipale
Herradis of Landsberg, *Hort. Delic.*,
 fol. 201v
Date: Second half 12th cent.
Personification: Vice, Obstinacy

SCULPTURE

Cologne: Cath., Peter und Maria
Choir stalls, south side
Date: First half 14th cent.
Scene: Liturgical, Confession

Regensburg: Ch., Jakob
Exterior, north
Date: Second half 12th cent.
Christ

VANITY

GLASS

Paris: Cath., Notre Dame
Window, west rose
Date: First half 13th cent.
Virgin Mary and Christ Child

MANUSCRIPT

Forlì: Lib., Bibl. Comunale, 853
Office, S. Mariae, fol. 161r
Date: Late 14th–15th cent.
Scene: Liturgical, Confession

PAINTING

Florence: Gall., Uffizi
Panel (P752)
Attribution: Giovanni del Biondo
Date: ca. 1380
Evangelist: John

SCULPTURE

Bremen: Cath., Peter
Reliefs, from choir stalls
Date: 14th–15th cent.
Apostles

Cologne: Cath., Peter und Maria
Choir stalls, north side
Date: First half 14th cent.
Scene: Liturgical, Confession

Regensburg: Ch., Jakob
Exterior, north
Date: Second half 12th cent.
Christ

VENGEANCE

MANUSCRIPT

Cambridge: Lib., Trinity College,
 R.17.1
Psalter, Canterbury, fol. 167r
Date: ca. 1145–1170
Psalm 94 (Vulgate, 93)

Utrecht: Lib., Bibl. der Universiteit, 32
Psalter, fol. 55r
Date: ca. 820–830
Psalm 94 (Vulgate, 93)

SCULPTURE

Reims: Cath., Notre Dame
Exterior, west
Date: ca. 1230–1240
Virgin Mary: Coronation

VIOLENCE

MANUSCRIPT

Brussels: Lib., Bibl. Royale, 9968-72
Prudentius, *Psychomachia*, fol. 106v
Date: 11th cent.
Personification: Virtue, Peace

Brussels: Lib., Bibl. Royale, 9987-91
Prudentius, *Psychomachia*, fol. 117v
Date: 10th cent.
Personification: Virtue, Peace

Cambridge: Lib., Corpus Christi
 College, 23
Prudentius, *Psychomachia*, fol. 33r
Date: Early 11th cent.
Personification: Virtue, Peace

Leiden: Lib., Bibl. der Univ., Burm. Q.3
Prudentius, *Psychomachia*, fol. 141v
Date: Second quarter 9th cent.
Personification: Virtue, Peace

Leiden: Lib., Bibl. der Univ., Voss. lat.
 oct. 15
Prudentius, *Psychomachia*, fol. 41v
Date: Early 11th cent.
Personification: Vice, Avarice

London: Lib., British, Cott. Cleo.
 C.VIII
Prudentius, *Psychomachia*, fol. 27r
Date: Early 11th cent.
Personification: Virtue, Peace

Lyons: Lib., Bibl. Municipale, Pal. des
 Arts 22
Prudentius, *Psychomachia*, fol. 15v
Date: Last quarter 11th cent.
Personification: Vice, Fear

Paris: Lib., Bibl. Nat. de France, lat.
 8085
Prudentius, *Psychomachia*, fol. 65v
Date: Late 9th cent.
Personification: Virtue, Peace

Paris: Lib., Bibl. Nat. de France, lat.
8318
Prudentius, *Psychomachia*, fol. 61v
Date: Late 10th cent.
Personification: Virtue, Generosity

Paris: Lib., Bibl. Nat. de France, lat.
15158
Prudentius, *Psychomachia*, fol. 55v
Date: 1289
Personification: Virtue, Peace

Strasbourg: Lib., Bibl. Municipale
Herradis of Landsberg, *Hort. Delic.*,
fol. 201v
Date: Second half 12th cent.
Personification: Vice, Obstinacy

Strasbourg: Lib., Bibl. Municipale
Herradis of Landsberg, *Hort. Delic.*,
fol. 202v
Date: Second half 12th cent.
Personification: Virtue, Temperance

Strasbourg: Lib., Bibl. Municipale
Herradis of Landsberg, *Hort. Delic.*,
fol. 203v
Date: Second half 12th cent.
Personification: Vice, Avarice

SCULPTURE

Laon: Cath., Notre Dame
Exterior, west
Date: ca. 1180–1210
Magi: Adoration

WEAKNESS

ENAMEL

Langres: Museum
Plaques, on reliquary
Date: Third quarter 12th cent.
Personification: Virtue, Fortitude

MANUSCRIPT

Malines: Lib., Grand Séminaire
Bible, Nicolò de Alifio, p. 1
Date: Mid-14th cent.
Robert of Anjou

WICKEDNESS

MANUSCRIPT

Rome: Lib., Bibl. Vaticana, gr. 394
John Climacus, *Climax*, fol. 107r
Date: Late 11th cent.
*John Climacus: Climax, Chapter
XXIII, Part 2*

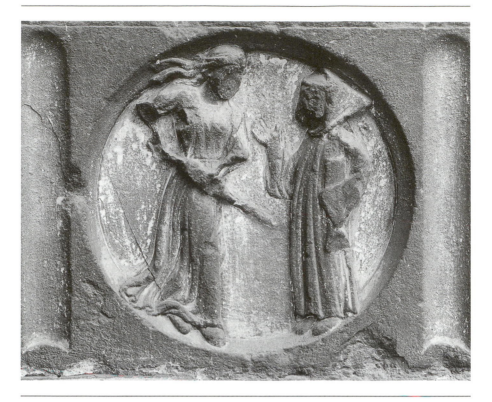

WRATH

FRESCO

Brioude: Ch., Julien
Porch
Date: 12th–13th cent.
Christ: Last Judgment

Forchheim: Castle
Decoration
Date: Mid-14th–15th cent.
Magi: Adoration

London: Pal., Westminster
Painted Chamber
Date: Late 13th cent.
Maccabees: Battle

Montoire: Ch., Gilles
Crossing
Date: 12th cent.
Lamb of God

Padua: Chap., Madonna dell'Arena
Decoration
Attribution: Giotto
Date: ca. 1303–1308
Virgin Mary: Birth

Saint-Jacques-des-Guérets: Church
Decoration
Date: 12th cent.
Christ and Four Beasts

Siena: Ch., Francesco
Chapel, Bandini Piccolomini
Date: First half 14th cent.
Louis of Toulouse: Scene

Tours: Ch., Martin
Tower, Charlemagne
Date: Second half 11th cent.
Florentius of Bavaria

GLASS

Lyons: Cath., Jean
Window, apse
Date: ca. 1220
Magi: Before Herod the Great

Mulhouse: Ch., Etienne
Windows
Date: First half 14th cent.
Personification: Virtue, Sobriety

Paris: Cath., Notre Dame
Window, west rose
Date: First half 13th cent.
Virgin Mary and Christ Child

IVORY

London: Lib., British
Plaques, in book cover (Egerton 1139)
Date: 1131–1143
David: Slaying Lion

MANUSCRIPT

Berne: Lib., Stadtbibl., 264
Prudentius, *Psychomachia*, fol. 38v
Date: Early 10th cent.

Berne: Lib., Stadtbibl., 264
Prudentius, *Psychomachia*, fol. 39r
Date: Early 10th cent.
Personification: Virtue, Patience

Berne: Lib., Stadtbibl., 264
Prudentius, *Psychomachia*, fol. 39v
Date: Early 10th cent.
Personification: Virtue, Patience

Berne: Lib., Stadtbibl., 264
Prudentius, *Psychomachia*, fol. 40r
Date: 9th cent.

Brussels: Lib., Bibl. Royale, 9968-72
Prudentius, *Psychomachia*, fol. 82r
Date: 11th cent.
Personification: Virtue, Patience

Brussels: Lib., Bibl. Royale, 9968-72
Prudentius, *Psychomachia*, fol. 82v
Date: 11th cent.
Personification: Virtue, Patience

Brussels: Lib., Bibl. Royale, 9968-72
Prudentius, *Psychomachia*, fol. 83r
Date: 11th cent.
Personification: Virtue, Patience

Brussels: Lib., Bibl. Royale, 9968-72
Prudentius, *Psychomachia*, fol. 83v
Date: 11th cent.
Personification: Virtue, Patience

Brussels: Lib., Bibl. Royale, 9968-72
Prudentius, *Psychomachia*, fol. 84r
Date: 11th cent.

Brussels: Lib., Bibl. Royale, 9968-72
Prudentius, *Psychomachia*, fol. 84v
Date: 11th cent.
Personification: Virtue, Patience

Brussels: Lib., Bibl. Royale, 9987-91
Prudentius, *Psychomachia*, fol. 103r
Date: 10th cent.
Personification: Virtue, Patience

Brussels: Lib., Bibl. Royale, 9987-91
Prudentius, *Psychomachia*, fol. 103v
Date: 10th cent.

Brussels: Lib., Bibl. Royale, 9987-91
Prudentius, *Psychomachia*, fol. 104r
Date: 10th cent.
Personification: Virtue, Patience

Brussels: Lib., Bibl. Royale, 10066-77
Prudentius, *Psychomachia*, fol. 118v
Date: 10th–first half 11th cent.

Brussels: Lib., Bibl. Royale, 10066-77
Prudentius, *Psychomachia*, fol. 119r
Date: 10th–first half 11th cent.

Brussels: Lib., Bibl. Royale, 10066-77
Prudentius, *Psychomachia*, fol. 120r
Date: 10th–first half 11th cent.
Personification: Virtue, Patience

Brussels: Lib., Bibl. Royale, 10066-77
Prudentius, *Psychomachia*, fol. 120v
Date: 10th–first half 11th cent.
Personification: Virtue, Patience

Cambridge: Lib., Corpus Christi
 College, 23
Prudentius, *Psychomachia*, fol. 10v
Date: Early 11th cent.
Personification: Virtue, Chastity

Cambridge: Lib., Corpus Christi
 College, 23
Prudentius, *Psychomachia*, fol. 11r
Date: Early 11th cent.
Personification: Virtue, Patience

Cambridge: Lib., Corpus Christi
 College, 23
Prudentius, *Psychomachia*, fol. 11v
Date: Early 11th cent.

Cambridge: Lib., Corpus Christi
 College, 23
Prudentius, *Psychomachia*, fol. 12r
Date: Early 11th cent.

Cambridge: Lib., Corpus Christi
 College, 23
Prudentius, *Psychomachia*, fol. 12v
Date: Early 11th cent.

Cambridge: Lib., Corpus Christi
 College, 23
Prudentius, *Psychomachia*, fol. 13r
Date: Early 11th cent.

Cambridge: Mus., Fitzwilliam, 330
Psalter, W. de Brailes, no. 1
Date: ca. 1240
Psalms: Illustration

Kremsmünster: Lib., Stiftsbibl., 243
Spec. Hum. Salvationis, fol. 3r
Date: First half 14th cent.
Tree of Vices

Leiden: Lib., Bibl. der Univ., Burm. Q.3
Prudentius, *Psychomachia*, fol. 126r
Date: Second quarter 9th cent.
Personification: Virtue, Patience

Leiden: Lib., Bibl. der Univ., Burm. Q.3
Prudentius, *Psychomachia*, fol. 126v
Date: Second quarter 9th cent.
Personification: Virtue, Patience

Leiden: Lib., Bibl. der Univ., Burm. Q.3
Prudentius, *Psychomachia*, fol. 127r
Date: Second quarter 9th cent.

Leiden: Lib., Bibl. der Univ., Burm. Q.3
Prudentius, *Psychomachia*, fol. 127v
Date: Second quarter 9th cent.
Personification: Virtue, Patience

Leiden: Lib., Bibl. der Univ., Voss. lat.
 oct. 15
Prudentius, *Psychomachia*, fol. 38r
Date: Early 11th cent.
Personification: Virtue, Chastity

Leiden: Lib., Bibl. der Univ., Voss. lat.
 oct. 15
Prudentius, *Psychomachia*, fol. 38v
Date: Early 11th cent.

London: Lib., British, Add. 24199
Prudentius, *Psychomachia*, fol. 8r
Date: Early 11th cent.
Personification: Virtue, Chastity

London: Lib., British, Add. 24199
Prudentius, *Psychomachia*, fol. 8v
Date: Early 11th cent.
Personification: Virtue, Patience

London: Lib., British, Add. 24199
Prudentius, *Psychomachia*, fol. 9r
Date: Early 11th cent.
Personification: Virtue, Patience

London: Lib., British, Add. 24199
Prudentius, *Psychomachia*, fol. 9v
Date: Early 11th cent.

London: Lib., British, Add. 24199
Prudentius, *Psychomachia*, fol. 10r
Date: Early 11th cent.

London: Lib., British, Add. 24199
Prudentius, *Psychomachia*, fol. 10v
Date: Early 11th cent.

London: Lib., British, Cott. Cleo.
 C.VIII
Prudentius, *Psychomachia*, fol. 7v
Date: Early 11th cent.
Personification: Virtue, Patience

London: Lib., British, Cott. Cleo.
C.VIII
Prudentius, *Psychomachia*, fol. 8r
Date: Early 11th cent.

London: Lib., British, Cott. Cleo.
C.VIII
Prudentius, *Psychomachia*, fol. 8v
Date: Early 11th cent.

London: Lib., British, Cott. Cleo.
C.VIII
Prudentius, *Psychomachia*, fol. 9r
Date: Early 11th cent.

London: Lib., British, Cott. Cleo.
C.VIII
Prudentius, *Psychomachia*, fol. 9v
Date: Early 11th cent.
Personification: Virtue, Patience

London: Lib., British, Cott. Titus
D.XVI
Prudentius, *Psychomachia*, fol. 9v
Date: ca. 1100
Personification: Virtue, Patience

London: Lib., British, Cott. Titus
D.XVI
Prudentius, *Psychomachia*, fol. 10r
Date: ca. 1100

London: Lib., British, Cott. Titus
D.XVI
Prudentius, *Psychomachia*, fol. 10v
Date: ca. 1100

London: Lib., British, Cott. Titus
D.XVI
Prudentius, *Psychomachia*, fol. 11r
Date: ca. 1100

Lyons: Lib., Bibl. Municipale, Pal. des
Arts 22
Prudentius, *Psychomachia*, fol. 4r
Date: Last quarter 11th cent.
Personification: Virtue, Patience

Lyons: Lib., Bibl. Municipale, Pal. des
Arts 22
Prudentius, *Psychomachia*, fol. 4v
Date: Last quarter 11th cent.
Personification: Virtue, Patience

Lyons: Lib., Bibl. Municipale, Pal. des
Arts 22
Prudentius, *Psychomachia*, fol. 7r
Date: Last quarter 11th cent.
Personification: Virtue, Patience

Lyons: Lib., Bibl. Municipale, Pal. des
Arts 22
Prudentius, *Psychomachia*, fol. 7v
Date: Last quarter 11th cent.
Personification: Virtue, Patience

Munich: Lib., Staatsbibl., Clm. 30055
Gospel Book, Henry the Lion, fol. 16r
Date: ca. 1175
Apostle: Jude

Paris: Lib., Bibl. Nat. de France, lat.
2077
Miscellany, fol. 163r
Date: 10th–11th cent.
Personification: Vice, Pride

Paris: Lib., Bibl. Nat. de France, lat.
2077
Miscellany, fol. 168r
Date: 10th–11th cent.

Paris: Lib., Bibl. Nat. de France, lat.
8085
Prudentius, *Psychomachia*, fol. 58v
Date: Late 9th cent.
Personification: Virtue, Patience

Paris: Lib., Bibl. Nat. de France, lat.
8085
Prudentius, *Psychomachia*, fol. 59r
Date: Late 9th cent.
Personification: Virtue, Patience

Saint Gall: Lib., Stiftsbibl., 135
Prudentius, *Psychomachia*, p. 395
Date: First half 11th cent.
Personification: Virtue, Patience

Salzburg: Lib., Studienbibl., V 1 H 162
Miscellany, fol. 75v
Date: First half 12th cent.
Tree of Vices

Soissons: Lib., Bibl. Municipale, 221
Somme le Roi, fol. 21r
Date: 14th cent.

Strasbourg: Lib., Bibl. Municipale
Herradis of Landsberg, *Hort. Delic.,*
fol. 199v
Date: Second half 12th cent.
Personification: Vice, Pride

Strasbourg: Lib., Bibl. Municipale
Herradis of Landsberg, *Hort. Delic.,*
fol. 200v
Date: Second half 12th cent.

Strasbourg: Lib., Bibl. Municipale
Herradis of Landsberg, *Hort. Delic.,*
fol. 201r
Date: Second half 12th cent.
Personification: Virtue, Patience

Valenciennes: Lib., Bibl. Municipale,
563
Prudentius, *Psychomachia,* fol. 8r
Date: Early 11th cent.
Personification: Virtue, Patience

Valenciennes: Lib., Bibl. Municipale,
563
Prudentius, *Psychomachia,* fol. 8v
Date: Early 11th cent.
Personification: Virtue, Patience

Valenciennes: Lib., Bibl. Municipale,
563
Prudentius, *Psychomachia,* fol. 9r
Date: Early 11th cent.
Personification: Virtue, Patience

Valenciennes: Lib., Bibl. Municipale,
563
Prudentius, *Psychomachia,* fol. 10r
Date: Early 11th cent.
Personification: Virtue, Patience

Valenciennes: Lib., Bibl. Municipale,
563
Prudentius, *Psychomachia,* fol. 10v
Date: Early 11th cent.

Valenciennes: Lib., Bibl. Municipale,
563
Prudentius, *Psychomachia,* fol. 11r
Date: Early 11th cent.
Personification: Virtue, Patience

Wolfenbüttel: Lib., Herzog August
Bibl., Guelf. 105 Noviss. 2°
Gospel Book, Henry the Lion, fol. 16r
Date: ca. 1175
Apostle: Jude

METALWORK

New York: Mus., Metropolitan,
Cloisters
Bowl, copper-gilt (N.65.89)
Date: First half 12th cent.
Personification: Vice, Pride

Nuremberg: Mus., Germ.
Nationalmus.
Bowl, copper-gilt (KG 1183)
Date: First half 13th cent.
Personification: Vice, Pride

Trier: Ch., Maximin
Font, of Folcardus
Date: Early 12th cent.
Personification: Virtue, Humility

SCULPTURE

Argenton-Château: Ch., Gilles
Exterior, west
Date: After 1130
Ornament: Figured

Aulnay-de-Saintonge: Ch., Pierre
Exterior, west
Date: ca. 1130–1150
Month: Occupation

Autun: Cath., Lazare
Apse
Date: First half 12th cent.
Ornament: Figured

Autun: Cath., Lazare
Chapter room
Date: First half 12th cent.
Scene: Ecclesiastic, Donation

Clermont-Ferrand: Ch., Notre Dame
du Port
Choir
Date: 12th cent.
Angel

Louvain: Abbey, Gertrude
Cloister
Date: Late 14th cent.
Beasts of Apocalypse

Magdeburg: Cath., Mauritius und
 Katharina
Choir
Date: First half 13th cent.
Apostle: Andrew

Paris: Cath., Notre Dame
Exterior, west
Date: ca. 1220–1230
Christ: Last Judgment

Regensburg: Ch., Jakob
Exterior, north
Date: Second half 12th cent.
Christ

Reims: Cath., Notre Dame
Exterior, west
Date: ca. 1230–1240
Virgin Mary: Coronation

Southrop: Church
Font
Date: ca. 1160
Personification: Church and
 Synagogue

Stanton Fitzwarren: Church
Font
Date: ca. 1160
Personification: Church

Vézelay: Ch., Madeleine
Nave
Date: First half 12th cent.
Saint

UNIDENTIFIED VICES

ENAMEL

Copenhagen: Mus., National
Vessel, cruet
Date: 1333
Christ: Parable, Prodigal Son

FRESCO

Aquileia: Cathedral
Crypt
Date: 1180s
Virgin Mary: Death

Brixen: Ch., Frauenkirche
Nave
Date: First half 13th cent.
Saint

Brooke: Ch., Peter
Nave
Date: ca. 1400

Limburg: Cath., Georg
Date: First half 13th cent.
Personification: Ocean and Earth

GLASS

Freiburg: Cath., Unsere Liebe Frau
Window, tower
Date: 14th cent.
Month: Occupation

Paris: Cath., Notre Dame
Window, west rose
Date: First half 13th cent.
Virgin Mary and Christ Child

MANUSCRIPT

Bamberg: Lib., Staatsbibl., Bibl. 140
Apocalypse-Pericope, fol. 60r
Date: Early 11th cent.
Personification: Virtue, Obedience

Berne: Lib., Stadtbibl., 264
Prudentius, *Psychomachia*, fol. 38r
Date: Early 10th cent.
Personification: Virtue, Chastity

Berne: Lib., Stadtbibl., 264
Prudentius, *Psychomachia*, fol. 41r
Date: Early 10th cent.
Personification: Virtue, Patience

Brussels: Lib., Bibl. Royale, 9968-72
Prudentius, *Psychomachia*, fol. 82r
Date: 11th cent.
Personification: Virtue, Patience

Brussels: Lib., Bibl. Royale, 9987-91
Prudentius, *Psychomachia*, fol. 102v
Date: 10th cent.
Personification: Virtue, Chastity

Brussels: Lib., Bibl. Royale, 9987-91
Prudentius, *Psychomachia*, fol. 105r
Date: 10th cent.
Personification: Virtue, Patience

Brussels: Lib., Bibl. Royale, 9987-91
Prudentius, *Psychomachia*, fol. 114r
Date: 10th cent.
Personification: Vice, Avarice

Brussels: Lib., Bibl. Royale, 9987-91
Prudentius, *Psychomachia*, fol. 117v
Date: 10th cent.
Personification: Virtue, Peace

Florence: Lib., Bibl. Naz. Centrale,
 Palat. 600
Bartholomew of S. Concordio,
 Ammaestramenti, fol. 63r
Date: 14th cent.

Florence: Lib., Bibl. Naz. Centrale,
 II.II.319
Bartholomew of S. Concordio,
 Ammaestramenti, fol. 21r
Date: 1342

Hague: Mus., Meermanno-
 Westreenianum, 10 B 29
Roman de la Rose, fol. 1r
Date: Second half 14th cent.
Scene: Secular

Leiden: Lib., Bibl. der Univ., Burm. Q.3
Prudentius, *Psychomachia*, fol. 128r
Date: Second quarter 9th cent.
Personification: Virtue, Patience

Leiden: Lib., Bibl. der Univ., Burm. Q.3
Prudentius, *Psychomachia*, fol. 137r
Date: Second quarter 9th cent.
Personification: Vice, Avarice

Leiden: Lib., Bibl. der Univ., Burm. Q.3
Prudentius, *Psychomachia*, fol. 141r
Date: Second quarter 9th cent.
Personification: Virtue, Peace

Leiden: Lib., Bibl. der Univ., Voss. lat.
 oct. 15
Prudentius, *Psychomachia*, fol. 38r
Date: Early 11th cent.
Personification: Virtue, Chastity

Leiden: Lib., Bibl. der Univ., Voss. lat.
 oct. 15
Prudentius, *Psychomachia*, fol. 39v
Date: Early 11th cent.
Personification: Virtue, Hope

London: Lib., British, Add. 18719
Bible, Moralized, fol. 224r
Date: Early 14th cent.
Zechariah: Prophecy

London: Lib., British, Cott. Cleo.
 C.VIII
Prudentius, *Psychomachia*, fol. 15r
Date: Early 11th cent.
Personification: Vice, Luxury

Lyons: Lib., Bibl. Municipale, Pal. des
 Arts 22
Prudentius, *Psychomachia*, fol. 4r
Date: Last quarter 11th cent.
Personification: Virtue, Patience

Lyons: Lib., Bibl. Municipale, Pal. des
 Arts 22
Prudentius, *Psychomachia*, fol. 15v
Date: Last quarter 11th cent.
Personification: Vice, Fear

Oxford: Lib., Bodleian, 270b
Bible, Moralized, fol. 13v
Date: First half 13th cent.
Abraham: Battle against Kings

Paris: Lib., Bibl. Nat. de France,
fr. 12399
*Livre du Roi Modus et de la Reine
Ratio*, fol. 134v
Date: 1379

Paris: Lib., Bibl. Nat. de France,
lat. 2077
Miscellany, fol. 168r
Date: 10th–11th cent.
Personification: Vice, Wrath

Paris: Lib., Bibl. Nat. de France,
lat. 8085
Prudentius, *Psychomachia*, fol. 59v
Date: Late 9th cent.
Personification: Virtue, Patience

Paris: Lib., Bibl. Nat. de France,
lat. 8085
Prudentius, *Psychomachia*, fol. 63v
Date: Late 9th cent.
Personification: Virtue, Sobriety

Paris: Lib., Bibl. Nat. de France,
lat. 8085
Prudentius, *Psychomachia*, fol. 65v
Date: Late 9th cent.
Personification: Virtue, Peace

Paris: Lib., Bibl. Nat. de France,
lat. 11535-34
Bible, II, fol. 204r
Date: Late 12th cent.
Balaam: Opposed by Angel

Paris: Lib., Bibl. Nat. de France,
lat. 15158
Prudentius, *Psychomachia*, fol. 55v
Date: 1289
Personification: Virtue, Peace

Paris: Lib., Bibl. Sainte-Geneviève, 8-10
Bible, II, fol. 227v
Date: Late 12th cent.
Psalm 110 (Vulgate, 109)

Paris: Lib., Bibl. Sainte-Geneviève, 8-10
Bible, III, fol. 128r
Date: Late 12th cent.
Balaam: Opposed by Angel

Pommersfelden: Coll., Schönborn,
Library, 215
Miscellany, fol. 162v
Date: 14th cent.
Alanus de Insulis: Text

Rome: Lib., Bibl. Vaticana, gr. 394
John Climacus, *Climax*, fol. 89v
Date: Late 11th cent.
John Climacus: Climax, Chapter XV

Rome: Lib., Bibl. Vaticana, gr. 394
John Climacus, *Climax*, fol. 94r
Date: Late 11th cent.
John Climacus: Climax, Chapter XVIII

Saint Gall: Lib., Stiftsbibl., 135
Prudentius, *Psychomachia*, p. 395
Date: First half 11th cent.
Personification: Virtue, Patience

Saint-Omer: Lib., Bibl. Municipale, 34
Origen, *Homilies*, fol. 1v
Date: 12th cent.
Creation Scene

Toledo: Lib., Bibl. del Cabildo
Bible, Moralized, II, fol. 224r
Date: First half 13th cent.
Zechariah: Prophecy

Toledo: Lib., Bibl. del Cabildo
Bible, Moralized, III, fol. 187r
Date: First half 13th cent.
Apocalypse: John and Angel

Valenciennes: Lib., Bibl. Municipale,
563
Prudentius, *Psychomachia*, fol. 8r
Date: Early 11th cent.
Personification: Virtue, Patience

Valenciennes: Lib., Bibl. Municipale,
563
Prudentius, *Psychomachia*, fol. 12r
Date: Early 11th cent.
Personification: Virtue, Patience

Valenciennes: Lib., Bibl. Municipale,
563
Prudentius, *Psychomachia*, fol. 24v
Date: Early 11th cent.
Personification: Vice, Avarice

METALWORK

Ghent: Mus., Archéologie
Bowl, bronze (1283)
Date: 12th–13th cent.
Personification?

Hamburg: Mus., Kunst und Gewerbe
Aquamanile, bronze
Date: 1200–1230
Animal Vessel

London: Mus., British
Bowl, bronze (55.6-25.23)
Date: 12th cent.

PAINTING

Florence: Mus., Opera del Duomo
Panel (9152)
Attribution: Bigallo Master
Date: ca. 1240–1250
Zenobius of Florence

SCULPTURE

Albe: Ch., Pietro
Relief
Date: 12th cent.

Bardone: Ch., Assunta
Statue, marble
Date: 13th cent.
Figure: Female

Castelvieil: Ch., Notre Dame
Exterior, south
Date: 12th cent.
Scene: Sports and Games, Hunting

Clermont-Ferrand: Ch., Notre Dame
 du Port
Choir
Date: 12th cent.
Angel

Florence: Loggia dei Lanzi
Exterior
Date: 14th cent.
Personification: Virtues, Cardinal

Freiburg: Cath., Unsere Liebe Frau
Tower
Date: 13th–14th cent.
Virgin Mary: Coronation

Guebwiller: Ch., Léger
Exterior
Date: Late 12th cent.
Ornament: Figured

Hal: Ch., Notre Dame
Chapel, seventh
Date: ca. 1400
Catherine of Alexandria

Magdeburg: Cath., Mauritius und
 Katharina
Choir
Date: First half 13th cent.
Apostle: Andrew

Nuremberg: Ch., Frauenkirche
Choir
Date: 14th cent.
Figure: Male

Oxford: Cath., Christ Church
Chapter house
Date: First half 13th cent.
Christ

Philadelphia (Penn.): Mus., Museum
 of Art
Capital, sandstone (45.25.47)
Date: Late 12th cent.

Piacenza: Cath., Assunta
Exterior, west, central portal
Date: ca. second quarter 12th cent.
Personification: Vice, Avarice

Regensburg: Ch., Jakob
Exterior, north
Date: Second half 12th cent.
Christ

Reims: Cath., Notre Dame
Exterior, west
Date: ca. 1230–1240
Virgin Mary: Coronation

Santiago de Compostela: Cathedral
Narthex
Date: 1188
Christ: Last Judgment

Schöngrabern: Church
Exterior, east
Date: First half 13th cent.
Weighing of Soul

Strzelno: Ch., Trinity
Nave, column
Date: Last quarter 12th cent.
Christ: Baptism

TREE OF VICES

FRESCO

Bardwell: Ch., Peter and Paul
Nave
Date: Late 14th cent.

Cranborne: Ch., Mary and
 Bartholomew
Nave
Date: 14th cent.
*Christopher of Lycia: Carrying Christ
 Child*

Crostwight: Ch., All Saints
Nave
Date: 14th cent.

Dalham: Ch., Mary
Nave
Date: ca. 1400

Felstead: Ch., Holy Cross
Nave
Date: Mid-14th cent.

Hoxne: Ch., Peter and Paul
Nave
Date: Late 14th cent.

South Leigh: Church
Aisle, north
Date: 14th cent.

MANUSCRIPT

Baltimore: Gall., Walters, W. 72
Speculum Virginum, fol. 25v
Date: First half 13th cent.
Personification: Vice, Pride

Cologne: Arch., Historisches, W 276a
Speculum Virginum, fol. 11v
Date: Mid-12th cent.
Personification: Vice, Pride

Ghent: Lib., Bibl. de l'Université, 92
Lambertus, *Liber Floridus*, fol. 232r
Date: 1120

Kremsmünster, Lib., Stiftsbibl., 243
Spec. Hum. Salvationis, fol. 3r
Date: First half 14th cent.

Leipzig: Lib., Universitätsbibl., 148
Miscellany, fol. 113v
Date: 1133

Leipzig: Lib., Universitätsbibl., 305
Miscellany, fol. 151r
Date: 13th cent.
Personification: Vice, Pride

Leipzig: Lib., Universitätsbibl., 665
Speculum Virginum, fol. 39v
Date: Mid-14th cent.
Personification: Vice, Pride

London: Lib., British, Arundel 44
Speculum Virginum, fol. 28v
Date: ca. 1140–1150
Personification: Vice, Pride

London: Lib., British, Arundel 83
Psalter, fol. 128v
Date: First half 14th cent.
Psalms: Illustration

Salzburg: Lib., Studienbibl., V 1 H 162
Miscellany, fol. 75v
Date: First half 12th cent.

Troyes: Lib., Bibl. Municipale, 252
Speculum Virginum, fol. 29v
Date: ca. 1190
Personification: Vice, Wrath

SEVEN VICES

MANUSCRIPT

Paris: Lib., Bibl. Nat. de France, fr. 167
Bible, Moralized, fol. 59r
Date: ca. 1350
Samson: Delilah Bribed by Philistines

Vienna: Lib., Nationalbibl., 370
Miscellany, fol. 155v
Date: 14th cent.

WHEEL OF VICES

FRESCO

Ingatestone: Ch., Mary and Edmund
Decoration
Date: Late 14th cent.

Conflict of Virtues and Vices

🎇

ENAMEL

Cologne: Ch., Heribert
Casket, S. Heribertus
Date: ca. 1150–1175
Heribertus of Cologne: Scene

Cologne: Mus., Angewandte Kunst
Plaques, from reliquary
Date: 12th cent.

Paris: Coll., Ratton
Candlestick
Date: 13th cent.

FRESCO

Brioude: Ch., Julien
Porch
Date: 12th–13th cent.
Christ: Last Judgment

Claverly: Ch., All Saints
Nave
Date: ca. 1200
Scene: Battle

Deddington: Ch., Peter and Paul
Aisle, north
Date: 13th cent.
Scene: Unidentified

Kingston: Ch., Andrew and All Saints
Choir
Date: 13th cent.
Saint

Laval: Ch., Martin
Crossing
Date: 12th cent.

Méobecq: Ch., Abbey
Apse
Date: 12th cent.
Ledoaldus of Méobecq

Passau: Mon., Niederenburg, Kreuz
 Kapelle
Narthex
Date: ca. 1200
Christ: Anointed by Woman

Saint-Desiré: Church
Decoration
Date: 1116
Soldier

Schwarzrheindorf: Ch., Pfarrkirche,
 Lower
Nave
Date: 1151–1156
Christ: Purging of Temple

Summaga: Ch., Maria Assunta
Decoration
Date: 11th cent.
Virgin Mary and Christ Child

Tavant: Ch., Nicolas
Crypt
Date: 11th–13th cent.
Adam and Eve: Fall of Man

Vicq: Church
Nave
Date: Second quarter 12th cent.
Christ and Apostles

GLASS

Naumberg: Cathedral
Choir, west
Date: 13th cent.

IVORY

Florence: Mus., Naz. di Bargello
Plaque, from book cover? (30 C)
Date: Early 9th cent.

MANUSCRIPT

Bamberg: Lib., Staatsbibl., Bibl. 140
Apocalypse-Pericope, fol. 60r
Date: ca. 1000–1010
Personification: Virtue, Obedience

Brussels: Lib., Bibl. Royale, 10176-78
G. de Digulleville, *Pèlerinage*, fol. 193r
Date: 14th–15th cent.
*Guillaume de Digulleville, Pèlerinage
 de l'Ame*

Lisbon: Mus., Gulbenkian, L. A. 139
Apocalypse, fol. 34v
Date: Second half 13th cent.
Apocalypse: Illustration

London: Lib., British, Add. 42555
Apocalypse, fol. 39r
Date: Before 1263
Apocalypse: Illustration

Oxford: Lib., Bodleian, 270b
Bible, Moralized, fol. 13v
Date: First half 13th cent.
Abraham: Battle against Kings

Oxford: Lib., Bodleian, 270b
Bible, Moralized, fol. 26r
Date: First half 13th cent.
Joseph: As Interpreter of Dreams

Paris: Lib., Bibl. Sainte-Geneviève, 8-10
Bible, II, fol. 194r
Date: Late 12th cent.
Psalm 1

METALWORK

Arnhem: Mus., Historisch
Book cover, silver (PG 2)
Date: ca. 1200–1250
Christ and Four Beasts

London: Mus., Victoria and Albert
Plaque, bronze-gilt
Date: First half 14th cent.
Personification: Virtue

Milan: Cathedral
Candelabrum, bronze-gilt
Date: ca. 1180
Virgin Mary and Christ Child

Novgorod: Cath., Sophia
Door, bronze
Attribution: Riquinus of Magdeburg
Date: 1152–1156
Christ and Peter and Paul

SCULPTURE

Angers: Préfecture
Cloister
Date: First half 12th cent.
Ornament: Figured

Aulnay-de-Saintonge: Ch., Pierre
Exterior, south
Date: ca. 1130–1150

Biron: Church
Exterior, west
Date: 12th cent.
Ornament: Figured

Blasimon: Ch., Maurice
Exterior, west
Date: 12th cent.
Scene: Sports and Games, Hunting

Bourges: Cath., Etienne
Exterior, south
Date: 12th cent.
Christ and Four Beasts

Brioude: Ch., Julien
Capitals
Date: 12th cent.

Castelvieil: Ch., Notre Dame
Exterior, south
Date: 12th cent.
Scene: Sports and Games, Hunting

Chadenac: Ch., Martin
Exterior, west
Date: 12th cent.
Saint

Châlons-sur-Marne: Mus., Cloister
Column (RF 1105, RF 1108)
Date: Second half 12th cent.

Châteaudun: Ch., Madeleine
Exterior, south
Date: 12th cent.
Ornament: Figured

Civray: Ch., Nicholas
Exterior, west
Date: 12th cent.
Prophet

Cologne: Cath., Peter und Maria
Choir stalls
Date: First half 14th cent.
Scene: Secular

Corme-Royal: Church
Exterior, west
Date: 12th cent.
*Christ: Parable, Wise and Foolish
 Virgins*

Fenioux: Church
Exterior, west
Date: 1130
Ornament: Figured

Fishlake: Church
Exterior, south
Date: 12th cent.

Fontaines-d'Ozillac: Ch., Martin
Exterior, west
Date: 12th cent.

Malmesbury: Ch., Abbey
Exterior, south
Date: Second half 12th cent.
Virgin Mary: Annunciation

Melle-sur-Béronne: Ch., Hilaire
Exterior, north
Date: 12th cent.
Month: Occupation

Millstatt: Ch., Salvator und Allerheiligen
Cloister
Date: 12th–13th cent.
Apostle: Paul

Parthenay: Ch., Notre Dame de la
 Couldre
Exterior, west
Date: 12th cent.
Elders, Four and Twenty

Pérignac: Ch., Pierre
Exterior, west
Date: 12th cent.
Christ: In Mandorla

Pont-l'Abbé-d'Arnoult: Ch., Pierre
Exterior, west
Date: 12th cent.
*Christ: Parable, Wise and Foolish
 Virgins*

Saint-Pompain: Church
Exterior, west
Attribution: Gilglelm
Date: 12th cent.

Saint-Symphorien: Church
Exterior, west
Date: First half 12th cent.
Elders, Four and Twenty

Salisbury: Cathedral, Chapter House
Decoration, vestibule
Date: ca. 1260–1280

San Cugat del Vallés: Church
Cloister
Date: Late 12th–13th cent.
Adam and Eve: Commanded by God

Strasbourg: Cath., Notre Dame
Exterior, west
Date: ca. 1280
Solomon: Throne

Varaize: Church
Exterior, south
Date: 12th cent.
Angel

Xanten: Chap., Dionysius
Exterior
Date: ca. 1080
Soldier

TEXTILE

Nuremberg: Mus., Germ. Nationalmus.
Hanging
Date: Late 14th cent.

Index of Catalogued Objects